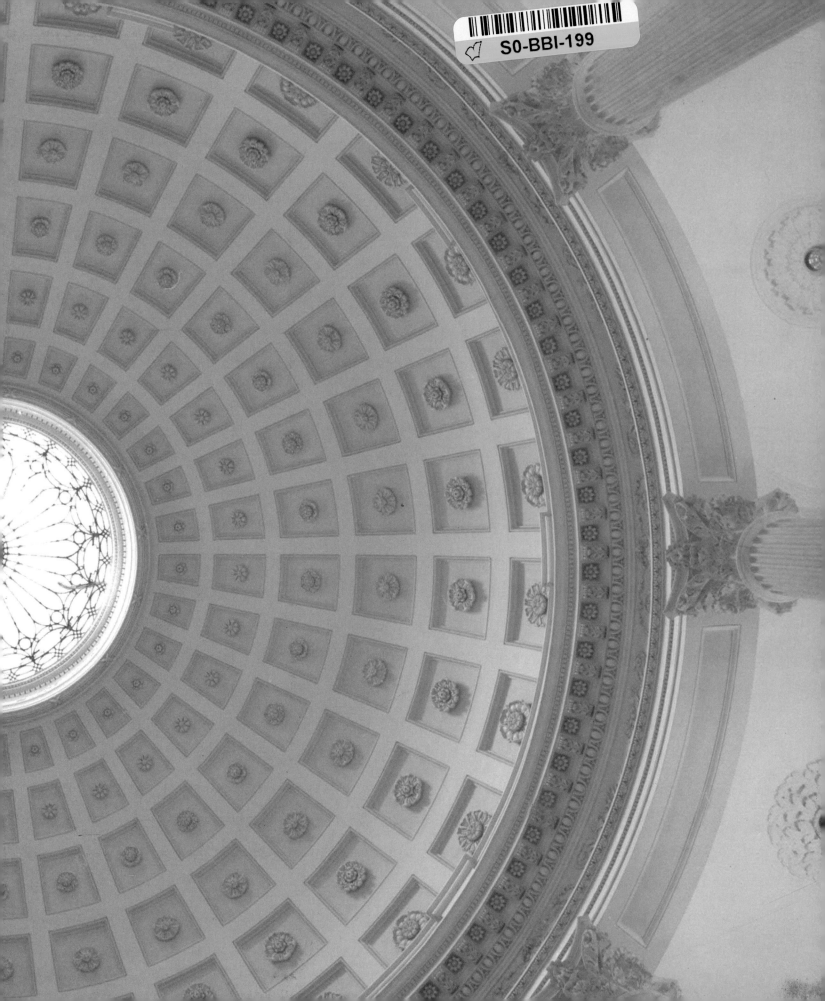

THE LANDMARKS OF NEW YORK

THE LANDMARKS OF NEW YORK

AN ILLUSTRATED RECORD OF THE CITY'S HISTORIC BUILDINGS

Barbaralee Diamonstein-Spielvogel

THE MONACELLI PRESS

For Sally Dworkin Simmons, Carl D. Spielvogel
and Jake, Harrison, Sophia, Nicholas, Katharine, Chloe, Acadia, Robert,
and all the owners, occupants, friends, and supporters
of the Landmarks of New York

First published in the
United States of America in 2005 by
The Monacelli Press, Inc.
611 Broadway, New York, New York 10012

Library of Congress Cataloging-in-Publication Data
Diamonstein, Barbaralee.
The Landmarks of New York : an illustrated record of the city's historic buildings /
Barbaralee Diamonstein-Spielvogel.-- 1st ed.
p. cm.
Includes index.
ISBN 1-58093-154-5
1. Historic buildings—New York (State)—New York. 2. Historic buildings—New
York (State)—New York.)—Pictorial works. 3. New York (N.Y.)—Buildings, struc-
tures, etc. 4. New York (N.Y.)—Buildings, structures, etc.—Pictorial works. 5. New
York (N.Y.)—Pictorial works. I. Title.
F128.7.D57 2005
974.7'1'0222-dc22 2004026135

Printed in Italy

Designed by Pentagram
Design production by Lisa Paruch

Contents

THE LANDMARKS OF NEW YORK 1965–2005
FORTY YEARS OF PRESERVATION

For most of our history, Americans have been fervent believers in progress, which has often meant, in the realm of architecture, tearing down the old and building again—bigger, bolder, and taller than before. This is particularly true of New Yorkers, whose city, in its ceaseless ebb and flow, is a monument to transience, a moveable feast. New York City's quintessential characteristic is its quicksilver quality, its ability to transform itself not just from year to year, but almost from day to day. Cast your eyes upward almost anywhere in the city: a forest of cranes challenges the sky. The French architect Le Corbusier saw New York as a "white cathedral" that is never finished, "a geyser whose fountains leap and gush in continual renewal." He said of our city: "It has such courage and enthusiasm that everything can be begun again, sent back to the building yard, and made into something greater . . . A considerable part of New York is nothing more than a provisional city. A city which will be replaced by another city." This is New York: its motion perpetual, its details a blurred collage.

Yet amid this constant change, we have managed to preserve at least part of the city's legacy of great architecture. Until recently, it seemed that this would not be possible. During the first three centuries of the city's existence, many of its fine buildings were destroyed. Not until the 1960s did an urban preservation movement emerge with the objective of conserving the best of our past—architecturally, historically, and culturally.

Preservationists have long argued the intangible social benefits of protecting the past from the wrecker's ball. By conserving our historical and physical heritage, preservation provides a reassuring chain of continuity between past and present. And a sense of continuity, an awareness that some things last longer than mortal existence, is important to people. Cities, as the greatest communal works of man, provide the deepest assurance that this is true. This reality may be the city's most valuable cultural function. Lewis Mumford put it most succinctly when he observed, "In the city, time becomes visible."

Through the centuries, many of mankind's greatest buildings have been destroyed, some by acts of vandalism, others by not-always-benign neglect. The ongoing saga of destruction and construction, the endless clash between old and new, between tradition and progress, has always engaged poets and politicians. But in the last few decades, the delicate mesh that weaves the new into the old, continuing the layering process that creates a

culture, has captured the interest of a far larger, and still-growing, number of people. Public attention has been focused not only on the protection of our fast-vanishing wilderness, but also on the urgent need to protect our architectural environment—from its irreplaceable structures to its cherished open spaces and parks. These natural and cultural resources, it has been said, are inherited from our ancestors and borrowed from our children. We are challenged to honor this pact and protect our legacy from human, industrial, and aesthetic pollution. Fortunately, we Americans have grown in our appreciation of our historical environment as being both beautiful and useful. For nearly a half-century, a dedicated army of women and men, some holding official positions in public and private preservation organizations and others laboring in far less visible capacities, has had a remarkable impact on the character and appearance of our cities.

Historic Preservation in the United States

The need to protect and preserve our cultural resources was first recognized by various groups of private citizens in the early 1800s, when voices began to be raised against the demolition of buildings identified with the nation's history. Perhaps the most significant nineteenth-century effort was the fight to save Mount Vernon, spearheaded by Ann Pamela Cunningham, a remarkable, dedicated and persevering woman. Her success in saving that national monument inspired other efforts to protect and preserve historic sites and gave rise to a number of pioneering organizations and societies. In 1888, the Association for the Preservation of Virginia Antiquities was formed to protect Jamestown. Such societies as the Daughters of the American Revolution and the National Society of the Colonial Dames of America began to center their efforts on historic preservation. The Society for the Preservation of New England Antiquities, begun in 1910, rescued many important landmarks in that region. The idea of preserving larger areas, though later subject to revisionist criticism, gained ground. The model was John D. Rockefeller's reconstruction of Colonial Williamsburg, which began in 1926.

The first official federal legislation resulted from the Antiquities Act of 1906, which authorized the nation's president to designate as national monuments those areas of the public domain containing historic landmarks, historic and prehistoric structures, and objects of historical importance that were situated on federal property. A decade later, in 1916,

the National Parks Service was created to protect historic and national parks. Local governments, too, started to enact preservation laws authorizing the designation and preservation of local buildings and neighborhoods of historic significance. New Orleans adopted its laws in 1925; Charleston in 1937; and San Antonio in 1939. State governments also began to support preservation efforts.

With the Historic Sites Act of 1935, Congress proclaimed "a national policy to preserve for public use historic sites, buildings, and objects of national significance." Unfortunately, the declared national policy was by no means the standard national practice, and despite it, precious structures were demolished. Aware that its earlier efforts had been inadequate, Congress chartered the National Trust for Historic Preservation in 1949 to foster awareness and advocacy. In 1966, the National Historic Preservation Act called for preserving the integrity of cultural property of national, state, and local importance. At the same time, the National Register of Historic Places was created to encourage the identification and protection of the nation's historic structures through an ongoing inventory of such landmarks.

Preservation's coming-of-age was most evident in the expansion of activity at the local government level. By 1966, approximately one hundred communities had established landmarks commissions or their equivalents. A decade later, the figure rose to five hundred; by 1982, roughly one thousand; and by 1987 more than twelve hundred. In 1998, there were nineteen hundred local preservation commissions, and by the end of 2004, the National Alliance of Preservation Commissions estimated that there were as many as twenty-four hundred local preservation commissions. Clearly, preservation has come a long way from the early days of limited, ad hoc activity.

HISTORIC PRESERVATION IN
NEW YORK CITY

As far back as 1831, New Yorkers had begun to fret that many important structures were being destroyed in order to make way for new ones. In March of that year, the *New York Mirror* carried a picture of an old Dutch house on Pearl Street, in Lower Manhattan, with the caption "Built in 1626, Rebuilt 1647, Demolished 1828," accompanied by a ringing editorial criticizing the destruction. Just seven years later, Mayor Philip Hone had this to say about the city's penchant for tearing itself apart: "The city is

9

now undergoing its usual metamorphosis; many stores and houses are being pulled down and others altered to make every inch of ground productive to its utmost extent. It looks like the ruins occasioned by an earthquake." Not a bad way to describe the situation, more than one hundred and fifty years later.

In its early history, the city grew by moving uptown in Manhattan and outward in the other boroughs. By the early 1900s, the land, at least in Manhattan, was largely filled. In most cases, the only way to build something new was to tear down something else or to build on top of it. At first, most New Yorkers accepted the destruction of the past as the price to be paid for progress. They had little use for Victor Hugo's injunction: "Let us, while waiting for new monuments, preserve the ancient monuments." Instead, they relished what Walt Whitman referred to in the mid-1840s as the "pull-down-and-build-over-again" spirit, which seemed to epitomize their city and all of America.

Yet some citizens fully endorsed Mayor Hone's appeal to resist the temptation to "overturn, overturn, overturn." During the prosperous post–Civil War years, Americans who had traveled throughout Europe on the grand tour came home with a new awareness and appreciation of the indigenous American culture that had taken root, particularly its architecture. In 1904, Henry James returned from Europe to find that his home in Boston had been demolished. "This act of obliteration had been breathlessly swift," he wrote, "and if I had often seen how fast history could be made, I had doubtless never so felt that it could be unmade still faster." About the same time, the writer Edith Wharton warned that if New York kept tearing down its great old buildings and putting up inferior replacements, one day it "would become as much a vanishing city as Atlantis or the lowest layer of Schliemann's Troy." In the October 23, 1869, issue of *Harper's Weekly*, a caption read "In a city where new construction is constantly in progress, demolition of the old and the excavation of the site are a commonplace to which New Yorkers have long been accustomed."

Indeed, much of older New York's most treasured architecture—in SoHo, in parts of Greenwich Village, in Little Italy—has survived solely by chance. At critical moments, the development climate simply was not vigorous enough to make it worthwhile to knock down the older buildings in those areas and put up new ones. In fact, we owe it to

accident alone that some of the most valuable artifacts of our past have survived. But accidents are, by definition, sometime things. The sad truth is that of all the works of architecture in this country still standing in 1920 that we would now find worth saving for historic or aesthetic reasons, almost 90 percent have been wantonly destroyed. Today, preserving our built environment—not just the exteriors of structures but their interiors as well—is less a matter of chance. All about us, in New York, are buildings that have been saved, in large measure due to the dedication of the New York City Landmarks Preservation Commission, the Municipal Art Society, the New York Landmarks Conservancy, the Historic Districts Council, and the vigilance of citizen activists and neighborhood associations.

The emergence of the New York City Landmarks Preservation Commission came about as the result of years of work by concerned citizens. Among them were members of two groups that helped to educate the public about the city's architectural heritage, the Municipal Art Society and the New York Community Trust, as well as lobbyists for such community organizations as the Brooklyn Heights Association. Between the late 1950s and the mid-1960s, the city lost some of its finest architecture to one glass-and-steel tower after another, in a building binge that threatened to obliterate whatever old and good structures remained. Public concern was so manifest that the modernist architect Philip Johnson, one of the leading practitioners of the International Style, joined other marching protesters to mourn the loss of Pennsylvania Station in 1963.

Other important buildings were lost during the same period, but it was the destruction of Penn Station that accelerated the creation of the New York City Landmarks Preservation Commission. The original Pennsylvania Station, one of the acknowledged monuments of our century, was designed by Charles Follen McKim of McKim, Mead & White. "In our history there was never another building like Penn Station," wrote Philip Johnson. "It compares with the great cathedrals of Europe." In 1962, its fate was determined, when the financially ailing Pennsylvania Railroad sold the air rights above the station to permit construction of a new Madison Square Garden (a building utterly lacking in distinction or quality.) The station was torn down and replaced with a new, "smaller" one. What planners did not imagine at that time was that intercity and commuter rail service would revive and that, in fewer than twenty years, the new station

11

would be impossibly congested. The Penn Station facility has undertaken a long series of renovations to accommodate its increasing number of daily passengers. The result does not suffice at peak periods, and even at regular levels, traffic is impeded by accessways that do not function. Since 1999, there has been a proposal to convert the Farley Building, the central post office adjacent to the Penn Station site, and its underground spaces to serve as a new station that would recall the grandeur of the lost 1910 structure. According to Nicolai Ouroussoff of the *New York Times*:

> A new Pennsylvania Station has been a pet project of politicians from both sides of the aisle, including the late Sen. Daniel Patrick Moynihan, for whom the proposed station is named, and Gov. George Pataki . . . Skidmore's expansive design would be a big step toward rectifying one of the greatest architectural tragedies in the city's history: the 1964 [sic] demolition of McKim, Mead & White's glorious 1910 Pennsylvania Station, a monument to American democratic values, and its replacement by the dark, claustrophobic present-day station, one of the most dehumanizing public spaces in the city. The Skidmore, Owings & Merrill proposal acknowledges this historical context without slipping into nostalgia. The Farley Building's main façade, with its grand staircase and row of Corinthian columns, would remain intact and would continue to serve as a post office.

Preservationists, architects, and humanists were stunned that such a desecration could take place. By the time they had rallied to save the building, however, it was too late. No legal mechanism existed, nor was sufficient public pressure generated, to fight for its survival. "Until the first blows fell," wrote the *New York Times* on October 30, 1963, "no one was convinced that Penn Station really would be demolished or that New York would permit this monumental act of vandalism . . . Any city gets what it admires, will pay for, and ultimately deserves. Even when we had Penn Station, we couldn't afford to keep it clean. We want and deserve tin-can architecture in a tin-horn culture. And we will probably be judged not by the monuments we build but by those we have destroyed." In reply to mounting public criticism, the president of the Pennsylvania Railroad Company wrote a letter to the *Times* asking, "Does it make any sense to preserve a building merely as a 'monument'?" As Nathan Silver states in *Lost New York*, "The station was sacrificed through the application of real

estate logic that often dictates the demolition of the very building that makes an area desirable." The absurdity and the iconoclasm of the act were noted by many constituencies: how could a city as civilized and culturally oriented as New York permit the annihilation of one of its most important physical legacies?

Soon thereafter, the most important legislative and regulatory institution to preserve New York's built heritage, was born. On April 19, 1965, Mayor Robert F. Wagner signed the legislation that created the New York City Landmarks Preservation Commission. Despite the fact that a hundred other cities had already established preservation commissions by 1965, New York has since become the pacesetter in preservation work. By one estimate, New York has succeeded in designating at least four times as many landmarks and five times as many historic districts, compared to fourteen major cities whose combined population is twice that of New York. Over the last forty years, the law has helped transform the process of preservation from a series of brushfire rescue operations into an integral part of city government.

Numbers, of course, cannot tell the whole story. It is neither feasible nor desirable to measure the success of the preservation effort merely by the number of old buildings that have been saved. Nor, for that matter, does it make sense to preserve structures by restricting their functions to what they had been in the past; the effect would be to create a city of mausoleums rather than one of functioning, evolving buildings that people actually use. With its mandate to conserve New York's architectural past, the Landmarks Preservation Commission is justifiably proud that it "has not wanted to make museums of all its historic treasures," but has vigorously promoted the recycling of carefully selected buildings instead. For example, at least five new uses were proposed for the Astor Library, but it was theater producer Joseph Papp's vision and imagination—in combination with the New York City landmarks preservation ordinance— that in the mid-1960s succeeded in saving the elegant structure from destruction, and transforming it into the Joseph Papp Public Theater, a thriving cultural institution.

The New York City Landmarks Preservation Commission is charged with identifying and designating landmarks and with regulating their preservation. The identification of structures and sites is an important part of guarding New York City's rich past. Some sites represent events of historical significance, people's association with the city's history, or a certain style or period of architecture. Others are designated because they represent a way of life, a way of doing business, or a way of maintaining a community in an ever-changing world.

Of the 837,844 tax lots (as of January 1, 2004, excluding condominiums) in the city, the number of structures in historic districts is more than 22,402. Among these are banks, bridges, apartment houses, piers, theaters, streets, churches, factories, schools, cemeteries, parks, clubs, museums, office towers, archeological sites, and even trees. As of October 2004, those designated include more than 1,116 exterior landmarks, 84 historic districts, including 11 extensions to the existing historic districts (which themselves include nearly 23,000 sites), 104 interior landmarks, and 9 scenic landmarks. The vast majority of both landmarks and districts are in Manhattan: 800 landmarks and 50 districts. Brooklyn has 122 landmarks and 16 districts; The Bronx has 64 landmarks and 9 districts; Staten Island has 78 landmarks and 3 districts; while Queens has 52 landmarks and 6 districts. Although this may sound like a great many, it actually accounts for approximately 2 percent of the property in New York City.

What makes a "landmark" a landmark? The New York City Landmarks Preservation Commission law defines a landmark as a structure at least thirty years old, which has "a special character or special historical or aesthetic interest or value as part of the development, heritage or cultural characteristics of the city, state, or nation." The chief criterion for designating landmarks is architectural integrity; approximately six percent have been designated for their historical significance. Buildings and scenic landmarks are also designated for cultural reasons, such as being associated with celebrated people or events. The law further states:

> It is hereby declared as a matter of public policy that the protection, enhancement, perpetuation and use of improvements and landscape features of special character or special historical or aesthetic interest or value is a public necessity and is required in the interest of the health,

prosperity, safety and welfare of the people. The purpose is to effect and accomplish the protection, enhancement and perpetuation of such improvements and landscape features and of districts which represent or reflect elements of the city's cultural, social, economic, political and architectural history; safeguard the city's historic, aesthetic and cultural heritage; stabilize and improve property values; foster civic pride in the beauty and noble accomplishments of the past; protect and enhance the city's attractions to tourists and visitors and the support and stimulus to business and industry; strengthen the economy of the city; promote the use of historical districts, landmarks, interior landmarks, and scenic landmarks for the education, pleasure and welfare of the city.

An interior landmark is defined as an interior of a structure, or any part thereof, which is at least thirty years old, that is customarily open and accessible to the public and that has special landmark qualities. Some examples include the Bartow-Pell Mansion in the Bronx, the Woolworth Building in Manhattan, and the Brooklyn Historical Society Building. However, the law prohibits the designation of the interiors of places of worship.

A scenic landmark is defined as a landscape feature, or a group of features, which is of special character or historical or aesthetic interest, and is at least thirty years old. It must also be situated on city-owned property. Some examples include Central Park, Verdi Square on Broadway and 73rd Street, and Prospect Park in Brooklyn.

With 25 million visitors each year to its 843 acres, Central Park is the most frequently visited urban park in the United States. The Central Park Conservancy provides more than 85 percent of the park's annual $20 million operating budget and is responsible for all basic care of the park. The Central Park Conservancy is a private, not-for-profit organization that manages Central Park under a contract with the City of New York/Department of Parks and Recreation. According to its history, the Conservancy has raised more than $300 million to transform Central Park into a model for urban parks nationwide. Since its founding in 1980, the Conservancy has prescribed a management and restoration plan for the Park; funded major capital improvements; created programs for volunteers and visitors; and set new standards of excellence in park care.

Distinct from individual landmarks, a historic district is an area that has a special character or special historical or aesthetic interest representing one or more architectural styles or periods and that constitutes a distinct section of the city. For example, the Charlton-King-Vandam Historic District, on the site of Richmond Hall, once Aaron Burr's estate, contains fine Federal and Greek Revival houses. The St. Mark's Historic District, on land that was Peter Stuyvesant's, contains very early Federal and fine Anglo-Italianate row houses. The Ladies' Mile Historic District, the fashion center of New York's Gilded Age, had a concentration of the city's first department stores, including Lord & Taylor, B. Altman & Co., and Tiffany & Co. Its best-known residents included Edith Wharton, Isabella Stewart Gardner, Samuel F. B. Morse, and Emily Post.

The Landmarks Preservation Commission consists by law of eleven members, one of whom is a full-time paid chairman. The law requires that the commission include at least one resident from each borough, three architects, one historian, one realtor, and one city planner or landscape architect. Members are appointed by the mayor for three-year terms, and the chairman and vice-chairman are selected at the pleasure of the mayor from among the commissioners. There has been an extraordinary continuity of informed and courageous leadership in the last thirty-three years, thanks to the six men and four women who have chaired the commission: Geoffrey Platt (1965–68); Harmon Goldstone (1968–73); Beverly Moss Spatt (1974–78); Kent Barwick (1978–83); Gene Norman (1983–89, the first full-time paid commissioner); David F. M. Todd (1989–90); Laurie Beckelman (1990–94); Jennifer Raab (1994–2001); Sherida Paulsen (2001–2002); and Robert B. Tierney (2003–present.) The Commission has also enjoyed the support of the elected leaders of New York over the last four decades: Mayors Wagner, Lindsay, Beame, Koch, Dinkins, Giuliani, and Bloomberg.

The commissioners are assisted by a full-time, paid professional staff, including researchers, historians, archeologists, lawyers, administrators, and secretaries. In the late 1980s, the staff of the commission peaked at approximately 80 members. The subsequent, economic downturn, and resulting budget cuts of the past decade reduced that number to below 50, a decrease of 37.5 percent. During the same period, the workload of the commission has increased dramatically, by nearly 50 percent, with new

work permit applications alone rising from nearly 4,000 in 1992. Currently the commission has a staff of 53 and processes approximately 8,100 applications a year.

In 1992, to further offset budget cuts, the city's Office of Management and Budget mandated that the commission establish a schedule of fees for applications and permits. The proposed fees would have fractured the broad public support and cooperation needed for landmark regulation. That same year, after widespread and vehement public disapproval, the commission unanimously rejected the proposal.

By July 2004, in the midst of another fiscal crisis, the Landmarks Preservation Commission adopted rules for permit fees. These fees would affect all owners of historic properties, except charitable institutions. The fees are calculated on the cost of proposed work, or its square footage, depending on the type of work; they start at a minimum of fifty dollars, and can range into thousands of dollars for the construction of new commercial buildings in an historic district. The fees are projected to raise approximately $1 million annually. As before, there is concern that fees will discourage owners from seeking designation, properly maintaining their properties, seeking required approvals for work, and encourage violations.

The Work of the Landmarks Preservation Commission

The work of the Landmarks Preservation Commission is divided into three main functions: to identify, to designate, and to regulate. The identification function consists of a survey—which is an inventory of all the building lots in the city's five boroughs, as well as research, evaluating requests for landmark status, and determination of the histories of individual buildings—leading to designation. The regulation and preservation function consists of considering and approving or disapproving changes to already designated landmark structures and districts.

The Designation Process

For the first decade of its existence, from 1965 to 1974, public hearings for designations were held every six months, and the commission designated clearly important and obvious architectural works. In 1974, its jurisdiction was extended to include scenic and interior landmarks, and greater volume necessitated more frequent designation hearings. Over the last fifteen years or so, the work of the commission has shifted away from

designation to preservation and regulation and, most importantly, to the determination of appropriateness of new and extended construction on landmark sites—thus influencing land development in New York City.

Buildings are designated only after a process that was deliberately designed to be as thorough and exhaustive as possible. The five stages of the designation process are: identification; evaluation and prioritization; calendaring; public hearing and further research; designation.

Sources relied upon for identification are the general public; property owners; commission staff; commissioners; public officials; and the survey of properties conducted by the commission. Regardless of who proposes a building, the commission staff undertakes to evaluate its significance, which often involves a field visit, photographs, and research. The staff presents its findings, with its recommendations of buildings to be considered, to the commissioners in a public executive session, and the commissioners decide which buildings should be researched further. Whenever possible, the commissioners visit those buildings or sites that are advanced for further consideration. At a subsequent public executive session, they vote on which buildings to calendar for a public hearing. A letter of notification regarding this hearing is sent to the owner, to community boards, to public officials, and to the Buildings Department; printed calendars are mailed to the same people and those members of the general public on the commission's mailing list. At the public hearing, the Commission decides whether to close the hearing and the record, and then act; take no action until the record closes at a later meeting; or continue the hearing until a later date. A decision is not usually made at this public hearing. Rather, staff members are instructed to continue research and report back with their findings. Commissioners often hear the owner's point of view and receive additional information from others who testify.

Assuming the building or site is still proceeding toward landmark status, all of the research is then summarized in a draft of a designation report prepared by the research department and discussed by the commission at a later public executive session. A vote is then taken at this session. To declare the proposed site a landmark, six affirmative votes of the commissioners are needed to designate. Once the vote to designate is taken, a building is protected; all subsequent changes to it must be approved by the commission before a building permit may be issued. In the 1980s and 1990s, on

average, the commission received and reviewed requests from the public to designate approximately one hundred new individual landmarks and several historic districts. The Commission held hearings on about sixty to one hundred individual buildings and districts and wrote up to fifty reports a year. During fiscal year 2004, the Commission received two hundred thirty-three requests to evaluate potential landmarks and historic districts. In response, fifteen landmarks and four historic districts were designated.

Despite an increase in requests for consideration, the number of buildings heard at public hearings and ultimately designated continues to decrease. In addition, in recent years, the importance of the public hearing process has gradually eroded. It would appear that sites with potential to generate long and acrimonious debate, and which are not certain to be designated, tend not to be calendared for public hearing. This results in a commendable success rate for the Landmarks Preservation Commission's designation process, and it may have the welcome effect of abbreviating what sometimes feels like the endless process of public review. However, it may have the unintended effect of stifling debate and raises questions about the integrity of the public hearing process. There is also the risk that a site that deserves landmark status may not be heard for a variety of issues, including owner objections, and therefore not be designated in a timely manner. If calendaring a site for public hearing is tantamount to designation, then the public may effectively be denied full access to the process, and many important political and economic concerns make take priority over preservation concerns, creating a climate that threatens to undermine historic preservation in New York City.

A vote by the Landmarks Preservation Commission, however, is by no means the end of the approval process. Up until the 1989 revision of the New York City Charter, the Board of Estimate was the final decision-maker on designations. Recognizing, among other things, that the validity of a designation is more readily defended in any litigation if it is approved by an elected legislative body, the Charter revision made the Board of Estimate defunct, and its role in the landmark designation process was given to the City Council. To handle these new responsibilities the Council created a Land Use Committee, with three separate subcommittees: Landmarks, Public Siting & Maritime Uses, Planning, Dispositions & Concessions, and Zoning & Franchises. In addition, all landmarks decisions are required to

go through a public committee process, as are any other land use matters.

After designation, the Landmarks Preservation Commission must file reports with the Department of Buildings, the City Planning Commission (CPC), the Board of Standards and Appeals, the Fire and Health Departments, and the City Council. The CPC then submits to the City Council a report on the designation and its potential impact, if any, on the zoning resolutions, projected public improvements, and plans for development, growth, improvement, or renewal of the area involved. (In the case of a historic district designation, the CPC also holds a public hearing.) Next commences a 120-day period during which the City Council may, by majority vote, either approve, modify, or disapprove a designation. Its subcommittees hold hearings and make recommendations to the Land Use Committee, which in turn refers a resolution or a designation to the full Council for a vote. Finally, the vote is filed with the mayor, and the designation, with modification, if any, by the City Council becomes final unless disapproved by the mayor within five days. (A mayoral veto may be overridden by a two-thirds vote of the Council.)

Only rarely has either the Board of Estimate or the City Council rejected or amended landmark designations. The Commission attributes the limited number of denials and modifications to its careful process of review and to detailed discussions with owners before a designation is made. There are, of course, a few exceptions. In June 1991, the City Council did overturn the designation of Dvořák House, home of the renowned Czech composer Antonín Dvořák, where he wrote the New World Symphony in the 1880s. The owner, Beth Israel Medical Center, opposed the designation. The hospital wanted to tear it down in order to build an AIDS hospice. Interestingly, many AIDS activists opposed the hospital's plans—and supported the designation—claiming that the proposed facility would be substandard. Nonetheless, the designation was overturned. In response to the overwhelming public demand for a memorial to the composer, East 17th Street between First and Second Avenues was renamed Dvořák Place. The Council also modified slightly the Tribeca West Historic District during its review of that designation in September 1991. In September 1992, the designation of the Jamaica Savings Bank in Queens was overturned, and the landmark site of the Knickerbocker Field Club was rescinded after the building was badly damaged in a fire and demolished.

In fall 2003, the City Council voted to overturn the designation of the Cathedral Church of St. John the Divine as an official landmark. The cathedral had also been heard for designation in 1966 and 1979. The cathedral, undercapitalized since its inception, had been seeking designation for its church alone, but not its other structures, many historic, or close (the whole site encompasses 11.3 acres.) The cathedral thereby hoped to allow for portions of its land to be free for future development, including a proposal to lease a part of the site to Columbia University for a twenty-story tower. There were protests from the neighborhood, as well as from preservationists, and concern for the site as a whole. Nonetheless, the City Council rejected the landmark status, arguing that the proposed development would be detrimental to the historic site and that the landmark designation was piecemeal. It was a rare instance of the city overturning a landmark designation. As a result, the cathedral is not designated, and it is free to pursue a plan for development of the site. Neighbors worry that the plan could be out of scale and context for the historic cathedral, its close and surrounding neighborhood. The cathedral promises that any development will be architecturally appropriate to the existing buildings on the close and the neighborhood.

THE REGULATORY PROCESS

Once a building or site is designated, it is subject to the regulatory procedures of the commission. All work, with the exception of routine repair and maintenance, on designated structures and within historic districts, is reviewed by the commission. The commission issues several types of permits depending on the work proposed by the applicant, which include Permits for Minor Work, Certificates of No Effect, and Certificates of Appropriateness. Certificates of Appropriateness, which include major alterations and new constructions, among other things, require a public hearing. Proposals for changes must take into account not only the owner's plans but also the retention of the architectural and/or historical integrity of the building/site and its surroundings. How the modified building or site may be used is not within the purview of the commission. The commission's regulatory department reviews applications for changes to designated structures, which may range from replacement of exterior door moldings in Brooklyn Heights, to the constructions of office or residential towers in Manhattan. When a change is approved, the commission issues

the appropriate permit and the owner may then proceed with the work. In fiscal year 2004, the commission received more than 8,100 applications for work on designated structures (including alterations and new construction) and more than 86 percent of active applications were approved.

The commission issues preservation policy statement guidelines that address the character of a specific historic district, as well as individual building elements. A number of these, the Roof Top Addition Guidelines, the Riverdale Guidelines and the Window Guidelines for example, have been successfully implemented. These regulations have not only provided clear directions for applications, but have expedited the regulatory process.

If an owner wishes to demolish a landmark, there are provisions in the landmarks law that ensure his or her right to claim economic hardship; the law also gives the commission a specific time period in which to seek a feasible alternative.

In July 1998, the Landmark Protection Bill became law, allowing for the commission to seek civil fines for violations of its regulations. Civil fines augment the commission's existing enforcement powers, which included criminal penalties. For the most serious violations, partial or total unauthorized destruction of a landmark, an action must be brought in civil court. The commission may also issue stop work orders and seek injunctive relief. In general, the commission uses its administrative fine system to enforce the landmarks law. The commission has a small enforcement staff, which investigates complaints and handles compliance actions for the agency. In fiscal 2004, the commission issued 980 Warning Letters, 7 percent of which were resolved at this stage. The commission also issued 54 Stop Work Orders. More than 99 percent of Notices of Violations issued were upheld by the administrative courts.

An example of a major violation of the landmark regulations is the destruction by neglect of the New Brighton Village Hall on Staten Island. The historic structure, one of only three village halls left in the city, had been vacant and in decline since 1968. The Department of Buildings determined that the building was structurally unsound with the roof gone and much of the interior rotted away. The Village Hall was demolished. This violation engendered the violation by neglect bill. In 2002, the commission sued the owners, and the lawsuit will be pursued by the city even though the building has been torn down.

Despite the fact the commission will continue to pursue this issue, this landmark is lost forever, and cannot be replaced. Civil remedies, after the fact, seem of little consequence for the neglect and even destruction of a landmark property. The triumph of benign neglect may set a dangerous precedent for an owner to avoid an unwanted designation, resulting in an impetus to destroy a structure through inaction, and ultimately lift the designation. The importance of enforcing proper upkeep on designated buildings, as well as addressing and rectifying violations, is an important issue facing the commission for the future.

In recent years, an emerging issue has been a qualitative shift in the focus of proposed designations. In the past, the majority of the commission's designations were based on architectural or aesthetic qualities, many in combination with historic significance. Recently, there has been a move to address issues of even-handedness and geographic distribution, some would say at the expense of architectural integrity. Others believe that place matters, and that it is important to examine buildings that should be recognized for cultural rather than architectural values. For some, there is a question of how these places would be regulated, if at all. The desire to recognize and preserve structures for historical or cultural significance and to reach broader sectors of the city, such as the other boroughs and Northern Manhattan, has taken on new urgency. In some of these instances, disrepair, encroachments, inappropriate additions, and a general lack of uniformity impinge on the architectural integrity of an area. Recent individual designations of wood-framed workers' housing on Staten Island; Lewis Latimer's modest and relocated house in Queens; and the much renovated and currently stripped-down house at 12 West 129th Street, are a few examples. Similarly, recent district designations primarily fall into a few categories: neighborhoods with primarily sociological significance, those that reflect cultural/historical identities or types or styles of development from particular economic periods. These include districts such as Jackson Heights in Queens and Gansevoort Market in Manhattan. In addition, the commission has also designated areas where, despite historical significance, thorny issues of disputed regulation and control are at the forefront—Governors Island, Ellis Island and the African Burial Ground and Commons Historic Districts, for example. While these designations unmistakably fall within the purview of the landmarks law,

they present new challenges for regulation. The Landmarks Preservation Commission has been in existence since 1965, and there is a body of opinion that contends that nearly all of the truly important historic and iconic structures and spaces (excepting those constructed in the last thirty years) have already been designated. It is true that the majority of individual and district designations are in Manhattan. However, it is important to recognize the diversity of architectural, historic, and cultural resources within the five boroughs. Each borough has its own history, patterns of economic and cultural development, and distinct evolution to be celebrated. Among these are the early rural history of Staten Island, the suburban nature of parts of Queens, Brooklyn and the Bronx, the development of worker housing, seaside architecture, industrial development, and cultural migrations from Manhattan to the other boroughs.

As always, the challenge, after identifying the best, most significant and representative examples of the city's rich heritage, is how best to preserve and regulate them. If a structure or district is not designated primarily for its architectural merit, then traditional regulatory assumptions may need to be re-examined. In this instance, guidelines and master plans could set standards appropriate to the significance of non-architecturally based designations. They could also address specific issues pertaining to distinct building types, as well as neighborhood character, and yet be flexible enough to, over time, retrieve the lost character within an area, or reverse inappropriate additions, or repairs. This would help facilitate broader preservation efforts and be responsive to community needs.

COMPETING INTERESTS: PRESERVATIONISTS, DEVELOPERS, OWNERS, AND THE COURTS

As preservation activity has grown, so has resistance from some owners and real estate developers, who object to the often stringent limitations that the law places on land use. But a milestone court decision more than two decades ago gave tremendous impetus to further preservation efforts by endorsing such limitations. The case grew out of efforts by the Penn Central Transportation Co. to abolish the restrictions put on landmark buildings and property owners in New York City. Penn Central sought to construct an office tower above Grand Central Station. In 1978, the U.S. Supreme Court affirmed the designation of the terminal as a landmark, noting that cities had the right to enhance their quality of life by preserving aesthetic features.

In 1992, a ruling by the Appellate Division of the Supreme Court in Manhattan signified that landmark designations cannot be compromised for political reasons. Peter S. Kalikow, then owner of the *New York Post*, planned to replace four of the fourteen designated City and Suburban Homes Company York Avenue Estate buildings with a very large apartment tower. In April 1990, the Board of Estimate removed the four buildings from the designation to accommodate Kalikow's building plans. The Board's decision was upheld by the New York Supreme Court, thus setting a precedent for negotiating designations that, it was feared, could be perpetuated by the City Council. In overturning the ruling, the Appellate Court sent a clear message affirming landmark designation as a process with reason and integrity, not one to be diluted to satisfy the competing political demands of powerful landowners. The commission had designated the complex as a whole, instead of fourteen individual buildings. The position that single elements of the designated complex could be considered in isolation from the whole was found to be inherently inconsistent with the designation.

In another important case, the U.S. Supreme Court's action regarding St. Bartholomew's landmark appeal upheld the validity of preservation laws across the country with respect to religious properties. The vestry of St. Bartholomew's planned to raze its community house and build a forty-seven-story glass office building that would generate revenue to fund its religious activities and outreach. The church challenged the commission's denial of the plan arguing that the designation interfered with its First Amendment rights. The long battle ended four years later, in 1991, when the U.S. Supreme Court refused to hear the church's challenge to the designation of the church complex as a landmark, thus affirming the Landmarks Preservation Commission's actions.

Though these battles were won, others were less successful. In the 1980s, the processes and procedures of the Landmarks Preservation Commission were put to the test in the Coty-Rizzoli designation, Bryant Park's renovation, and Grand Central Terminal's office tower at 383 Madison Avenue, to mention but a few controversies. The debate continues to rage over the best way to keep worthy buildings from falling victim to the demolition crews before the commission can designate them.

The central question is how can we preserve the past without jeopardizing a vital future for a vibrant city? Simply stated, developers argue that the landmarks process interferes with the workings of the market; they contend that many opportunities are lost because of the commission's overly rigorous scrutiny. Property owners, for their part, argue against landmark restrictions and resent the lack of freedom to do as they please with their buildings. Preservationists must strike a balance between saving the public patrimony and yielding to the imperatives of progress.

Francis Bacon wrote that "the monuments of wit survive the monuments of power." Unfortunately, when "wit" is a charming eighteenth-century frame house that lends an air of scale and civility to an already crowded neighborhood, and when "power" is a block-square behemoth that promises to generate thousands of jobs and millions in sales and property taxes, Bacon's dictum is placed in jeopardy. The fate of Broadway's theaters was a case in point. They were under increasing pressure for years, as large office towers, whose construction was made possible by a 1982 revision of the zoning law, sprang up in the theater district. The loss of older buildings was gradual and occurred in relative obscurity until 1982. In that year, the Morosco and the Helen Hayes, two of the district's most beloved older theaters, were demolished to make way for the Marriott Marquis Hotel. Those theaters are sometimes referred to as "sacrificial lambs," since their demolition galvanized support for saving those that remained. What should have been obvious all along became clear only belatedly. The more than forty older theaters in the Broadway district represent the heart and soul of the American theater; they are cultural resources without peer. By January 1988, after protracted hearings and negotiations, the exterior, interior, or both of twenty-eight theaters were designated. The theater owners filed a lawsuit to overturn the designation of twenty-two of these playhouses. Their efforts finally concluded in 1992, when the U.S. Supreme Court refused to hear their case, turning back the owners' challenge without comment. The high court let stand the 1991 New York State of Court Appeals ruling upholding the designation. According to Jack Goldstein, then director of Save the Theaters, of the forty-four extant theaters, only those protected by landmark laws are expected to survive the economic business cycles that have always plagued the commercial theater business.

The effect of landmark designation on the value and use of properties owned by nonprofit and religious institutions also is a contentious issue. These groups are often housed in older, architecturally distinctive structures. Since designation can prohibit demolition and redevelopment to a higher density of use, leaders of these groups have charged that designation compels them to remain in buildings that are no longer suitable to their needs, which are, in short, no longer economically viable. In response, preservationists claim that the suitability of property to an organization's needs is not at the heart of designation. But they acknowledge that problems can indeed arise and preservation advocates have devised solutions to offer necessary relief. A specific section of the Landmarks Law addresses these issues. In addition, in 1991, the Hardship Panel, which is independent of the commission, was created to review denials of hardship applications to nonprofit institutions by the Landmarks Preservation Commission. The panel will uphold the commission's decision unless it finds that the decision is not supported by a reasonable or rational basis, and allows for other alternatives to demolition. To date there have been no appointments to the Hardship Panel.

Many of the city's religious properties are the work of America's finest architects, constructed at a time when craftsmanship was at its height. Today, many of these properties face an uncertain future, due not only to changing demographic patterns and evolving family and religious practices, but also to the high maintenance costs of older structures. Deferred maintenance is a problem common to both thriving houses of worship and those with dwindling congregations. Rising land values and, in some cases, development pressures further endanger the survival of these buildings and sites. Many institutions wish to preserve their properties, but restoration work is costly, and financial and technical resources are limited.

Fortunately, community preservation groups have emerged that seek to restore and revive older structures that can no longer meet their expenses. The restoration of the Eldridge Street Synagogue, on the Lower East Side, by a community group, and the S.O.U.L. project for the Universalist Church on Central Park West at 76th Street, have helped to encourage others to restore religious structures. These and similar efforts stand as a clear and positive response to all, that the St. Bartholomew's controversy has come to symbolize.

The wanton partial destruction of the Willkie Memorial Building at 20 West 40th Street was the catalyst for certain changes in the procedures for landmark designation. The structure, a beautiful building by the architect Henry J. Hardenbergh, was identified by the commission staff as being of landmark quality, but was never scheduled for formal consideration. While the Willkie Building stood unprotected, one Friday night in February 1985 a work permit went out from the Buildings Department. Scaffolding went up, work commenced immediately, and by Monday, without any notice ever having been given to the commission, the elaborate stone moldings and carvings on the facade had been stripped away—and the building's architectural beauty permanently lost.

At about the same time, the commission designated the Coty (which features original windows, by René Lalique) and Rizzoli buildings on Fifth Avenue after learning that a developer planned to replace them with a forty-four-story office and residential tower. The commission's action, however, angered the real estate community, and Mayor Koch established the Cooper Committee, in 1985, to review the concerns of owners, developers, and preservationists with the designation process. The Cooper Committee, a five-member group chaired by Alexander Cooper, an architect and planner, was directed to pay particular attention to the objectives of the landmarks law, the calendaring procedures of the Landmarks Preservation Commission, the Building Department procedures for issuing permits in connection with structures that may be of landmark quality, and communication between the Building Department and the commission.

The committee's report recommended that the landmark designation process include reasonable time limits for action by the commission in order to make the development process more predictable and that buildings being considered for designation be protected from last-minute stripping, damage, or demolition while the commission decided whether to designate. The committee also suggested that the commission be given adequate funding to accelerate its citywide survey and establish a "protected buildings list" of potential designations, which could help to alleviate some of the antagonisms between developers and preservationists and possibly save many structures from untimely disaster. Some of these, as well as other recommendations of the Cooper Committee, have been adopted, including the establishment of the commission as a separate

agency and the creation of published rules and guidelines.

During the years of its existence, numerous proposals to strengthen, clarify, and sometimes limit the landmarks law have emerged. Further proposals to strengthen the Landmarks Preservation Commission also emerged from the Historic City Commission (sometimes known as the Conklin Commission) in the fall of 1988. On July 1, 1990, the Landmarks Preservation Commission was separated administratively from the Department of Parks, and became an independent mayoral agency of the City of New York. The need for increased staffing and funding was partially addressed upon the commission's separation, but subsequent budget cuts have rolled back resources to the lowest level in two decades.

ADAPTIVE REUSE

Preservation was once seen as an "elitist" concern, something best left to ladies' lunches and the organizers of walking tours. No longer. Never before in modern history have so many people been aware and involved in the design of the places where they live and work, as they struggle with the forces of change. Thanks to this awareness, there is now a choice; it is no longer a given that an older building or entire neighborhood will be razed for the construction of a huge, new monolith—a monument of power, as Bacon would put it. The technique of adaptive reuse—refitting old buildings for different uses from the ones for which they were originally intended—has made a practical means of preservation available.

In the 1980s, changes in the federal tax code also made adaptive reuse economical. Chief among the incentives that now exist are tax credits for restoring landmarks and direct appropriations to attract developers and investors. By means of such incentives, historic rehabilitation has been placed on a more equal footing with new construction. It is now economically feasible to prolong the usefulness of buildings that otherwise would suffer continuing decline or demolition. There are numerous proposals for state and local initiatives, as well.

Tax and other incentives have triggered private investment, whose public benefits—in housing, new jobs, and increased property, sales, and income taxes—far outweigh the public cost. Perhaps the greatest benefit has been to enhance the stability of neighborhoods, and in some cases to make their survival possible.

In the 1970s, New York City gave a striking demonstration of just how

well incentives can work. A nationwide economic recession, and an even worse situation on the local level, had the city reeling. At that time the city enacted its J–51 legislation, designed to offer significant incentives so that builders, who were doing very little new construction, would be encouraged to reclaim old structures. Wisely, and immediately, the development community pounced on J–51 and put it to excellent use. Suddenly scores of loft buildings and tin-ceiling interiors in SoHo, Tribeca, Chelsea, and elsewhere were being rehabilitated and recycled into artists' apartments or shops or restaurants. Much of this work had an unintended or at least unforeseen consequence: the process we now know as gentrification, which has forced poorer residents and mom-and-pop stores out of changing neighborhoods.

THE ARCHITECTURE OF NEW YORK

Through the accomplishments of several organizations, primarily the New York City Landmarks Preservation Commission, we have learned to revere and guard our past by carefully and systematically conferring landmark status on deserving structures. Many architectural assets have been restored to their original state, and many old buildings have been adapted to serve new, vital functions. This has had a pronounced and positive influence on the attitudes of contemporary architects, who are now faced with the challenge of building alongside older structures. Rather than ignoring context, much contemporary design celebrates the historic tapestry of our city and incorporates many historic elements and allusions.

And what a brilliant, richly textured tapestry New York is! The city's architecture is the richest in the country, with respect to the diversity of buildings. There are farmhouses, brownstones, cast-iron buildings, Art Deco towers, and glass-and-steel skyscrapers. One can journey through the boroughs and travel back in history: from the early-nineteenth-century wood-frame houses of Brooklyn's Weeksville Houses, to the late-nineteenth-century brownstones of Longwood in the Bronx, to the early-twentieth-century attached brick row houses in Ridgewood, Queens. Then there are the structures that have come to symbolize New York: the distinctive Flatiron Building, standing in majestic isolation at the corner of Fifth Avenue and 23rd Street, the Dakota Apartments at Central Park West and 72nd Street, the Empire State Building, the Chrysler Building, the Statue of Liberty, St. Patrick's Cathedral, and Rockefeller Center.

New York is also the richest in the diversity of styles that have survived three hundred and fifty years of construction and demolition: Federal, Georgian, Greek and Gothic Revival, Italianate and French-inspired, Victorian, International, Post-Modern, and Post-Post-Modern. Between 1830 and 1930, more architectural styles were employed in New York than at any other place, or point in history. It was a period of rapid growth and change in the midst of technological, economic, and ideological revolutions that transformed America from a spread-out, agricultural society to a highly urbanized, industrial one. Although this nation's roots still reached back to Europe, the new republic spent a century putting down indigenous ones. Bursting with the innocence and impatience of youth, the new nation was willing and eager to try anything. In architecture, styles such as the Greek Revival, Gothic Revival, and Italianate came and went as swiftly as did fashions in clothing. Styles were revived, abandoned, revived again. Sometimes a building's appearance changed in mid-construction because a new look had become fashionable overnight.

Different building periods have given New York its great variety of colors and forms, and within a single block, we may encounter many styles, shapes, and textures. Between 1640 and 1850, New York was characterized by thousands of beautiful red-brick buildings and farmhouses, some of which survive today. In the middle of the nineteenth century, a brownish-violet coating seemed to descend like a cloak over everything. "Brownstone," a soft, fine-grained sandstone could be easily shaped into the pedestals and oriels, consoles, and ornamental touches that the Italianate style of the period demanded. In *Things as They Are in America*, William Chambers, the Edinburgh publisher of *Chambers' Encyclopedia*, said this about the New York of 1853: "Wherever any of [the] older brick edifices have been removed, their place has been supplied by tenements built of brown sandstone; and it may be said that at present New York is in process of being renewed by this species of structure." The choice of brownstone for cladding the grandiose Vanderbilt mansions along Fifth Avenue (built between 1880 and 1884, and since demolished) finally confirmed the material's supremacy. By the 1880s, New York had become a red-and-brown city, as Bath was cream and Jerusalem gold.

Architecturally, cast-iron construction represented one of the most important building innovations of the nineteenth century and was a giant

step toward modern skyscraper construction. The building type was modeled after the Italian Renaissance–style palazzo, a spacious, rectangular building of several stories, suited to a functional commercial structure. While the great European cities were showplaces for royalty and pageantry, New York was always a merchants' city. By the late nineteenth century, however, the successful merchants had formed a distinctly American aristocracy of their own. They had the money and the manners. Now they wanted their city to be as grand as any in Europe. One by one, they hired the finest architects of their time, and in the sumptuous style of the day, they built palaces befitting their empires. The district known as Ladies' Mile, from Union Square to the Madison Square, exemplifies this trend, as do some structures along Fifth Avenue as far north as the nineties.

MODERN LANDMARKS

Modern movement buildings have come of age, and many are now old enough (thirty years) to be eligible for designation as New York City landmarks. Public perception has greatly changed recently regarding many of these glass and steel buildings once thought to be ugly, and even a blight, on the historic fabric of our cities. The ironic result of saving many of these modern buildings is the proliferation of modern architecture in the 1960s developed, at the same time as historic preservation emerged to counter it. Modernism and preservation were very much at odds with each other; and now preservationists, whether they like it or not, must consider the complications, and implications, of saving these buildings, many of which were once antithetical to the entire preservation movement.

Some of the most iconic of the modern buildings in New York City have been recently designated, including the Pepsi-Cola Building, completed in 1960 by Gordon Bunshaft and Natalie de Blois of Skidmore, Owings & Merrill, and the bronze and dark glass tower of the Seagram Building, completed in 1958 by Mies van der Rohe and Philip C. Johnson, which reintroduced the public plaza to New Yorkers. Lever House by Gordon Bunshaft of Skidmore, Owings & Merrill, a marvel of green glass curtain wall, opened in 1952, forever changing the face of Park Avenue from stately heavy masonry to soaring towers of glass. Examples of modern residential architecture include the Rockefeller Guest House (1949–50) by Philip C. Johnson; and the Crimson Beech House (1958–59) by Frank Lloyd Wright. The Ford Foundation building (1963–67) by Kevin Roche John

Dinkeloo Associates, is the youngest designated landmark in New York City. Clad in granite, and Cor-ten steel, the building also contains one of the most beautiful interior landmarks—a terraced garden.

In addition to the motivation behind saving a modern building are the technical conservation issues related to the use of modern materials and structural systems, seen in the 2001 renovation of the glass curtain wall of Lever House. One of the most difficult issues in the preservation of modern architecture lies in functionally driven designs, especially when the function has progressed beyond the architecture. This is most evident in the TWA Terminal at John F. Kennedy International Airport in Queens designed by Eero Saarinen, and opened in 1962. One of the greatest examples of Expressionistic modern architecture, the building is now empty and lifeless, looking more like a ruin then a magnificent swooping form intended to invoke flight. The building is a New York City landmark, but since it is owned by the Port Authority, the commission had no official role in determining the appropriateness of any proposed plans. In October 2004, its fate was finally decided after years of negotiation. Jet Blue airlines developed a scheme for a new 625,000 square-foot terminal, designed by Gensler. According to *Architectural Record* magazine, "The Jet Blue Terminal and the TWA Terminal will be connected via pedestrian tubes. The new terminal will feature a trim, contemporary profile of taut metal and glass that is meant to keep a low profile next to the Saarinen building, which is regarded as a classic of modern architecture."

Perhaps it is the towering skyscrapers of the 1920s and 1930s, replete with dramatic Art Deco adornment, that embody "classic" New York: the Empire State Building, Rockefeller Center, the Chrysler Building. The post–World War II years brought the glass curtain walls and sleek boxes that line the midtown avenues. In the twenty-first century, who knows? Perhaps these are the structures that will be considered "classic" as New York, in its time-honored fashion, replaces them with even newer styles.

A BROADER MANDATE FOR PRESERVATION

In the past, much of the time of ardent preservationists was spent trying to stop the wrecker's ball from destroying architectural treasures. Now, in some parts of the world, their efforts have been so successful that they are invoking the same wrecker's ball to remove architectural outrages. To that end, the Royal Institute of British Architects (RIBA) has proposed a novel

plan to introduce a new Grade X-listing—in contrast to the Grade I, Grade II, and Grade III status awarded to protect England's most cherished historic buildings. The proposed Grade X designation would be for those buildings *no one* wants to preserve. It would offer owners financial and tax incentives to demolish discredited structures, and replace them with contemporary masterpieces. RIBA believes, and many will concur, this plan has the potential to cull the world of its worst architectural blights, and make way for—it is to be hoped—first-rate replacements.

After decades of change and neglect, Americans have come to understand why their architectural and cultural landscape is important to preserve. Now, there is also a nascent movement, initiated by Scott Stowell of *Metropolis* magazine to save threatened examples of graphic design, and every day artifacts—the UPS logo, TV network logos, the one dollar bill, the Bell System logo, FAWA fonts, and others of this type.

Don Henley, the Grammy Award-winning co-founder of the Eagles, and the founder of the Walden Woods project (saving the woods around Thoreau's Walden Pond), was recently asked if he was a preservationist or an environmentalist. He responded that he was both, that

> our historic landmarks are part of our environment and environmentalists and preservationists share a common goal—the preservation of the "common-wealth," the natural and built treasures that define us as Americans. Whether they be historic buildings, cultural landscapes, national landmarks, urban or national parks, wilderness areas, or coast lines, the same threats loom large—a lack of funding for preservation, unbridled urban sprawl, and the increasing pressures exerted on dwindling resources by population growth. In recent years, far too much of our "common-wealth" has been sold off, or given away, to special interests.

A broader mandate will place an even greater demand on the resources of the Landmarks Commission. In 1987 at the New York City Charter Review Commission hearings, I issued a call for "an act of civic maturity"—namely, that Section 2204 of the New York City Charter be amended to put several changes into effect regarding the Landmarks Preservation Commission. During my testimony, I noted that during the Landmarks Preservation Commission's existence, "the workload of the agency has grown enormously. Not only is the Commission responsible for research,

public review, and designation of new city landmarks, but also for review and approval of applications to alter previously designated properties . . . For new construction in historic districts, for demolition, and for hardship; assessing the impact of public projects on landmark properties; advising on changes to city-owned landmarks; and approving proposals to transfer development rights from landmark sites." And, I noted, "there is more, including the citywide survey of property to identify possible future designations, two grant programs, and the continual development of policies and guidelines for preservation."

"Given the range and scope of its activities," I continued, "the Commission at this time is not adequately equipped, either structurally or economically, with the resources necessary to carry out its appointed tasks." In addition, I supported officially establishing the Commission as a separate municipal body. "In keeping with this change the Commission's growing responsibilities must also be recognized with an increase in its budget that will allow for adequate staffing and operations The Commission is limited by a modest budget, small staff, and cannot hope to effectively ensure the integrity of landmark sites and historic districts."

The need for change was all too clear. For the Landmarks Commissioners, unpaid, volunteer appointees, as I testified, the "demanding workload is not compatible with career responsibilities and is, in fact, unfair to those who care deeply about our city." I concluded: "These are necessary steps if the Commission is to be endowed with the resources, both professional and financial, that will enable it to carry out its mandate to preserve and protect our city's landmark buildings and districts. It will permit our city to remain in the vanguard of the challenge to enhance the urban texture and further economic progress."

What is remarkable is how much the Landmarks Preservation Commission has been able to accomplish since 1965 with its severely limited resources and its overburdened staff. Thanks to the workings of the often-embattled commission, it is no longer easily or entirely possible to destroy great works of architecture. Nevertheless, the commission has largely allowed for the delicate equilibrium that must exist between new and old, between economics and aesthetics, between progress and history.

Today, many of the issues outlined in the testimony are still pressing concerns. While the Landmarks Preservation Commission has implemented

many measures to streamline and expedite its procedures as well as to strengthen its enforcement activities, much remains to be done. Struggles with fiscal constraints, an ever-increasing workload, and inadequate staffing are an ongoing burden. The regulatory role has expanded beyond expectations, and now dominates the work of the agency. Competing concerns between new construction and development, because of the recent economic real estate boom of the 1990s, and the concerns of historic preservation, continue to evolve. With the passage of time, new and more significant issues have also emerged. For example, new challenges of historical and cultural designations, and their appropriate regulation, are evident. Also, the time has come for the other boroughs, with their rich history, to claim their place on the landmarks horizon.

The need for a forward-looking plan that is proactive, and not reactive, addressing the commission's mission is of primary importance. The purpose here is not to tamper with or rewrite the landmarks law, although there are always those who would seek to do so in an effort to weaken or dismantle it. The law is sound. It has successfully withstood challenges, and its implementation and administration has been successful beyond what could have been hoped. Rather it is important to examine, in the light of forty years of progress, the state of preservation in New York City, and the issues that currently confront it, and seek to address them in the best and most comprehensive way for the new millennium. It is again time for a task force to be formed to identify major issues for study and consideration, and make specific recommendations for a cohesive plan. This body should be composed of individuals, organizations, and government and community representatives, and it should reflect the expertise of the widest range of disciplines impact the issues of preservation in our ever changing and dynamic city. This should include historians, architects, cultural representatives, landmarks commissioners (present or past), representatives of the financial and real estate industries, to name a few specialties.

There are several potentially ripe areas for study and evaluation within the commission's mission to identify, designate, and regulate.

Identification of new resources: One area is examination of the survey function, which is at the heart of identifying new landmarks. In recent years, this activity has dwindled to the point of nonexistence, and it is now

driven almost entirely by requests from outside the agency. A new comprehensive survey of the city is past due. This would be a proactive step, and ensure the even handed evaluation of all geographic areas of the city. As with prior survey initiatives, it is imperative that the survey remain an internal commission document. This is not suggested in an effort to be secretive, but rather to acknowledge a real need to safeguard potential resources during consideration. In addition, it would provide a framework for approaching designations, provide a sense of certainty, and geographic equality and accountability. It would also allow for the identification of structures currently coming within the thirty-year-old mandate of the commission, as well as undiscovered, neglected, or endangered resources prior to their destruction. This would also help avoid the need for last minute emergency actions and reduce the impacts of such actions.

Designation processes: Also in need of study are the current practices of the designation process. As mentioned earlier, if hearings are increasingly tantamount to designation, then fewer proposals are reaching the public hearing process. It is important that the procedure that ensures full public participation and the gathering of information remains central to the process. Broader initiatives in historical and cultural designation, and resources within the other boroughs need to be addressed. In addition, timely action, coordinated pre-designation safeguards, and addressing appropriate regulation by highlighting significant features in designation reports, are key issues. A bill, widely supported by many Council members, was introduced in April 2004 (which is now in the Land Use Committee) to amend the Landmarks Law to require a timely review by the commission of potential landmark eligibility before a demolition permit may be issued for a building, any portion of which is fifty or more years old. Such pre-designation safeguards are a hopeful sign.

Regulation and enforcement: In probably no other area has there been more change than in the area of regulation. The increasing number of landmarks under the commission's jurisdiction challenges prior assumptions regarding staffing, procedures, and approach. Appropriate staffing levels for review of applications and enforcement are of paramount concern. Failure to address this issue has wide-ranging economic implications. The regulatory system must be efficient and encourage the managed and appropriate growth and revitalization of our historic fabric, especially at a time when

preservation is known to increase property values and its benefits are all the more tangible.

Enormous efficiencies have been gained through the use of guidelines that allow the public hearing process to focus, among other things, on the most challenging proposals. Additional guidelines and master plans will not only further expedite reviews, but address new challenges for regulating primarily culturally or historically based designations. They may also allow regeneration, over time, of areas architecturally eroded by inappropriate changes. In this age of instant, digitized, and global communication, increased coordination with other governmental agencies, regarding land use in particular, must be explored.

New issues in enforcement, such as demolition by neglect, face the commission as it exercises its relatively new civil enforcement powers. In July 2004, an amendment to the Landmarks Law was proposed by Councilman Tony Avella of Queens that would further extend the reach of the commission's civil enforcement powers making property owners subject to civil penalties for "demolition by neglect" of landmarked buildings that are allowed to fall into disrepair, including substantial fines up to the value of the landmarked building itself. "Demolition by neglect" is defined by the city as occurring when "an owner fails to maintain a building," said Mark Silberman, general counsel of the commission. "It can result in the deterioration or loss of significant architectural features or, in its more pernicious expression, result in such structural damage to a building that it collapses or has to be demolished because it is an imminent hazard to the public . . . Administrative fines will enhance the agency's ability to proactively . . . confront maintenance issues by putting owners on notice that serious conditions exist and must be cured." He noted that if the law were amended to allow the imposition of civil penalties the Environmental Control Board or the Office of Administrative Trials and Hearings would become the forum for such hearings rather than the State Supreme Court, expediting the process. The City Council is expected to vote on the amendment this year.

On October 20, 2004, the Demolition by Neglect Bill sponsored by Councilman Avella was approved by the City Council Subcommittee on Landmarks, Public Siting & Maritime Uses. This bill will enhance the Landmarks Preservation Commission Civil Fines Legislation to allow for

civil penalties for cases of demolition by neglect.

Incentives and Supports: Lastly, despite gains in efficiency and the recognized economic benefits of preservation, it is a reality that there are significant costs to the work of maintaining and repairing landmarks. To preserve our heritage, our history, and our environment, in essence to honor our past, while looking toward the future, comes at a price. It is time to address this practical issue through education and tangible incentives. Proposals for additional and workable financial incentives, such as tax credits, and deferrals, as well as grants and low interest loans, need to be crafted. One such successful program is Save America's Treasures, a public/private grant program initiated by Senator Hillary Rodham Clinton, while First Lady, to commemorate the new millennium. Save America's Treasures has awarded over $188 million in support for projects, including, in New York City, the Weeksville Houses, an African-American community established by freed New York slaves, which maintains its original nineteenth-century wood-frame buildings in Brooklyn, as well as the Eldridge Street Synagogue on the Lower East Side of Manhattan. Another initiative worth exploring is the creation of an affordable skilled workforce to address preservation needs, also the availability of competitively priced and appropriate materials, ideally in public/private partnerships, to continue to make preservation competitively viable.

LOWER MANHATTAN
REDEVELOPMENT

Many historic buildings were adversely affected by the terrorist attacks of September 11, 2001. No designated buildings were completely destroyed, but significant historic buildings were badly damaged, particularly the West Street Building (90 West Street,) and the Barclay-Vesey Building (140 West Street.) A historic, but undesignated, Greek Orthodox Church was completely destroyed. 90 West Street and 140 West Street buildings are being renovated.

The Lower Manhattan Emergency Preservation Fund (LMEPF) was created to raise awareness of the historic buildings in Lower Manhattan, and to dedicate itself to the role of preservation in the redevelopment of the area. LMPEF consists of a consortium of five prominent preservation agencies: the World Monuments Fund, the National Trust for Historic Preservation, the Municipal Art Society, the New York Landmarks Conservancy, and the Preservation League of New York State. The group has three hundred

historical sites on its watch list including the Barclay-Vesey Building, the West Street Building, and the Corbin Building, a beautiful early terra-cotta skyscraper. As a result of their initiatives, the Metropolitan Transportation Authority has agreed that the new Fulton Street Transit center will preserve the Corbin Building by incorporating it into the transit hub.

The World Trade Center site has been determined eligible for inclusion in the National Register of Historic Places by joint consensus of the six federal and state agencies sponsoring the three proposed projects on the site. This is an unprecedented action by the National Register to overlook the fifty-year rule for inclusion based on the extreme situation at the World Trade Center site. Each project will individually assess historic resources before continuing.

This includes the World Trade Center Memorial and Redevelopment Plan, the permanent PATH terminal, and the Rouse reconstruction project. According to Herbert Muschamp, writing in the *New York Times* on January 1, 2004, "Preservation has the potential to foster some of the most advanced thinking in modern social space."

LANDMARKS OF NEW YORK

This book attempts to provide a brief indication of the history and significance of each of the designated properties in New York City through 2004. The text has been based in part on the designation reports of the Landmarks Preservation Commission. Initially, my assistants and I systematically gathered and catalogued each report. Next we communicated, orally and in writing, with property owners, city officials, historical societies, architects, preservationists, and citizens, requesting historical and anecdotal material. Then began the elaborate process of documenting the designated landmarks: cross-checking and authenticating the historical information, architectural descriptions, photographs, and fresh anecdotal material that we had gathered about each of them. The exhaustive research involved interviews, conversations, and digging in archives so that each building or site would be presented with its own story, its own intricate history. Exhaustive and repeated efforts to verify the accuracy of the material were made. This was not possible in every instance because of the inability to locate verifiable sources. Therefore, it is our hope that if you have, or are aware of, verifiable data, or emendations, that relate to any of these landmarks, you will share them with us. We hope to continue our

researches and incorporate appropriate changes in future editions of this book. In an attempt to document New York's architectural history, the landmarks in this book have been organized chronologically, by date of construction. In several instances, to accommodate all of the material, this order is not strictly followed.

One of my motivations for writing this book was to further enhance the level of awareness of the places we inhabit and to encourage even more citizens to get involved in helping to revitalize their communities—and not simply for aesthetic reasons. I firmly believe that landmark preservation improves the well-being of a community's citizens, not just by means of the "product"—the rescued buildings and sites—but also through the process of involving large numbers of people and nurturing a constituency for civic concern and pride. What was once, and in some quarters still considered to be, an impediment to progress, has proven that appropriate recognition and protection of the built environment does create economic value and foster neighborhood pride, as well. It has not been, and will not be the Landmarks Preservation Law itself, but the individuals and grass-roots organizations that give voice and vitality to the movement that has indeed transformed the city aesthetically, culturally, and economically.

Another reason for writing this book was to attempt to correct some misconceptions regarding landmark preservation, in particular the notion that a building is "frozen" once it receives landmark status. Hardly! In fact, as we accumulated data, our greatest problem was keeping track of all the changes that had taken place in a landmark since designation, and determining to what use the landmark was currently being put. Effecting changes in landmark structures is not only wholly possible, but has been vast, constant, and widespread. Due to repairs, renovations, and adaptations to landmarks, even their appearance can change—which proves that a landmark is not static and museum-like, but, as is true of almost any building in active use, constantly evolving. Far from seeking simply to preserve a bygone world, the members of the New York City Landmarks Preservation Commission accept the circumstances of a changing world and attempt to preserve the past without jeopardizing the future. But, while giving progress and change their due, we must not permit the best of our past to be buried or otherwise lost.

Cities are most interesting when they combine the new with the old,

the traditional with the avant-garde. New York juxtaposes high rises with church spires, crammed spaces with green vistas, streets of shops with streets of houses, glass-and-steel towers with cast-iron buildings or houses of brick and timber. The older buildings of our cities give us the possibility of visualizing the past, for they are, in a very real sense, time capsules. The Capitol Building of Virginia, in Richmond, brings Robert E. Lee to life; Louis XIV is best understood amid the carefully calculated grandeur of Versailles, and the remnants of the Parthenon give voice to Demosthenes. The original Pennsylvania Station is gone, as are the Bartholdi Hotel and the Atheneum Club building and the old Metropolitan Opera House. No generation has the right to make the city a monotonous monument to a single moment. Daily living was as varied in the past three centuries as it is for us in the initial years of the twenty-first century. And our schools, churches, and commercial structures testify to this diversity and remind us where we have been and how far we have come, in a few hundred years. In the many buildings, parks, and districts that survive in New York City, and are recorded in this book, we see the history of the city and its architecture. We see the untouchable past, with the unspoken beginning, and new spires rising alongside the old.

Having come this far as we enter a new century, where do we go from here? Richard Moe, President of the National Trust for Historic Preservation, offers these thoughts:

> I've been thinking lately about how expansive, how all encompassing historic preservation has become over the past half-century. Seeing examples of magnificent but threatened ancient Native American rock art shortly after helping the Trust to acquire an equally threatened twentieth-century icon like the Farnsworth House can cause you to do that . . . a breadth of human experience that is hard to grasp, let alone connect . . . How should we define the mission of historic preservation today? It is certainly broader than it was fifty-five years ago. For what it's worth, I think the preservation movement, through its ability to adapt to changing needs and opportunities, has defined our mission something like this: we work to recognize and honor man's efforts to shape his environment by preserving humanity's most significant imprints on the land whether they be historic, architectural or artistic. Perhaps. In any case it's right that we start thinking about it.

The mission of the preservation movement in New York City must continue to evolve in order to recognize the very best and the most representative of our achievements in the structures that have been created, and will continue to shape our city. Preservationists have long understood the benefits of protecting the past from destruction. The architecture of New York City must be saved so that future generations can experience the magic of stepping into the past. Preservation of our landmarks provides a sense of continuity between past and present, and an appreciation of the accomplishments that outlast the individual life. We are reminded that the values and aspirations these landmarks embody possess continuing relevance today, and make us aware of the past's importance to the future.

A friend, the noted anthropologist, Professor Lionel Tiger, was preparing for the visit of his year-old granddaughter. He told me of his plan to provide for her the battered tin cup he had used as a toddler himself. The banal object was filled with the gravity of meaning of the routines and stream of life. Words could not describe the pageant of certainty that an old object so improbably carried. When I asked why he chose to share this particular object, this is what he so eloquently wrote: "Human beings cherish and adore the exemplification of the lives they have factually led. With tin cups, and with cities, too, because they are the physical rendition of our skills, turmoils, strolls to the movies, first dates, and first disappointments. The story of private life rests in public spaces. The frailer the times, the denser the episodes, the more reassuring and affirmative are the physical displays of how and where we managed in the past."

Preservation, perseverance, pride. What a tribute to ourselves . . .

Barbaralee Diamonstein-Spielvogel
December 12, 2004

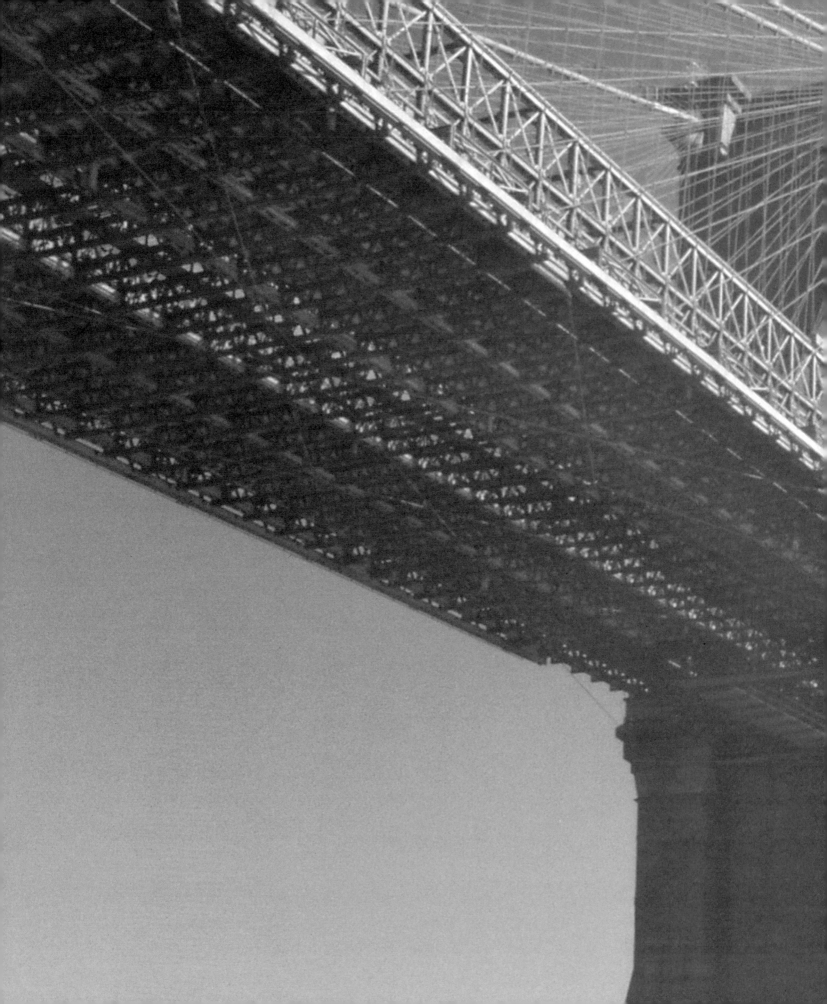

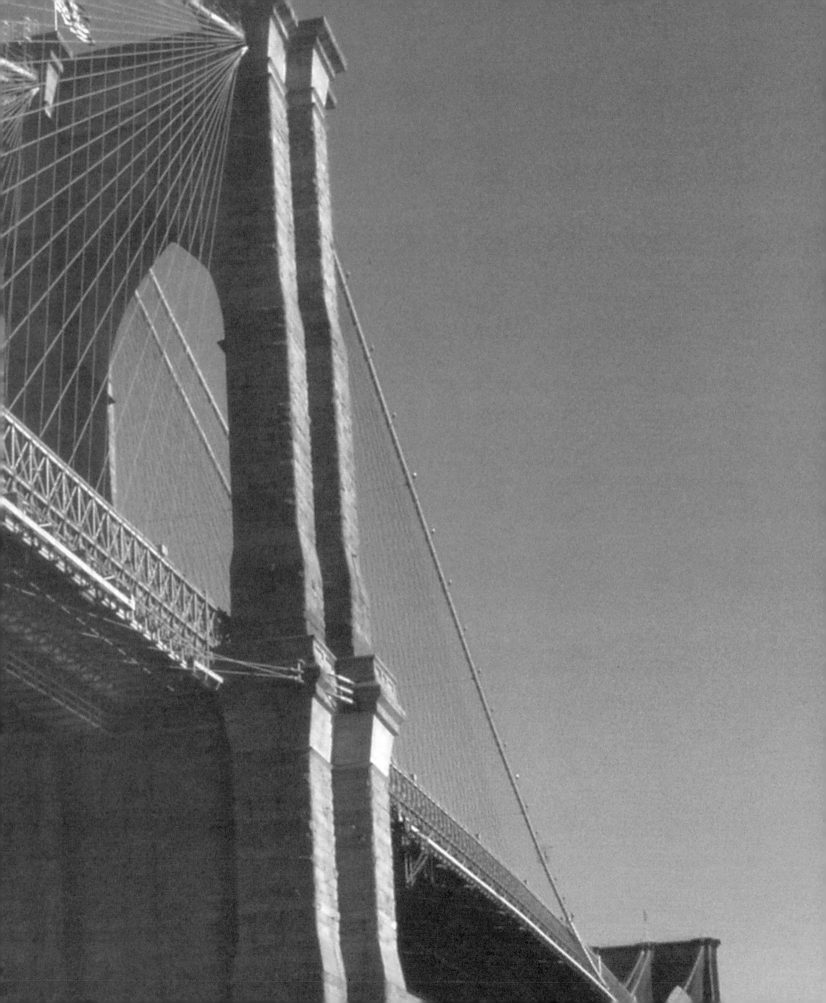

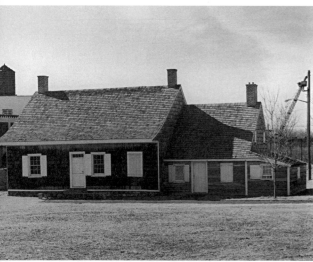

PIETER CLAESEN WYCKOFF HOUSE

OLD GRAVESEND CEMETERY

PIETER CLAESEN WYCKOFF HOUSE

BEFORE 1641

5816 CLARENDON ROAD AND
RALPH AVENUE, BROOKLYN

ARCHITECT: UNKNOWN

DESIGNATED: OCTOBER 14, 1965

The Pieter Claesen Wyckoff House, in the Flatlands section of Brooklyn, is the oldest building in New York State and one of the oldest wooden structures in this country. The one-story building has a full attic reached by a boxed-in stair. The earliest part of the house is the lower part of the building to the west. The "ski-jump" curve, or spring eave, of the overhanging roof is characteristic of the Dutch Colonial vernacular. Pieter Claesen was a wealthy landowner and superintendent of Peter Stuyvesant's estate. The house stands on land that four men, including Wouter Van Twiller, Stuyvesant's predecessor as director general of New Netherland, bought in 1636 from the Canarsie Indians. Van Twiller injudiciously put the property in his own name instead of that of the Dutch West India Company; Stuyvesant confiscated the land and turned the farm over to Claesen.

After 1664, Claesen adopted the surname Wyckoff (a combination of wyk, meaning "parish," and hof, meaning "court") as a fitting name for a magistrate. The original homestead remained in his family until 1901. In 1969, the Wyckoff House Foundation donated the house to the City of New York, and it has since been completely restored.

OLD GRAVESEND CEMETERY, INCLUDING THE VAN SICKLEN FAMILY CEMETERY

ESTABLISHED C. 1650

VILLAGE ROAD SOUTH, GRAVESEND
NECK ROAD, VAN SICKLEN AVENUE,
AND MCDONALD AVENUE, BROOKLYN

DESIGNATED: MARCH 23, 1976

A picturesque old cemetery, Gravesend is the most tangible reminder of the village of the same name. The village patent was the first land document in the New York area written in English. An unusual example of early town planning in America, Gravesend was reminiscent of cities in sixteenth- and seventeenth-century Europe, with the town center, residences, and other buildings all contained within protective walls. The community was also the first town charter in the colonies to list a woman patentee, Lady Deborah Moody, an Anabaptist leader who had fled the intolerant climate of the Massachusetts Bay Colony to seek religious freedom. Lady Moody is believed to be buried in the cemetery.

Occupying an irregularly shaped 1.6-acre lot, the cemetery is one of the smallest in the city. Many of the headstones are brownstone. Some have inscriptions in Dutch and English, while others depict angel heads with wings. Among the legible gravestones are those of Revolutionary War veterans, most of the original patentees, and many prominent families of the community. The Van Sicklen family maintained their own burial plot in the northwest corner of the site, which is still separately fenced.

NEW UTRECHT REFORMED DUTCH CHURCH CEMETERY

New Utrecht Reformed Dutch Church Cemetery

Established c. 1653–54

8401-8427 16th Avenue,
1602-1622 84th Street, and
1601-1621 85th Street, Brooklyn

Designated: January 13, 1998

The New Utrecht Reformed Dutch Church Cemetery, a rare surviving Dutch Colonial-era burial ground, is one of the oldest burial grounds in New York City. The communal cemetery was organized about 1653–54, prior to the construction of the first church building in 1700. Occupying an acre of land in southwestern Brooklyn, the cemetery and church were centrally located in the town of New Utrecht, established by Cornelius Van Werkoven in 1661 as one of the first towns in Kings County. Werkoven, a member of the Dutch West India Company, began purchasing the land from the Nyack Indians in 1652.

Burial within the cemetery was a sign of an individual's importance to the community; buried closest to the site of the 1700 church building, near the current church, are the graves of the original New Utrecht families. Nearby is a communal unmarked grave of Revolutionary War soldiers. In the northwest corner is another unmarked gravesite, belonging to free and enslaved Africans, who were allowed membership in the church.

The oldest surviving headstones date from the late eighteenth century. The earliest gravestones were destroyed by British troops who occupied the church during the Revolutionary War and used them for target practice. Other early grave markers, of less durable materials, have not lasted. Approximately 1,300 people have been interred here, through the twentieth century.

Street Plan of New Amsterdam and Colonial New York

c. 1660–present

Beaver, Bridge, Broad Streets, Broadway, Exchange Place, Hanover Square, Hanover and Marketfield Streets, Mill Lane, New, Pearl, South William, Stone, Whitehall, Wall, and William Streets, Manhattan

Designated: June 14, 1983

The street plan of Lower Manhattan south of Wall Street, within the confines of the Dutch settlement of New Amsterdam, is a striking reminder of New York's colonial past, and provides virtually the only above-ground physical evidence in Manhattan of the Dutch presence in New York during the seventeenth century.

The Dutch arrived in Manhattan (whose name means "hilly island" in the Algonquin language) in the early seventeenth century; there is evidence that Native Americans had lived on the island since 10,000 B.C. From Henry Hudson's 1609 voyage until 1624, the Dutch sailed the Hudson River and other waterways such as Long Island Sound, slowly establishing a fur trade with Native Americans in the region. In 1624, Dutch families established their claim to the land by settling Nut Island (now Governors Island) under the sponsorship of the Dutch West India Company. In the same year, some of these people may also have settled in Lower Manhattan. In 1626, Peter Minuit purchased the island of Manhattan from the Algonquins for

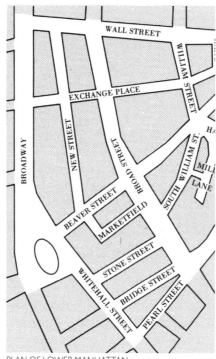

PLAN OF LOWER MANHATTAN

European trade goods "the value of sixty guilders." Nieuw Amsterdam, as the new Dutch settlement was called, began to take shape under the guidance of Crijn Fredericksz, who in 1625 had been assigned the task of laying out the city by the Dutch West India Company. In 1664, the English captured the city and colony and renamed it New York.

A detailed plan of the city in 1660, known as the Castello Plan, is the earliest and most detailed guide to the city's street pattern just before the English conquest. (The original was lost or destroyed, but a copy, redrawn by an unknown draftsman, has survived.) Most of the streets shown in the Castello Plan are still evident today in roughly the same configuration, and even their very names evoke the city's

early physical character. For example, Beaver Street was named for the animal that was central to the city's fur trade—the major source of the colony's early wealth; Bridge Street marks the location of one of the three bridges built by the Dutch settlers to cross the canal at Broad Street. Broadway was originally a Native American thoroughfare called Wickquasgeck, meaning "birch-bark country"; the route led through the Bronx and Westchester to the north of present-day Albany and remains the oldest thoroughfare in New York City and one of the oldest in North America. Exchange Place received its name in 1827 after the construction of the Merchants Exchange Building at Wall and William Streets. Marketfield Street was the location of the first Dutch live-stock market; during the English period, the street was known as Petticoat Lane, for it was here that prostitutes gathered. Mill Lane was named after a mill built in 1628 to grind bark used by tanners. Pearl Street refers to the abundance of oysters in the East River, whose pearls—the colonists hoped—would make their fortune instantly. South William Street was known by several early Dutch names—Glaziers' Street, Muddy Lane, Mill Street, and Jews' Alley—that reflected its industries, character, and the presence of a Jewish synagogue. Stone Street was the first paved street in the city—surfaced with cobblestones in 1655. Wall Street was named for a wall built by the Dutch to defend the city against attacks by Indians or the English. After the English took over, another sur-vey—the Nicolls Map—was made in

1668, and by the eighteenth century, city plans were plentiful. The streets in these maps are nearly identical to those in the earlier Castello Plan, but some additions include New Street—the first street added by the British to the Dutch street plan—and Hanover Street and Square, named for the royal family of England.

The street patterns of Lower Manhattan, unlike the formal grid introduced with the Commissioners Plan in 1811, were determined by the natural terrain and the city's primary functions, defense and trade. In contrast to many European towns, New Amsterdam did not have a religious focus. Indeed, when the first church was built in 1633, it was erected within the walls of the defensive fort that shaped the layout of the town.

Only modest alterations to the original street plan have been made over the last two centuries. These include the demolition of colonial buildings and changes in the grade, composition, and paving of the streets. Today, the street plan of New Amsterdam and colonial New York is the last visible remnant of a major colonial city. Despite its age and its narrow, curving roadways, the plan of Lower Manhattan has somewhat miraculously accommodated change and growth for almost 360 years.

BOWNE HOUSE

1661; ADDITIONS, 1680, 1691, 1830

37–01 BOWNE STREET, QUEENS

BUILDER: JOHN BOWNE;
ADDITIONS, UNKNOWN

DESIGNATED: FEBRUARY 15, 1966

The oldest surviving dwelling in Queens, the Bowne House is both an extremely important example of early, wood-frame Anglo-Dutch vernacular architecture and a monument to religious freedom in America. Little changed since its construction in 1661, it still occupies its original site. The earliest portion of the house, containing a kitchen with bedroom upstairs, was built by John Bowne. Additions were made in 1680 and 1696; the roof was raised and the north wing added in the 1830s. The steeply sloping roof, medieval in both tone and influence, has three shed dormers across the front that contribute to the picturesque quality of the facade. The historical importance of the house stems from John Bowne's defiance of Governor Peter Stuyvesant's ban on Quaker worship. Challenging Stuyvesant's opinion of Quakers as "an abominable sect," Bowne refused to sacrifice his religious freedom and instead invited fellow Quakers to meet in his house. His trial and subsequent acquittal helped establish the fundamental principles of freedom of conscience, and religious liberty, an act which established the principles later codified in the Bill of Rights.

The house continued to be used as a place of worship until 1694, when

BOWNE HOUSE

the Friends Meeting House of Flushing was built. Nine generations of Bownes lived in this house. Prominent family members include four early mayors of New York, a founder of the oldest public company in the United States, the first Parks Commissioner, abolitionists, educators, and horticulturalists.

In 1946, the house became a museum, and today it is owned by the City of New York and operated by the Bowne House Historical Society as a shrine to religious freedom. Now under extensive restoration, the house is closed for long-term renovation.

BILLIOU-STILLWELL-PERINE HOUSE

BILLIOU-STILLWELL-PERINE HOUSE

C. 1660S;

ADDITIONS, 1700, 1750, 1790, 1830

1476 RICHMOND ROAD,
STATEN ISLAND

ARCHITECT: UNKNOWN

DESIGNATED: FEBRUARY 28, 1967

The original portion of the Billiou-Stillwell-Perine House was built by Captain Thomas Stillwell, a prominent resident of Staten Island. After his death in 1704, it was passed down to his son-in-law, Nicholas Britton. At some point, the Perine family acquired the farmhouse and occupied it until it was purchased in 1919 by the Antiquarian Society, now the Staten Island Historical Society.

The original one-and-one-half-story farmhouse, built of rough-cut fieldstone, is distinguished by its steep, medieval-style roof and an immense Dutch fireplace with a huge chimney head supported by two wooden posts. This structure, which is now the rear wing, overlaps in an unusual way the stone addition nearer to Richmond Road. To avoid cutting down the tree that stood at one end of the original house, the newer structure was placed against only a portion of the side of the older dwelling. Both stone sections are built of undressed rubble fieldstone known as Dutch construction (the roughly squared stone of a later date is called English construction). The section added in 1700 is notable for its fine paneled fireplace, transitional type panel, and feather-edge partition. Later stone and frame additions of the same height were built about 1750, 1790, and 1830.

RICHMONDTOWN RESTORATION

1670–1860

RICHMONDTOWN, STATEN ISLAND

ARCHITECTS: UNKNOWN

DESIGNATED: AUGUST 26, 1969

BRITTON COTTAGE

C. 1670; ADDITIONS, C. 1755,
C. 1765, C. 1800

DESIGNATED: NOVEMBER 9, 1976

VOORLEZER'S HOUSE

C. 1695

TREASURE HOUSE

C. 1700; ADDITIONS C. 1740,
C. 1790, C. 1860

REZEAU–VAN PELT FAMILY CEMETERY

ESTABLISHED EIGHTEENTH CENTURY

CHRISTOPHER HOUSE

C. 1720; ADDITION, C. 1730

GUYON-LAKE-TYSEN HOUSE

C. 1740; ADDITIONS, C. 1820,
C. 1840

BOEHM HOUSE

1750; ADDITION, C. 1840

KRUSER-FINLEY HOUSE

C. 1790; ADDITIONS, C. 1820,
C. 1850–60

VISITORS CENTER, FORMERLY THIRD COUNTY COURTHOUSE

1837

BASKETMAKER'S HOUSE

C. 1810–20

SYLVANUS DECKER FARM

C. 1810

435 RICHMOND HILL ROAD (OFF SITE)

ELTINGVILLE STORE

COURTHOUSE

1837

STEPHENS-BLACK HOUSE

C. 1838–40

BENNETT HOUSE

1839; ADDITION, C. 1854

HISTORICAL MUSEUM, FORMERLY RICHMOND COUNTY CLERK'S AND SURROGATE'S OFFICE

1848; ADDITIONS TO C. 1918

PARSONAGE, 1855

ELTINGVILLE STORE

C. 1860

From 1729 until 1898—when New York's five boroughs were united—Richmondtown served as the county seat of Staten Island. The movement to preserve local heritage, begun in the 1930s, resulted in the establishment of the Richmondtown Restoration.

At its founding about 1690, Richmondtown was humbly known as

PARSONAGE

Cocclestown—presumably a reference to the mollusks abundant nearby. Here, about 1695, the Dutch erected the Voorlezer's House, their first meeting house, used as both a church and a school. Subsequently a town hall and a jail were built. By 1730, the town was thriving; it had a new courthouse, one tavern, about a dozen homes, and the Church of St. Andrew. This tiny town had become the largest and most important on the island, and the name Cocclestown was changed to the more solid-sounding Richmondtown. By the time of the Revolution, when the British occupied it, the town had a blacksmith shop, a general store, a poorhouse, a tanner's shop, a Dutch Reformed church, a gristmill, and several private homes.

Surviving buildings in situ have been joined by others, moved here from elsewhere on the island to save them from demolition. The restoration and reconstruction provide a fascinating picture of life on Staten Island over the course of

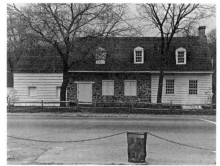

BRITTON COTTAGE

BOEHM HOUSE

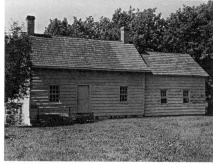

KRUSER-FINLEY HOUSE

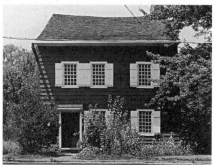

VOORLEZER'S HOUSE

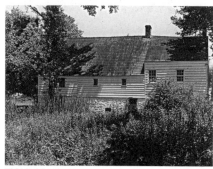

TREASURE HOUSE

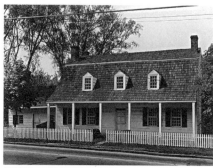

GUYON-LAKE-TYSEN HOUSE

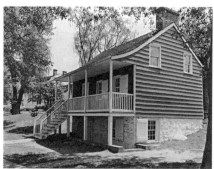

BASKETMAKER'S HOUSE

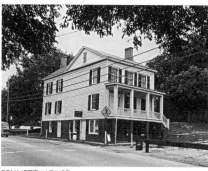

BENNETT HOUSE

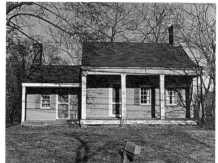

SYLVANUS DECKER FARM

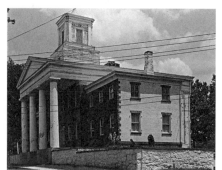

VISITOR'S CENTER

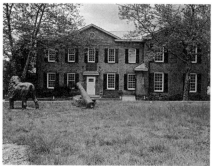

HISTORICAL MUSEUM

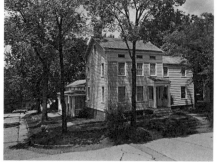

STEPHENS–BLACK HOUSE

more than two centuries. In all, there are about thirty-six buildings, the earliest dating back to the 1670s, not all of which are designated landmarks.

The Britton Cottage, built in four stages from 1670 to about 1800, is an outstanding example of the island's early civic and domestic architecture. The Voorlezer's House is a two-story, clapboard-sheathed building erected about 1695 as a school, church, and home for the lay minister and teacher; it is this country's oldest surviving elementary school, and its restoration in 1939 initiated the Richmondtown Restoration. The Treasure House is a modest clapboard structure built about 1700, with additions between about 1740 and 1860; a $7,000 cache of British coins was discovered within its walls about 1860—hence the name. The Rezeau–Van Pelt Family Cemetery is a tiny eighteenth-century family graveyard of a type known as a homestead burial plot. The Christopher House is a vernacular stone farmhouse whose oldest sections date from about 1720. The Guyon-Lake-Tysen House, built about 1740 for a French Huguenot, is a fine example of a Dutch Colonial–style farmhouse with gambrel roof and spring eaves. The Boehm House is a simple clapboard building with brick end chimneys dating from 1750; it was enlarged in about 1840. The Kruser-Finley House is a simple, one-and-one-half-story clapboard house of about 1790 with a cooper's workshop attached. The Basketmaker's House, of about 1810, is a clapboard and shingle house with a veranda sheltered by spring eaves. The Sylvanus Decker Farm, also of about 1810, is a fine clapboard

and shingle farmhouse, of a type once quite common on the island. The Visitors Center, formerly the Third County Courthouse of 1837, is an imposing Greek Revival structure with pedimented portico and square cupola erected of local stone and wood. The Stephens-Black House of about 1838–40 has a fascinating reconstruction of a nineteenth-century general store attached. Built in 1839, the Bennett House is a two-story, clapboard-sheathed house with Greek Revival elements. The Historical Museum, formerly the Richmond County Clerk's and Surrogate's Office, is a charmingly scaled, red-brick building in a simplified Italianate style built in 1848. The Parsonage was erected in 1855 for the nearby Dutch Reformed Church. It is a clapboard house with Gothic Revival ornament. The Eltingville Store dates from about 1860 and is a typical country store that is now furnished as a nineteenth-century printshop.

The Richmondtown Restoration is a unique project in the New York metropolitan region. Since 1958, it has been maintained by the Staten Island Historical Society under contract from the New York City Department of Parks and Recreation.

RICHMONDTOWN RESTORATION

CHRISTOPHER HOUSE

PROSPECT CEMETERY

PROSPECT CEMETERY

ESTABLISHED C. 1668

159TH STREET AND BEAVER ROAD,
QUEENS

DESIGNATED: JANUARY 11, 1977

Prospect Cemetery is the oldest public
burial ground in Queens. Several
Revolutionary War veterans are buried
here, as are members of many promi-
nent families of early New York, includ-
ing the Sutphins and Van Wycks. Many
of the older headstones are made of
brownstone and carved with motifs
of angel heads and skulls; more recent
nineteenth- and twentieth-century
graves are marked with granite obelisks.

The cemetery was originally affiliated
with the Presbyterian congregation
whose Old Stone Church, built in the
1690s, stood near present-day Union
Hall Street. The church served as the
town hall, and its cemetery was accord-
ingly considered town property.

The cemetery expanded during the
first half of the nineteenth century as
individual plots were purchased on
surrounding land. Small plots were
purchased for family use, but larger
tracts, which held a profit incentive,
were purchased, subdivided, and resold
by several people, including Nicholas
Ludlum, whose Romanesque Revival
chapel now stands as the focal point of
this historic burial ground. On his own
land, Ludlum erected a memorial to
his three young daughters. Today the
cemetery is maintained by the Prospect
Cemetery Association of Jamaica Village.

CONFERENCE HOUSE, FORMERLY THE CHRISTOPHER BILLOPP HOUSE

C. 1675

7455 HYLAN BOULEVARD,
STATEN ISLAND

ARCHITECT: UNKNOWN

DESIGNATED: FEBRUARY 28, 1967

The Christopher Billopp House, now
called Conference House, is the only
surviving seventeenth-century manor
house on Staten Island. The two-and-
one-half-story fieldstone residence
was built in about 1675 by Christopher
Billopp, a captain in the British navy;
a wood-frame lean-to was added
some years later.

The building was the setting for
a fruitless peace conference held on
September 11, 1776. After the British
seized New York in the Battle of Long
Island on August 27, 1776, Admiral
Richard Howe, the king's commissioner,
invited members of the Continental
Congress to discuss terms of surrender.
Benjamin Franklin, John Adams, and
Edward Rutledge, the Congress's
three representatives, traveled from
Philadelphia to the Billopp House, the
home of Christopher Billopp, a great-
grandson of Captain Billopp and a Tory
colonel. In this house, the patriots
refused the king's offer of an honorable
return to British rule in exchange for
renunciation of their demand for
independence, reaffirming their con-
stituency's desire for independence, and
fixing the course of American history.

After the Revolution, the Billopps'

CONFERENCE HOUSE

FIRST SHEARITH GRAVEYARD

Tory connections prompted the State of New York to confiscate the house. Over the next century and a half, a succession of private owners lived there, and for a short time it was used as a rat-poison factory.

In 1925, the Conference House Association was formed to preserve the house as a model of colonial architecture. Since 1929, the association has maintained the dwelling. The house is open to visitors.

FIRST SHEARITH GRAVEYARD

ESTABLISHED 1683

55–57 ST. JAMES PLACE, MANHATTAN

DESIGNATED: FEBRUARY 1, 1966

The First Shearith graveyard is a tiny remnant of the early history of the Congregation Shearith Israel, the oldest Jewish congregation in the United States. Shearith Israel dates from September 12, 1654, when a group of recently landed Spanish and Portuguese Jews who had fled the Inquisition held a New Year's service in New Amsterdam.

The small, quaint burial ground is marked by handsome tombstones; interspersed are marble sarcophagi with simple, flat-slab tops. The oldest gravestone dates from 1683, just a few years later than the earliest legible stone in Trinity Churchyard. Over the years, surrounding streets have been widened and new ones cut through. The congregation established other graveyards on West 11th and West 21st Streets.

FRIENDS MEETING HOUSE

POILLON-SEGUINE-BRITTON HOUSE
(DEMOLISHED)

FRIENDS MEETING HOUSE

1694; ADDITIONS, 1716–19

137–16 NORTHERN BOULEVARD,
QUEENS

ARCHITECT: UNKNOWN

DESIGNATED: AUGUST 18, 1970

The eastern third of the Friends Meeting House is the oldest structure in New York City in continuous use for religious purposes (with the exception of the years 1776 to 1783 when the British used it successively as a prison, a storehouse for hay, and a hospital). The meeting house was built on land held in the names of John Bowne and John Rodman, two prominent Quakers. Their ownership of the property, however, was a legal convenience. The Society of Friends was forbidden to own land in the province of New York, but the property and the meeting house belonged in spirit, if not in fact, to the Friends.

Simplicity is the keynote of the meeting house, both inside and outside. The interior, with its hardwood benches and total lack of ornament, is typical of the restraint and austerity that have always characterized the Quakers, who desired that no worldly ostentation should distract their attention from worship.

The original meeting house, a small frame structure comprising the eastern-third of the present building, dates from 1694. The plain, shingled, rectangular building, erected on a frame of forty-foot-long oak timbers, each hand-hewn from a single tree, is notable for the rustic European character of its proportions, framing system, and tiny windows.

The unusually steep, hipped roof is almost as high as the two stories below it—a feature that can be traced to seventeenth-century Holland.

Between 1716 and 1719, the building was enlarged to its present size; the original chimney, removed for the construction, was not rebuilt. The division between the two construction periods is evident in the interior structure and in the spacing of the windows on the south side. There are separate double doors for men and women on the south side; the south porch was added in the nineteenth century.

The pleasant, landscaped setting was formerly separated from Northern Boulevard by a picket fence; there is now a stone wall. The building still faces south, with its back to the street. A feeling of inherent peace survives, in perfect accord with the simple charm of the gray-shingled building and the sense of a long and continuous history.

POILLON-SEGUINE-BRITTON HOUSE

C. 1695; ADDITIONS, 1730, 1845,
1930

361 GREAT KILLS ROAD,
STATEN ISLAND

ARCHITECT: UNKNOWN

DESIGNATED: AUGUST 25, 1981

DEMOLISHED: APRIL 1996

The Poillon-Seguine-Britton House, named for its various owners, the first being Jacques Poillon, who came to America from France in 1671, was one of the oldest surviving houses on Staten

Island. Situated a short distance from the seashore, the house commanded a view to the south across the water of the Great Kills Bay to the distant hills of the New Jersey Highlands. Built in a local vernacular style, the stone and wood structure was two and one-half stories high. The first-story stone portion of the house was the oldest; the western part was probably built in the late seventeenth century. The wood portions of the house, including the colonnaded veranda and the Greek Revival woodwork, were mid-nineteenth-century additions and alterations; a large sunroom on the western end was added in 1930.

In 1996, the owners requested an emergency demolition permit from the New York City Buildings Department on the basis of an unsafe building. They received the permit (without Landmarks Preservation Commission approval) on a Thursday, and a bulldozer leveled the building the following day.

MANEE-SEGUINE HOMESTEAD

LATE SEVENTEENTH TO EARLY
NINETEENTH CENTURY

509 SEGUINE AVENUE,
STATEN ISLAND

ARCHITECT: UNKNOWN

DESIGNATED: SEPTEMBER 11, 1984

Located on the shore of Prince's Bay near the southern tip of Staten Island, the Manee-Seguine Homestead is characteristic of the rubblestone and clapboard or shingle dwellings built by

Staten Island's earliest settlers. Of the fewer than twenty extant houses built before 1750 on Staten Island, the Manee-Seguine Homestead is one of the oldest, dating to about 1690.

The house consists of two main sections, both of which were constructed in several stages. The larger, one-story rubblestone section was built first and a smaller, two-story gabled wood-frame addition was attached to the west side of the original house in the early eighteenth century. One of the distinctive features of the house is the spring eave, a mid-eighteenth-century addition to the north eave; deriving from northern France, it reflects the construction techniques of French Huguenots—such as Abraham Manee—who settled in the area.

The house was originally built for Manee; his family occupied the structure for three generations, until Manee's grandson's death in 1780. A few years later the house became the property of the Seguine family. The Seguines made a great deal of money in oystering; by 1840, Joseph Seguine had built himself a much finer residence on what is now Seguine Avenue. In 1867, Joseph's widow sold the old house, and in 1874, it was acquired by Stephen Purdy, who converted it into a hotel—known as the Homestead Hotel or the Purdy's Hotel—to serve Staten Island's burgeoning tourist trade. Today the house is a private residence.

MANEE-SEGUINE HOMESTEAD

RICHARD CORNELL GRAVEYARD

LAWRENCE FAMILY GRAVEYARD

RICHARD CORNELL GRAVEYARD

ESTABLISHED 1700S

ADJACENT TO 1457 GATEWAY BOULEVARD (GREENPORT ROAD), QUEENS

DESIGNATED: AUGUST 18, 1970

The Richard Cornell Graveyard is the oldest burial ground in the Rockaways and one of the few surviving eighteenth-century cemeteries in New York City. Enclosed by an iron picket fence, the graveyard is seventy-five feet wide and sixty-seven feet deep. It is named for the first European settler in the Rockaways, Richard Cornell, who had emigrated from England with his parents by 1638.

In 1687, Richard Cornell purchased most of the area now known as Far Rockaway from John Palmer, who had acquired the land two years earlier from the Indians for £31. The cemetery was established sometime in the early eighteenth century and used into the nineteenth as a private burial ground for the Cornell family. Family members interred here include Thomas Cornell, who served as a representative from Queens in the New York State Colonial Assembly for twenty-seven years. Among Richard Cornell's descendants were Ezra Cornell, the founder of Cornell University, and his son Alonzo Cornell, governor of New York from 1879 to 1882.

LAWRENCE FAMILY GRAVEYARD

ESTABLISHED 1703

20TH ROAD AND 35TH STREET, QUEENS

DESIGNATED: APRIL 19, 1966

The Lawrence Family Graveyard, situated in the center of a residential block, is chiefly important for its social heritage. The grounds of this half-acre plot do have aesthetic merit: the graveyard is enclosed by a brick wall, surmounted by a wrought-iron fence and entrance gate. The brown slate gravestones have remained legible through the centuries, and a hand-carved statue of an angel overlooks the burial ground. Nonetheless, it is the Lawrence family's distinguished record of civic service that qualifies their graveyard as a landmark.

Buried here are Major Thomas Lawrence, an officer in Her Majesty's army and the first to be buried in 1703, and Major Jonathan Lawrence, a soldier, statesman, and patriot who aided General George Washington in obtaining additional forces for the Revolutionary army at Brooklyn. Among the other family members interred were twelve ranking military officers, whose service spanned the period from Dutch Colonial rule in New York to the Civil War, and seven major government officials of the state of New York. Oliver Lawrence, who died in 1975, was the last of the Lawrence family to be buried here.

ALICE AUSTEN HOUSE

C. 1700; ADDITIONS, C. 1730, 1846, 1852, AND 1860–78

2 HYLAN BOULEVARD, STATEN ISLAND

ARCHITECT: UNKNOWN; ADDITIONS, JAMES RENWICK JR.

DESIGNATED: NOVEMBER 9, 1971

The Austen House was the longtime residence and workshop of Elizabeth Alice Austen, a pioneer American photographer who lived here for over seventy years.

Built sometime between 1691 and 1710 by a Dutch merchant, the house originated as a one-room dwelling erected parallel to the shoreline of the Verrazano Narrows. A southern extension, which later became the Austens' parlor, was added to the house before 1730. A wing, featuring three-foot-thick walls and including a kitchen, was constructed before the Revolution, changing the plan to an L shape.

When John Austen, Alice's grandfather, purchased the house in 1844, he immediately began a series of renovations to Clear Comfort (as his wife fondly called their new home). The plan changed again when Austen built a north room, which later became a bedroom shared by Alice and her mother. Austen hired his friend James Renwick Jr., who had recently completed Grace Church (p. 127), to execute further renovations.

By inserting Gothic Revival dormers into the Dutch-style roof, adorning the roof with a ridge crest and scalloped shingles, and decorating the entire structure with intricate gingerbread trim, Renwick transformed the matter-of-fact Dutch Colonial house into an exemplar of Victorian architectural romanticism. Japanese wisteria and Dutchman's pipe vines once trailed down from the house's roof and complemented its lacy aspect.

From the 1880s through the 1930s, Alice Austen made more than seven thousand glass negatives, many of which feature her house in its magnificent natural setting. Austen's images are marked by a sensitive but unsentimental realism, which provides us with a valuable glimpse of nineteenth-century Staten Island. Recently restored, the house now serves as a museum of Alice Austen's work.

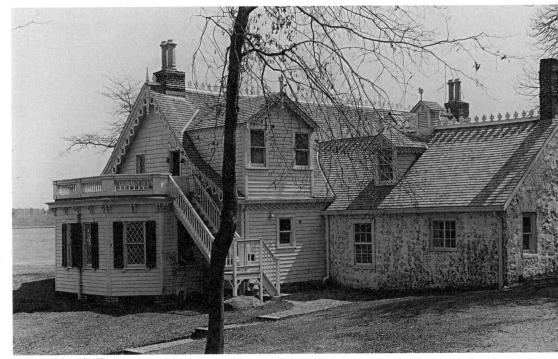

ALICE AUSTEN HOUSE

59

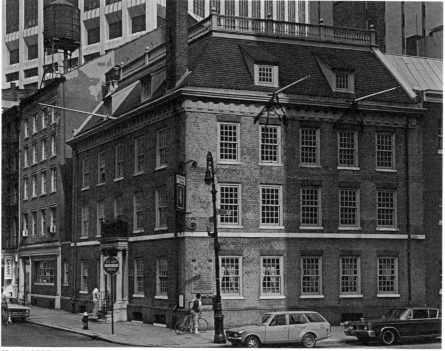

FRAUNCES TAVERN

FRAUNCES TAVERN

1719; RECONSTRUCTION AND
RENOVATION, 1904–7

54 PEARL STREET, MANHATTAN

ARCHITECT: UNKNOWN; RESTORATION
WILLIAM H. MERSEREAU

DESIGNATED: NOVEMBER 23, 1965

American taverns in the eighteenth century were centers of communication, transportation, business, and politics. Today, Fraunces Tavern Museum includes the only surviving public house of Colonial New York. The Fraunces Tavern building, which occupies a site that was one of the earliest landfill developments in the city, is a good example of a fashionable eighteenth-century Georgian residence.

The tavern is a 1907 reconstruction by William H. Mersereau of what the original may have been. The house was first built about 1719 as a residence for Etienne Delancey but apparently was not occupied. Samuel Fraunces, a well-known West Indian innkeeper, purchased the building in 1762 and opened it as a tavern the following year. Originally called At the Sign of Queen Charlotte, the tavern became a popular meeting place for colonists; several organizations, including the New York Chamber of Commerce, were founded there. It was not until after the Revolution that Fraunces renamed the tavern after himself. The place became the site of several celebrations, including General George Washington's farewell to his officers on December 4, 1783.

In 1785, Fraunces sold the building to George Powers, who leased it to the new Department of War, Treasury, and Foreign Affairs for three years. In the ensuing years, the tavern was used for many purposes, including a hotel, a meeting place, and a tavern, and it was nearly destroyed by fires in 1832, 1837, and 1852. The earliest visual record of the building—a print from Bryant and Gay's *Popular History of the United States* (1854)—shows that two floors had been added to the original eighteenth-century structure. By the beginning of the twentieth century, very little of the original structure was left.

In 1904, the Sons of the Revolution in the State of New York purchased the building; the restoration they undertook was one of the earliest in this country. Now the Fraunces Tavern building is a well-maintained site, one of five historic structures comprising Fraunces Tavern Museum. The ground-floor restaurant and upper-story meeting rooms are leased by the museum's board.

The structure reproduces the principal elements of the Georgian style. Restored to its original height of three and one-half stories, the rectangular, red-brick building has a centrally placed, ornately carved classical main doorway, with an arched semicircular fanlight. Above the door the entablature is supported with columns, and each side of the building has three rows of double-hung windows, shed dormers, and a balustrade running along the top. The high basement helped to keep the house warm and dry, and allowed for an imposing flight of steps, with hand railings, to the front entrance.

POILLON HOUSE

HENDRICK I. LOTT HOUSE

Fraunces Tavern Museum, the eighth-oldest museum in the city, opened to the public in 1907; it interprets the history and culture of early America through its permanent collection of prints, paintings, decorative arts, and artifacts.

POILLON HOUSE

C. 1720; ADDITIONS, 1837, 1848

4515 HYLAN BOULEVARD,
STATEN ISLAND

ARCHITECT: UNKNOWN; 1848
ADDITION, FREDERICK LAW OLMSTED

DESIGNATED: FEBRUARY 28, 1967

The first owner of the Poillon House property was Dominic Petrus Tesschenmaker, who built a one-room stone shelter here in 1685; the foundations of his house now form half of the present basement. Jacques Poillon, a road commissioner, purchased the property in 1696 and enlarged the shelter into a farmhouse. Many generations of the Poillon family resided here, including John Poillon, who, during the Revolutionary War, was a member of the Committee of Safety for Richmond.

The farmhouse was remodeled twice: first in 1837, when it was enlarged to thirteen rooms, and again in 1848, when noted landscape architect Frederick Law Olmsted added a one-and-one-half-story wooden extension. The exterior of the 1837 addition features massive stone arches over the windows in the basement and first-story areas. In 1848, porches were added on three sides of the house. The original stone door arches were enclosed and two pairs of windows were added in each arched opening. Above the narrow porch, the house was sided with wide clapboard.

HENDRICK I. LOTT HOUSE

EAST WING, 1720; MAIN SECTION
AND WEST WING, 1800; 2002

1940 EAST 36TH STREET, BROOKLYN

ARCHITECT: UNKNOWN

DESIGNATED: OCTOBER 3, 1989

Eight years after his marriage into the socially prominent Brownjohn family, Hendrick Lott built this house, which integrates characteristics of the traditional Dutch Colonial frame house with the symmetrical composition and architectural details of the newly fashionable Federal style. For the east wing, Lott used the kitchen he had removed from the house built in the village of Flatlands by his grandfather Johannes Lott, a prosperous farmer and member of the New York Colonial Assembly from 1727 to 1747. The older wing is readily identified by its low doorway, steeply pitched roof, twelve-over-eight window sashes, and small scale. The larger scale of the west wing and its porch, formed by posts that support the eaves, are typical of later construction.

Unlike many other houses of the period, this house retains its southern orientation, with sufficient surrounding property to give some sense of its original setting. Hendrick Lott's home contains some of the oldest surviving elements of any Dutch Colonial house in Brooklyn, with the exception of portions of the Pieter Claesen Wyckoff House (p. 46). The house was occupied by members of the Lott family until the 1980s. The City of New York purchased the house in 2002, and a restoration of the house and grounds is underway.

KREUZER-PELTON HOUSE

LENT HOMESTEAD

HOUSMAN HOUSE

KREUZER-PELTON HOUSE

1722; ADDITIONS, 1770, 1836

1262 RICHMOND TERRACE,
STATEN ISLAND

ARCHITECT: UNKNOWN

DESIGNATED: AUGUST 24, 1967

Two additions, built in varying textures and materials, reflect the three stages of construction of the Kreuzer-Pelton House. The original one-room cottage was built in 1722 by Cornelius Van Santvoord, a native of Holland and minister of the Dutch Reformed church. It is composed of random fieldstone. Inside, a trapdoor led from the kitchen to a so-called dungeon and adjacent wine cellar.

The larger steep-roofed, one-and-one-half-story central section, built from rough-cut stone, was joined to the cottage by Cornelius Kreuzer about 1770. During the Revolutionary War, General Cortlandt Skinner used the residence as his commanding headquarters for the American Loyalist party. In 1836, a two-story brick extension to this central structure was completed. The addition was supervised by Daniel Pelton, whose son, Daniel Pelton Jr., was a noted poet around 1900.

LENT HOMESTEAD

C. 1729; 1979

78–03 19TH ROAD, QUEENS

ARCHITECT: UNKNOWN

DESIGNATED: MARCH 15, 1966

Lent Homestead is one of the oldest remaining private residences in Queens. This Dutch Colonial stone farmhouse with its steeply sloping roof was built about 1729 by Abraham Lent, the grandson of Abraham Riker. The house faces Rikers Island, once owned by the Riker family and now the site of several city prisons.

A prominent family, the Rikers were among the first Dutch settlers in this area. They obtained the land grant from Governor Peter Stuyvesant in 1654 and built this house several decades later. The larger family homestead that once stood nearby burned down in 1938. The property includes a family cemetery in which many generations of Rikers and Lents are buried.

Damaged by fire in 1955, the house was intermittently occupied until 1979. The present owners, Michael and Marion Smith, began extensive renovations that year to restore their house to its original colonial charm.

HOUSMAN HOUSE

C. 1730; ADDITION, C. 1760

308 ST. JOHN AVENUE,
STATEN ISLAND

ARCHITECT: UNKNOWN

DESIGNATED: OCTOBER 13, 1970

The earliest part of this structure is a small, one-room stone house built about 1730 on the estate of Governor Thomas Dongan. In 1760, Peter Housman, a prosperous millwright, purchased forty-six acres of the Dongan manor and built an addition to the house. The building combines stone and frame construction. One notable feature of the older section is the unusually deep overhang of the steeply pitched roof. The larger, three-bay addition has a clapboard front and a slightly less steep roof, broken by two dormer windows. A four-paneled Greek Revival door serves as the entrance. Both sections of the roof are covered with shingles, and wood siding has replaced shingles at the gable ends. A rustic porch built of logs shelters the doorway and runs along the end of the house.

The house and twenty-five acres were sold in 1887, and the property was divided into smaller lots for a summer resort; this resort became the residential neighborhood now known as Westerleigh. The Housman House is still a private residence.

SCOTT-EDWARDS HOUSE

Scott-Edwards House

C. 1730; ADDITION, 1840

752 DELAFIELD AVENUE,
STATEN ISLAND

ARCHITECT: UNKNOWN

DESIGNATED: AUGUST 24, 1967

This one-and-one-half-story structure with a stone basement dates from the early eighteenth century. A Dutch Colonial country residence with Greek Revival alterations, it was built on a parcel of Governor Dongan's grant of 1677. Throughout the eighteenth century, the structure was probably a tenant house on the Dongan estate. During the 1840s, it became the home of Judge Ogden Edwards. A descendant of Jonathan Edwards and a cousin of Aaron Burr, Edwards was the first New York supreme court justice from Staten Island. The house was later owned by Adam Scott, a florist, and then by Samuel Henshaw, an employee of the New York Botanical Garden in the Bronx, who was responsible for the skillful planting of the shrubbery.

The house is constructed of quarry-faced ashlar masonry and sandstone at the ground floor, with clapboard above. The 1840 additions include a Greek Revival portico. The long sweep of the roof is supported by seven box columns forming a veranda that extends the width of the facade. Floor-to-ceiling, double-hung windows are complemented by paneled shutters; above these windows is a row of low attic windows set under eaves. The two entrance doors are framed with plain pilasters and flanked by narrow sidelights. The rear of the house features a bay window; the insets of tinted English glass are believed to be more than two hundred years old.

King Manor

C. 1730, C. 1755, C. 1805,
1810, 1830S; 1989–90

KING PARK, JAMAICA AVENUE AND
153RD STREET, QUEENS

ARCHITECT: UNKNOWN

DESIGNATED: APRIL 19, 1966
INTERIOR DESIGNATED:
MARCH 23, 1976

Three stages of construction reflect architecturally diverse styles—Georgian, Federal, and Greek Revival—in this large, two-and-one-half-story, L-shaped residence. The western section was added to the original rear portion by the Reverend Thomas Colgan, rector of Grace Episcopal Church, in 1755. In 1805, Rufus King—a member of the Continental Congress, ambassador to Britain, and U.S. senator from New York—purchased the estate from one of Colgan's daughters and enlarged the house.

The main, gambrel-roofed portion of the building is symmetrical in plan, with rooms on each side of a central hallway. An elaborate ceiling cornice containing several rows of molding, plus

KING MANOR

a row of Greek fretwork and dentils, decorates the hall. From here, four doorways lead to the principal rooms. In the western section is the parlor, which was renovated several times; it features an ornate ceiling cornice in addition to its elegant Greek Revival mantelpiece of dark gray and white marble. A mantel with pulvinated frieze and paneled overmantel is found in the library, above a fireplace surrounded by blue-and-white Dutch tiles depicting landscape scenes. Both the library and Rufus King's bedroom on the second story have plaster walls painted to simulate wood-grained paneling that, in combination with a chair rail, resembles a wainscot.

The eastern part of the house, built about 1805, contains a dining room with an inscribed, curved end wall and a Federal-style fireplace. The large sitting room on the second floor retains architectural features that date from 1755, including an ornate chimneypiece. On the second floor, sunk slightly below the level of the other rooms, is the children's playroom.

Cornelia King was the last family member to occupy the house. The building is now owned by the City of New York, which undertook a major exterior and interior restoration in 1989–90, and maintained as a museum by the King Manor Association.

Moore-Jackson Cemetery

Established by 1733

31–30 to 31–36 54th Street, Queens

Designated: March 19, 1997

In the mid-1650s, a group of English, nonconformist settlers negotiated with Governor Peter Stuyvesant and the local Native Americans for the rights to land near Newtown Creek, in what is now Woodside. Among them was the Reverend John Moore (d. 1657), whose family became prominent farmers and married into such notable families as the Jacksons, Rikers, Rapelyes, and Blackwells. The Moores were loyalists during the Revolution, allowing the British to use their farmhouse to plan the capture of Manhattan and to stockpile arms and quarter troops on their property.

The earliest gravestone in the Moore-Jackson Cemetery, located on what was the family's farmland, reads "SxR, dyed May [th]e 29, 1733"; the last recorded burial was in the 1880s. As Queens became urbanized early in the twentieth century, most of its small cemeteries were obliterated. The cemetery was one of the few catalogued by the Queens Topographical Bureau in 1919. The site became overgrown and forgotten until 1935, when a WPA project uncovered grave markers; the fifteen surviving stones were then relocated to a small plot on the eastern end of the property. In the absence of surviving Moore heirs, the Surrogate Court of Queens County now holds the title to the cemetery.

MOORE-JACKSON CEMETERY

CORNELIUS VAN WYCK HOUSE

Cornelius Van Wyck House

c. 1735; additions, before 1770

126 West Drive, Queens

Architect: Unknown

Designated: April 19, 1966

The Van Wyck house is one of two surviving Dutch Colonial farmhouses in the Douglaston section of Queens. It is considered by some authorities to be one of the finest of its kind on Long Island. The earliest part of the house was built by Cornelius Van Wyck in about 1735 in a vernacular rural style and consisted of what serve today as the dining room, the master bedroom, and the living hall—each retaining its original oak beams. Between 1735 and 1770, the house was expanded to the south and west. There are handsome Georgian mantelpieces in the present living room and in the downstairs bedroom. The scalloped shingles on the exterior west and south walls are original; the asphalt roof shingles are a recent addition. The history of this house is intimately linked with that of early Dutch settlers in New York. Cornelius Van Wyck was the eldest son of Johannes Van Wyck, whose father had emigrated from Holland in 1660. Cornelius had three sons, Stephen, Cornelius II, and Gilbert; Stephen, who inherited the property and added to the house, was a delegate to the Continental Congress. The Van Wyck family sold the house in 1819 to Winant Van Zandt, who added his adjoining 120 acres, including an area to the north known as The Point, to the property.

In 1835, all of this land was sold to George Douglas, a wealthy Scottish merchant; in 1876, his son William donated land for the Long Island Railroad station nearby, and the area became known as Douglaston. In 1906, the Van Wyck House and its property were sold to the Douglas Manor Company, which began to develop the community of Douglaston Manor. The Van Wyck House became the first home of the Douglaston Club. In 1921, when the club moved, Mr. and Mrs. E. M. Wicht bought the house; they undertook major restoration of the structure. Mr. and Mrs. L. K. Larson purchased the Van Wyck House in 1933, and sold it to their son, Stallworth M. Larson, and his wife in 1980.

STOOTHOFF-BAXTER-KOUWENHOVEN HOUSE

STOOTHOFF-BAXTER-KOUWENHOVEN HOUSE

SMALL WING, C. 1747;
ADDITION, 1811

1640 EAST 48TH STREET, BROOKLYN

ARCHITECT: UNKNOWN

DESIGNATED: MARCH 23, 1976

The Stoothoff-Baxter-Kouwenhoven House is named for a succession of related families who occupied it from the time of its construction until the 1920s. The first member of the Stoothoff family arrived in New Netherland from Holland in 1633 as a ten-year-old Dutch farmboy named Elbert Elbertsen. He later assumed the name "Stoothoff" when the British required distinctive surnames. This wood-frame Dutch Colonial building type is quite different from those of Manhattan and the Hudson River Valley, where a masonry tradition prevailed. A shingled dwelling, this house was built in two sections; the small wing, which dates from about 1747, was moved and consolidated with the new house of 1811. Both parts were shifted and oriented to their present position around 1900.

One and one-half stories high, the building profile features pitched roofs, end chimneys, and projecting eaves. The windows on the front facade at the main floor have paneled shutters; those at the upper floor of the newer section are set directly under the eaves. The Dutch-style front door has a rectangular glass transom.

VAN CORTLANDT MANSION

1748

BROADWAY AND WEST 242ND STREET, THE BRONX

ARCHITECT: UNKNOWN

DESIGNATED: MARCH 15, 1966;
INTERIOR DESIGNATED: JULY 22, 1975

The freestanding landmark houses and mansions remaining in the Bronx provide excellent illustrations of all the important styles of architecture that captured American taste from the Colonial period to the Civil War. One of the earliest is the splendid Georgian-style Van Cortlandt Mansion. Dating from 1748, the Van Cortlandt Mansion is a handsome manor house, almost square, built of rough fieldstone with fine brick trim around the windows. The stone was quarried and dressed locally. The bricks, also made locally, form a neat transition between the irregular shapes of the stonework and the multi-paned double-hung windows. The carved heads that form the keystones over the principal windows are a touch of unexpected whimsy in this otherwise very staid and English-looking house.

VAN CORTLANDT MANSION

The roof is pierced by regularly spaced dormer windows.

Unlike other Georgian houses in the city, whose interiors were updated in the nineteenth century, the Van Cortlandt Mansion retains most of its handsome original interior architectural features. Departing from the typical Georgian design of two rooms on each side of a central hall, the plan is L-shaped, perhaps reflecting the Dutch Colonial influence. The interior combines the formal elegance and symmetry of the Georgian style with practical features incorporated to best withstand the climate. Among the original architectural details are the floorboards, fireplaces, and paneled and plaster walls in their original colors; a U-shaped staircase in the front hall; and eared moldings and window cornices. The furnishings include beautiful examples of eighteenth-century English and American furniture, some of which belonged to the Van Cortlandts.

Oloff Van Cortlandt arrived in New Amsterdam in 1638 and founded a dynasty that at one time owned almost two hundred square miles of land. The Van Cortlandts were traders, merchants, and shipbuilders, and they married into

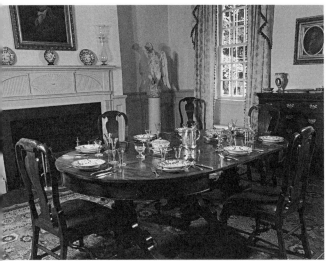

VAN CORTLANDT MANSION INTERIOR

SLEIGHT FAMILY GRAVEYARD

such wealthy and influential families as the Schuylers, the Philipses, and the Livingstons. Oloff's son Stephanus was appointed mayor in 1677, the first native-born American to hold that post. Oloff's grandson Frederick built the family mansion just a few years before his death. During the Revolution, General George Washington kept campfires burning around the house for several days to fool the British while he withdrew his troops across the Hudson. Members of the family lived in the house continuously until 1889, when the building and grounds were donated to the city as a public park. The National Society of Colonial Dames in the State of New York has maintained the house as a museum since 1897.

SLEIGHT FAMILY GRAVEYARD

ALSO KNOWN AS THE ROSSVILLE OR BLAZING STAR BURIAL GROUND

ESTABLISHED C. 1750

ARTHUR KILL ROAD AT ROSSVILLE AVENUE, STATEN ISLAND

DESIGNATED: JANUARY 17, 1968

Located just east of Rossville, on the north side of Arthur Kill Road, the Sleight Family Graveyard was one of the earliest burial grounds on Staten Island. Such early burial grounds were referred to as homestead graves; often deeds to property containing homestead graves included a restriction stating that the graves were not to be moved.

The Sleight Family Graveyard is located on a narrow strip of land on rising

ground that lies between a highway and a steep bank leading to a salt meadow. The plot was originally used solely for members of the Sleight family; it came to be shared by other families. Peter Winant (whose father was one of the first permanent settlers of Staten Island, in 1661) was buried here in 1758. In addition to the Sleights and Winants, some other well-known Staten Island families represented here include the Seguines, Perines, and Poillons. This graveyard is widely known as the Rossville or the Blazing Star Burial Ground (after the Blazing Star Ferry, which used to sail to New Jersey). The earliest graves date from 1750.

VANDER ENDE-ONDERDONK HOUSE

C. 1750–75;
RECONSTRUCTED, 1980–82

1820–1836 FLUSHING AVENUE, QUEENS

ARCHITECT: UNKNOWN; RECONSTRUCTION, GIORGIO CAVAGLIERI ASSOCIATES

DESIGNATED: MARCH 21, 1995

Situated one block from the Queens-Brooklyn border, this is one of the few extant Dutch-American farmhouses in New York, and a rare example of a surviving stone house with a wood-framed gambrel roof. The main facade is one-and-a-half stories and symmetrical, and has an addition to the east. Also unusual for a New York City farmhouse, the house remains on its original site with a

VANDER ENDE-ONDERDONK HOUSE

VALENTINE-VARIAN HOUSE

substantial parcel of land. The estate has yielded significant archaeological finds from prehistoric and historic periods.

In 1821, after a succession of farming families, the house and property were purchased by Adrian Onderdonk, a fifth-generation descendant of a Dutch Long Island family, and his new bride, Ann Wyckoff, of a prominent Dutch Brooklyn family. The house remained in their family until 1912. It was then used for a variety of commercial and industrial purposes. Plans for demolition and a fire in 1975 threatened the house's survival, but extensive reconstruction in 1980–82, undertaken by architect Giorgio Cavaglieri in cooperation with the Greater Ridgewood Historical Society, restored the structure to its 1936 appearance. It is now open to the public as the Vander Ende-Onderdonk House.

VALENTINE-VARIAN HOUSE

C. 1758

3266 BAINBRIDGE AVENUE, THE BRONX

ARCHITECT: UNKNOWN

DESIGNATED: MARCH 15, 1966

The Valentine-Varian House exemplifies the vernacular Georgian style popular before the emergence of professional architects in America. Built by Isaac Valentine, a blacksmith and farmer, it is a fieldstone farmhouse bonded with a mud-based mortar.

Four rooms on both the first and second floors are arranged symmetrically around a central hallway to form the straightforward rectangular plan. In contrast to the simple pitched roof that crowns the entire structure, the door-way—with its pediment and fluted pilasters—follows the tenets of classical architecture. Within the house are hand-hewn beams and Valentine's hand-forged

nails. From 1792 to 1905, the house was owned and occupied by the Varian family. Isaac L. Varian served as mayor of New York between 1839 and 1841. Purchased by William F. Seller, the house was entrusted to caretaker tenants until 1960. In 1965, it was moved from its original site on Van Cortlandt Avenue, east of Bainbridge, to property owned by New York City. Ownership and administration of the house were transferred to the Bronx County Historical Society, which continues to operate it as the Museum of Bronx History.

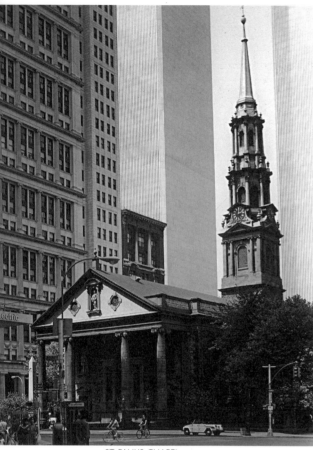

ST. PAUL'S CHAPEL

ST. PAUL'S CHAPEL AND CHURCHYARD

1764–66; TOWER, 1794

BROADWAY AT FULTON STREET, MANHATTAN

ARCHITECTS: ATTRIBUTED TO THOMAS McBEAN (CHURCH); JAMES CROMMELIN LAWRENCE (TOWER)

DESIGNATED: AUGUST 16, 1966

St. Paul's Chapel is the oldest church building in continuous use in Manhattan. Although it is commonly attributed to Thomas McBean, there is no evidence among church records to support this, and the chapel may have been designed by Andrew Gautier and others.

Modeled on James Gibbs's famous St. Martin-in-the-Fields in London, St. Paul's Chapel is built of small stone blocks reinforced at the window openings by brownstone frames. Giant pilasters flank the two stories of windows with Gibbs surrounds, and a stone belt course is topped by a continuous balustrade. The spire was built in 1794 by James Crommelin Lawrence. It is topped by a replica of Athens's Choragic Monument of Lysicrates, and decorated with consoles and pediments. The entire chapel, whose main entrance originally faced west, is surrounded by a handsome iron fence.

George Washington worshiped here for nearly two years, and was officially received in the chapel in 1789 following his inauguration. Brigadier General Richard Montgomery, a Revolutionary War hero, was interred underneath the east porch after his death in 1775. Benjamin Franklin, acting for the Second Continental Congress, commissioned the Italian sculptor Jacques Caffieri to design a memorial in Montgomery's honor, which was erected in 1789.

In 2001, in the aftermath of the collapse of the World Trade Center Towers, St. Paul's opened its doors to rescue workers, offering shelter and solace over many months.

MORRIS-JUMEL MANSION

1765; REMODELED 1810

WEST 160TH STREET AND EDGECOMBE AVENUE, MANHATTAN

ARCHITECT: JOHN EDWARD PRYOR

DESIGNATED: JULY 12, 1967; INTERIOR DESIGNATED: MAY 27, 1975

Situated in a one-and-one-half-acre park, the Morris-Jumel Mansion is the only surviving pre-Revolutionary house in Manhattan. The mansion and its grounds were originally part of a 160-acre estate that spanned the width of the island at Harlem Heights.

The house was built in 1765 by Colonel Roger Morris, a member of the British Executive Council of the Province of New York; his wife was Mary Philipse, who was rumored to have been romantically involved with George Washington before her marriage. Morris was the son of a well-known British Palladian architect, and his knowledge of the Palladian style is reflected in the double-storied portico and the octagonal wing, both among the first of their type in America.

The Morrises used the house as a summer villa until increasing hostilities endangered both Morris and his property. He then fled to England, entrusting the estate to his wife's care. Before Morris returned to New York in 1777, Mount Morris had served as General Washington's headquarters, as the post of General Sir Henry Clinton and his British officers, and as the home of Baron von Knyphausen and his Hessian troops. When peace was declared, in 1783, the Morris property was confiscated and sold. For a short period—before Stephen and Eliza Jumel bought it in 1810—the house was a fashionable inn, the first stop north of New York City on the Albany Post Road.

Madame Jumel, whose social aspirations were checked by an unsavory past, sought to enter New York society by redecorating the mansion in the finest French style, which she had seen in Paris. After her husband died in 1832, Eliza Jumel married Aaron Burr, the former vice-president, then seventy-seven and notorious for his duel with Alexander Hamilton. Burr died in 1836, and his widow became a recluse; she died in the house in 1865, and her heirs occupied it until around 1887.

In 1903, the last private owners of the house persuaded the City of New York to purchase the property. It is now a museum featuring period rooms that evoke the Morris, Washington, and Jumel eras.

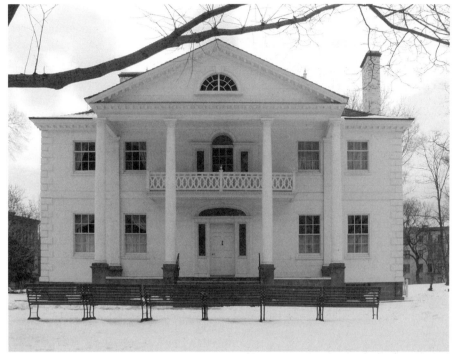

MORRIS-JUMEL MANSION

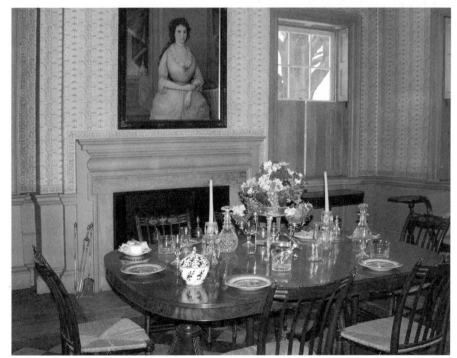

MORRIS-JUMEL MANSION DINING ROOM

WYCKOFF-BENNETT HOMESTEAD

BOWLING GREEN FENCE

WYCKOFF-BENNETT HOMESTEAD

C. 1766

1669 EAST 22ND STREET, BROOKLYN

ARCHITECT: UNKNOWN

DESIGNATED: JANUARY 17, 1968

The Wyckoff-Bennett Homestead is considered the finest example of Dutch colonial architecture in Brooklyn. It is believed to have been built by Henry and Abraham Wyckoff, descendants of Pieter Claesen Wyckoff, whose house in the Flatlands section of Brooklyn is the oldest building in New York State (p. 46). The date 1766, carved into a beam of the old barn, is the basis for dating the house to that year. Other souvenirs of the past include two little glass windowpanes, into which were scratched the names and ranks of two Hessian soldiers quartered in the house during the Revolution.

One and one-half stories high, the rectangular frame house has an extension on the northern end containing a kitchen and what was once a milk house. In the late 1890s, the structure was turned around to face west and placed upon a brick foundation; dormers were then added. A long porch extends the width of the south exposure, and six slender columns support the roof, which is swept down over the porch area in a gentle curve. The upper half of the divided front door still has its two thick, bluish green bull's-eye windows. The interior retains much of its original paneled woodwork.

In 1835, the house was purchased by Cornelius W. Bennett, and four generations of Bennetts lived here. It is still privately owned.

BOWLING GREEN FENCE

1771; 1786; 1914; 1970S

BOWLING GREEN PARK, MANHATTAN

DESIGNATED: JULY 14, 1970

One of the oldest landmarks in Lower Manhattan is small and inconspicuous—the simple iron fence at Bowling Green.

The fence was erected in 1771 to protect the gilded equestrian statue of George III of England and to prevent the green (which was—not surprisingly—used for bowling) from becoming a neighborhood dumping ground; the cost was £843. The statue, a hated symbol of tyranny, was pulled down and hacked apart by a crowd of soldiers and civilians on July 9, 1776—the day the Declaration of Independence reached New York from Philadelphia. It is said that pieces of the statue were melted down and molded into 42,000 bullets by the patriotic wife and daughter of the governor of Connecticut. The fence, too, was partially destroyed, and the ornaments that capped the posts (variously described as iron balls and royal crowns) were broken off by patriots and melted down for ammunition.

The iron fence was repaired in 1786, and old prints show that graceful lamps once adorned it. During the course of the nineteenth century, the surrounding neighborhood became completely commercial. In 1914, the fence was dismantled to allow construction of the subway beneath the green. The iron railings were removed to Central Park and lay there, forgotten, until 1919, when most of the fence was rediscovered and restored to Bowling Green. In the 1970s, the fence was again restored.

QUEENS COUNTY FARM MUSEUM, FORMERLY ADRIANCE FARMHOUSE, ORIGINALLY CREEDMOOR (CORNELL) FARMHOUSE

1772; ADDITIONS, C. 1840, 1875,
C. 1885, 1932, 1945–46; 1982

73–50 LITTLE NECK PARKWAY,
QUEENS

ARCHITECTS: UNKNOWN

DESIGNATED: NOVEMBER 9, 1976

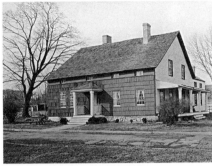
QUEENS COUNTY FARM MUSEUM

KINGSLAND HOMESTEAD

KINGSLAND HOMESTEAD

1785; 1996

143–35 37TH AVENUE, QUEENS

ARCHITECT: UNKNOWN

DESIGNATED: OCTOBER 14, 1965

The earliest part of the Adriance Farmhouse dates from the mid-eighteenth century; it is believed that Jacob Adriance built the house on about eighty acres of land purchased from his brother, Elbert. The essentially Dutch Colonial house had two unusual characteristics: the north facade, rather than the south, was intended to be the front; and the fireplace was located in the center rather than on the end wall, suggesting an English influence. Set on a basement of dressed fieldstone, the house originally contained a parlor, bedroom, and kitchen, surmounted by an unfinished attic. It was covered in shingles, and the north eave has a typical Dutch overhang.

About 1840, after Peter Cox purchased the house, two rooms and a one-story wing were added. This portion was built on a brick foundation laid in common bond. In 1875, a wing was added to the north; around 1885, after Daniel Stattel purchased the property, a narrow porch was added to the east and south facades, the north wing roof was raised, and three eyebrow windows put in.

In 1926, what was then the Creedmoor branch of the Brooklyn State Hospital acquired the property. The farm then served as a vegetable garden for the hospital's psychiatric patients, some of whom worked in the gardens as part of their therapy. A minor fire in 1932 necessitated repair work, and a nearby one-room building was moved and joined to the main house by a shed. The State added a pantry and extended the east porch in 1945. In 1982, the title of the property, now encompassing about forty-eight acres, passed to the City of New York. It is operated as the Queens County Farm Museum.

The Kingsland Homestead is Flushing's only remaining eighteenth-century dwelling and the second-oldest house in the area, predated only by the historic Bowne House (p. 49). It was built by Charles Doughty during the pre-Revolutionary period and named for Captain Joseph King, a British seaman and Doughty's son-in-law. The Kingsland Homestead was built in a style that might be characterized as Dutch-English Colonial. The two-story wooden structure with basement and attic has the divided front door and bold, even proportions of Dutch architecture, but the gambrel roof, central chimney, and round-headed and quadrant windows are typical of the English Colonial style. As with many Dutch-influenced dwellings (once common in western Long Island), the front elevation is dominated by a narrow porch covered by a column-supported roof. The door on one side is offset by two windows on the other, an asymmetrical arrangement that is repeated by the windows of the second floor. With the exception of some minor interior alterations and a modern replacement of the original service wing, the house retains its original structure. In 1996, the house was restored by the New York City Department of Parks and Recreation.

71

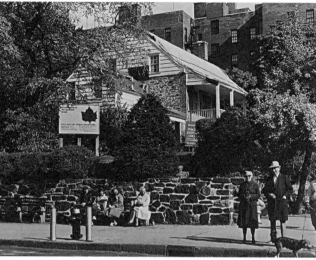

DYCKMAN HOUSE

DYCKMAN HOUSE

C. 1785; RESTORATION 1915–16

BROADWAY BETWEEN WEST 204TH
AND WEST 207TH STREETS,
MANHATTAN

ARCHITECT: UNKNOWN;
RESTORATION, ALEXANDER M. WELCH

DESIGNATED: JULY 12, 1967

Once the center of a prosperous farm, the Dyckman House is a typical Dutch Colonial farmhouse and the last surviving one in Manhattan.

The Dyckman family settled in the northern end of Manhattan in 1661 and helped to build the Free Bridge—sometimes called Dyckman's Bridge—over the Harlem River in 1758. During the Revolution, the Continental army, in its retreat from Harlem Heights, occupied the original Dyckman farmhouse, and the British subsequently used it during their occupation of Manhattan. When the British withdrew in 1783, they burned the building. The Dyckman family returned and reconstructed the house, reusing the materials from their former house.

The building as it stands today is of fieldstone, brick, and wood, with a sweeping, low-pitched gambrel roof, spring eaves, and a porch. On the grounds are a smokehouse and a military hut that were used during the British occupation.

In 1915, when the house was threatened by demolition, Dyckman family descendants purchased the building and restored it, filling it with family heirlooms. They presented it to the City of New York, which opened it to the public as a museum. Recently restored, the Dyckman House is now administered by the Historic House Trust in partnership with the Department of Parks and Recreation.

EDWARD MOONEY HOUSE

1785–89

18 BOWERY, MANHATTAN

ARCHITECT: UNKNOWN

DESIGNATED: AUGUST 23, 1966

Dating from 1785—shortly after the British evacuated New York but before Washington was inaugurated as the first president—the structure at 18 Bowery is one of the city's most interesting town houses and its oldest row house. It formed the end of Pell Street and the Bowery, on the edge of what is now Chinatown. Built by Edward Mooney, a well-to-do merchant in the wholesale meat trade, the house retains its original hand-hewn timbers.

Two windows in the gable end on Pell Street are particularly interesting for their quarter-round shape and interlacing muntins, which also appear in a central window. These features are characteristic of the incoming Federal style, whereas the splayed lintels and splayed double keystones at the heads of the other windows are typically Georgian.

The house, formerly an off-track betting parlor (appropriately since Mooney was a breeder of racehorses) has been restored to its original state by a recent owner.

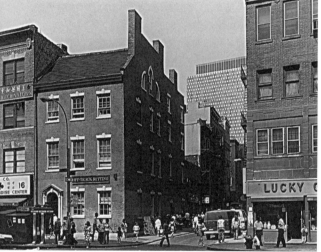

EDWARD MOONEY HOUSE

ERASMUS HALL MUSEUM

ERASMUS HALL MUSEUM

1786

COURTYARD OF ERASMUS HIGH
SCHOOL, 911 FLATBUSH AVENUE,
BROOKLYN

ARCHITECT: UNKNOWN

DESIGNATED: MARCH 15, 1966

This wood-frame, clapboard Federal building stands in the center of an ivy-towered quadrangle of brick and stone Collegiate Gothic buildings (p. 387). The second oldest public school in the country and the first secondary school to be chartered by the Regents of New York State, Erasmus Hall began as a private academy in 1787 with funds contributed by John Jay, Alexander Hamilton, Aaron Burr, and others. The land was donated by the Flatbush Dutch Reformed Church (p. 75), located across the street.

The rectangular structure's facade is divided into three equal sections, with the center section defined by sharply cut corner blocks. It has a stone basement and four-columned porch with a low-pitched pediment set into the hipped roof. The Palladian window on the second floor is centered in a row of eight evenly spaced, double-hung windows. Sidelights and delicate pilasters of the front door divide the symmetrically balanced first-floor windows.

The building now houses a museum and administrative offices.

REMSEN CEMETERY

COE HOUSE

REMSEN CEMETERY

ESTABLISHED C. 1790

BETWEEN ALDERTON STREET AND
TROTTING COURSE LANE, QUEENS

DESIGNATED: MAY 26, 1981

The Remsen Cemetery is the burial
ground of one of New York City's
earliest families, whose members played
a vital role in the American Revolution.
The Remsen family ancestors emigrated
from northern Germany to America and
eventually settled in Queens County in
the seventeenth century. The founding
father of the clan in America was Rem
Jansen Van der Beeck; his sons changed
the name to Remsen. The original ceme-
tery, believed to have been used from
the mid-eighteenth century through
the nineteenth, lay solely within the
property of the Remsen family. The
oldest known grave is that of Jeromus
Remsen, who died in 1790.

The oldest memorials in the cemetery
are a group of three brownstone
gravestones near Alderton Avenue, two
more along the northwesterly perimeter,
and the remnants of another tombstone
along the southern property line.
Commemorative marble gravestones
have been erected by the Veterans
Administration in honor of Colonel
Jeromus Remsen, Major Abraham
Remsen, and their two brothers, Aert
and Garrett, who were officers in the
Revolution. A memorial honoring the
community's participation in World
War I occupies the center of the
cemetery. The graveyard and memorials
are preserved and maintained by various
local organizations and citizens within
the community.

COE HOUSE

1793–94

1128 EAST 34TH STREET, BROOKLYN

ARCHITECT: UNKNOWN

DESIGNATED: NOVEMBER 19, 1969

This late-eighteenth-century Dutch
Colonial farmhouse is a striking contrast
to the twentieth-century houses that
now surround it. Sometimes referred to
as the Van Nuyse House, after Joost Van
Nuyse's eighty-five-acre farm, the house
was rented to Ditmas Coe by Johannes
Van Nuyse, Joost's son. Today the build-
ing is better known as the Coe House.

The one-and-one-half-story frame
house stands behind a white fence of an
unusual design, known as an Adams
fence. A low, brick stoop leads to the
paneled Dutch door with transom
above. The main portion of the house,
two bays wide, has low windows at
floor level under the eaves of a steeply
pitched roof with a cantilevered

overhang. The smaller wing of the house is similar in design; it has an immense walk-in cooking fireplace and a beamed ceiling. Two windows and one door wide, the wing has a covered porch supported by five square posts.

FLATBUSH DUTCH REFORMED CHURCH

1793–98; ADDITION, 1887

866 FLATBUSH AVENUE, BROOKLYN

ARCHITECT: THOMAS FARDON

DESIGNATED: MARCH 15, 1966

PARSONAGE

1853

2101–2103 KENMORE TERRACE

ARCHITECT: UNKNOWN

DESIGNATED: JANUARY 9, 1979

CHURCH HOUSE

1923–24

890 FLATBUSH AVENUE

ARCHITECTS: MEYER & MATHIEU

DESIGNATED: JANUARY 9, 1979

GRAVEYARD

ESTABLISHED LATE SEVENTEENTH CENTURY

890 FLATBUSH AVENUE

DESIGNATED: JANUARY 9, 1979

In 1654, under orders from Director General Peter Stuyvesant, the First Dutch Reformed Church was built in Flatbush. By 1698, as the neighborhood prospered, a more substantial building was financed by local inhabitants. In August 1793, in the mood of expansion that

FLATBUSH DUTCH REFORMED CHURCH

followed the Revolution, they voted to erect still another church, this one to be designed by Thomas Fardon. Three courses of squared sandstone blocks rest above the foundation of gray Manhattan schist. The octagonal wooden lantern with Tuscan columns supports entablature blocks topped by graceful urns. The tall, wooden steeple is also octagonal; at the top is a gilded weather vane. The apse was extended in 1887 to accommodate the organ and choir loft.

Thirteen years after the church was designated, the landmark site was expanded to include the Parsonage, Church House, and graveyard. The Parsonage, a large, imposing wood-frame residence, was built south of the church in 1853. The structure—two and one-half stories high with four

chimneys and a peaked roof—is five bays wide with a center hall, in the Greek Revival tradition with some Italianate details. A porch extends across the front of the house, with a roof supported by ten wooden, fluted Corinthian columns, connected by a railing of delicately turned wooden balusters. The floor-length parlor windows on each side of the front door retain exterior wooden louvered shutters. The front door has a three-light transom and flanking sidelights. In 1918 the parsonage was moved to its present location across from the cemetery.

Meyer & Mathieu designed the Church House of 1922. Two stories high and nine bays wide, the Georgian-style structure is built of red brick laid in Flemish bond. The five central bays project slightly to create a pavilion with six fluted Corinthian pilasters supporting a heavy entablature. The four round-arched window openings and main entrance contain stone lunettes with oval medallions in the center and draped swags on either side. The building rests on a basement of cast stone blocks that project forward to create a broad terrace.

Members of the early Dutch families are interred in the cemetery adjoining the church, which is included in the expanded landmark site.

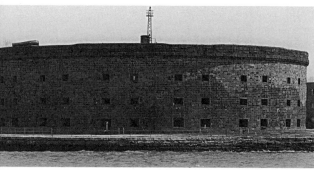

FORT JAY

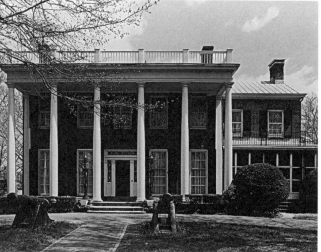

THE GOVERNOR'S HOUSE

GOVERNORS ISLAND

DESIGNATED: SEPTEMBER 19, 1967

FORT JAY

1794–98; REBUILT 1806

ARCHITECT: LT. COL. JONATHAN WILLIAMS

THE GOVERNOR'S HOUSE

1805–13

ARCHITECT: UNKNOWN

CASTLE WILLIAMS

1807–11

ARCHITECT: LT. COL. JONATHAN WILLIAMS

THE ADMIRAL'S HOUSE

1843; SOUTH WING 1886; PORCH 1893–1918

ARCHITECT: MARTIN E. THOMPSON

THE BLOCK HOUSE

1839

ARCHITECT: MARTIN E. THOMPSON

After the British captured New Amsterdam, Governors Island was used for "the benefit and accommodation of His Majestie's Governors for the time being"—hence the name. This little piece of land has also been used as a quarantine station, a pheasant preserve, a garrisoned fortress, a summer resort, a recruiting depot, a prison, an embarkation port, and a flying field. The island was an army installation for more than 150 years and served as the headquarters of the Coast Guard's Eastern Area between 1966 and 2003. The City and State of New York have purchased the island from the federal government, and studies are underway to determine the best way to develop the land for cultural and educational use. In 1996, 70 percent of Governors Island was designated a Historic District, including the entire original island and a portion of the landfill area constructed with fill from subway excavations between 1902 and 1912.

Built in the early 1800s, the austere brick Governor's House was designed in a modified Georgian style. It was erected during the era of rule by British colonial governors and was reputedly the home of Lord Cornbury, the first British governor of the new colony. Two stories high, it is symmetrical in plan, with the original portion designed in the form of a Greek cross.

Fort Jay was begun in 1794 when war with France was threatened. It was completed by 1798 using volunteer labor and named for John Jay, then secretary of foreign affairs. It was rebuilt in 1806 and renamed Fort Columbus in 1808; in

1904 the original name was restored.

Like so many other fortifications in this country, Fort Jay owes its inspiration to the great French architect Sébastian de Vauban, military engineer to Louis XIV. Impressive in size and design, the pentagonal breastworks occupy a knoll and dominate the northern end of the island; in combination with other forts on the island, it made invasion from the sea unlikely. Originally equipped with batteries of powerful guns and well-trained men, its might has gone untested. Fort Jay has never been called into action against an enemy.

The fort's imposing Federal-style stone entrance gateway shows considerable French influence; a low-arched opening set within a tall blind arch is flanked by four large Doric pilasters. Surmounting the cornice is a handsome carved sculptural composition of flags, cannon, weapons, banded fasces with liberty cap, and a spread eagle.

Castle Williams—originally called "The Tower" and nicknamed "The Cheesebox"—was erected in 1811. This circular red sandstone bastion was built to guard the waterway between Governors Island and Manhattan. It was named after its designer, Lt. Col. Jonathan Williams, chief engineer of the army and Benjamin Franklin's nephew, who had studied military architecture in France. Its walls are some forty feet high and eight feet thick. The stones in the outer walls are dovetailed so that no stone can be removed without first being broken into pieces.

The Admiral's House, formerly the Commanding General's Quarters, is an elegant late Federal-style manor house

resembling a southern plantation house. Built in 1843, it is rectangular in plan and two stories high with a basement; both the front and rear of this brick house have wide verandas dominated by six-columned Doric porticoes. The regal entrance doorway, centered between four full-length windows with large, paneled shutters, is noted for its intricate leaded transom and sidelights with four handsome pilasters capped with ornate acanthus leaves.

The Block House, built in 1839, is a severely simple house. Almost square, this two-story Greek Revival structure has superb architectural character, deriving its austere dignity from the strict, disciplined scale expressed in its proportion and components, and from the large, unadorned surfaces of brick interspersed with evenly spaced, well-proportioned openings.

Governors Island is not open to the public, but it can be visited by special appointment. The Historic American Buildings Survey has undertaken an extensive study of archival documents in recent years, revealing a wealth of new information about the site.

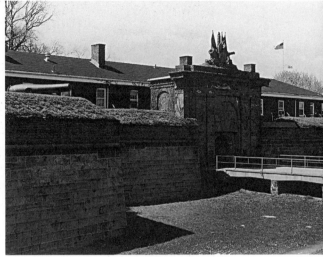

THE ADMIRAL'S HOUSE

THE BLOCK HOUSE

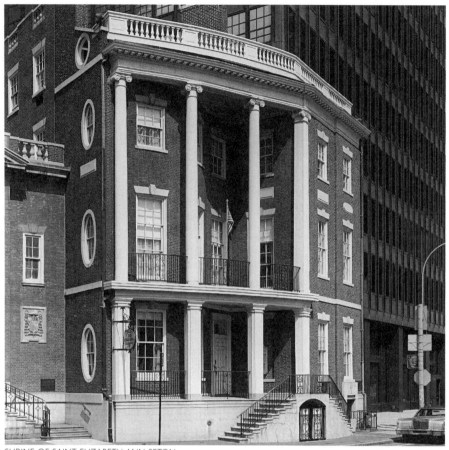

SHRINE OF SAINT ELIZABETH ANN SETON

oval windows enhance the west wall. The attenuation of columns, always a characteristic of the Federal style, is particularly exaggerated here because the columns were made from ships' masts.

Built as a gentleman's home, this building demonstrates that even when pressed together in rows, such houses retained elegance and individuality. Surrounded today by sheer glass walls of modern office towers, the house still stands out. On the basis of a print from *Valentine's Manual* of 1859, the house has been restored to its original appearance by Shanley & Sturges, with a fine cornice, distinctive second-floor porch windows, and attractive balustrade at the edge of the roof.

SHRINE OF ST. ELIZABETH ANN SETON, FORMERLY THE JAMES WATSON HOUSE

EAST PORTION, 1793; WEST PORTION, 1806; RESTORED, 1965

7 STATE STREET, MANHATTAN

ARCHITECTS: ATTRIBUTED TO JOHN MCCOMB JR.; RESTORATION, SHANLEY & STURGES

DESIGNATED: NOVEMBER 23, 1965

The Shrine of St. Elizabeth Ann Seton is the last of an elegant row of houses that once faced the Bowery on State Street. The older part of the house, two windows wide, was built in 1793 and is Georgian in feeling, except for the typically Federal detail of two marble plaques inserted in the brickwork over the second-story windows. The house is more famous for the Federal wing of 1806, attributed to John McComb Jr. The addition is noted for its curved porch with delicate Ionic columns rising two stories from the second floor; graceful

St. Mark's-in-the-Bowery Church

1795–99; steeple, 1828;
portico, 1854; 1983

East 10th Street at Second
Avenue, Manhattan

Architects: Unknown (church);
Ithiel Town (steeple)

Designated: April 19, 1966

St. Mark's-in-the-Bowery, an Episcopalian church and once part of the parish of Trinity Church, was erected in 1799 on the site of a 1660 Dutch chapel on Peter Stuyvesant's farm, or bouwerie; funds for the construction of the new church were donated by Stuyvesant's great-grandson. Peter Stuyvesant's remains, along with those of his heirs and his English successor, Governor Sloughter, are buried in the church's vault.

Just months after the consecration in 1799, the vestry of St. Mark's considered setting up its own parish. By the terms of its charter, Trinity was supposed to be the only parish in the city. Churches built before St. Mark's—such as St. Paul's Chapel—were in fact part of Trinity and administered by the Trinity parish. Two prominent members of St. Mark's, Alexander Hamilton and Richard Harrison, found a legal detour around this part of Trinity's charter and were able to establish their church as the second independent Episcopal parish in New York. This precedent enabled other Episcopalian congregations to create new parishes as the city grew.

The church itself, with a west tower over a colossal portico, was probably modeled after James Gibbs's St. Martin-in-the-Fields in London. Gibbs published engravings of his church, and his design, with a lofty tower rising over a pediment, was imitated all over the eastern seaboard.

The most distinctive features of these Gibbsian Colonial designs are the steeple, a translation of Gothic into classical forms, and the prominent quoins used to subdivide the elevation. In 1828, Ithiel Town altered the steeple, making the Gibbsian type into a Greek Revival tower. The colossal cast-iron portico is in a Renaissance mode. A chancel was added in 1836, and the present altar in 1891. The mosaics above the reredos are based on the lions outside St. Mark's in Venice. In the mid-nineteenth century, the rough fieldstone exterior received a coat of smooth plaster, which was removed in the 1930s.

After a fire in 1978, the Preservation Youth Project—a work-training program sponsored by the church—undertook the building's restoration, which was completed in 1983.

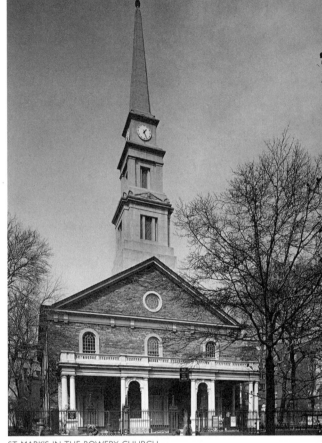

ST. MARK'S-IN-THE-BOWERY CHURCH

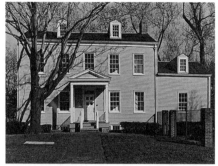

BLACKWELL HOUSE

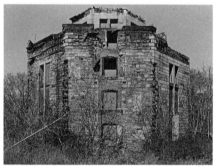

OCTAGON TOWER

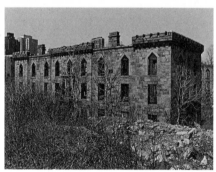

SMALLPOX HOSPITAL

ROOSEVELT ISLAND

DESIGNATED: MARCH 23, 1976

BLACKWELL HOUSE

1796–1804

BLACKWELL PARK,
ADJACENT TO MAIN STREET

ARCHITECT: UNKNOWN

OCTAGON TOWER

1835–39; ADDITIONS, 1847–48, 1879

NORTH OF NORTHTOWN

ARCHITECT: ALEXANDER JACKSON
DAVIS; ADDITIONS, JOSEPH M. DUNN

SMALLPOX HOSPITAL

1854–56; SOUTH WING, 1903–4;
NORTH WING, 1904–5

SOUTHWEST OF STRECKER LABORATORY

ARCHITECT: JAMES RENWICK JR.;
SOUTH WING, YORK & SAWYER;
NORTH WING, RENWICK,
ASPINWALL & OWEN

LIGHTHOUSE

1872

NORTH TIP OF ISLAND

ARCHITECT: JAMES RENWICK JR.

GOOD SHEPHERD COMMUNITY
ECUMENICAL CENTER, FORMERLY
CHAPEL OF THE GOOD SHEPHERD

1888–89

543 MAIN STREET

ARCHITECT: FREDERICK C. WITHERS

STRECKER LABORATORY

1892; THIRD FLOOR, 1905

SOUTHEAST OF CITY HOSPITAL

ARCHITECTS: WITHERS & DICKSON;
THIRD FLOOR, WILLIAM FLANAGAN

Across the East River from midtown Manhattan lies Roosevelt Island, a sliver of land two and one-half miles long. The island was not always known by that name. In the 1630s, the Dutch called it Varken Island; some years later the English renamed it Manning's Island. After the Revolution, it became Blackwell's Island. Jacob Blackwell's restored Federal-style mansion remains a link to the last private owner.

In 1828, the City of New York paid Blackwell a mere $30,000 for the 120-acre island and began developing it with institutional buildings—some penal, others humanitarian, and many a combination of both. The quality of the architecture was uncompromising; in that era of strong civic pride, city officials rejected the commonplace and chose top architects to ensure the excellence of the design. Today, six landmark structures, dating from the late eighteenth century to the late nineteenth century, illustrate the transformation of 107 acres of open farmland to institutional use.

The oldest structure on the island, the Blackwell House is a modest clapboard farmhouse built in the vernacular style in 1796–1804 by the Blackwell family. Restored in 1973, the house is one of the few farmhouses dating from the years following the Revolution; it is now used as a community center.

Surrounded by an attractive plaza, the Chapel of the Good Shepherd was designed by Frederick C. Withers and completed in 1889. Late Victorian Gothic in style, the chapel is in the tradition of English parish churches. The richly textured and subtly polychromatic wall

surfaces enrich the simply massed structure. The chapel was the gift of banker George M. Bliss and was intended for use by inmates of the city's almshouse, which stood nearby. The chapel closed in 1958 and reopened in 1975 following restoration. It is now one of the island's community centers and an ecumenical place of worship.

On the southern end of the island stand two exceptional landmarks. The older, and for many the most romantic, is James Renwick Jr.'s original Smallpox Hospital. When it was officially opened in 1857, it was a miraculous haven, the first public facility in the United States to provide professional care for those afflicted with that dreaded contagious disease. Today, the bare and weathered Gothic walls are reminiscent of ancient English ruins.

Faced with gray gneiss quarried on the island, the hospital is three stories high and U-shaped in plan. The dramatic focal point of the building is the entry: a heavy stone porch is surmounted by a crenellated bay and enhanced by a massive towerlike structure above, with recessed Gothic pointed arch on corbels. The whole is crowned by crenellations and a smaller, freestanding pointed arch. Additions were made in 1903–4 and in 1904–5.

The second building on the southern end is the Strecker Laboratory, also by Withers and considered one of the most advanced facilities of its kind when it opened in 1892. This petite yet elegant Romanesque revival building reflects the late-nineteenth-century shift of mood to the more restrained neo-Renaissance tradition popularized by McKim, Mead &

White. In 1999, the building was adapted for use as an electric substation by architect Page Ayres Cowley.

The picturesque silhouette of the Octagon Tower is still a prominent feature of the island's skyline. It is the sole surviving portion of the Lunatic Asylum, which opened in 1839. The tower was the central core of a much larger structure planned by architect Alexander Jackson Davis in 1834–35, partially completed in 1848, and added to in 1879. The Davis plan reflected a change in attitude toward mental illness: the recognition that patients required medical assistance, not merely custodial care. The bold geometry of the building, carried out in smooth, crisply faced walls of gneiss, is enhanced by simple detail and a "modern" treatment of fenestration. Paired windows appear at each floor, separated by heavy mullions and by simple stone transverse members, creating a very modern feeling of continuous verticality. The domelike convex mansard roof and entrance were additions of 1879. Following the transfer of the indigent insane to Ward's Island in 1894, the name of the facility was changed to Metropolitan Hospital. It was closed in 1950. In December 2004, Governor George Pataki announced the groundbreaking for five hundred units of mixed-income housing in wings that will flank the Octagon Tower.

Standing on a point of land that was once a separate, tiny island, the fifty-foot-tall lighthouse was built in 1872 under the supervision of James Renwick Jr. The octagonal shaft of rock-faced random ashlar is enlivened by boldly scaled Gothic-style detail.

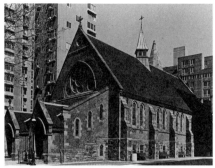
GOOD SHEPHERD COMMUNITY CENTER

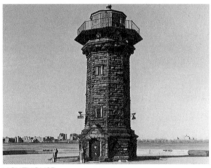
LIGHTHOUSE

According to legend, it was built by John McCarthy, an inmate of the Asylum.

In the 1920s, the island's name was changed again, to Welfare Island, and in 1973 to Roosevelt Island, in honor of Franklin Delano Roosevelt. Redevelopment plans for the island began in the late 1960s under the direction of the New York State Urban Development Corporation, and some of the abandoned and dilapidated landmarks were restored. Restoration of the structures was undertaken by architect Giorgio Cavaglieri.

HARRISON STREET HOUSES

MANHATTAN

DESIGNATED: MAY 13, 1969

317 WASHINGTON STREET, 1797

ARCHITECT: JOHN MCCOMB JR.

JONAS WOOD HOUSE, 1804

314 WASHINGTON STREET

ARCHITECT: UNKNOWN

315 WASHINGTON STREET, 1819

ARCHITECT: JOHN MCCOMB JR.

EBENEZER MILLER HOUSE, 1827

35 HARRISON STREET

ARCHITECT: UNKNOWN

JACOB RUCKLE HOUSE, 1827

31 HARRISON STREET

ARCHITECT: UNKNOWN

SARAH R. LAMBERT HOUSE, 1827

29 HARRISON STREET

ARCHITECT: UNKNOWN

JOHN RANDOLPH HOUSE, 1828

329 WASHINGTON STREET

ARCHITECT: UNKNOWN

WILLIAM B. NICHOLS HOUSE, 1828

331 WASHINGTON STREET

ARCHITECT: UNKNOWN

WILSON HUNT HOUSE, 1828

327 WASHINGTON STREET

ARCHITECT: UNKNOWN

This unique group of nine restored Federal-style brick town houses—forming an L-shaped enclave surrounded by the apartment towers of Independence Plaza—were erected between 1797 and 1828 on Harrison and Washington

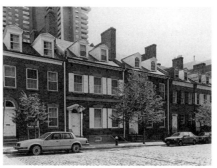

HARRISON STREET HOUSES

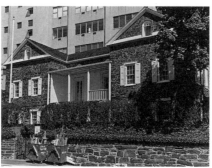

MOUNT VERNON HOTEL MUSEUM

Streets for specific owners. Two houses were designed by John McComb Jr., the city's first native-born architect, who lived at 317 Washington Street for many years. All display the scale and craftsmanlike attention to detail characteristic of the Federal style; each is two and one-half stories high, built of Flemish bond brickwork, and retains its original pitched roof and dormers. Though built for people of considerable means, these houses nonetheless have discreet and modest interiors.

As the city grew and Washington Market moved northward, the houses became engulfed in a busy commercial environment; they were used for warehousing and deteriorated rapidly. By 1968, the houses were threatened with demolition. The Landmarks Preservation

Commission worked with the Housing and Development Administration to secure funding to incorporate the landmarks within the redevelopment area and to pay for their restoration. This work was completed by the firm of Oppenheimer, Brady & Vogelstein, and the houses have been sold to private owners.

MOUNT VERNON HOTEL MUSEUM, FORMERLY ABIGAIL ADAMS SMITH MUSEUM

1799; 1939

421 EAST 61ST STREET, MANHATTAN

ARCHITECT: UNKNOWN

DESIGNATED: JANUARY 24, 1967

This handsome stone building, also known as Smith's Folly and Mount Vernon on the East River, was designed as the carriage house for the elaborate estate of Colonel William Stephens Smith and his wife, Abigail Adams Smith, daughter of John Adams and sister of John Quincy Adams. Before the Smiths finished the buildings on their property, financial troubles forced them to sell the estate to William T. Robinson, who completed the work in 1799.

The original manor house was destroyed by fire in 1826; the carriage house and several acres were purchased by Joseph Coleman Hart, who remodeled the building as an inn. In 1833, the Mount Vernon Hotel and the land were purchased by Jeremiah Towle, and sold by his daughters to the Standard Gas and Light Company in 1905. The house soon

fell into neglect. In 1919, Jane Teller, president of the Society of American Antiquarians, leased the house and opened a shop for antiques and colonial crafts. The Colonial Dames of America, who purchased the building in 1924, they have operated a museum here since 1939.

The architectural interest of the Federal stone stable lies in its superb masonry construction and excellent proportions. The low-pitched, pedimented gable roofs are cut in sharp profiles. Originally, large arched openings accommodated horse and carriage traffic; these were filled in with brick when the Harts converted the stable to an inn. They also added the Greek Revival porticoes and interior details, subdivided the large rooms, and added six fireplaces. The eighteenth-century-style garden that now surrounds the building was planted by the Colonial Dames, who furnished nine rooms in the Federal style.

Gracie Mansion

1799; 1966; 1980s; 2003

East End Avenue at 88th Street in Carl Schurz Park, Manhattan

Architect: Attributed to Ezra Weeks

Designated: September 20, 1966

New York's official mayoral residence, Gracie Mansion, is the only Federal-style country seat in Manhattan still used as a home. Archibald Gracie, a Scottish immigrant and successful New York merchant, built this house in 1799 on Horn's Hook, the site of loyalist Jacob Walton's 1774 dwelling. Walton's house was destroyed during the Revolutionary War. The American army confiscated the site for use as a fort, which was also destroyed by British bombardment. Gracie used some of the old Walton house foundations for his house.

In 1809, Gracie moved the entrance from the southeast to the northeast and created an entrance hall at the center of the house. He also added two bedrooms. Although the architect is unknown, it is possible that the designer was Ezra Weeks, who became notorious in 1800 for his involvement in a murder trial.

Despite the threat of British attack, Gracie and his family summered in the house during the War of 1812; Gracie's business, however, was crippled by the war and never recovered. In 1823, Archibald Gracie & Sons was dissolved, and Rufus King, Gracie's longtime friend and trustee, sold the mansion to Joseph Foulke in the same year.

Prompted by the population increase downtown, Foulke made Gracie's summer estate his permanent residence, where he remained for nearly twenty-seven years. Noah Wheaton, a house builder, purchased the mansion and twelve surrounding lots in 1857; in their thirty-nine years there, the Wheatons decorated lavishly.

The Parks Commission purchased the house in 1896 and renamed the grounds Carl Schurz Park, in honor of the German immigrant, who had arrived in New York in 1852 and settled in Yorkville in 1881. Among other accomplishments, Schurz served

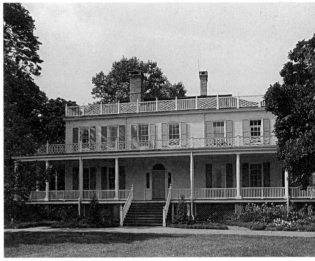

GRACIE MANSION

as a U.S. senator and editor of the *Nation* and the *New York Evening Post*. It is fitting that the land surrounding Gracie's mansion was named in Schurz's honor since Gracie had helped to establish the *Post* in 1801.

The house was neglected for several years, but in 1927 the city undertook a first restoration; the house was restored again in 1942, when Mayor Fiorello La Guardia moved in. A reception wing was added in 1966. In the 1980s, extensive renovations, funded by private contributions from the Gracie Mansion Conservancy, were completed. The interior and exterior were restored again in 2003. Today, Gracie Mansion is known as the "People's House," serving as an official guest house and venue for meetings and events and open for tours.

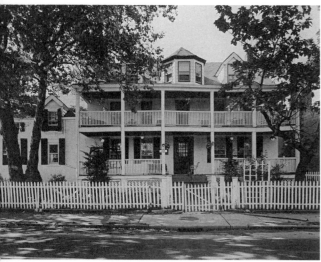

NEVILLE HOUSE

VAN NUYSE-MAGAW HOUSE

NEVILLE HOUSE

C. 1800

806 RICHMOND TERRACE,
STATEN ISLAND

ARCHITECT: UNKNOWN

DESIGNATED: NOVEMBER 15, 1967

This large country house is one of the few remaining colonial houses in New York City. It stands as a reminder of a time when the city stopped at Chambers Street and farms and villages filled the rest of Manhattan and the outer boroughs. The house was built as a retreat for Captain John Neville, a retired officer of the British navy. Later, it passed into the hands of the family of Judge Jacob Tysen, whose son Raymond wrote a brief history of Staten Island. Many of the city's country houses were used as taverns at some point after the Revolution; their large size suited the purpose well. The Neville House was no exception—as The Old Stone Jug, it served the retired sailors at nearby Snug Harbor for many years.

The house is built of quarry-faced red sandstone ashlar, unusual for a time when skilled masons were in short supply. In marked contrast to the rough surface of the walls is the dressed ashlar used for lintels and door surrounds. A broad flight of stairs in the center of the facade leads to another distinguishing feature of this Georgian vernacular house—the three-bay-wide, two-story veranda. A West Indian convention, the veranda may have been inspired by Neville's travels with the navy.

VAN NUYSE-MAGAW HOUSE

C. 1800–1803

1041 EAST 22ND STREET, BROOKLYN

ARCHITECT: UNKNOWN

DESIGNATED: FEBRUARY 11, 1969

After his marriage to Nellie Lott on April 2, 1800, Johannes Van Nuyse constructed this Dutch Colonial–style frame farmhouse on the west end of his father's eighty-five-acre farm. Robert Magaw bought the house at some time between 1844 and 1852; Frederick, one of his three sons, sold it in 1909. George C. Case purchased the house in 1916; at about that time he moved it to its present site, removed the kitchen wing, and added the new dormer windows.

The rectangular, two-and-one-half-story, shingled dwelling is on a lot bounded by two driveways. There are two large double-hung windows on the first floor, two paired windows on the floor above, and a single round-arched window in the attic in the west gable end of the house. A gambrel roof with out-sweeping curves projects beyond the two long sides, forming cantilevered overhangs. A brick path leads to a raised platform in front of the main entrance, which is flanked by two freestanding, fluted Doric columns supporting a low entablature.

HAMILTON GRANGE

CHURCH OF THE TRANSFIGURATION

CHURCH OF THE TRANSFIGURATION

1801; ADDITIONS 1868

25 MOTT STREET, MANHATTAN

ARCHITECT: UNKNOWN; ADDITIONS, HENRY ENGLEBERT

DESIGNATED: FEBRUARY 1, 1966

The English Lutheran congregation built this charming and unpretentious church in 1801. Called the Lutheran Zion Church, it was constructed of the same rubble masonry as St. Paul's Chapel, but it is far less sophisticated in its detailing. It is Georgian in style, with steeply pitched end gables, rich entablature and quoins, and rectangular plan with the tower set forward. Decidedly not Georgian, however, and somewhat unexpected in the early 1800s, are the pitched window heads reminiscent of English Gothic parish churches.

The church was partially destroyed by the Great Fire of 1835. In 1853, the Roman Catholic Church of the Transfiguration, known as the Church of Immigrants, bought this building and moved to 25 Mott Street, at which time the church was remodeled and the bell tower replaced.

HAMILTON GRANGE

1801

287 CONVENT AVENUE, MANHATTAN

ARCHITECT: JOHN McCOMB JR.

DESIGNATED: AUGUST 2, 1967

John McComb Jr. designed the Grange as a country seat for Alexander Hamilton. The two-story clapboard house originally had elegant verandas and a shallow hipped roof masked by a balustrade. Doric columns carried the veranda roof; the order was repeated in the main cornice. Two of the four large chimneys were false, made of wood, an unusual manifestation of the period's obsession with symmetry.

Originally located on a thirty-five-acre tract along the Old Albany Post Road (now Kingsbridge Road), the Grange was moved to its present site in 1889 to escape demolition. The front door and porch were moved to create a more impressive entrance on the street. After its relocation, the Grange served as a chapel and rectory for St. Luke's Church.

Purchased by a preservation organization in 1924 and donated to the U.S. Department of the Interior in 1962, the house is National Monument, administered by the National Park Service.

Alexander Hamilton served George Washington during the Revolution as secretary and as aide-de-camp. Following the war, he was a member of the Continental Congress and the New York State Legislature. As secretary of the treasury he proposed a national bank in 1791 and the U.S. Mint in 1792. Hamilton, always a staunch Federalist, passionately held political convictions that led to his 1804 duel with Aaron Burr, in which Hamilton was mortally wounded.

STUYVESANT-FISH HOUSE

STUYVESANT-FISH HOUSE

1803–4

21 STUYVESANT STREET, MANHATTAN

ARCHITECT: UNKNOWN

DESIGNATED: OCTOBER 14, 1965

This three-story brick residence exhibits the restraint and beauty of proportion that were hallmarks of Federal design. The house was built by Peter Stuyvesant on a tract of land granted in 1651 to his great-grandfather, also Peter Stuyvesant, the last Dutch director general of New Netherland. The younger Peter Stuyvesant constructed the house for his daughter, Elizabeth, at the time of her marriage to Nicholas Fish, a close friend of Alexander Hamilton and General Lafayette. Fish entertained Lafayette here on the evening of September 10, 1824, during his return to America in anticipation of the fiftieth anniversary of the Revolution. Hamilton Fish, Nicholas and Elizabeth's son, was born at 21 Stuyvesant Street in 1808; he continued the family tradition of public service as governor of New York, U.S. senator, and secretary of state.

The three-bay facade remains intact, with its high New York stoop, splayed brownstone lintels, and arched dormer windows with double keystones. Inside as well, many features remain unchanged, including the archway in the entrance hall, the stairway, and the elaborate plaster ceiling ornament.

CITY HALL

1803–12; 1954–56; 1995–98; 2003

BROADWAY AT CITY HALL PARK, MANHATTAN

ARCHITECT: JOHN McCOMB JR. AND JOSEPH F. MANGIN

DESIGNATED: FEBRUARY 1, 1966; INTERIOR DESIGNATED: JANUARY 27, 1976

City Hall ranks among the finest architectural achievements of its period in America. The exterior is a blend of Federal and French Renaissance styles; the interior, dominated by the cylindrical, domed space of the Rotunda, reflects the American Georgian manner. Serving today—as it has since 1812—as the center of municipal government, City Hall continues to recall the spirit of the early years of the new Republic, when both the nation and the city were setting forth on new paths.

The building, actually New York's third city hall, is the result of the successful collaboration of John McComb Jr., the first American-born architect, and Joseph Mangin, a French emigré. There is considerable debate over the exact nature of the contribution of each man. Trained in the master-builder tradition of his father, John McComb Jr. was the leading architect in New York after the American Revolution and is often credited with the majority of the interior design. Joseph Mangin was, some feel, probably the principal designer of the exterior, particularly in view of the French character of the building. McComb and Mangin carried off first

prize and a $350 award following the open architectural contest in 1802. The cornerstone was laid by Mayor Edward Livingston on May 26, 1803; after numerous financial setbacks, the building was dedicated on July 4, 1811. City Hall, which Henry James described as a "divine little structure," was ready for use the following year.

At the time of City Hall's construction, no one expected the city to extend north of Chambers Street. To cut costs, only the front and side facades were covered in marble; the rear received a less dignified treatment in New Jersey brownstone. The building is a clearly defined central structure with projecting side wings, elegantly articulated by a parade of windows decorated with pilasters and, on the top story, typical French Renaissance swags. A one-story Ionic portico sits atop a broad sweep of entry steps. Its roof, bordered by a balustrade, forms an open deck in front of large, arched windows set between Corinthian columns. Above the attic rises the clock tower (1831), whose cupola is crowned by a copper figure of Justice. The two-story building was sheathed in durable Alabama limestone during a complete restoration in 1954–56. The roof was restored and the facade cleaned in 1998, in tandem with conservation of the sculpture of Justice.

The interior is dominated by the Rotunda. Its grandeur is the product of an impressively simple spatial organization (extending back to the Roman Pantheon), the colors and light emanating from the coffered dome's oculus, and the refined decorative detail throughout. The central space encloses a magnificent double stairway that unfolds and circles up to the landing at the second floor, itself surrounded by ten Corinthian columns supporting the great dome. It was at the top of this staircase, just outside the Governor's Room, that the body of Abraham Lincoln lay in state on April 24 and 25, 1865.

The chandeliers in the rotunda were restored in 1995–96, followed by the renovation of the interior dome and rotunda in 1997. That work included removal of eighteen layers of paint, repair and restoration of plaster decoration and rosettes, and the development of a new paint scheme. Renovation of the Blue Room in 1997–98 included removal of some later additions and cleaning of the original 1812 fireplace. The most recent work on City Hall was the renovation of the Governor's Room, completed in 2003.

Although repeatedly threatened with demolition, City Hall stands within its park, beautifully restored and maintained. Its scale and style provide a dramatic contrast to the buildings that have grown up around it in the last century and a half.

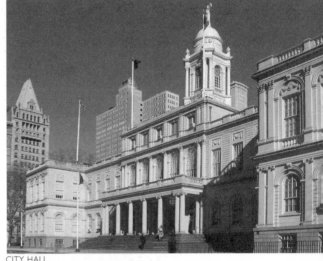
CITY HALL

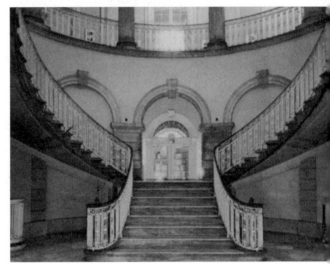
CITY HALL INTERIOR

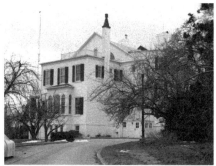
COMMANDANT'S HOUSE

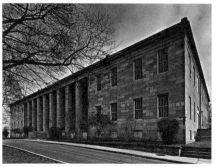
U.S. NAVAL HOSPITAL

DRY DOCK #1

SURGEON'S HOUSE

BROOKLYN NAVY YARD

BROOKLYN

COMMANDANT'S HOUSE, 1805–6

HUDSON AVENUE AND EVANS STREET

ARCHITECTS: ATTRIBUTED TO
CHARLES BULFINCH AND
JOHN McCOMB JR.

DESIGNATED: OCTOBER 14, 1965

U.S. NAVAL HOSPITAL, 1830–38;
WINGS, 1840 AND C. 1862

HOSPITAL ROAD BETWEEN SQUIBB
PLACE AND OMAN ROAD

ARCHITECT: MARTIN E. THOMPSON

DESIGNATED: OCTOBER 14, 1965

DRY DOCK #1, 1840–51

DOCK STREET AT THIRD STREET

ARCHITECT AND MASTER OF MASON-
RY: THORNTON MacNESS NIVEN

ENGINEER: WILLIAM J. McALPINE

DESIGNATED: SEPTEMBER 23, 1975

SURGEON'S HOUSE, 1863

FLUSHING AVENUE
opposite RYERSON STREET

BUILDERS: TRUE W. ROLLINS
AND CHARLES HASTINGS

DESIGNATED: NOVEMBER 9, 1976

In 1801, the U.S. Navy purchased this property from John Jackson, owner of a small private shipyard; by 1812, the yard had become an important servicing facility, and it remained so for over a century. During the Civil War, 5,000 workers fitted out 400 merchant-marine vessels as cruisers; during World War II, 70,000 workers were employed here, turning out battleships and destroyers for the war effort.

The property includes four designated landmarks. The earliest of these is the former Commandant's House, a three-story Federal structure attributed to Charles Bulfinch with John McComb Jr. The elaborately carved front entrance—which is actually on the second floor—has a leaded fanlight; the attic is crowned by dormer windows and a widow's walk, and there is an ornate cornice at the level of the roof.

Built in 1830–38, the U.S. Naval Hospital (formerly the U.S. Marine Hospital) is a two-story, 125-bed Greek Revival structure in the shape of an E. The refined granite building contains a recessed portico with eight classical piers of stone that reach the full height of the building.

Occupying the same property as the hospital, the Surgeon's House follows the style of the French Second Empire with its low, concave mansard roof and dormer windows. It is a two-story brick structure divided into two main sections, the house proper and a servant's wing, together totaling sixteen rooms. The symmetrical entrance facade has a central doorway flanked by segmental arches and low balustrades. Also on the first floor is a handsome, projecting

three-sided bay window; on the second floor, segmental-arched windows rest on small corbel blocks. The side elevations of the house show both segmental-arched and square-headed windows.

The first permanent dry dock in the New York area was primarily engineered by William J. McAlpine. He solved several massive problems posed by the excavation site, which included a faulty cofferdam and flooding underground springs. The successful masonry super-structure, still active today, consists primarily of 23,000 cubic yards of granite facing. Designed to withstand the uplifting forces, the stone at the bottom of the dry dock forms a great inverted arch below a flat, thirty-foot-wide floor. The sides of the dock are stepped. The dock's landward end terminates in a curve, while the seaward end is an inverted arch set back to accommodate a large metal floating gate. This gate can be raised and floated free to one side, thus eliminating the need for hinges and allowing large ships to enter. Among the ships that have been built or serviced here are the *Monitor*, of Civil War fame, and the *Niagara*, which laid the first transatlantic cable.

The Brooklyn Navy Yard Development Corporation now operates the facility on behalf of the City of New York. There are more than 220 companies employing 3,700 people involved in manufacturing, distribution, and warehousing. The Steiner Studios, a 15-acre facility of 280,000 square feet of film and production space, will make the Brooklyn Navy Yard the premier entertainment center on the East Coast.

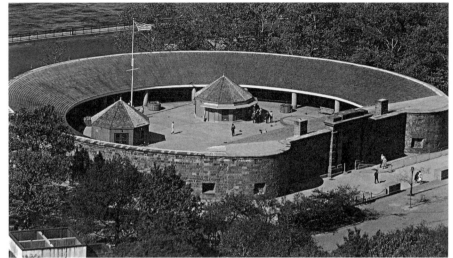
CASTLE CLINTON

CASTLE CLINTON

1807–11; 1946

THE BATTERY, MANHATTAN

ARCHITECT: JOHN MCCOMB JR. AND LT. COL. JONATHAN WILLIAMS

DESIGNATED: NOVEMBER 23, 1965

Castle Clinton once promised great security to Manhattan, although none of its twenty-eight guns were ever fired in battle. Once three hundred feet from the tip of the island and connected by a causeway, the fort has since incorporated into Manhattan by landfill. The rock-faced brownstone structure, designed by John McComb Jr., is a formidable presence, with massive walls measuring eight feet thick at the gun ports. The more refined rusticated gate reflects the influence of French military engineer Sébastian de Vauban.

After the federal government ceded the fort to the city in 1823, it was converted to Castle Garden, a fashionable gathering place that was the scene of some spectacular social events, notably Jenny Lind's 1850 American debut. In 1855, it became an immigrant landing depot, processing more than 7.5 million people. Remodeled again by McKim, Mead & White in 1896, the fort became the New York Aquarium, remaining a popular attraction until 1941. Thwarted in his desire to construct a bridge from the Battery to Brooklyn on the site, Robert Moses retaliated by attempting to demolish the building in 1946. Only a public outcry stopped him, but not before the McKim, Mead & White addition had been destroyed. The federal government recognized Castle Clinton as a National Monument in 1946; it has since been under the jurisdiction of the National Park Service. It stands today as an outstanding example of nineteenth-century American military architecture and as a testament to the rich cultural patrimony of Lower Manhattan.

2 WHITE STREET

OLD ST. PATRICK'S CATHEDRAL

2 White Street	**Old St. Patrick's Cathedral**
1809	Manhattan
Manhattan	**Old St. Patrick's Cathedral**
Builder: Gideon Tucker	1809–15; restored, 1868
Designated: July 19, 1966	Mott and Prince Streets
	Architect: Joseph F. Mangin
	Designated: June 21, 1966
	Old St. Patrick's Convent and Girls' School, 1826
	32 Prince Street
	Architect: Unknown
	Designated: June 21, 1966
	St. Michael's Chapel, 1858–59
	266 Mulberry Street
	Architects: James Renwick Jr. and William Rodrigue
	Designated: July 12, 1977

A modest, two-story building that has surprisingly survived the times is the tiny house at 2 White Street. It was erected as a residence by and for Gideon Tucker, a prominent New Yorker in his day. He was the assistant alderman of the Fifth Ward, a school commissioner, and commissioner of estimates and assessments. Although it was completed in 1809, this house is eighteenth century in its feeling and style. The gambrel roof, splayed lintels, and double keystones of the second story are Georgian. The very flat, pedimented dormers containing elliptical-headed openings are rare Federal survivors. There has probably always been a shop on the ground floor.

The original St. Patrick's Cathedral and its companions—St. Michael's Chapel and the Convent and Girls' School—are among the oldest ecclesiastical structures

ST. MICHAEL'S CHAPEL

in the city. The cathedral was begun in 1809, a year after the Diocese of New York was established by Pope Pius VII. The War of 1812 interrupted the work, but Joseph Mangin, co-architect of City Hall, was able to complete the church by 1815. The original church, with its tripartite facade, was among the first Gothic revival churches in this country; half a century after its completion, it was destroyed by a disastrous fire. All that we see today, with the exception of the pointed windows along the nave, was added in 1868 when the church was rebuilt; yet the rebuilt church is an impressive, if severely plain, masonry structure.

Around the corner from the cathedral is the Convent and Girls' School. Completed in 1826, the convent and school were conservatively designed in the late Federal style; the main doorway is one of the finest surviving examples of this restrained yet elegant style.

St. Michael's Chapel was built in 1858–59 as a chancery office; designed

by James Renwick Jr. in association with William Rodrigue, it is a Gothic Revival masterpiece. Three stories high and built of red brick, this small building is noted for its central projecting stone entrance vestibule with pointed-arched doorway outlined by a drip molding. It is currently used for worship by Catholics of the Russian rite.

90–94 MAIDEN LANE BUILDING

C. 1810–30; NEW FACADES AND INTERNAL ALTERATIONS, 1870–71

MANHATTAN

DESIGNERS: ATTRIBUTED TO CHARLES WRIGHT FOR MICHAEL GROSZ & SON, IRON FOUNDERS; IRON ELEMENTS CAST BY ARCHITECTURAL IRON WORKS OF NEW YORK

DESIGNATED: AUGUST 1, 1989

This small and elegant building has long been associated with the Roosevelt family, which owned a store at 94 Maiden Lane from 1796 to the mid-nineteenth century. In 1810, James Roosevelt erected a mercantile structure next door, which has been incorporated into the present building. Under the direction of Cornelius Van Schaack Roosevelt, grandfather of future president Theodore Roosevelt, the business—importing hardware, plate glass, and mirrors—prospered handsomely. In 1870, to accommodate the growing business, Roosevelt & Son—as the company was known—expanded into adjoining buildings at 90–92 Maiden Lane and 9–11 Cedar. Street. A new cast-iron

90–94 MAIDEN LANE BUILDING

facade with a fish-scale mansard roof was erected on the Maiden Lane buildings, and a new brick-and-iron facade on the Cedar Street side. Charles Wright, an architect known for his cast-iron buildings, is credited with carrying out these alterations. This building is the sole remaining example of the French Second Empire style in a post–Civil War commercial building constructed in the financial district. It is the southernmost cast-iron building in Manhattan.

Since 1910 the building has undergone several modifications. The arrangement of windows and doors on the first story has changed several times, and the mansard roof was altered in the 1960s. The building is presently owned by the International Commercial Bank of China.

SCHERMERHORN ROW

POE COTTAGE

SCHERMERHORN ROW

1811–49; 1983; 2002; 2004

2–18 FULTON STREET, 91–92 SOUTH STREET, 159–171 JOHN STREET, AND 189–195 FRONT STREET, MANHATTAN

ARCHITECTS: UNKNOWN; RESTORATION, JAN HIRD POKORNY, BEYER BLINDER BELLE

DESIGNATED: OCTOBER 29, 1968

Schermerhorn Row, one of the earliest commercial developments in New York City, consists of twelve red-brick warehouses erected between 1811 and 1812 by Peter Schermerhorn. One of New York's leading merchants, Schermerhorn ran a ship chandler's business at 243 Water Street. Designed in the Federal style, and originally of equal height, the group is made up of nine row houses on Fulton Street, and houses at 195 Front Street and 91 and 92 South Street around the corner. The buildings were used as warehouses and stores for cargo in an era when New York Harbor was a busy port for sailing ships. The row on the south side of Fulton Street runs from number 2 at South Street to number 18 at Front Street. The building

at 92 South Street, which adjoins 2 Fulton Street at the corner, was converted into a hotel in the late nineteenth century; at this time, the cornice was removed, and two stories, with mansard roof and dormers, were added.

The row is today part of the South Street Seaport Museum, an institution that oversees the preservation of the structures in this part of the city. The exteriors were restored by Jan Hird Pokorny in 1983; Beyer Blinder Belle has recently completed an interior renovation.

POE COTTAGE

1812

2640 GRAND CONCOURSE AT KINGSBRIDGE ROAD, THE BRONX

ARCHITECT: UNKNOWN; RESTORATION, JOHN HARDEN

DESIGNATED: FEBRUARY 15, 1966

Poe Cottage, named for its most famous resident, Edgar Allan Poe, is one of the few extant nineteenth-century wood-frame residences in the Bronx. Built for

John Wheeler, the simple clapboard farmhouse with attic and porch stands one and one-half stories tall. The siding and shutters are original; the doors and windows, while period originals, were added in 1913 by architect John Harden. Initially located on Kingsbridge Road, the cottage was moved in 1895 to allow for the widening of the road and again in 1913 to occupy a two-and-one-half-acre plot designated Poe Park by the City of New York.

When Poe lived here, the cottage was still at Kingsbridge Road. He rented the small farmhouse from 1846 to 1849 in the hope of providing his dying wife, Virginia, with therapeutic country air. The treatment failed, and Virginia died here in 1847. It is generally believed that Poe wrote "Annabel Lee," a memorial to his young wife, and his last great work, "Eureka," while he lived here.

Poe Cottage is operated as an historic house museum by the Bronx County Historical Society; it is jointly administered by the society and the New York City Department of Parks and Recreation.

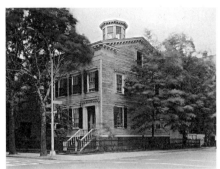
STEELE HOUSE

OLD WEST FARMS SOLDIER CEMETERY

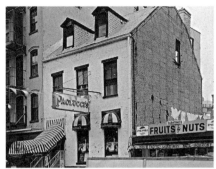
STEPHEN VAN RENSSELAER HOUSE

STEELE HOUSE

C. 1812

200 LAFAYETTE AVENUE, BROOKLYN

ARCHITECT: UNKNOWN

DESIGNATED: MARCH 19, 1968

This two-and-one-half-story Greek Revival frame house, with later Italianate embellishments, dates from the first quarter of the nineteenth century. An ornate iron fence encloses the corner lot, and a flight of wooden steps—complete with newel posts, turned spindles, and a wide handrail—projects from the front of the house. The doorway supports an entablature with a modillioned cornice, a feature repeated at the shuttered, octagonal cupola rising above the roof. Adjoining the main facade but set back is a wing with a narrow porch raised several feet above the ground; French doors lead into the first floor. An engaged pilaster and two fluted Ionic columns support an entablature and low-pitched roof, and a dentiled cornice crowns the wing.

OLD WEST FARMS SOLDIER CEMETERY

ESTABLISHED 1815

2103 BRYANT AVENUE, THE BRONX

DESIGNATED: AUGUST 2, 1967

The remains of forty soldiers lie in this small cemetery, the oldest veterans' graveyard in the Bronx. Samuel Adams, a veteran of the War of 1812, was the first buried here; Valerino Tulosa, a veteran of World War I, was the last. Veterans of the Civil and Spanish-American Wars are interred here. A bronze statue of a Union soldier once stood in the cemetery.

The neighborhood around the cemetery was given the name West Farms in 1663 by Edward Jessup and John Richardson, who hoped to distinguish their recently acquired property from the nearby Westchester Village. John Butler founded the cemetery in 1815 on property that he had laid out as a private burial ground the year before. The Butler family retained control of the site until 1954, when the city assumed responsibility for the cemetery's upkeep.

STEPHEN VAN RENSSELAER HOUSE

1816; MOVED, 1841

149 MULBERRY STREET, MANHATTAN

ARCHITECT: UNKNOWN

DESIGNATED: FEBRUARY 11, 1969

The Stephen Van Rensselaer House is a lonely reminder of the small Federal-style row houses built in Lower Manhattan during the early nineteenth century. Its high-shouldered gambrel roof and round-headed dormers with delicate pilasters are typical of the period, as are the lintels, with their flat, incised panels.

Built at 153 Mulberry in 1816 for Stephen Van Rensselaer and assessed at $3,750, the building was moved to 149 Mulberry Street in 1841. The basement and first floor were occupied for nearly sixty years by Paolucci's Restaurant, which re-opened in Staten Island in early 2005. The upper stories have been vacant since 2002.

JAMES BROWN HOUSE

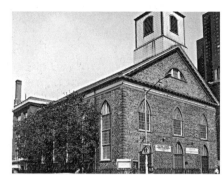

FIRST CHINESE PRESBYTERIAN CHURCH

JAMES BROWN HOUSE

1817; 1977

326 SPRING STREET, MANHATTAN

ARCHITECT: UNKNOWN

DESIGNATED: NOVEMBER 19, 1969

Several small residences, remnants of the city's early history, are found today in densely developed manufacturing sections of Manhattan. One of the earliest is the James Brown House. Built in 1817—when it was assessed for the considerable sum of $2,000—it is a charming, modest Federal-style structure with the high gambrel roof characteristic of many small Federal houses. It has a brick facade, laid up in Flemish bond, three windows wide with stone sills. The splayed lintels and double eared keystones are a throwback to the earlier Georgian style. The two dormers are a later modification.

In the nineteenth century, the house was a brewery; it became a restaurant at the turn of the century. During Prohibition, it was a speakeasy, with a boardinghouse, brothel, and smugglers' den upstairs. Later on, it became a sailors' bar. Today it is a casual night spot; the present owner, who bought the building in 1977, runs the bar and resides in the building. The house has an unexpected sense of scale and intimacy.

FIRST CHINESE PRESBYTERIAN CHURCH, FORMERLY CHURCH OF SEA AND LAND

1817

61 HENRY STREET, MANHATTAN

ARCHITECT: UNKNOWN

DESIGNATED: JANUARY 18, 1966

Colonel Henry Rutgers, a Revolutionary War patriot, donated land for the construction of this attractive church, whose design shows a Georgian influence. In 1866, when the church began to serve seamen, it was named the Church of Sea and Land.

Ashlar quoins, horizontal stone belt courses, and stone window and door frames animate the simple brick building. Full-length windows flank its sides; on the interior, the windows are backed by balconies. The pointed-arched windows anticipate the Gothic Revival by some thirty years.

MOORE-McMILLEN HOUSE, FORMERLY RECTORY OF THE CHURCH OF ST. ANDREW

1818; 1944

3531 RICHMOND ROAD, STATEN ISLAND

ARCHITECT: UNKNOWN

DESIGNATED: AUGUST 24, 1967

The Moore-McMillen House is one of the few nineteenth-century Federal-style farmhouses surviving on Staten Island. This modest, two-story shingle house is characterized by a low-pitched, high-shouldered gambrel roof. Among its beautifully executed architectural details are the entry door, highlighted by well-proportioned pilasters, panels, sidelights, and transom; a denticulated cornice; and flush siding beneath the veranda. The simple floor plan consists of a central hall and staircase with two rooms extending from each side.

The Moore-McMillen House was built by the Episcopal Church of St. Andrew, located in the nearby village of Richmondtown. Set on a sixty-acre farm known as Little Glebe, the house was the home and rectory for the church's minister, the Reverend David Moore. He served the parish for forty-eight years and eventually received the house from the church; it remained in the Moore family until 1943. In 1944, Loring McMillen, borough and county historian for Richmond, restored the house, where he lived until his death in 1990.

John Y. Smith House

1818–19

502 Canal Street (also known as 480 Greenwich Street), Manhattan

Architect: Unknown

Designated: June 30, 1998

Located on an irregular shaped corner lot, the red-brick double building at 502 Canal Street is one of a rare surviving group of four early nineteenth-century structures in Lower Manhattan. Built in the Federal style, with Flemish bond brickwork, brownstone window sills and lintels, entrance archways, and a curved bay that unifies the two separate street fronts, the building has retained most of its original features, with the exception of the storefronts. These have been altered by various occupants, which included a drug store, a lunch counter, and a liquor store. It is thought the original building had a peaked roof, which has since been removed. In the early nineteenth century, the city granted water lots next to Greenwich Street (originally laid out as "First Street" in 1761) for landfill, expanding the shoreline to what is now West Street. Previously used as farmland, the undeveloped lot was purchased by John Y. Smith in 1818. He and his family lived in the upper floors of the building, and he operated his starch and hair powder manufacturing business in the ground floor commercial space.

83, 85, and 116 Sullivan Street

1819–32

Manhattan

Architects: Unknown

Designated: May 15, 1973

Sullivan Street—named for John Sullivan, a Revolutionary War general—has three surviving Federal-style town houses built on what was once part of the farm belonging to Nicholas Bayard, Peter Stuyvesant's brother-in-law. A later Nicholas Bayard sold the land in 1789; over the next three decades the property was subdivided into lots and changed owners four times. The houses at 83 and 85 were built in 1819 and number 116 in 1832.

Modest yet elegant, these houses typify the Federal style—sometimes referred to as "the architecture of good breeding." Among their most distinctive features are original Federal doorways, Flemish bond brickwork, six-over-six pane windows, and wrought-iron stoop railings.

The house at 116, built more than ten years later than its neighbors, has an unusual and elaborate Federal doorway enframement. Flanked by plain brownstone pilasters, with a semicircular band of brownstone defining the simple, round-arched masonry opening, the doorway has unusual sidelights. Each sidelight is divided into three oval sections, formed by a richly carved wood enframement that simulates a cloth sash curtain drawn through a series of rings.

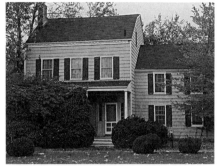
MOORE-MCMILLEN HOUSE

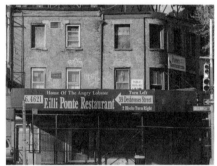
JOHN Y. SMITH HOUSE

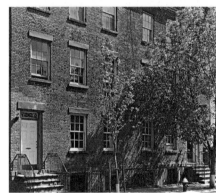
SULLIVAN STREET HOUSES

New Lots Community Church

1823

630 New Lots Avenue, Brooklyn

Architect: Unknown

Designated: July 19, 1966

The New Lots Community Church, formerly the New Lots Reformed Dutch Church, is one of New York's oldest standing wooden churches. Built in 1823 during the late Federal period, the church is an example of a rural clapboard structure. Local oaks were cut and hand-shaped in order to frame the building, and a raising bee was held to construct it. The timbers themselves were jointed and secured by pegs.

The church includes details in the early Gothic Revival style. The front elevation is dominated by a plain, low-pitched pediment with three windows above three doors, all framed with pointed wooden arches. At the center is a triple Palladian window. Four pointed-arched windows are included in both of the identical side elevations. The low-pitched gable roof supports a square tower base with an octagonal belfry.

NEW LOTS COMMUNITY CHURCH

51 MARKET STREET

51 Market Street

1824–25

Manhattan

Architect: Unknown

Designated: October 14, 1965

The house at 51 Market Street exemplifies the architecture of the newly created Republic. This four-story brick building is an admirable urban example of the late Federal style; well preserved, it sets a standard by which other houses of the period may be judged today.

The front entrance is one of the few fine, complete late Federal doorways in the city; both original outer and inner entryways are intact. An eight-paneled door is flanked by fluted Ionic columns, leaded-glass sidelights, and similar half-columns; the whole is surrounded by a molded, elliptical-arched stone frame. A handsome leaded-glass fanlight is set above the door. The basement windows are framed with a rusticated architrave composed of alternating smooth and textured blocks of stone; the windows on the first three floors retain their original lintels, which are elaborately decorated with panels and rosettes. Much of the exterior ironwork is also original. In the Federal tradition, it is predominantly wrought iron, in contrast to the cast iron that was used later in Greek Revival architecture.

FORT HAMILTON

1825–31

FORT HAMILTON PARKWAY AT 101ST
STREET, BROOKLYN

ARCHITECT: UNKNOWN

GENERAL DESIGNER: SIMON BERNARD

DESIGNATED: MARCH 8, 1977

No shot was ever fired from this fort in battle. Nevertheless, Fort Hamilton remained in a constant state of military readiness from 1831 until World War II, and the original structure is still part of an active army base—the third-oldest continuously garrisoned federal post in the nation. When vertical-walled masonry defenses became obsolete during the Civil War, Fort Hamilton became a barracks, then the post stockade, and finally—after 1938—an officers' club. A large function room was added at that time, another in 1958, and a third in 1985.

Built of granite blocks in random ashlar, the fort today takes the form of an elongated C, since the wall facing the Verrazano Narrows was destroyed in the 1890s for newer coastal guns. At the rear of the fort, the original casemates—a series of chambers for cannon that were fired through embrasures in an outer wall or scarp—face another wall or counterscarp across the dry ditch, now used for parking. This system, developed by the French engineer Montalembert in the 1780s, provided greater protection to guns and crews and made possible multiple gun tiers.

Today the main fort is a private club. New rooms have been added, and the exterior is lined with stucco; the embrasures have been enlarged to form windows. The original architecture can be seen at the nearby caponier, or flank defense, now the Harbor Defense Museum of New York City, which is almost unchanged.

BIALYSTOKER SYNAGOGUE, FORMERLY WILLETT STREET METHODIST CHURCH

1826

7–13 BIALYSTOKER PLACE,
MANHATTAN

ARCHITECT: UNKNOWN

DESIGNATED: APRIL 19, 1966

The Bialystoker Synagogue, originally the Willett Street Methodist Church at 7–13 Willet Street, is a severely plain late Federal building. With its fieldstone facade, the structure is a fine example of masonry construction in the vernacular tradition. Its simple exterior is marked by three windows over three doors, framed with round arches; a base course with a low flight of brownstone steps; a low-pitched, pedimented roof pierced by a lunette window; and a very plain wooden cornice.

In 1905, the building was purchased by the Bialystoker Synagogue, whose congregation was composed chiefly of immigrants from the province of Bialystok, then part of the Russian Empire and now Poland.

FORT HAMILTON

BIALYSTOKER SYNAGOGUE

97

JOHN G. ROHR HOUSE

508 CANAL STREET

JOHN G. ROHR HOUSE

1826

506 CANAL STREET, MANHATTAN

ARCHITECT: UNKNOWN

DESIGNATED: JUNE 30, 1998

Canal Street, a 100-foot wide street, was becoming a thriving retail district by the 1820s, when John G. Rohr began to develop vacant lots on either side of the street. Number 506 is a rare example of Federal architecture and has the only storefront of its kind to survive in New York City. The original three-bay cast-iron arcade with semi-elliptical arches distinguishes the building as one of only a few surviving early-nineteenth century structures in Lower Manhattan. Rohr, a German merchant tailor, lived in the building with his fifteen-person household; the storefront was leased out together with another apartment above. Number 506 has remained viable for commercial and residential use.

508 CANAL STREET

1826

MANHATTAN

ARCHITECT: UNKNOWN

DESIGNATED: JUNE 30, 1998

In 1826, John G. Rohr built 508 Canal Street, along with number 506 and several other buildings that do not survive. A three-story brick structure in the Federal style, the building features Flemish bond brickwork (now painted), cast-iron lintels, brownstone window sills, and a peaked roof. Its cast-iron storefront, was removed in 1941 during conversion of the commercial space to restaurant use. Visible on the right is the western elevation of a stepped brick party wall, once shared with 510 Canal Street (demolished in the 1930s). In 1850, Rohr sold number 508 to Joseph Batby, a French ivory turner, who moved in with his wife and children, leasing residential space to three other families.

HENRY STREET SETTLEMENT

MANHATTAN

ARCHITECTS: UNKNOWN

DESIGNATED: JANUARY 18, 1966

263 HENRY STREET, 1827; 1989

265 HENRY STREET, 1827; 1992

267 HENRY STREET, 1834

Founded in 1893 by Lillian Wald to alleviate the living conditions of slum dwellers on the Lower East Side, the Henry Street Settlement occupies three well-preserved early-nineteenth-century houses. The eight-paneled front door of number 265 is a rare survivor of the Federal period; it is flanked by attenuated Ionic columns and surmounted by a transom that once held leaded glass. The sidelights (also once of leaded glass) are framed by richly carved moldings, and just over the front door itself is a break in the entablature, a typical Federal detail. The houses at 263 and 267, while practically contemporary with number 265, have been much modified by later changes. Numbers 263 and 265 were restored in 1989 and 1992, respectively.

The Henry Street Settlement was one of the earliest social programs of its kind in the United States. Miss Wald, a nurse and settlement worker from a privileged, middle-class Jewish family in Rochester, was struck by the intolerable filth and desperation that were the immigrants' lot on the Lower East Side. She persuaded some wealthy friends—notably philanthropist Jacob Schiff—to finance a small establishment on Henry Street to serve as a volunteer nursing service and social center.

In 1895, Schiff acquired number 265 Henry Street for the use of the Henry Street Settlement/Visiting Nurse Service; numbers 267 and 263 were added to the settlement in 1903 and 1934. Schiff's estate included a $300,000 bequest to the settlement for the construction of a central administration building for the Visiting Nurse Service. Over the years, some of the country's most fundamental health and social programs were generated here, among them district nursing, school nurses, the U.S. Children's Bureau, and the whole concept of public-health nursing.

NEW UTRECHT REFORMED DUTCH CHURCH

18TH AVENUE AT 83RD STREET, BROOKLYN

CHURCH, 1828

ARCHITECT: UNKNOWN

DESIGNATED: MARCH 15, 1966

PARISH HOUSE, 1892

ARCHITECT: LAWRENCE B. VALK

DESIGNATED: JANUARY 13, 1998

The New Utrecht Dutch Reformed Church, organized in 1677, is home to one of the oldest surviving congregations in New York. By 1699, a fieldstone church building had been erected on this site. During the Revolutionary War, the British used the building as a hospital and cavalry-training school. The current Georgian-Gothic church building was constructed in 1828 incorporating stones of the old church building, which had been brought over from

Holland as ship ballast. The structure has painted brick arches and a handsome stone tower with wooden Gothic pinnacles. A round, late Federal-style window pierces the wall over the main entrance, and a cornice extends around the building. The first liberty pole in front of the church was erected in 1783 to celebrate New Utrecht's freedom from the occupation of British soldiers during the Revolution. The pole has been replaced six times, most recently in 1946.

Farther south on the large wooded lot stands the brick parish house, constructed in 1892 to meet the needs of its expanding congregation, designed by Lawrence B. Valk, a prolific architect of Brooklyn-area churches. The picturesque Romanesque Revival style building features a varied roofline, asymmetrical massing, towers and turrets, brick facing and round-arched windows. The parish house has remained largely unchanged for more than 100 years, with the exception of relocating the main entrance to the base of the tower. Original stained glass has been replaced in some of the smaller windows on the upper level and a Tiffany-like stained glass window was installed in 1908 on the western wall.

The Parish House has housed many ongoing and significant activities, including the establishment in 1911 of Boy Scout Troop Number 20, the longest continuously functioning U.S. troop.

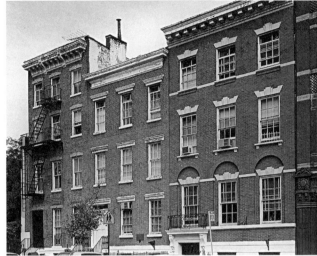
HENRY STREET SETTLEMENT

NEW UTRECHT REFORMED DUTCH CHURCH

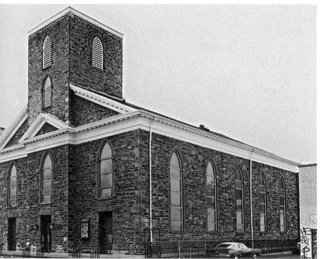

ST. AUGUSTINE'S CHAPEL

127 MACDOUGAL STREET

129 MACDOUGAL STREET

St. Augustine's Chapel, formerly All Saints' Free Church

1828–29; additions, 1850, 1871

290 Henry Street, Manhattan

Architect: Attributed to John Heath

Designated: August 16, 1966

St. Augustine's Chapel—originally known as All Saints' Free Church—was founded in 1827 by a group of wealthy clipper-ship owners and builders. In 1850, the chancel was added to the original building, and the tower was built in 1871. The motto "All Saint's Church Free" was carved over the entrance when pew rent was abolished.

Built of Manhattan schist in a random ashlar pattern with wooden cornices, the church has a simple, boxlike mass with a slightly projecting central tower that breaks the front facade into three bays. The tower cuts through the pediment of the roof and is embellished with a

smaller pediment, sharing the same horizontal cornice. A wooden spire was planned, but it was never built. Classical motifs are kept to the pediments; the windows follow the Gothic tradition with their pointed arches. Each bay of the front facade has a door surmounted by a window. Windows pierce the side elevations too, as well as the tower.

In 1946, with a dwindling parish and bleak financial situation, All Saints' merged with Trinity Church, which assumed full financial responsibility. Renamed St. Augustine's, it is now one of Trinity's four chapels.

127, 129, and 131 MacDougal Street

1828–29

Manhattan

Architect: Unknown

Designated: June 8, 2004

"The rowhouses at 127, 129, 131 MacDougal Street were constructed in the Federal style. They were originally a group of four houses (No. 125-131) speculatively built on lots owned by Alonzo Alwyn Alvord, a downtown hat merchant, as the area around Washington Square was being developed as an elite residential enclave. Until at least the Civil War, the rowhouses were inhabited by the families of prosperous downtown merchants and professionals, with the Rankin-Freeland family owning it between 1839 and 1901. In the later 19th century, as the neighborhood's fashionable heyday waned, these houses were no longer single-family dwellings and became lodging houses. Despite the loss of some architectural details, these houses are among the relatively rare surviving and significantly intact Manhattan buildings of the Federal style, period, and two-and-one-half story, dormered peaked-roof type."*

131 MACDOUGAL STREET

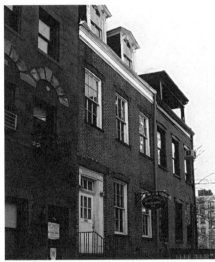

ISAAC T. LUDLAM HOUSE

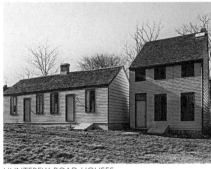

HUNTERFLY ROAD HOUSES

ISAAC T. LUDLAM HOUSE

C. 1829; 1998

281 EAST BROADWAY, MANHATTAN

ARCHITECT: UNKNOWN

DESIGNATED: JUNE 30, 1998

This Federal-style row house is a rare survivor of urban renewal in this portion of Lower Manhattan. Built circa 1829, with two other houses for Isaac Ludlam, the two-and-one-half story, three bay wide building is characteristic of the Federal style with Flemish bond brickwork, brownstone window sills and lintels, and a peaked roof with two pedimented dormers. Ludlam's other house, number 279, survives but in a much altered state.

Ludlam, a New York City surveyor, lived in the house from 1836 to 1853, when the Lower East Side was a fashionable residential district. Between 1864 and 1903, George Leicht lived and worked in the house; he converted the high basement into a storefront for his shoemaking business. By the turn of the century, the Lower East Side had become overcrowded with the arrival of new waves of immigrants. Many of the single-family homes were converted into boarding houses or torn down to make way for tenements. The Henry Street Settlement, a social service organization established in 1893 (p. 99), restored 281 East Broadway in 1998 and uses it for offices and program space.

HUNTERFLY ROAD HOUSES

C. 1830; 2003

1698, 1700, 1702–04, 1706–08 BERGEN STREET, BROOKLYN

ARCHITECTS: UNKNOWN; RESTORATION, LI-SALTZMAN ARCHITECTS

DESIGNATED: AUGUST 18, 1970

Four wooden houses remain along the old Hunterfly Road, within the boundaries of what was once Weeksville, a nineteenth-century free black community that is now known as Bedford-Stuyvesant. A refuge for families during the draft riots of the Civil War, the area became a predominantly African-American community with the abolition of slavery in New York in 1827. The road, documented as early as 1662, was an avenue of communication under British rule; it fell into disuse with the installation of a grid system in 1838.

The houses at 1698 and 1700 Bergen Street are two and one-half stories tall and three bays wide. On the latter, casement windows occupy the second-floor front. The pitched roof is covered with shingles on the north side and by clapboard at the south side. Similar in style, the houses at 1702–04 and 1706–08 are one story and one and one-half stories, respectively.

The Society for the Preservation of Weeksville and Bedford-Stuyvesant History now owns the houses and recently restored them with Li-Saltzman Architects to serve as a living museum of African American history and culture.

LAWRENCE GRAVEYARD

NEW YORK MARBLE CEMETERY

NEW YORK CITY MARBLE CEMETERY

LAWRENCE GRAVEYARD

ESTABLISHED C. 1830

216TH STREET AND 42ND AVENUE, QUEENS

DESIGNATED: AUGUST 2, 1967

A plot of land originally known as Pine Grove was granted by Dutch Governor Kieft of New Amsterdam to John and William Lawrence in 1645. For years the land was a favorite picnic ground, but the Lawrence family converted it to a burial plot about 1830. It was used for this purpose until 1925.

The Lawrence family included many notables in the spheres of politics and commerce. Among those buried here are Cornelius W. Lawrence, the mayor of New York from 1834 to 1837; Effingham Lawrence, a county judge; and Frederick Newbold Lawrence, president of the New York Stock Exchange from 1882 to 1883. Each of the forty-eight graves has been carefully restored.

Many of the gravestones are Gothic in design. One particularly interesting example is a twin marker for two children, Margaret and Clarence, who died in their infancy. The stones have a trefoil pointed arch surrounded by foliate carving and surmounted by the head of a child enfolded in an angel's wings.

Today, the graveyard is maintained by public-spirited Bayside residents, descendants of the Lawrence family, and the Bayside Historical Society.

NEW YORK MARBLE CEMETERY

ESTABLISHED C. 1830

INTERIOR OF THE BLOCK BETWEEN EAST 2ND AND EAST 3RD STREETS AND SECOND AVENUE AND THE BOWERY, MANHATTAN

DESIGNATED: MARCH 4, 1969

Manhattan's first nonsectarian burial ground open to the public was begun as a joint business enterprise on July 13, 1830. The founders, Perkins Nichols, Anthony Dey, and George W. Strong, prurchased 156 underground vaults of Tuckahoe marble, sold them, and then charged a ten-dollar fee for opening and maintaining them.

There are no monuments or individual tombstones in the cemetery; only marble plaques set in the north and south walls, which bear the names of the 156 original owners and vault numbers.

Among those buried here are David Olyphant, a China trade merchant who refused to deal in opium; Uriah Scribner and his son, Charles, the publisher; and James Tallmadge, one of the founders and first presidents of New York University.

An endowment fund was established by 1915, run by descendants of the original vault owners, to preserve the cemetery from deterioration.

NEW YORK CITY MARBLE CEMETERY

ESTABLISHED 1831

52–74 EAST 2ND STREET, MANHATTAN

DESIGNATED: MARCH 4, 1969

The New York City Marble Cemetery was established in 1831 by Evert Bancker, Samuel Whittemore, Henry Booraem, Garret Storm, and Thomas Addis Emmet, as the second public, nonsectarian burial ground in the city. The land originally belonged to Samuel Cowdrey, who

owned a vault in the first New York Marble Cemetery nearby. Among those interred here are James Lenox, whose library was to be incorporated into the New York Public Library, and several members of the Roosevelt family.

The cemetery was considered a fashionable burial place; monuments and markers to signal the locations of the marble vaults are laid out along parallel walks. It is surrounded by a high brick wall on three sides and bordered on the south by an iron fence with gate.

REFORMED DUTCH CHURCH OF NEWTOWN AND FELLOWSHIP HALL

85–15 BROADWAY, QUEENS

ARCHITECT: UNKNOWN

DESIGNATED: JULY 19, 1966

REFORMED DUTCH CHURCH, 1831

FELLOWSHIP HALL, 1860; MOVED AND EXPANDED, 1906

One of the oldest wooden churches in New York City, the white clapboard Reformed Dutch Church was built in 1831. Its cornerstone originally was part of an earlier church, erected in 1735. The Georgian-style church features a flat-roofed porch with seven neoclassical columns. Three round-headed windows (originally square-headed) are located above the porch, one above each of three doorways. Five windows adorn the sides of the sanctuary. A square base supports the octagonal bell tower, which straddles the west end of the roof.

Constructed in 1860 as a chapel,

REFORMED DUTCH CHURCH OF NEWTOWN

the Fellowship Hall was built in the Greek Revival style. It, too, features a fine portico of wooden columns. These are surmounted by an entablature and a pedimented gable with a circular window. In 1906, Fellowship Hall was aligned with the church; an addition now used as a wayside chapel was built to connect the two buildings.

HAMILTON-HOLLY HOUSE

4 ST. MARK'S PLACE, MANHATTAN

1831

BUILDER/DEVELOPER: THOMAS E. DAVIS

DESIGNATED: OCTOBER 19, 2004

"The Federal-style row house at 4 St. Mark's Place in the East Village section of Manhattan was constructed in 1831. The entire fashionable block of St. Mark's Place (East 8th Street) between Third and Second Avenues was developed by English-born builder and real estate developer Thomas E. Davis. In 1833, Davis sold this house to Col. Alexander Hamilton, son of Alexander Hamilton. Col. Hamilton lived in the house until

HAMILTON-HOLLY HOUSE

1842 with his wife and extended family.

In the early twentieth century, the basement level of the building was adapted for commercial use, including the construction of an auditorium. In the 1950s and 60s, the building had a significant theatrical history, reflecting its location on St. Mark's Place during the cultural ascendancy of the East Village. Among other uses, it served as the Tempo Playhouse, which staged the American premieres of works by Genet and Ionesco, and the New Bowery Theater, site of a number of early underground film debuts.

No. 4 St. Mark's Place is among the rare surviving and significantly intact buildings of the Federal-style and period in Manhattan, characterized and made notable by its 26-foot width and 3-1/2-story height, Flemish bond brickwork, high stoop, Gibbs surround entrance with triple keystone and vermiculated blocks, molded pediment lintels, peaked roof, and double segmental dormers."*

OLD MERCHANT'S HOUSE

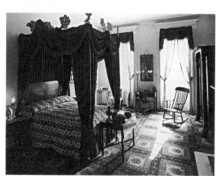

OLD MERCHANT'S HOUSE MASTER BEDROOM

OLD MERCHANT'S HOUSE, FORMERLY THE SEABURY TREDWELL HOUSE

1831–32

29 EAST 4TH STREET, MANHATTAN

BUILDER: JOSEPH BREWSTER

DESIGNATED: OCTOBER 14, 1965; INTERIOR DESIGNATED: DECEMBER 22, 1981

Home to prosperous merchants during the nineteenth century, the row houses near Astor Place attest to the rapid growth of early New York. Owned by the Seabury Tredwell family for ninety-eight years, the Old Merchant's House—in its mixture of Federal and Greek Revival elements—preserves both the conservative and flamboyant sides of this transitional period in industrial society. The builder was Joseph Brewster, who was influenced by Minard Lafever.

The tall, red-brick house has a steep, slate roof with dormer windows. The fanlight over the doorway and the wrought-iron stoop railings mark the otherwise restrained, predominantly Federal facade; the fluted Ionic columns flanking the door hint at the Greek Revival opulence within.

The floor plan is typical of early-nineteenth-century homes; the comfortable basement contains a kitchen and a dining or family room, while the first floor houses a pair of formal parlors. Spacious bedrooms are located on the second and third floors, with finer woodwork and marble chimneypieces found on the former. The top floor contains smaller rooms for servants.

The increased availability of architectural items at the beginning of the Industrial Revolution made possible the extravagant interior, with its simulated Siena marble walls and highly decorative plasterwork, such as a rosette in the entranceway and cornice with egg-and-dart moldings. The front and rear parlors are identical, with fourteen-foot ceilings, eight-panel mahogany doors, and six-over-six windows at the front and rear walls. Each room is bounded by wide paneled baseboards and carpeted from wall to wall with a reproduction French moquette carpet, whose pattern imitated the mosaic floors discovered at Pompeii and Herculaneum. On the second floor, the two large bedrooms are also identical in plan. The hallways sustain the Greek Revival style; the mahogany stairways are partially carved with acanthus leaves in high relief, and the woodwork here, as elsewhere in the house, is painted off-white.

All the furnishings originally belonged to the Tredwell family. Gertrude Tredwell, Seabury's reclusive youngest daughter, continued to live in the house until her death in 1933 at the age of 93. Heavy mortgages were incurred as finances dwindled, and arrangements were made to sell the house and its contents upon her death. But George Chapman, a New York lawyer and Gertrude's nephew, persuaded the assignee to cancel the mortgages. The Merchant's House Museum is New York City's only family home preserved intact—inside and out—from the nineteenth century.

Daniel LeRoy House

1832

20 St. Mark's Place, Manhattan

Architect: Unknown

Designated: November 19, 1969

The Daniel LeRoy House is one of an entire blockfront of gracious houses erected on the south side of St. Mark's Place (formerly 8th Street), one of the most elegant residential streets in early-nineteenth-century New York. Daniel LeRoy was the son-in-law of Elizabeth and Nicholas Fish, who lived in nearby 21 Stuyvesant Street (p. 86).

The LeRoy House is constructed in Flemish bond brickwork trimmed with stone. It is one of four houses on the block that retain the ornately decorated iron handrails at the stoop, low, bird-cage newel posts, and iron railings in the windows of the parlor floor. The arched stone entrance has a triple keystone and a Gibbs surround. Utilitarian doors and a plain transom have replaced the original entrance and its beautiful fanlight.

Colonnade Row, formerly LaGrange Terrace

1832–33

428–434 Lafayette Street, Manhattan

Architect: Attributed to Seth Geer

Designated: October 14, 1965

These four town houses were once part of a group of nine such buildings that extended south along Lafayette Street. The buildings were the first row-house development in New York to be unified behind a single monumental facade—a long Corinthian colonnade, executed in white Westchester marble cut by inmates of Sing Sing Prison in Ossining, New York.

Developer Seth Geer built, and possibly designed, the row on land bordering on the Astor estate, well outside the fashionable Washington Square area. Contemporaries, who thought that no one would live so far east, dubbed the complex "Geer's Folly." The unique design and rich appointments soon attracted buyers, however, including Franklin Delano, grandfather of Franklin D. Roosevelt; within a decade, many other elegant town houses had been erected near Astor Place.

The individual unit plans were unusual in their day, as were the elevations. In the typical New York City row house, the main parlor was entered directly from the stoop and was only half a floor above street level. Here, the rusticated ground floor served as an entry from the street. Inside, a grand stair rose to the main floor, or piano nobile, in the European fashion. Geer accentuated the European associations by calling the row La Grange Terrace, after General Lafayette's country house. The row now contains apartments, restaurants, and theaters.

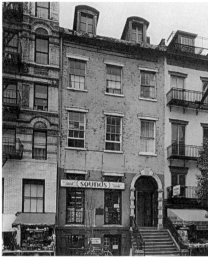

DANIEL LEROY HOUSE

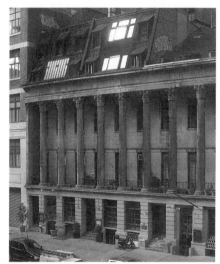

COLONNADE ROW

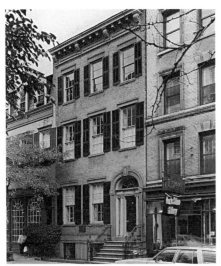

203 PRINCE STREET

STATE UNIVERSITY OF NEW YORK MARITIME COLLEGE

203 PRINCE STREET

1833–34; ADDITIONS, 1888

MANHATTAN

ARCHITECT: UNKNOWN

DESIGNATED: FEBRUARY 19, 1974

A characteristic upper-class residence of the 1830s, this house was built in an area originally known as Richmond Hill—after Aaron Burr's eighteenth-century estate, which was eventually purchased, subdivided, and sold off by John Jacob Astor. As a favored area for well-to-do New Yorkers until the mid-nineteenth century, its population doubled between 1815 and 1825. The original owner of this house, John P. Haff, was a leather inspector; his family retained the building until the 1860s.

The house exhibits both Federal and Greek Revival stylistic elements. Set above a high stoop, an impressive Federal-style entrance features a semi-elliptical arched doorway with Ionic columns enframing three-paned sidelights. The facade is red Flemish bond brickwork with a brownstone basement. The third floor and the metal roof cornice were added in 1888.

STATE UNIVERSITY OF NEW YORK MARITIME COLLEGE, FORMERLY FORT SCHUYLER

1833–56; ALTERATIONS, 1934, 1967

THROGS NECK, THE BRONX

ARCHITECTS: CAPTAIN T. L. SMITH

DESIGNATED: APRIL 19, 1966

Named for Philip J. Schuyler, a general of the American Revolution, this structure was designed, along with Fort Totten, to protect New York City. A square-headed main entrance announces the restrained simplicity of detail that characterizes this fort. The pentagonal structure was built from horizontally coursed, rock-faced granite ashlar. Small arches are cut out of single pieces of ashlar; the larger openings are composed of voussoirs with a keystone at the top. An armament of 312 guns could be aimed through the five- to eleven-foot-thick walls.

Used as a prison camp during the Civil War, the fort was finally abandoned in 1870. In 1934, it was restored by the WPA for use by the New York State Merchant Marine Academy, currently the State University of New York Maritime College. The gun galleries were converted into a library in 1967.

131 CHARLES STREET

131 CHARLES STREET

1834

MANHATTAN

BUILDER: DAVID CHRISTIE

DESIGNATED: APRIL 19, 1966

This small, red-brick Federal row house in Greenwich Village remains original in almost every detail. It was built by David Christie, a stonemason, one of thirty or so speculative houses built (each for about $2,600) on an old tobacco farm that once belonged to the Earl of Abingdon.

This modest yet charming house, twenty-four feet wide and two stories high, is graced by white lintels and a denticulated cornice. The eight-paneled oak door is flanked by slender Ionic columns and topped by a rectangular, leaded fanlight. The frames of the six-over-six windows, lintels, and cornice outlining the roof are all intact. The steep-pitched roof with delicate dormers and the low brownstone stoop with wrought-iron rails and fence add to the refined character of the house.

Each floor contains two rooms and a small cubicle. The house was well maintained by its many occupants, and the original doors, moldings, and yellow pine floorboards have survived. The interior is sparsely ornamented; the window and door moldings in the parlor, however, form pilasters with acanthus-leaf and acorn or pineapple trim, and two of the five fireplaces have decorative clipper-ship mantels, inset with carved wooden panels.

The house remained in the Christie family until 1865; since then, approximately ten different families have lived here.

ELIAS HUBBARD RYDER HOUSE

1834; ALTERATIONS, 1929

1926 EAST 28TH STREET, BROOKLYN

ARCHITECT: UNKNOWN

DESIGNATED: MARCH 23, 1976

The Elias Hubbard Ryder House is located in Gravesend, one of the six original townships of Kings County (later included in the city of Brooklyn). Gravesend was the only English settlement to receive a patent from the Dutch director general and council; the patentee was Lady Deborah Moody, the first woman so included. The patent also contained a proviso permitting freedom of worship "without magisterial or ministerial interference."

ELIAS HUBBARD RYDER HOUSE

The house is a typical early-nineteenth-century Dutch Colonial farmhouse, distinguished by a projecting roof eave that may initially have acted as an overhang to protect the masonry walls from rain and snow. Two stories high and with a wood frame, this vernacular structure was built on the edge of the farmland inherited by Elias Hubbard Ryder, a member of a prominent Gravesend family. The Hubbard Ryder family occupied the house until 1966.

SAILORS' SNUG HARBOR BUILDINGS

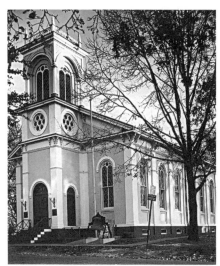
VETERANS MEMORIAL HALL

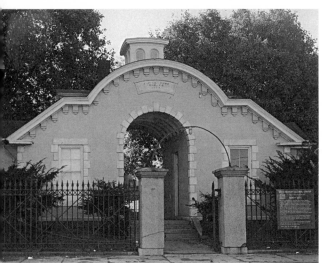
GATEHOUSE

BUILDING C

SAILORS' SNUG HARBOR

RICHMOND TERRACE, STATEN ISLAND

BUILDING C, 1831–33;
INTERIOR REDECORATED, 1884

ARCHITECT: MINARD LAFEVER

DESIGNATED: OCTOBER 14, 1965;
INTERIOR DESIGNATED:
OCTOBER 12, 1982

BUILDING B, 1839–40

BUILDER: SAMUEL THOMPSON,
AFTER PLANS BY MINARD LAFEVER

DESIGNATED: OCTOBER 14, 1965

BUILDING D, 1840–41

BUILDER: SAMUEL THOMPSON,
AFTER PLANS BY MINARD LAFEVER

DESIGNATED: OCTOBER 14, 1965

IRON FENCE, 1842; LATER ADDITIONS

ARCHITECT: RICHARD P. SMYTHE

DESIGNATED: MAY 15, 1973

**VETERANS MEMORIAL HALL, FORMER-
LY THE CHAPEL,** 1855–56

ARCHITECT: JAMES SOLOMON

DESIGNATED: OCTOBER 14, 1965

BUILDING A, 1879

ARCHITECT: SAMUEL THOMPSON

DESIGNATED: OCTOBER 14, 1965

BUILDING E, 1880

ARCHITECT: SAMUEL THOMPSON

DESIGNATED: OCTOBER 14, 1965

GATEHOUSE, THIRD QUARTER,
NINETEENTH CENTURY

ARCHITECT: FREDERICK DIAPER

DESIGNATED MAY 15, 1973

The breadth of scale and stylistic uniformity of Sailors' Snug Harbor mark this complex as one of the finest essays in Greek Revival architecture in the country. Sailors' Snug Harbor was founded with an 1801 bequest from New York merchant Robert Randall to care for "aged, decrepit and worn out sailors." Nineteenth-century medical theory suggested that health care was best provided in locations where patients would not be taxed by the difficulties of urban life. Many New York institutions, notably Leake and Watts's Orphan Asylum and the Bloomingdale Insane Asylum, adhered to this notion; in 1831, Sailors' Snug Harbor, too, followed suit with its purchase of eighty acres on Staten Island. Construction began immediately, and the complex continued to expand throughout the nineteenth century, eventually comprising over twenty buildings that were home to 900 men in 1900. It operated as a home for retired sailors until the mid-1960s, when the City of New York purchased the buildings. Since 1976, Sailors' Snug Harbor has been home to the Snug Harbor Cultural Center, a multidimensional project serving all members of the artistic community. Plans are progressing under SHCC supervision for the construction of a recital hall, the first significant addition to the complex since the turn of the century.

The first building at Snug Harbor was Minard Lafever's administration building, now known as Building C; it established the stylistic and formal model for the rest of the complex. While the body of the two-story building is brick, its main facade is sheathed in Westchester marble quarried by inmates at Sing Sing Prison. The monumental Ionic order of the facade, derived from the Little Temple of Ilyssus near Athens, carries a full entablature and shallow pediment. This, Lafever's earliest extant work, is his only surviving essay in the Greek Revival vocabulary. It bears a strong resemblance to the design for a courthouse he included in *The Young Builder's General Instructor*, the first of his influential works on building. The interior was redecorated toward the end of the nineteenth century and is distinguished by the nautical theme of its ornament.

Buildings B and D are identical and were built almost simultaneously about 1840 as dormitories to accommodate the growing population of Snug Harbor. Rising two stories above a high basement, each has a three-bay facade dominated by a broad, shallow pediment. The central bay of the first story is the entrance, distinguished by a small Ionic porch. These dormitories connect with Building C by four hyphens that Lafever designed in anticipation of such an expansion.

Built in 1879–80 as the terminal phase of the central complex, Buildings A and E are also identical. These dormitories are identified by their hexastyle Ionic porticoes. They, too, are two stories above a raised basement with a three-bay facade.

The chapel, built in 1856, was expanded in 1883 with the addition of a tower. This small Italianate brick building has round-arched windows and a bracketed cornice. Its interior is extremely simple, with a coved ceiling and trompe l'oeil Ionic pilasters. This building has been rehabilitated to house a performance space, known as Veterans Memorial Hall.

The gatehouse on Richmond Terrace is a vernacular synthesis of Romanesque, Italianate, and Second Empire influences. It was intended as a pedestrian entrance, providing a formal entry to the Snug Harbor complex. The elevation is composed of a large central arch flanked by a window in a lower wing on each side. The composition is completed with a square cupola above the vaulted tunnel that leads through the gatehouse. Each side of the cupola has a pair of round-arched windows with red glass panes.

A cast-iron fence marks the northern boundary of the original Snug Harbor property; its pickets are topped by spikes, supported by X-shaped cross-members, and ornamented with east rosettes. This design was inspired by the Cumberland Gates at Hyde Park in London.

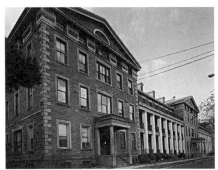

BAYLEY-SETON HOSPITAL MAIN BUILDING

PHYSICIAN-IN-CHIEF'S RESIDENCE

BAYLEY-SETON HOSPITAL, FORMERLY SEAMEN'S RETREAT

75 VANDERBILT AVENUE, STATEN ISLAND

DESIGNATED: APRIL 9, 1985

MAIN BUILDING

1834–53; 1911–12

ARCHITECT: ABRAHAM P. MAYBIE

PHYSICIAN-IN-CHIEF'S RESIDENCE

1842

BUILDER: STATEN ISLAND GRANITE COMPANY

For more than 150 years, the Seamen's Retreat provided care for merchant seamen. Established by the New York State Legislature in 1831, "to provide for sick and disabled seamen," the retreat has won recognition for medical research related to its maritime mission.

The Main Building, dating from 1834–53, is a Greek Revival granite ashlar structure built by Abraham P. Maybie. The center pavilion is five bays wide and three stories high, with a basement and attic. The center bay is emphasized by wide window openings, a pediment fanlight, and a projecting portico with a

tall, granite-block podium and fluted Doric columns. The end bays are essentially identical to the center. The wings linking the end pavilions have colonnades of large stuccoed piers that rise through two stories to support double porches. Tall door openings on the second floor of the wings provide direct access from the wards to the porches. Copper detailing is used throughout.

The Physician-in-Chief's Residence is also constructed of local granite ashlar. It, too, has columned porches and a concentration of Greek Revival detailing at the doorway.

In 1882, the retreat became the U.S. Marine Hospital, which was disbanded in 1981. Today it functions as the Bayley-Seton Hospital.

FEDERAL HALL NATIONAL MEMORIAL

1834–42

28 WALL STREET, MANHATTAN

ARCHITECTS: TOWN & DAVIS, SAMUEL THOMPSON, WILLIAM ROSS, JOHN FRAZEE

DESIGNATED: DECEMBER 21, 1965; INTERIOR DESIGNATED MAY 27, 1975

Rich in historical associations, Federal Hall National Memorial occupies the site of New York's second city hall. Remodeled and enlarged in 1789 by the expatriate French architect Pierre L'Enfant, this city hall was renamed Federal Hall and served as the seat of the federal government until 1790. It was here, on the balcony, that George Washington took the oath of office as first president of the United States on April 30, 1789. L'Enfant's Federal Hall reverted to use as a city hall in 1790 and was demolished in 1812, when the current City Hall was opened.

The present building on the site, Federal Hall National Memorial, was built between 1834 and 1842 as the U.S. Custom House. The original design of the marble building was a product of the partnership of Ithiel Town and Alexander Jackson Davis, two of New York's most influential early-nineteenth-century architects. In 1862, the building became the U.S. Sub-Treasury and acted as the center of the government's fiscal operations in the Northeast. From 1920 to 1939, it housed a variety of federal offices. In 1939, the building was taken over by the National Park Service in conjunction with the Federal Hall Memorial

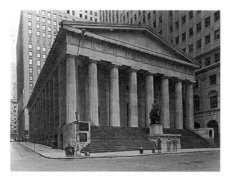

FEDERAL HALL NATIONAL MEMORIAL

Associates. Renamed Federal Hall National Memorial in 1955, the former Custom House/Sub-Treasury is now a museum devoted to early American and New York history as well as a center for civic functions.

With its austere Doric porticoes, the building is the finest example in New York of a Greek Revival temple. The original Town & Davis plans had called for a crowning dome in the Roman tradition, but the dome was eventually removed from the design owing to stylistic, spatial, and structural inconsistencies. The interior design, derived from Greek and Roman prototypes, is dominated by a two-story rotunda. The most impressive feature of this space is the circular colonnade that supports the deep entablature and the low, paneled dome decorated by anthemion motifs. The Corinthian columns (modeled after those of the Roman temple of Jupiter Stator) are simple shafts of white marble from Tuckahoe, New York; the richly foliated capitals were imported from Italy. Behind the colonnade runs a cast-iron balcony whose railing is supported by a series of slender caryatids. The bronze finish of this ornamental ironwork was restored in 1987.

Samuel Thompson, appointed superintendent of construction at Town's suggestion, is believed to have been responsible for the revised plan of the building. It has also been documented that Robert Mills was involved in advising the Treasury Department on the design changes of 1834. Most of the interior ornamental detail was the work of sculptor John Frazee, who became architect and superintendent after Thompson resigned in 1835. It has long been believed that William Ross, a British architect and magazine correspondent living in New York in the 1830s, was responsible for many of the alterations to the original Town & Davis design. According to recent research by the National Park Service, however, Ross was a draftsman for Thompson and made no official contribution to the design. The only attribution for Ross's involvement came from his own article in London's *Architectural Magazine* in 1835.

The classical traditions of architecture that flourished in America's early years epitomized the ideals of Greek democracy and Roman republicanism that had inspired this nation's Founding Fathers. These ideals lived on into the middle decades of the nineteenth century, typified by public buildings such as this one. In Federal Hall National Memorial, the outstanding architecture of that age is preserved.

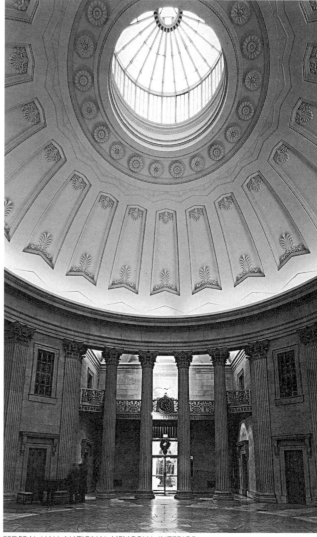

FEDERAL HALL NATIONAL MEMORIAL INTERIOR

111

CALEB TOMPKINS WARD MANSION

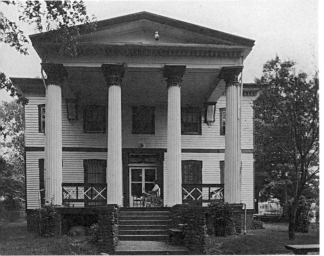

GARDINER-TYLER HOUSE

CALEB TOMPKINS WARD MANSION

c. 1835

141 NIXON AVENUE, STATEN ISLAND

ARCHITECT: SETH GEER

DESIGNATED: AUGUST 22, 1978

The Caleb Tompkins Ward Mansion is an imposing Greek Revival structure built about 1835 on the crest of Ward's Hill, Staten Island. It commands a magnificent view of the New York harbor and the metropolitan area. Originally surrounded by an estate of 250 acres, the Ward mansion is one of the last great houses from a time when the north shore of Staten Island was a fashionable resort for wealthy New Yorkers.

GARDINER-TYLER HOUSE

c. 1835

27 TYLER STREET, STATEN ISLAND

ARCHITECT: UNKNOWN

DESIGNATED: APRIL 12, 1967

This two-story frame house demonstrates how pervasive the Greek Revival had become by the second quarter of the nineteenth century. The design of the Gardiner-Tyler House must certainly have come from its builder rather than a trained architect. Yet, with the aid of pattern books, he was able to include, albeit in greatly simplified form, many of the elements essential to the style. The five-bay facade has four columns with Corinthian capitals but no bases. The exterior walls are shingled, in contrast to the plainer surfaces found in high-style models of the Greek Revival.

Elizabeth Racey built the house about 1835 on land once farmed by Nathaniel Britton. Juliana and David Gardiner purchased the house for their daughter Julia, who married President John Tyler in 1844. Mrs. Tyler rarely visited the house before 1868, when, as a widow, she returned to Staten Island with Tyler's seven children from a previous marriage. Julia Tyler left the house in 1874, and it was later owned by William M. Evarts, who served as attorney general under Andrew Johnson and as secretary of state under Rutherford B. Hayes.

364 VAN DUZER STREET

c. 1835

STATEN ISLAND

ARCHITECT: UNKNOWN

DESIGNATED: DECEMBER 18, 1973

Part of the property surveyed and subdivided by Minthorne Tompkins and William J. Staples in 1834, the land at 364 Van Duzer Street was originally developed by Captain Robert M. Hazard. Currently owned by Thomas Turbett, the house has undergone extensive restoration.

The Greek Revival structure features classical double porticoes with two-story Doric columns. In place of the traditional triangular gable, the entablature of the frieze rests below an overhanging spring eave characteristic of the Dutch Colonial style. This curious combination is enhanced by the elegant windows opening onto the portico and by the delicate

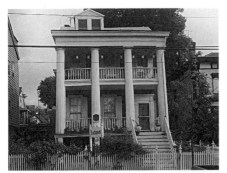

364 VAN DUZER STREET

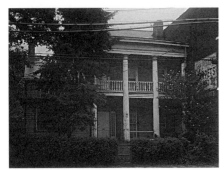

390 VAN DUZER STREET

railings that decorate the parlor floor and second floor.

390 VAN DUZER STREET

1835

STATEN ISLAND

ARCHITECT: UNKNOWN

DESIGNATED: DECEMBER 18, 1973

This frame house, built in modified Greek Revival style, is located in the old village of Stapleton. Of the original structure built in 1835, only the kitchen wing still remains. A tetrastyle portico, with Corinthian columns rising two stories to an entablature, projects from the front facade. Above the entablature is a spring eave—unusual in Greek Revival houses, which more often have a pediment.

The house was built by Richard G. Smith, whose wife was a member of an important Staten Island family; her father, Daniel D. Tompkins, was governor of New York State and vice president of the United States under James Monroe.

CHURCH OF ST. JAMES

1835–37

32 ST. JAMES STREET, MANHATTAN

ARCHITECT: ATTRIBUTED TO
MINARD LAFEVER

DESIGNATED: JANUARY 18, 1966

One of the oldest Roman Catholic church structures in Manhattan, the Church of St. James displays the handsome proportions and extreme refinement of the Greek Revival style. In a modification of the classical temple, the walls were extended forward to enclose stairs on the sides of the portico, with doors opening onto the street. This construction places the entire front under one great gable or pediment. The front entrance, in line with the side entrances, stands between two massive columns on the recessed porch. All three doorways are decorated by Tuscan porticoes with pilasters. The attribution to Lafever is based on the ornament above the entrance door and on the interior balcony, which is similar to designs published by the architect.

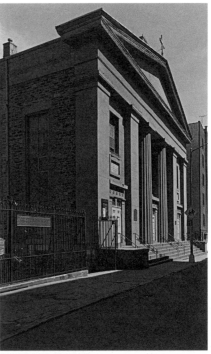

CHURCH OF ST. JAMES

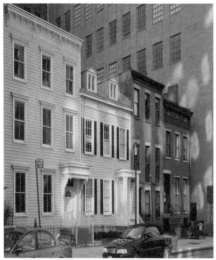

DUFFIELD STREET HOUSES

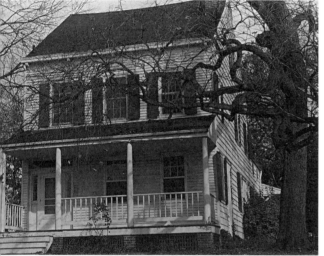

JOHN KING VANDERBILT HOUSE

DUFFIELD STREET HOUSES, FORMERLY JOHNSON STREET HOUSES

| 182 DUFFIELD STREET, C. 1839–40 |
| 184 DUFFIELD STREET, 1847 |
| 186 DUFFIELD STREET, C. 1835–38 |
| 188 DUFFIELD STREET, C. 1835–38, REMODELED C. 1881–83 |
| BROOKLYN |
| ARCHITECT: UNKNOWN |
| DESIGNATED: APRIL 24, 2001 |

Erected between circa 1835 and 1847, these four row houses are survivors of the early nineteenth-century residential neighborhood that once flourished near what is now Borough Hall. The Johnson Street neighborhood evolved between the late 1820s and 1840s as a middle-class enclave, in contrast to wealthier Brooklyn Heights and the more working class area near the Brooklyn Navy Yard. In 1990, the buildings were moved to Duffield Street, between Willoughby and Myrtle Avenues, from Johnson Street as part of the Metro Tech redevelopment plan, and they are used as office space.

Numbers 182, 186, and 188 were all developed by Rev. Samuel R. Johnson, who had inherited a portion of his grandfather's Colonial-era farm. Number 184, erected in 1847 as an investment property by a wealthy merchant, shares aspects of the Greek Revival style with its neighbors. Number 186 is one of the few surviving row houses in the city with a free standing Greek Revival portico. Number 188, built in the 1830s and remodeled in the 1880s, features a combination of Queen Anne and Second Empire elements, including an elaborate bracketed porch hood.

JOHN KING VANDERBILT HOUSE

| C. 1836; 1955 |
| 1197 CLOVE ROAD, STATEN ISLAND |
| ARCHITECT: UNKNOWN |
| DESIGNATED: OCTOBER 6, 1987 |

In 1825, John King Vanderbilt, a first cousin of Commodore Cornelius Vanderbilt, moved to Staten Island with his family and many other relatives. Listed as a farmer in census records, Vanderbilt was also active in the local real estate market. His business dealings prospered, yet his house—while stately—is simple in comparison to other, more ostentatious temple-fronted houses of the period. The colonnaded porch rises to a spring eave rather than the pediment so characteristic of the Greek Revival. Unusual, too, is the two-and-one-half story structure.

The house remained in the Vanderbilt family until 1908, when it was sold by Joseph Mortimer Vanderbilt. In 1955, the house was purchased and restored by Dorothy Valentine Smith, a member of the Vanderbilt extended family.

LATOURETTE HOUSE

C. 1836; ADDITIONS, 1936

LATOURETTE PARK, STATEN ISLAND

ARCHITECT: UNKNOWN

DESIGNATED: JULY 30, 1968

At the end of the nineteenth century, the Latourette farm—with this large Greek Revival house at its center—was considered the finest on Staten Island. David Latourette, who built the house, was descended from a family that had been active on Staten Island since 1702, when Jean Latourette's name appeared in records as a witness and a freeholder. After the family sold the farm to the City of New York in 1928, the grounds became a park with a golf course, and the house a clubhouse.

The stone staircase leading to the veranda that dominates the facade was added in a 1936 restoration. The veranda roof is supported by six square columns, joined by a balustrade; the pattern of the balustrade is repeated in the railing around the edge of the porch roof. The entrance door is a model of Greek Revival design, with paneled pilasters, narrow sidelights, and a glazed transom. No spandrel panel separates the windows of the first story from those of the second, an effect that creates the appearance of a single-story building.

ST. PETER'S CHURCH

1836–40

22 BARCLAY STREET, MANHATTAN

ARCHITECTS: JOHN R. HAGGERTY AND THOMAS THOMAS

DESIGNATED: DECEMBER 21, 1965

Built in the Greek Revival style, St. Peter's Church belongs to the oldest Roman Catholic parish in New York. The present building's predecessor was a Georgian church, constructed on this site in 1785, which partially collapsed after the great New York fire of 1835.

Both the facade on Barclay Street and the west wall on Church Street are faced with gray granite. The structure has a handsome, six-column Ionic portico and a shallow pediment; a niche holds a statue of St. Peter.

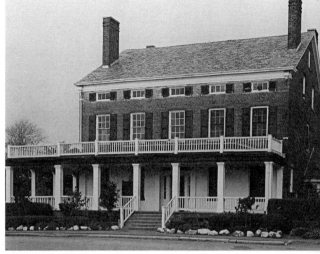

LATOURETTE HOUSE

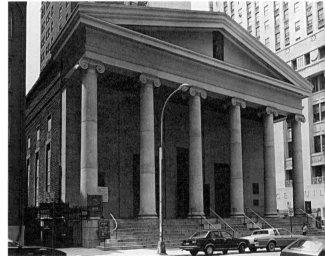

ST. PETER'S CHURCH

115

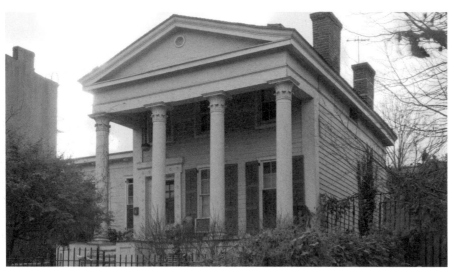

LEFFERTS-LAIDLAW HOUSE

LEFFERTS-LAIDLAW HOUSE

C. 1836–40; 1970S–80S

136 CLINTON AVENUE, BROOKLYN

ARCHITECT: UNKNOWN

DESIGNATED: NOVEMBER 13, 2001

This house may be the only freestanding, temple-fronted Greek Revival residence remaining in Kings County. Retaining much of its original clapboard siding and decorative elements, it is an exceptional example of the villas erected in the suburbs of Brooklyn during the early-to-mid nineteenth century. The design includes elements that were popularized in building guides of the period—a temple-front, pedimented gable roof, Corinthian columns, and corner pilasters.

In 1836, Rem Lefferts and his brother-in-law John Laidlaw purchased number 136 Clinton Avenue and the adjacent vacant lot. They moved a small, existing house to the rear where it became part of the service wing for the villa. Lefferts's sister-in-law, Amelia Lefferts, then occupied the house with her three children, including Marshall Lefferts, who became an inventor and a commander during the Civil War. The house was restored in the late 1970s and early 1980s and is still a private residence.

BARTOW-PELL
MANSION MUSEUM

1836–42; RESTORED, C. 1914; 1947

PELHAM BAY PARK, SHORE ROAD,
THE BRONX

ARCHITECTS: UNKNOWN; 1947
RESTORATION, DELANO & ALDRICH

DESIGNATED: FEBRUARY 15, 1966;
INTERIOR DESIGNATED MAY 27, 1975;
EXPANDED LANDMARK DESIGNATED:
JANUARY 10, 1978

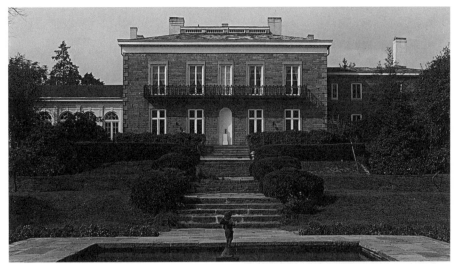

BARTOW-PELL MANSION MUSEUM

The Bartow-Pell Mansion is noteworthy for the history of its site and for its association with some of New York's most prominent families. Thomas Pell, an English physician who settled in Connecticut, purchased nine thousand acres of land from the Siwanoy Indians in 1654; in 1666, he received a charter from Charles II to create the Manor of Pelham. In 1675, his heir, Sir John Pell, built the house that his family occupied until it was destroyed during the Revolution.

In 1813, Hannah LeRoy, wife of the Dutch diplomat Herman LeRoy, purchased the estate from John Bartow, a Pell descendant, for use as a summer home. In 1836, John Bartow's grandson Robert bought back the property. The house that now stands here—the third house to occupy the site—was completed by Robert Bartow in 1842. It has a distinguished Greek Revival interior that features elaborate over-door pediments, graceful pilasters, and an elegant, free-standing elliptical staircase.

In 1888, the Bartows sold their estate to the city, and for a short while at the turn of the century the house was used as a home for crippled children. The mansion gradually deteriorated, however, until 1914, when the International Garden Club was established there and restorations were made by the firm of Delano & Aldrich. Opened as a museum in 1947, the mansion has been furnished with fine Greek Revival objects, many on loan from the Metropolitan Museum of Art, the Brooklyn Museum, and the Museum of the City of New York.

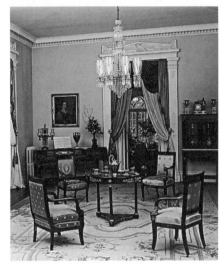

BARTOW-PELL PARLOR

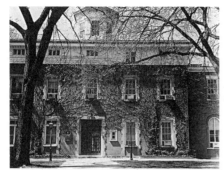

ADMINISTRATION BUILDING

ALUMNI HOUSE

ST. JOHN'S RESIDENCE HALL

FORDHAM UNIVERSITY

EAST FORDHAM ROAD AND EAST
191ST STREET, THE BRONX

DESIGNATED: FEBRUARY 3, 1981

**ADMINISTRATION BUILDING,
FORMERLY ROSE HILL, 1836–38**

ARCHITECT: UNKNOWN

ALUMNI HOUSE, 1840

ARCHITECT: WILLIAM RODRIGUE

**ST. JOHN'S RESIDENCE HALL,
1841–45**

ARCHITECT: WILLIAM RODRIGUE

**UNIVERSITY CHURCH,
FORMERLY FORDHAM UNIVERSITY
CHAPEL, 1845; TRANSEPT
COMPLETED, 1929**

ARCHITECT: WILLIAM RODRIGUE

Fordham University takes its name from
the Manor of Fordham, granted in 1671
to John Archer by the British royal gov-
ernor of New York, Francis Lovelace.
Robert Watts acquired the property in
1787 and named it Rose Hill, after the
former residence of his father. After
changing hands several times, the estate
was purchased in 1839 by the Right
Reverend John Hughes (later New York's
first Catholic archbishop) for use as a
seminary and college. The first six
students arrived for classes at St. John's
College, Fordham, on June 24, 1841.
In 1905 the institution became
Fordham University.

The Greek Revival manor house,
Rose Hill—now the Administration
Building—is superbly sited on a semi-
circular tree-lined driveway. It is a two-
and-one-half-story random-ashlar

structure. The entrance porch, standing
on a raised platform with wide steps,
Ionic columns, and square corner posts
supporting a full entablature, is one of
the finest in New York. A full wooden
entablature with a dentiled cornice
crowns the house and an octagonal
cupola surmounts the roof.

The former Greek Alumni House,
which now serves as the housing office,
is a small fieldstone house by architect
William Rodrigue, who worked with
James Renwick Jr. on St. Patrick's
Cathedral. A stone plaque beneath the
central attic window bears the date 1840,
two years after the completion of
the Administration Building, but the
house displays certain earlier details,
such as the window lintels that appear
to be a holdover from the Federal peri-
od. The house is constructed of random-
laid, dark-colored fieldstone, with
fieldstone quoins; keyed red brick
frames the windows. The wooden attic
story has three small, rectangular win-
dows inset on both the front and back
facades. The entrance door is framed by
wooden pilasters and sidelights. The end
walls are simple planes of fieldstone, and
in the rear is a double door, flanked by
paired windows.

The University Church, constructed of
rough-hewn stone in the Gothic Revival
style, is adjacent to St. John's Residence
Hall; together these buildings frame
Queen's Court. The dominant feature of
the chapel is a tall, square tower, with
large stepped buttresses projecting from
the corners, that rises to a louvered bel-
fry, terminating in graceful pinnacles,
and decorated with crockets and finials.
In 1928–29, a large transept was added.

Marking the crossing of the transept and the nave is a heavily decorated copper lantern that features small flying buttresses. The stained glass windows were donated by King Louis Philippe of France; the altar, installed in 1943, was once part of St. Patrick's Cathedral and was donated by Francis Cardinal Spellman.

SEGUINE HOUSE

1837; 1981

440 SEGUINE AVENUE,
STATEN ISLAND

ARCHITECT: UNKNOWN

DESIGNATED: MAY 25, 1967

Built as a waterfront residence on the highest point overlooking Prince's Bay, this eighteen-room mansion is a monument to the Greek Revival style. Formerly the focus of the two-hundred-acre Seguine estate, the house gives evidence of the grand life of Staten Island's past. The Seguines, who first settled on the island in 1706, were one of the most prominent families on Staten Island during the eighteenth and nineteenth centuries.

The two-and-one-half-story stone structure is covered with white clapboard. The low-pitched, pedimented gable of the attic story is supported by six two-story square columns. Centered in the pediment beneath the peak of the roof is a handsome fanlight. The main entrance is framed by an arrangement of pilasters, in which plain moldings and blocks serve as capitals and bases.

The mansion remained in the Seguine family until 1969, whereupon it fell into disrepair. The house was eventually sold at auction in 1981 and stabilized by its new owners. In 1989, the house was donated to the City of New York.

HIGH BRIDGE AQUEDUCT AND PEDESTRIAN WALK

1838–48; ADDITION, 1860; 1923

HARLEM RIVER AT WEST 170TH
STREET, THE BRONX, TO HIGH
BRIDGE PARK, MANHATTAN

ENGINEER: JOHN B. JERVIS

DESIGNATED: NOVEMBER 10, 1970

High Bridge, designed by engineer John B. Jervis, is a monument to the system that brought to New York its first adequate public water supply. The elegant masonry of the structure and the severity of its lines are a triumph of architecture as well as engineering. Resembling a Roman aqueduct, the High Bridge consists of fifteen arches that span the river eighty-four feet above high water. The High Bridge was part of the Croton Aqueduct, opened in 1842, which carried drinking water from the Croton Reservoir in Westchester County to New York City. In 1923, navy engineers replaced the central piers in the Harlem River with a steel arch to allow larger ships to pass up the river. The bridge is no longer used as an aqueduct, and the pedestrian bridge is closed.

FORDHAM UNIVERSITY CHURCH

SEGUINE HOUSE

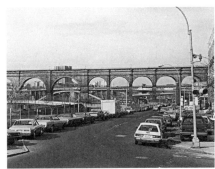
HIGH BRIDGE AQUEDUCT

119

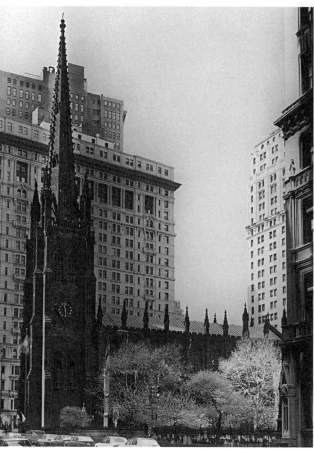

TRINITY CHURCH AND GRAVEYARD

TRINITY CHURCH AND GRAVEYARD

1839–46; 1913

BROADWAY AT WALL STREET, MANHATTAN

ARCHITECT: RICHARD UPJOHN

DESIGNATED: AUGUST 16, 1966

Established on land granted by Queen Anne in 1705, Trinity was the first Episcopalian parish in New York; the current church, however, is actually the third built on this site. The first, built in 1698, was burned in 1776. It was rebuilt in 1787 but razed in 1839 on the advice of Boston architect Richard Upjohn, who had been called in to correct the building's structural defects. Before the year was over, Upjohn submitted designs for the present building, which was one of the grandest American churches of its day. Upjohn specialized in Gothic Revival churches, but his early works were inaccurate, rather provincial versions of the English Gothic; Trinity was his first convincing application of Gothic forms in a truly massive and richly decorated structure. As such, it marks the beginning of the mature Gothic Revival in the United States.

Executed in New Jersey brownstone, Trinity is now black from city grime. A recent study has shown that this surface dirt helps to protect this unusually soft, poorly weathering stone; where rainwater has washed the stone clean, spalling is evident. In both massing and detail, Trinity shows the influence of the late Decorated style of the later fourteenth century. The steeple is decorated with crocketed ogee arches and shallow, tracery-paneled buttresses. At just over 280 feet, it was the tallest structure in the city until the late 1860s. The bell was presented to the church by the bishop of London in 1704 and installed in the original church in 1711, when the steeple was completed. It is topped by an octagonal spire with flying buttresses, crocketed finials (echoed on the nave roof), and an early-fifteenth-century-style paneled parapet (repeated at the cornice levels of the three remaining elevations.) The chancel wall, from which the sacristy and chapel project, is supported by flying buttresses.

The side-aisle window tracery is repeated in the clerestory above, while the proportions and moldings of the windows reappear in the nave arcades. The sexpartite rib vaults are executed in plaster and lath rather than stone.

Richard Morris Hunt was responsible for the overall design of the three sculpted bronze doors. To achieve variety, he assigned each portal to a different sculptor. The west door is the work of Karl Bitter and the north door was designed by J. Massey Rhind; both show biblical scenes. The south door, sculpted by Charles H. Niehaus, shows the history of Trinity Church. All three constitute a memorial to John Jacob Astor III.

The furnishings and decorative details are average by European standards, but remarkable for a country that was then an artistic backwater. All Saint's Chapel was constructed in 1913 as a memorial to the Reverend Dr. Morgan Dix, rector from 1862 to 1908; he is buried under the chapel altar.

Many well-known New Yorkers have been members of Trinity parish. Interred in the graveyard, which recounts this history, are such notables as Alexander Hamilton, Captain Jones Lawrence, Robert Fulton, and Francis Lewis—the only signer of the Declaration of Independence buried in Manhattan. Trinity Church's present congregation is drawn from all parts of the metropolitan area; members worship at weekday and Sunday services.

5910 AMBOY ROAD

1840

STATEN ISLAND

ARCHITECT: UNKNOWN

DESIGNATED: MARCH 19, 1974

This simple Greek Revival frame house is situated on a low, grassy knoll set back from Amboy Road, which was laid out in 1709 and is one of the oldest roads on Staten Island.

The building is composed of three clapboard sections with the central portion projecting above the flanking wings. The porch at the center has four square, paneled columns with molded capitals that support a projecting roof decorated with dentils. Two square pilasters engage the main section where it meets the wings. The doorway still retains its original small-paned transom and sidelights.

F.G. GUIDO FUNERAL HOME

1840

440 CLINTON STREET, BROOKLYN

ARCHITECT: UNKNOWN

DESIGNATED: JULY 14, 1970

This Greek Revival mansion was built in 1840, when the area was rural farmland and clipper ships sailed into New York harbor. Its original owner, John Rankin, was an affluent merchant; his home on a corner lot had a magnificent view of the bay.

Imposing in size, the austere-looking, almost square, three-story house is distinguished by classical orderliness and symmetry. The facade is divided into three sections; the middle section, projecting forward from the two sides, contains a centrally located doorway with stoop. Stone pilasters around the doorway support an entablature enriching the entrance. Crowning the dwelling is a simple but dominant entablature with moldings and dentils below the cornice.

5910 AMBOY ROAD

F.G. GUIDO FUNERAL HOME

121

170–176 JOHN STREET

JOHN STREET UNITED METHODIST CHURCH

170–176 JOHN STREET

1840; 1983

MANHATTAN

ARCHITECT: ATTRIBUTED TO
TOWN & DAVIS

DESIGNATED: OCTOBER 29, 1968

Hickson W. Field, a successful commission merchant, had this exceptional warehouse constructed in 1840 to house his business. The granite facade is nearly unique in New York, where, for reasons of economy, granite was rarely used above the ground story. The regularity of the twelve-bay facade and the near-total absence of ornament emphasize the utilitarian nature of the building and at the same time provide a model of Greek Revival restraint.

John Street has long been associated with maritime activity. The area where 170–176 John Street stands was originally Burling Slip, a docking area for ships. Filled in about 1835, the new street

retained the extra width of the former berth. Originally a warehouse for seagoing cargo, the building later housed Baker, Carver & Morrell, a renowned ship's chandlery. In 1983, the building was converted to an apartment house. The area experienced a rebirth after the development of South Street Seaport by the Rouse Company.

JOHN STREET UNITED METHODIST CHURCH

1841

44 JOHN STREET, MANHATTAN

ARCHITECT: ATTRIBUTED TO
PHILIP EMBURY

DESIGNATED: DECEMBER 21, 1965

John Street United Methodist Church, with its pleasing, austere brownstone facade, has survived untouched in the heart of the city's financial district. Built

in 1841, the church is contemporary with the Greek Revival churches in the city, but it shows the incoming Anglo-Italianate style. The windows, like those of their Renaissance prototypes, are crowned with semicircular arches. The Palladian window dominating the facade is a Northern Italian detail that reached the United States after a long period of popularity in England.

The present building is the third Methodist church erected on the site (earlier buildings were constructed in 1768 and 1817). It houses the oldest Methodist congregation in the United States, organized in 1766 under the leadership of two Irish cousins, Philip Embury and Barbara Heck. Peter Williams, a slave and one of the first members of the congregation, worked as the church sexton. To save him from the auction block, the church trustees purchased him for £40; he was given his freedom and later, as a tobacco merchant, helped to found the city's first Methodist church for African Americans, the African Methodist Episcopal Zion Church.

The church library contains volumes dating from its founding in the 1790s; a museum collection of early American objects includes a 1767 clock, a painting of the 1768 church, and a 1767 Windsor chair.

St. Ann's Church of Morrisania and Graveyard

1841

295 St. Ann's Avenue, The Bronx

Architect: Unknown

Designated: June 9, 1967

Gouverneur Morris Jr. commissioned St. Ann's Church as a memorial to his mother, Ann Gary Randolph Morris, a direct descendant of Pocahontas and a member of one of the most influential families in Virginia. She is buried in a vault in front of the altar; with her are other members of the Morris family, notably Judge Lewis Morris, first lord of the Manor of Morrisania, and Major General Lewis Morris, a member of the Continental Congress and a signer of the Declaration of Independence.

Gouverneur Morris Sr. is buried in the adjacent graveyard. A close friend of George Washington, the elder Morris was a member of the Constitutional Convention, ambassador to France, and a member of Congress.

This fieldstone Greek Revival church reflects the increased influence of the Gothic Revival. While the detail of the steeple is classically inspired, all of the window and door openings are brick-framed pointed arches. The south facade has a large, central stained glass window with tracery. The church complex includes a large parish house connected to the sanctuary by a covered walkway, notable for its Gothic-style arcade.

504 Canal Street

c. 1841

Manhattan

Architect: Unknown

Designated: June 30, 1998

The four-story Greek Revival building at 504 Canal Street is notable for its trabeated granite storefront, consisting of New England granite posts supporting a continuous lintel with a projecting top molding. It complements its Federal-style neighbors on Canal Street (p. 98) in its brickwork, window details, and a sloping roof. A fire escape with wrought iron railings is the only noticeable addition to the building's exterior.

This site was originally part of the farmland owned by Leonard Lispenard, which his heirs later divided into lots and sold off for development. Robert Stewart, a descendant of the Lispenard family, built this house on a lot reacquired by his family. Stewart's heirs sold the property in 1897 to Samuel Weil who subsequently acquired the adjacent buildings at 502 Canal Street/480 Greenwich Street (p. 95). Since Weil's time, these three properties have been under the same ownership.

ST. ANN'S CHURCH OF MORRISANIA

504 CANAL STREET

123

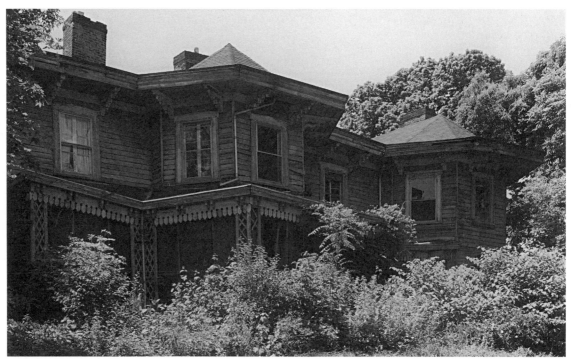

MCFARLANE-BREDT HOUSE

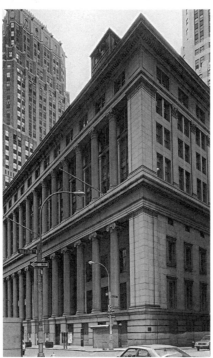

55 WALL STREET

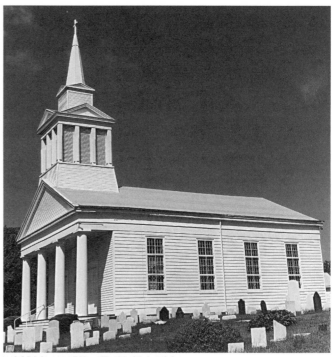

WOODROW UNITED METHODIST CHURCH

124

McFarlane-Bredt House, formerly the New York Yacht Club

c. 1841–45; additions, 1860, 1870s, 1890s

30 Hylan Boulevard, Staten Island

Architect: Unknown

Designated: October 12, 1982

This villa was built in the mid-1840s as a residence for Henry McFarlane, an early Staten Island developer. The house later served as the second clubhouse of the New York Yacht Club from 1868 to 1871. In 1870, the start of the first race for the America's Cup took place in the Narrows in front of the clubhouse.

The long, low house—a two-story, clapboard-covered, wood-frame cottage with brick-filled walls—was designed to resemble an Italian-Swiss villa, in a short-lived style that was popular in the 1840s. The main entrance, centered on the southern side, features a hood above paneled double doors. Narrow, latticed posts support a sharply concave tin roof with a wooden valance of pointed jigsaw ornament. Above the main entrance, a shallow balcony rests on a pair of console brackets with a wooden railing of diamond design. The broad cornice is supported by elaborate brackets ornamented with wooden acorn pendants. The northern facade features a long, open veranda with flat, wooden posts of diamond trelliswork. The west wing is nearly square and rises three stories above a red-brick foundation to a pyramidal hipped roof.

In the mid-1970s, the New York City Department of Parks and Recreation assumed ownership of the house; the Parks Department currently administers the building as a multifamily rental dwelling.

55 Wall Street, formerly Citibank and National City Bank, originally Merchants Exchange

1842; addition, 1907; 1998

Manhattan

Architects: Isaiah Rogers; McKim, Mead & White

Designated: December 21, 1965; interior designated: 1999

Occupying an entire city block at 55 Wall Street, the National City Bank building is a monumental structure representing the zenith of the Greek Revival in New York City. It is the result of two building campaigns. The lower portion, with its monolithic Ionic columns, was built as the Merchants Exchange and later housed the U.S. Custom House. After the National City Bank acquired the building in 1907, McKim, Mead & White added a Corinthian colonnade to the upper portion, completing the addition without marring the integrity and proportion of the original structure.

One of the few truly classical buildings in New York City, this is an important example of great commercial power expressed in stone and mortar. Since 1998, the magnificent main banking room has been used as a ballroom.

Woodrow United Methodist Church

1842; tower, 1876

1075 Woodrow Road, Staten Island

Architect: Unknown

Designated: November 15, 1967

This small Greek Revival church is a model of simplicity. The body of the church is a four-bay-deep rectangular structure, its rhythm defined by tall windows along the length of the nave. A flight of steps spanning the width of the building leads to the entrance portico, which has four fluted Doric columns, a simple entablature, and a plain pediment. A pair of well-proportioned paneled portals, with eared surrounds below pediments, leads into the sanctuary. The building is crowned by a bell tower with an octagonal spire.

The church was built on the site of the first Methodist church on Staten Island, established in 1787. It is also associated with two of New York's most influential Methodist missionaries, Bishop Francis Asbury and the Reverend Henry Boehm.

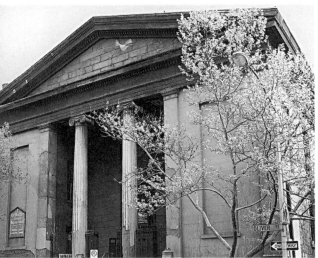

MARINERS' TEMPLE

MARINERS' TEMPLE

1844–45

12 OLIVER STREET, MANHATTAN

ARCHITECT: ATTRIBUTED TO
ISAAC LUCAS

DESIGNATED: FEBRUARY 1, 1966

This superb Greek Revival church in brownstone with fluted Ionic columns was built in 1842. Like the nearby St. James Church (p. 113), which is attributed to Minard Lafever, the Mariners' Temple has a recessed entrance loggia with a central pair of columns flush with the front wall. The flanking extensions contain stairs to the gallery.

The Mariners' Temple, organized by Baptists in 1795 to serve seamen when their ships were in port, was moved to Oliver Street from Cherry Street in 1842. During the period of heavy European immigration, the temple opened its doors to immigrants of all faiths. Among the congregations organized here were the First Swedish Church, the First Italian Church, the First Latvian Church, the Norwegian-Danish Mission, the First Russian Church, and the First Chinese Church. From the turn of the century until World War II, its main concern was working with homeless men of the Bowery. Today the older members of the church tutor the youngsters in after-school programs that provide remedial help and stress social skills and community involvement.

GRACE CHURCH COMPLEX

MANHATTAN

GRACE CHURCH AND RECTORY, 1843–47; 2006

800–804 BROADWAY

ARCHITECT: JAMES RENWICK JR.

DESIGNATED: MARCH 15, 1966

GRACE CHURCH SCHOOL MEMORIAL HOUSE, 1882–83

94–96 FOURTH AVENUE

ARCHITECT: JAMES RENWICK JR.

DESIGNATED: FEBRUARY 22, 1977

GRACE CHURCH SCHOOL CLERGY HOUSE, 1902

92 FOURTH AVENUE

ARCHITECTS: HEINS & LA FARGE

DESIGNATED: FEBRUARY 22, 1977

GRACE CHURCH SCHOOL NEIGHBORHOOD HOUSE, 1907

98 FOURTH AVENUE

ARCHITECTS: RENWICK, ASPINWALL & TUCKER

DESIGNATED: FEBRUARY 22, 1977

The Grace Church complex is a remarkably coherent Gothic Revival ensemble, even though its building history spans sixty years. The congregation's first church was a modest structure at the corner of Rector Street and Broadway across from the second Trinity Church (which was replaced between 1839 and 1845 by Richard Upjohn's Gothic Revival masterpiece). In 1843, architect James Renwick Jr. received the commission for the new Grace Church and rectory on this site north of the Astor estate. The congregation purchased

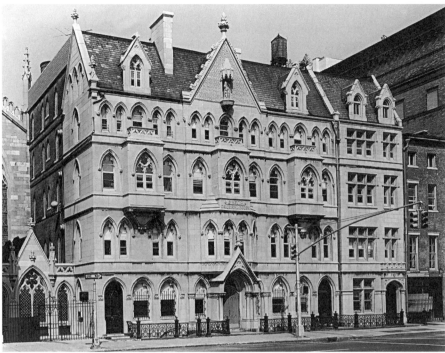

GRACE CHURCH SCHOOL CLERGY HOUSE

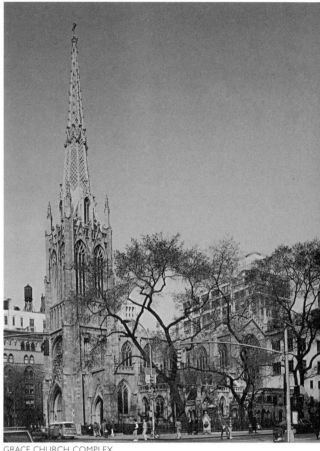

GRACE CHURCH COMPLEX

the land from Renwick's uncles, Henry and Elias Brevoort, whose prosperous farm extended to 23rd Street. Renwick himself was a lifelong member of the congregation.

Like the more famous Trinity (p. 120), Grace Church was one of the first Gothic Revival buildings in the United States to accurately reflect Gothic—in this case, fourteenth-century—forms. The rose window in the west facade recalls the curvilinear tracery of the flamboyant style; the windows and buttresses are mixtures of French and English details; the openwork spire is a typical German form. Renovation of the church and repairs to the spire, which now lists noticeably, are expected to be completed in 2006.

Grace Memorial House, at 94–96 Fourth Avenue, was built as a memorial to Mrs. Levi P. Morton, whose husband was vice president of the United States under Benjamin Harrison. It became a day nursery for children of working mothers, along with the Neighborhood House. The latter building and the Clergy House, as well as the gate facing the Vestry House on Fourth Avenue, blend seamlessly with Renwick's work. These later buildings originally served as the choir school and as housing for associated clergy. In 1973, the congregation considered replacing them to provide more space for community programs, but in the wake of a public out-cry, the buildings were adapted to satisfy the church's needs. Since 1942, all three buildings have been part of the Grace Church School.

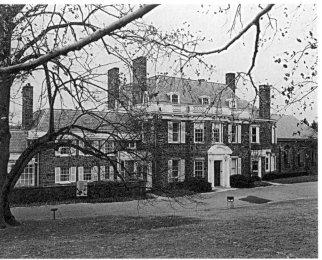

WAVE HILL

WAVE HILL

CENTER SECTION, 1843;
NORTH WING, LATE NINETEENTH
CENTURY; ARMOR HALL, 1928;
SOUTH WING, 1932

675 WEST 252ND STREET, THE BRONX

ARCHITECTS: DWIGHT JAMES BAUM
(ARMOR HALL) OTHERWISE UNKNOWN

DESIGNATED: JUNE 21, 1966

Built in 1843 as a summer residence for jurist William Lewis Morris, Wave Hill has been the residence over the years of such notables as Theodore Roosevelt, Samuel Clemens, and Arturo Toscanini. Purchased from the Morris family in 1866 by publisher William Henry Appleton, the property was subsequently incorporated into an eighty-acre estate in 1903, by financier George W. Perkins. Perkins's daughter and son-in-law, Mr. and Mrs. Edward U. Freeman, owned Wave Hill until 1960, when they donated it to the New York Department

of Parks and Recreation. Today, the property serves as a botanic garden and cultural and educational institution.

The house is a fieldstone structure with white wood trim. Constructed over a ninety-year period, the building is an amalgam of architectural styles. Morris's original central portion is designed in the Federal style; the entrance doorway, added during a twentieth-century remodeling, has the heavy columns and broken pediment of Georgian architecture; the armor hall, built by Metropolitan Museum of Art curator Bashford Dean in 1928 to house his collection of armor, is predominantly Gothic in character.

CHURCH OF THE HOLY COMMUNION BUILDINGS

47 WEST 20TH STREET, MANHATTAN

ARCHITECT: RICHARD UPJOHN

DESIGNATED: APRIL 19, 1966

CHURCH, 1844–46

RECTORY, 1850

SISTERS' HOUSE, 1854

CHAPEL, 1879

Belonging stylistically to the Gothic Revival, the buildings of the Church of the Holy Communion are nonetheless simple and symmetrical in form. They are constructed with random brownstone ashlar, more typical of a rural parish than an urban construction. The rectory is one of the finest masonry town houses in New York City. The gable ends of the rectory and the Sisters' House face the street, the steep pitch of

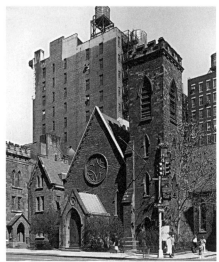

CHURCH OF THE HOLY COMMUNION

their roofs emphasized by stone caps and horizontal returns at the eaves. This exaggerated outline is echoed above the entrance doors in the porch roofs.

Known as the first free church in the city, the Church of the Holy Communion Chapel offered open pews to all worshipers. In line with the rectory, it features a similar design with an additional tower and rose windows. The Sisters' House, which resembles both buildings, has its own smaller tower, gable, and gabled entrance door.

Milestones throughout the church's history include the first "boy choir" in the city and the first Anglican sisterhood in the country. More important, the plans for St. Luke's Hospital were originated under the rectorship of the Reverend William Muhlenberg. Now located in Morningside Heights, the hospital was originally administered in the Sisters' House by the Sisters of Charity.

26, 28, and 30 Jones Street

1844

Manhattan

Architect: Unknown

Designated: April 19, 1966

Very similar in overall design, these three brick row houses, each with three stories over a low basement, are good examples of the urban expression of the Greek Revival style. Their warm brick, with limited use of brownstone, is typical of the period.

The doors and sidelights at 26 and 28 are recessed within pilastered door frames. At number 30, the entrance is a double door with a vestibule. A dentiled cornice capping the original wood frieze board at the roofline successfully completes the design.

The buildings are owned by a small cooperative that was formed in 1920 to purchase them from Greenwich House, a well-known settlement house founded in 1902 at 26 Jones Street.

Garibaldi Meucci Museum

c. 1845

420 Tompkins Avenue,
Staten Island

Architect: Unknown

Designated: May 25, 1965

General Giuseppe Garibaldi, the charismatic military leader of the nineteenth-century wars that liberated and unified Italy, lived in this modest country house from 1850 to 1851 as a guest of the Italian-American inventor Antonio Meucci. Driven into temporary exile, Garibaldi worked for Meucci in his candle factory on Staten Island until he was able to resume his career as a merchant-ship captain while waiting to take up the struggle for freedom in Italy.

Meucci lived in the house until his death in 1889; he developed a wide range of inventions, but his greatest achievement was an early prototype of the telephone, for which he received a U.S. patent in 1871. A marker commemorating Garibaldi's residence was placed on the house in 1884.

After Meucci's death, the house was relocated just two blocks from its original site and enclosed in a memorial pantheon; it became the responsibility of the Order of the Sons of Italy in America in 1907. The pantheon was removed in 1956, and the exterior of the house has been restored to its original condition in almost every detail.

The structure is three windows wide, clapboarded, and has a wood shingle roof. On both the front and rear of the house, a single pointed-arched window is located in the center of the roofline gable. Beneath these, three "tummy-on-the-floor" windows run across the front and facades. Verges with a fleur-de-lis motif and crowning pendants, which were depicted in an 1882 view of the house in *Leslie's Illustrated Weekly*, were removed in the late 1880s, but the house retains the main line evident in this early illustration.

26, 28, AND 30 JONES STREET

GARIBALDI MEUCCI MUSEUM

SAMUEL TREDWELL SKIDMORE HOUSE

33–37 BELAIR ROAD

SAMUEL TREDWELL SKIDMORE HOUSE

1845

37 EAST 4TH STREET, MANHATTAN

ARCHITECT: UNKNOWN

DESIGNATED: AUGUST 18, 1970

This house was built for Samuel Tredwell Skidmore, cousin of Seabury Tredwell, whose house at 29 East 4th Street (p. 104) survives in much better condition. Both buildings suggest the type and scale of residential development that filled the area adjacent to the Astor family estate in the 1840s. Seth Geer's development of La Grange Terrace (Colonnade Row, p. 105) on Lafayette Street began to attract wealthy New Yorkers here in the 1830s. Their row houses were generally brick and detailed in the Greek Revival. The Skidmore House is a perfect example of this mode. A stoop over a high basement, which has traces of the original rustication, leads to a door marked by a pair of Ionic columns with entablature. Although the original sidelights are now blocked up, the three-paned transom remains with traces of carved molding surrounding it. The low attic windows (which marked the servants' quarters) and simple wood cornice with fascia below are characteristic of the Greek Revival. No original ironwork survives, but traces of it found by the present owners suggest it was identical to the ironwork on the Tredwell House.

Skidmore was involved in the wholesale drug business, later served as president of the Howard Insurance Company at 66 Wall Street, and finally became a trustee of the U.S. Trust Company. He served as a vestryman and senior warden for Trinity Church. He died in 1881; his large family remained here until 1883. By that time, light industry and printing houses had transformed this once-fashionable block into a commercial district, pushing residential areas farther north. The Skidmore house, however, is still a private residence.

33–37 BELAIR ROAD, FORMERLY WOODLAND COTTAGE

C. 1845; ADDITION, 1900

STATEN ISLAND

ARCHITECT: UNKNOWN

DESIGNATED: OCTOBER 12, 1982

The house at 33–37 Belair Road is one of the few surviving Gothic Revival cottages dating from the early period of Staten Island's suburban development. Constructed about 1845 by a developer as a rental residence known as Woodland Cottage, it was one of the many Gothic Revival villas and cottages built in the east shore suburb of Clifton after the late 1830s. Although its architect is unknown, the cottage reflects the influence of Alexander Jackson Davis, whose work included a number of residences for Staten Island clients.

The property was once part of the farmland that the Simonson family had owned since the 1700s. Between 1834 and 1841, the land changed hands several times before being acquired by David Abbott Hayes, a New Jersey lawyer, in 1841. In 1849, Hayes sold the cottage to

a Manhattan pottery merchant. Between 1858 and 1869 the cottage served as the rectory for St. John's Episcopal Church. Since that time it has been a private residence.

The original portion of the house is a cross-gabled structure of clapboard with a prominent center chimney. The steep center and end gables, with wide eaves, are ornamented by sturdy baseboards. A broad porch, with fluted and turned posts set on tall bases, extends across the front facade. The main doorway on the west end of the facade, with upper and lower panels of thin, turned spindles fronting tall panes of glass, is flanked by French windows with diamond-shaped panes. The gabled section of the western end of the house, added in 1900, repeats the Gothic Revival bargeboard of the original structure but adds Queen Anne features such as the decoratively treated window sash.

SUN BUILDING, FORMERLY A.T. STEWART STORE

1845–46; ADDITIONS, 1850–51, 1852–53, 1872, 1884, 1921; 2002

280 BROADWAY, MANHATTAN

ARCHITECTS: JOSEPH TRENCH; TRENCH & SNOOK, 1850–51 AND 1852–53; FREDERICK SCHMIDT, 1872; AND EDWARD D. HARRIS, 1884

DESIGNATED: OCTOBER 7, 1986

Originally the A.T. Stewart store, this building is one of the most influential erected in New York City during the nineteenth century, significant both in terms of architectural and social history. It initiated a new architectural mode based on the palazzo of the Italian Renaissance. In this building, Alexander Turney Stewart opened the city's first department store, a type of commercial enterprise that was to have a great effect on the city's economic growth as well as on merchandising throughout the entire country. From 1919 until 1952, the building housed one of the oldest dailies, the *New York Sun*; the paper's motto ("The Sun—It Shines For All") is still visible on the facade.

The present configuration of the building is the result of a series of additions over a forty-year period, but the whole is visually unified. The structure is faced with a light-colored marble, intended to convey a sense of wealth, luxury, and extravagance. The Broadway facade, always intended as the main facade, has a colonnade of smooth pilasters on the ground floor. The exterior is profusely ornamented with Corinthian columns and pilasters, quoins, embossed spandrels, and windows framed with architrave moldings.

The building was acquired by the city in 1970, and it has housed a variety of municipal agencies. The building reopened in 2002 after extensive renovations by the Starrett Corporation and now houses retail on the street level and the city's Department of Buildings on the upper levels.

SUN BUILDING

131

THE PLAYERS

WEST 16TH STREET HOUSES

THE PLAYERS

1845; REMODELED 1888

16 GRAMERCY PARK, MANHATTAN

ARCHITECT: UNKNOWN;
ALTERATIONS, McKIM,
MEAD & WHITE

DESIGNATED: MARCH 15, 1966

This Gothic Revival town house was built for the New York banker Elihu Townsend in 1845. In 1888, the actor Edwin Booth bought it to house a club where "actors and dramatists could mingle in good fellowship with craftsmen of the fine arts, as well as those of the performing arts." Booth commissioned Stanford White to transform the brownstone into a clubhouse, which he then called the Players.

White's new front was an ingenious way to disguise the conversion of the original raised stoop to a ground-floor entrance in the English style. The new front porch at the second-story level, supported by square uprights below, displays a fine series of Tuscan columns; the handsome roof deck is topped by an iron railing.

5, 7, 9, 19, 21, AND 23 WEST 16TH STREET

C. 1845–46

MANHATTAN

ARCHITECT: UNKNOWN

DESIGNATED: MAY 1, 1990

As Manhattan expanded northward in the 1840s, the area west of Union Square and above 14th Street became a prosperous neighborhood of mansions and fine row houses. Built in the Greek Revival style that dominated American architecture in the 1840s, these elegantly proportioned brick-front row houses are distinguished by an eared and battered entrance surround executed in stone. This feature, derived from Egyptian sources, was a popular element of the Greek Revival style. A commanding presence on the street, numbers 5, 7, 9, and 17 have generous curved bow front exteriors, more commonly found on early-nineteenth-century houses in Boston.

At least a dozen houses on the block were planned and probably built by businessman Edward S. Mesier. A restrictive agreement regulated their appearance and use to ensure that the area developed as an enclave of fine residences. These elegant and simple houses, now divided into apartments, recall an early stage of a neighborhood that has since been largely transformed by commercial use.

17 West 16th Street

c. 1846; 1980

Manhattan

Builder: Attributed to Edward S. Mesier

Designated: November 9, 1976

Built about 1846, this handsome Greek Revival hosue was one of a row of nine town houses, only four of which survive today. Located in the then-fashionable Union Square area in the Ladies' Mile Historic District, the houses were planned and most likely built by Edward S. Meiser, whose goal was to make West 16th Street between Fifth and Sixth Avenues a first-class residential street. This house and its neighbors at 5–9 West 16th Street are among the very few bow-fronted survivors in New York. Another handsome feature is the original Greek Revival doorway with its eared architrave, frieze, modillioned cornice, and crisp details. The recessed double doors are framed with an egg-and-dart molding, flanked by sidelights and surmounted by a three-light transom that, in turn, is crowned by a decorative frieze supporting a rich cornice.

The house was purchased in 1846 by George S. Fox, and after 1876 was the residence of Mr. and Mrs. William B. Rice, a socially prominent family. From 1930 to 1973, it served as the clinic of Margaret Sanger, the pioneer of family planning in the United States.

Andrew Norwood House

1845–47

241 West 14th Street, Manhattan

Architect: Unknown

Designated: May 9, 1978

A handsome, generously proportioned building set above a brownstone basement and subtly accented with brownstone trim, the Norwood House was designed in a transitional style that combined Greek Revival and Italianate features. At the first floor are two full-height French doors with eared Greek Revival frames; these doors open onto the original Italianate cast-iron balcony. The doorway, above a high stoop, has an elegant Doric entablature carried on Doric pilasters. The windows grow progressively smaller at each ascending level; those at the second, third, and fourth floors have distinctive Italianate enframements and sills, and each sill is supported by two corbels. The wooden roof cornice, with its fascia board below a series of modillions, is a familiar feature of the Greek Revival style.

The house remained in the Norwood family until the turn of the century. The interior retains all the original crown moldings as well as the oculus in the hall ceiling; the thirteen fireplaces are all in working order. Listed on the National Register of Historic Places, the house survives as a striking remnant of the fashionable 14th Street residential area of the 1840s; it is still a private residence.

17 WEST 16TH STREET

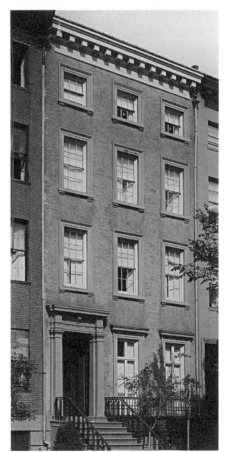

ANDREW NORWOOD HOUSE

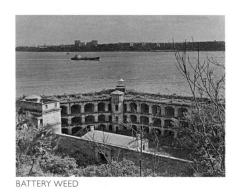

BATTERY WEED

FORT TOMPKINS

FORT WADSWORTH RESERVATION

HUDSON ROAD, STATEN ISLAND

ARCHITECTS: UNKNOWN

BATTERY WEED, FORMERLY FORT RICHMOND, 1845

DESIGNATED: OCTOBER 12, 1967

FORT TOMPKINS, 1858–76

DESIGNATED: SEPTEMBER 24, 1974

Battery Weed and Fort Tompkins are the two major fortifications in the Fort Wadsworth Reservation. Fort Tompkins is built at the crest of the hill above Battery Weed, located at the water's edge on the Narrows. Both were part of the third system of U.S. coastal fortifications constructed between 1817 and 1864, although Fort Tompkins was not actually completed until years after the Civil War. Unlike the first system, which was initiated when it seemed the United States might be drawn into the European wars that followed the French Revolution, and the second, started during the threat of war with Britain, the construction of the third system came chiefly during periods of peace.

At the height of its glory, Battery Weed (then called Fort Richmond) was one of the most powerful forts on the eastern seaboard. In 1862, it mounted between 140 and 150 cannon and was manned by a large force of volunteer artillery. Battery Weed, like Fort Tompkins, is a superb example of a granite masonry structure. The battery is laid out in the form of an irregularly shaped trapezoid, with the shorter side facing the water. The open inner courtyard is framed on all sides by tiers of segmental arches resting on heavy piers with octagonal towers at the corners.

A low polygonal structure, Fort Tompkins stands on a platform carved out of the eastern side of the hill. The eastern facade, an uninterrupted stretch of smooth-faced granite, is barely visible from the water's edge. In contrast, the rear, or western, facade of the fort, covered with rough-hewn granite, rises up in front of a deep dry moat. Fort Tompkins served primarily as a barracks for Battery Weed.

POLYTECHNIC INSTITUTE, FORMERLY THE FIRST FREE CONGREGATIONAL CHURCH

1846–47; RENOVATED, 1996

311 BRIDGE STREET, BROOKLYN

ARCHITECTS: UNKNOWN; RENOVATION, JAMES WONG

DESIGNATED: NOVEMBER 24, 1981

The former First Free Congregational Church, with its simple, rectangular shape and temple front, is one of the few remaining examples of the vernacular Greek Revival building popular in the mid-nineteenth century. The "Free" in the name refers to the policy of not charging a rental fee for its pews. Known as the Bridge Street Church, the building has changed hands many times. By 1854 it housed the oldest African American congregation in Brooklyn, the African Wesleyan Methodist Episcopal Church, which used the basement to hide escaping slaves.

Despite a fire in 1885 that burned part of the interior, the church appears today as it did when it was constructed. The two fluted wooden columns, the low-pitched, full-width pediment, and the lack of applied ornament were stylistic statements then considered fitting for a religious structure. Although the architect is unknown, the style was made popular by architect Minard Lafever, who designed similar churches in Manhattan at the time. An extensive renovation was carried out by architect James Wong in 1996. It now houses the Polytechnic Institute, which is in merger talks with New York University.

Brooklyn Borough Hall, formerly Brooklyn City Hall

1846–51; alterations, 1898; 1987

209 Joralemon Street, Brooklyn

Architect: Gamaliel King; alterations, Vincent Griffith and Stoughton & Stoughton

Designated: April 19, 1966

The oldest of Brooklyn's public buildings, Borough Hall was designed by architect Gamaliel King and built between 1846 and 1851. To this day, it remains a monument to the civic pride and immense growth and prosperity that characterized the newly incorporated city of Brooklyn in the mid-nineteenth century.

Until Brooklyn's consolidation into greater New York in 1898, the building served as the city hall and housed many governmental and judicial offices. Its elegant and stately Greek Revival architecture, typical of public buildings of the period, appropriately recalls the spirit of democracy and civic duty associated by America's founders with ancient times. Conceived as Brooklyn's response to New York's City Hall (p. 86,) Borough Hall has symbolized from its inception both independence and unity of purpose.

Brooklyn received its charter as a city in 1834. Soon thereafter the search began for an architect to design a city hall on a one-and-one-half-acre triangle of land that had been sold to the city by two of Brooklyn's preeminent families, the Pierreponts and the Remsens. A grandiose plan was prepared by the well-known New York City architect Calvin Pollard, and the cornerstone was laid in 1836. The financial panic of 1837 and ensuing depression of 1841 halted work on the building.

The project was resumed in 1845. King, who had been a runner-up in the 1835 competition and superintendent and site architect for the Pollard design, became principal architect. His design, loosely based on Pollard's, was reduced and more severe by comparison.

Architecturally, Borough Hall is one of the most splendid of the many Greek Revival buildings that sprang up in Brooklyn during its boom years. Rectangular in plan, it has two stories cadenced above and below by a high basement and a low attic. An impression of solemn dignity is created by the symmetrical ordering of the facades. At the northern end an imposing Greek portico, consisting of six fluted Ionic columns rising above a steep flight of steps, commands a view out over Cadman Plaza and the commemorative statue of Henry Ward Beecher. A simple pediment surmounts the columns.

The rear and side facades echo this front portico in low relief. The slightly projecting central bay of the sides is accentuated by pilasters between the windows, which extend the full height of the facade above the basement level, ending in a low-pitched pediment. This arrangement is repeated on the two end wings of the rear facade. The whole is sheathed in Tuckahoe marble.

The present cupola, constructed of cast iron and built in an eclectic and decorative Beaux-Arts style, was designed in 1898 by Stoughton &

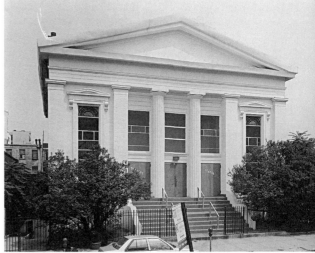

POLYTECHNIC INSTITUTE

BROOKLYN BOROUGH HALL

Stoughton; the original wooden structure was destroyed by fire in 1805. The allegorical figure of Justice that crowns the cupola was part of the original design, but the statue was first executed and installed in 1987 in conjunction with the restoration of the building.

ST. GEORGE'S CHURCH

ST. GEORGE'S CHURCH

1846–56; RESTORED, 1867

RUTHERFORD PLACE AT 16TH STREET, MANHATTAN

ARCHITECTS: BLESCH & EIDLITZ

DESIGNATED: JUNE 20, 1967

St. George's Church is one of the finest examples of early Romanesque Revival architecture in New York City. It ranks among architect Leopold Eidlitz's major works, and it was, in fact, his first building; he designed it in 1846, at the of age twenty-three, in collaboration with the older Bavarian architect Charles Blesch. The parish house to the west of the church was Eidlitz's last work; the stylistic development of his entire career can be read on 16th Street. The church

burned in the 1860s, but in 1867 it was restored according to the original plans.

A bold demonstration of the celebrated unity between architecture and engineering, the style of the church may be identified with the sturdy Romanesque of southern Germany. The massive exterior radiates solidity and an impression of permanence. A fine rose window is a conspicuous feature of the heavily decorated end gable of the nave. The church houses what was once the largest interior space in New York, with the huge roof beams elegantly exposed. Stone spires, damaged by fire in 1865, were removed in 1889, but the towers have lost none of their powerful thrust.

COLLEGE OF MOUNT ST. VINCENT

WEST 261ST STREET, THE BRONX

FONTHILL, 1848

ARCHITECT: UNKNOWN

DESIGNATED: MARCH 15, 1966

COTTAGE AND STABLE, 1848–52

ARCHITECT: UNKNOWN

DESIGNATED: JULY 28, 1981

ADMINISTRATION BUILDING, 1857–59; ADDITIONS, 1865, 1883, 1906–08, 1951

ARCHITECTS: HENRY ENGELBERT; 1906 ADDITION, E. WENZ

DESIGNATED: FEBRUARY 8, 1979

Fonthill, a Gothic castle overlooking the Hudson River at the extreme northwest corner of Riverdale, was built in 1848 as the home of Edwin Forrest, a famous Shakespearean actor, and his wife, Catherine. This extravagantly romantic building was inspired by William Beckford's Fonthill Abbey in England, as was much Gothic Revival architecture in America. Though the identity of the architect remains unknown, the design has been attributed to Alexander Jackson Davis, who corresponded with Forrest about Fonthill. The connection of Davis with the design of Fonthill and its outbuildings is of particular interest because it was Davis who initiated the picturesque cottage tradition, of which the castle and its cottage and stable are a part.

Built of dark, hammer-dressed fieldstone, the castle consists of six octagonal turrets of different heights and dimensions, joined together. The highest, the

staircase tower, rises seventy feet from the base; the window styles include round-arched, flatheaded, and ogival. The towers are battlemented and machicolated in the Gothic tradition. The cottage and stable were built in 1848 as outbuildings for Fonthill and combine elements of the Gothic and Italianate modes in a typically picturesque manner. The cottage is a small, two-story building crowned by a half-hipped roof with deep eaves projecting out over ornately carved wooden brackets. The stable, a rambling structure with peaked roof gables of various sizes that create a picturesque roofline, functions today as the archives of the Sisters of Charity.

The Forrests never occupied the house. During lengthy divorce proceedings, Fonthill and its surrounding property were bought by the Sisters of Charity of New York (the first Roman Catholic religious community in this country); the sisters were looking for a new location for the Academy of Mount St. Vincent, which was forced to relocate to make way for the expansion of Central Park. In 1911, the academy's charter was amended and the College of Mount St. Vincent was incorporated. Fonthill has served numerous functions for Mount St. Vincent since 1856.

The Administration Building is the main campus building, containing classrooms and departmental offices. It was constructed in 1857 in an early Romanesque Revival/Byzantine style. The first college building to be erected on the Forrest estate, it was designed by Henry Engelbert, an architect active in New York City from 1852 to 1879.

FONTHILL

Extensions were added in 1865, 1883, 1906–08, and 1951; together, they form an imposing asymmetrical group, with the main facade facing west, overlooking the Hudson.

The original structure is red brick and rises four stories with an attic fifth story pierced by dormers; a central six-story tower is crowned by a copper lantern and spire. The major focus is the square tower, screened at its base by a two-story-high wooden porte cochere and porch flanked by gabled sections. The central tower of the building rises 180 feet and houses a bell that is rung on special occasions. A south wing was added in 1865, followed by a north wing in 1883, both by Engelbert. The extension to the complex in 1906–8, by architect E. Wenz, is a neoclassical structure. The chapel, built in 1859 and located on the second floor, features a fresco by the American artist Constantino Brumidi.

COTTAGE

STABLE

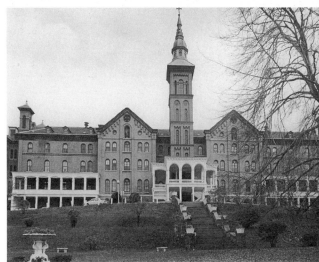
ADMINISTRATION BUILDING

HENRY HOGG BIDDLE HOUSE

WEEPING BEECH TREE

HENRY HOGG BIDDLE HOUSE

LATE 1840S

70 SATTERLEE STREET, STATEN ISLAND

ARCHITECT: UNKNOWN

DESIGNATED: MAY 1, 1990

Set high on a bluff, commanding panoramic views of Raritan Bay, this house is a superb example of the response of Staten Island builders to the high-style Greek Revival homes built by wealthy Manhattan merchants in the 1830s. Dramatic two-story, Doric-columned porticoes in the front and rear are combined with spring eaves, a French detail introduced to America in the seventeenth century by Huguenot immigrants.

Henry Biddle Hogg, born in New York City around 1806, changed the order of his names in 1828 to become Henry Hogg Biddle, and soon after moved to Staten Island. There he married Harriet Butler, the daughter of a wealthy landowner, innkeeper, and ferry operator. His wife's inheritance provided him with the means to speculate in real estate. His fortunes fluctuated until the 1840s when he began to prosper from developing the village of Stapleton and by selling off land from the Butler farm.

Set back on two waterfront acres, Biddle's house reflects his improved financial status. The double-height porticoes used on the front and rear of his home create an imposing effect, whether approached from the street or the waterfront. The long approach drive, fences, and plantings enhance the dramatic character of this unusual site.

WEEPING BEECH TREE

1847

37TH AVENUE BETWEEN PARSONS BOULEVARD AND BOWNE STREET, FLUSHING, QUEENS

DESIGNATED SCENIC LANDMARK: APRIL 19, 1966

While traveling through Europe in 1847, a Flushing nurseryman named Samuel Bowne Parsons purchased a small section from a tree on the estate of Baron DeMan in Beersal, Belgium. The mature tree that took root from that cutting stood over sixty feet high. The circumference of the trunk was fourteen feet, and the spread of the crown was about eighty-five feet. The Weeping Beech Tree died in 1998, at the age of 151, but seven offspring have taken root around the stump, continuing the mother tree's legacy. The Weeping Beech Tree is on the property adjacent to the Bowne House (p. 49).

BENNETT-FARRELL-FELDMAN HOUSE

C. 1847, MOVED TO PRESENT SITE 1913

119 95TH STREET, BROOKLYN

ARCHITECT: UNKNOWN

DESIGNATED: AUGUST 3, 1999

Considered the grandest mid-nineteenth century house still standing in Brooklyn, the Bennett-Farrell-Feldman House is a rare, exceptionally intact Greek Revival style villa. Built for Joseph S. Bennett, the two-and-one-half story frame building retains its original clapboards and characteristic Greek Revival detail, including a veranda with fluted columns, flat corner pilasters, denticulated cornices, and a low attic story articulated as a crowning entablature. Historic photos show a parapet ornamented with Greek motifs, which no longer survives.

A rare survivor from the era when fashionable summer villas lined Shore Road along the heights of Bay Ridge, the house stands on the grounds of Bennett's original estate, which was part of the mid-eighteenth century farm owned by his grandparents.

James P. Farrell, an Irish immigrant who became a successful businessman and Tammany Hall politician, purchased the house in October 1890. After Farrell's death, his oldest son inherited the property, divided the land, and sold the house to the Feldman family, who moved it to its present location on the Bennett property in 1913.

ODD FELLOWS HALL

1847–48; ADDITION, 1881–82

165–171 GRAND STREET, MANHATTAN

ARCHITECTS: TRENCH & SNOOK; ADDITION, JOHN BUCKINGHAM

DESIGNATED: AUGUST 24, 1982

Built in 1847–48, the Odd Fellows Hall is an early and particularly fine example of the austere and restrained Anglo-Italianate style that Joseph Trench and John Butler Snook helped to introduce to New York. Moreover, it is one of the few surviving institutional buildings from the 1840s. Faced in brownstone and four stories high, the original building was distinguished by its emphasis on planar surfaces, accented by a rusticated base, central projections, and colossal pilasters. The two uppermost floors, designed in a reserved Queen Anne style with characteristic chimneys enlivened by vertical patterns of indented brick, were added by the architect John Buckingham.

The Independent Order of Odd Fellows was one of the many mutual aid societies and fraternal organizations established in New York to contribute to the welfare of the underprivileged. The second building owner, R. Hoe and Co, was one of the most innovative manufacturers of printing presses in the United States.

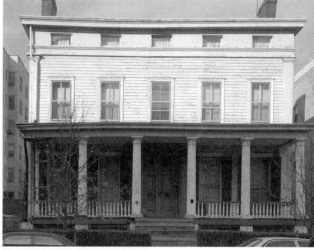

BENNETT-FARRELL-FELDMAN HOUSE

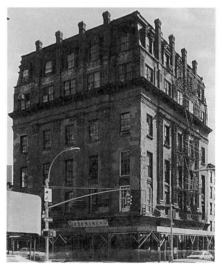

ODD FELLOWS HALL

THE ARSENAL

THE ARSENAL

1847–51

CENTRAL PARK AT 64TH STREET, MANHATTAN

ARCHITECT: MARTIN E. THOMPSON

DESIGNATED: OCTOBER 12, 1967

Standing serenely in a slight hollow west of Fifth Avenue, this five-story structure was erected "to house and protect the arms of the State of New York." Until 1848, the state's armaments were located at Centre and Franklin Streets, but concern for the security of the arms and ammunition kept there prompted a move uptown. The building was used as an arsenal for less than ten years. In 1857, New York City purchased the site and converted the arsenal into the headquarters of the 11th Police Precinct. In 1869, the second and third stories housed the American Museum of Natural History; the upper story contained the Municipal Weather Bureau,

and until 1914 the parks commissioner also had his office here. In 1934, the structure was renovated to accommodate the consolidated New York City Department of Parks (now Parks and Recreation), which is located here today.

The facade is organized around crenellated octagonal towers that rise a full story above the fourth-floor cornice. The massing and the square-headed windows with simplified hood moldings recall fortified Tudor castles. The basement is faced with rough-cut granite blocks: the doors above are of plain orange brick. Ornamental carving is kept to a minimum—due perhaps as much to a lack of architectural sculptors at the time as to the building's original function. The simply articulated brick masses are nonetheless elegant and provide a pleasant backdrop to the carved door frame with eagle resting on cannon balls above.

STATE STREET HOUSES

c. 1847–c. 1874

290–324 STATE STREET, BROOKLYN

BUILDER: MICHAEL MURRAY

DESIGNATED: NOVEMBER 20, 1973

Located in the Boerum Hill neighborhood of the old town of "Breukelen," State Street was developed between the 1840s and 1870s for merchants and professionals working in the Wall Street and Fulton Street areas. Standing on what was once the farmland of Dutch colonist Jacob Van Brunt, the twenty-three State Street Houses reflect the transition from

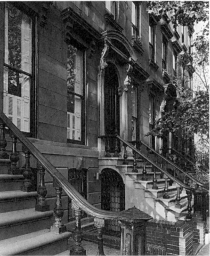

STATE STREET HOUSES

Greek Revival to Italianate that was taking place during the period.

Although completed over a thirty-year period, the block is remarkably uniform. Each three-story house is constructed of brick and brownstone and stands upon a rusticated brownstone or stuccoed basement (with the sole exception of number 322, which has a wood frame on a brick foundation). All have high stoops leading to arched double doorways framed in either engaged columns and pilasters or decorative moldings. The houses have projecting cornices embellished with modillions and dentils; most are fenced in by elaborate wrought-iron and cast-iron railings.

The block is saved from a dull homogeneity by the decorative details that distinguish one facade from another. Numbers 291 through 299 have engaged wooden columns with Italianate Corinthian capitals framing the doors while those of numbers 310 through 316 have Greek Revival pilasters with Doric capitals. The projecting lintels

above the windows of number 298 decrease progressively in size in contrast to those of numbers 290 through 294 and 304, which are flush and uniform; the remaining houses all have decorative cap moldings.

FLATLANDS DUTCH REFORMED CHURCH

1848; 1997

KINGS HIGHWAY AND EAST 40TH STREET, BROOKLYN

ARCHITECT: UNKNOWN

DESIGNATED: JULY 19, 1966

Flatlands Dutch Reformed Church stands in a spacious churchyard enclosed by a fine wrought-iron fence. Buried in the adjacent cemetery is the Reverend Ulpianus Van Sinderen, the outspoken Revolutionary War minister known as the "Rebel Parson." Beneath the pulpit lie the remains of Pieter Claesen Wyckoff, who founded the church in 1654 and whose house is the oldest still standing in New York City (p. 46).

This Greek Revival church, set on a stone foundation, is built of white clapboard. The stately front contains a handsome door and two tall triple-sash windows; its simple cornice is crowned by a low-pitched pediment. Four pilasters on the front are repeated in the simple belfry, which supports a graceful spire topped with a gold ball and weather vane. The church, which is the third building to occupy this site, was restored after a fire in 1997.

710 BAY STREET, FORMERLY THE BOARDMAN-MITCHELL HOUSE

1848

STATEN ISLAND

ARCHITECT: UNKNOWN (AFTER A DESIGN BY ANDREW JACKSON DOWNING)

DESIGNATED: OCTOBER 12, 1982

The Boardman-Mitchell House was built in 1848 in the village of Edgewater, now part of Stapleton. Situated atop a steep bluff with an extensive view across the Narrows to the Manhattan skyline, the house was the home of Dr. James R. Boardman, resident physician at the nearby Seaman's Retreat, and later Captain Elvin Eugene Mitchell, founding member and hero of the Sandy Hook Pilots Benevolent Association. Mitchell bought the house with a reward from Cunard Lines for saving 176 passengers and crew members from the SS *Oregon*, which sank off Fire Island in 1886.

This early Italianate villa is clad in cedar shingles, painted gray with contrasting buff trim. The overhanging eaves are supported by broad double-volute brackets. A low, triangular pediment shelters a pair of central arched windows that light the small room that Captain Mitchell maintained as a lookout. At each side of the pediment, set below the eaves, are narrow, horizontal windows with three panes each, flanking a projecting central bay. At the second-floor level, a pair of French doors opens onto a balustraded balcony above the entrance pavilion. The entrance is flanked by wide balconies

FLATLANDS DUTCH REFORMED CHURCH

710 BAY STREET

in front of the living room and dining room and fronted by a balustraded stoop with flanking entrance steps. The sides of the house, visible from Bay Street, are identical in design, each with four double-hung windows. An Italianate cornice continues around the sides of the house and across the rear roofline.

THEODORE ROOSEVELT BIRTHPLACE

THEODORE ROOSEVELT BIRTHPLACE NATIONAL HISTORIC SITE

1848; RECONSTRUCTED, 1923

28 EAST 20TH STREET, MANHATTAN

ARCHITECT: UNKNOWN; RECONSTRUCTION, THEODATE POPE RIDDLE

DESIGNATED: MARCH 15, 1966

The original of this handsome town house was built in 1848 and demolished in 1916; in 1923, Roosevelt's boyhood home was replicated by Theodate Pope Riddle, one of the first women architects in the United States. The brownstone house is distinguished by its shutters, decorative balcony and railings, entrance door with transom above and a delivery entrance under the stoop, Gothic Revival blind arcade-supported cornice, and drip moldings above the windows and front door—all typical of the houses on 20th Street built during the mid-nineteenth century. A fourth story with dormers and a slate-shingled mansard roof crown the building.

A descendant of one of the old Dutch families of Manhattan, Theodore Roosevelt is the only native of New York City to be elected president. The family moved to a larger house uptown in 1872, and the former Roosevelt home was severely altered for commercial purposes. In 1919, a few months after Roosevelt's death, the Woman's Roosevelt Memorial Association (later to merge with the Roosevelt Memorial Association) bought it and the adjoining house where Roosevelt's uncle lived (number 26). The two buildings were demolished and the present building

CHURCH OF THE HOLY APOSTLES

reconstructed by Riddle. In 1962, the house was named a National Historic Site, and today it is administered by the National Park Service as a museum.

CHURCH OF THE HOLY APOSTLES

1848; TRANSEPT, 1858; 1990S

300 NINTH AVENUE, MANHATTAN

ARCHITECTS: MINARD LAFEVER (CHURCH); RICHARD UPJOHN & SON (TRANSEPT)

DESIGNATED: OCTOBER 19, 1966

While simple in style, the Church of the Holy Apostles features a handsome square, brick tower skillfully connected to a copper-clad, octagonal steeple. Round-arched windows rhythmically punctuate the building's surface, while others, with a bull's-eye design, appear in the arched pediments.

Inside, a Tuscan order and groin vaults echo the external touches of classic Italianate design. These details are exceptions for Lafever, generally noted for his work in the Greek Revival and Gothic Revival styles.

The nave has a series of stained glass windows by William Jay Bolton. Simple, sepia-toned round panes illustrating Biblical and early Christian scenes are surrounded by stylized panels of geometric and floral glass. They are the only American example of this style that Bolton designed.

The church is notable not only for its architecture, but also for the distinguished rectors who have served it. The Reverend Robert Shaw Howland, second rector of the church, later founded the

Church of the Heavenly Rest on Fifth Avenue; the Reverend Lucius A. Edelblute, rector for thirty years, wrote *The History of the Church of the Holy Apostles* (*A Hundred Years in Chelsea*), published in 1949. For five years the church has operated a nationally known soup kitchen, which now feeds more than 1,200 each day. The church suffered a devastating fire in 1990. Soon after the destruction, the church raised enough money to restore the church while continuing to feed the homeless.

ALLEN-BEVILLE HOUSE

c. 1848–50; 1946

29 CENTER DRIVE, QUEENS

ARCHITECT: UNKNOWN

DESIGNATED: JANUARY 11, 1977

The Allen-Beville House is a handsome Greek Revival dwelling in what is now known as Douglaston, Queens. One of the few remaining nineteenth-century farmhouses in New York City, the structure retains many of its fine details. Resting on a low basement, the house is clad in white clapboard, with front and rear porches extending its full width. Characteristic of the Greek Revival style are the elegant fluted Doric columns that support the porch entablature, which in turn is highlighted by dentils and Italianate paired brackets. A pair of later Queen Anne doors replace the original entry. Set beneath the projecting cornice, the fascia board is accented by alternating panels, small, shuttered attic windows, dentils, and paired brackets.

A striking bracketed, octagonal cupola crowns the house.

It is believed that Benjamin P. Allen erected the house soon after he acquired the property in 1847 from a relative. Allen and his wife, Catherine, the parents of seven, reportedly opened a school for local children in the house in 1865. The property later became part of the William P. Douglas estate and was probably used as a guesthouse. Douglas, for whom the village of Douglaston is named, is best known for his yacht *Sappho*, which defeated the British challengers and won the America's Cup in 1876. In 1905 and 1906 the land of the Douglas estate was sold and subdivided as a real estate development. In 1946, the house was sold to Hugh and Eleanor Beville. The house was added to the National Register in 1983. The Beville heirs offered the house for sale in 2004.

ALLEN-BEVILLE HOUSE

SON-RISE INTERFAITH CHARISMATIC CHURCH

CHARLIE PARKER RESIDENCE

SON-RISE INTERFAITH CHARISMATIC CHURCH, FORMERLY ASBURY METHODIST CHURCH

1849; REMODELED, 1878

2100 RICHMOND AVENUE, STATEN ISLAND

ARCHITECT: UNKNOWN

DESIGNATED: MARCH 19, 1968

This simple, mid-nineteenth-century Federal-style church was named after Bishop Francis Asbury, a Methodist preacher who first came to Staten Island in 1771. During the forty-five years of his ministry, Bishop Asbury saw, largely through his own efforts, the expansion of his congregation from five hundred to more than two hundred thousand members. The first Asbury Methodist Church, then called the North End Church, was constructed in 1802 near the site of the present building. It was removed from the property in 1850. The gravestones in the cemetery date from 1813.

The present church is rectangular in plan. The front elevation consists of a square tower, projecting forward from the front wall and containing an entrance way with plain double doors in a round arch with a fanlight above the doors. The entrance is surrounded by windows, one centered above the door and one in each flanking wall. The tower supports a belfry with angular side openings and a single bell. The bonded side walls are pierced by four square-headed windows with plain lintels and sills. A wide fascia board and cornice complete the building at roof level.

CHARLIE PARKER RESIDENCE

C. 1849; 1990

151 AVENUE B (ALSO KNOWN AS CHARLIE PARKER PLACE), MANHATTAN

ARCHITECT: UNKNOWN

DESIGNATED: MAY 18, 1999

Charlie "Bird" Parker, the gifted alto saxophonist, lived on the ground floor of this row house from 1950 to 1954. Famous as the inventor of bebop with trumpeter Dizzy Gillespie, Parker had arrived in New York in the 1930s. He leased the garden apartment with his common-law wife, Chan Richardson, and their two children were born here. After 1954, the building had two other notable tenants: painter Franz Kline and sculptor Peter Agostini. Judith Rhodes, a jazz concert producer, acquired the building in 1979 and continues to rent out the apartments.

Restored in 1990, the facade, incorporates Gothic Revival elements, frequently adopted by church designers, but rarely employed for private residences, notably the pointed-arch entranceway, which retains its original wood doors, and the trefoil relief below the box cornice.

ANGEL ORENSANZ FOUNDATION CENTER FOR THE ARTS, FORMERLY CONGREGATION ANSHE SLONIM, ORIGINALLY CONGREGATION ANSHE CHESED

1849–50S; 1990S

172–176 NORFOLK STREET, MANHATTAN

ARCHITECT: ALEXANDER SAELTZER

DESIGNATED: FEBRUARY 10, 1987

Congregation Anshe Slonim, located on the Lower East Side, was the largest congregation in the city at the time of its construction in 1849–50. Established in 1828, the German congregation was the third Jewish congregation in New York, after Shearith Israel and B'nai Jeshurun, and the second to practice Reform Judaism. The Gothic Revival building was designed by German architect Alexander Saeltzer, who was also responsible for the Astor Library at 425 Lafayette Street, now the Joseph Papp Public Theater (p. 146).

Saeltzer's background influenced the pronounced Gothic style of the synagogue, said to be inspired by the Cologne Cathedral. The tripartite facade of the building is of brick covered with stucco. Two square towers flank the recessed central section. These towers have a lancet window at each level; now truncated above the second story, they were originally three stories tall with concave, pyramidal roofs. The three main doors of the building are surmounted by pointed-arched windows. A large central window dominates the facade and is flanked by two smaller windows.

A pointed gable frames the top of the facade and includes the remains of a foliate cornice.

During its history, the synagogue has housed three congregations: Anshe Chesed, from 1850 until 1874; Ohab Zedek, from 1886 until 1921; and Anshe Slonim, a Polish congregation, from 1921 until 1974. Today the building is owned by Spanish sculptor Angel Orensanz, who has renovated the space into a visual and performing arts center.

ANGEL ORENSANZ FOUNDATION CENTER

167–171 JOHN STREET

1849–50

MANHATTAN

ARCHITECT: UNKNOWN

DESIGNATED: OCTOBER 29, 1968

Abiel Abbot Low, one of the foremost merchants of the China trade, commissioned this granite Greek Revival building, which commanded an impressive view of the harbor—including his own clipper ships, offices, and warehouses. Low and his brother, Josiah, lived in the building, which was intended to symbolize the success of their firm.

Although the brownstone front, Corinthian capitals, and molded sills have been removed, the imposing scale still conveys a sense of grandeur. The eight-bay, five-story structure stands on a raised brownstone basement. Tall windows on the second, third, and fourth floors contrast with shorter windows on the top story. The restrained facade is completed by a simple cornice.

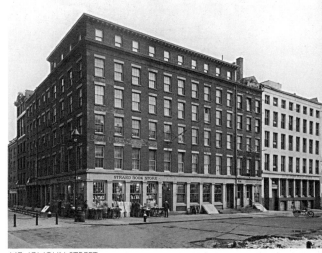

167–171 JOHN STREET

145

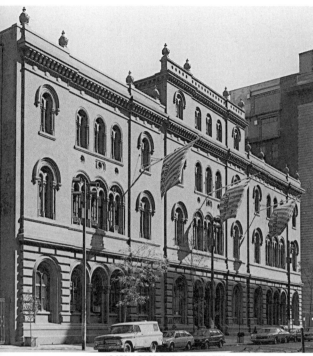

JOSEPH PAPP PUBLIC THEATER

WEST 24TH STREET HOUSES

JOSEPH PAPP PUBLIC THEATER,
FORMERLY THE NEW YORK
SHAKESPEARE FESTIVAL PUBLIC
THEATER, ORIGINALLY THE
ASTOR LIBRARY

1849–53; 1856–59; 1879–81;
RENOVATED, 1966

425 LAFAYETTE STREET, MANHATTAN

ARCHITECTS: ALEXANDER SAELTZER
(SOUTH WING); GRIFFITH THOMAS
(CENTER WING); THOMAS STENT
(NORTH WING); RENOVATION,
GIORGIO CAVALGIERI

DESIGNATED: OCTOBER 26, 1965

Funds for the Astor Library were bequeathed by John Jacob Astor, a German-born entrepreneur who made his fortune first in the fur trade and later in New York City real estate. The Astor collection would eventually become, with the Lenox and Tilden collections, the core of the New York Public Library. When it opened in 1854, the Astor was the first free library in New York—but it was open only during daylight hours, and so was inaccessible to most of the working public. The aged Washington Irving was the Astor's first librarian.

With the $400,000 bequest, Astor's son William B. Astor hired Alexander Saeltzer to design and build what is now the southern third of the structure. The facade is divided into three bays by two slightly projecting pavilions. The rusticated base is of brownstone, as are the early Renaissance–style windows above. The whole is capped by a strapwork cornice, Ionic frieze, and solid parapet. The arches set in a plain brick surface are marks of the *Rundbogenstil*, literally "round-arched style," an interpretation of the Romanesque used for German civic architecture from the early to mid-nineteenth century. The Astor Library design draws on early Renaissance forms.

In 1856, William B. Astor commissioned Griffith Thomas, who was well known for his cast-iron facades in what is now SoHo, to extend the library to the north. In turn, his sons, John Jacob Astor and William B. Astor Jr., hired Thomas Stent to add the northernmost section as a memorial to their father. Stent also built an attic story over Thomas's annex to give the long, unbroken facade a central emphasis. What is most interesting about the entire complex is the care with which the two later architects matched the original building in design as well as materials.

In 1920, the Hebrew Immigrant Aid Society (HIAS) purchased the building, but by 1965 it was facing demolition. Joseph Papp's New York Shakespeare Festival convinced the city to buy it and Giorgio Cavaglieri designed and superintended the 1966 renovation into theaters, offices, and auditoriums. At the time, this area—the westernmost border of the East Village—was run down. As the neighborhood was revitalized beginning in the 1970s, the Public Theater and Cooper Union provided the focus for redevelopment to the east and south.

146

WEST 24TH STREET HOUSES

1849–50

437-459 WEST 24TH STREET,
MANHATTAN

ARCHITECT: UNKNOWN; PHILO V.
BEEBE, BUILDER

DESIGNATED: SEPTEMBER 15, 1970

This handsome row of paired three-story houses was built by Philo V. Beebe, in association with the attorney Beverly Robinson and George F. Talman, to provide housing for merchants and professionals of the expanding Chelsea community. Set behind landscaped yards, they have an appealing architectural character that reflects the transition between the Greek Revival and the Italianate.

The basic proportions are Greek Revival. With later modifications in the neo-Grec, Queen Anne, and Federal Revival styles, the houses represent more than a century of architectural taste. In general, they retain their setbacks behind front yards, original height, bold modillioned roof cornices, and ironwork—features that unify this charming row.

CHURCH OF THE TRANSFIGURATION

1849–61; LYCH-GATE, 1896; CHAPELS,
C. 1906–08

1 EAST 29TH STREET, MANHATTAN

ARCHITECT: FREDERICK C. WITHERS
(LYCH-GATE); OTHERWISE UNKNOWN

DESIGNATED: MAY 25, 1967

This is the Little Church Around the Corner—also called the Actors' Church, but officially known as the Church of the Transfiguration. Reminiscent of an English parish church, it stands serenely in its garden, in the shadow of the Empire State Building.

The main entrance to the church is through the tower, which is reinforced at the corners by diagonally placed, stepped buttresses and crowned by a small peaked roof. At the base of the tower and to the left are the three arched windows of the Lady Chapel. The main body of the church, which lies to the right, is divided into four sections of unequal size by squat buttresses. Small dormers serve as clerestory windows above the nave. The octagonal crossing tower contains St. Joseph's mortuary chapel. The lych-gate, an unusual feature in an American churchyard, is a pagoda-like structure supported by stone Gothic arches. Usually found at the entrance to a churchyard, a lych-gate (from the Old English *lich*, meaning corpse) was intended to provide a covered resting place for a coffin before the start of the burial service.

The actor Joseph Jefferson made popular the church's sobriquet in 1870. An actor friend, George Holland, had died,

CHURCH OF THE TRANSFIGURATION

and Jefferson went to a fashionable church in the neighborhood to arrange for the funeral service. When the rector learned that the deceased had been an actor, he politely declined but suggested that there was a "little church around the corner where the matter might be arranged." Whereupon Jefferson, with deep feeling, replied, "Thank God for the little church around the corner." From that day, there has been a special bond between the stage and this church. Sir Henry Irving, Dame Ellen Terry, and Sarah Bernhardt attended services here, and there are memorial windows to the distinguished actors Richard Mansfield, John Drew, and Edwin Booth.

The rectory of the Little Church, designed as a subsidiary part of a larger composition, is an excellent example of Gothic Revival architecture. Its strong architectural character blends well with the adjacent church, forming one of the most picturesque ecclesiastical enclaves in the city.

BETH HAMEDRASH HAGODOL SYNAGOGUE

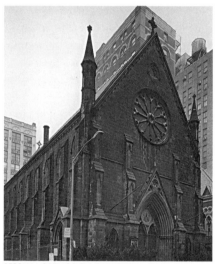

SERBIAN ORTHODOX CATHEDRAL OF ST. SAVA

BETH HAMEDRASH HAGODOL SYNAGOGUE, FORMERLY THE NORFOLK STREET BAPTIST CHURCH

1850

60-64 NORFOLK STREET, MANHATTAN

ARCHITECT: UNKNOWN

DESIGNATED: FEBRUARY 28, 1967

Originally built as the Norfolk Street Baptist Church, this austere building is a restrained example of the Gothic Revival style. In 1860, when the Baptists moved north, Methodists took it over for the next quarter century; they were replaced by Russian Jews, who had been settling on the Lower East Side for some time. The church was rededicated as Beth Hamedrash Hagodol Synagogue in 1885 and still serves the oldest congregation of Russian Orthodox Jews (founded 1852) organized on this country.

Raised on a platform of steps above the street, the recessed central section of the symmetrical facade is flanked by square towers pierced by coupled, pointed-arched windows that light the side vestibules. The focus of the facade is the main double entrance door with an over-door panel joining it to the tall, tripartite arched window. The whole is surmounted by a pedimented roof affixed with the Star of David. At the top of each tower is a square decorative panel of Gothic quatrefoil design. A print published in the *New York Almanac* of 1851 shows that the towers originally had battlements or crenellations. In 2001, a fire severely damaged the roof, ceiling, mural paintings, and decorative plasterwork.

SERBIAN ORTHODOX CATHEDRAL OF ST. SAVA, FORMERLY TRINITY CHAPEL COMPLEX

15 WEST 25TH STREET, MANHATTAN

DESIGNATED: APRIL 18, 1968

CATHEDRAL, 1850–55

ARCHITECT: RICHARD UPJOHN

PARISH SCHOOL, 1860

ARCHITECT: JACOB WREY MOULD

CLERGY HOUSE, 1866

ARCHITECTS: R. & R.M. UPJOHN

A large English-style Gothic Revival church, this brownstone structure is celebrated for its fine proportions and for the great length of its nave. Designed by Richard Upjohn, the church was consecrated in 1855 as a chapel of Trinity Church to serve uptown communicants of the parish. It was purchased by the Serbian Orthodox Church in 1945, and renamed the Cathedral of St. Sava.

The lofty nave is situated below a steep-pitched slate roof; the angular gable of the south elevation faces 25th Street. Centered in this gabled wall is a large wheel window. Directly below and flanked by buttresses accented with slender columns and graceful arches within its deep reveal a pointed-arched portal, serves as the main entrance to the cathedral. The nave walls are pierced by pointed-arched windows; the seven-bay apse has an octagonal slate roof.

The Clergy House forms the short leg of the L-shaped plan of the ensemble. The Parish School, about forty feet east of the church, was completed about five years after the cathedral.

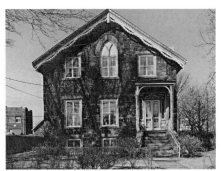

DR. SAMUEL MACKENZIE ELLIOTT HOUSE

DR. SAMUEL MACKENZIE ELLIOTT HOUSE

C. 1850

69 DELAFIELD PLACE, STATEN ISLAND

ARCHITECT: DR. SAMUEL MACKENZIE ELLIOTT

DESIGNATED: APRIL 12, 1967

The Dr. Samuel MacKenzie Elliott House is said to be one of more than twenty-two houses designed by Dr. Elliott, an eye surgeon of wide repute and an enthusiastic amateur architect.
The house was built around 1850 in a country version of the Gothic Revival. Constructed of locally quarried random with twenty-three-inch walls, has eight rooms, an attic, and a large cellar. The entrance, situated at the gable end of the building, is framed by blue and amber diamond-shaped glass sidelights and surmounted by a polychrome fan-patterned glasswork transom. On one side of the entrance, the first-floor windows are double-hung with vertical, central muntins that simulate casements, and are topped by sandstone lintels. On the second floor, a Gothic pointed-arched window, designed to light the

attic through its upper portion, accents the facade. Above, scalloped wooden vergeboards trim the gables of the roof.

Dr. Elliott, who emigrated from Scotland in the 1830s, was a citizen of enormous prestige; his influence was so great that the area around his estate on Staten Island's north shore was often called "Elliottville." One reason for Elliott's popularity was his devotion to the abolitionist cause. This house was reputedly part of the Underground Railroad, and the cellar was fitted with a special fireplace for cooking. The house is still a private residence.

MARBLE COLLEGIATE CHURCH

1851–54

275 FIFTH AVENUE, MANHATTAN

ARCHITECT: SAMUEL A. WARNER

DESIGNATED: JANUARY 11, 1967

The Collegiate church, founded by the Dutch in 1628, is the oldest Protestant congregation in America, and it has had a continuous ministry since it began.

To house this venerable congregation, Samuel A. Warner designed a distinguished marble structure that synthesized European and American styles. Succeeding the "Stone Church in the Fort" of 1642, the Marble Collegiate Church has the rounded arches, heavy buttresses, and massive planes of thirteenth- and fourteenth-century Romanesque architecture, as well as the soaring spires, delicately carved finials, and decorative detail of the Gothic style of the fifteenth and sixteenth centuries.

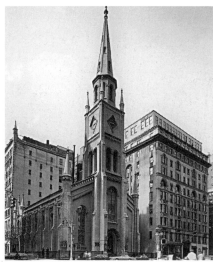

MARBLE COLLEGIATE CHURCH

The most impressive feature is the central tower that contains the belfry and clock. This tower is flanked at its base by tall double windows; it is supported by graduated buttresses that are in turn used to support the walls of the main building. The sides of the building are punctuated by five Romanesque arched windows. Octagonal turrets and pinnacles capped with molded cornices and carved finials complete the structure.

While European architecture informs much of the detail of Warner's design, the overriding impression is nonetheless that of a New England church, complete with tower, spire, and weather vane.

149

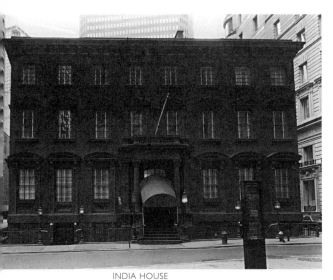

INDIA HOUSE

INDIA HOUSE, FORMERLY HANOVER BANK

1851–54

1 HANOVER SQUARE, MANHATTAN

ARCHITECT: UNKNOWN

DESIGNATED: DECEMBER 21, 1965

Reminiscent of a Florentine palazzo, India House is typical of the brownstone commercial buildings that once dotted this area. Built for the Hanover Bank between 1851 and 1854, the Anglo-Italianate structure is a prototype of the New York brownstone row house that was to be built on a large scale in the latter half of the nineteenth century.

Above a rusticated basement, smooth masonry walls rise to a well-detailed cornice supported by closely spaced brackets. The windows are defined by the use of triangular and segmental arched pediments on the first and second stories and brackets beneath the sills on the second and third stories.

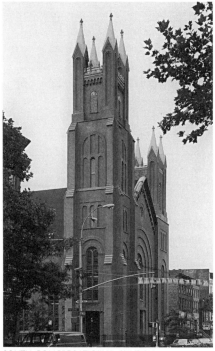

SOUTH CONGREGATIONAL CHURCH

Handsome Corinthian columns and a fine balustrade create a distinguished entrance.

India House played an important role in the city's commercial life in the latter part of the nineteenth century. From 1870 to 1886 it served as the New York Cotton Exchange, and later it housed the offices of W. R. Grace & Co. Today it is a clubhouse, harboring a fine maritime museum, and continues to provide a warm intimacy amidst the austere concrete and steel structures of lower Manhattan.

SOUTH CONGREGATIONAL CHURCH

253–269 PRESIDENT STREET AND 358–366 COURT STREET, BROOKLYN

DESIGNATED: MARCH 23, 1982

CHAPEL, 1851

ARCHITECT: UNKNOWN

CHURCH, 1857

ARCHITECT: UNKNOWN

LADIES' PARLOR, 1889

ARCHITECT: FREDERICK CARLES MERRY

RECTORY, 1893

ARCHITECT: WOODRUFF LEEMING

The South Congregational Church is located on a prominent corner in Carroll Gardens, one of Brooklyn's oldest residential neighborhoods. Although Congregationalism was the dominant Protestant sect in New England, it was a latecomer to New York. Here it became closely associated with the Reverend Henry Ward Beecher, the outspoken abolitionist and minister of the nearby Plymouth Church. Beecher is reputed to have stood on this spot in 1850 and declared, "Here the next Congregational church should be built."

The church is a brick structure enhanced by a series of recessed arches expressive of the finest and most sophisticated early Romanesque Revival designs of the pre–Civil War period. The main gable contains a rectilinear entrance with a stone lintel below. It is flanked by square towers with pinnacles. The chapel exhibits a rectangular entrance, round arches, and recessed panels. A continuous corbeled cornice links the two buildings.

An addition, built in 1889 for use as a ladies' parlor and Sunday school, was designed in the Richardsonian Romanesque style by architect Frederick Carles Merry. A red-brick and terra-cotta structure, its massive forms and Byzantine carving are typical of this phase of the Romanesque Revival. The focal point of this two-story building is the entrance bay, which is in the form of a tower.

In 1893, the church built a rectory adjoining the ladies' parlor. This four-story Gothic Revival structure, designed by Brooklyn architect Woodruff Leeming, forms a transitional link between the church and the mid-nineteenth-century row houses to the west. The church and chapel have been converted into apartments; the congregation now worships in the ladies' parlor.

ROSSVILLE A.M.E. ZION CHURCH CEMETERY

ESTABLISHED 1852

CRABTREE AVENUE, STATEN ISLAND

DESIGNATED: APRIL 9, 1985

The Rossville A.M.E. Church Cemetery, located near the western tip of Staten Island, commemorates the history of Sandy Ground, a community established in the mid-nineteenth century by free African American oystermen and their families. Most had moved north from Snow Hill, Maryland, one of a number of settlements in the Chesapeake Bay area where African Americans had prospered in the oystering industry. The mid-century relocation to Staten Island

was a logical step, for the island at that time was the center of a flourishing oyster trade.

The area that eventually became Sandy Ground was a plateau on the outskirts of Woodrow, a small fanning community. The A.M.E. Zion Church, incorporated in 1850, provided a spiritual center for the new settlement.

The community's growth and prosperity continued until the first years of the twentieth century, when water pollution dramatically altered the oyster industry. Despite such major disasters as the condemnation of the oyster beds in 1916 and a destructive fire in 1963, Sandy Ground has survived. Today, the Rossville A.M.E. Zion Church and its cemetery remain in use, a link with history. The cemetery bears the markers and stones of some thirty-four families, many associated with Sandy Ground's beginnings, and the plots provide a visual record of the network of relationships that constituted the community.

SOUTH CONGREGATIONAL CHURCH RECTORY

ROSSVILLE A.M.E. ZION CHURCH CEMETERY

151

359 Broadway

1852

Manhattan

Architect: Field & Correja

Designated: October 16, 1990

This early Italianate commercial building, in the heart of Ladies' Mile, is known for its most prominent tenant, photographer Mathew B. Brady. Later renowned for his photographs of the Civil War, Brady operated one of New York's finest daguerreotype portrait studios in the top three stories of the building. Trained by painter and inventor Samuel F. B. Morse, Brady—like the many other photographers along lower Broadway who capitalized on the novelty of the medium—catered to society ladies, who felt at ease amid the rosewood, velvet, and gilt appointments of his studio.

Equally lavish outside, this five-story building was embellished with a profusion of ornament and set a precedent for picturesque stacked window openings, presaging their use in cast-iron facades.

At the end of the century, the Ladies' Mile neighborhood changed from a fashionable shopping district to a textile manufacturing and wholesaling zone.

Light of the World Church, formerly New England Congregational Church

1852–53

179 South Ninth Street, Brooklyn

Architect: Thomas Little

Designated: November 24, 1981

Virtually contemporary with the South Congregational Church in Carroll Gardens (p. 150), this rectangular Italianate church was organized on March 18, 1851, under the popular minister Thomas Kinnicut Beecher. He was the brother of the Reverend Henry Ward Beecher, the abolitionist, leader of the Congregationalist sect, and rector of nearby Plymouth Church. Their sister, Harriet Beecher Stowe, was the author of *Uncle Tom's Cabin.*

Between 1845 and 1850, the population of Williamsburg tripled; this fact, coupled with the popularity of Congregational worship, caused a number of Congregational churches to be built in Williamsburg during the decades before the Civil War. Thomas Little, principally a commercial architect, was selected to design this church, a choice that reflected Williamsburg's strong connections to commercial New York.

While the body of the church is brick, the facade is clad in brownstone, articulated with metal and wood trim, and flanked by large quoins. Courses of quarry-faced stone form a basement level. Within, the structure's generous galleries allow as much seating with as little obstruction as possible between the congregation and the preacher. The town

359 BROADWAY

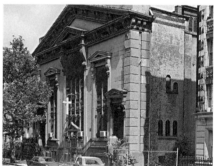

LIGHT OF THE WORLD CHURCH

house immediately to the west was built in 1868 to serve as the church rectory and is linked to the church by the return molding on the church's side elevation. The design of the gable front is repeated in the doorways and fenestration, with sharply projecting triangular pediments on the console brackets.

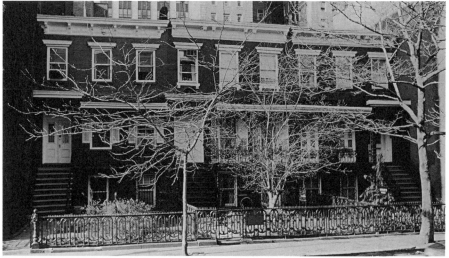

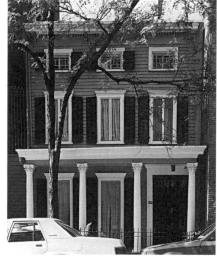

326, 328, AND 330 EAST 18TH STREET

1852–53

MANHATTAN

ARCHITECT: UNKNOWN

DESIGNATED: MARCH 20, 1973

These three relatively modest brick row houses—the oldest buildings surviving on this block—were built between 1852 and 1853 on land that was once part of Peter Stuyvesant's bouwerie, or farm. They recall a period—when rows of single-family dwellings were beginning to line the city's "uptown" side streets, from the East River to Avenue A.

Reflecting a vernacular interpretation of the Italianate style of the mid-nineteenth century, their features include deep front yards and original cast-iron work on the stoops and verandas.

Number 326 was home for many years to Henry Wilson, a stonecutter. Wilson and John Edwards, a builder, were partners and were associated with the construction of these houses.

160 EAST 92ND STREET

1852–53; 1929–31; 1956

MANHATTAN

ARCHITECT: ATTRIBUTED TO ALBRO HOWELL, CARPENTER-BUILDER

DESIGNATED: JUNE 7, 1988

This two-and-a-half-story clapboard dwelling is a rare reminder of the early years of Yorkville, a village that began as a stop along the Boston Post Road in the eighteenth century and was later settled by Irish immigrants who worked on Central Park and Manhattan's railroads. The structure is one of only six intact wood-frame houses on the east side of Manhattan. (While many houses on the outskirts of the city were of frame construction, the building of wooden structures in Manhattan itself was banned as a fire hazard.) As development of the Upper East Side pushed northward in the 1880s and 1890s, masonry row houses and tenements filled in empty lots and replaced older frame buildings. Most probably built by Albro Howell, a local carpenter and builder who was active in developing this block, the house incorporates elements of both Greek Revival and Italianate styles.

In 1914, Willard Dickerman Straight, a diplomat and financier, and his wife, the former Dorothy Whitney, a philanthropist and social activist, purchased the house as quarters for the staff of their Georgian-style mansion at 94th Street and Fifth Avenue (p. 457). The four fluted Corinthian columns on the front porch were replaced by the Straights in a 1929–31 renovation. Jean Schlumberger, an internationally prominent jewelry designer with a salon at Tiffany & Co., owned the building from 1956 to 1987. It is still a private residence.

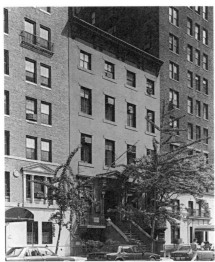

SALMAGUNDI CLUB

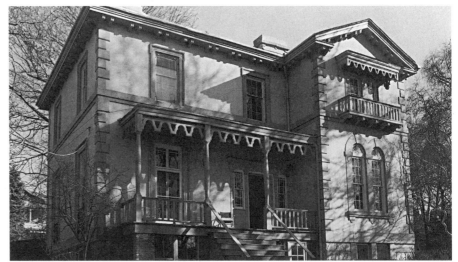

PRITCHARD HOUSE

2876 RICHMOND TERRACE

SALMAGUNDI CLUB, FORMERLY THE IRAD HAWLEY HOUSE

1853

47 FIFTH AVENUE, MANHATTAN

ARCHITECT: UNKNOWN

DESIGNATED: SEPTEMBER 9, 1969

The Salmagundi Club is the last of the brownstone mansions that once lined Fifth Avenue almost solidly from Washington Square to Central Park— "Two Miles of Millionaires." The mansion was built for Irad Hawley, president of the Pennsylvania Coal Company. The club, which was organized in 1871 for "the promotion of social intercourse among artists and the advancement of art," bought the building in 1917 and has maintained it. *Salmagundi* was the title of Washington Irving's satirical periodical of 1807–08; the word originally denoted a spicy concoction of chopped meat, anchovies, eggs, onions, and oil.

The building was erected in 1853 in the newly fashionable Italianate style. The characteristics of the style show clearly in the heavy pediment over the arched doorway, the richly carved consoles that support this pediment, and the little brackets that carry the individual cornices over each of the French windows of the main floor. The moldings around the windows were later stripped off, but the main cornice along the top of the building is still supported on its original heavy, paired brackets.

PRITCHARD HOUSE

C. 1853

66 HARVARD AVENUE, STATEN ISLAND

ARCHITECT: UNKNOWN

DESIGNATED: MARCH 19, 1968

This brick Italianate mansion with stucco and stone trim was erected about 1853 for C. K. Hamilton. Two and one-half stories high, the house features a rectangular floor plan with a short gabled wing projecting from the southwestern corner, accented by round-arched windows. Dominating the main structure is the imposing hipped roof with generous overhang, supported by paired brackets. The roof is crowned by two large chimneys and a monitor roof containing low windows, which provide the attic with light.

A stringcourse at the second floor surrounds the mansion, cutting through the sharply beveled quoins that mark the corners of the structure. Enframed with Greek ears at the top, the main block windows are square-headed as are the French doors opening to the porch. Its low-pitched roof is supported by slender, turned columns. The entrance is a double-paneled door with sidelights set between plain pilasters; the doorway is crowned by a molded entablature.

The house is still a private residence.

2876 RICHMOND TERRACE

C. 1853

STATEN ISLAND

ARCHITECT: UNKNOWN

DESIGNATED: JULY 13, 1976

This simple brick house, built for oysterman Stephen D. Barnes, is one of few surviving structures on "Captain's Row," an area of predominantly Greek Revival designs along the Shore Road. Unlike most of the other houses, Barnes's home combines elements from the Italianate and Gothic Revival styles, with the Italianate dominating the two-and-one-half-story square house. The broad, symmetrical facade contains a central doorway with square-headed windows on each side. Flanking the doorway are paneled pilasters that support an arched transom with rope molding.

On the second story, a cast-iron balcony marks a simple central window with segmental arch. Windows at the sides and rear of the house have flat brick arches and plain granite sills. Beneath the roof at the center of the house is a pair of small, arched windows sharing a common sill. The roof itself, flat with overhanging eaves, is supported on four sides by paired, vertical brackets. Stylized ornament in low relief marks these brackets, along with foliate terminations.

In the 1880s, following the death of Judith Barnes, the house was bought at auction by William Wheeler. He transferred it to Jane Van Pelt Wheeler, the last known owner.

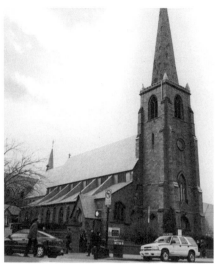

ST. GEORGE'S CHURCH

ST. GEORGE'S CHURCH

1853–54

38-02 MAIN STREET (ALSO KNOWN AS
135–33 39TH AVENUE), FLUSHING,
QUEENS

ARCHITECT: WILLS & DUDLEY;
CHANCEL, 1894: J. KING JAMES

DESIGNATED: FEBRUARY 8, 2000

OLD PARISH HOUSE

1907–8

ARCHITECT: CHARLES C. HAIGHT

GRAVEYARD

ESTABLISHED 1745–46

Located in the heart of downtown
Flushing, St. George's Church is a fine
example of Gothic Revival design and
one of few surviving works by the ecclesiastical architects Wills & Dudley. The
use of medieval architectural details,
such as the high pitched roofs and lofty
tapered spire, reflects the influence of
the Oxford Movement that sought

spiritual renewal through a return to
medieval rituals and building forms.
The design is straightforward, with the
interior spaces clearly articulated in the
exterior massing, and the facade is
enriched by randomly laid granite
rubble walls, trimmed with red sand-
stone, and stained glass windows in
wood tracery. In 1894, a new chancel
wing, sympathetic to Wills & Dudley's
design, was added; it incorporates fine
stained glass windows. The Old Parish
House, designed by Charles C. Haight,
complements the church building with
its asymmetrical massing and neo-
Gothic style.

This building is the congregation's
third structure on this site since 1746.
The complex also includes a graveyard.
Established by the same deed as the
original church, it remained in use until
1887. The church remains an active
neighborhood institution, serving an
international community.

REFORMED CHURCH OF
SOUTH BUSHWICK

1853; ADDITIONS, 1885, 1903

855–867 BUSHWICK AVENUE,
BROOKLYN

ARCHITECTS: MESSRS MORGAN;
CHAPEL AND SUNDAY SCHOOL,
J.J. BUCK

DESIGNATED: MARCH 19, 1968

The Reformed Church of South
Bushwick, a Greek Revival building
surmounted by a Georgian tower, was
modeled after the great Georgian

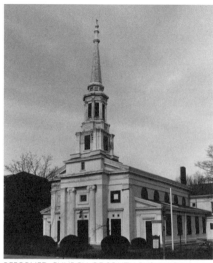

REFORMED CHURCH OF SOUTH BUSHWICK

churches of Wren and Gibbs in London.
The original congregation was made up
of families from the rural farming
community; the cornerstone was laid
in 1852, a late date for Greek Revival
and Georgian architecture.

Among the dominant features are the
classical portico and the soaring tower,
which rises from a square base through
a handsome octagonal belfry to an
octagonal spire. The influence of the
Greek Revival is seen in the pilasters of
the steeple and in the two fine fluted
Ionic columns of the portico set
between slender pilasters. The capitals
are noteworthy for their delicate carving.

In 1885, the church was enlarged to
include the church house, and the side
wings were added. In 1903, the gallery
and north and east extensions were
added to the church house.

Today the Reformed Church of South
Bushwick continues to function as a part
of the Reformed Church in America, a
descendant of the church that the Dutch
settlers established in New Amsterdam.

COOPER UNION FOR THE ADVANCEMENT OF SCIENCE AND ART

1853–59; RENOVATION, 1975–76; 2001

COOPER SQUARE BETWEEN ASTOR PLACE AND EAST 7TH STREET, MANHATTAN

ARCHITECT: FREDERICK A. PETERSON; RENOVATION, JOHN HEJDUK

DESIGNATED: MARCH 15, 1966

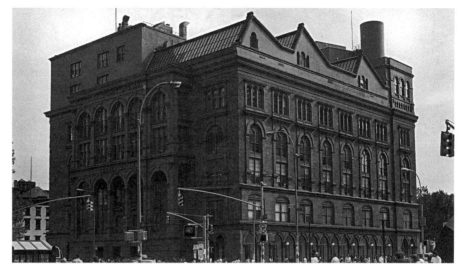

COOPER UNION FOR THE ADVANCEMENT OF SCIENCE AND ART

Cooper Union embodies the ideals of its founder, Peter Cooper, a self-made entrepreneur who built the Tom Thumb locomotive, participated in laying the first transatlantic cable, and owned iron and steel-rolling mills in Trenton, New Jersey. In 1859, he established Cooper Union as one of the first institutions in the country to offer a free education for the sons and daughters of the working class. Cooper wanted to provide students—men and women alike—with the means to earn a living, just as Charles Pratt was to do later in the century at Pratt Institute (p. 243) in Brooklyn.

The six-story brownstone building displays some of the first wrought-iron beams used in New York City; these were designed and produced in Peter Cooper's plant. Rolled rather than cast, these beams were produced on machinery that made possible the later development of the skyscraper. The building also contains the prototype for the modern elevator.

The predominant style is Anglo-Italianate, demonstrated in the heavily enframed round-arched windows and handsome loggias. The long arcade of cast-iron arches on both the Third Avenue and Lafayette Place facades is the work of Daniel D. Badger of Architectural Iron Works.

The building was extensively restored and renovated in 1975 and 1976 under the direction of John Hejduk, then dean of the Irwin S. Chanin School of Architecture at Cooper Union. The project entailed glazing the ground-floor arcades, encasing Cooper's wrought-iron columns in smooth plaster, and extending the elevator shaft through the roof. Hejduk also corrected structural weaknesses that had threatened to destroy the building. In 2001, a masonry restoration, executed by Platt Byard Dovell, rehabilitated and stabilized the exterior fabric.

157

NEW DORP LIGHT

W. S. PENDLETON HOUSE

NEW DORP LIGHT

C. 1854

25 DOYLE STREET, NEW DORP
HEIGHTS, STATEN ISLAND

ARCHITECT: UNKNOWN

DESIGNATED: NOVEMBER 15, 1967;
EXTENDED TO INCLUDE THE ENTIRE
SURROUNDING LOT,
DECEMBER 18, 1973

The New Dorp Light, also known as the New Dorp Beacon or the Moravian Light, was once a sentinel to ships in New York Bay. Well situated on a commanding perch in New Dorp Heights, the light was placed under the jurisdiction of the federal Lighthouse Service in 1856 and operated by that agency until 1939. At that time, the light was acquired by the U.S. Coast Guard. Then on June 15, 1964, after almost ninety years of operation, the New Dorp Light was decommissioned. The lighthouse and the surrounding property are now used as a private residence.

The architect used a simple vernacular design to build a utilitarian structure. A low brick foundation supports a clapboard frame pierced by plain, double-hung sash windows, and a steeply pitched gable roof. The square lighthouse tower, covered by a low-pitched, pyramidal roof supporting a light beacon, rises from the center of the building and is flanked by a brick chimney at each end of the roof. The ground-level wing, with a covered entrance and screened porch, was added for the lighthouse keeper.

W. S. PENDLETON HOUSE

C. 1855

22 PENDLETON PLACE, STATEN ISLAND

ARCHITECT: ATTRIBUTED TO
CHARLES DUGGIN

DESIGNATED: MARCH 4, 1969

The two-and-one-half-story Gothic Revival Pendleton House overlooks the Kill Van Kull. The house is a charming shingle structure with a square tower, steeply pitched gable roofs, and windows of varying shapes and sizes. A gabled vestibule doorway projects forward from the southern elevation, adorned with scalloped scrollwork. Similar motifs are repeated in the roof dormers and in those of the spire. A special feature of the west elevation is an oriel with paired windows. Two one-story extensions and a greenhouse were added to the west side of the building at a later date.

WATCH TOWER

1855

MARCUS GARVEY PARK, OPPOSITE EAST
122ND STREET, MANHATTAN

ARCHITECT: ATTRIBUTED TO JULIUS
KROEHL

DESIGNATED: JULY 12, 1967

This skeletal cast-iron fire lookout tower for New York City stands on the tall, rocky outcropping in Marcus Garvey Park on upper Fifth Avenue. From the little cupola four stories high on the octagonal tower, the watchman gazed

across the roofs of Harlem, striking the bell to signal local fire companies when he spotted a fire. Before the first alarm-box system was installed in 1871, and before the advent of the telephone, fire watchtowers played a vital role in the city's fire control system. Although it ceased to function as an alarm in 1878, the bell continued to ring daily, at 9:00 a.m. and noon, for years afterward, for the benefit of citizens who enjoyed the tradition.

The slender iron columns of the watchtower are delicately fluted, and the sweep of the staircase spiraling up around the bell creates a lacy silhouette against the sky. The fire tower is, in the twenty-first century, an unexpected and rare souvenir.

ST. PETER'S CHURCH, CEMETERY, AND FOSTER HALL

2500 WESTCHESTER AVENUE, THE BRONX

DESIGNATED: MARCH 23, 1976

ST. PETER'S CHURCH

1855; RESTORED 1879

ARCHITECT: LEOPOLD EIDLITZ; RESTORATION, CYRUS L.W. EIDLITZ

FOSTER HALL, FORMERLY THE CHAPEL

1867–68

ARCHITECT: LEOPOLD EIDLITZ

CEMETERY, ESTABLISHED C. 1700

The Parish of St. Peter's was organized in 1693 but it was not until 1700 that the town meeting house, previously used for religious services, was abandoned and the first church was erected. This is the third church on the site, designed Leopold Eidlitz, who had immigrated to New York from Czechoslovakia in 1843. After a fire in 1879, the building was restored by his son Cyrus.

St. Peter's Church is a Gothic structure with a bold profile, dominated by a steeply pitched roof and a towering spire at the corner of the nave. Cruciform in plan, it has a high nave with clerestory, narrow side aisles, and shallow transepts. The clerestory, the only change from the original design, was added by Cyrus Eidlitz.

The chapel, now called Foster Hall, was built as a Sunday school. This modest, one-story Victorian Gothic structure is made of the same rough-faced stone as the church, with windows and other details in contrasting sandstone. There are entrance doors on each side of the gable tower, beneath a low, sloping slate roof. The tower terminates in a free-standing bell cot with a pointed-arched opening. Two small engaged colonnettes with foliate capitals flank the entrance. Two slender chimneys with gable capstones pierce the lower edge of the roof on one side.

The cemetery, which surrounds the church and chapel, contains gravestones dating from the 1750s and 1760s; headstones of soldiers killed during the Revolution can be seen near the chapel. There are also a Romanesque Revival vault, a Victorian Gothic tomb, and several twentieth-century mausoleums.

WATCH TOWER

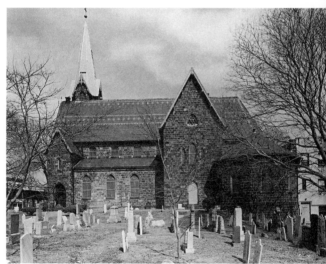

ST. PETER'S CHURCH

159

POLICE ATHLETIC LEAGUE BUILDING

POLICE ATHLETIC LEAGUE BUILDING, ORIGINALLY GRAMMAR SCHOOL 47

1855

34 1/2 EAST 12TH STREET, MANHATTAN

ARCHITECT: THOMAS R. JACKSON

DESIGNATED: SEPTEMBER 15, 1998

Originally opened by the New York City Board of Education in 1855 as Grammar School 47, this is one of the oldest surviving school buildings in Manhattan. One of the first built for girls, the building was used by the 12th Street Advanced School for Girls, founded by Lydia Wadleigh, in 1856. That institution operated without the support of the Board of Education until 1897, when it was reorganized and established as the city's first official public high school for girls. Renamed Wadleigh High School in 1900, it moved to a new building in Harlem in 1902 (p. 349). The Girls' Technical High School (later renamed

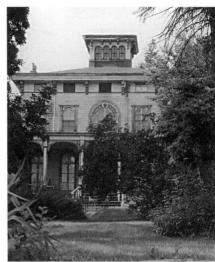

GUSTAVE A. MAYER HOUSE

Washington Irving High School) was also established in this building. An active educational facility until 1914, the building was then converted to Board of Education offices. The Police Department's Juvenile Aid Bureau and the Police Athletic League occupied the building in 1958 and continue to use it.

Designed by Thomas R. Jackson in the Anglo-Italianate style, the four-story, freestanding building features prominent arched openings and a central entrance porch with paired Corinthian piers supporting an entablature. The symmetrical brownstone and brick facade with two pedimented pavilions flanking a recessed middle panel, is largely intact.

GUSTAVE A. MAYER HOUSE

1855–56

2475 RICHMOND ROAD, STATEN ISLAND

ARCHITECT: UNKNOWN

DESIGNATED: MARCH 21, 1989

Situated on the crest of a hill, this Italianate villa overlooks grounds that recall the original landscaping. Originating in England as part of the Picturesque movement, the Italianate villa style had been introduced to the United States about twenty years before this house was built. The house was designed for the enjoyment of vistas. Its informal and secluded setting was in keeping with the picturesque emphasis on texture, variety, and intricacy in landscape design. The structure is a two-and-half-story cube capped by a square belvedere with a porch on three sides. The construction uses the then-revolutionary—and economical—balloon-framing system, which replaced hewn joints and massive timbers with quickly assembled nailed joints and boards.

Gustave Mayer, a German-born confectioner who invented the Nabisco sugar wafer, bought the villa in 1889 and moved his family and small business there. Mayer used the basement for experiments, creating holiday decorations, making birch beer, and inventing a room humidifier that he later patented. Mayer descendants occupied the house for one hundred years.

271 Ninth Street, formerly William B. Cronyn House

1856–57

Brooklyn

Architect: Unknown

Designated: July 11, 1978

An impressive suburban house in the French Second Empire style, 271 Ninth Street was built on four farm lots for William B. Cronyn, a prosperous Wall Street merchant. The three-story house is constructed of wood and brick and covered with stucco. It features a central half-story cupola with clerestory above a slate mansard roof with end pavilions pierced with dormers, ornamental iron crestings, and handsome detail.

The house remained in the Cronyn family until 1862; in 1879, it became the residence of Daniel H. Gray, who was in the sulfur-refining business. Gray's daughter lived there until 1896, and Charles M. Higgins acquired the property two years later. Like many former residences in this changing neighborhood, the house was converted to commercial use, serving as the headquarters for Higgins's India Ink Company. Today the house is again a private residence.

311–313 East 58th Street

Manhattan

311 East 58th Street, 1856–57

Architect: Unknown

Designated: May 25, 1967

313 East 58th Street, 1856–57

Builder: Hiram G. Disbrow

Designated: July 14, 1970

No more startling contrast can be imagined than that provided by the towering skyscrapers that now surround these two charming vernacular houses. Today the buildings are below the sidewalk level—the result of the construction of a new approach to the Queensborough Bridge in 1930.

In 1676, the land on which the houses stood was granted by Governor Edmund Andros to John Danielson. In Colonial times, a tavern called The Union Flag, which served travelers on the Eastern Post Road, occupied part of the property.

Two stories high with a basement and constructed of brick with stone trim, both houses have small wooden stoops and a sunken front yard. Number 313 was built by Hiram G. Disbrow as his own residence in a vernacular style with Greek Revival and Italiante elements. The simple, square-paneled pilasters, plain window treatment, and row of dentils under the porch roof recall the Greek Revival, while the brackets over the doorway, frieze section, larger paired console brackets supporting the roof cornice, and muntined windows on the second story are typical of the Italianate mode of the 1850s.

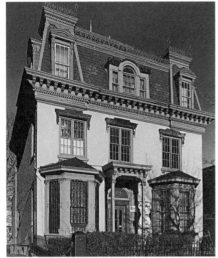

271 NINTH STREET

311–313 EAST 58TH STREET

ST. MONICA'S CHURCH (BEFORE COLLAPSE)

254–260 CANAL STREET

ST. MONICA'S CHURCH

1856–57

94–20 160TH STREET, QUEENS

BUILDER: ANDERS PETERSON, UNDER THE SUPERVISION OF THE REVEREND ANTHONY FARLEY

DESIGNATED: MARCH 13, 1979

COLLAPSE OF SANCTUARY AND APSE; STABILIZATION OF FACADE AND CAMPANILE, 1998

Today, the entrance facade and campanile are all that remain of St. Monica's Church. The historic fabric has been incorporated in a new child care facility on the York College campus, which is scheduled for completion in 2005. Originally part of a building program initiated by Archbishop John Hughes in response to the influx of Irish Catholic immigrants around 1850, St. Monica's remained an active parish until 1973, when the property became part of the York College Urban Renewal Site.

With its tall central campanile, round-arched openings, corbel tables, and pilaster strips, the basilica-shaped church exemplified the early Romanesque Revival, a style developed by Robert Dale Owen and James Renwick Jr. as "Arch Architecture." Veering away from the Anglican ecclesiological movement's decorative use of Gothic Revival, other denominations turned toward the earlier and simpler forms of the Romanesque.

254–260 CANAL STREET

1856–57

MANHATTAN

ARCHITECT: ATTRIBUTED TO JAMES BOGARDUS

DESIGNATED: MARCH 12, 1985

Located at the southwest corner of Canal and Lafayette Streets, this is one of the earliest and largest surviving cast-iron buildings in New York City. Its design has been attributed to James Bogardus, who promoted cast iron as a material for the commercial building facades commercial from the 1850s to the 1890s.

The building was erected for George Bruce, a prominent figure in the printing industry who was regarded as the "father and chief" of typography in America. His technological innovations were largely responsible for the rapid and efficient advancement of newspaper and book publishing in America during the latter part of the nineteenth century.

As was the vogue at the time for commercial buildings, the facade was rendered in the Italianate palazzo style and sought to give the effect of being a solid masonry structure. The Venetian-inspired design includes a storefront level punctuated by columns; four stories of arched and rectangular-edged windows, rhythmically spaced and separated by fluted columns; and ornamental details such as the Medusa-head keystones on the fourth level.

This was one of the first commercial structures erected in a neighborhood that was quickly being transformed

from an industrial area to a center of retail trade. The building is still in commercial use today, its ground floor devoted to shops and its upper floors to lofts and offices.

CARY BUILDING

1856–57

105–107 CHAMBERS STREET, MANHATTAN

ARCHITECTS: KING & KELLUM

DESIGNATED: AUGUST 24, 1982

The Cary Building is one of New York's most important nineteenth-century cast-iron commercial structures. It was designed by Gamaliel King and John Kellum, whose firm specialized in commercial architecture, with cast-iron fronts fabricated by Daniel D. Badger's Architectural Iron Works. The structure was built for the firm of Cary, Howard & Sanger, dry-goods merchants, as both a store and a warehouse.

The building exemplifies three contemporary developments that set major patterns for the economic growth of post–Civil War New York: the commercial development of the area north and west of City Hall; the introduction of the Italianate palazzo; and the invention of the cast-iron facade. The five-story facade consists of a series of arched windows set between Corinthian columns and crowned with a heavy bracketed cornice and a large triangular pediment. The design shows the historic combination of the Italianate style with cast-iron architecture.

FRIENDS MEETING HOUSE

1857

110 SCHERMERHORN STREET, BROOKLYN

MASTER BUILDER: ATTRIBUTED TO CHARLES T. BUNTING

DESIGNATED: OCTOBER 27, 1981

The Friends Meeting House at 110 Schermerhorn Street beautifully reflects the restrained character of Quaker architecture. The meeting house, which replaced an earlier structure at Henry and Clark Streets in Brooklyn Heights, is a transitional blend of the Greek Revival and Italianate styles; Charles T. Bunting is generally credited with its design.

The main facade rises through three and one-half stories to a peaked roof with a low gable that contains a bisected lunette window. The walls are constructed of hard-pressed red brick, laid in running bond. The window lintels and sills are brownstone, as are the foundations. The restrained ornament consists of a porch with a triangular pediment supported by plain, wooden Doric columns and a raking cornice faced with simple moldings.

The building continues to be used as a meeting house by the Brooklyn Monthly Meeting of the Religious Society of Friends.

CARY BUILDING

FRIENDS MEETING HOUSE

BROTHERHOOD SYNAGOGUE, FORMERLY FRIENDS MEETING HOUSE

1857; 1974

144 EAST 20TH STREET, MANHATTAN

ARCHITECTS: KING & KELLUM; RENOVATION, JAMES STEWART POLSHEK

DESIGNATED: OCTOBER 26, 1965

In 1859, King & Kellum, architects of the Cary Building (p. 163), designed a meeting house, "exactly suited for a Friends Meeting, entirely plain, neat and chaste, of good proportions, but avoiding all useless ornament, so much so as to not wound the feelings of the most sensitive among us." Anglo-Italianate in style, the original building is three stories high with a large basement and attic; simple and austere, it is decorated with Renaissance-style cornices and segmental-arched windows. A beautifully proportioned triangular pediment crowns the building; the exterior is constructed of blocks of Dorchester olive stone quarried in Ohio.

In 1974, the Brotherhood Synagogue purchased the building and commissioned James Stewart Polshek to undertake its renovation. His additions include the Garden of Remembrance, a serene courtyard to the east of the building with a limestone wall, on which are engraved the names of Holocaust victims and members of the congregation who have died; a memorial mosaic at the far end symbolizes the synagogue's goal of peace. On the west side, a Biblical garden was added.

BROTHERHOOD SYNAGOGUE

75 MURRAY STREET

75 MURRAY STREET

1857; 1994–96

MANHATTAN

ARCHITECT: ATTRIBUTED TO JAMES BOGARDUS

DESIGNATED: DECEMBER 10, 1968

Commissioned in 1857 to house the glassware business of Francis and John Hopkins, this building was designed in the manner of late-fifteenth-century Venetian palazzi and enlivened with rich Italianate detail. On each floor of the five-story structure, four engaged fluted columns, which probably once had Corinthian capitals, support full entablatures with ornate modillions and leaf moldings. Cast-iron units formed by twelve contiguous, semicircular arches supported by small engaged columns on paneled pedestals fill the spaces between the columns. In contrast to the verticality of these colonnades, elaborate cornices at each floor and a crowning cornice with large, decorative brackets provide strong horizontal emphasis.

The building has arched, double-hung windows surmounted by bull's-eye openings and flanked by trefoil openings on the upper two floors. The windows of the second and fourth floors have volute-shaped keystones, and those of the third and fifth floors have Medusa-head keystones, identical to those found on 254–260 Canal Street and 63 Nassau Street, both by Bogardus. An original iron step in the entrance bears the legend "James Bogardus originator and patentee of iron buildings Pat, May 7, 1850," further supporting the

attribution. The building was restored in 1994–96, when it was converted to residential use.

E. V. HAUGHWOUT BUILDING

1857; 1995

488–492 BROADWAY, MANHATTAN

ARCHITECT: JOHN P. GAYNOR; IRON COMPONENTS BY DANIEL D. BADGER; RESOTRATION, JOSEPH PELL LOMBARDI

DESIGNATED: NOVEMBER 23, 1965

The Haughwout Building is an outstanding example of early cast-iron commercial architecture in New York City. Designed in 1857 by J. P. Gaynor and built by Daniel D. Badger of Architectural Iron Works, it was originally designed as a department store that sold cut glass, silverware, clocks, and chandeliers. It was the first building to have an Otis passenger elevator equipped with a safety device (patented 1861).

The five-story building elegantly displays the Venetian palazzo style that was gaining popularity as a mercantile idiom in the 1850s and 1860s. Above the ground level, arched windows are set between colonnettes flanked by crisply detailed Corinthian columns in a manner reminiscent of Sansovino's great library in Venice. The Haughwout Building represented the state of the art in architectural design when it was built. Not only was it made from a very new building material—easier to use and more economical than traditional stone—but it was also bold in design; its Italianate style was considered avant-garde, since it consciously rejected the conservative Greek Revival manner often adopted for government buildings.

One of the major advantages of cast-iron architecture is that it allows an opening up of the facade. As Badger stated in his influential 1865 publication, *Illustrations of Iron Architecture* (which acted as a pattern book of sorts):

> A light and ornamental edifice of iron may be safely substituted for the cumbrous structures of other substances, and sufficient strength be secured without exclusion of light—which is often highly desirable for mercantile and mechanical purposes.

Originally a blacksmith, Badger became second in importance only to James Bogardus as a manufacturer and promoter of this distinctively American building material and method of construction. Cast iron's strength, lightness, economy, durability, and fire-resistance won it popularity. Architectural Iron Works began fabricating full cast-iron facades in 1856 and shipped them throughout the United States and abroad until Badger retired in 1873.

Many of the architectural details of cast-iron construction had a significant influence on the development of the skyscraper aesthetic. The load-bearing potential of metal-frame construction allowed for an expansion upward, a trend that was further encouraged by the elevator. Stylistically, the rhythmic and repetitive orientation of the facade—standardized units without any central or peripheral focus—fostered the growth of the mechanical precision associated with the skyscraper.

For the most part, the ornate style of

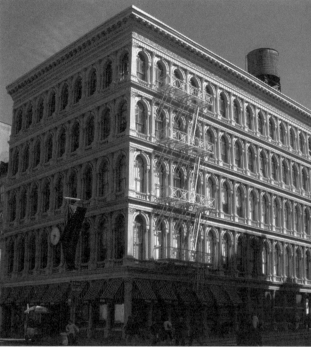

E. V. HAUGHWOUT BUILDING

the Haughwout Building had been eclipsed by the 1870s, when a more functional and declarative approach became popular. In 1995, after years of neglect, the building was restored and the facades repainted their original color, under the direction of architect Joseph Pell Lombardi.

SWIFT, SEAMAN & CO. BUILDING

1857–58

122 CHAMBERS STREET (ALSO KNOWN AS 52 WARREN STREET), MANHATTAN

ARCHITECT: UNKNOWN

DESIGNATED: MAY 16, 2000

In the early-nineteenth-century, the rapidly growing dry goods industry in Lower Manhattan prompted construction of store-and-loft buildings, offering open spaces suitable for wholesale or manufacturing businesses. Completed in 1858 for Emily Jones, a wealthy real estate investor, this distinctive building was rented the same year by Swift, Seaman & Co., a saddlery hardware business, which remained a tenant in various incarnations until 1879. For the next seventy years, the tenants included a continuous line of saddlery/harness hardware businesses. The building remained in commercial use until 1980, when it was converted to cooperative apartments.

The facades on Warren and Chambers Streets each incorporate similar elements of the Italian Renaissance palazzo style; there is elaborately carved Rococo Revival ornament above the windows, which are crowned with shells, cartouches, rosettes, and foliated scrolls, an unusual flourish of 1850s architecture. The upper stories are clad in a tan-colored Dorchester stone, sought after for its color and durability, and crowned by modillion and bracketed metal cornices.

STEPHENS-PRIER HOUSE

STEPHENS-PRIER HOUSE

C. 1857–59; 1977–86

249 CENTER STREET, STATEN ISLAND

ARCHITECT: UNKNOWN

DESIGNATION: MAY 25, 1999

This unusually well-preserved clapboard house is an impressive Richmondtown residence, surviving from the mid-nineteenth century, when the village served as Staten Island's governmental center.

Greek Revival and Italianate elements are both incorporated in the identical facades on Center Street and Richmond Road. Notable elements are projecting columned porches that extend from molded entrance surrounds with narrow sidelights and transoms, and a central tripartite second story window. An uncommon cross-gabled roof caps the building, and low pediments are pierced by lunette windows. The exterior of the house was restored, based on historic photographs, between 1977 and 1986.

Daniel Lake Stephens, the blind son of a butcher and real estate investor, built the house about 1857–59, and lived there with relatives and servants. After

his death in 1866, the house was occupied by several family members, notably Judge Stephen D. Stephens Jr., one of the most significant public figures in Staten Island before the turn of the century. James E. Prier acquired the house in 1886. Since 1991 the administrative offices of Historic Richmond Town, the village historical society, have been headquartered there.

HANSON PLACE SEVENTH-DAY ADVENTIST CHURCH

1857–60; 1970s

88 HANSON PLACE, BROOKLYN

ARCHITECT: GEORGE PENCHARD

DESIGNATED: OCTOBER 13, 1970

This building was originally erected as the Hanson Place Baptist Church, an outgrowth of the Atlantic Street Baptist Church. Since 1963, the church has been owned by the Seventh-Day Adventists. Constructed of brick above a brownstone base and trimmed with wood, this Italianate church gives distinction to a neighborhood that still retains much of its nineteenth-century atmosphere.

A flight of stone steps leads up to an elevated portico with a steeply pitched pediment supported on four tall Corinthian columns; the upper entablature is enriched with modillions and dentils. The details of the door enframements are distinctly Greek Revival; above each doorway is an eared rectangular frame; those to the left and right are filled with stained glass. Slightly

HANSON PLACE SEVENTH-DAY ADVENTIST CHURCH

projecting corner pavilions flank the entrance portico, and the classical entablature is carried along the sides of the church. A projecting section, facing South Portland Avenue, was built as a lecture hall and is now used for classes. Its four tall, segmental-arched windows are crowned by similar segmental arches in the architrave. The windows are separated by fluted pilasters with Corinthian capitals and crowned by a pediment similar to the one at the front of the church. A restoration of both the exterior and the interior was undertaken in the late 1970s.

167

CONSERVATORY GARDEN

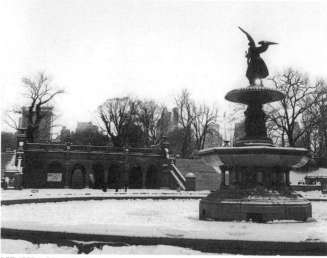

BETHESDA FOUNTAIN

BELVEDERE CASTLE

COP COT

CENTRAL PARK

1857–PRESENT

BOUNDED BY FRAWLEY CIRCLE, WEST
110TH STREET, CATHEDRAL PARKWAY,
FREDERICK DOUGLASS CIRCLE,
CENTRAL PARK WEST, COLUMBUS
CIRCLE, CENTRAL PARK SOUTH (WEST
59TH STREET), GRAND ARMY PLAZA,
AND FIFTH AVENUE TO FRAWLEY
CIRCLE, MANHATTAN

ARCHITECTS: FREDERICK LAW
OLMSTED AND CALVERT VAUX

DESIGNATED SCENIC LANDMARK:
APRIL 16, 1974

America's first great planned public park, Central Park masterfully integrates landscape and architectural elements. Now flanked on four sides by sandstone walls, the park reflects the foresight of its mid-nineteenth-century proponents.

When, in the mid-nineteenth century, an already staggering rate of urban growth was complicated by an outbreak of cholera, concerned New Yorkers began to articulate the need for an open space where they could seek relief from the pressures of urban life. Originally envisioned along the East River, the park was moved west because of the opposition of East Siders, and the site was purchased in 1856. This 843-acre tract extended far to the north, into an area then only sparsely settled; shortly thereafter, a real estate boom occurred, and the lots surrounding the site were quickly purchased for the construction of villas.

When the Board of Park Commissioners was established in 1857, it announced a competition for the park's design. Frederick Law Olmsted and Calvert Vaux, whose Greensward Plan was selected in 1858, had proposed a seemingly unrestricted garden landscape, suggestive of the Romantic garden so popular in eighteenth-century England.

The site's irregular topography was the heritage of Ice Age glaciers. Olmsted and Vaux's design made use of this unevenness, creating an apparently "natural," but carefully cultivated, landscape. For the initial construction alone, 10 million cartloads of dirt were moved from one location to another; plantings included 4 to 5 million trees, representing 632 species, and 815 varieties of vines, plants, and flowers. To enrich the glacial soil, half a million cubic yards of topsoil were introduced to the site.

The Olmsted and Vaux plan incorporated architecture into the wild garden. Gates dedicated to groups of citizens—such as scholars, engineers, and inventors—mark the twenty-one entrances. The design also accommodated two existing architectural features that predate the park: the Arsenal (p. 140) and the Croton Reservoir. Paths surrounding the reservoir and the carriage lanes throughout the park were deliberately curved to discourage racing on the newly landscaped public grounds.

Among the few works commissioned specifically for the park were the Bethesda Fountain by Calvert Vaux and its sculpture, *Angel of the Waters* by Emma Stebbins, completed in 1873. Situated on a formal terrace overlooking the lake, the fountain serves as the focus of its immediate surroundings. Other sculptures include the bronze figures of Alice in Wonderland and Samuel F. B. Morse. The seventy-one-foot-tall Egyptian obelisk was built about 1600 B.C. by Thutmose III, given to the City of New York in 1877, and installed in its present location in 1881.

Central Park's true genius resides in its careful integration of landscape and architectural elements that direct and enhance the visitor's experience. Each of the circuit routes, for example— pedestrian walks, bridle paths, sunken transverse roads, and a circular loop—is visually and physically distinct from the others. Where routes cross, a series of underpasses and overpasses, nearly all different, permits a continuous traffic flow without the need for intersections. The cast-iron Bow Bridge, designed, like the other bridges, by Calvert Vaux, was completed in 1879; it spans the lake and connects the wooded Ramble with the more open slope of Cherry Hill.

Throughout Central Park, the visitor moves from one landscape experience to another within a relatively small area. Hills and paths follow a rising and sinking route, while the masonry and towers that now delineate the periphery offer a sense of distant constancy. The towers and facades that border the park help to create a stage set that amplifies the drama of the park's ever-shifting natural vistas.

152 East 38th Street

1858; altered, 1934–35

Manhattan

Architect: Unknown; redesign, Robert Ward

Designated: May 25, 1967

Typical of the hundreds of modest semi-suburban houses that once dotted the uptown cross streets of mid-nineteenth-century Manhattan is the charming house at 152 East 38th Street, in Murray Hill. Originally built as a gatehouse for an estate that belonged to member of President Martin Van Buren's family, the house is set back from the street by a forecourt and a landscaped garden. It was sold by Van Buren's descendants in 1929 to the publisher Cass Canfield, who remodeled it in 1934–35, giving it a Federal Revival look, with modified Greek architectural details.

One of the most handsome features is the superb doorway with glass sidelights framed by slender pilasters supporting a molded entablature and a handsomely designed transom. Delicate iron trellises support a graceful, scalloped bronze canopy covering the stoop, and a frieze over the third-floor windows is decorated with rosettes. The simple cornice is crowned by a low brick parapet, and the handsome double-hung sash windows have attractive black shutters.

152 EAST 38TH STREET

STEINWAY HOUSE

Steinway House

c. 1858

18–33 41st Street, Queens

Architect: Unknown

Designated: February 15, 1967

Originally surrounded by tennis courts, stables, lawns, and orchards, this rambling, asymmetrical structure was home to the Steinway family until the 1920s. Built for Benjamin Pike, it was acquired by the piano manufacturer William Steinway during the 1870s.

A two-story, T-shaped section forms the building's central portion. The first floor contains several parlors, a dining room, and a kitchen; the bedrooms are on the second floor. The west end of the T is connected to a striking, four-story tower with additional living quarters. At the opposite end is an open porch. Other porches and terraces are located on the southern and eastern sides.

An imaginative combination of classical and medieval elements animates the twenty-seven-room house. Typical classical features include four cast-iron Corinthian columns supporting the main entrance porch, modillions, and the triangular, pediment-like gable in both the central hall and eastern elevation. The double-arched window in the main hall and the several rows of round-arched tower windows are reminiscent of those of an Italian villa; the rough-surfaced stonework resembles medieval domestic architecture.

Actors Studio, formerly the Seventh Associate Presbyterian Church

c. 1858; 1995

432 West 44th Street, Manhattan

Architects: Unknown; restoration, Davis Brody & Associates

Designated: February 19, 1991

The Actors Studio building, with its painted brick facade adorned with smooth pilasters and topped by an undecorated pediment, is a fine and rare example of the vernacular Greek Revival style. It was designed for the Seventh Associate Presbyterian Church, a small working-class congregation formed in 1855.

Between 1825 and 1857, when Manhattan's population grew by

ACTORS STUDIO

CULTURAL COLLABORATIVE JAMAICA,
FORMERLY FIRST REFORMED CHURCH
OF JAMAICA, ORIGINALLY FIRST
REFORMED CHURCH

1858–59; EXTENSION, 1902; 2006

153–10 JAMAICA AVENUE, QUEENS

ARCHITECT: SIDNEY J. YOUNG;
EXTENSION, TUTHILL & HIGGINS

DESIGNATED: MARCH 13, 1979

CULTURAL COLLABORATIVE JAMAICA

300,000, the number of churches in the city soared from 84 to 290. During this boom, the west side of Manhattan, particularly near the water's edge, seemed to attract the necessary but undesirable elements of urban life: garbage dumps, stables, slaughterhouses, factories, and distilleries. The nearby commerce from piers and railroad tracks brought a rough crowd to the neighborhood, which soon came to be known as Hell's Kitchen. There the small congregation—it began with only fifty-five members—maintained the building until 1944, when it officially disbanded.

The Actors Studio has occupied the building since 1955. The "Method" acting technique taught at the studio is based on the Moscow Art Theater director Konstantin Stanislavsky's theory, which emphasizes the use of an actor's personal experiences to portray dramatic characters. This acting style was promoted in this country by Lee Strasberg, longtime artistic director of the Actors Studio.

In 1995, the building was restored by Davis, Brody & Associates.

This site was previously occupied by the Dutch Reformed Church of Jamaica for almost 150 years. Brick was selected for the new building after a fire destroyed one of the original church buildings in 1857. Its design follows the tenets of "Arch Architecture," based on the German *Rundbogenstil*.

Slightly projecting towers—four stories high on the west side, three stories on the east—flank the building's broad, gabled facade. A belt course runs above the first story, emphasized by dentils in the center section. A triad of round-arched windows rests above this course; two round-arched portals pierce the floor below. The openings in both sections are outlined by square-cut reveals.

On the towers, brownstone courses mark the separate levels. A blind rondel appears on the third floor of the larger, western tower; its fourth floor is pierced by a triad of louvered openings, flanked by octagonal turrets, and crowned by crenellation. The smaller, eastern tower follows a similar design. The main body of the church behind the towers is five bays long, with a two-bay addition attached to the south end.

A memorial chapel, built in 1902 and since demolished, inaugurated a broader building program, under which architect Cuyler B. Tuthill extended and refurbished the main church. Emil Zundel, a member of the congregation, designed and executed all but one of sixteen stained glass windows as part of the renovation. Although seventeen feet high, the main windows employ a minimum number of construction bars, and their multiple layers of glass are combined to produce an opalescent effect.

In 1973, the church was incorporated into the Central Jamaica Urban Redevelopment Project. From 1982 to 1990, the Glorious Church of God in Christ occupied the building. The Greater Jamaica Development Corporation helped to create the Cultural Collaborative Jamaica. That group, together with the Jamaica Culture for Arts and Learning and Black Spectrum Theater, are working with the architectural firm Wank Adams Slavin to convert the church into a performing arts facility, which is expected to open in 2006. Featured are a multipurpose theater with 400 movable seats for traditional or dinner theater, two rehearsal rooms and a conference room.

171

ST. MARY'S EPISCOPAL CHURCH

1858–59

230 CLASSON AVENUE, BROOKLYN

ARCHITECT: RICHARD T. AUCHMUTY

DESIGNATED: OCTOBER 27, 1981

St. Mary's Church, located just north of the Pratt Institute in the Clinton Hill section of Brooklyn, is a beautiful Gothic Revival structure reminiscent of an English rural parish church. Built in 1858, it was designed by a relatively unknown architect, Richard T. Auchmuty, in accordance with the religious philosophy of ecclesiology. This movement, which originated in England in the 1830s, called for a doctrinaire interpretation of Christian teachings. It laid out a strict set of rules for the design of Episcopal churches; the more dogmatic style drew its inspiration from medieval Gothic parish churches. Ecclesiological principles required the honest use of the best materials; it was also considered important that the exterior design reflect the plan and construction of the interior, and that the church be oriented on an east-west axis.

According to the rules of the movement, as established by the New York Ecclesiological Society, the chancel is the most important design element of a church. At St. Mary's, the chancel is twenty-four feet deep; a square tower with polygonal extension and a broached spire located to the south give added emphasis to the portion of the building facing Classon Avenue. The nave, which extends to the west, has a steep sloping roof that is clearly distinct

ST. MARY'S EPISCOPAL CHURCH

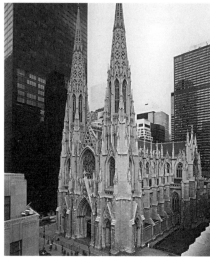
ST. PATRICK'S CATHEDRAL

from the shallower slope of the side aisle roofs—all originally covered with slate shingles. To the north of the chancel is a low, polygonal vestry room that connects the chancel and side aisle. An unusually picturesque pointed-arched gateway in the form of a stepped flying buttress serves as an ingenious method of channeling the parishioners to the southwest entrance porch. In addition to its handsome form, St. Mary's has beautiful ornamentation and attractive pointed-arched and rose windows.

ST. PATRICK'S CATHEDRAL

MANHATTAN

DESIGNATED: OCTOBER 19, 1966

ST. PATRICK'S CATHEDRAL, 1858–79; TOWERS, 1888; LADY CHAPEL, 1900–1908

FIFTH AVENUE BETWEEN 50TH AND 51ST STREETS

ARCHITECTS: JAMES RENWICK JR. (CATHEDRAL); CHARLES T. MATHEWS (LADY CHAPEL)

ARCHBISHOP'S RESIDENCE, 1882

452 MADISON AVENUE

ARCHITECT: JAMES RENWICK JR.

PARISH HOUSE, 1884

460 MADISON AVENUE

ARCHITECT: JAMES RENWICK JR.

The largest Catholic cathedral in the United States, St. Patrick's stands as a monument to the faith of New York City's Irish immigrant population of the mid-nineteenth century and represents an American adaptation of the cathedral building, which was not established in the architectural canon at the time.

The Gothic Revival cathedral, Archbishop's Residence, and Parish House were designed by James Renwick Jr., who had completed Grace Church (p. 126) in 1846. The Lady Chapel was designed by Charles T. Mathews and added to east end in 1908. Distinctly American in its eclecticism and adaptation to New York's gridded street plan, St. Patrick's recalls the elements of the English, French, and German styles that inspired it.

Two identical towers rise 330 feet

from the entrance facade on Fifth Avenue. Completed in 1888, the spires are decorated with foliated tracery that suggests the English Decorated style. Such tracery recurs in the rose window (designed by Charles Connick), which is surmounted by a gable and flanked by pinnacles. The transept doors also echo these motifs. The cruciform plan is oriented, in the traditional manner, to the east; the Lady Chapel was inspired by thirteenth-century French Gothic, complementing Renwick's somewhat heavier, English masses.

St. Patrick's was formally opened in 1879 by His Eminence John Cardinal McCloskey, the first American cardinal. Pope Paul VI prayed before the Blessed Sacrament here during the first papal visit to the United States in 1965, as did Pope John Paul II in 1979. Both were guests in the Archbishop's Residence. Today, St. Patrick's is the seat of New York's Roman Catholic archdiocese and the place of worship for between 5,000 and 8,000 people each Sunday.

BROOKLYN CLAY RETORT AND FIRE BRICK WORKS STOREHOUSE

c. 1859; 1990s

76–86 VAN DYKE STREET (ALSO KNOWN AS 224–234 RICHARDS STREET), BROOKLYN

ARCHITECT: UNKNOWN

DESIGNATED: DECEMBER 18, 2001

This significant mid-nineteenth-century industrial building was part of a manufacturing complex established during the first wave of industrial development of Red Hook. J.K. Brick & Company, the original occupant, was founded by Joseph K. Brick in 1854. He is credited with introducing a key component in the production of illuminating gas, the fire-clay retort, in the United States. This structure is an important reminder of the extensive New York–New Jersey refactory (or "fire") brick manufacturing industry.

The structure was probably designed by Joseph Brick, with main facades of roughly coursed gray rubble schist, highlighted with brick and sandstone details. The basilica-like form is representative of industrial workshops of the period, featuring a clerestory of windows, skylights, and a bull's eye window in the Van Dyke Street facade. Restored in the mid-1990s, the building is currently used for produce distribution and glass manufacturing.

121 HEBERTON AVENUE

c. 1859–61

STATEN ISLAND

ARCHITECT: JAMES G. BURGER, DESIGNER AND BUILDER

DESIGNATED: DECEMBER 17, 2002

Architectural pattern books allowed carpenter-builders like James G. Burger to construct picturesque houses by following the published plans. Burger adapted components of many popular patterns, most notably the English rustic-style villa, from which he drew broad gables, decorative brackets, a broad veranda,

BROOKLYN CLAY RETORT AND FIRE BRICK WORKS

121 HEBERTON AVENUE

and raised basement. Classical window brackets are extracted from other sources, as are the oriel windows of medieval influence. The house is sheathed in its original clapboards and retains original wood moldings and first-floor fenestration.

Burger sought gold in California in 1850, but soon returned home because of poor health. He probably built the house as a speculative investment, but financial trouble forced him to sell it, soon after completion, to Captain John J. Houseman, a prosperous oysterman and noted abolitionist. Acquired by Robert Brown, saloon owner and well-known politician, it was owned by the Brown family from 1892 until the 1940s. The house remains a private residence.

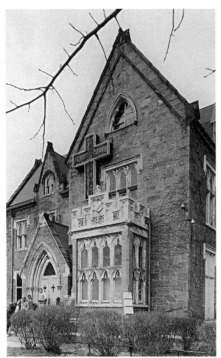

BRIGHT TEMPLE A.M.E. CHURCH

BRIGHT TEMPLE A.M.E. CHURCH, FORMERLY SUNNYSLOPE

C. 1859–64

812 FAILE STREET, THE BRONX

ARCHITECT: UNKNOWN

DESIGNATED: JULY 28, 1981

Originally a manor house, Sunnyslope was built in the early 1860s in the Hunts Point section of the Bronx on a 14.6-acre estate belonging to Peter S. Hoe. The neighborhood was then a rural district of Westchester County, and Hunts Point was part of the town of West Farms, a quiet area of estates and manor houses.

The house was designed in the mid-nineteenth-century picturesque Gothic tradition, which produced many of the most handsome estates in New York City. A square, compact, high-style villa, it is in the manner of Calvert Vaux. There is no known connection between the Hoe house and Vaux, but the house greatly resembles several of the designs published in Vaux's *Villas and Cottages*, 1857.

Sunnyslope is a two-and-one-half-story stone residence with light stone trim and a tiled gabled roof, above which rise two broad chimneys with pointed chimney pots. It is the arrangement of the gables and gable-dormers that gives the house its characteristic picturesque look; the Gothic style is evident primarily in the treatment of the windows and doors. Each gable has a pointed-arched attic window in its center, while the first- and second-floor windows are treated as paired or tripled lancets grouped together under a stone label lintel. The pointed-arched entrance, articulated by a heavy stone enframement, is situated on a projecting porch. To the right of the entrance, an angular, three-sided bay with multiple trefoil panels is crowned with an elaborately carved crenellation. A small, one-story extension at the rear is not part of the original house.

Peter S. Hoe sold Sunnyslope in 1864, but it remained a country estate long after the annexation of West Farms to New York City. By the turn of the century, however, West Farms was becoming increasingly urban; in 1912, Stephen Jenkins, in *The Story of the Bronx*, described the area as being "in a transition state; for, though there are a great many apartments and flats, there are still more vacant lots. The old estates have been cut up, and very few of the elegant mansions of the middle of the last century remain to show us how the well-to-do merchants of that epoch used to live." Sunnyslope was one of the few mansions that survived. The estate lands were eventually sold off, and Sunnyslope itself was sold in 1919 to Temple Beth Elohim to serve the area's Jewish community. Today the house is occupied and maintained by the Bright Temple A.M.E. Church, and serves as a religious center for the area of which it was once the manor house. It is one of the most unusual, and finest, of the few country houses surviving within the city limits.

EAST 92ND STREET HOUSES

MANHATTAN

DESIGNATED: NOVEMBER 19, 1969

122 EAST 92ND STREET, 1859; ADDITION, 1927

ARCHITECT: ATTRIBUTED TO ALBRO HOWELL, CARPENTER-BUILDER

120 EAST 92ND STREET, 1871

ARCHITECT: UNKNOWN

Survivors from a time before this neighborhood became fashionable, these quaint wooden houses on East 92nd Street between Park and Lexington Avenues were constructed in 1859 and 1871. Both have great charm, mirroring in clapboard some of the details of the more elaborate brick houses that were being built during this period.

Each house is slightly Italianate in feeling, with large brackets supporting the cornice, a handsome, columned porch, and two French doors on either

side of a paneled entry door. In 1927, a penthouse was added to number 122, providing a fourth floor; an earlier, two-story addition with a service entrance is set back to the left.

HAMILTON PARK COTTAGE

1859–72

105 FRANKLIN AVENUE,
STATEN ISLAND

ARCHITECT: CARL PFEIFFER

DESIGNATED: OCTOBER 13, 1970

Hamilton Park Cottage was one of the original houses in New Brighton, an important early residential suburban park that was derived from the romantic landscapes of Andrew Jackson Downing. In addition to its significance in planning history, the house is also notable as a pleasing example of a brick Italianate cottage. Thomas E. Davis, a speculative builder, conceived the idea for New Brighton. Named for the English seaside resort, it was only twenty minutes from the Battery by ferry.

Picturesquely sited, with a fine view of the Kill Van Kull from the rear, the house was constructed sometime between 1859 and 1872. The dominant architectural feature is a central triple-arched porch over the main entrance that links the bay windows of the parlor and dining room. A window above the main entrance has a sill resting on corbels and is crowned by a triangular sheet-metal pediment. Other decorative features include carved console brackets, ornamental modillions, and window

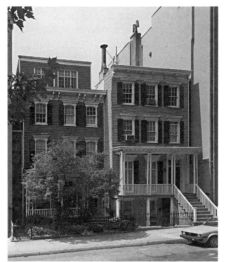

EAST 92ND STREET HOUSES

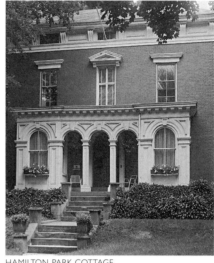

HAMILTON PARK COTTAGE

moldings with keystone arches.

Within the tract of land assembled by Davis, Charles K. Hamilton and his wife purchased thirty-two acres in 1851 and 1852, where Hamilton built this and at least three other houses as a planned group. The community was developed as a single-ownership residential district, with houses approached by winding carriage roads. There was a common stable, and common quarters were reportedly provided for the servants. Hamilton defaulted on his mortgage in 1878 and the lots were put up for sale individually in 1894.

Still a private residence, Hamilton Park Cottage is listed on the National Register of Historic Places.

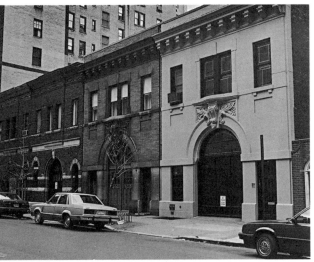

EAST 73RD STREET BUILDING

This group of buildings between Lexington and Third Avenues is a reminder of a time when the transportation needs of New Yorkers were served by horses instead of automobiles. In the 1860s the north side of East 73rd Street was built up with brick row houses of simple Italianate design; only the houses at 171 and 175 survive from that period. At about the turn of the century, the others were replaced by carriage houses and stables serving the fashionable mansions of Upper Fifth Avenue; these structures include 161, 163, 165, 167, and 173 East 73rd Street. Another series of stables and carriage houses adorns the south side of the street at numbers 168, 170, 172–174, 178, 180, and 182; most are somewhat earlier. The handsome building at number 177–179 was built specifically as an "auto garage" in 1906. Although designed by several different architects, the buildings on East 73rd Street have a unity and coherence of design—a result of the short time span in which they were built, the use of similar materials and ornamental details, and a relatively uniform cornice line.

Many of these carriage houses have been converted for use as garages, with living quarters on the upper floors. The house at 161, which once belonged to the Harkness family, was acquired in 1950 by the Dalcroze School of Music and remodeled by Edward Larrabee Barnes.

85 LEONARD STREET

1860–61

MANHATTAN

ARCHITECT: JAMES BOGARDUS

DESIGNATED: NOVEMBER 26, 1974

85 Leonard Street is significant as the only remaining structure in the city definitely known to be as the work of James Bogardus, the self-described "inventor of cast-iron buildings." Built as a storehouse for dry-goods merchants Kitchen, Montross & Wilcox, this five-story structure stands as one of a row of similar buildings, many with facades made largely of stone. Most of the buildings on both sides of Leonard Street west of Broadway were built in 1860–61 for commercial purposes, replacing residences that had previously stood on the block. 85 Leonard Street is one of the few surviving cast-iron structures designed in the "sperm candle" style, which became popular in the city in the late 1850s. The name derives from the use of two-story columns that resemble candles made from sperm whale oil.

Designed in the form of an Italian Renaissance palazzo, the building emphasizes verticality, lightness, and openness—intrinsic qualities of cast-iron architecture. The structure is three bays wide with two tiers of elongated columns that span the second to the third and the fourth to the fifth stories; spandrel panels separate the floors of each two-story grouping. Rope moldings and foliate motifs enhance the surface. An impressive entablature, composed of a paneled frieze formed by a rope molding, a row of dentils, and a modillioned cornice, crowns the facade.

FRIENDS MEETING HOUSE AND FRIENDS SEMINARY

MANHATTAN

ARCHITECT: ATTRIBUTED TO CHARLES T. BUNTING

DESIGNATED: DECEMBER 9, 1969

FRIENDS MEETING HOUSE, 1861

15 RUTHERFORD PLACE

FRIENDS SEMINARY, 1861

226 EAST 16TH STREET

The Friends Meeting House and Seminary on Rutherford Place, facing Stuyvesant Square, were built in 1861 by a group of Quakers known as the Hicksites. Designed in a restrained, austere Greek Revival style, the buildings reflect the simplicity and architectural conservatism of the Quakers. Charles T. Bunting, a member of the meeting and a builder, was responsible for the construction and probably also for the design.

The three-story brick meeting house is distinguished by its spare, pedimented entrance porch and double-hung, muntined sash windows with plain sills and lintels. The T-shaped Seminary building, to the north on 16th Street, replicated the meeting house as closely as possible, with the entrance porch and gable also facing the square.

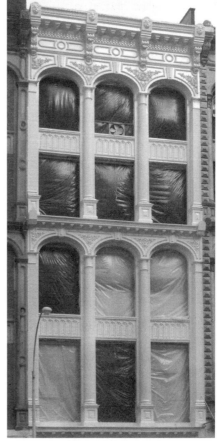

85 LEONARD STREET

FRIENDS MEETING HOUSE AND FRIENDS SEMINARY

BROOKLYN CITY RAILROAD COMPANY BUILDING

1860–61; 1975

8 CADMAN PLAZA WEST AND 8–10 FULTON STREET, BROOKLYN

ARCHITECT: UNKNOWN

DESIGNATED: FEBRUARY 20, 1973

The building at 8 Cadman Plaza West was built as the office of the Brooklyn City Railroad Company, which was created in 1853 to replace the former stagecoach line and to link the Manhattan ferry with principal points on Long Island. Remnants of the tracks are still visible next to the building, in a cobblestone parking area.

The five-story building is constructed of brick above cast-iron piers at the street level on Fulton Street. Granite quoins define the wall surface, which is distinguished by stone sills, lintels, and pediments. Carved console brackets, corbels, dentil molding, and paneled pilasters in the Italianate style further enrich the stonework.

With the end of ferry service, the building was converted to manufacturing and warehousing. Later, it was occupied by the Berglas Manufacturing Co. In 1975, architect David Morton purchased the building and converted it to loft apartments.

BROOKLYN CITY RAILROAD COMPANY

NICHOLAS KATZENBACH HOUSE

NICHOLAS KATZENBACH HOUSE, FORMERLY STONEHURST

1860–61

5225 SYCAMORE AVENUE, THE BRONX

ARCHITECT: UNKNOWN

DESIGNATED: OCTOBER 13, 1970

Originally known as Stonehurst, the Katzenbach House is one of the most elegant mid-nineteenth-century country residences along the Hudson. It was built in 1861 for Robert Colgate, manufacturer and philanthropist and the eldest son of William Colgate, the pioneer soap manufacturer; it was later the home of Nicholas de B. Katzenbach, a former U.S. attorney general and undersecretary of state. As the name suggests, Stonehurst continued the Bronx tradition of great stone mansions—this time in superbly cut random ashlar of smoothly dressed gray granite from Maine.

Stonehurst is quite different from other Anglo-Italianate villas in the Hudson River Valley. It has a classical quality and symmetry that are most unusual in romantic, picturesque architecture. Its most notable features include a bold, semicircular, two-story projection, a low-pitched roof with broad eaves, round-arched windows, a bull's-eye window set beneath a low-pitched central gable, and a massive pair of paneled doors in an arched opening.

Stonehurst offers a sensitive response to its beautiful setting. The rooms in the projecting portions all have large windows, providing spectacular views in three directions—characteristic of the interest in landscape that typified the age of Emerson and transcendentalism.

157, 159, 161, 163–165 EAST 78TH STREET

1860–61

MANHATTAN

BUILDER: HENRY ARMSTRONG

DESIGNATED: APRIL 18, 1968

Just prior to the Civil War, the area above 42nd Street developed as a

residential district for working-class and lower-middle-class New Yorkers. These red-brick row houses are among the few remnants of this earliest development. John Turner, described as a painter, hired Henry Armstrong, a local builder, to erect the houses in 1861. The prices of lots on this block were rising more rapidly than they had in the previous fifty years, and Turner apparently decided to build these speculative houses when he could be assured of making a profit. Work began in the fall of 1860 and finished in March 1861, in time for the city's moving day on May 1, when leases were traditionally renewed.

Developer architecture in the mid-nineteenth century—although often well built—was "designed" in a watered-down version of the style of the day. (The same is true today.) The predominant style since the 1850s was Italianate. In modest structures such as these, the style manifests itself only in slightly distended proportions, especially of the main floor, where the formal parlor was located. The molded lintels and pressed metal cornices stand in marked contrast in detail to Greek Revival fascia and the short attic story. The cornice has four acanthus brackets with three modillions between each pair. The unmolded brownstone stringcourse is a vestigial base molding, historically marking the lower rustication in an Italian palazzo. The original stoops, which were probably of brownstone or wood, have been removed. The houses are still in good condition; number 159 retains the most original features both inside and out.

EAST 78TH STREET HOUSES

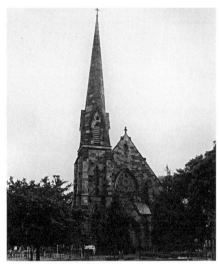

GRACE EPISCOPAL CHURCH

GRACE EPISCOPAL CHURCH

155–03 JAMAICA AVENUE, QUEENS

DESIGNATED: MAY 25, 1967

GRACE EPISCOPAL CHURCH, 1861–62;
CHANCEL 1901–2

ARCHITECTS: DUDLEY FIELD, NAVE
AND TOWER; CADY, BERG & SEE

GRAVEYARD

ESTABLISHED C. 1734

Grace Episcopal Church was founded in 1702, when members of the congregation requested a minister from the

Society for the Propagation of the Gospel in Foreign Parts, an English missionary association. The widow and heirs of Colonel C. Heathecote of New York deeded about half an acre of land to the rector, Thomas Colgan, in 1733; the first church on the site was completed in the following year. The graveyard dates largely from this time, although the presence of several seventeenth-century graves suggests that an earlier church stood here.

A second building from the late eighteenth century replaced the 1734 structure and was in turn replaced by the present structure, built by Dudley Field, a little-known New York City architect. Field worked in an Anglo-American version of the Gothic Revival, established as the dominant style for Episcopal church design by Upjohn's Trinity Church (p. 120). The specific sources, however, are earlier than the fourteenth-century models used for Trinity. Here, the basis for the design is twelfth-century English Gothic, characterized by narrow, single lancet windows without tracery and a feeling for heavy forms, which Field rendered in a local rough-cut sandstone. The steeply pitched roof and heavy, gabled steeple with broached spire are also typical. The New York City firm of Cady, Berg & See added the chancel between 1901 and 1902; in material and style, it matches the earlier structure perfectly.

The most famous person buried in the graveyard is Rufus King, a member of the first U.S. Senate in 1789, owner of King Manor (p. 63), and an active member of the congregation.

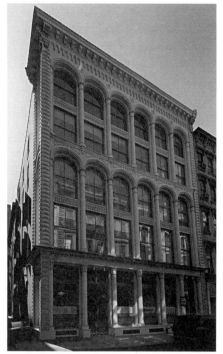

CONDICT STORE

CONDICT STORE

1861; 1989–90

55 WHITE STREET, MANHATTAN

ARCHITECTS: JOHN KELLUM & SON; IRON COMPONENTS BY DANIEL D. BADGER

DESIGNATED: MARCH 22, 1988

Commissioned by cousins John Eliot and Samuel H. Condict as a store and warehouse for their saddlery business, this cast-iron Italianate building is among the few "sperm candle" designs remaining in New York, so-called because their tall, slender columns resemble candles made from sperm-whale oil. Its vertical and open design, unique to New York, was the forerunner of the modern skyscraper. The large plate-glass windows that allowed for well-lit interiors brought the term "window-shopping" into vogue. The corner site permitted a unique one-bay return, which continues the articulation of the cast-iron facade fabricated by Daniel D. Badger. The utilitarian iron rolling shutters in the rear have been retained, as have the iron pilasters—bearing the Badger foundry plaques—that frame the basement and first floor. The facade was restored in 1989–90, when the building was converted for residential use.

GREEN-WOOD CEMETERY GATES, INCLUDING ATTACHED COMFORT STATION AND OFFICE

1861–65; 1996

FIFTH AVENUE AND 25TH STREET, BROOKLYN

ARCHITECT: RICHARD UPJOHN & SON

DESIGNATED: APRIL 19, 1966

The 25th Street gateway of the Green-Wood Cemetery is an imposing main entrance to the 478-acre cemetery in Sunset Park. Designed by Richard Upjohn, the gateway is a masterful synthesis of late Gothic Revival and High Victorian Gothic architecture.

The central element of the red sandstone entryway is a clock tower flanked by spiked arches that extend over the cemetery gates. The tower's steeple—the apex of the gateway—rises above an open niche and is supported on each side by flying buttresses; these in turn are anchored by massive pinnacled piers that form the outer sides of the arches. Openwork gables surmount the bas-relief sculptures that lie within the recesses of the arches. In keeping with the gate's ecclesiastical Gothic architecture, these decorative features—carved in Nova Scotia sandstone—present religious themes, including the resurrections of Jesus, Lazarus, and the widow's son, as well as allegorical scenes representing Faith, Hope, Love, and Memory, conceived and executed by John Moffit.

On one side of the gate is a cemetery office building and on the other a comfort station. These low, slate-roofed structures complete the entryway. The

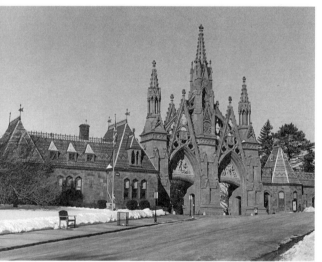

GREEN-WOOD CEMETERY GATES

tower bell announces the approach of a funeral procession to this day.

At the time of its opening, Green-Wood Cemetery offered an alternative to the traditional churchyard cemetery: the rural graveyard. The first such cemetery was Mount Auburn, in Cambridge, Massachusetts, which opened in 1831. Green-Wood opened a decade later in a picturesque landscape of rolling hills, winding paths, streams, and ponds situated on the highest land in suburban Brooklyn. During the mid-nineteenth century, the privately owned cemetery was a popular recreational site and tourist attraction; guidebooks and guided tours celebrated Green-Wood's natural setting, historical monuments, and tombs. Today's visitors can see the graves of such famous Americans as Nathaniel Currier, James Ives, De Witt Clinton, Horace Greeley, and Henry Ward Beecher. Platt Byard Dovell completed the restoration of the gates in 1996.

208–218 East 78th Street

1861–65	
Manhattan	
Architect: Unknown	
Designated: May 9, 1978	

These six houses, of the original fifteen on East 78th Street between Second and Third Avenues, are representative of New York City row house development during the 1860s. When they were built, the block was considered part of the village of Yorkville. Manhattan's residential section had gradually moved northward from the lower tip of the island, although this block was still undeveloped in 1861. Howard A. Martin purchased the property, which he subdivided into fifteen lots, each exactly thirteen and one-third feet wide. The houses were erected by Warren and Ransom Beman and John Buckley, and it is likely that they were identical. William H. Brower, an investment broker, bought the property while the houses were still under construction and sold them to several different owners before building was completed. The four-year construction period was long, but work was no doubt hampered by the Civil War.

The builders were probably responsible for the design of the three-story brick residences. The row houses all share an Italianate style, popular in New York at this time, but the elliptically arched door and window openings are exceptional.

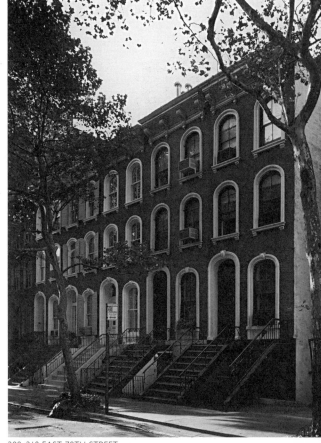
208–218 EAST 78TH STREET

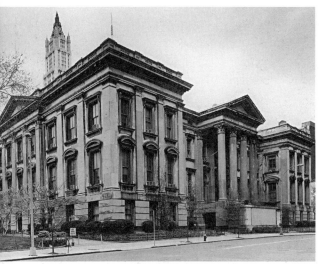

52 CHAMBERS STREET

52 CHAMBERS STREET, FORMERLY NEW YORK COUNTY COURTHOUSE

1861–81; ALTERATIONS, 1911, 1913, 1942, 1978–79; RESTORED, 2002

MANHATTAN

ARCHITECTS: JOHN KELLUM AND LEOPOLD EIDLITZ; RESTORATION, JOHN WAITE

DESIGNATED (INCLUDING FIRST-FLOOR INTERIOR): OCTOBER 16, 1984

Working with his infamous ring of cronies, William M. ("Boss") Tweed, whose name is synonymous with political corruption in New York City, misappropriated nearly $9 million from the construction budget of this building. As a member of the Courthouse Commission, Tweed could skim funds with impunity. In 1861, he bought a stone quarry, from which he sold building materials at an enormous profit to the courthouse contractors. Variations on this procedure were repeated for every

piece of hardware and all the building materials. The exposure of the kickbacks and other illegalities brought about the downfall of the Tweed ring in 1871, and this building has since been popularly known as the Tweed Courthouse.

John Kellum, the principal architect, died in 1871. Before his death, he completed the east and west wings, most of the north facade, and the central hall. All are executed in the Beaux-Arts style and were partly inspired by the design of the U.S. Capitol in Washington, D.C. The four-story facade on Chambers Street contains a pedimented portico with four engaged Corinthian columns and two flanking bays. Foliated brackets and pilasters ornament its smooth-faced marble walls. Each window is supported by consoles on paneled pilasters; the molded sills rest on corbels. On the upper floor, the windows are separated by pilasters with molded capitals. Eyebrow casement windows pierce the frieze. The identical east and west facades are composed of three bays crowned with a central pediment.

After the death of Kellum and the simultaneous breakup of the Tweed ring, construction halted in 1871. In 1876, Leopold Eidlitz was commissioned to finish the north (Chambers Street) porch, to replace the south porch, and to complete the rotunda, skylight, and interior main hall. Eidlitz departed from Kellum's design, employing round-arched windows and bands of rich foliate carving characteristic of the Romanesque Revival. Throughout his additions, ornamental details such as arches, foliation, and octagonal shapes

52 CHAMBERS STREET INTERIOR

unify the external and internal divisions.

Each floor of Eidlitz's south wing varies in design. On the first floor, a cluster of three arched windows appears on the east and west facades; a door with two windows on each side decorates the south facade. The latter resembles Kellum's main facade, minus the portico. It is three windows wide and three windows deep with marble ashlar facing, similar in color to that of the main portion of the building.

A gray asphalt roof, replaced the original corrugated iron roof. Other changes include the construction of two elevator penthouses and the destruction of the grand stairway to allow for the widening of Chambers Street in 1942.

Functional changes have also occurred: in 1927, county pleadings were transferred to New York City's new courthouse. From that year until 1961, City Court was held here; the building then provided overflow office space for the Municipal Building and City Hall. In 2002, a restoration was completed by architect John Waite, including the reconstruction of the grand entrance stairway. The building is now the headquarters of the Education Department.

ST. PATRICK'S CHURCH

1862

53 ST. PATRICK'S PLACE,
STATEN ISLAND

ARCHITECT: UNKNOWN

DESIGNATED: FEBRUARY 20, 1968

St. Patrick's Roman Catholic Church is an early example of the simplicity of design and elegance of proportion that characterized the best of Romanesque Revival architecture. The body of this brick church is rectangular, almost a double cube, with its corners reinforced by square buttresses. Below the gable roof, at the cornice line, is a running arched corbel. Centered on the main facade is a projecting tower; in each wall next to it is a round-arched stained glass window. At the base of the tower is the entrance door, recessed below a large round arch. Above the arch, set in a recessed panel, is a pair of narrow, round-arched stained glass windows beneath a blind rondel. The transition from the tower to the belfry is marked by the same running arched corbel found on the body of the building. A pair of louvered arched openings fills the sides of the belfry, which is capped by a polygonal spire carrying a cross.

This church replaced an earlier, smaller frame structure; the cornerstone for this building was laid on St. Patrick's Day, 1862.

FLUSHING TOWN HALL

1862; 1964

137–35 NORTHERN BOULEVARD,
QUEENS

ARCHITECT: UNKNOWN

DESIGNATED: JULY 30, 1968

Flushing Town Hall, the only remaining small town hall of the 1860s in New York City, is a fine example of the early phase of the Romanesque Revival, a style that became popular in the United States just before the Civil War. From 1862 to 1900, the building was the Flushing Town Hall, and during the Civil War, Flushing's Volunteer Artillery Unit was housed here. Theodore Roosevelt gave one of his presidential campaign speeches from the steps of the portico, and the building later served as an office for municipal bureaus and as a police precinct for the 1964 World's Fair.

The masonry structure appears today much as it did when first built. The front facade is divided vertically into three sections by tall, thin buttresses that rise above the roofline. The walls are topped by continuous bands of diminutive, round-arched corbels and a simple cornice. Pairs of windows under larger, rounded arches adorn the facade. Dominating the front from its position on a platform five steps above the street, the triple-arched entrance carries a full classical entablature on massive pilasters. The building is now the venue for a program of performances and exhibitions under the aegis of the Flushing Council on Culture and the Arts.

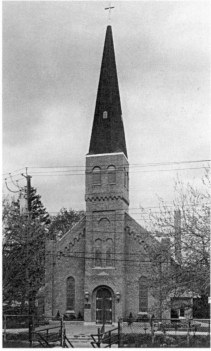

ST. PATRICK'S CHURCH

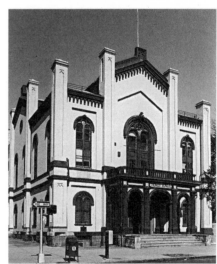

FLUSHING TOWN HALL

FORT TOTTEN BATTERY

FORT TOTTEN BATTERY

1862–64; 2004

WILLETS POINT, QUEENS

SUPERVISING ENGINEER: WILLIAM PETIT TROWBRIDGE

DESIGNATED: SEPTEMBER 26, 1974

The Fort Totten Battery was constructed between 1862 and 1864 opposite Fort Schuyler in the Bronx as part of the seacoast fortification system developed by Joseph G. Totten, chief engineer of the army and an internationally known military engineer. The Totten System featured brick and stone construction and casemate emplacements—that is, vaulted chambers from which guns are fired through embrasures. Totten's innovations determined the form of the superbly constructed battery on Willets Point.

Built of stone, the battery was constructed in the shape of a shallow V with a polygonal bastion at the vertex of the two ramparts. Today the most striking features of the fortification are its sense of weight and the visual rhythm of the openings in the massive walls. The embrasures on the seaward side are square-faced, contrasting with the more

gentle segmental arches of the inner face. The series of tall, narrow openings on both tiers and the broad, segmentally arched openings of the lower tier create sharp contrasts of light and dark.

The Fort Totten Battery is an impressive monument of superior stone construction rarely equaled in the United States. Carefully cut granite blocks, rough-hewn on the seaward face, make up the thick walls. The second tier, which was never completed, today recalls the romantic ruins of post-Renaissance Europe. The battery and the majority of the other buildings at Fort Totten are incorporated in the Fort Totten Historic District, designated in 1999 . In 2004, the City of New York acquired approximately ninety acres of the site from the federal government, with plans to develop about fifty acres as a public park.

RIVERDALE PRESBYTERIAN CHURCH

1863–64

4765 HENRY HUDSON PARKWAY WEST, THE BRONX

ARCHITECT: JAMES RENWICK JR.

DESIGNATED: APRIL 19, 1966

Resembling the parish churches scattered throughout England, the Riverdale Church was constructed of small stones capped by a steep, slate roof. Side wings embrace a small, square tower set within the reentrant angle. The copper steeple was added to the tower at a later date. Following the style of the late Gothic Revival, a projecting stone vestibule and

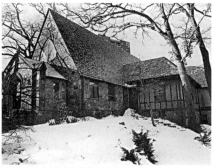

RIVERDALE PRESBYTERIAN CHURCH

a pointed-arched doorway, with a niche above, mark the main entrance. The main gable rises directly behind the entrance and contains a triangular window with traceried trefoils of stone.

12 WEST 129TH STREET

C. 1863; ADDITIONS AND ALTERATIONS, 1882–83, 1896, AND C. 1920S

MANHATTAN

ARCHITECTS: C. 1863, UNKNOWN; 1882–83, EDWARD GUSTAVESON; 1896, ASBURY BAKER; C. 1920S, UNKNOWN

DESIGNATED: JULY 26, 1994

A rare survivor of Harlem's suburban past, this house has undergone many changes. Located in what was once an area of freestanding houses, this structure is now an anomaly, surrounded by apartments, tenements, and row houses. Originally a two-and-a-half-story frame structure, it was built circa 1863 for—and possibly by—two carpenters. Several owners later, in 1883, it acquired its eye-catching, ornamented porch,

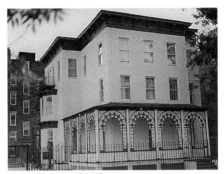
12 WEST 129TH STREET

composed of eight Moorish-inspired arches; a third story was added in 1896, when the property was bought by Franciscan nuns. The final alterations to the building, including a stucco treatment and quoins, gave it the air of an Italian Renaissance villa. Currently vacant, the property is owned by the neighboring Christ Temple Church, which intends to convert it into a seniors residence.

The most significant architectural feature is the wooden porch extending along the original front elevation and the eastern side elevation. At the time of designation, much of the porch had been removed because of deterioration. As built, a series of arches rested on vertical supports and were ornamented with openwork quatrefoils and trefoils and separated by narrow pilasters with beaded edges. The design, created with a scroll saw, demonstrates the sophistication of nineteenth-century woodworking machinery.

GREYSTON

1863–64; 1961; 1970s

690 WEST 247TH STREET, THE BRONX

ARCHITECTS: JAMES RENWICK JR.; RESTORATION: JOSEPH PELL LOMBARDI

DESIGNATED: OCTOBER 13, 1970

Erected during the Civil War, Greyston was commissioned by William Earl Dodge Jr., a prominent merchant closely associated with Phelps, Dodge & Company, international dealers in copper and other metals.

Built as a country residence, this large mansion designed by James Renwick Jr. was influenced by early English Victorian country houses, which combined Tudor features with earlier Gothic traditions. The balanced design is largely the result of later additions to the more picturesque, asymmetrical original design. Constructed of gray granite laid up in random ashlar, the house rises three stories to a polychrome slate roof. The main entrance is enframed by paired Gothic trefoil niches cut into smooth stone. A wood porch continues the Gothic trefoil design in its carved balusters. The river side of the structure is dominated by a polygonal porch, of which a portion has been glazed. The southern roofline is partially hidden by pointed gables and chimneys. Paired and tripled window openings reflect a variety of decorative elements—pointed Gothic arches, cusping, trefoil and quatrefoil motifs, and mullioned windows—derived from English Gothic and Tudor traditions.

The eldest of Dodge's six children,

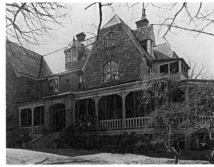
GREYSTON

Grace Hoadley Dodge, was a social worker with an interest in education. In 1887, she founded Teachers' College as an outgrowth of her first organization, the Kitchen Garden Association, which focused on for training for domestic workers. Her nephew, Cleveland E. Dodge, donated Greyston to Teachers' College in 1961. Columbia University used the house as a conference center until the late 1970s, when it was sold to a Zen Buddhist community. Restored by Joseph Pell Lombardi, Greyston is now a private residence.

BRIGHTON HEIGHTS REFORMED CHURCH

325–333 BROADWAY

BRIGHTON HEIGHTS REFORMED CHURCH

1863–64; ADDITION, 1881

320 ST. MARK'S PLACE, AT THE COR-
NER OF FORT PLACE, STATEN ISLAND

ARCHITECT: JOHN CONEJA

DESIGNATED: OCTOBER 12, 1967

DEMOLISHED: JUNE 29, 1996

The Brighton Heights Reformed Church
was demolished following a fire that
started during paint removal work. First
established 1817 in Tompkinsville

as a mission of the Port Richmond
Church and the first missionary church
on Staten Island, the congregation
became independent in 1823 and relo-
cated to St. Mark's Place during the Civil
War. Donations of money and farmland
from Daniel D. Tompkins, governor of
New York and later vice-president of the
United States under James Monroe,
aided the construction. The church was
Gothic Revival with two pairs of stepped
wooden buttresses supporting an octag-
onal steeple. In 1881, the addition of a
terminal transept at the rear of the
church was made possible by the sale
of the Tompkinsville property.

325–333 BROADWAY, ALSO KNOWN AS 90 WORTH STREET

1863–64

MANHATTAN

ARCHITECT: UNKNOWN

DESIGNATED: AUGUST 13, 2002

This commercial palace, at the corner of
Broadway and Worth Street, was con-
structed when this section of Lower
Manhattan was the center of American
wholesale textile trade. One of many real
estate investments by Henry Barclay, the
building is a distinguished example of
the Renaissance-inspired commercial
structures that flourished from the 1850s
through the 1870s in the area now
known as Tribeca, catering to both shop-
pers and manufacturers. Clad in marble,
with cast-iron columns punctuating the
sidewalk storefronts, the building
composition is articulated within a

muted design of segmented arches. The
treatment of the facade as a series of flat
planes layered to express the concealed
structure of the building and the inven-
tive detailing that incorporates abstract-
ed classical motifs, are especially striking
features. Very unusual for the period,
these suggest that the designer had a
sophisticated knowledge of contempo-
rary European architectural trends.

Originally constructed as separate
store-and-loft buildings, the three were
joined internally when all were under
lease as the international headquarters of
Wyckoff, Seamans & Benedict, the mak-
ers and distributors of the Remington
typewriter.

The building remains in commercial
use, with retailing and restaurants at the
street level and offices in the upper
stories.

CHURCH OF THE INCARNATION AND PARISH HOUSE

205–209 MADISON AVENUE,
MANHATTAN

DESIGNATED: SEPTEMBER 11, 1979

CHURCH OF THE INCARNATION,
1864–68; RESTORED, 1882;
SPIRE, 1896

ARCHITECTS: EMLEN T. LITTEL;
RESTORATION, D. & J. JARDINE

RECTORY, NOW PARISH HOUSE,
1864–68; REMODELED 1905–6

ARCHITECTS: EMLEN T. LITTEL;
REMODELING, E. P. CASEY

Built as an uptown chapel of Grace Church (p. 126), the Church of the Incarnation continues to serve the Murray Hill community for which it was erected. Architect Emlen Littel had a large practice, and he specialized in Protestant Episcopal churches in the Pennsylvania, New York, and New Jersey area. The brownstone ashlar structure has a broached early English spire (completed to Littel's designs in 1896). The coping and trim are executed in a lighter sandstone, although city grime has obscured the original contrast in materials. The masonry, tracery, and shallow buttresses, along with the asymmetrical placement of the tower, are characteristic of English thirteenth-century Gothic style, often called the decorated Gothic.

In 1882, a fire destroyed sections of the south and west windows and the east end. David Jardine rebuilt them, lengthened the nave, and added a shallow north transept with additional pews. The interior contains outstanding elements: an oak communion rail carved by Daniel Chester French, a reredos by Heins & La Farge, and windows designed by Edward Burne-Jones, William Morris, John La Farge, and Louis Comfort Tiffany. The chancel mural of the *Adoration of the Magi* is also by John La Farge. The H. E. Montgomery Memorial, dedicated to the second rector, is one of only two works by H. H. Richardson in New York City.

E. P. Casey gave Littel's rectory a neo-Jacobean facade in 1905–6. This building became the Parish House in 1934, when the old parish house and mission

chapel at 31st Street and Third Avenue were abandoned. The small scale and rural character of this church complex recall that of the earliest residential settlement of the country estate of Robert and Mary Murray that gave the neighborhood its name.

17 EAST 128TH STREET
c. 1864
MANHATTAN
ARCHITECT: UNKNOWN
DESIGNATED: DECEMBER 21, 1982

The house at 17 East 128th Street is one of a few surviving frame houses that date from the period when Harlem was still an independent rural village. Constructed about 1864, this two-and-one-half-story, three-bay house was once one of many similarly styled frame houses built in Harlem—particularly between 110th and 130th streets—immediately after the Civil War.

Although its architect is unknown, the house exemplifies a pleasing and picturesque synthesis of Second Empire and Italianate elements. Among its more prominent features are a polychromatic, slate-covered mansard roof and a covered porch that runs the width of the facade at the parlor-floor level.

CHURCH OF THE INCARNATION

17 EAST 128TH STREET

187

WEST 18TH STREET STABLES

West 18th Street Stables

1864

126, 128, 130–132, 136, 140–142
West 18th Street, Manhattan

Architect: Unknown

Designated: December 11, 1990

For private transportation in New York, a horse and carriage were necessities before Eli Olds began mass production of automobiles in 1901. While most New Yorkers either rented horses or boarded their own in large commercial stables, the very wealthy maintained private stables near their houses. In the early 1860s, stables were usually erected a few blocks away from residential areas so that the noises and smells would not disturb the character of the exclusive

WOODS MERCANTILE BUILDINGS

neighborhoods.

This row of stables on 18th Street is an early example of the once-numerous streets devoted to private stables and commercial liveries during the late-nineteenth and early twentieth centuries. All the stables in the row—there were originally thirteen—were designed in the *Rundbogenstil* (round-arched style), which came to the United States in the 1840s with the immigration of German and central European architects. Incorporating Romanesque and Renaissance details, the style was characterized by an emphasis on flat wall surfaces and crisply executed architectural elements, such as the large central arch with a pair of inscribed arches and a bull's-eye tympanum that can be seen on this facade. The typical interior consisted of a ground-floor front room for carriages, a coachman's quarters above, and, in back, horse stalls topped by a hayloft.

Woods Mercantile Buildings

1865

46, 48–50 White Street,
Manhattan

Architect: Unknown

Designated: September 11, 1979

The Woods Mercantile Buildings are handsome examples of mid-nineteenth-century commercial architecture, built when White Street was part of this country's textile and dry-goods center. Built of marble with a cast-iron ground floor, the two were designed as a single unit in a simplified style based on Renaissance architecture. They were erected in 1865 by Samuel and Abraham Wood as first-class storehouses.

Five stories high and ten windows wide with a pedimented roof, the buildings were designed in the form of a cube, flat-roofed and nearly flat-surfaced. The unit had the practical advantages of providing large window areas for better interior lighting, as well as more floor space. A simple, straightforward design with little surface ornamentation, the Woods Buildings are distinguished by their cast-iron storefront with Tuscan columns on polygonal pedestals supporting an unadorned fascia and modillioned cornice, single-window bay units repeated across each floor in disciplined regularity in the upper stories, and a handsome dentiled roof entablature.

ST. JAMES EPISCOPAL CHURCH

2500 JEROME AVENUE, THE BRONX	
DESIGNATED: NOVEMBER 25, 1980	
ST. JAMES EPISCOPAL CHURCH	
1864–65	
ARCHITECT: HENRY M. DUDLEY	
PARISH HOUSE, 1891–92	
ARCHITECT: HENRY F. KILBURN	

ST. JAMES EPISCOPAL CHURCH

St. James Episcopal Church is a picturesque stone building designed for a rural parish in what was then part of Westchester County. The design of the church reflects the ecclesiological movement, which called for a more dogmatic style of architecture inspired by medieval Gothic parish churches. St. James is among New York City's finest Gothic Revival religious structures.

English emigré Henry Dudley, a leading architect of the ecclesiological movement in North America, designed St. James following the eccclesiological principles that emphasized quality materials and orientation on an east-west axis, with the interior plan legible on the exterior. The prominence of the chancel, the steep slope of the roof, the transepts, and the placement of the entrance porch on the southwest corner of the building were also important. Constructed of stone with timber arcades and an open-beamed ceiling on the interior, St. James illustrates these ideas in a simple, beautifully massed structure. The polychromatic effect and various idiosyncratic details of the facade demonstrate that the Victorian Gothic movement was beginning to influence American church design in the early 1860s. The neighborhood of the church is now a heavily urbanized section of the Bronx, only one block north of Fordham Road. With its landscaped grounds, situated next to St. James Park, the church is one of the few surviving reminders of the more rural past of this part of the city.

ST. ALBAN'S EPISCOPAL CHURCH, FORMERLY CHURCH OF THE HOLY COMFORTER

1865; MOVED AND ENLARGED, 1872; 1990	
76 ST. ALBAN'S PLACE, STATEN ISLAND	
ARCHITECTS: RICHARD M. UPJOHN; RESTORATION: LI-SALTZMAN ARCHITECTS	
DESIGNATED: SEPTEMBER 9, 1980	

Located in the old village of Eltingville near the southern tip of Staten Island, this mid-nineteenth-century rural church, constructed of board-and-batten siding, takes full advantage of the versatility of wood as a building material.

ST. ALBAN'S EPISCOPAL CHURCH

Originally known as the Church of the Holy Comforter, it was designed in 1865 by Richard Upjohn. In 1872, the small church was moved to its present site and enlarged, probably also by Upjohn.

The structure, with its vertical members sawed to form a zigzag pattern, has a steeply pitched roof. Under the gable is the entrance porch, with a pitched roof and wooden struts. A polygonal apse is lit by pointed-arched windows with frames constructed of sticks. The transepts and a square bell tower in three sections were added later.

The congregation was first organized in 1865 by Albert Journeay, who donated the land for the first site. He had the assistance and support of many members of the surrounding community. Li-Saltzman Architects completed a major restoration of the church in 1990, including repainting the building in historically accurate colors.

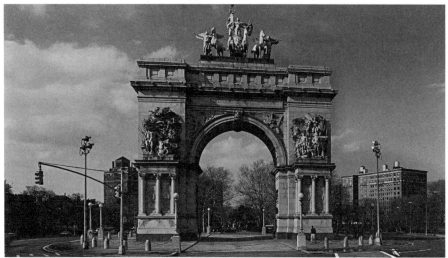

SOLDIERS' AND SAILORS' MEMORIAL ARCH

PROSPECT PARK

BROOKLYN

PROSPECT PARK, DESIGN BEGUN 1865; CONSTRUCTION BEGUN 1866

BOUNDED BY PROSPECT PARK WEST, BARTEL-PRITCHARD CIRCLE ROADWAY, PROSPECT PARK SOUTHWEST, PARK CIRCLE ROADWAY, PARKSIDE AVENUE. OCEAN AVENUE, FLATBUSH AVENUE, AND GRAND ARMY PLAZA ROADWAY ARCHITECTS: FREDERICK LAW OLMSTED AND CALVERT VAUX

DESIGNATED SCENIC LANDMARK: NOVEMBER 25, 1975

LEFFERTS HOMESTEAD, 1777–83; MOVED 1918

PROSPECT PARK (FLATBUSH AVENUE AT EMPIRE BOULEVARD)

ARCHITECT: UNKNOWN

DESIGNATED: JUNE 21, 1966

LITCHFIELD VILLA

1854–57, PROSPECT PARK (PROSPECT PARK WEST AT 5TH STREET)

ARCHITECT: ALEXANDER JACKSON DAVIS

DESIGNATED: MARCH 15, 1966

SOLDIERS' AND SAILORS' MEMORIAL ARCH, 1889–92; ALTERATIONS, 1894–1901

GRAND ARMY PLAZA

ARCHITECTS: JOHN H. DUNCAN; ALTERATIONS, McKIM, MEAD & WHITE

DESIGNATED: OCTOBER 16, 1973

GRECIAN SHELTER, COMPLETED 1905

PROSPECT PARK (NEAR PARKSIDE AVENUE)

ARCHITECTS: McKIM, MEAD & WHITE

DESIGNATED: DECEMBER 10, 1968

BOATHOUSE, 1904

PROSPECT PARK (ON THE LULLWATER)

ARCHITECTS: HELMLE & HUBERTY

DESIGNATED: OCTOBER 14, 1968

Prospect Park, 526 acres of picturesque landscape dotted by flower gardens, meandering pathways, and historic buildings, is one of the largest and most scenic urban parks in the United States. It was designed, starting in 1865, by Frederick Law Olmsted and Calvert Vaux, the landscape architects who had earlier been responsible for Central Park in Manhattan (p. 169). Like Central Park, Prospect Park offered the urban dweller a pastoral escape from the congestion of city life. As Egbert L. Viele, chief topographical engineer of the project, remarked: "The primary object of the park [is] as a rural resort where the people of all classes, escaping from the glare and glitter, and turmoil of the city, might find relief for the mind, and physical recreation."

Construction of the park began in 1866, although planning by the city's commissioners had been initiated as early as 1859, when an act was passed authorizing the selection and location of the park grounds. The outbreak of the Civil War in 1861 delayed any further work until 1865, when Vaux, later to be joined by Olmsted, was appointed. Their plan, based on the popular English-garden mode, called for three very distinct regions: a large open meadow, a hilly wooded area planted with an extensive variety of native and exotic plants and trees, and a vast lake district. A traffic circulation system like that used in Central Park artfully segregated vehicles, pedestrians, and equestrian traffic; the flow of roads and paths connected these regions without disturbing the natural scenery.

In addition to the park's natural landscape, Olmsted and Vaux designed a number of formal spaces, including the Concert Grove, now referred to as the Flower Garden, and the great elliptical Plaza, renamed the Grand Army Plaza, at the main entrance to the park. Dominating the plaza is the monumental neoclassical Soldiers' and Sailors' Memorial Arch originally built by John H. Duncan and altered by McKim, Mead & White; it is dedicated to the men who fought in the Union forces during the Civil War.

Olmsted and Vaux felt that any buildings within the park should be subordinated to the natural setting. Many structures built in the nineteenth century were—they provided rustic architecture in keeping with the rural environment. A number of structures dating from the early twentieth century, however, were products of a renewed interest in classicism and tend to dominate the landscape. The Boathouse, designed by Helmle & Huberty and completed in 1904, is a graceful two-story terra-cotta building recalling Sansovino's magnificent library in Venice. Once threatened with demolition, the Boathouse has been adapted for use as the Prospect Park Audubon Center and Visitors Center by the Prospect Park Alliance. McKim, Mead & White designed the Grecian Shelter, which was completed in 1905. The flowing rhythm of its twenty-eight Corinthian columns, topped by a balustraded terra-cotta entablature, evokes poetic associations of the Greek temple and classical antiquity.

There are two historic houses located in the park. The Lefferts Homestead, built between 1777 and 1783 and moved down Flatbush Avenue to Prospect Park in 1918, is a charming Dutch Colonial farmhouse with a low-pitched roof, arched dormer windows, and a colonnaded porch. Litchfield Villa, already contained within the precincts of the park, was completed in 1856 after a design by Alexander Jackson Davis. It is one of the finest extant evocations of a romantic Italian villa, with its irregular towers, arched doorways and windows, and balustrades.

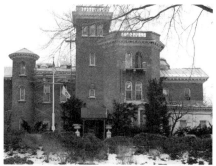
LITCHFIELD VILLA

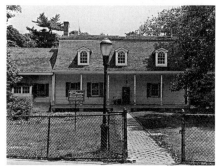
LEFFERTS HOMESTEAD

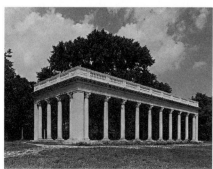
GRECIAN SHELTER

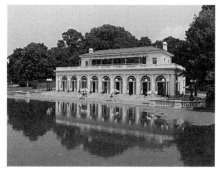
BOATHOUSE

CHRIST CHURCH RIVERDALE

312 AND 314 EAST 53RD STREET

on brackets—recall the French Second Empire style, popular in post–Civil War architecture. The arrangement of the windows is somewhat unusual: the two long ones at the left of the door follow an asymmetrical pattern, while the two above, as well as the dormers, are situated symmetrically. They are all double-hung, with the broad central muntin intended to simulate casement windows. This arrangement was characteristic in buildings that were meant to look French but retain the practicality of double-hung windows.

CHRIST CHURCH RIVERDALE

1866; 1991

5040 RIVERDALE AVENUE,
THE BRONX

ARCHITECT: RICHARD UPJOHN & SON

DESIGNATED: JANUARY 11, 1967

Built in 1866 solely with funds donated by its founders, Christ Church is an example of the Victorian Gothic style. The combination of locally quarried stone and colorful brick creates the patterned facade characteristic of this style.

The west elevation has a pointed-arched stained glass window framed in stone tracery; a pierced wall belfry rises above this elevation. The windows around the altar were executed by the English artist Wailes; a large window in the transept depicting the Supper at Emmaus is by the French artist Oudinot, and the oldest windows in the church were made in Montclair, New Jersey, by Doremus.

The wood framing and the doorway are characteristic of Upjohn's later work with Gothic detail. The church, which is a parish of the Episcopal diocese of New York, has remained unaltered since its consecration, except for the addition of windows on the nave and the construction of a parish house in 1923. The polychromatic slate roof was restored in 1991.

312 EAST 53RD STREET

1866

MANHATTAN

ARCHITECT: ATTRIBUTED TO ROBERT AND JAMES CUNNINGHAM, BUILDERS

DESIGNATED: JUNE 12, 1968

An enchanting wooden structure, 312 East 53rd Street was built for R.V.J. Cunningham. Its mansard roof and heavy door and window enframements—all displaying cornices carried

314 EAST 53RD STREET

1866

MANHATTAN

ARCHITECT: ATTRIBUTED TO ROBERT AND JAMES CUNNINGHAM, BUILDERS

DESIGNATED: JUNE 20, 2000

This narrow rowhouse and its identical neighbor, number 312, were completed just before the 1866 fire law took effect, prohibiting further construction of wood-frame buildings. Few wooden vernacular buildings above 23rd Street have survived; most were demolished in favor of masonry or metal structure.

Both houses combine subdued elements of the French Second Empire and Italianate styles. The mansard roof, dormers, and bracket wooden cornice top two stories of clapboard, all resting on a high brick basement. The pair continue to be used as private residences.

ST. PAUL'S MEMORIAL CHURCH

FIRST UKRAINIAN ASSEMBLY OF GOD

ST. PAUL'S MEMORIAL CHURCH AND RECTORY

1866–70; 1985

217–225 ST. PAUL'S AVENUE, STATEN ISLAND

ARCHITECT: EDWARD T. POTTER

DESIGNATED: JULY 22, 1975

These two buildings are the sole surviving works in New York City by the distinguished church architect Edward T. Potter. Examples of the High Victorian Gothic style, they are noted for their subdued polychromy and skillful use of local stone.

A freestanding structure built on a hill, the church is clearly visible from all four sides and has a view of the Narrows. Constructed of rough-faced, irregularly cut blocks of Staten Island traprock and Connecticut brownstone, the building is distinguished by its broad gable ends and buttressed side walls, which are surmounted by a steeply pitched roof. The pointed-arched entrance is set beneath a gable and a central rose window. Slender stained glass lancet windows are set in the side walls between the buttresses, and the end gables are crowned by crosses.

An example of post–Civil War domestic architecture, the rectory adjoins the church to the south and complements the earlier building in its overall design and use of materials. It is reminiscent of many country gate lodges of the period.

The congregation was organized in 1833, and the first church building consecrated in 1835. Caleb Tompkins Ward —for whom Ward's Hill was named— was the first donor of land for the church. The church was restored after a fire in 1985.

FIRST UKRAINIAN ASSEMBLY OF GOD, FORMERLY THE METROPOLITAN SAVINGS BANK

1867; 1937

9 EAST 7TH STREET, MANHATTAN

ARCHITECT: CARL PFEIFFER

DESIGNATED: NOVEMBER 19, 1969

The Metropolitan Savings Bank built this fireproof commercial building in 1867 and occupied it for sixty-eight years. Since 1937, it has been owned and used for religious purposes by the Ukrainian Church.

The Second Empire masonry skin conceals a structural iron frame. The building presents two impressive facades: one with five bays on Third Avenue, the other with eight bays on 7th Street. A horizontal band at each floor unifies the composition, as do the boldly rusticated base and the ornate cornice. The vertical emphasis of the pilasters framing the windows contrasts with an otherwise horizontal composition. A series of dormer windows, crowned with segmental arches, appears in the mansard roof. A handsome doorway, framed by a central arch and flanked by Corinthian columns, marks the entrance to the building.

193

PUBLIC SCHOOL 34

PUBLIC SCHOOL 340

PUBLIC SCHOOL 34

1867; EXTENSIONS, 1870, 1887–88

131 NORMAN AVENUE, BROOKLYN

ARCHITECTS: SAMUEL B. LEONARD;
EXTENSIONS, JAMES W. NAUGHTON

DESIGNATED: APRIL 12, 1983

One of the oldest schools in continuous use in New York City, P. S. 34 is known as the Oliver H. Perry School, in honor of the hero of the Battle of Lake Erie during the War of 1812. The building occupies the entire block front on the north side of Norman Avenue between Eckford Street and McGuiness Boulevard in Brooklyn. The architect, Samuel B. Leonard, was the superintendent for education of the City of Brooklyn and responsible for many schoolhouse designs until 1879, when Naughton succeeded him.

The school was built in 1867 to meet the needs of the expanding school system in Greenpoint, which—thanks to the efforts of industrialist Martin Kalbfleisch—was flourishing. Dissatisfied with the quality of public education, Kalbfleisch established a school for his own children and others in the Greenpoint area after 1842; he initiated the construction of several similar school buildings, of which this was one.

Brick with stone trim, the school was designed in the Romanesque Revival style with Italianate ornamental motifs. The gabled central section rises two and one-half stories above a rusticated brownstone base, with a central round-arched entrance enframed by brownstone. The flanking two-story pavilions on the Norman Avenue side were added between 1887 and 1888.

PUBLIC SCHOOL 340, FORMERLY P.S. 111, ORIGINALLY P.S. 9

1867–68; ADDITIONS, 1887

249 STERLING PLACE, BROOKLYN

ARCHITECT: SAMUEL B. LEONARD
ADDITIONS, JAMES W. NAUGHTON

DESIGNATED: JANUARY 10, 1978

Prominently sited at the northwest corner of Sterling Place and Vanderbilt Avenue near Grand Army Plaza, this handsome red-brick schoolhouse was designed in early Romanesque Revival style by Samuel B. Leonard. The central portion of the building is gable-fronted and two stories high. The centrally placed entrance, approached by a flight of steps, has a handsome brownstone enframement with Italianate detail. Among the other notable features are paneled pilasters flanking the doorway, round-arched windows, and a ranking cornice outlining the gable. The flanking two-story wings were added to the gabled section in 1887.

In the last years of the nineteenth century, P.S. 9 moved across the street and this building was renamed P.S. 111. Today it is a special high school known as P.S. 340.

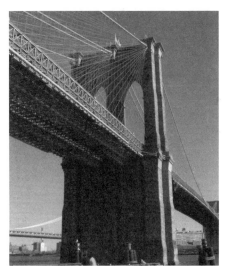

BROOKLYN BRIDGE

BROOKLYN BRIDGE

1867–83

EAST RIVER FROM CITY HALL PARK, MANHATTAN, TO CADMAN PLAZA, BROOKLYN

ARCHITECTS: JOHN A. ROEBLING; WASHINGTON AND EMILY ROEBLING

DESIGNATED: AUGUST 24, 1967

The first to span the East River, the Brooklyn Bridge is the most picturesque of all the bridges in New York City. Embodying the ingenuity of the American spirit, the bridge tied two shores together and united two cities. Its awesome stone towers and the elegant sweep of the cables have inspired more painters, poets, and photographers than any other bridge in America.

This great structure was the largest suspension bridge in the world from the time of its completion in 1883 until 1903, spanning 1,595 feet and rising 135 feet from the river below. The con-

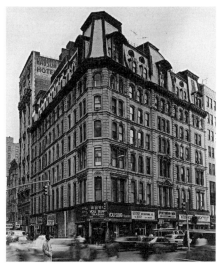

GRAND HOTEL

struction took sixteen years and claimed more than twenty lives. The ultimate triumph of the construction can be attributed to two men, designer John A. Roebling and his son, builder Washington A. Roebling. The cablework is strung across two stone towers and is anchored at both sides by an inventive system of supports embedded in stone. Among the significant engineering feats was the pulley-and-reel system that made it possible to weave the enormous supporting cables.

John Roebling died in an accident at the outset of the fourteen-year construction. His son, Washington, took over as Chief Engineer, but he suffered a crippling attack of the bends during the construction of the Manhattan caisson. He never returned to the site. His wife, Emily, acted as his intermediary.

A milestone in the history of American engineering, the Brooklyn Bridge is an immediately recognizable symbol of New York City.

GRAND HOTEL

1868

1232–1238 BROADWAY, MANHATTAN

ARCHITECT: HENRY ENGELBERT

DESIGNATED: SEPTEMBER 11, 1979

The Grand Hotel, built for Elias S. Higgins, an important manufacturer and vendor of carpets, was designed in 1868, at the beginning of the transformation of Broadway, between Madison and Herald Squares, into the heart of a glittering entertainment district.

The marble building reflects the Second Empire style of the new *hôtels particuliers* lining the side streets of the Paris of Napoleon III. Among its prominent characteristics are slightly projecting end and central bays, with quoins and rich window enframements, that add verticality to the facade; square-headed windows at the second and third floors; segmental-arched windows at the fourth and fifth floors; and full, round-arched windows at the sixth floor, creating an arcade effect below the roof. The sophisticated restraint of the facade contrasts with the elaborate mansard roof above the heavily bracketed roof cornice. Its towers are boldly embellished with dormers that, unfortunately, have been stripped of their ornament.

Both the Grand Hotel and its landmark neighbor, the Gilsey House (p. 200), are symbols of the prosperous post–Civil War era when the hotels of the Ladies' Mile sought to outdo one another in opulence and elegance.

195

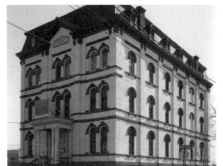

POPPENHUSEN INSTITUTE

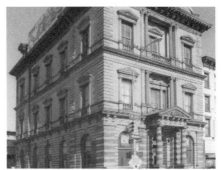

WLLIAMSBURG ART AND HISTORICAL CENTER

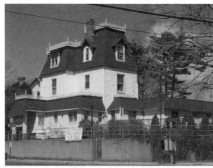

ARROCHAR HOUSE

POPPENHUSEN INSTITUTE

1868

114–04 14TH ROAD, QUEENS

ARCHITECTS: MUNDELL & TECKRITZ

DESIGNATED: AUGUST 18, 1970

The Poppenhusen Institute, a symmetrical three-story brick building with a mansard roof, combines features of the Italianate style with a French Second Empire roof, in a manner typical of civic architecture in the period following the Civil War.

Conrad Poppenhusen, a German immigrant and pioneer of the American hard rubber industry, founded the institute as an adult evening school. Here a newly arrived immigrant could both study English and learn a trade. For the children of working mothers, the Poppenhusen Institute provided a free kindergarten—the first in the United States. Services provided by the institute were eventually expanded to include a library, a savings bank, a youth center, and a town jail.

WILLIAMSBURG ART AND HISTORICAL CENTER, FORMERLY KINGS COUNTY SAVINGS BANK BUILDING

1868

135 BROADWAY, BROOKLYN

ARCHITECTS: KING & WILCOX

DESIGNATED: MARCH 15, 1966

The Kings County Savings Bank is an impressive four-story French Second Empire building. A cast-iron balustrade flanks the structure on the property line enclosing the bank. The main entrance doorway is dominated by a porch with elaborate carving in the pediment. Arched windows at the ground-floor level, with carved keystone blocks, support the strong, horizontal, stone belt course extending around the building. Belt courses supported by columns at the front of the second and third floors also extend around the structure. The ornate bracketed cornice is topped by a mansard roof. Quoins at the corners of the building are a strong unifying element and add to the solidity and dignity of a bank that served the banking needs of Williamsburg for 120 years.

ARROCHAR HOUSE, FORMERLY THE HENRY HOBSON RICHARDSON HOUSE

1868

45 MCCLEAN AVENUE, STATEN ISLAND

ARCHITECT: HENRY HOBSON RICHARDSON

DESIGNATED: MARCH 30, 2004

H. H. Richardson built this house for himself and his family. They lived there until 1874 , when they moved to Brookline, Massachusetts, so that Richardson could supervise the construction of Trinity Church in Boston. The house is one of only two buildings in New York City attributed to Richardson, one of the most influential nineteenth-century American architects.

The house is set on a hill overlooking the harbor. The distinctive massing has an assortment of spaces, projections, and picturesque details, including a steep, slate-covered mansard roof with intricate iron cresting that emphasizes its height and irregularity. Tall brick chimneys extending above the roof further accentuate the picturesque. The building has been altered over the years, but the original roofline, cresting, cornice

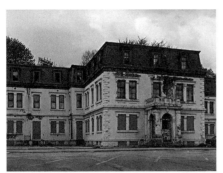

U.S. COAST GUARD STATION

brackets, and dormer features still exist.

For many years, the house was used as medical offices. In 2004, The Landmarks Preservation Commission moved to designate the house, which was under contract for sale and threatened with demolition. In response to concerns by the owners, the LPC agreed not to designate half the tax lot, about 16,000 square feet, leaving open the possibility of future development on that part of the property.

U.S. Coast Guard Station Administration Building, formerly Third District U.S. Lighthouse Depot

1868–71; additions, 1901

1 Bay Street, Staten Island

Architect: Alfred B. Mullett

Designated: November 25, 1980

This French Second Empire building was designed by Alfred B. Mullett, supervising architect of the Treasury Department from 1865 to 1874. Built in granite and red brick, the three-story structure was enlarged in 1901, with the additions also in the French Second Empire style. Centrally located on the grounds of the former Coast Guard Station at the foot of Bay Street, the building has a long history of government service; for nearly seventy years it was the main office of the Lighthouse Service Depot for the Third Lighthouse District.

Originally the building had the same basic arrangement of openings on all four sides. Today only the front facade remains totally unaltered, with a central square entrance porch built of rock-faced granite. The sloping mansard roof has metal-framed dormer windows with decorative Flemish scrolls. The wings, added in 1901, are joined to the original building by small, square entrance bays that fill the corners and rise the height of the building. The rear facade was redone in the same year.

All six buildings on the site are now vacant. Building 11 is being rehabilitated by the New York City Economic Development Corporation as the National Lighthouse Museum, which is expected to open in 2005. NYCEDC hopes to reactivate the entire site.

The Century Center for Performing Arts, formerly Century Association Building

1869; 1996–97

109–111 East 15th Street, Manhattan

Architects: Gambrill & Richardson

Designated: January 5, 1993

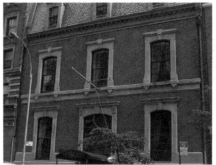

CENTURY CENTER FOR PERFORMING ARTS

Of the many nineteenth-century clubs, the Century Association is the earliest surviving example. The Century Association, dedicated to "plain living and high thinking," was founded in 1847 to promote interest in literature and the arts. Its membership has been an eclectic mix of some of New York's cultural, business, and political leaders. Since 1891, the Century Association has occupied the building at 7 West 43rd Street (p. 265).

The club purchased a building on this site in 1857, but in 1866, the members decided to replace it. Gambrill & Richardson, the firm that subsequently designed Trinity Church in Boston and the State Capitol in Albany, were selected as architects. The building exemplifies the neo-Grec style that became popular in the 1870s. An American interpretation of Parisian models, the facade is characterized by abstracted classical motifs, angular forms, and incised ornamentation. A mansard roof caps the symmetrical, three-bay, three-story building, and keyed quoins surround the windows on the basement level. In 1996–97, the building was restored and converted to a theater.

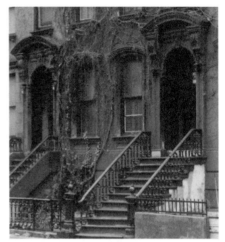

LANGSTON HUGHES HOUSE

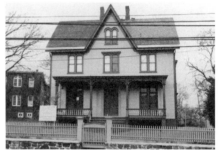

EDWARDS-BARTON HOUSE

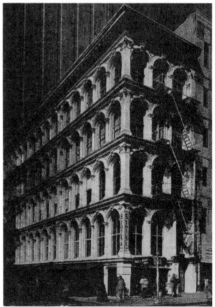

319 BROADWAY BUILDING

LANGSTON HUGHES HOUSE

1869

20 EAST 127TH STREET, MANHATTAN

ARCHITECT: ALEXANDER WILSON

DESIGNATED: AUGUST 11, 1981

Typical of the row houses built in Harlem during the period after the Civil War, this modest building was the home of Langston Hughes, one of the foremost figures of the Harlem Renaissance.

The brownstone house in the Italianate style is three stories above a basement. It was constructed in 1869 by James Meagher and Thomas Hampson. Cast-iron stair railings lead to the entrance at the parlor-floor level. The facade is crowned by a bracketed and modillioned sheet-metal cornice.

Langston Hughes was born in Joplin, Missouri, on February 1, 1902. After a childhood of frequent moves, he came to New York to attend Columbia College in 1921. His first publications—*The Weary Blues* (1926) and *Fine Clothes to the Jew* (1927)—date from this period. During the 1930s, he published four books and a play and established the Harlem Suitcase Theater.

Although Hughes traveled widely, he always returned to Harlem, which he described as the source of his literary inspiration. During the 1930s, he met Emerson and Ethel Harper. When the Harpers purchased this house in 1947, Hughes moved in with them, occupying the top floor. Here he spent the last twenty years of his life, writing poetry, nonfiction, humor, and libretti.

EDWARDS-BARTON HOUSE

1869; RESTORED 1970S

3742 RICHMOND ROAD, STATEN ISLAND

BUILDERS: BEDELL & HILL

DESIGNATED: JUNE 26, 2001

The Edwards-Barton house is fine and well-preserved example of a rural house type that is now very unusual in New York City. Built for Webley Edwards, a prosperous businessman and government official, the house occupies a prominent site in Richmondtown. After his death in 1870, the house passed to his widow, Deborah Mereseau Edwards, and later to his daughters Lucretia Edwards and Ella Barton; the Aquilino family occupied it until 1966.

319 BROADWAY BUILDING

1869–70

MANHATTAN

ARCHITECTS: D. & J. JARDINE

DESIGNATED: AUGUST 19, 1989

This exquisite cast-iron building is the survivor of a pair built for General Thomas A. Davies, a Civil War hero and Croton Aqueduct engineer. Because of their location off Thomas Street, the pair of Italianate buildings was referred to as the Thomas Twins until number 317 was demolished in 1971.

The buildings were constructed to house a bank and offices on land leased by General Davies from the New York Hospital, which was formerly adjacent to this site. Thomas Street was once the carriage drive into the grounds of the

INSTITUTO CERVANTES

hospital. Davies hired as architects David and John Jardine. They modeled their design after the Sun building in Baltimore, which had introduced the Italianate style to the United States in 1850. Characteristically, the building has a lively facade capped by a flat roof with a deep cornice. The cast iron was manufactured by Architectural Iron Works.

INSTITUTO CERVANTES, FORMERLY AMSTER YARD

1869–70

211–215 EAST 49TH STREET, MANHATTAN

ARCHITECT: HAROLD STERNER

DESIGNATED: JUNE 21, 1966

RECONSTRUCTED: OCTOBER 2002

Amster Yard, a picturesque, L-shaped courtyard in the heart of midtown Manhattan, is one of the most charming enclosures in the city. It is named for James Amster, a designer, who had the

idea in 1945 to take this oddly shaped lot and convert it into an oasis. Amster transformed aging brownstones and workshops into a cloister of shops, and small residences, which he presided over until his death in 1986.

The Instituto Cervantes, a Spanish cultural organization, bought the property in 1999. The Landmarks Preservation Commission issued a permit for renovation, but instead the owner demolished the buildings without public notice, citing safety reasons. New construction, closely following Amster's original plans, has sought to recreate and in many cases, replicate down to the details, the character of the courtyard, as it existed in Amster's time. A new multi-level glass bridge, designed by Barcelona architects, is compatible with the eccentricities of the original space. Preservationists, disturbed by the lack of process, posed the question "putting aside all the public issues, 'is this preservation?'"

The courtyard reopened in October 2002, with a reproduction that accommodates the Institute's programmatic needs, including a new auditorium under the courtyard, a library, and office, classroom, and exhibition space.

901 BROADWAY, FORMERLY THE LORD & TAYLOR BUILDING

1869–70; 2003

MANHATTAN

ARCHITECT: JAMES H. GILES

DESIGNATED: NOVEMBER 15, 1977

The former Lord & Taylor Building is a vivid reminder of the architectural

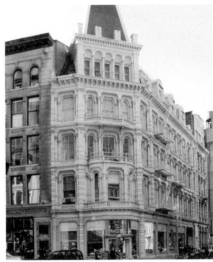

901 BROADWAY

splendor of the Ladies' Mile, where many commercial emporiums were built in the grandest and most impressive styles. Designed in the French Second Empire style, the building was constructed in cast iron and glass. The slender structural system of the facade allowed for eye-catching display windows, which became a chief attraction.

The structure is dominated by its diagonal corner tower, which is flanked by a single bay facing Broadway. The long side on 20th Street is crowned by a mansard roof with dormers. Above the ground floor, the cast-iron facade displays a profusion of decorative features; the play of projections and recessions, the contrast of light and shadow, skillfully combine to give the building a highly ornate and distinctive character.

The building, including the historic cast-iron facade and slate mansard roof, was restored by Daniel K. Bernstein of Kutnicki Bernstein Architects.

199

St. John's Church

1869–71

1331 Bay Street, Staten Island

Architect: Arthur D. Gilman

Designated: February 19, 1974

St. John's Church sits on the corner of Belair Road and what is now called Bay Street. The first church on the site was consecrated in 1843. This larger and more elaborate structure accommodated a growing congregation.

The church is noted for its beautifully colored stained glass windows. Reminiscent of an English parish church in both style and setting, St. John's was designed by Arthur D. Gilman in a Victorian Gothic style. The handsome pink granite structure is dominated by a tower surmounted by a high spire above the crossing. Flanking buttresses on the western and eastern ends and at the transepts accentuate the large pointed-arched windows, distinguished by their tracery. Cruciform in plan, the church has three aisles and a steep, peaked roof that extends the length of the nave and above the transepts. Windows, each consisting of three Gothic arches under a segmental arch, are set in the clerestory walls above the roofs of the side aisles. The square belfry tower above the crossing has a louvered pointed-arched opening on each side and is crowned by a crenellated parapet. The pointed, eight-sided spire was added in the 1960s after wind damage had destroyed the original.

The front churchyard is set behind a handsome cast-iron fence of the period.

ST. JOHN'S CHURCH

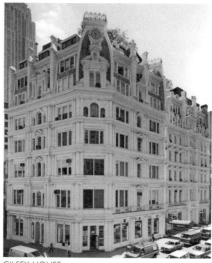

GILSEY HOUSE

The spire has always been a prominent landmark for ships coming through the Narrows along the shore of Staten Island, and the church bells tolled a welcome to troopships returning from Europe after World War I.

Gilsey House

1869–71; 1992

1200 Broadway, Manhattan

Architect: Stephen Decatur Hatch

Designated: September 11, 1979

The last surviving farmhouse in Midtown was demolished to make way for the Gilsey House, one of the city's most imposing French Second Empire cast-iron and marble buildings. It was designed as a hotel by Stephen Decatur Hatch for Peter Gilsey, a prominent real estate developer and an alderman for the city. Although expensive to build, Gilsey House became highly profitable when the theater district moved up Broadway.

Its baroque, modulating surface is very different from many flat-fronted cast-iron buildings, and this difference is emphasized by two recessed pavilions topped by a mansard tower with a curved roof. These pavilions are distinguished by flat pilasters bordering Palladian windows at every story. Flat marble areas along the 29th Street facade, now removed, once separated narrower windows. They still have a hierarchy of pediments: urns and broken arches at the lower level, pediments at the next, segmental arches above, and finally, round-headed windows. The three-story, curved, crowning tower of the flamboyant mansard roof calls attention to the grand front entrance on the corner of 29th Street and Broadway.

Described by the *New York Times* as "one of the most imposing of our metropolitan palace hotels," Gilsey House attracted coal magnates, railroad opera-

tors, congressmen, and military officers. The hotel later became a center for theater luminaries, and such notables as the opera impresario Oscar Hammerstein (grandfather of the lyricist) resided there. The hotel closed on temporarily on December 10, 1904 and finally ceased operation in 1911. It is now used for retail stores, with cooperative apartments on the upper floors. Except for the ground-floor modernization, the exterior remains to a considerable degree as it was when built more than a century ago. The facades were repainted in a historically accurate cream color in 1992 by Building Conservation Associates.

PUBLIC SCHOOL 65K

1870; FRONT AND REAR EXTENSIONS, 1889

158 RICHMOND STREET, BROOKLYN

ARCHITECTS: SAMUEL LEONARD; JAMES W. NAUGHTON (EXTENSION AND FACADES)

DESIGNATED: FEBRUARY 3, 1981

Built in 1870, P. S. 65K was given its present Romanesque Revival facade in 1889 by James W. Naughton, superintendent of buildings for the Board of Education in Brooklyn from 1879 to 1898. The brick two-story school rises high over a stone basement, with a slightly projecting three-story central tower. The round-arched entrance at the base of the tower is enhanced by a molded archivolt. The second-story tower windows are square-headed with

PUBLIC SCHOOL 65K

BAYSIDE HISTORICAL SOCIETY

stone lintels, and the tympana are decorated with Gothic-derived trefoils; the third-story windows are round-arched. The tower-roof entablature is decorated by a frieze with terra-cotta plaques in the Queen Anne style and is crowned by a balustrade.

The windows of the main section of the school are arched with brick voussoirs and stone archivolts. There are compound segmental-arched windows on the first floor and round-arched windows with terra-cotta tympana on the second. The frieze of the roof entablature is ornamented with terra-cotta plaques.

BAYSIDE HISTORICAL SOCIETY, FORMERLY FORT TOTTEN OFFICERS' CLUB

C. 1870; ENLARGEMENT 1887

FORT TOTTEN ROAD, QUEENS

ARCHITECT: UNKNOWN

DESIGNATED: SEPTEMBER 24, 1974

The first Fort Totten Officers' Club was a modest, frame building topped with late Gothic crenellations. Two additional stories and a second polygonal tower were added subsequently, followed by a rear section and back porch to accommodate the growth of the fort and garrison. Both entrance and side porches feature Tudor arches. Other Tudor details include hood or drip moldings over the windows and roof-level parapets that suggest its military affiliation.

During the Civil War, the site served as a depot for recruits, as a camping ground for volunteer units, and, at one point, as a hospital for wounded Union soldiers. In 1868, an engineering school (which became the U.S. Engineer Depot in 1870) was established by the War Department. In 1898, the "Fort at Willets Point," as it had come to be known, was renamed for General Joseph G. Totten, who had been instrumental in the planning of seacoast defenses.

In recent years, the club building served as a New York City Job Corps center. Today it houses the Bayside Historical Society, which has undertaken the restoration of the structure.

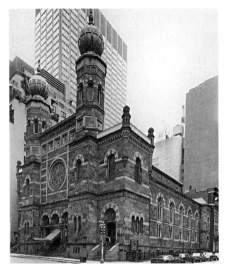

CENTRAL SYNAGOGUE

CENTRAL SYNAGOGUE, FORMERLY CONGREGATION AHAWATH CHESED

1870–72; RESTORED, 2001

652 LEXINGTON AVENUE, MANHATTAN

ARCHITECT: HENRY FERNBACH; RESTORATION, HARDY HOLZMAN PFEIFFER ASSOCIATES

DESIGNATED: JUNE 7, 1966

Central Synagogue houses one of the oldest Reform congregations in continuous service in New York State. It was founded on Ludlow Street in Lower Manhattan as Ahawath Chesed in 1846, when one rabbi, Max Lilienthal, began to share his services with the Shaar Hashomayim, a congregation of German Jews founded in 1839. The present building, designed by Henry Fernbach, a German Jew, was occupied in 1872.

Although nineteenth-century architects felt that the Gothic style was suitable for Christian edifices, there was little agreement on the appropriate architecture for synagogues. Gradually, what might loosely be called a "Moorish-Islamic Revival" came to be favored. The chief characteristics of this style were the banded horseshoe arch and twin onion domes in vestigial minarets applied to either side of a synagogue—the latter conceived of as references to the two columns that stood in front of Solomon's Temple. The Central Synagogue conforms to this type.

The unusual identification of Islamic forms with Jewish religious architecture came about in the early nineteenth century. Historians believed that mosques had incorporated the forms of earlier Jewish architecture, and that the banded arch was the precursor of the pointed Gothic arch. What more appropriate style was there, then, for a synagogue than a literally pre-Christian—i.e., pre-Gothic—style? The Islamic-Jewish typology was set largely by two buildings: Friedrich von Gartner's Munich Synagogue (1832), and Gottfried Semper's Dresden Synagogue (1837), which was widely known through publication in the *Allgemeine Bau-Zeitung* of 1847. Fernbach could have known the building through publication or directly; he was born in Prussian Silesia and studied at the Berlin Building Academy. After he immigrated to the United States in 1855, he used the Moorish Revival and the German *Rundbogenstil* in several other important synagogues.

The exterior coloration of Central Synagogue is muted. The interior, arranged on a Gothic plan, is a riotous

EASTERN PARKWAY

explosion of colorful Near Eastern motifs. The designs and color are indebted to Semper's interior, and to the brilliant color plates of the Alhambra that were published in the mid-nineteenth century by English designer and color theorist Owen Jones. Following a major renovation, the synagogue was gutted by fire in 1998. Hugh Hardy of Hardy Holzman Pfeiffer Associates restored the building to its original splendor in 2001.

EASTERN PARKWAY

1870–74; 1990S

BROOKLYN

LANDSCAPE ARCHITECTS: OLMSTED & VAUX

DESIGNATED SCENIC LANDMARK: AUGUST 22, 1978

Eastern Parkway was the first of Frederick Law Olmsted's parkways to be

completed. His new concept of road building consisted of a mall, to be divided down the center by a road to be used for "pleasure riding and driving." Although his original plan—to go "through the rich country lying back of Brooklyn . . . to approach the East River"—was never carried out, Olmsted used the parkway approach in other cities to encourage suburban development within the bounds of the city and provide much needed open space.

Designed as an extension of Prospect Park, the roadway featured a central pleasure drive flanked by picturesque lawns bordered by residential streets. When completed in 1874, Eastern Parkway ran east from Grand Army Plaza to the city limit of Brooklyn.

Today, the parkway is divided into three roadways by two broad, tree-lined pedestrian malls. Concrete and wooden park benches have been placed along the mall walkways, now shaded by trees and paved with asphalt tiles. Although the parkway is now a major artery within the city's transportation system, its original character has been maintained by the generous path it cuts through the early twentieth-century neighborhoods it helped to stimulate.

The formal elegance of the parkway attracted such prestigious cultural institutions as the Brooklyn Museum, the Brooklyn Botanic Garden, and the Brooklyn Public Library—all of which continue to enhance the area. The parkway was restored in the 1990s.

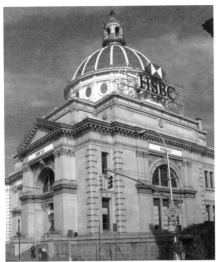

REPUBLIC NATIONAL BANK

REPUBLIC NATIONAL BANK, FORMERLY WILLIAMSBURGH SAVINGS BANK

1870–75; ALTERATIONS, 1905, 1945

175 BROADWAY, BROOKLYN

ARCHITECT: GEORGE B. POST

INTERIOR DESIGNER: PETER B. WIGHT

DESIGNATED: MAY 17, 1966; INTERIOR DESIGNATED: JUNE 25, 1996

With its massive entrance portico and towering dome, the Williamsburgh Savings Bank is an impressive and powerful structure. Constructed in the style of the Classical Revival, this four-story building of limestone, sandstone, and marble displays magnificent architectural detail, such as bronze candelabra flanking the entrance stairs, massive stone quoins at the corners, a rich cornice and lantern, an ornate cast-iron railing extending around the building at street level, and, surmounting the unusual dome, an elaborate cupola topped by a delicate weather vane.

DETAIL OF REPUBLIC NATIONAL BANK DOME

In designing this building, architect George B. Post anticipated by a full generation the American classical resurgence, which was not to come into full flower until after the World's Columbian Exposition of 1893.

The focus of the interior is the great banking hall, a rare extant example of a monumental public space from the post–Civil War era in New York. A grand entrance vestibule with a balcony and a massive vault opens into the banking hall. Dominating the space is a soaring, 110–foot-high cast-iron dome capped by an interior vault. This vault is decorated with an abstract radial mural designed by architect and designer Peter B. Wight, who lost to Post in the initial competition for the commission. The mural, the only known surviving decoration by Wight, contains boldly outlined shapes intended to exaggerate the surface's two-dimensional quality. Stylized botanical details throughout the space complement the mural's forms.

102–45 47TH AVENUE

NEW BRIGHTON VILLAGE HALL (DEMOLISHED)

JONATHAN W. ALLEN STABLE

102–45 47TH AVENUE

C. 1871

QUEENS

ARCHITECT: UNKNOWN

DESIGNATED: FEBRUARY 10, 1987

Built for Edward E. Sanford in about 1871, this small, two-story frame house is one of the last intact nineteenth-century houses in the former village of Newton, one of western Long Island's oldest settlements. Typical of suburban and rural nineteenth-century dwellings in this region, the building was probably designed on site by the contractor. Fine detailing on the porch, eaves, and property-line fence reflects both the nineteenth-century carpenter's skill and the scope of individual expression in routine construction. Additional decorative ornaments, such as window frames and foliate brackets, were mass-produced and available to both carpenter and patron in local lumberyards.

NEW BRIGHTON VILLAGE HALL

1871

66 LAFAYETTE AVENUE,
STATEN ISLAND

ARCHITECT: UNKNOWN

DESIGNATED: OCTOBER 14, 1965

DEMOLISHED: FEBRUARY 2004

The New Brighton Village Hall, which served as the governmental seat of New Brighton until the consolidation of New York City in 1898, was demolished after fifty years of neglect and the eventual collapse of its roof. One of the first buildings to be designated a landmark in the 1960s, it was once a model of Second Empire elegance. The red-brick building had been abandoned by Heritage House, a community group that had acquired it in 1970 but was unable to secure funding for its programs. The City of New York filed suit against the owners in 2002 and continues to pursue them in the courts.

JONATHAN W. ALLEN STABLE

1871

148 EAST 40TH STREET, MANHATTAN

ARCHITECT: CHARLES E. HADDEN

DESIGNATED: JUNE 17, 1997

This stable is a rare survivor from the era when horses were a vital part of everyday life in New York City, used to pull coaches, fire-fighting equipment, delivery wagons, and private carriages. In 1896, it was reported that there were 4,649 stables accommodating 73,746 horses. After 1860, stables were located in the less exclusive areas of the city, a block away from residential sections.

In 1871, Jonathan W. Allen, a broker living at 18 East 42nd Street, purchased an eighteen-foot lot on East 40th Street for a private stable. At the time, the neighborhood of 40th Street east of Lexington Avenue was fully developed with small brick houses, factories, stables, and breweries. The two-story stable

was designed with room for a carriage and horses on the ground floor and living space for the groom above. The structure is faced with brick and accented by stonework. The central carriage entrance has double wooden doors set beneath a segmental brick arch with a contrasting keystone and is flanked by two narrow doors under round brick arches. The mansard roof, with bold pedimented dormers, is crowned with iron cresting.

The stable was owned by Allen and his heirs until 1919, and records indicate the structure was still a stable in 1928. By 1946, the building had been converted to commercial use, with a storage area on the ground floor and an office above.

287 BROADWAY BUILDING

1871–72

MANHATTAN

ARCHITECT: JOHN B. SNOOK

DESIGNATED: AUGUST 29, 1989

The family of Stephen Storm, a prominent wholesale grocer and tobacco merchant, erected this cast-iron building to house banks and offices when Lower Broadway was being transformed into the city's commercial center. Designed in a hybrid Italianate and French Second Empire style, the building features a high mansard roof and an early Otis elevator —both signs of prestige associated with the rise of banking and insurance industries in the 1860s.

The cast-iron facades and the ironwork on both Broadway and Reade

287 BROADWAY

Street were manufactured by Jackson, Burnet & Co. The facades are marked by round-arched windows separated by Ionic columns at the second story and Corinthian columns above, each story crowned by a cornice. The arched window openings are a muted American adaptation of a motif derived from the Colosseum in Rome. The mansard roof —pierced by dormers with segmented pediments and round-arched windows and topped by lacy iron cresting—still boasts its original slate shingles.

While 287 Broadway continues to house commercial establishments, upper floors have been converted to residences.

ST. LUKE A.M.E. CONGREGATION, FORMER 30TH POLICE PRECINCT STATION HOUSE, ORIGINALLY 32ND POLICE PRECINCT

1871–72

1854 AMSTERDAM AVENUE, MANHATTAN

ARCHITECT: NATHANIEL D. BUSH

DESIGNATED: JULY 15, 1986

The former 30th Police Precinct Station

ST. LUKE A.M.E CONGREGATION

House was built as part of a citywide reconstruction and renovation campaign to modernize police facilities. By the early 1860s, the Police Department had retained a full-time official architect, Nathaniel D. Bush. Over the next twenty years, Bush designed more than twenty new or renovated station houses. These larger and more architecturally commanding buildings reflected not only the growth and prosperity of the city, but also the increased professionalism of its police force.

The 32nd Police Precinct erected its first documented station house on land acquired in 1864. By 1869, plans were laid for a "new and more commodious building to meet the requirements of the 32nd Precinct." The new station had a stable building and an annex with a jail and lodging for vagrants.

A fine example of the French Second Empire style, the building is massed in a compact block with symmetrical tripartite elevations. The mansard roof has delicate metal crestings. The brick was originally painted off-white, with classical detail in a contrasting brownstone.

It is now owned by the St. Luke A.M.E. Congregation and the African Methodist Church Self Help Program.

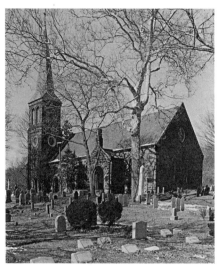

CHURCH OF ST. ANDREW

CHURCH OF ST. ANDREW

1872

OLD MILL ROAD AND ARTHUR KILL
ROAD, STATEN ISLAND

ARCHITECT FOR FINAL REBUILDING:
WILLIAM H. MERSEREAU

DESIGNATED: NOVEMBER 15, 1967

Set in a rolling, verdant churchyard, the
Church of St. Andrew is reminiscent of a
twelfth-century English Norman parish
church. The church was established in
1705 by the Reverend Aeneas
MacKenzie; its charter was granted by
Queen Anne in 1713. The original stone
church with gambrel roof was built in
1709–12; over the next century and a
half, it was damaged by fires and rebuilt
several times, in 1743, 1770, 1807–10,
and 1867. Finally in 1872, William H.
Mersereau constructed the present
building using the original stone walls.
Wall openings ranging in type from
round-arched windows to circular

oculi are framed by keyed brickwork;
they contrast in color and texture with
the rough-cut random fieldstone of the
walls. The steeple consists of a square
tower and a belfry with paired, louvered
openings on each of the four sides, sur-
mounted by a plain octagonal spire. The
stone wall surrounding the churchyard
was constructed in 1855.

During the Revolution, the church
functioned as a hospital for the wound-
ed British; it was the scene of battle in
1777, when Americans attacked the
British troops who had barricaded
themselves inside the building.

614 COURTLANDT AVENUE

1871–72; RENOVATED, 1882

THE BRONX

ARCHITECTS: UNKNOWN; ALTER-
ATIONS, HEWLETT S. BAKER

DESIGNATED: FEBRUARY 10, 1987

This early multi-use building, construct-
ed for Julius Ruppert, originally con-
tained a saloon, public rooms, meeting
rooms, and a residential flat. Although
the architect is unknown, the building is
most likely the work of a builder-con-
tractor. A variety of French Second
Empire motifs are successfully combined
to evoke the several uses of the building.
The structure was renovated in 1882 by
Hewlett S. Baker, who further enriched
the facade.

The building is a monument to the
first stages of urbanization within the
South Bronx, helping to establish a sense
of place in the new village of Melrose

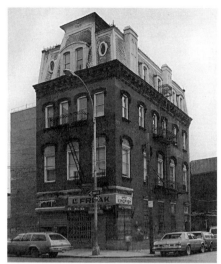

614 COURTLANDT AVENUE

South. In many features it resembles the
buildings along the Bowery, in the area
known as Kleine Deutschland, where
Ruppert first established his business
before moving to the Bronx.

The three-story structure features a
tall second-story window, a heavy, neo-
Grec galvanized metal cornice, Italianate
cast-iron segmental window heads with
foliate corbels and Queen Anne fan-
motif ornament, and raised decorative
ornament on the roof dormers.

WATER TOWER

1872; 1990

HIGHBRIDGE PARK, OPPOSITE
AMSTERDAM AVENUE AT WEST 173RD
STREET, MANHATTAN

ARCHITECT: ATTRIBUTED TO JOHN B.
JERVIS

DESIGNATED: JULY 12, 1967

This slender and graceful water tower in

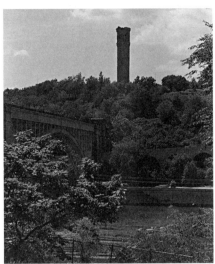

WATER TOWER

Highbridge Park was once an essential link in the system that supplied New York City with water from Croton Reservoir. It was built in 1872 from a design attributed to engineer John B. Jervis, who designed the adjoining High Bridge (p. 119). Resembling a medieval campanile, the tower is a vigorous Romanesque Revival structure that originally supported a 47,000-gallon tank. Water flowed from the tank with adequate pressure to supply the upper parts of the city—in fact, as far south as Murray Hill.

The octagonal tower originally consisted of a base, a simple but high shaft, a louvered belfry, and a conical roof surmounted by a lantern, spire, and weather vane. The arched doorway is crowned by a massive horseshoe arch with heavy voussoirs carried on corbels at each side.

Similar water towers were later built in other parts of the city, but the Highbridge tower, is the only one that remains, although it has not been used as a water tower for many years. In 1958, the Altman Foundation donated a carillon—since removed—for the belfry as a memorial to Benjamin Altman, the department-store owner and art collector. In 1990, the stonework was cleaned and restored, and the prominent cupola, which had burned, was reconstructed.

BENNETT BUILDING

1872–73; ADDITIONS, 1890–92, 1894; RENOVATED, 1983

139 FULTON STREET (ALSO KNOWN AS 135–139 FULTON STREET, 93–99 NASSAU STREET, 28–34 ANN STREET), MANHATTAN

ARCHITECTS: ARTHUR D. GILMAN; ADDITIONS, JAMES M. FARNSWORTH

DESIGNATED: NOVEMBER 21, 1995

The Bennett Building, among the tallest cast-iron buildings in New York City, was designed in the French Second Empire style that Arthur D. Gilman helped to make popular. It is Gilman's only surviving major office building, and one of only two Second Empire office structures left in Lower Manhattan. Instead of the typical cast-iron, column-on-top-of-column design, the Bennett Building's three fully articulated facades are adorned with cornices, paneled pilasters, segmental arch window openings, and distinctive curved corners.

As commissioned by James Gordon Bennett Jr., the publisher and editor of the *New York Herald* who financed Henry Stanley's expedition to Africa in search

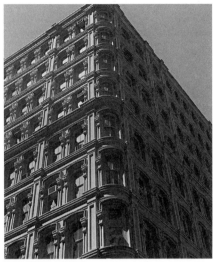

BENNETT BUILDING

of David Livingstone, the building was originally six stories with a mansard roof. In 1889, John Pettit, a leading real estate investor, acquired the building and commissioned the architect James M. Farnsworth to enlarge it by adding four full stories and a two-story masonry penthouse and extending it twenty-five feet to the west. The lower-story facades underwent significant renovations again when Haddad & Sons acquired it in 1983. The off-white facade was painted in pink, aqua, and cream, leading the *New York Times* to call it a "multicolored cast-iron confection," and to compare it to "an ice cream parlor at Disneyland." E.N.T. Realty bought the building in 1995.

BOUWERIE LANE THEATRE, FORMERLY THE BOND STREET SAVINGS BANK

1873–74

330 BOWERY, MANHATTAN

ARCHITECT: HENRY ENGELBERT

DESIGNATED: JANUARY 11, 1967

The Bond Street Savings Bank, which became the German Exchange Bank and after 1963 the Bouwerie Lane Theatre, was built on a conventional 2,500-square-foot building lot at the northwest corner of the Bowery and Bond Street. Architect Henry Engelbert was faced with the problem of creating an impressive bank building with only a twenty-five-foot facade on the more important of the two streets, the Bowery. He solved this by designing an elaborate entrance on the Bowery and giving the Bond Street side a facade of considerable elegance. He devised a lavish French Second Empire creation with Corinthian columns, single and coupled, divided into bays that stressed its verticality but were offset by cornices at every floor.

The entire impression of the cast-iron building is of a great stone structure, with its heavy quoins apparently bracing the corners, its pediments, its ponderous cornice, and its emphasis on the horizontal. There is a subtle balance between the narrow facade on the Bowery and the long facade on Bond Street. The columns flanking the windows alternate between single and double, and rusticated piers recall the quoins. The central second-story windows are emphasized with pediments, and round-headed windows are played against flat-headed one.

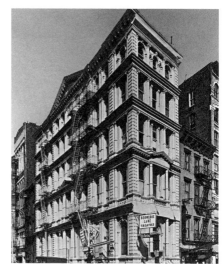

BOUWERIE LANE THEATRE

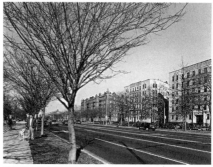

OCEAN PARKWAY

The wealth of almost sculptural ornamental detail makes this building an unusually fine example of the elaborate style of the French Second Empire.

When the bank became a theater, the windows on Bond Street were blocked to darken the interior, as was a secondary entrance. Having served first as a bank, then as a loft building, and finally as a theater, 330 Bowery demonstrates how a century-old building can meet varied needs without compromising its architectural integrity.

OCEAN PARKWAY

1874–76

PROSPECT PARK TO CONEY ISLAND, BROOKLYN

ARCHITECTS: CONCEPT BY OLMSTED & VAUX

DESIGNATED SCENIC LANDMARK: JANUARY 28, 1975

Ocean Parkway, stretching some six miles from Coney Island to just south of Prospect Park, was the first landscaped parkway with adjoining recreation space to be built in the United States. Frederick Law Olmsted and Calvert Vaux, as part of their plans for Prospect Park, suggested that a pleasure drive be extended from the west side of the park to the ocean. This parkway plan was influenced by Baron Haussmann's Avenue Foch in Paris and the Unter den Linden in Berlin.

Two hundred and ten feet wide, the parkway was divided into a central roadway, two malls, two side roads, and two sidewalks. The entire construction cost was initially borne by property owners whose property lay within 1,050 feet on either side of the parkway, and reimbursement did not occur until 1882. Lined with trees, the parkway is also provided with benches, playing tables, and a bicycle path. For many Brooklyn residents, Ocean Parkway is the only readily accessible large, open space with trees and grass. Olmsted and Vaux's original intention that the parkway should serve as a promenade and green belt has to a great degree been realized.

AMERICAN MUSEUM OF NATURAL HISTORY

1874–PRESENT

77TH TO 81ST STREETS AND CENTRAL PARK WEST, MANHATTAN

ARCHITECTS: CALVERT VAUX AND JACOB WREY MOULD (SOUTH CENTRAL WING, 1877); CADY, BERG & SEE (77TH STREET FACADE AND WEST WING, 1908); TROWBRIDGE & LIVINGSTON (EAST WING, 1924, NORTH WING OF ROOSEVELT MEMORIAL HALL, 1933, AND HAYDEN PLANETARIUM, 1935); JOHN RUSSELL POPE (ROOSEVELT MEMORIAL HALL, 1933); POLSHEK PARTNERSHIP, 2000

DESIGNATED: AUGUST 24, 1967; INTERIOR DESIGNATED: JULY 22, 1975

Built chiefly between 1875 and 1935, the American Museum of Natural History consists of twenty-two interconnected units on the site formerly known as Manhattan Square and currently called Theodore Roosevelt Park. The museum's early collections were first housed in the Arsenal in Central Park. In 1869 a group of distinguished New Yorkers, including J. P. Morgan and Theodore Roosevelt (the president's father), donated funds for a new museum. From 1874 to 1877, Calvert Vaux and Jacob Wrey Mould, collaborators on many structures in Central Park, designed a five-story building of pressed red brick with brownstone trim. This structure, now visible only from Columbus Avenue, is in the High Victorian Gothic style. J. C. Cady of Cady, Berg & See designed the central section of the 77th Street facade, whose warm-

toned, expressively worked, pink Vermont granite refers to the work of H. H. Richardson. Equally Richardsonian are the towers and smaller tourelles, as well as the feeling for broad masses with subtle picturesque accents. Cady added the east and west ranges in a matching style between 1894 and 1900.

In 1912, plans were made to extend the museum along Central Park West after designs by Trowbridge & Livingston. Begun in 1920, the new construction included several wings, courts, and the Hayden Planetarium. The monumental entrance front planned to face Central Park was left unfinished. In 1924, John Russell Pope won the competition for this entrance pavilion, which is a memorial to President Theodore Roosevelt, who had a lifelong interest in natural history and environmental conservation. The building is of gray granite and is based loosely on a monumental Roman triumphal arch. The spartan character of the design is entirely appropriate for a memorial. Above the cornice are larger-than-life-size figures of Meriwether Lewis, George Rogers Clark, Daniel Boone, and John James Audubon. The bas-relief on the columnar plinths depicts various animals. The parapets on each side list Roosevelt's accomplishments, and the whole serves as an elaborate backdrop for an equestrian statue of Roosevelt accompanied by an African tribesman and an American Indian. James E. Fraser executed the sculpture.

The ample interior hall has a coffered, barrel-vaulted ceiling. At each end are colossal Corinthian columns of red

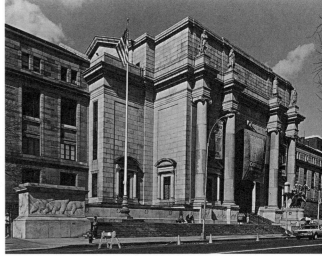

AMERICAN MUSEUM OF NATURAL HISTORY

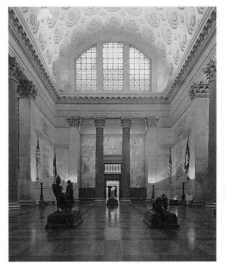

ROOSEVELT MEMORIAL HALL

Alcanti and Verona marbles on bases of Botticini marble. The rich materials are further enhanced by elaborate murals, executed by William Andrew MacKay in 1933, that depict scenes from Roosevelt's life. In 2000, the Rose Center for Earth and Space, the Arthur Ross Terrace, and a new entrance on Columbus Avenue were completed by the Polshek Partnership.

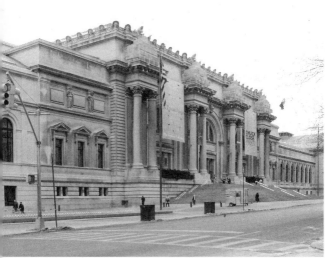

METROPOLITAN MUSEUM OF ART

METROPOLITAN MUSEUM OF ART, INCLUDING THE ASSAY OFFICE FACADE

1874–PRESENT

FIFTH AVENUE AT 82ND STREET, MANHATTAN

ARCHITECTS: CALVERT VAUX AND JACOB WREY MOULD; THEODORE WESTON; ARTHUR L. TUCKERMAN; RICHARD MORRIS HUNT; RICHARD HOWLAND HUNT AND GEORGE B. POST; MCKIM, MEAD & WHITE; BROWN, LAWFORD & FORBES; ASSAY OFFICE FACADE, 1824, MARTIN E. THOMPSON; KEVIN ROCHE/JOHN DINKELOO & ASSOCIATES.

DESIGNATED: JUNE 9, 1967; INTERIOR (VESTIBULE, GREAT HALL, GRAND STAIRCASE) DESIGNATED NOVEMBER 15, 1977

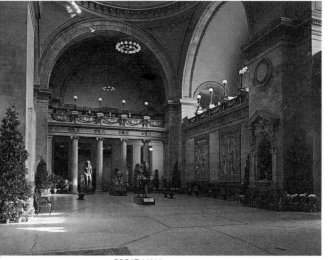

GREAT HALL

Since it opened 1880, the Metropolitan Museum of Art has undergone expansions that have made it one of the largest museum complexes in the world. Majestically sited on Fifth Avenue, the museum offers its millions of annual visitors a collection that is remarkable both in scope and quality.

The original building, designed by Calvert Vaux and Jacob Wrey Mould in the Victorian Gothic style, was oriented toward Central Park. Adjoining wings of red brick, stone bases, and high-pitched slate roofs were completed in 1888 and 1894 after plans by Theodore Weston and Arthur L. Tuckerman. This composite structure was virtually hidden by the monumental Beaux-Arts Fifth Avenue facade, designed by Richard Morris Hunt and extended by McKim, Mead &

White between 1911 and 1926. Henceforth, the building was oriented toward an urban rather than a bucolic setting.

Richard Morris Hunt's imposing entrance centers on three monumental arches set between four pairs of freestanding Corinthian columns on high pedestals, each with its own heavy entablature. These columns support massive blocks of stone which were intended to be carved as sculptural groups. The wings by McKim, Mead & White offer a more restrained classical vocabulary that harmonizes with Hunt's central section. In 1924, the Federal-style marble facade of the Assay Office building, which had been located on Wall Street from 1824 to 1912, was moved to its present location as a part of the American Wing.

As the collections increased and the museum expanded its activities, more space was required. Another series of additions was initiated with the building of the Thomas J. Watson Library in 1964, designed by Brown, Lawford & Forbes. In the late 1960s, Kevin Roche/John Dinkeloo & Associates redesigned the Fifth Avenue staircase entrance. Their building program continued through the 1980s, with the addition of the Robert Lehman Wing (1975), the Sackler Wing (1978) with its Temple of Dendur, the American Wing (1980), the Michael C. Rockefeller Wing (1982), and the Lila Acheson Wallace Wing (1987). This complex of wings presents an austere, modernistic facade to Central Park and creates a dialogue of continuing architectural and historical interest with the Fifth Avenue exterior.

The interior of the museum accentuates this dialogue between the classical Beaux-Arts idiom and the modern aesthetic. The entrance vestibule that opens into the Great Hall, designed by Richard Howland Hunt with the aid of George B. Post after Richard Morris Hunt's death in 1895, is a vast, two-story space that rises beneath three saucer domes with circular skylights; a gallery in the form of a balcony at the second-floor level intensifies the sense of spaciousness, as do the colonnades at each side of the room on the main floor. The Grand Staircase, contained within a long, narrow hallway, sweeps up to the second level, creating a compelling visual axis. In the galleries, Hunt's grandiose, Roman-inspired spatial schemes give way to the more angular, less monumental spaces of the modern style. There is in this progress a logic of movement and harmony of conception. The museum has launched an ambitious interior plan to renovate and reinstall galleries for Islamic art, nineteenth-century and modern art, Greek and Roman art, and photography and to rebuild the Uris Center for Education, to be completed in 2007.

Since its beginning, the museum has sought to encourage and develop the study of the fine arts and the applied arts at every level of society. With continuing expansion and growing historical collections of truly superb paintings, sculpture, furniture, objects, and architectural elements, the Metropolitan Museum of Art has become one of the most important and comprehensive museums in the world.

RIVERSIDE PARK AND DRIVE

PROPOSAL COMPLETED 1875; CONSTRUCTION BEGUN 1877; ADDITIONS, 1934–37

WEST 72ND STREET TO WEST 129TH STREET, MANHATTAN

ARCHITECTS: FREDERICK LAW OLMSTED, CALVERT VAUX, SAMUEL B. PARSONS, JULIUS MUNKWITZ; ADDITIONS, CLIFTON LLOYD

DESIGNATED SCENIC LANDMARK: FEBRUARY 19, 1980

Riverside Park is a long strip of green that runs along the Hudson River from 72nd Street to 129th Street. A successful neighborhood park encompassing 293 acres, it also represents an innovative use of land that otherwise would have been difficult to work into the city's grid plan. Riverside Drive is a significant variation of the Olmsted and Vaux parkway concept. The park was extensively redesigned under the Robert Moses administration in the 1930s, and its appearance today is radically different from the original plan.

The park and a separate drive, known as Riverside Avenue until 1908, were first proposed in 1867; in 1875 Olmsted completed a plan that combined the roadway with the park. The park today contains four basic levels: the drive, the hillside, the plateau constructed over the New York Central railroad tracks, and the landfill at the water's edge, which was added between 1934 and 1937. The Moses restructuring added 132 acres of land, 140,000 feet of paths, and eight new playgrounds to the park.

RIVERSIDE PARK AND DRIVE

Distinctive features include Grant's Tomb (p. 277) and the Soldiers and Sailors Monument (p. 344), the 79th Street marina, the outcroppings of Manhattan schist throughout the park, the promenade from 100th to 110th Streets, and the tree-lined, serpentine drive, with a green island between the two stretches of road on the upper drive. Some of the original walkways and plantings within the park were designed by Vaux, others by Samuel B. Parsons and Julius Munkwitz after Olmsted was dismissed. The walkways follow the contours of the hillside and employ the Olmsted and Vaux device of sequencing, allowing glimpses of the drive, the river, and various statues.

211

FLATBUSH TOWN HALL

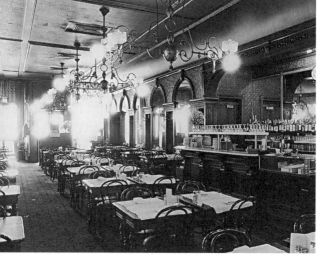

GAGE & TOLLNER DINING ROOM

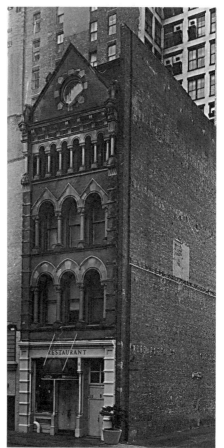

8 THOMAS STREET

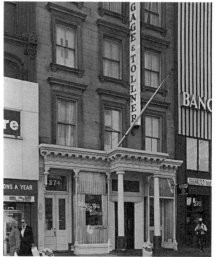

GAGE & TOLLNER

FLATBUSH TOWN HALL

COMPLETED 1875; 1980S

35 SNYDER AVENUE, BROOKLYN

ARCHITECT: JOHN Y. CULYER

DESIGNATED: OCTOBER 16, 1966

Constructed on historic ground—near the site of the August 1776 Battle of Long Island—the Flatbush Town Hall has served as a police headquarters and the seat of the Seventh District Magistrates Court, as well as a venue for social and cultural functions.

The red-brick Victorian Gothic building has buff stone trim accentuated by a series of pointed window arches with carved drip moldings ornamented with bosses. The triple-arched entrance is enhanced by a large central gable, a structural device that crowns the side facades as well. The striking corner tower also has arched windows and a peaked roof above a cornice that rests on corbels. An open terrace, formed by the frontal extension of the building's rusticated granite base, is decorated with limestone balustrades with pierced circular motifs.

A rear addition, consisting of a simple, brown-brick exterior with large, round-arched Georgian Revival windows, was built to house the Homicide Court in 1929–30. Since the relocation of the 67th Police Precinct in 1972, attempts have been under way to transform the building into a civic and cultural center for community use. The building was restored in the late 1980s.

GAGE & TOLLNER

MID-1870S; 2004

372–374 FULTON STREET, BROOKLYN

ARCHITECT: UNKNOWN

DESIGNATED: NOVEMBER 12, 1974; INTERIOR DESIGNATED: MARCH 25, 1975

The restaurant Gage & Tollner had its beginnings in 1879 when Charles M. Gage opened an eating establishment at 302 Fulton Street. In 1880, Eugene Tollner joined Gage, and the restaurant was renamed Gage & Tollner in 1882. Ten years later, the restaurant moved to 372–374 Fulton Street, in the center of downtown Brooklyn. When Gage and Tollner retired in 1911, they sold the business with the proviso that the new owners maintain the customs established by the founders. Joseph Chirico, the most recent owner, closed the restaurant on February 14, 2004 due to financial difficulties. Acquired by T.G.I. Friday's, the restaurant reopened in August 2004 and is operated by their licensee, the Riese Organization. A vertical T.G.I. Friday's sign, in a style consistent with the building, has been approved by the Landmarks Preservation Commission. Interior changes, also approved by the LPC include replacing worn carpeting on the first floor with oak planed flooring and new carpeting and new chairs, tables, and banquettes to replace those removed by the previous owner.

The unusually high, neo-Grec painted wooden storefront that adorns this Italianate building was probably added when the restaurant opened here. The entrance is protected by a portico with modified Doric columns. Secondary entrances set at each side of the front are flanked by slender colonnettes with stylized foliate capitals. A continuous cornice above the ground floor is carried on closely spaced angular brackets with incised motifs, alternating with raised, eight-pointed star motifs in the frieze. A brownstone facade rises above the storefront and a simple modillioned roof cornice with wide facia crowns the whole.

The interior projects the atmosphere of the Gay Nineties. Patrons waited for their tables in two bays, created by projecting wood-framed windows, which flank the entrance. The ceilings are covered with Lincrusta Walton, embossed with a sunburst design. The wall covering has swirling patterns of a more classical type. Arched mirrors with dark red cherry trim lend a sense of spaciousness to the room, which measures only 25 by 90 feet. The paneled bar was transferred from the old restaurant at 302 Fulton Street.

The restaurant used both gas and electricity for illumination, and it was possibly the only restaurant in New York to do so at the time of its closing. This unusual lighting scheme is accomplished by means of the original combination gas-electric fixtures installed from front to rear along the ceiling in 1888, which remain in the designated interior.

8 THOMAS STREET

1875–76

MANHATTAN

ARCHITECT: JARVIS MORGAN SLADE

DESIGNATED: NOVEMBER 14, 1978

Described by the architectural historian Henry-Russell Hitchcock as "one of the handsomest specimens of High Victorian Gothic architecture which survives in the city," this building was erected as a store for the soap-manufacturing firm of David S. Brown Co.

Characterized by a red-brick facade with contrasting stone arcades adorned with banded voussoirs, the style of the building is clearly derived from the Venetian Gothic made popular by the English writer and critic John Ruskin. The ground floor retains its original cast-iron storefront with trabeated bays separated by slender, iron colonnettes and flanked by coursed piers; this motif of the piers is carried into the brickwork of the remaining stories. Other distinguishing features are round arches with pointed extrados, a brick gable crowning the facade, and the abstract, zigzag patterning of the brick.

Although New York once boasted several fine examples of this style, very few survive today. In addition, the building is an interesting reminder of the first large-scale commercial development of the area following the destruction of the grounds of the New York Hospital, which had occupied the site between Broadway, Duane, Church, and Worth Streets since 1773.

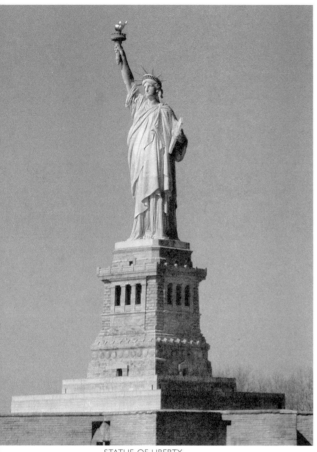

STATUE OF LIBERTY

STATUE OF LIBERTY NATIONAL MONUMENT

DESIGN BEGUN 1871; CONSTRUCTED 1875–86; 1986

LIBERTY ISLAND, MANHATTAN

DESIGNERS: FRÉDÉRIC-AUGUSTE BARTHOLDI (STATUE); RICHARD MORRIS HUNT (PEDESTAL); GUSTAVE EIFFEL (INTERNAL BRACING)

DESIGNATED: SEPTEMBER 14, 1976

The Statue of Liberty has welcomed millions of immigrants to the New World.

It has become known, worldwide, as the quintessential American monument. The idea for the statue, however, was born in France where, in the constrained climate of the Second Empire, America was seen as the embodiment of liberty and republicanism. Edouard-René Lefebvre de Laboulaye, a scholar of American history and a moderate republican intellectual activist, first suggested the statue at a dinner in 1865: "If a monument to independence were to be built in America, I should think it very natural if it were built by united effort,. . . a common work of both nations." Frédéric-Auguste Bartholdi, an eminent French sculptor, was present at the gathering and soon began collaborating with de Laboulaye on the project.

As a result of a series of political setbacks at home—notably the disastrous defeat of the French in the Franco-Prussian War—Bartholdi was not able to set sail for New York until the summer of 1871. He arrived armed with instructions to study America and to propose a joint monument to liberty. He chose the site—Bedloe's Island (renamed Liberty Island in 1956) in New York Harbor—and by the time he returned to France in the fall of 1871, Bartholdi had pretty well decided upon the program of his monument. One contemporary historian described it as "a sublime phrase which sums up the progress of modern times: Liberty Enlightening the World," represented "by a statue of colossal proportions which would surpass all that have ever existed since the most ancient times."

Funding drives began in both

countries in 1875: France was to raise the capital to pay for the statue, and the United States would contribute the cost of the pedestal. By 1881, France had raised her contribution of $400,000, and French enthusiasm even inspired Charles Gounod to compose his 1876 cantata, Liberty Enlightening the World. In the United States, however, the public response was not so favorable; by 1885, only half of the required sum had been raised. In March, Joseph Pulitzer, publisher of the New York World, declared the inability to raise the funds a disgrace. Through Pulitzer's efforts, the required $100,000 was generated in less than five months.

Bartholdi began the statue in 1875, making a series of clay models and various enlargements in the form of plaster cast fragments, until the projected size of 151 feet was reached. For the final statue, wooden molds were made from full-scale plaster fragments, then more than three hundred sheets of copper were riveted and hammered into shape over the molds. The internal structure of wrought-iron bracing was designed by Gustave Eiffel, who entered the project in 1879, ten years before his famous tower opened in Paris. The Statue of Liberty was assembled and displayed in Paris before being shipped, in parts, to New York for reconstruction. The 98-foot granite pedestal and its 65-foot concrete base were designed by Richard Morris Hunt.

On October 28, 1886, the statue was unveiled to the American people. Bartholdi's grandiose project, uniting France and the United States in the

common pursuit of freedom and liberty, was finally realized after fifteen years. A century later, on October 28, 1986, Liberty was rededicated after an ambitious renovation financed by the American public, restored her to youthful glory.

HENRY BRISTOW SCHOOL, FORMERLY PUBLIC SCHOOL 39

1876–77

417 SIXTH AVENUE, BROOKLYN

ARCHITECT: ATTRIBUTED TO SAMUEL B. LEONARD

DESIGNATED: MARCH 8, 1977

Erected in 1876–77 as P. S. 39, this building was renamed in 1916 to honor Henry Bristow, whose home had served as a temporary schoolhouse during the building's construction. Believed to have been designed by Samuel B. Leonard, the three-story brick structure is transitional in style, combining distinctive Italianate features—such as round-arched windows, cornices with modillions, and paired brackets—with mansard roofs typical of the French Second Empire style.

The dominant feature of the Sixth Avenue facade is a central tower with a rusticated first floor. The recessed, arched main entranceway is surmounted on the second floor by two corbel-headed windows beneath a common lintel. These, in turn, are topped by Venetian windows and, finally, by a pair of round-arched windows joined by a central column and framed by a single stone arch.

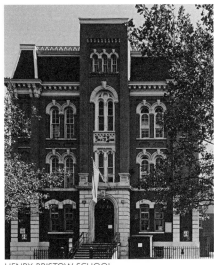

HENRY BRISTOW SCHOOL

Flanking this tower are elongated corner pavilions with stone quoins on the first floor and truncated pyramidal roofs. Steep slate mansard roofs with iron crestings extend to the tower, and a bold roof cornice with modillions and paired brackets crowns the structure.

SAMUEL PELL HOUSE

C. 1876; 1970S

586 CITY ISLAND AVENUE, THE BRONX

ARCHITECT: UNKNOWN

DESIGNATED: OCTOBER 29, 2002

While many freestanding frame houses have been altered or demolished, this commanding residence retains its original clapboards and two-over-two fenestration. The patterned polychrome slate shingles that over the mansard roof are also original; the pedimented dormers and decorative metal flashing were

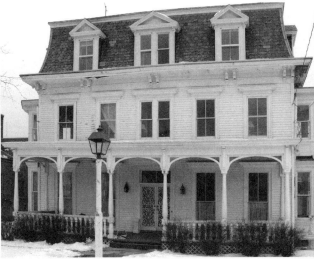

SAMUEL PELL HOUSE

constructed with the rest of the house, around 1876. The French Second Empire style is unusually well represented on City Island. Of the thirteen houses that still maintain these stylistic details, the Pell house is the grandest and best preserved. It is richly embellished with heavy molded door and window surrounds, bracketed cornices, bay windows, and spacious porches with turned posts and curved wood braces.

The house was built for Samuel Pell, a descendant of colonial landowners whose holdings once included most of the eastern Bronx. He made his own fortune in the oyster industry, which brought wealth to the maritime industry on City Island in the nineteenth century. Pell's heir sold the house to James Feeley, an importer of lace curtains, in 1907. Feeley's son, Edgar Feeley, an attorney and part-owner of the New York Giants baseball team, lived in the house until his death in 1972. It is still a private residence.

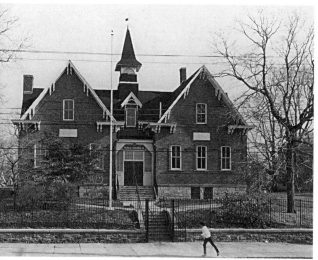

LITTLE RED SCHOOLHOUSE

LITTLE RED SCHOOLHOUSE, FORMERLY PUBLIC SCHOOL 15

1877

4010 DYRE AVENUE, THE BRONX

ARCHITECT: SIMON WILLIAMS

DESIGNATED: JANUARY 10, 1978

About 1875, Simon Williams, head teacher at a single-room frame schoolhouse, drew up designs for a new schoolhouse. In 1877, his building was erected a few blocks southwest of the former schoolhouse near the intersection of Kingsbridge Road and the old White Plains Road. For the next two years, Williams served as the principal of the school, now known as P.S. 15.

P.S. 15 stands on a large grassy lot that slopes down behind the building to Rombouts Avenue; its main entrance faces Dyre Avenue. Like many nineteenth-century schoolhouses in metropolitan areas, it has an H-form plan. The facades consist of a gabled pavilion at

each end with a lower recessed central section. The pavilions stand on rough-faced stone bases. The ground floor of each pavilion is pierced by three segmental-arched windows on the front and rear facades and four identical windows on the sides. At the second story there is a single segmental-arched window in the front and rear gable and bull's-eye windows in the gable sides. A chimney rises through the gable of the side facade of the north pavilion.

Raking cornices, carried on paired brackets and returned slightly under the ends of the gables, crown the building. Over the central entrance is a dormer window with a gable supported on two brackets; above this is a bell tower with pyramidal roof topped by a weather vane. The building is now a community cultural center known as the Little Red Schoolhouse.

175 WEST BROADWAY

1877

MANHATTAN

ARCHITECTS: SCOTT & UMBACH

DESIGNATED: NOVEMBER 12, 1991

An exceptional example of late-nineteenth-century polychromatic brick design, this small four-story office building was erected at a time when improved transportation spurred the construction of commercial buildings in the Tribeca area. During the 1870s, the Metropolitan elevated railway was built at the Sixth Avenue line, drawing West Broadway into the city's transportation

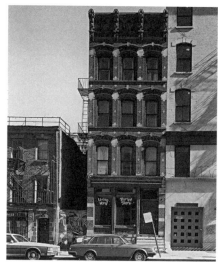

175 WEST BROADWAY

network. Although the area was initially residential—containing the houses and shops of blacksmiths, carpenters, and comb makers—its accessibility to Lower Manhattan quickly attracted four- and five-story loft and office buildings.

The building is typical of many others in Tribeca in the division of the facade into a cast-iron and brick first story and brick upper stories. It is distinguished, however, by its polychromatic brick design and elaborate brick corbeling along the entablature and above the segmental arched windows. The corbeled moldings, stone imposts, and stone courses that enliven the facade show the influence of the German *Rundbogenstil*, or "round-arched style," particularly on architects, like Umbach, of German descent. It is possible that the choice of brick was influenced as well by the major fires in Chicago and Boston in the 1870s, which had proved that brick facades were more fire-resistant than stone or iron.

7TH REGIMENT ARMORY

1877–79; ADDITIONS, 1909, 1930

INTERIOR 1877–78; ADDITIONS AND ALTERATIONS, 1909–11; 1930

643 PARK AVENUE, MANHATTAN

ARCHITECTS: CHARLES W. CLINTON; ADDITIONS AND ALTERATIONS, ROBINSON & KNUST

INTERIOR DESIGNERS: LOUIS C. TIFFANY & CO. WITH STANFORD WHITE, HERTER BROTHERS, POTTIER & STYMUS, ALEXANDER ROUX, KIMBEL & CABUS, MACOTTE & CO., GEORGE C. FLINT & CO.

DESIGNATED: JUNE 9, 1967; INTERIOR DESIGNATED: JULY 19, 1994

7TH REGIMENT ARMORY COLONEL'S ROOM

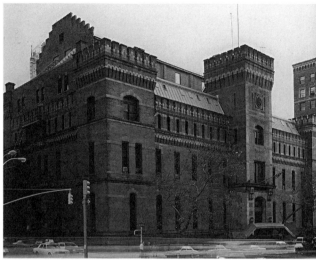

7TH REGIMENT ARMORY

This palatial armory, among the nineteenth century's finest and costliest, was influential in establishing the armory as a distinct building type, in terms of functional design and architectural imagery. The regiment was formed in 1806. It has a long list of battle honors (including service in the War of 1812, the Civil War, and both world wars). During public disturbances (such as the riots of the 1830s and 1840s) the regiment controlled and subdued civilian crowds and protected private and city property from looting and vandalism.

Beyond its official function, the lavish armory was intended to serve as a social club for the prestigious "Silk Stocking Regiment," so called because of its ties to prominent New York families.

The Park Avenue facade of the 7th Regiment Armory evokes the fortified palazzi of north Italian city-states from the thirteenth and fourteenth centuries. The proportions of the three square towers (the central tower was originally topped by a two-story, open bell tower) as well as the insistently flat surfaces of pressed red brick and granite trim mark the building as a High Victorian production. The architect was Charles W. Clinton, a veteran of the regiment and a student of Richard Upjohn, and the premier Gothic revivalist in the United States.

The armory interiors are examples of high-style, late-Victorian taste, possessing the decorative sensibilities of the Aesthetic Movement and using woodwork in the rich Renaissance Revival style. Particularly noteworthy are the drill hall, with the oldest extant "balloon shed" (a barrel-vaulted roof supported on visible arch trusses) in America, and the opulent Veterans' Room and adjoining library (known today as the Trophy Room) designed by Louis Comfort Tiffany and Stanford White. Among the other firms who contributed to the interiors were Herter Brothers (Board of Officers Room, Colonel's Room, Reception Room), Pottier & Stymus (Field and Staff Room), and George C. Flint & Co. (corridors, Entrance Hall, grand central Stair Hall) as well as Alexander Roux, Kimbel & Cabus, and Marcotte & Co.

In 1909, a floor was added to the administration area; in 1930 a fifth floor was added and the third and fourth floors were redone. The first and second floors, however, are unchanged. A landscaped areaway behind a low railing surrounds the building on all but the Lexington Avenue side. The interior is accessible on a regular basis during art and antique shows. The 7th Regiment Armory Conservancy has been formed with the goal of renovating the building and creating a center for the visual and performing arts.

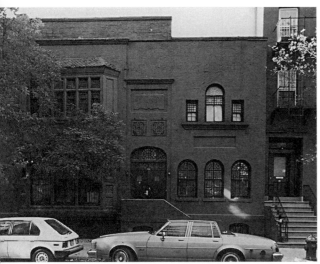

YOUNG ADULTS INSTITUTE

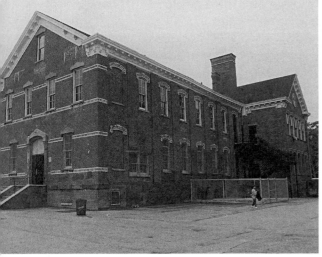

PUBLIC SCHOOL 1 ANNEX

THE YOUNG ADULTS INSTITUTE, FORMERLY THE NEW YORK HOUSE AND SCHOOL OF INDUSTRY

1878

120 WEST 16TH STREET, MANHATTAN

ARCHITECT: SIDNEY V. STRATTON

DESIGNATED: OCTOBER 2, 1990

In 1850, political unrest in Europe, famine in Ireland, and the discovery of gold in California drew thousands of immigrants to this country. Most of them entered through New York, straining the city's existing social and political structures to the breaking point. Individual charities, like the New York House and School of Industry founded in that year, stepped in to provide assistance. Established and run by women from such leading merchant families as the Astors, Van Rensselaers, DePeysters, and Livingstons, the New York House and School of Industry employed "infirm and destitute females" in needlework, keeping "idle hands busy" and lessening "the chances for vice."

Commissioned for the institution, this building is one of the earliest in New York designed in the Queen Anne style. The asymmetrical massing, decorative plaques, projecting oriel, and recessed bays suggest the craftsman's hand—an approach linked to the work of English designer and social reformer William Morris, who believed the preservation of the dignity of labor required a return to production by hand.

In 1951, the school merged with Greenwich House, a settlement facility serving Greenwich Village. The Young Adults Institute, a not-for-profit organization that provides care and shelter for New Yorkers, now uses the building, which has been restored by Anderson Associates.

PUBLIC SCHOOL 1 ANNEX, FORMERLY WESTFIELD TOWNSHIP DISTRICT SCHOOL NO. 5

1878; ENLARGED, 1896–97

58 SUMMIT STREET, TOTTENVILLE, STATEN ISLAND

ARCHITECTS: UNKNOWN; ENLARGEMENTS, PIERCE & BRUN

DESIGNATED: MAY 16, 1995

The small town of Tottenville was named for the family who built Totten's Landing wharf at the southern tip of Staten Island. In 1869, the town was connected to the rest of the island by rail, reorienting its economy toward land transportation and ending its dependence on the ferry. Tottenville became the largest, most populous, and most cohesive settlement on the southern part of the island, and it still retains its character as a distinct suburban village.

Also called "Bay View Academy" for its impressive view of the New Jersey Hills and Sandy Hook, Tottenville's school is set on a T-plan around a central stairwell. The brick facade, with its temple-inspired forms, incorporates stylized classical elements and incised ornament; pilasters and window openings mark the side walls. Denticulated brick window heads, patterned bands, and a bracketed wood cornice stylistically unify the

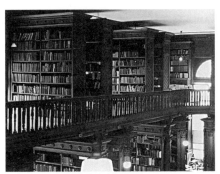

original building and the 1897 addition. Currently serving as P.S. 1 Annex, this is the oldest public school building in use on Staten Island. It houses classrooms and a small gymnasium on the main floor of the original building.

BROOKLYN HISTORICAL SOCIETY INTERIOR, FORMERLY LONG ISLAND HISTORICAL SOCIETY

1878–81; 2003

128 PIERREPONT STREET, BROOKLYN

ARCHITECTS: GEORGE B. POST; RESTORATION: JAN HIRD POKORNY

DESIGNATED: MARCH 23, 1982

Modern techniques employed in conjunction with a stylistic unity produced the most striking internal feature of this building—a light-filled library with generous stack space. On three sides, windows extend from the reading-room level to the balcony level. The north and south walls display three round-headed windows with geometrically patterned stained glass attributed to Charles Booth; five similar windows are located on the east wall. The room itself contains an

octagonal gallery, punctuated by alternating rectilinear and curvilinear posts.

Throughout the structure, black ash bookcases, tables, columns, and railings provide a subtle contrast to this bright and open space. The massive bookcases are ornamented with diagonally arranged panels and a delicate sunburst motif suggestive of the Queen Anne style. Even the twenty-four columns at the ends of the bookcases on the main level were designed to avoid impeding the flow of light. By using iron columnar supports enclosed in newly developed machine-carved casings, Post was able to make the structures less bulky.

Another interesting feature is a freestanding paneled wainscot railing with entrances at each corner of the main room. The walls and the ceiling are finished in white to contrast with the dark wood. Through a balance of texture and form, Post created a structure that reflects the prestige of cultural institutions at the turn of the century, and the consequent attention to detail displayed by these institutions. A restoration of the building was completed by Jan Hird Pokorny Associates in 2003.

ROBBINS & APPLETON BUILDING

1879–80

1–5 BOND STREET, MANHATTAN

ARCHITECT: STEPHEN DECATUR HATCH

DESIGNATED: JUNE 19, 1979

This five-story cast-iron building, one of the finest of its period, was built for Henry Robbins and Daniel Appleton,

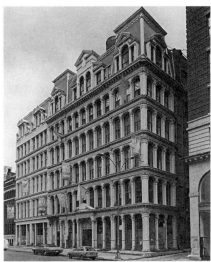

proprietors of the American Waltham Watch Company. The name "Waltham Watches" appeared in gold letters over the two arched windows of the center dormer, while above them was once a large clock face. The high-ceilinged ground floor provided headquarters for D. Appleton & Co., publishers, who also occupied two other floors.

Architect Stephen Decatur Hatch used the French Second Empire style for the building, giving it a mansard roof, the dormered end towers of which suggest symmetrical pavilions. A cast-iron cresting ran along the top of the roof.

When the Landmarks Preservation Commission designated the structure, research revealed that an earlier cast-iron-front building on the site had been destroyed by fire in 1877. An 1876 woodcut shows this earlier Bond Street building to be nearly identical with the present one, and records prove that it was also designed by Hatch for Robbins and Appleton.

219

COACHMAN'S RESIDENCE

COACHMAN'S RESIDENCE, H.F. SPAULDING HOUSE

1879–80; MOVED, 1909;
REMODELED, 1914

4970 INDEPENDENCE AVENUE,
THE BRONX

ARCHITECT: CHARLES W. CLINTON

DESIGNATED: JULY 28, 1981

The Spaulding coachman's house was built as part of an exclusive rural community of private country villas and gardens called The Park, Riverdale. Designed by Charles W. Clinton, the stick-style house was originally part of Parkside, Henry Foster Spaulding's estate.

Head of the woolens firm of Spaulding, Vail & Fuller and the commissions business of Spaulding, Hunt & Co., Spaulding was a prominent community leader and a member of Governor Samuel J. Tilden's committee that overthrew the notorious Tweed ring. Together with New York businessmen William E. Dodge and Percy Pyne, he founded The Park, Riverdale, in 1856. Parkside came into the possession of Percy Pyne Jr. after Spaulding's death in 1893 and was subsequently incorporated into Wave Hill (p. 128), George W. Perkins's estate, about 1900. During the 1930s, Parkside and the neighboring estate Oaklawn were given by Mrs. Perkins to the Riverdale Country School, although the Spaulding coachman's house was retained as part of the Perkins estate.

Originally located on the west side of Independence Avenue—then a carriage route named Palisade Avenue—the coachman's house was moved across the street in 1909 and remodeled in 1914. Another cottage had also been moved to the site in 1909, and the two were joined by an extension added in 1968. Despite these modifications, the picturesque cottage retains much of its original structure and appearance. Its two-story facade is sheathed with board-and-batten siding on the first floor; the second floor has crisscrossed exterior boards that suggest a structural purpose, as if revealing the framing that lies behind them. A steep roof of polychrome slate tops intersecting and overhanging gables with bracketed eaves and jigsaw-ornamented dormer windows. There is a bracketed porch at the entrance. The house is now a private residence.

FORMER COLORED SCHOOL NO. 3, LATER PUBLIC SCHOOL 69

1879–81; 2001

270 UNION AVENUE (ALSO KNOWN
AS 270–276 UNION AVENUE),
BROOKLYN

ARCHITECT: SAMUEL B. LEONARD

DESIGNATED: JANUARY 13, 1998

Located in Williamsburgh, the former Colored School No. 3 schoolhouse is the only known "colored" school building remaining in Brooklyn. Largely intact, the one-and-a-half story red-brick building incorporates elements of the *Rundbogenstil*, including arched window openings and a prominent entrance with large keystones, a raised central section with a gable roof and blind arcade, corbelled brickwork, and dentil courses.

As an institution, Colored School No. 3 evolved from the town of Williamsburgh's original African Free School, founded prior to 1841. The Brooklyn Board of Education took over the school in 1855 and gave it the name "Colored School No. 3," reflecting the city's policy of race-based school segregation. In 1887, it was renamed P.S. 69 to conform to the numbering of other public schools and was later absorbed by the New York City school system following the consolidation of Greater New York in 1898.

Many notable African American educators were associated with the school, including Sarah S.J. Tompkins and Georgiana F. Putnam; Brooklyn's first female black principal, Catherine Clow, became head of the school in 1876.

The Board of Education relinquished ownership of the property in 1934 to the Public Works Commission, and it was later used by the Department of Sanitation. Vacant for many years, the building has been restored by private owners Linda and James Clark, who have salvaged as many architectural elements as possible and restored the front facade in 2001.

JULIA DE BURGOS CULTURAL CENTER, FORMERLY PUBLIC SCHOOL 72

1879–82; ANNEX, 1911–13; 1994–95

1674 LEXINGTON AVENUE (ALSO KNOWN AS 1674–1686 LEXINGTON AVENUE, 129–131 EAST 105TH STREET), MANHATTAN

ARCHITECTS: DAVID I. STAGG; ANNEX, C.B.J. SNYDER

DESIGNATED: JUNE 25, 1996

Named for a Puerto Rican poet who lived in East Harlem, the Julia de Burgos School (P.S. 72) is exemplary of the neo-Grec style that was prominent in New York City public school design during the 1870s and 1880s. David Stagg, super-intendent of school buildings from 1872 to 1886, created a plan that includes airy classrooms and hallways, wide windows, and indoor bathrooms. The symmetrical red-brick building is enhanced by angular and classically inspired brick-and-stone ornament and a dramatic entrance. The stair towers rise one story higher than the surrounding tenement neighborhood to ensure its visibility within the community.

The extension of the Second and Third Avenue elevated trains in 1879–80 precipitated a population boom in East Harlem, and P.S. 72 was part of a broad construction and renovation program to accommodate the increase. Even with this program, the school was over-crowded when it opened; by 1905, East Harlem was the most densely populated uptown district. Seventy years later, P.S. 72 closed due to declining enrollment. It has since been used by Touro College and as a vocational training center. In 1994–95, the building was restored and converted into the Julia de Burgos Cultural Center.

FORMER COLORED SCHOOL NO.3

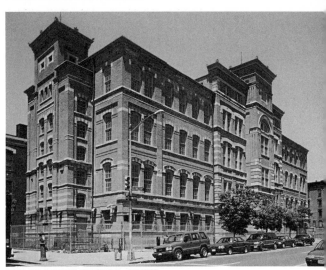

JULIA DE BURGOS CULTURAL CENTER

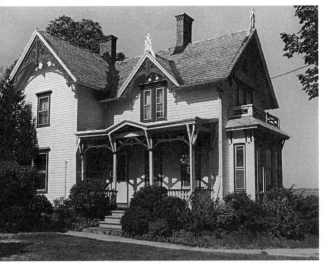

175 BELDEN STREET

175 BELDEN STREET

c. 1880

THE BRONX

ARCHITECT: UNKNOWN

DESIGNATED: JULY 28, 1981

Cottage architecture, developed during the mid-nineteenth century for simple but comfortable living, is seldom found in urban areas. The house at Belden Street is one of only a few cottages known to exist in New York City. Hundreds of architectural pattern books on cottage building were published; the design of the Belden Street house was clearly inspired by these books. A prototype appears in Bicknell's *Victorian Architecture*, published in 1878.

The main section of the clapboard, two-and-one-half-story structure abuts a wing on the north side; there is a one-story porch with jigsaw brackets on both sides of the house. The gable windows, decorative bargeboard marking the eaves, bay windows with bracketed shed roofs, crossed stick-work, corbeled brick chimney, and imbricated slate roof are also typical of cottage architecture and closely resemble Bicknell's composition. The small porches, bay windows, and dormers express the domestic purpose of the cottage.

LITTLE RED LIGHTHOUSE, FORMERLY JEFFREY'S HOOK LIGHTHOUSE

1880; MOVED TO CURRENT SITE AND RECONSTRUCTED, 1921

FORT WASHINGTON PARK, MANHATTAN

DESIGNATED: MAY 14, 1991

Formerly the North Hook Beacon at Sandy Hook, New Jersey, Jeffrey's Hook Lighthouse is the only lighthouse on the island of Manhattan. The forty-foot cast-iron conical tower was erected in 1880 and moved to its current site in 1921 as part of a project to improve navigation on the Hudson River. The lighthouse, with a flashing red light and a fog signal, was in operation from 1921 to 1947, and became known through a celebrated 1942 children's book, *The Little Red Lighthouse and the Great Gray Bridge*, by Hildegarde H. Swift.

In 1931, the usefulness of the lighthouse was diminished by the construction, almost directly above it, of the George Washington Bridge; an aeronautical beacon was placed on the bridge in 1935. By 1951, the lighthouse was no longer needed as a navigational aid,

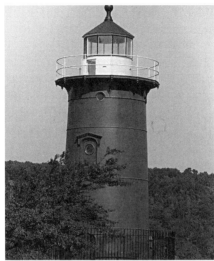

LITTLE RED LIGHTHOUSE

but—thanks to the book's popularity—its impending loss aroused a public outcry, including editorials in the *New York Times* and the *New York Herald Tribune*; a four-year-old boy even offered to buy the lighthouse himself. In response to this overwhelming display of concern, Parks Commissioner Robert Moses requested that the lighthouse be given to the city, and it was placed under the jurisdiction of the Department of Parks and Recreation. In 1979, the lighthouse was added to the National Register of Historic Places.

CENTURY BUILDING

1880–81; 2003

33 EAST 17TH STREET AND 38–46 EAST 18TH STREET, MANHATTAN

ARCHITECT: WILLIAM SCHICKEL; LI-SALTZMAN ARCHITECTS

DESIGNATED: OCTOBER 7, 1986

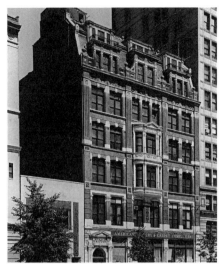

CENTURY BUILDING

The Century Building is one of the few surviving commercial examples of the Queen Anne style in the city. The style is distinguished by the picturesque mixture of seventeenth- and eighteenth-century English motifs. The tall oriel window, gambrel roof, prominent chimneys, and molded terra-cotta ornament are all characteristic of the style. Although classical details are commonly used (such as the Jacobean doorway), these are combined in an unusual and thoroughly non-classical way.

The building takes its name from the Century Co., publishers of *The Century* and *St. Nicholas* magazines, which had offices there. *The Century* was a noted literary publication, carrying work by Twain, James, Whitman, and Melville. Another prominent tenant was the architect George B. Post.

Schickel might have used the Queen Anne style, which was common in domestic suburban designs but almost unknown in urban commercial struc

tures, to draw attention to what was essentially a speculative office building. The Union Square area was booming in the last quarter of the nineteenth century. Unusual or distinctive building design would have been one way of appealing to potential tenants, especially those who thought themselves socially or artistically progressive. Championed by such artists and writers as James McNeill Whistler and Oscar Wilde, the Queen Anne style developed along with the English Aesthetic movement. The building recently underwent an extensive exterior and interior renovation, executed by Li-Saltzman Architects, and now houses a Barnes & Noble store.

MARY HALE CUNNINGHAM HOUSE

1880–81; 1941; 2000

124 EAST 55TH STREET, MANHATTAN

ARCHITECTS: THOM & WILSON; NEW FACADE AND FRONT EXTENSIONS, 1909, ALBRO & LINDEBERG

DESIGNATED: MAY 1, 2001

The Mary Hale Cunningham House is an unusual example of neo-Tudor design and a rare unaltered revival-style town house in Midtown Manhattan. Originally built as French flats in 1880–81, the building was remodeled with a front extension in 1909 as side-street blocks in this area became fashionable. The facade was designed by Harrie T. Lindeberg, one of the leading American specialists in revival-style houses in early twentieth century.

Four stories high and twenty-five feet

MARY HALE CUNNINGHAM HOUSE

wide, the house is constructed of rough-faced purplish brick with limestone-colored terra-cotta trim and a white marble base. The facade features a ground-story enframement with paired fluted Doric pilasters; a monumental keyed enframement on the upper stories; narrow windows with multi-pane sash and ornamental terra-cotta; a band of windows on the top story; and a brick gable flanked with crenels.

Mary Hale Cunningham was the widow of James Cunningham, a partner in the San Francisco firm of Cunningham, Curtiss & Welch. Mary Cunningham moved to New York City sometime before 1905, and later commissioned this house for her family and staff. After her death in 1923, her children rented it to real estate investment broker Richard Collins and his wife, Harriet de Raismes Cutting, an interior decorator. From 1941 to 1978, it was the gallery of Vernay & Jussel. In 2000, Alpha Property Holdings acquired the house.

ASTOR ROW

Astor Row

West 130th Street between Fifth
and Lenox Avenues, Manhattan

Designated: August 11, 1981

8–22 West 130th Street, 1880–81

Architect: Charles Buek

24–38 West 130th Street, 1882–83

Architect: After Charles Buek

40–62 West 130th Street, 1883

Architect: After Charles Buek

The group of buildings known as Astor
Row is made up of twenty-eight houses,
effectively grouped in pairs, that extend
along most of the south side of 130th
Street between Fifth and Lenox Avenues.
Built as a speculative development in the
1880s on land owned by William B.
Astor, the group forms a splendid street
front, recalling the period when Harlem
was evolving from a rural country town
to an urbanized area. The Astor Row
houses were designed by Charles Buek,
who was known for creating elaborate
private homes and apartments for
wealthy clients.

The houses were built in three
groups. Only the first was constructed
under Buek's supervision; the last two
were built without the help of an archi-
tect but were almost identical to those in
the first group. The most significant
difference is that numbers 24–62 stand
as a single row, rather than as freestand-
ing pairs of houses. This difference is
minimized by the deep recesses between
each pair of houses, which give the
effect of separated buildings.

The style of the Astor Row houses
was not only distinct from Buck's other
structures, but was also unlike that of
most other row houses of the time. The
neo-Grec details, typified by the simple,
linear incised design in the lintels, were
more commonly found on commercial
cast-iron buildings. Three stories high,
the buildings are constructed of brick
with light stone trim. Each pair is sym-
metrical, with the center indicated by a
projecting brick pier topped by a stone
triglyph at the cornice line. Each house
is two bays wide and has double doors
and a full-height window on the first
floor. On the upper stories, each bay has
a double-hung window surmounted by
a broad, shouldered stone lintel whose
midpoint is emphasized by a small tri-
angular extension that points down in
front of the window molding. A simple,
projecting stringcourse wraps around
the building at each sill line, with footed
sills located just below. A complete
entablature crowns the front of these
houses, and a cornice with brick dentils
finishes the roofline.

Originally, each house had a large
wooden porch running the width of the
building. Many are still in place, although
some have been rebuilt or replaced.

AUGUST AND AUGUSTA SCHOVERLING HOUSE

August and Augusta Schoverling
House

c. 1880–82; 1930s; 1999

344 Westervelt Avenue,
Staten Island

Architect: Unknown

Designated: January 30, 2001

The Schoverling House, an imposing
and architecturally distinguished Second
Empire style house in northeastern
Staten Island, is one of the remaining
brick buildings in the style. The house
was designed for August Schoverling,
one of the world's foremost importers
and distributors of firearms, and his
wife, Augusta, in Fort Hill, a fashionable
suburban neighborhood settled by well-
to-do German-American families.

Capturing the harbor view provided
by the hilly terrain, the Schoverling
house is set back from the avenue on a
terraced lawn, establishing a command-
ing presence. Asymmetrical in plan, it is
faced in tawny-red iron-spot brick
accented by stone and wood trim. A late
example of the Second Empire style
with neo-Grec detailing, its principal
feature is a projecting towerlike bay

with windows on three sides, set on an angle at the southeast corner of the house. Although missing its railings, the elevated wood porch is original. A multi-colored slate mansard roof with gabled dormers and large chimneys crown the house. Other features include soldier brick band courses, jigsaw-cut elements of the porch and roof gables.

Judge Morgan L. Ryan, the second owner, organized the first juvenile court system in New York City. Salvatore and Fannie Cassariell, who converted the house into apartments in the 1930s, owned the property until the early 1990s. Purchased by its present owners in 1999, the house remains a multiple dwelling.

THE DAKOTA APARTMENTS

1880–84; 1990s

1 WEST 72ND STREET, MANHATTAN

ARCHITECT: HENRY J. HARDENBERGH

DESIGNATED: FEBRUARY 11, 1979

In 1884, the Dakota opened its doors on 72nd Street, across from a still-unlandscaped section of Central Park. The rather desolate area around the new building was dotted with squatters' shacks, and the odd goat, cow, and chicken could be seen in the neighborhood. Many New Yorkers were astounded and most were skeptical, but Singer Sewing Machine magnate Edward S. Clark's dreams for developing the Upper West Side soon proved well founded. His building was fully rented even before it opened, and this at a time when apartment houses,

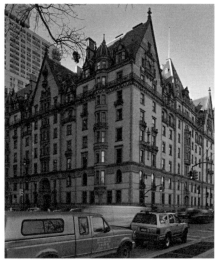

THE DAKOTA APARTMENTS

like hotels, were looked upon as "architectural inducements to immorality." Clark's prosperous tenants had no difficulty overcoming that prejudice. The Dakota, after all, "guaranteed . . . comforts which would require unlimited wealth in a private residence."

"Clark's Folly," as it was dubbed soon after construction began in 1880, was not the first luxury apartment building in New York City, but it quickly became the most famous. Clark defiantly resisted public opinion and called his building the Dakota after the remote Indian territory of the same name. Hardenbergh was instructed to make full decorative use of the Wild West metaphor throughout: motifs such as arrowheads and sheaves of wheat embellish both exterior and interior. A carved Indian head looks out over 72nd Street from above the main entrance. The imposing eight-story yellow-brick and stone-trimmed structure reflects the romanticism of the German Renaissance style. The

principal facades—the north, south, and east (the west, overlooking a lawn that later became a tennis court, was unembellished)—are divided horizontally and vertically into three sections. Horizontally the divisions between the basement, the main body, and the roof are accented by cornices, balconies, and railings. Vertically the building is defined by a simple series of bays; the central bay is slightly recessed from the end. The elaborate roof, with turrets, gables, chimneys, and dormers, continues the tripartite symmetry.

The Dakota offered the some two hundred tenants of its sixty-five ornate apartments complete seclusion from the bustle of New York City. The exterior walls at the base are approximately twenty-eight inches thick, and the three-foot-deep floors were constructed of alternating layers of brick and Central Park mud. A dry moat, bordered by an iron fence punctuated with the heads of sea gods intertwined with sea urchins, surrounds the exterior. The building has an inner courtyard, originally conceived as a carriage turnaround. To give tenants a sense of the privacy of a single dwelling, Otis hydraulic passenger elevators were installed in the small entrance lobbies in the corners of the courtyard.

The Dakota soon became a conversation piece of New York, not merely as an architectural oddity, but also, because of its famous tenants. Boris Karloff's ghost is said to roam the corridors, and its past and present inhabitants include Lauren Bacall, Leonard Bernstein, Roberta Flack, John Lennon, and Yoko Ono.

MAGNOLIA GRANDIFLORA HOUSES

MAGNOLIA GRANDIFLORA HOUSES

LAFAYETTE AVENUE, BROOKLYN

678 LAFAYETTE AVENUE, 1880–83

ARCHITECT: UNKNOWN

DESIGNATED; JULY 12, 1977

679 LAFAYETTE AVENUE, 1880–83

ARCHITECT: UNKNOWN

DESIGNATED: JULY 12, 1977

MAGNOLIA GRANDIFLORA, C. 1885

679 LAFAYETTE AVENUE

DESIGNATED SCENIC LANDMARK:
MAY 12, 1970

677 LAFAYETTE AVENUE, 1890

ARCHITECT: L. C. HOLDEN

DESIGNATED; JULY 12, 1977

Some twenty species of the genus Magnolia are distributed throughout Japan, China, the Himalayas, and the southeastern United States. The most beautiful of the North American species is the *Magnolia grandiflora*, an evergreen that grows with a straight trunk to a height of over seventy feet. The species *grandiflora*, bearing large, white, lemon-scented flowers that are the official state flowers of both Louisiana and Mississippi, rarely flourishes north of Philadelphia. It is remarkable, therefore, that the seedling that William Lemken received from North Carolina in the mid-1880s and planted in the front yard of his house at 679 Lafayette Avenue should have survived so long. Beginning in the 1950s, Hattie Carthan, affectionately known as "the tree lady," led a neighborhood campaign to protect the tree, which is now sheltered by a wing-wall to the north.

Of the three neighboring houses, numbers 678 and 679 are nearly identical three-story neo-Grec residences built in the early 1880s. Number 677 was built in 1890 from designs by the New York architect L. C. Holden.

JAMES WHITE BUILDING

1881–82

361 BROADWAY, MANHATTAN

ARCHITECT: W. WHEELER SMITH

DESIGNATED: JULY 27, 1982

Number 361 Broadway was built for James White, who had inherited the property from his father. It is one of the few late stylized cast-iron structures in an area that was developed before the Civil War. Designed by W. Wheeler Smith, it is one of his few forays into the field of cast-iron architecture.

Based on the design of the Italian

JAMES WHITE BUILDING

palazzo, the building has two facades composed of columns supporting heavy entablatures and adorned with some of the finest and most inventive cast-iron ornamentation based on abstract floral forms. The building is six stories high, six bays wide on Broadway, and eighteen bays wide along Franklin Street. The six Broadway bays are defined by a row of columns terminated at each end by square piers; attached to each pier is a quarter-pilaster, creating the illusion of a row of columns that continues into the piers—a convention dating back to fifteenth-century Italy. The architrave, cornice, and panel-linked pedestals at each floor combine to form a powerful horizontal effect.

For over a century, this building has been connected with the textile trade, which is concentrated at nearby Worth Street. The building is still in commercial use.

TEMPLE COURT BUILDING AND ANNEX

TEMPLE COURT BUILDING AND ANNEX

1881–83; ANNEX 1889–90

3–9 BEEKMAN STREET (ALSO KNOWN AS 119–133 NASSAU STREET AND 10 THEATER ALLEY), MANHATTAN

ARCHITECTS: BENJAMIN SILLIMAN JR. AND JAMES M. FARNSWORTH; ANNEX, JAMES M. FARNSWORTH

DESIGNATED: FEBRUARY 10, 1998

An early "fireproof" office buildings of the period prior to the full development of the skyscraper, the Temple Court building, is also an early example of the use of brick and terra-cotta for the exterior cladding of tall buildings. It is a rare example of an office building of its era constructed around a full-height interior skylighted atrium.

The Temple Court Building and Annex consists of two connected structures. The nine-story main building was commissioned by Eugene Kelly, an Irish-American multimillionaire merchant banker. Constructed of red Philadelphia brick, tan Dorchester stone, and terra-cotta on a two-story granite base, the design employs the Queen Anne, neo-Grec, and Renaissance Revival styles.

The annex was designed by Farnsworth in an arcaded Romanesque Revival-style, and constructed in Irish limestone, which complements the original building. Temple Court is notable for its commanding presence above the low buildings of Park Row facing City Hall Park. The properties were transferred in 1953 to the Larson Holding Corp./ Satmar Reality Corp.

NATIONAL ARTS CLUB, FORMERLY SAMUEL J. TILDEN RESIDENCE

1881–84

15 GRAMERCY PARK SOUTH, MANHATTAN

ARCHITECT: VAUX & RADFORD

DESIGNATED: MARCH 15, 1966

Samuel J. Tilden purchased the house at 15 Gramercy Park South in 1863. He hired Griffith Thomas to remodel the structure, and took residence there in 1866. The house soon became a center of power, where Tilden—who became governor of New York in 1874 and the Democratic contender for the presidency in 1876—entertained politicians, businessmen, and friends.

Tilden bought the adjoining house at 14 Gramercy Park South in 1874, but it was not until 1881 that he asked Calvert Vaux to combine the two structures into

NATIONAL ARTS CLUB

a single residence. Construction was completed in 1884 at a cost of $500,000. The exterior of the two houses was finished in the Gothic Revival style. Griffith Thomas's Renaissance Revival rooms were left intact, but the parlor floor at number 14 was redesigned in the Aesthetic style of the 1880s. Three rooms were combined as a library, with oak carvings, a blue tiled ceiling, and a backlit stained glass dome by Donald MacDonald. Massive sliding doors were installed to shield the windows in the second-floor parlors; Tilden, who had helped to bring about the downfall of the Tweed ring, was fearful of an assassination attempt. The stained glass in the front parlor of number 15 was designed by John La Farge.

After Tilden died in 1886, the bulk of his estate was combined with the Lenox and Astor Libraries to form the New York Public Library. The house was bought in 1906 by the National Arts Club, which occupies it today.

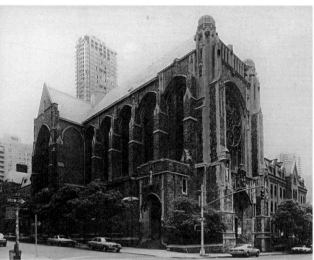

CHURCH OF ST. VINCENT FERRER

St. Vincent Ferrer Complex

869 Lexington Avenue and
141–151 East 65th Street,
Manhattan

Priory, 1880–81

Architect: William Schickel

Designated: May 19, 1981

Church, 1918

Architect: Bertram G. Goodhue

Designated: February 28, 1967

Holy Name Society Building, 1930

Architect: Wilfrid K. Anthony

Designated: May 19, 1981

School, 1948

Architect: Elliot L. Chisling of
Ferrenz & Taylor

Designated: May 19, 1981

The St. Vincent Ferrer complex was developed by the Roman Catholic order of the Dominican fathers, who purchased the site in 1867. Bertram G. Goodhue's church replaced an 1869 church designed by Patrick C. Keely, the noted Roman Catholic Gothic Revivalist. Executed in the architect's own distinctive version of late Gothic, the Goodhue structure is a long rectangle with chancel and friar's chapel to the east. The exterior facing is rough-cut, split Plymouth granite with limestone trim. The crucifixion panel over the entrance and the figures that emerge from the octagonal turrets are the work of Goodhue's frequent collaborator, Lee Lawrie. Inside, Guastavino tile vaulting fills the area between the ribs that connect the nave arcades; the whole is a kind of abstracted Gothic design.

The Priory was influenced by English Gothic Revival designs, especially in the use of pointed arches in the ground story and central pavilion. The flat-headed windows with light, brownstone lintels above are close to the commercial designs (the so-called neo-Grec) developed by Richard Morris Hunt in the 1860s. In 1930, Wilfrid E. Anthony designed the six-story Holy Name Society Building for various charities. The stone and brick structure is symmetrically massed about a recessed central section. The shallow buttresses through the second story are copied from Goodhue's church, as is the wonderfully imaginative reticulated panel tracery in the eastern pavilion. Anthony's design combines elements of those earlier works without being a pastiche. The design of the 1948 school, although less successful, is also mindful of the earlier Gothic Revival work.

Huntington Free Library and Reading Room, formerly Van Schaick Free Reading Room

1882–83; addition, 1890–92

9 Westchester Square, The Bronx

Architects: Frederick C. Withers;
addition, William Anderson

Designated: April 5, 1994

The original Van Schaick Free Reading Room was the first library in the village of Westchester, which was later incorporated into the Bronx. It was built with money bequeathed by local tobacco

HUNTINGTON FREE LIBRARY

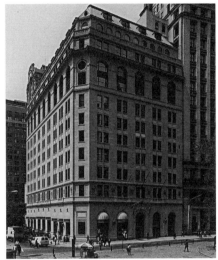

INTERNATIONAL MERCANTILE MARINE COMPANY

merchant Peter C. Van Schaick, but his estate did not provide enough funds for maintenance of the facility, so the building was left vacant after its completion. Eight years later, Collis Potter Huntington, who derived his fortune from the Southern Pacific Railroad, provided funding for the library's operations and an addition, which followed the architectural style of the original structure. He also renamed the building in his own honor as the Huntington Free Library and Reading Room.

The picturesque library has simple, monochromatic brickwork, asymmetrical massing, and varied rooflines derived from Gothic Revival designs. The round-arched tower entrance, terra-cotta tiled chimney, and overall simplicity of form evoke a hominess characteristic of nineteenth-century middle-class America. Today this non-circulating library specializes in Bronx history, while a New York Public Library branch across the street houses general-interest materials.

INTERNATIONAL MERCANTILE MARINE COMPANY BUILDING

1882–87; REDESIGNED AND RECLAD, 1919–21; 1993–94

1 BROADWAY (ALSO KNOWN AS 1–3 GREENWICH STREET AND 1 BATTERY PLACE), MANHATTAN

ARCHITECTS: EDWARD HALE KENDALL; ALTERATIONS, WALTER B. CHAMBERS

DESIGNATED: MAY 16, 1995

In 1919, the original Queen Anne facade of this thirteen-story iron-frame structure was replaced with a neoclassical design, and the building became headquarters of the International Mercantile Marine Company (IMMC). Organized by J. P. Morgan, the IMMC was created in 1902 by the merger of six of the leading American and British steamship companies. Contrary to expectations, however, it never received government subsidies and failed to eliminate the competition, thereby removing the threat of another

monopoly. Until World War II, IMMC operated the largest American-owned merchant fleet in the world, and this building was one of the many occupied by shipping companies that gave the area north of Bowling Green the name "Steamship Row" in the 1920s.

Designed on a C-plan with chamfered corners, the building sits on a two-story granite base; the upper stories are clad in Indiana limestone with marble spandrels. Seaweed, seashells, ropes, and waves appear as decorative motifs, while Neptune, the god of the sea and Mercury, the messenger of the gods and the god of commerce, adorn the entrances. Shields from the company's major ports of call line the third-story balustrade. Currently owned by Allstate Life Insurance Co., the building underwent an exterior restoration in 1993–94.

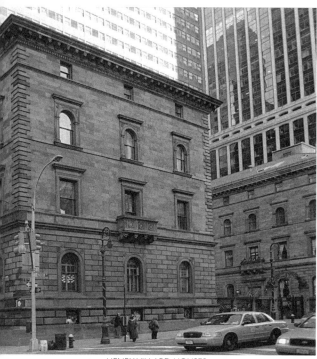

HENRY VILLARD HOUSES

HENRY VILLARD HOUSES

1882–86; 1980

451–457 MADISON AVENUE AND
24–26 EAST 51ST STREET,
MANHATTAN

ARCHITECTS: MCKIM, MEAD & WHITE

DESIGNATED: SEPTEMBER 30, 1968

A Bavarian emigré, Henry Villard started his career as a journalist for English- and German-language dailies; he would eventually have a controlling interest in the *New York Evening Post*. In 1872, he was hired by a group of German businessmen to look after their investments in an Oregon railroad operation. At the same time, he acquired an interest in East Coast shipping firms, and before

long he was a millionaire. In 1881, he purchased the Madison Avenue site opposite St. Patrick's Cathedral and commissioned McKim, Mead & White to design six luxury town houses, one of which he planned to occupy and the others he hoped eventually to sell.

Responsibility for the design fell to Stanford White's chief assistant, Joseph Morrill Wells, who transformed White's preliminary plans into a powerful, Renaissance-inspired complex, using the Palazzo della Cancelleria in Rome as a model. This choice of a model signaled a move away from Richardsonian Romanesque and Queen Anne work toward the classicism that became the foundation of the firm's reputation.

Six four-story houses are arranged in a U-shape around a central courtyard. This novel arrangement was ideally suited to the site because the church also had an open area facing the street. Together, these spaces gave the feeling of a large expanse of green. The town houses were designed to appear as a single building. They have a rusticated ground story separated from the upper stories by a small cornice. Quoins tie the second and third stories together. Above the heavy main cornice was an attic story and a tile roof. Villard's house, occupying the entire south wing, was the largest. Two houses filled the east courtyard side, and two more, the north. The sixth house, at northeast corner of the complex, was entered from 51st Street.

Shortly after the building was completed, financial difficulties forced Villard to sell his house to Whitelaw Reid, the

publisher of the *New York Tribune*. All six houses continued to be used as residences until after World War II, when the changing character of Madison Avenue led to their conversion into offices. The Villard Houses served for many years as the headquarters of the Roman Catholic Archdiocese of New York, Random House, and the Capital Cities Broadcasting System. All but Capital Cities eventually outgrew the space, however, and by the 1970s the houses were facing demolition.

In 1980, after complicated and lengthy negotiations, the Helmsley Corporation purchased the air rights to build the fifty-one-story Helmsley Palace Hotel (now under new ownership as the Palace Hotel). The two houses on the east side of the courtyard were destroyed to build the hotel, but the main public rooms of the Villard/Reid house have been preserved. Until January 1, 2005, Le Cirque 2000, one of New York's legendary restaurants, occupied the drawing room overlooking Madison Avenue. The north wing now houses the Urban Center exhibition space and bookshop on the ground floor with the Municipal Art Society offices above.

New York Youth Hostel, formerly Association Residence for Women, originally the Association Residence for Respectable Aged Indigent Females

1881–83; addition, 1907–08; 1965; 1990

891 Amsterdam Avenue, Manhattan

Architect: Richard Morris Hunt; addition, Charles A. Rich

Designated: April 12, 1983

Chartered in 1814, the Association for the Relief of Respectable Aged Indigent Females was founded by a group of socially prominent women to aid the less fortunate, specifically, those widowed during the War of 1812 or the Revolution. The association's first building at 226 East 20th Street was erected in 1837–38.

The Victorian Gothic style of 891 Amsterdam Avenue shows Hunt's hand, particularly in the picturesque mansard roof with dormers and the Gothic pointed arches, as well as neo-Grec detail. The addition, by architect Charles A. Rich, extends and duplicates the original Hunt elevation on Amsterdam Avenue for an additional five bays.

After 1965, when the interior was remodeled, the building became known as the Association Residence for Women. Closed in 1974, the building was severely damaged by fire in 1977. In 1990, the building was restored and converted into New York City's first youth hostel.

Potter Building

1882–86; 1973

36–38 Park Row and 145 Nassau Street, Manhattan

Architect: N. G. Starkweather

Designated: September 17, 1996

Orlando Potter commissioned this building to replace his World Building, which was destroyed by fire in 1882. A prominent figure in New York State Democratic politics and a U.S. Congressman, Potter was president of the Grover and Baker Sewing Machines Company.

The Potter Building was constructed after cast-iron framing and the express elevator made it possible to build structures of more than ten stories, but before the emergence of the true skyscraper. It incorporated modern fireproofing techniques, including pressed-brick and terra-cotta walls and facade, and joists encased in flat-arch tile (fireproof bricks).

The eleven-story building is a flamboyant combination of Queen Anne, neo-Grec, Renaissance Revival, and Colonial Revival styles, and it is characterized by a high degree of ornamentation throughout, especially in terra-cotta. Not surprisingly, Otis & Bros. Company elevators and the New York Architectural Terra Cotta Company were among the noteworthy tenants. In 1973, Pace University acquired the building, intending to demolish it. When this plan was not realized, it became a cooperative apartment building.

NEW YORK YOUTH HOSTEL

POTTER BUILDING

NY & NJ TELEPHONE AND TELEGRAPH BUILDING

NEW YORK AND NEW JERSEY TELEPHONE AND TELEGRAPH BUILDING

1883

81 WILLOUGHBY STREET, BROOKLYN

ARCHITECT: RUDOPHE L. DAUS

DESIGNATED: JUNE 29, 2004

"Founded in 1883, the New York and New Jersey Telephone and Telegraph Company served the ever-increasing populations of Long Island, Staten Island and northern New Jersey. The fast growth of the city and the company created the need for a large headquarters building for this local service provider of the Bell system. This elaborate and elegantly designed Beaux-Arts style building served as a major statement of the company's expansion in the area, providing offices and telephone switching in the heart of Brooklyn's expanding business district. Distinctive ornamentation establishes a strong presence on this busy street corner. Daus drew on his classical French training to create a dramatic structure, epitomized by the rounded corner accented by an elaborate cartouche and a projecting cornice." *

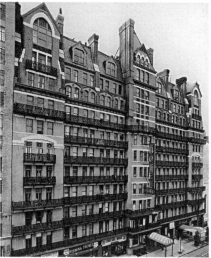
CHELSEA APARTMENTS

CHELSEA APARTMENTS, formerly CHELSEA HOTEL

1883–85

222 WEST 23RD STREET, MANHATTAN

ARCHITECTS: HUBERT, PIRSSON & CO.

DESIGNATED: MARCH 15, 1966

The flamboyant Chelsea Hotel is one of the oldest surviving cooperative apartment houses in New York City. The building was planned in collaboration with artists who wished to have studio space adjacent to their living quarters. Although converted to a hotel for permanent and transient residents in 1905, it has maintained associations with the arts, as home to many artists, writers, and musicians, including Thomas Wolfe, Dylan Thomas, Edgar Lee Masters, John Sloan, Samuel Clemens, Eugene O'Neill, Janis Joplin, Andy Warhol, Sam Shepard, Bob Dylan, and Tennessee Williams.

The most striking architectural features are the wrought-iron balconies

decorated with interlaced sunflowers. This motif and the high, clustered brick chimneys and patterned brick gables were inspired by the Queen Anne style, while the flattened segmental arches and horizontal granite divisions were a later American development from French neo-Grec designs.

P.G. Hubert was both an innovator in fireproof building technology and an ardent supporter of apartment house (then called "French flats") reform. He advocated masonry walls, thick floors, and duplex arrangements with spacious rooms as an alternative to the speculatively built, overcrowded middle-class apartment. In the early cooperative apartments, the tenants—in exchange for cheaper rents and larger rooms—did without plumbing and other less essential features. Restaurants and private kitchens were located on lower floors since no apartments had permanent cooking facilities. The ground floor was rented to commercial establishments, all to defray the cost of building quiet, ample apartments. In addition, tenants contributed toward the maintenance of the building itself. The movement had declined by the turn of the century.

GORHAM MANUFACTURING COMPANY BUILDING

1883–84; ALTERATIONS, 1893, 1912

889–891 BROADWAY, MANHATTAN

ARCHITECTS: EDWARD HALE KENDALL; 1912 ALTERATION, JOHN H. DUNCAN

DESIGNATED: JUNE 19, 1984

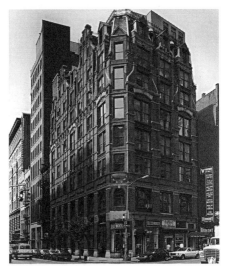

GORHAM BUILDING

The Gorham Building is one of the few surviving buildings designed by Edward Hale Kendall. Erected for Robert and Ogden Goelet when this section of Broadway was a fashionable shopping district, the building housed the store of the Gorham Manufacturing Co., a producer of fine silver, in its lower two floors, with apartments above.

An unusual remaining example of the Queen Anne style, the Gorham Building is noted for its picturesque massing and rich ornamental detail. The structure is constructed of pink brick with brick and light gray Belleville sandstone trim; the high-pitched slate roof with green copper elements adds to the building's appeal. The ornament, which includes decorated segmental arches and panels embellished with sunflowers and floral motifs, is more elaborate at the top.

The 1893 alterations were carried out by its original architect, in the same basic style; in 1912, John H. Duncan removed a corner tower and added

dormers in the roof. Although primarily associated with the Gorham store, the building is unusual for its early combination of commercial and residential use. Today, after many decades as a strictly commercial building, the Gorham is again residential on the upper floors.

NEW YORK PUBLIC LIBRARY, OTTENDORFER BRANCH

1883–84

133 SECOND AVENUE, MANHATTAN

ARCHITECT: WILLIAM SCHICKEL

DESIGNATED: SEPTEMBER 20, 1977; DESIGNATED AUGUST 11, 1981

The Ottendorfer is the oldest branch library in Manhattan and the first one built specifically as a library. In 1884, even before the building was completed, Oswald and Anna Ottendorfer turned the library over to the New York Free Circulating Library. At the time, the Lower East Side was filled with German immigrants; Oswald Ottendorfer, himself a German-American, wanted to help immigrants to assimilate into American culture and educate themselves. He personally selected the first library volumes, which were equally divided between German and English titles.

The design of the Ottendorfer Library reflects William Schickel's varied design background. Trained in Germany, he worked for Richard Morris Hunt and other firms after he arrived in New York in 1870. The arched entry porch and terra-cotta arcading above belong to the

NYPL, OTTENDORFER BRANCH LIBRARY

German *Rundbogenstil* tradition. The flattened arches with alternating voussoirs of brick and ornamental terra-cotta blocks, on the other hand, are closer to the commercial style developed by Hunt in the late 1860s.

Originally, the stacks were closed to the public. During a remodeling in the 1890s, the library converted to an open-shelf system, in response to contemporary ideas of library design.

The terra-cotta ornament includes many symbols of the library's function: urns and books fill the spandrel panels beneath the windows, and the frieze above the entry arch is embellished by owls and globes, which stand for wisdom and knowledge; over the door is the inscription "Freie Bibliothek u. Lesehalle" (Free library and reading room). The ornamentation and attractive coloration distinguish the library from the surrounding nineteenth-century tenements and more recent commercial structures.

STUYVESANT POLYCLINIC

STUYVESANT POLYCLINIC, FORMERLY THE GERMAN DISPENSARY

1883–84

137 SECOND AVENUE, MANHATTAN

ARCHITECT: WILLIAM SCHICKEL

DESIGNATED: NOVEMBER 9, 1976

The building at 137 Second Avenue, adjacent to the Ottendorfer Library, was also commissioned by Anna and Oswald Ottendorfer and designed by Schickel.

Dispensaries were the nineteenth-century equivalent of health clinics, providing medical care free of charge. The German Dispensary, or health clinic, which was founded in 1857, became a branch of the German Hospital (today's Lenox Hill) at Park Avenue and East 77th Street. In 1906, the building was sold to the German Polyklinik, and renovated and repaired. The name was changed to Stuyvesant Polyclinic as a result of the anti-German sentiment that was rampant during World War I. In the 1970s,

MOUNT MORRIS BANK BUILDING

the dispensary became affiliated with the Cabrini Medical Center.

The building is a handsomely ornate version of Italian Renaissance Revival design. It is constructed of Philadelphia pressed brick above a stone basement, with ornamental detail executed in molded terra-cotta. Like the library, the ornament on the facade reflects the building's function. It features portrait busts of famous physicians and scientists, including the English physiologist William Harvey, Swedish botanist Carolus Linnaeus, German scientist and explorer Karl Wilhelm von Humboldt, French chemist Antoine Laurent Lavoisier, and German physician and author Christoph Wilhelm Hufeland.

MOUNT MORRIS BANK BUILDING

1883–84; ENLARGEMENT, 1889–90; ALTERATION, 1912; 2005–

81–85 EAST 125TH STREET (ALSO KNOWN AS 1820 PARK AVENUE), MANHATTAN

ARCHITECTS: LAMB & RICH; ALTERATION, FRANK A. ROOKE

DESIGNATED: JANUARY 5, 1993

Before the construction of the elevated Park Avenue rail line, the Mount Morris Bank Building was visible for some distance along 125th Street. In 1913, the bank was acquired by the Corn Exchange Bank, the first New York Bank to have local branches. The Corn Exchange merged with Chemical Bank in 1954, and this building remained a bank until Chemical sold it in 1964.

The Mount Morris Bank Building was a dual-purpose structure. The commercial function of the lower levels is reflected in a massive sandstone base with wide arched entrances, typical of the Romanesque Revival. Above, the residential character of the upper stories is indicated by red Philadelphia brick, ornate terra-cotta ornamentation, small squared windowpanes, and other classic Queen Anne motifs. The original structure sat on a single lot, but an 1890 addition, also designed by Lamb & Rich, doubled its size. In 1912, the entrances and stairs were altered.

After years of neglect, the exterior will be restored by Danois Architects. The building will be converted into retail and office space, with the Harlem Culinary School on the top two floors.

WASHINGTON APARTMENTS

1883–84

2034–2040 ADAM CLAYTON POWELL JR. BOULEVARD, MANHATTAN

ARCHITECT: MORTIMER C. MERRITT

DESIGNATED: JANUARY 5, 1993

The Washington Apartments is the oldest apartment building in central Harlem, and one of the few in New York City that survives from the 1880s, when multifamily buildings were just gaining acceptance among the middle and upper classes. This building is one of the earliest examples of "French flat" apartments, a reference to elegant Parisian multifamily dwellings that distinguished it from common tenements. Built only two years after elevated trains had connected Harlem to lower Manhattan, the Washington was at one point the only building on its block.

The eight-story, Queen Anne–style brick building incorporates many neo-Grec details, such as engraved stone lintels and decorative side panels. The main facade is symmetrically arranged around a wide, projecting pavilion and is crowned by an overscaled neo-Grec galvanized-iron frontispiece, consisting of a triangular pediment decorated with a sunburst motif. Other features, such as the delicately incised ornamentation on the impost blocks, are typical of New York Queen Anne buildings. The trim is made from stone, iron, and pressed brick, providing lively contrast and interesting textural dimensions.

OSBORNE APARTMENTS

1883–85, 1889; EXTENSION, 1906

205 WEST 57TH STREET, MANHATTAN

ARCHITECTS: JAMES EDWARD WARE; 1906 EXTENSION, ALFRED S.G. TAYLOR

DESIGNATED: AUGUST 13, 1991

By the time the Osborne Apartments were erected, 57th Street had already begun to develop an air of exclusivity, confirmed in 1879–82 when Cornelius Vanderbilt built his enormous mansion on the corner of Fifth Avenue. The wide street and the open expanse of nearby Central Park made possible the construction of larger buildings that could offer the level of privacy and spaciousness demanded by prosperous residents. The Osborne was named for its original owner and builder, Thomas Osborne, who promoted his building as "absolutely fireproof; lighted throughout by electricity."

In the Osborne Apartments, James Edward Ware combined the rustication of the Romanesque Revival with the massing of a Renaissance palazzo in an original manner. The elaborate entrance and lobby areas were the work of Swiss-born and French-trained J. A. Holzer, with contributions by the sculptor Augustus Saint-Gaudens and the muralist and stained glass artist John La Farge. The decor of the lobby was carried through in the apartments with marquetry floors, handcarved mantels, stained glass transoms, and mahogany, oak, and walnut paneling.

WASHINGTON APARTMENTS

OSBORNE APARTMENTS

In 1889, Ware raised the roof level, providing extra rooms for servants in the upper stories while creating fifteen additional stories at the rear of the building. A twenty-five-foot-wide extension designed by Alfred S.G. Taylor, a part-owner of the building, was added to the western side of the building in 1906.

FREE MAGYAR REFORMED CHURCH

FREE MAGYAR REFORMED CHURCH, PARISH HALL, AND RECTORY, FORMERLY ST. PETER'S GERMAN EVANGELICAL CHURCH AT KREISCHERVILLE

19–23 WINANT PLACE AND 25 WINANT PLACE, CHARLESTON STATEN ISLAND	
DESIGNATED: JULY 26, 1994	
CHURCH, 1883	
ARCHITECT: HUGO KAFKA	
PARISH HALL, 1898	
ARCHITECT: UNKNOWN	
RECTORY, 1926	
ARCHITECT: ROYAL DAGGETT	

Representative of the small churches built for immigrant congregations during the late nineteenth century, this church was constructed while the area was a quasi-company town centered around—and named for—Balthasar Kreischer's brick factory. Kreischerville's small German church was funded by Kreischer himself, who provided an organ, carved pews, and wainscoting. In 1919, a Hungarian congregation bought the church, renaming it the Magyar Reformed Church.

The small, wood-framed church has a front porch, making it residential in form and detailing, as well as a high foundation and steeply pitched roof with a spire, which also give it an institutional presence. Above the entrance is an arched enframement with a leaded rose window in its center. This building is a typical village church, but the architectural character reflects the involvement of a wealthy backer, whose tastes were even more evident in the church's interior. The Parish Hall consists of three parts: a dwelling, an entry connected to the church building, and a large hall. The rectory is a substantial building with a front porch spanning the facade, and a freestanding garage. Bricks from the Kreischer factory were used in the steps to the rectory, the church chimney, and brick piers on the church fence.

ST. CECILIA'S CHURCH AND CONVENT

MANHATTAN	
DESIGNATED: SEPTEMBER 14, 1976	
CHURCH, 1883–87	
120 EAST 106TH STREET	
ARCHITECTS: NAPOLEON LEBRUN & SONS	
CONVENT, 1883–84 AND 1885–86; ADDITIONS, 1887; FACADE, 1907	
112 EAST 106TH STREET	
ARCHITECTS: UNKNOWN; FACADE, NEVILLE & BAGGE	

The cornerstone of St. Cecilia's was laid in 1883, and the following year the congregation held its first service in the completed basement chapel. Napoleon Le Brun & Sons provided the plans, working drawings, and specifications for the construction of the church. The Reverend Michael J. Phelan, pastor of the parish (and known throughout the diocese as "The Builder of Churches"), served as general contractor.

St. Cecilia's Church, faced with

ST. CECILIA'S CHURCH AND CONVENT

FORMER YOUNG MEN'S INSTITUTE BUILDING OF THE YOUNG MEN'S CHRISTIAN ASSOCIATION

1884–85

222 BOWERY (ALSO KNOWN AS 222–224 BOWERY), MANHATTAN

ARCHITECT: BRADFORD L. GILBERT

DESIGNATED: NOVEMBER 17, 1998

FORMER YOUNG MEN'S INSTITUTE BUILDING

textured red brick and terra-cotta, follows a simplified basilica plan in the Romanesque tradition. A large arch in the central gable frames a high-relief terra-cotta panel depicting St. Cecilia, the patron saint of music, playing an organ, accompanied by a cherub. The portico has three arches surmounted by gables. Situated between the relief and the portico is a band of seven stained glass windows. Octagonal towers flank the facade.

St. Cecilia's Convent was originally two separate buildings; number 112–114, a four-family tenement house built in 1883–84, and 116–118, a two-story schoolhouse built in 1885–86 and expanded to four stories in 1887. In 1907, the firm of Neville & Bagge united the two buildings behind a single facade, faced with brick, brownstone, and terra-cotta. The Romanesque detailing of the church was repeated for the convent, which has the same decorative terra-cotta moldings and round-arched windows. The building is four stories high above a raised basement and has a central bay with a cross mounted on the roof above it.

This is the first YMCA branch established in New York City, and the only one to survive the nineteenth century. Bradford L. Gilbert chose the Queen Anne style for this building, his only major surviving work, because of its associations to England, where the YMCA was founded in 1844, and for its "progressive" quality. The five-story Institute has a largely intact planar facade, asymmetrically organized with a recessed entry; a rusticated sandstone base with segmental arches; and giant pilasters frame a double-story arcade with recessed metal-framed windows. The composition is crowned by a slate-covered mansard roof pierced by two dormers. The larger dormer has a pediment with terra-cotta decoration surrounding the 1884 commencement date. A signature element of the Queen Anne style are the floral motifs found at the garlanded window-panels, on the capitals of the pilasters, and within the pediment of the larger dormer.

The Young Men's Institute was a membership organization of the Young Men's Christian Association (YMCA), innovative in its promotion of the physical, intellectual, and spiritual health of

young working men in the densely crowded Bowery. The YMCA left the building in 1932 and since then, it has housed many artists, including Surrealist Fernand Leger, abstract artists Mark Rothko and James Brooks. Writer William S. Burroughs named it the "Bunker, " as it is still affectionately called. It remains a studio/residential space for artists and houses facilities for a community of Tibetan Buddhists.

F.E. COMPANY 39 AND 16 STATION HOUSE

FIRE ENGINE COMPANY 39 AND LADDER COMPANY 16 STATION HOUSE

1884–86; 1992

157–159 EAST 67TH STREET, MANHATTAN

ARCHITECTS: NAPOLEON LEBRUN & SON; STEIN PARTNERSHIP

DESIGNATED: JUNE 16, 1998

This six-story fire house is the first and only headquarters building constructed by the New York City Fire Department. The headquarters of the Fire Department relocated to East 67th Street from its quarters downturn in order to accommodate new modernization measures within a larger, fireproof structure.

Between 1880 and 1895, Napoleon LeBrun designed more than forty buildings for the department. The East 67th Street building, which served multiple functions, providing space for two fire companies, the office of the Commissioners, and various departmental

PIER A

bureaus, is monumental in design. During most of the twentieth century, the building continued to serve as the departmental training center.

The red brick six-story Romanesque Revival structure has round-arched windows, drip molds and organic ornament. The station house's most prominent feature, a 150 foot-tall brick lookout tower on top of the eastern bay, more symbolic than functional, was removed in 1949. In 1992, the facade was completely restored by the Stein Partnership, including cast-stone replacements for its greatly deteriorated brownstone, as part of a building project that preserved the facade while constructing a new facility behind it and the adjacent police precinct. The building continues to function a home to both an Engine and Ladder Company and is an outstanding example of New York's nineteenth-century public architecture.

PIER A

1884–86; ADDITIONS, 1900, 1908

BATTERY PARK, MANHATTAN

ENGINEER: GEORGE SEARS GREENE JR.

DESIGNATED: JULY 12, 1977

Pier A, a picturesque structure jutting into Upper New York Bay, is the last survivor of a maritime complex that once included a firehouse, a wharf for its lifeboats, a breakwater, a boat landing, and Pier New I (which had magnificent granite arches). For many years, distinguished visitors to the city who arrived by sea were officially greeted at Pier A; today it is the headquarters of the marine division of the New York Fire Department. The clock on the tower, installed in 1919, was donated by Daniel G. Reid as a memorial to the soldiers, sailors, and marines who lost their lives in World War I. It is one of only two clocks on the eastern seaboard whose chimes ring the hours in nautical time (the other is located at the U.S. Naval Academy in Annapolis, Maryland).

Pier A was built by the New York City Docks Department in 1884–86 under the direction of its chief engineer, George Sears Greene Jr. Structurally, the pier consists of eight subpiers, connected iron girders and concrete arches. The inshore end of the building was built of brick and terra-cotta with a tin roof, while the offshore end has a conventional wood-frame skeleton and clad with galvanized iron siding. In 1900 and 1908 additions were made at the inshore end.

455 CENTRAL PARK WEST

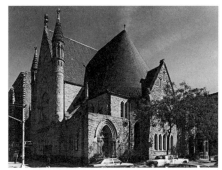

METROPOLITAN BAPTIST CHURCH

455 CENTRAL PARK WEST, FORMERLY THE TOWERS NURSING HOME, ORIGINALLY NEW YORK CANCER HOSPITAL

1884–86; ADDITIONS, 1889–90, 1925–26; 2004

CENTRAL PARK WEST AT 106TH STREET, MANHATTAN

ARCHITECTS: CHARLES COOLIDGE HAIGHT; PERKINS EASTMAN

DESIGNATED: AUGUST 17, 1976

The New York Cancer Hospital was founded in 1884 to further the study and treatment of cancer. The original building, funded by John Jacob Astor and known as the Astor Pavilion, housed female cancer patients. In 1889–90, an addition for male patients was built on the adjoining site on West 105th Street, also given by Astor in memory of his wife, Charlotte Augusta Astor. A chapel was added at the same time as a memorial for founder Elizabeth Hamilton Cullum. In 1899 the hospital became the General Memorial Hospital for the Treatment of Cancer and Allied Diseases. An X-ray building, attached to the 1899–90 addition, was constructed in 1925–26. In the 1950s, after the hospital closed, the building was converted for use as a nursing home. By the late 1990s, the building had been vacant for a number of years and had seriously deteriorated. In the fall of 2004, as part of a condominium development project, the landmark was completely restored by the firm of Perkins Eastman and converted into 17 apartments; a new 26-story red-brick tower, with an additional 81 apartments, was built behind it. Columbia University acquired 53 of these apartments to house distinguished professors and visiting dignitaries.

Built to resemble a French chateau, the original building was a complex arrangement of masses dominated by its five towers. Constructed of red brick with sandstone trim, its distinguishing features include the mansard roof, conical tower roofs, decorative gabled dormers, colonnettes, and late English Gothic detail and surface ornament. Unusual design features included circular wards, which allowed for generous amounts of light and pure air and prevented the accumulation of dirt in corners. Its technological advances, originating in nineteenth-century medical theory, made the hospital a model of its kind.

METROPOLITAN BAPTIST CHURCH, FORMERLY NEW YORK PRESBYTERIAN CHURCH

1884–85 AND 1889–90

151 WEST 128TH STREET, MANHATTAN

ARCHITECTS: JOHN R. THOMAS AND RICHARD R. DAVIS

DESIGNATED: FEBRUARY 3, 1981

The New York Presbyterian Church was built when Harlem was a fashionable haven for New Yorkers of affluence and elegance. John R. Thomas completed the initial portion of the existing structure—the small lecture room and chapel facing West 128th Street—in 1885. The Seventh Avenue facade and northern section housing the main auditorium were subsequently added in 1890 by Harlem architect Richard R. Davis.

Davis's extension incorporated many details from the Thomas design. The work of both men is characterized by the low proportions and massive volumes typical of Romanesque Revival architecture. Dwarf columns flank doorways and entrances; heavy, rough-cut stone increases the feeling of mass and weightiness. These Romanesque features exist in contrast to such Gothic Revival devices as pointed arches, trefoil decoration, and trefoil-arched lancets; the flying buttress of the later addition; the stone window tracery; and the free and generous use of windows to pierce the wall surfaces.

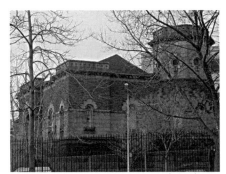

CROTON AQUEDUCT GATEHOUSE

CROTON AQUEDUCT GATEHOUSE

1884–90; 2004–

135TH STREET AND CONVENT
AVENUE, MANHATTAN

ARCHITECT: FREDERICK S. COOK

DESIGNATED: MARCH 23, 1981

Constructed in the manner of a medieval
fortress, the Croton Aqueduct Gatehouse
was built as part of a plan to alleviate
poor sanitary conditions in New York
City. Its massive appearance symbolically
relays the importance of its dual role—
to provide safe drinking water and to
serve as a reservoir for local fire
brigades.

The gatehouse conceals a complex
series of water chambers, sluice gates,
stop planks, and stopcocks designed to
contain and convey water from the old
and new Croton aqueducts. Arched
granite piers form the eight small pipe
chambers used to send water both north
of the reservoir and south, to Central
Park. The water flowed easily from the
elevated location. In the meantime, it
was held in a chamber over forty-three
feet deep with eighteen-inch granite
floors and two-foot-thick granite walls.

The exterior is unusually picturesque.
An entrance pavilion, an octagonal
tower, and an open terrace emphasize its
rectangular shape, and massive voussoirs
decorate the window and doorway
openings, complemented by granite
parapets with inset diamonds.

Although the interior is closed to the
public, its decoration is noteworthy. The
walls inside the gate house combine yel-
low brick with buff and black trim. All
in all, their hidden yet intensely colorful
coordination reflects the level of design
possible in a utilitarian structure. The
gatehouse is being adapted for use as the
entrance to Aaron Davis Hall.

DE VINNE PRESS BUILDING

1885–86; ADDITION, 1890–92

393–399 LAFAYETTE STREET,
MANHATTAN

ARCHITECTS: BABB, COOK & WILLARD

DESIGNATED: OCTOBER 19, 1966

A bold example of architectural inven-
tiveness, the De Vinne Press Building
exerted enormous influence on turn-of-
the-century commercial architecture.
This eight-story brick and terra-cotta
structure was named after Theodore De
Vinne, who was a master in the history
of the art of printing and in its practice.
Among his products were *Scribner's
Monthly*, *St. Nicholas Magazine*, and
Century Illustrated Monthly Magazine.

Designed by Babb, Cook & Willard in
the Romanesque style, the building's
elevations display interesting contrasts of
round- and segmental-arched windows.

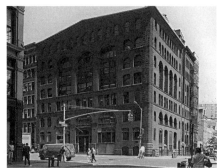

DE VINNE PRESS BUILDING

It has a low-pitched roof and quoins at
the rounded corner of the building.
Brick gable-end and round-arched attic
windows contribute a distinctive note.

CHURCH FOR ALL NATIONS, FORMER-
LY CATHOLIC APOSTOLIC CHURCH

1885–86; 1996

417–419 WEST 57TH STREET,
MANHATTAN

ARCHITECT: FRANCIS H. KIMBALL

DESIGNATED: FEBRUARY 27, 2001

This structure, virtually unaltered, is
considered one of the finest late-nine-
teenth century churches in New York
City. The Catholic Apostolic Church
formed a congregation in New York City
in 1851, and by the 1880s chose
Kimball, known for his ecclesiastical
work and his involvement with the con-
struction of the Gothic style building at
Trinity College.

Kimball's design, executed in red
brick laid in running bond with terra-
cotta above the brownstone base, is a
sophisticated statement, in the "muscu-
lar" Victorian Gothic style, and a

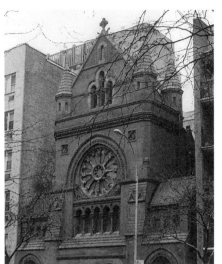
CHURCH FOR ALL NATIONS

WINTER GARDEN THEATER INTERIOR, FORMERLY THE AMERICAN HORSE EXCHANGE

C. 1885; REBUILT, 1896; CONVER-
SIONS, 1910–11, 1922–23

1634–1646 BROADWAY, MANHATTAN

ARCHITECTS: UNKNOWN; 1910–11
CONVERSION, W. ALBERT SWASEY;
1922–23 ALTERATION,
HERBERT J. KRAPP

DESIGNATED: JANUARY 5, 1988

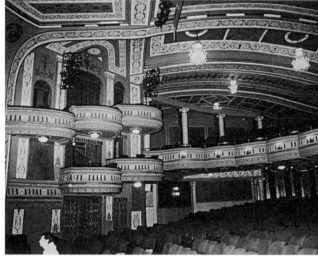
WINTER GARDEN THEATER INTERIOR

masterful solution that lends grandeur to a small mid-block church site. One of Kimball's first independent commissions, the church was widely admired for its design, proportions, color, and beauty of materials, and skilled ornament. Critic Montgomery Schuyler called it the "most scholarly Gothic work in New York."

Kimball was at the forefront of architects using exterior architectural terracotta in New York. This was one of the earliest buildings to employ structural terra-cotta, which was manufactured by the Boston Terra Cotta Co. The red matteglazed terra-cotta ornament on the facade, dominated by a central rose window within a pointed-arched surround, are some of the most complex elements yet attempted in the United States. Despite dwindling membership, the Catholic Apostolic Church retained its building until 1995. It is currently the Church for All Nations of the Lutheran Church Missouri Synod.

Compared to most other Broadway theaters, the Winter Garden has an unusual history. It was erected about 1885 by William K. Vanderbilt as the American Horse Exchange; at the time, Long Acre Square (now Times Square) was the center of the horse and carriage trade in Manhattan.

By 1910, Times Square had become the center of the theater district. At this time, Lee Shubert approached Vanderbilt, who agreed to lease him the building. Shubert employed architect W. Albert Swasey to convert the building into a large vaudeville theater, which he named the Winter Garden, after such well-known European institutions as the Berlin Winter Garden. Al Jolson made his Broadway debut in *La Belle Paree*, the revue that opened the theater in 1911.

Swasey left the trusses of the ceiling exposed and added wooden latticework to the walls. Behind these elements a sky and landscape were painted, creating the illusion of being outside. A wraparound balcony was installed, and a grand runway was added in 1912—an unusual element in theater at the time, intended to break the barrier between the audience and the actors.

By the 1920s, the demand for the kind of theatrical spectacles that the Winter Garden staged was subsiding, and smaller, more intimate productions gained popularity. Herbert J. Krapp, who designed almost all of the Shubert theaters, reworked the Winter Garden's interior in 1922. He lowered the ceiling, added two levels of triple boxes, added columns on each side of the balcony, and decorated the whole in his trademark Adamesque style.

241

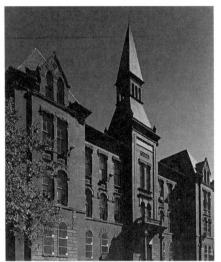
GIRLS' HIGH SCHOOL

Manhattan, was typical of school design in the city until the twentieth century. Here, the tower has a tall pyramidal roof topped by a square belfry, with a stone Corinthian portico capped with a balustrade over the main entrance.

This is an outstanding example of school architecture by one of its leading practitioners. Together with Boys' High School (p. 272) it served as the prototype for many schools in the city. The building was restored by the School Construction Authority and now houses the Board of Education Brooklyn Adult Training Center.

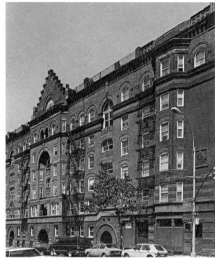
ASTRAL APARTMENTS

water, steam heat, marble floors and wainscoting, and polished ash woodwork. A substantial rear courtyard provided light and air to the rear of the apartments. Shared amenities included dumbwaiters in the halls at each floor, a large lecture room in the basement, and ground-floor stores organized on a cooperative basis to reduce apartment rents.

Designed in the Queen Anne style, the building is notable for the projecting central entrance section on the main facade with a four-story-high, round-arched recess. The facade is decorated with rich Byzantine-inspired floral ornament. The exceptional interior arrangement of space, the integration of communal and private space, and the abundance of amenities make the Astral a major example of its type.

GIRLS' HIGH SCHOOL

1885–86; ADDITION, 1912

475 NOSTRAND AVENUE, BROOKLYN

ARCHITECTS: JAMES W. NAUGHTON; ADDITION, C.B.J. SNYDER

DESIGNATED: JUNE 28, 1983

Girls' High School, one of the first public secondary schools in Brooklyn, was designed in a striking and dynamic combination of the Victorian Gothic and French Second Empire styles by James W. Naughton. As superintendent of buildings for the Board of Education in Brooklyn from 1879 to 1898, Naughton designed all the schools built there during this period. An addition along the Macon Street side, designed by C.B.J. Snyder in the Collegiate Gothic style, opened in 1912.

Girls' High School is a symmetrically massed structure composed of three pavilions. Use of a dramatic central tower, first seen in the Chelsea section of

ASTRAL APARTMENTS

1885–86

184 FRANKLIN STREET, BROOKLYN

ARCHITECTS: LAMB & RICH

DESIGNATED: JUNE 28, 1983

The Astral Apartments is a massive, six-story apartment house faced with brick and terra-cotta, occupying an entire block on the east side of Franklin Street between India and Java Streets in the Greenpoint section of Brooklyn. In 1885–86, Charles Pratt, oil merchant and philanthropist, built the apartments for workers in the area. Designed by Lamb & Rich, the building was considered highly innovative at the time of its construction. It raised contemporary standards for workers' housing by including a kitchen in each apartment with a scullery alcove from which a separate room with toilet opened, bathrooms with large tubs with hot and cold

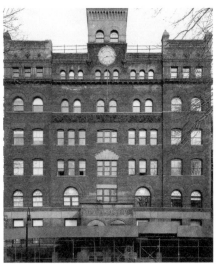

PRATT INSTITUTE

PRATT INSTITUTE

CLINTON HILL, BROOKLYN

DESIGNATED: DECEMBER 22, 1981

MAIN BUILDING, 1885–87

215 RYERSON STREET

ARCHITECTS: LAMB & RICH

SOUTH HALL, 1889–91

215 RYERSON STREET

ARCHITECT: WILLIAM B. TUBBY

LIBRARY, 1896

224–228 RYERSON STREET

ARCHITECT: WILLIAM B. TUBBY

MEMORIAL HALL, 1926–27; 1996–97

215 RYERSON STREET

ARCHITECT: JOHN MEAD HOWELLS

Pratt Institute was founded by industrialist Charles Pratt for the training of artisans and technicians, as an outgrowth of his interest in manual training and his belief in self-help. The Main Building, including the attached South Hall and Memorial Hall, is the focal point of the campus, located in the Clinton Hill section of Brooklyn. Built in three stages, the Main Building and its two wings were designed in two harmonious and interrelated styles: Romanesque Revival and Renaissance Revival.

The six-story Romanesque Revival Main Building, designed by Lamb & Rich, has picturesque corner towers and a central clock tower. A projecting portico with paired brownstone arches that rests on colonnettes is approached by a double staircase. The corner towers terminate in decorative parapets with small towers, and the side elevations of the building are punctuated by regularly spaced arched and rectangular window openings.

The attached Renaissance Revival South Hall, designed by William B. Tubby, is a three-story red-brick building with a sunken areaway enclosed by a railing. The first story, faced with brick simulating rustication, is punctuated by large, rectangular openings. Arched windows outlined by brick and stone moldings accent the second floor, while the third-story windows are rectangular. A modillioned cornice surmounted by a balustraded parapet extends around the building at the roofline.

Memorial Hall, designed by John Mead Howells in a Romanesque Revival style, is linked to the Main Building by a one-story sandstone gabled entrance containing a recessed, round-arched entrance with engaged colonnettes. The entrance section, with its gilded central portion, is flanked by two flat-roofed wings. A large arched opening

PRATT INSTITUTE LIBRARY

incorporates three smaller round-arched openings with engaged colonnettes at the first floor. Memorial Hall was restored in 1996–97 by H & H Building Consulting.

The Pratt Institute Library, also designed by Tubby, was the first free public library in the City of Brooklyn. Pratt's belief in self-help led him to an interest in the public library movement. The freestanding Renaissance Revival structure has slightly projecting end pavilions and a two-story stacks wing at the western end. The base of the building, faced with rusticated brick, is set off by brownstone belt courses. Round-arched windows, outlined by brick and brownstone moldings, accent the second story. The building is surmounted by a modillioned cornice supporting a balustraded parapet. A small arcaded porch was removed from the south side in 1980 and has been relocated as a freestanding sculpture elsewhere on campus.

243

PUCK BUILDING

PUCK BUILDING

1885–86; ADDITIONS, 1892–93;
1899: 1983–84

295–309 LAFAYETTE STREET,
MANHATTAN

ARCHITECTS: ALBERT WAGNER,
HERMAN WAGNER

DESIGNATED: APRIL 12, 1983

The Puck Building, originally the home of *Puck* magazine, occupies the block bounded by East Houston, Lafayette, Mulberry, and Jersey Streets on the edge of Manhattan's old printing district, which centered around the Astor Library. A large statue of Puck stands at the northeast corner. The building was erected in three stages, all supervised by Albert Wagner. The first two were designed by Wagner, and the third by Herman Wagner, a distant relative who took over the practice in the late 1880s. The original building is seven stories high, and the addition nine.

The building is executed in an adaptation of the German *Rundbogenstil*. The varying rhythm of the arches, the handsome courses of pressed red brick, and the brick corbels at the cornice combine

Cast-iron window enframements, statuary, and wrought-iron entrance gates provide an attractive contrast in materials. A porch of paired Doric columns marks the main business entrance.

Puck magazine, founded by caricaturist Joseph Keppler and printer/businessman Adolph Schwarzmann, was equivalent in style and tone to the London-based *Punch*. The magazine first appeared in German in 1876; an English-language edition was launched the following year. The magazine shut down in 1918. *Puck* was noted for its comic and satirical writers, most notably Henry Cuyler Bunner, and for its color lithographs. The J. Ottman Lithography Company, which printed these illustrations, was located in the building, which was restored in 1983–84.

JOSEPH LOTH AND COMPANY SILK RIBBON MILL

1885–86; ADDITIONS AND ALTERATIONS, 1905

1818–1838 AMSTERDAM AVENUE
(ALSO KNOWN AS 491–497 WEST
150TH STREET AND 500 WEST 151ST
STREET), MANHATTAN

ARCHITECT: HUGO KAFKA

DESIGNATED: SEPTEMBER 21, 1993

This building was constructed during a post–Civil War boom in the American silk industry spurred by popular fashions and heavy import tariffs. The "Joseph Loth & Co. 'Fair and Square' Ribbon Manufactory" was one of the few silk mills to operate outside of

JOSEPH LOTH & COMPANY SILK RIBBON MILL

Paterson, New Jersey, and one of the few factories of any kind located in Washington Heights. Austro-Hungarian émigré Hugo Kafka devised the unusual K-shaped floor plan, with the upright along Amsterdam Avenue, which both satisfied building codes and created an efficient work environment. The wings, less than thirty feet wide, were lit by large windows on both sides and required neither interior columns nor fire walls, both of which would have interfered with the operation of driveshaft looms.

The Loth Silk Ribbon Mill displays considerable architectural character, with rusticated comer pilasters organizing the brick facades in a visually engaging manner. The company name appears in raised brick above the factory's wings. A series of additions and changes were made beginning in 1905 to convert the building into commercial space; it has subsequently housed a movie theater, a dance hall, a bowling alley, a skating rink, and a variety of small businesses.

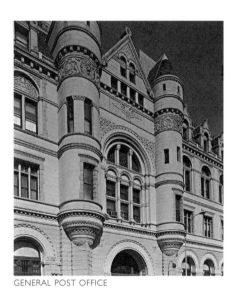

GENERAL POST OFFICE

GENERAL POST OFFICE

1885–91; ADDITION, 1933

271–301 CADMAN PLAZA EAST,
BROOKLYN

ARCHITECT: WILLIAM A. FRERET,
AFTER PLANS BY MIFFLIN E. BELL

DESIGNATED: JULY 19, 1966

The General Post Office displays a wealth
of skillfully blended Romanesque
Revival and Renaissance Revival details.
The older section of the building was
begun in 1885 and completed in 1891;
the original plans of Mifflin E. Bell were
modified by William A. Freret, Bell's suc-
cessor as supervisory architect of the
Treasury Department, while the building
was under construction.

The basement and first floor are faced
in rough rock-faced granite with pol-
ished granite on the upper stories.
Notable features include projecting half-
round turrets; a steep, slate-covered roof
and dormers; and a massive, squat

ground-story arcade.

The well-designed extension to the
north, completed in 1933, adheres faith-
fully to the design of the older part of
the building.

FORMER CHILDREN'S AID SOCIETY, TOMPKINS SQUARE LODGING HOUSE FOR BOYS AND INDUSTRIAL SCHOOL, ALSO KNOWN AS ELEVENTH WARD LODGING HOUSE

1886; 1977

296 EAST 8TH STREET (ALSO KNOWN
AS 127–129 AVENUE B), MANHATTAN

ARCHITECTS: VAUX & RADFORD

DESIGNATED: MAY 16, 2000

A significant example of the work of
Calvert Vaux, this is the oldest extant
Children's Aid Society building in New
York City, and the only remaining com-
bination lodging house and industrial
school designed by Vaux & Radford. It
is the best surviving example of the
nearly one dozen works Vaux designed
for the Society.

In an effort to address the city's
worsening problem of juvenile vagrancy,
Charles Loring Brace, a young Protestant
minister, founded the Children's Aid
Society in 1853 to house and educate
poor working children, in particular
newsboys and bootblacks aged seven
to seventeen. By 1885, the Society had
outgrown its space on East 11th Street
and with the support of Mrs. Robert L.
Stuart, the wife of a wealthy sugar
refiner, this building was opened in
1887.

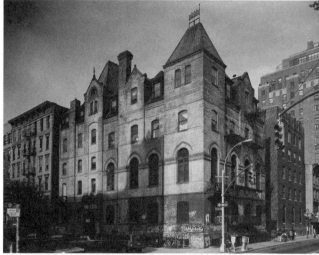

FORMER CHILDREN'S AID SOCIETY, TOMPKINS SQUARE LODGING HOUSE

Vaux & Radford designed the
Tompkins Square Lodging House, to
evoke a country inn or small hotel. The
four-and-five-story building combines
elements from the High Victorian Gothic
and Queen Anne styles with its dormers,
gables, chimney, and steep pyramidal
towers, distinguishing it from the sur-
rounding tenements.

In 1925, the Society sold the building
to the Darchei Noam congregation,
a Jewish center, whose programs
included after-school religious study
for Jewish immigrants. Later the East
Side Hebrew Institute operated a Yeshiva
in the building, reflecting the changing
population of the neighborhood. The
building was sold in 1977 and converted
to apartments.

SUNSET PARK SCHOOL OF MUSIC, FORMERLY 68TH POLICE PRECINCT STATION HOUSE AND STABLE

1886

4302 FOURTH AVENUE, BROOKLYN

ARCHITECT: EMILE M. GRUWE

DESIGNATED: APRIL 12, 1983

The former 68th Police Precinct Station House and Stable are located in Sunset Park, a planned community developed to accommodate the middle- and lower-class industrial workers who began migrating to the Brooklyn waterfront after the Civil War. Emile M. Gruwe designed the buildings in a Romanesque Revival style.

The front elevation of the three-story brick station house is dominated by a massive projecting corner tower with a stepped, corbeled cornice. The tower is decorated on the first floor by a limestone Byzantine band course carved with dogs' faces and foliate motifs, and on the third by a series of brick arches supported by carved foliate impost blocks and flanked by curvilinear wrought-iron tie washers. To the left of the tower, a Norman-inspired portico projects over the main entrance. Its arches are supported by truncated polished granite columns and surmounted by a corbel table of carved heads. To the left of the entrance is a first-floor extension topped by a sloping roof over a window arcade. Above this is a projecting pavilion, with a pair of round-arched windows on the second story and a Venetian-inspired interlaced colonnade of windows set beneath a diapered panel on the third.

SUNSET PARK SCHOOL OF MUSIC

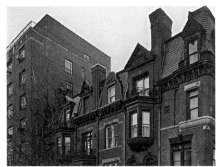

EAST 89TH STREET HOUSES

A brick passage leads to the stable. This two-story building has a simple rectangular entrance, surmounted on the second floor by round-arched windows and hayloft doors topped by a crenellated cornice and rectangular pediment. The stable and main building have been converted into the Sunset Park School of Music.

EAST 89TH STREET HOUSES

1886–87

146, 148, 150, 152, AND 156 EAST 89TH STREET, MANHATTAN

ARCHITECT: HUBERT, PIRSSON & CO.

DESIGNATED: MARCH 13, 1979

These town houses were built for William Rhinelander, a wealthy sugar merchant whose family had purchased the property in 1812. Constructed in response to the real estate opportunities created by the 1878 extension of the Third Avenue elevated railroad, all but one of these houses stand on an exceptionally narrow lot—just twelve and one-half feet wide.

The consistent use of brick with stone and terra-cotta ornament—unifies the group and creates richly textured surfaces. The seemingly capricious placement of the projecting window bays contrasts with the recessed entrance loggias to animate the picturesque facades of the four-story structures. Formally, as speculative East Side row houses, and aesthetically, as accomplished essays in the Queen Anne style, these buildings are pleasing survivors of a once widespread building type.

19TH (ORIGINALLY 25TH) POLICE PRECINCT STATION HOUSE

1886–87; 1992

153-155 EAST 67TH STREET, MANHATTAN

ARCHITECT: NATHANIEL D. BUSH

DESIGNATED: FEBRUARY 23, 1999

This is one of only ten station houses by Nathaniel Bush surviving in Manhattan and one of two serving its original function. Between 1862 and 1895, Bush, detective and architect, designed more then twenty station houses to address overcrowded, unsanitary patrolmen's

quarters and jails in station houses. Influenced by skyscraper and commercial designs of the previous decade, Bush's design is a significant departure from his earlier, simpler buildings. The mid-block station house was constructed as a cross-shaped plan with one-bay wings faced in red brick and gray granite and contrasting buff-colored stone detail. The design exemplifies elements of the *Rundbogenstil*, the Renaissance Revival, and neo-Grec styles. Its main facade made a commanding statement of the stature of the Police Department in the rapidly expanding Upper East Side neighborhood.

A facade rehabilitation in 1992 included a new fiberglass cornice and entrance porch as part of a project for a rear addition. Since 1929, this station house has served the 19th Precinct and remains an integral component of this streetscape of four impressive nineteenth-century institutional buildings, also designated as New York City landmarks.

ELDRIDGE STREET SYNAGOGUE, CONGREGATION K'HAL ADATH JESHURUN WITH ANSHE LUBZ

1886–87; 1991

12–16 ELDRIDGE STREET, MANHATTAN

ARCHITECTS: HERTER BROTHERS

DESIGNATED: JULY 8, 1980

The Synagogue of K'hal Adath Jeshurun, known as the Eldridge Street Synagogue, was the first major synagogue to be

19TH POLICE PRECINCT STATION

established on the Lower East Side by the Orthodox Eastern European Ashkenazi Jews. Although the congregation's early history remains obscure, K'hal Adath Jeshurun resulted from the union of two Ashkenazi congregations, Beth Hamed-rash (House of Study) and Holche Josher Wizaner (Those who Walk in Righteousness).

By 1890 more than two hundred thousand Jews settled in New York City, compared to the Jewish population of thirteen thousand in 1847. As a consequence, approximately sixty synagogues existed, and there was some competition among them for prominence in the Jewish community.

While earlier Lower East Side synagogues had been built by Western European Jews, the Eldridge Street Synagogue was the first to be established by Eastern European Jews. Determined to assert its presence in the community, the congregation commissioned Peter and Francis Herter to design a synagogue that would stand as a testament to its continued faith in the New World.

Rising from a side street of low buildings, the synagogue is an imposing presence. Like others of the period, the

ELDRIDGE STREET SYNAGOGUE

facade mixes Moorish, Gothic, and Romanesque elements, representing the trend from Euro-Christian elements to Oriental motifs.

The synagogue's most remarkable feature is its immense sanctuary, an opulent barrel-vaulted space. Stained glass windows and brass chandeliers with Victorian glass shades illuminate the interior. Ornate walnut carving covers the front of the balcony and the ark where the sacred Torah scrolls are preserved. Small domes rest over the balcony and along the sides of the large room. The interior paneling was marbleized and painted in 1894.

This great sanctuary was sealed in the 1930s after many Jewish people left the Lower East Side. In the mid-1970s the sanctuary was entered for the first time in three decades. Since then the congregation has been working to restore the building with architects Giorgio Cavaglieri and Robert Meadows. The master plan, completed in 1991, calls for repair of the skylight and upgrade of systems, followed by restoration of architectural elements. Eldridge Street is a nonsectarian project offering a variety of cultural and educational programs.

St. George's Protestant Episcopal Church

1886–87; ADDITION, 1889

800 MARCY AVENUE, BROOKLYN

ARCHITECT: RICHARD M. UPJOHN

DESIGNATED: JANUARY 11, 1977

St. George's Church in the Bedford section of Brooklyn is a fine Victorian Gothic structure erected in 1886–87 by the architect Richard M. Upjohn, son of the noted Gothic Revivalist. With his father, Upjohn founded the American Institute of Architects, and he served as the president of the New York Chapter for two years.

Designed in the dramatic polychromatic tradition of Victorian Gothic, St. George's is a striking red-brick building with light stone trim. Noted for its picturesque massing of elements, the church is sited facing Marcy Avenue with the nave running along Gates Avenue; the nave, with its steep, slate roof, is flanked by broad side aisles. A shallow clerestory with square windows rises lightly above the roofs of the side aisles. To the left of the nave from the porch, in place of a buttress, there is a polygonal tower that serves as a chimney. Adorned with slender stone colonnettes and supporting gablets and pointed arches at the top, it is the most distinctive feature of the building.

The Down Town Association

1886–87; ADDITION, 1910–11

60 PINE STREET (ALSO KNOWN AS 60–64 PINE STREET AND 20–24 CEDAR STREET), MANHATTAN

ARCHITECTS: CHARLES C. HAIGHT; ADDITION, WARREN & WETMORE

DESIGNATED: FEBRUARY 11, 1997

At the close of the nineteenth century, New York's wealthiest families created luncheon and dinner clubs for men in particular fields: those in the shipping business met at the India Club; merchants gathered at the Merchants Club; and bankers, lawyers, and brokers assembled at the Down Town Association, which held its first meeting at the Astor House in 1859. The club's mission was to provide social opportunities for those engaged in professional and commercial pursuits, especially while they were away from home, and to advance literature and art through the establishment of an on-site library, reading room, and art gallery.

In 1884, the Down Town Association purchased the lot at 60–62 Pine Street; two years later, club member Charles C. Haight was hired to design the new building. Height's three-bay, red-brick Romanesque Revival facade features a prominent arched main entranceway. The building is ornamented with a modest frieze above the fourth story and terra-cotta details throughout. Large arched windows emphasize the third-story dining area, which was considered the club's most important space. In 1902, the Association leased the adjoining property at 64 Pine Street and replaced an earlier structure with Warren & Wetmore's two-bay addition, which echoes Haight's original facade in materials, fenestration, and details.

FORMER BAILEY HOUSE

1886–88

10 St. Nicholas Place, Manhattan

Architect: Samuel B. Reed

Designated: February 19, 1974

This picturesque residence was built for James Anthony Bailey, partner in the famed Barnum & Bailey Circus, which he founded with Phineas T. Barnum in 1881. A fine example of domestic architecture influenced by the popular Romanesque Revival style, the house is one of Manhattan's few surviving free-standing mansions.

Situated on a corner, it has an impressive three-story corner tower surmounted by a conical roof and spiked finial, rising high above the curvilinear Flemish gables found on each of the four facades. The theme of the central tower is echoed by the small turrets at the other corners. The gray, slate roof, with dormer windows on all four sides, is crowned by a wrought-iron railing at the truncated apex. The rough-faced random-coursed ashlar, typical of the Romanesque Revival, is relieved by smooth-faced stone, notably at the window and door enframements, the main porch, and the spandrels above the third-story tower windows. Other notable features include projecting porches, arched windows, bays, high chimneys, and delicate ornamental detail associated with the Romanesque Revival style.

The neighborhood was largely rural until the 1880s. Although much of the area is now dominated by apartment buildings, the survival of this house and other buildings of the same period help to retain a pleasant nineteenth-century residential atmosphere. The building is currently occupied by a funeral home.

WASHINGTON BRIDGE

1886–89; reconstruction, 1989–93

Harlem River from West 181st Street, Manhattan, to University Avenue, The Bronx

Architects: Charles C. Schneider and Wilhelm Hildenbrand; modified by Union Bridge Company, William J. McAlpine, Theodore Cooper, and DeLemos & Cordes; Edward H. Kendall

Chief engineer: William R. Hutton

Designated: September 14, 1982

Constructed shortly after the completion of the Brooklyn Bridge, the Washington Bridge is a monument in the history of nineteenth-century American engineering. Made of steel, cast-iron, and wrought-iron arches with arched masonry approaches, the bridge was constructed over the Harlem River to connect the Washington Heights section of Manhattan with the Bronx. It has long been considered one of the nation's finest nineteenth-century steel-arch bridges, perhaps second only to the famous Eads Bridge in St. Louis, built in 1867–74. With its two immense archways and generally bold design, the Washington Bridge remains an ornament to the city.

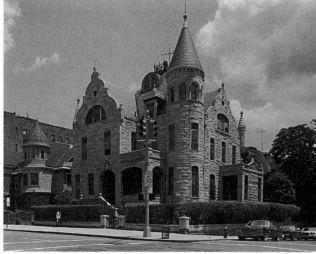

FORMER BAILEY HOUSE

WASHINGTON BRIDGE

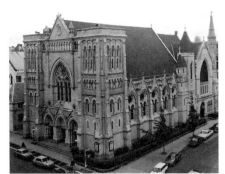

EMMANUEL BAPTIST CHURCH

F.J. BERLENBACH HOUSE

EMMANUEL BAPTIST CHURCH

279 LAFAYETTE AVENUE, BROOKLYN

DESIGNATED: NOVEMBER 12, 1968

CHURCH, 1887

ARCHITECT: FRANCIS H. KIMBALL

CHAPEL, 1882–83

ARCHITECT: EBENEZER L. ROBERTS

SCHOOL, 1925–27

ARCHITECT: UNKNOWN

With its square twin towers and triple entrance porch, Emmanuel Baptist Church is reminiscent of a small French Gothic cathedral. Its two richly decorated principal elevations are imposing, monumental, and somber, yet enlivened by a variety of fanciful carved ornament and structural forms. The impressive front elevation is skillfully composed; the twin towers with massive stepped buttresses at the corner are divided vertically into five sections. The main entrance comprises three arched and pedimented portals, and a large, pointed-arched window is centered in the middle section above the doors; a low arcade with a pediment above crowns the front. The tympanum above

the central doorway contains a beautiful bas-relief of Christ blessing the children. In the diapered surface of the gable crowning the building is a bas-relief of John the Baptist.

F.J. BERLENBACH HOUSE

1887

174 MESEROLE STREET, BROOKLYN

ARCHITECT: F.J. BERLENBACH JR.; CARPENTER: FRANZ J. BERLENBACH

DESIGNATED: MAY 11, 2004

"Located in the Williamsburg section of Brooklyn, the Berlenbach House is an extraordinary Queen Anne-style survivor from the last decades of the nineteenth century. The three-story frame building was built in 1887 by local carpenter Franz J. Berlenbach, a German immigrant, from plans drawn by his son, F.J. Berlenbach Jr., a young architect who had recently opened a design office nearby. The Berlenbach family occupied the house until 1899.

While most of the older wood-frame buildings in this section of Brooklyn have been resurfaced with new materi-

als, this house retains its original clapboard siding and is alive with inventive wood carving. The design exhibits an exuberant use of ornament and an animated treatment of the wall surface. The densely textured carving, including an entrance hood, bands of foliate ornament, incised sun designs, and vertical and wavy half-timber forms sets this house apart from others in the city. Crowning the building is a bracketed cornice with a paneled frieze, above which is a pediment with a band ornamented by a mask and a sunburst tympanum. Adding to the texture of the facade are a segmental-arched stained glass transom at the first story, and tinted smallpaned windows in the upper sash."*

JOHN AND ELIZABETH TRUSLOW HOUSE

1887–88

96 BROOKLYN AVENUE (ALSO KNOWN AS 1331–1343 DEAN STREET), BROOKLYN

ARCHITECT: PARFITT BROTHERS

DESIGNATED: SEPTEMBER 16, 1997

John Truslow, a major figure in Brooklyn business, church, and philanthropic affairs, commissioned this distinguished freestanding house from Parfitt Brothers. One of the firm's finest residential designs, the building was constructed when the northwestern section of Crown Heights was developing as a prestigious residential neighborhood.

JOHN AND ELIZABETH TRUSLOW HOUSE

ST. MARTIN'S EPISCOPAL CHURCH

LEWIS H. LATIMER HOUSE

Complex in its massing with a dynamic rooftop silhouette of towers, gables, finials and chimneys, the Queen Anne style house is an asymmetrically massed three-story structure faced with red brick with sandstone and granite trim. The facade details, the subtle use of raised and molded bricks, smooth and rough stone surfaces and metal cladding on the square towers, emphasizes the structure. The exterior retains almost all of its original architectural forms and materials. Now an apartment building, this structure has housed a number of active community members, including the Reverend Adolphus J.F. Behrends, minister of the Central Congregational Church (demolished), and Alezandro de Angel, a South American coffee exporter.

ST. MARTIN'S EPISCOPAL CHURCH AND PARISH HOUSE

1887–89

230 LENOX AVENUE, MANHATTAN

ARCHITECT: WILLIAM A. POTTER

DESIGNATED: JULY 19, 1966

St. Martin's is one of New York's finest

Richardsonian Romanesque churches. The dominant high tower houses one of only two carillons in Manhattan—a forty-two-bell instrument brought from Holland in 1949. A copper pyramidal steeple is adorned at each corner with simple square pinnacles. At the base of the tower a pair of handsome, arched doorways leads into the church, punctuating the gabled end wall of the main aisle.

The Parish House stands between the west end of the church and Lenox Avenue. This two-story structure with its steep gables is faced with the same rock-faced sandstone blocks and smooth-faced stone trim as the church itself.

LEWIS H. LATIMER HOUSE

1887–89; 2004

34–41 137TH STREET, FLUSHING, QUEENS

ARCHITECT: UNKNOWN

DESIGNATION: MARCH 21, 1995

Lewis Latimer was an electrical engineer and inventor who worked briefly with Alexander Graham Bell and later, for

twenty years, with Thomas Edison. Latimer's most important contribution was a process for making inexpensive, long-lasting carbon filaments, which reduced the production costs of light bulbs and made them affordable for the average household. His patents proved profitable for Edison's Electric Light Company, but Latimer did not benefit personally. In addition to his engineering accomplishments, Latimer was also an activist member of the African American community, and his house was a meeting place for civic and cultural leaders, including W.E.B. Du Bois and Paul Robeson.

This Queen Anne–style frame house, originally located on Holly Avenue in Queens, was bought by the Latimers in 1902 and remained in the family until 1963. It was threatened with demolition by developers in 1988, but the combined efforts of the Ebenezer Baptist Church, the Borough of Queens, and Latimer's granddaughter, Dr. Winifred Norman, saved and relocated the house. Its present site abuts the Latimer Gardens houses, which were named for the inventor. After restoration, the Latimer House opened as a museum in 2004.

ANTIOCH BAPTIST CHURCH

ANTIOCH, FORMERLY GREENE AVENUE, BAPTIST CHURCH

1887–92; CHURCH HOUSE, C. 1892–93

826–828 GREENE AVENUE, BROOKLYN

ARCHITECTS: CHURCH, LANSING C. HOLDEN; CHURCH HOUSE, LANGSTON & DAHLANDER

DESIGNATED: NOVEMBER 20, 1990

A splendid example of the Queen Anne style detailed with Romanesque Revival elements, the Antioch Baptist Church gracefully harmonizes with the character, scale, and texture of neighboring row houses, which were designed in the same architectural spirit shortly after the completion of the church. One of the original row of seven adjacent to the church was bought by the congregation in 1961 for use as a church house.

The church features a modulated, symmetrical facade of projecting and recessed masses faced in contrasting

colors of rock-faced and red-brown brick, russet slate shingles, and white rusticated limestone. The robust horizontal expanse is balanced by the vertical thrust of stacked windows and the four crowned and capped towers. Romanesque Revival details, like the round-arched windows, carved stone bartizan bases, and serpentine iron strap door hinges, enhance the building's medieval appearance.

The church has played a prominent role in Brooklyn's religious history. It was first the Greene Avenue Baptist Church, with a predominantly white congregation distinguished for local philanthropy and missionary work. In 1950, as economic forces transformed Bedford-Stuyvesant into one of the city's largest African-American neighborhoods, it became the Antioch Baptist Church. It remains a prominent African-American institution and has been host to many civil rights leaders, including the Rev. Dr. Martin Luther King Jr., Rev. Ralph Abernathy, Rev. Dr. Adam Clayton Powell Jr., Hazel Dukes (head of New York's NAACP), and Rosa Parks, as well as African-American politicians and celebrities in many fields.

376–380 LAFAYETTE STREET

1888–89

MANHATTAN

ARCHITECT: HENRY J. HARDENBERGH

DESIGNATED: MAY 17, 1966

This six-story commercial building was designed by Henry J. Hardenbergh,

376–380 LAFAYETTE STREET

better-known for elegant structures like the Plaza Hotel (p. 390), the Dakota Apartments (p. 225), and the Art Students League building (p. 273).

Handsome dark-brown brick piers form five bays for the windows on Great Jones Street and four on Lafayette Street. The four-story tier arrangement of windows terminates in brick segmental arches, above which are paired windows on the fifth floor and a row of round-arched windows on the sixth. The piers, supported at the first floor by dwarf columns of sandstone, rest on polished gray granite bases. Sections of light-colored brick wall terminate the succession of arched bays, marking entrances, stairs, and elevators. A richly decorated metal cornice crowns the entire composition, and two structures with pointed roofs form end-of-building accents.

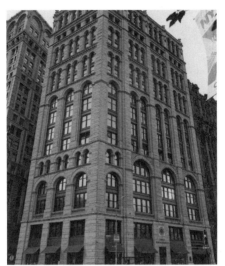

PACE UNIVERSITY

PACE UNIVERSITY, FORMERLY NEW YORK TIMES BUILDING

1888–89, ENLARGED 1903–5; 1951

41 PARK ROW (ALSO KNOWN AS 39–43 PARK ROW, 147–151 NASSAU STREET), MANHATTAN

ARCHITECT: GEORGE B. POST; ADDITION, ROBERT MAYNICKE

DESIGNATED: MARCH 16, 1999

From the 1830s to the 1920s, Park Row, also called "Newspaper Row," was the center of New York's newspaper publishing industry. The former headquarters of the *New York Times* is one of the few reminders of that era.

The *Times* requested that Post not disturb the presses in the original 1857 building while constructing the new building around it. He was forced to incorporate the existing floor framing and reinforce the structural elements to support the twelve-story Richardsonian-Romanesque building, which was an amazing technical feat.

In 1903–5, the mansard roof with gabled dormers was removed and four floors added by architect Robert Maynicke. Above the gray granite store-fronts, the floors are faced with rusticated limestone, and organized into a series of arches that emphasize the height of the early skyscraper. Post's designs also include carefully scaled details, compound colonettes, roll moldings, miniature balustrades, foliate reliefs and gargoyles.

In 1904, Adolph Ochs, the owner of the *Times*, decided to relocate to Times Square. Pace University purchased the building in 1951, converting its offices to classrooms, and still occupies it today.

GERMAN-AMERICAN SHOOTING SOCIETY CLUBHOUSE

1888–89

12 ST. MARK'S PLACE, MANHATTAN

ARCHITECT: WILLIAM C. FROHNE

DESIGNATED: JUNE 26, 2001

The German-American Shooting Society Clubhouse is one of the few institutional buildings left from a period when German immigrants populated this part of the Lower East Side, accounting for a quarter of the city's total population. The neighborhood became known as Kleindeutschland, or Little Germany, in the 1840s, and cultural institutions were founded to carry on traditions native to the immigrants. Some shooting clubs were founded as active militias and served in the Civil War, but by the

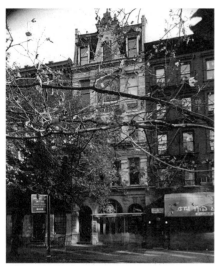

GERMAN-AMERICAN SHOOTING SOCIETY

1880s, they were primarily social organizations dedicated to target practice and marksmanship, a common middle-class hobby.

The yellow-brick clubhouse contained a shooting gallery, salon, restaurant, and assembly rooms for twenty-four shooting clubs. The German Renaissance Revival style building was unique at the time and served as a strong visual link to the homeland of its occupants. Most notable is the elaborate terra-cotta ornament depicting a target with crossed rifles, over an eagle with extended wings, and the motto, "Einigkeit-Macht-Stark" (Unity Makes [Us] Strong). It also features a steep mansard roof with tall, ornate dormers. The Shooting Society owned the building until 1920. In later years, the building served as a cultural center for the Polish and then Ukrainian immigrant communities. A restaurant currently operates in the building.

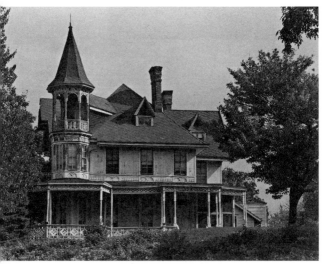

CHARLES KREISCHER HOUSE

CHARLES KREISCHER HOUSE

C. 1888

4500 ARTHUR KILL ROAD,
STATEN ISLAND

ARCHITECT: ATTRIBUTED TO PALLISER
& PALLISER

DESIGNATED: FEBRUARY 20, 1968

This two-and-one-half-story Victorian residence was named for its first owner, Charles Kreischer, whose family were the owners of a brick-manufacturing company. The frame house was executed in the so-called stick style; the extensive decorative patterns and forms have evoked comparisons to both Mississippi riverboats and nineteenth-century Swiss chalets.

The house is partially encircled by an old-fashioned veranda that follows the polygonal form of the base of a three-story tower, asymmetrically placed at the corner. The porch roof is supported by widely spaced posts carrying an ornate

railing. A top-floor balcony with a projecting gable overhang is supported by two diagonal brackets. This gable and the triangular panels beneath it are enhanced by jigsaw filigree designs.

FOURTEENTH WARD INDUSTRIAL SCHOOL, ASTOR MEMORIAL SCHOOL

1888–89; 2004

256–258 MOTT STREET, MANHATTAN

ARCHITECTS: VAUX & RADFORD

DESIGNATED: JULY 12, 1977

A splendid example of Victorian Gothic architecture, the Fourteenth Ward Industrial School was built in 1888–89 for the Children's Aid Society. Founded in 1853 by Charles Loring Brace, the society was the first organization established in this country to improve the living conditions of indigent children. By the end of the century, nearly all of the older buildings that were used by the society had been replaced by newer, more modern ones built specifically for its use—the majority of which were designed by the firm of Vaux & Radford.

This polychromatic four-story structure is dominated by a three-sided, centrally placed oriel on the facade, set on a convex sandstone corbel extending up through the second and third stories, and an impressive crow-stepped gable roof. Other prominent features include foliate terra-cotta ornament, arched windows, and a series of dormers set at the roofline.

The school—built with funds contributed by John Jacob Astor as a

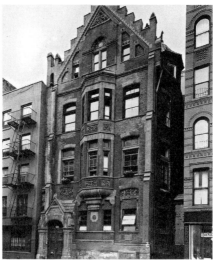

FOURTEENTH WARD INDUSTRIAL SCHOOL

memorial to his wife, who was a long-time supporter of the activities of the society—was built to serve the needs of the poor in the large Italian community in the neighborhood. It was the first society structure planned solely as a school. Dedicated in March 1889, it was used as an industrial and night school until 1913, when a larger structure was built nearby. It has recently been converted into cooperative apartments.

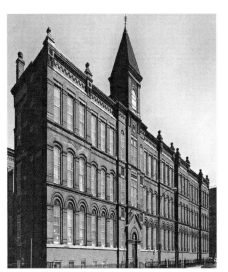

PUBLIC SCHOOL 73

PUBLIC SCHOOL 73

1888; ADDITION, 1895

241 MACDOUGAL STREET, BROOKLYN

ARCHITECT: JAMES W. NAUGHTON

DESIGNATED: SEPTEMBER 11, 1984

An impressive brick and stone structure, P. S. 73 is an excellent example of nineteenth-century school architecture by one of the major practitioners in that field, James W. Naughton, superintendent of buildings for the Board of Education of the City of Brooklyn. The school was built in two sections: the first, at the corner of Rockaway Avenue and MacDougal Street, was begun in 1888; the extension to the east was added in 1895.

Public education in New York dates back to the settlement of the area by the Dutch. The first school was established in 1638 on Manhattan Island, then the center of population. By the early nineteenth century, each of Brooklyn's six towns developed a separate though similar public education system, with the first village school opening in 1816. P. S. 73, located near the eastern boundary of Brooklyn and the town of New Lots, was erected to meet the needs of a growing population.

The main section is characterized by a projecting central entrance tower and flanking end pavilions. The structure has a number of architectural references to earlier styles: the long horizontal window arrangement suggests the Italianate palazzo style; the projecting end pavilions that divide the facade vertically are features of the French Second Empire; and the heavy pedimented entrance and rendering of the tower are late Romanesque Revival.

BETH JACOB SCHOOL, FORMERLY PUBLIC SCHOOL 71K

1888–89

119 HEYWARD STREET, BROOKLYN

ARCHITECT: JAMES W. NAUGHTON

DESIGNATED: FEBRUARY 3, 1981

The Beth Jacob School—originally P.S. 71K—was erected when Brooklyn was still a separate city with an independent education system. As superintendent of buildings for the Board of Education, Naughton designed all school buildings in Brooklyn between 1879 and 1898. The Beth Jacob School was built in the French Second Empire style, adopted in America when the building market in New York began to recover from the economic effects of the Civil War.

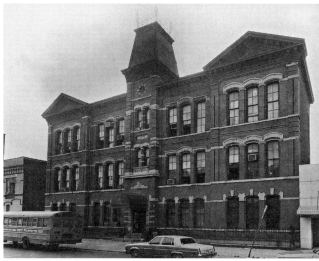

BETH JACOB SCHOOL

Pavilions, which emphasize verticality on the facade, and mansard roofs, which elaborate the pavilions, were characteristic of the style.

The symmetrical, three-story brick structure with stone trim has a round-arched entrance at the base of an elaborately embellished central tower. Recessed three-window sections connect the tower to the end pavilions, which are topped by pediments with raking cornices. Stone bands at sill and impost level, brick and stone quoins, grooved piers, and stone and brick window lintels further decorate the building, which is crowned by a high mansard roof that retains its original iron crestings.

CARROLL STREET BRIDGE

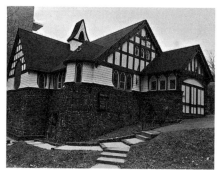

EDGEHILL CHURCH OF SPUYTEN DUYVIL

CARROLL STREET BRIDGE

1888–89; 1989

GOWANUS CANAL, BROOKLYN

BUILDER: BROOKLYN DEPARTMENT OF CITY WORKS

ENGINEERS: ROBERT VAN BUREN; GEORGE INGRAM

DESIGNATED: SEPTEMBER 29, 1987

The Carroll Street Bridge, spanning the Gowanus Canal, replaced an earlier structure, a change made necessary by the expansion of lower Brooklyn and the construction of the canal to accommodate the developing waterfront.

The bridge is the oldest of four known surviving retractile bridges built in the United States during the late nineteenth and early twentieth centuries. A comparatively rare type that became obsolete by the 1920s, the bridge rolls horizontally on wheels set on steel rails, allowing traffic to pass freely through the canal. It was constructed by the New Jersey Steel and Iron Company, a subsidiary of Cooper, Hewitt & Company, one of the leading producers of iron and steel at that time. Robert Van Buren, a descendant of President Martin Van Buren, was the chief engineer of the project for the Brooklyn Department of City Works. The bridge was restored in 1989.

EDGEHILL CHURCH OF SPUYTEN DUYVIL, FORMERLY RIVERDALE PRESBYTERIAN CHAPEL

1888–89

2550 INDEPENDENCE AVENUE, THE BRONX

ARCHITECT: FRANCIS H. KIMBALL

DESIGNATED: NOVEMBER 25, 1980

A remnant of the Bronx's bucolic past, the Edgehill Church of Spuyten Duyvil was originally a mission of the Riverdale Presbyterian Church and was built to serve the workers of the Johnson Iron Foundry. Isaac G. Johnson, the foundry's owner and a devout Baptist, sought to impart religious teachings to his workers; he initiated the construction of the chapel, and Mary E. Cox, his partner's wife, donated the land. For its design, they commissioned Francis H. Kimball, who incorporated Gothic, Tudor, and Richardsonian features.

A massive stone base laid in random ashlar provides support for lighter shingled and stone walls and half-timbered gables. The entrance is on the east side, through a peaked-roof porch that projects from a large gable, and is lined on either side by three trefoil-arched windows. The south side has a series of projections, including a rounded extension lit by Gothic arched windows, a short nave with trefoil windows, and a shallow transept with two signed Tiffany stained glass windows. The chancel is on the west side; a nave and transept with two Tiffany Studios stained glass windows mark the north. Also on the north side is a tall stone chimney that, together with the variously sloped roofs of the other architectural members, adds to the chapel's picturesque character.

For almost half a century, Edgehill has been affiliated with the Congregational Church, now part of the United Church of Christ.

FIRE ENGINE COMPANY 36, FORMERLY HOOK & LADDER COMPANY 14

1888–89; 1975

120 EAST 125TH STREET, MANHATTAN

ARCHITECTS: NAPOLEON LEBRUN & SONS

DESIGNATED: JUNE 17, 1997

Between 1880 and 1895, Napoleon LeBrun & Sons constructed forty-two firehouses and helped to define the New York Fire Department's expression of civic architecture. This four-story, brick-

and-stone Romanesque Revival firehouse reflects the firm's attention to setting, materials, and stylistic details.

The base of the building is dominated by a wood-paneled overhead door that is painted fire-engine red. Flanked by a door on the west side and a large window on the east side, the entrance is framed by cast iron and set in the center of a rusticated brownstone facade. Flame and fish-scale motifs decorate the cast-iron piers, transom bars, and lintel, and "Engine 36" is painted on the top center panel of the frame. The second and third floors, separated from the base by brownstone molding, are faced in brick and feature tripartite windows.

The fourth-story gable is the most detailed part of the structure. The stepped gable is trimmed in brownstone and capped with a finial and is set into a mansard roof with multicolored slate tiles. A wrought-iron jib, which was used to haul hay up to an attic store-room, is still in place above the window.

Hook & Ladder Company 14 relocated to 2282 Third Avenue in 1975. Since then this firehouse has been occupied by Engine Company 36, which relocated from 1849 Park Avenue.

CHURCH OF ST. LUKE AND ST. MATTHEW

1888–91

520 CLINTON AVENUE, BROOKLYN

ARCHITECT: JOHN WELCH

DESIGNATED: MAY 12, 1981

FIRE ENGINE COMPANY 36

The Church of St. Luke and St. Matthew on Clinton Avenue (once the "Gold Coast" of Brooklyn) is among the largest and finest of the ecclesiastical structures built in the city during the nineteenth century, and, like the other major buildings from the period, it reflects a sense of optimism in Brooklyn's future. The church is the masterpiece of Brooklyn architect John Welch, who established himself as a church architect, designing a number of notable Greek Revival and Gothic Revival churches in Brooklyn and New Jersey. Welch's designs for St. Luke's are loosely based on twelfth-century Romanesque churches of Northern Italy but adapted for use by a nineteenth-century urban congregation in America. The superb design also shows the influence of H. H Richardson's pioneering

CHURCH OF ST. LUKE AND ST. MATTHEW

Romanesque Revival designs, but his forms are used in a fresh and original manner.

Its facade is distinguished by a projecting round-arched entrance porch, large wheel window, corbeled cornice, and small octagonal towers. The varieties of rough and smooth stone and terra-cotta serve to create a subtle drama on the building. The beautifully modeled tower of the chapel, a sophisticated essay in the use of round arches, is based on the campaniles of Italian Romanesque churches. The interior has fine double-lancet stained glass windows produced by the Tiffany Studios and a stained glass window in the ceiling of the chancel.

The church has continued to serve a neighborhood that has seen great changes in the last decades. The congregation is now largely drawn from the West Indian population of the area, which has reinvigorated the church, allowing it to maintain its magnificent edifice.

EDGEWATER VILLAGE HALL

EDGEWATER VILLAGE HALL

1889

111 CANAL STREET IN TAPPAN PARK,
STATEN ISLAND

ARCHITECT: PAUL KÜHNE

DESIGNATED: JULY 30, 1968

Edgewater Village Hall was built at the end of the nineteenth century as a Municipal and City Magistrate's Courthouse. Originally serving the village of Edgewater, the Romanesque Revival hall stands on a small, landscaped public square called Tappan Park; it presently houses offices of the Health Department of the City of New York.

The first floor of the one-and-one-half-story, T-shaped brick building has paired, square-headed windows, set in brick arches surmounted by circular lights and joined at the spring lines of those arches by a brick band course. Above, the second floor is encircled by wide eaves with a pronounced molded cornice set on evenly spaced, fluted brackets that alternate with rosette-decorated square panels. This pattern is interrupted at intervals by double-hung dormer windows, enframed by large

MECHANICS' TEMPLE

brackets and resting on a brick, corbel-supported sill. Dominating the facade is a square tower that rises just above the hipped roof. The tower is embellished by brick corbels beneath its cornice and is crowned by a flagpole surmounting a low spire with a pedestal cap.

MECHANICS' TEMPLE, INDEPENDENT UNITED ORDER OF MECHANICS OF THE WESTERN HEMISPHERE, FORMERLY THE LINCOLN CLUB

1889; 1940s

65 PUTNAM AVENUE, BROOKLYN

ARCHITECT: RUDOLPH L. DAUS

DESIGNATED: MAY 12, 1981

Located in the affluent Clinton Hill section, the Lincoln Club was one of a number of large, sumptuous clubhouses erected in Brooklyn and Manhattan in the last two decades of the nineteenth century. One of the finest of Rudolph

Daus's buildings and one of the most sophisticated Queen Anne–style structures in New York City, the Lincoln Club is distinguished by its rich variety of subtly contrasting textures and colors and asymmetrical massing. The Roman brick and brownstone facade is enlivened by smooth brownstone bands and rich terra-cotta ornament. Other notable features are a highly decorative roof gable, a round tower capped by a large, flamboyant cornice, and an unusual, asymmetrical arrangement of windows, all of which contrast sharply with the austere simplicity of the building.

Founded in 1878 by a small group of men who banded together for social purposes and to further the interests of the Republican Party, the Lincoln Club was dissolved in 1931 as many of Brooklyn's elite moved away. The clubhouse was purchased in the 1940s by the Independent United Order of Mechanics of the Western Hemisphere, a private philanthropic society that has taken great pride in restoring this dignified building.

PUBLIC SCHOOL 11, FORMERLY PUBLIC SCHOOL 91

1889; ADDITIONS, 1905, 1930

1257 OGDEN AVENUE, THE BRONX

ARCHITECT: GEORGE W. DEBEVOISE;
ADDITIONS, C.B.J. SNYDER; WALTER
C. MARTIN

DESIGNATED: AUGUST 25, 1981

Built in 1889, this Romanesque Revival

schoolhouse was designed by George W. Debevoise, the superintendent of public school buildings for the New York City Board of Education between 1884 and 1891. Little is known of Debevoise, but during his tenure as superintendent, he designed more than twenty schools in the Bronx and Manhattan, all in the Romanesque Revival or Queen Anne styles. Debevoise introduced a number of structural innovations into school buildings, including the use of iron girders instead of wood to enlarge classroom space and the addition of metal-lined steam pipes in classrooms to improve ventilation and heating.

P.S. 11 is built of brick and Harlem River stone. A projecting central entrance tower incorporates a porch consisting of banded stone piers carrying a round arch with a gable hood supported by corbels. The tower's second floor is pierced by three narrow round-arched windows and the third is marked by a bull's-eye window. Above the corbeled cornice is a pyramidal roof with a peaked dormer. Walls on each side of the tower are pierced by secondary entrances with segmental arches. These entrances are flanked by round-arched windows. At the southern end of the structure is a pavilion with square-headed pediment openings on the ground floor and two tiers of flat and round-arched windows at the second floor. The pavilion, like the entrance tower, is crowned by a steep-pitched dormer roof. There is a narrow extension set back from the street at the northern end. In 1905, a large wing was added along Ogden Avenue. Three stories high, it is

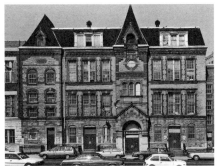

PUBLIC SCHOOL 11

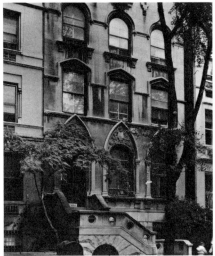

CHARLES A. VISSANI HOUSE

of red brick with stone trim above a rough-faced stone base. A gymnasium/auditorium was built along Merriam Avenue in 1930.

CHARLES A. VISSANI HOUSE

1889; 1946	
143 WEST 95TH STREET, MANHATTAN	
ARCHITECT: JAMES W. COLE	
DESIGNATED: FEBRUARY 19, 1991	

With a wealth of exuberant details, this limestone residence exemplifies the late Victorian version of the Gothic Revival style. An unusual choice for a city row house because of its picturesque yet space-consuming features, this style was considered more appropriate for places of worship, as Trinity Church, Grace Church, and St. Patrick's Cathedral so eloquently demonstrate.

The association between ecclesiastical and medieval, in fact, may have motivated the decision to use the Gothic style here. Commissioned by the Very Reverend Charles A. Vissani, the house was also to be used as headquarters for the religious work of the Franciscan priests who lived there; it even contained a chapel. Vissani had been appointed the first Commissary General of the Holy Land for the United States in 1880. The main tasks of the Commissariat—which moved to Washington, D.C., in 1889 and is still in operation today—are to increase public awareness about the holy places of Jerusalem and to preserve and recover the sanctuaries of Palestine.

Since 1946, the property has been used as a multi-unit residence. Nevertheless, the building's ecclesiastical overtones, heightened by pointed and ogee arches, pinnacles, trefoils, drip moldings, and lush foliated tympana, serve as an imposing reminder of its original mission.

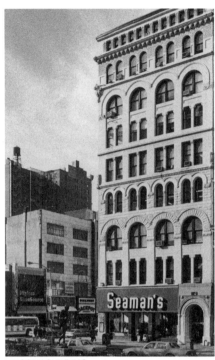

LINCOLN BUILDING

LINCOLN BUILDING

1889–90

1–3 UNION SQUARE WEST,
MANHATTAN

ARCHITECT: R. H. ROBERTSON

DESIGNATED: JULY 12, 1988

When the Commissioners Map of 1807–11 first laid out Manhattan's grid plan, the acute angle where Bloomingdale Road (now Broadway) intersected the Bowery at 16th Street demarked an island of land that was dubbed Union Place. Initially the poor built shanties there, but by 1839, Union Square (as it came to be known) had been graded, paved, and fenced in, and it was set aside for military and civic parades and festivities. By the 1850s, mansions had sprung up around the picturesque square. Within a few decades, tall commercial buildings, like the nine-story Lincoln, replaced the mansions as the city grew northward.

Combining metal-skeleton interior construction with masonry bearing walls, the Lincoln represents a transitional phase in skyscraper construction; eventually load-bearing walls were replaced by a steel skeleton that provides all the structural support—the essential criterion of a true skyscraper.

Romanesque Revival arcades articulate the skeletal construction, although the massiveness of the walls is evident, and the horizontality of traditional masonry is further emphasized by the stacked fenestration. Sheathed in Indiana limestone, granite, and brick, the building is ornamented with exceptional details: acanthus scrolls, Byzantine capitals, griffins, and human and lion heads, all carved in terra-cotta.

WILLIAMSBRIDGE RESERVOIR KEEPER'S HOUSE

1889–90; 1998

3400 RESERVOIR OVAL (ALSO KNOWN AS 3450 PUTNAM PLACE),
THE BRONX

ARCHITECT: GEORGE W. BIRDSALL,
CHIEF ENGINEER, CROTON AQUEDUCT,
FOR NEW YORK CITY DEPARTMENT OF
PUBLIC WORKS

DESIGNATED: FEBRUARY 8, 2000

The Reservoir Keeper's House is the only

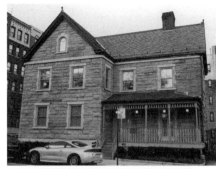

WILLIAMSBRIDGE RESERVOIR KEEPER'S HOUSE

remaining building from the Bronx and Byram Rivers water system, built in the 1880s, which served the western section of the Bronx, prior to the construction of the new Croton Aqueduct.

The L-shaped house is built of rough gray-tan gneiss ashlars, trimmed with smooth gray granite and embellished by keyed enframements. It served as the office and residence of the keeper of the Williamsbridge Reservoir (completed in 1889), the terminus of the fifteen-mile Bronx River pipeline. The reservoir was drained in 1925, and converted into Williamsbridge Oval Park in 1937. The house served as the private residence of Dr. Isaac H. Barkey until 1998, when the Mosholu Preservation Corporation purchased the house as offices for their community newspaper, Norwood News.

ALHAMBRA APARTMENTS

1889–90; ALTERED, 1923; 2000

500–518 NOSTRAND AVENUE AND
29–33 MACON STREET, BROOKLYN

ARCHITECT: MONTROSE W. MORRIS

DESIGNATED: MARCH 18, 1986

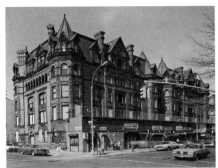

ALHAMBRA APARTMENTS

The Alhambra Apartments, in the heart of Bedford-Stuyvesant, is one of Brooklyn's major apartment houses. It was built in 1889–90 by developer Louis F. Seitz and was one of a number of commissions Montrose W. Morris executed for Seitz, including two other exceptional apartment houses, the Renaissance and the Imperial (p. 279). Although the Alhambra's ground floor was converted into storefronts in 1923, the building remains distinguished—a romantic and picturesque combination of the Romanesque Revival and the Queen Anne styles.

Built of Roman brick, stone, metal, and terra-cotta, the building is divided in the center, creating two separate but identical structures connected at each upper story by open, columned bridges. Each building rises five stories with a slate mansard roof. At each corner of the two buildings is a polygonal tower. The central bay of each building projects slightly and is characterized by deeply recessed, square-headed loggias with Corinthian columns (some recently removed) at the second and third floors, and an arcaded loggia at the fourth. The use of brick patterns, arched windows, carved brackets, foliate band courses, and quoins gives continuous movement to the facade. The ingenious use of open loggias and arcades relieves the strong horizontal massing of the building, as does the upward thrust of the towers. The subtle, polychromatic effect created by the various materials contributes an essential element to the architectural success of the building. Although alterations have been made, the upper floors are vacant, and the stores only partially occupied, the building has maintained its architectural dignity and remains, in form, detail, and massing, an outstanding example of turn-of-the-century apartment-house design. The building was restored in 2000.

FIRE ENGINE COMPANY 47

1889–90	
500 WEST 113TH STREET, MANHATTAN	
ARCHITECTS: NAPOLEON LEBRUN & SONS	
DESIGNATED: JUNE 17, 1997	

One of the first civic buildings in Morningside Heights, Engine Company 47 was built by Napoleon LeBrun & Sons during a fifteen-year period in which the firm designed more than forty firehouses in New York City. This firehouse combines elements of Romanesque Revival and Classical Revival styles.

The three-story structure has a rusticated brownstone base, while the

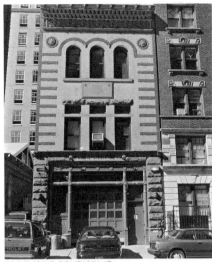

FIRE ENGINE COMPANY 47

second and third stories are faced in orange brick with terra-cotta quoins. The one-over-one, double-hung, second-story windows are defined by a brownstone transom bar and lintel, and the round-arched windows on the third floor are outlined by decorative terra-cotta. Between the second and third stories is a brownstone plaque inscribed with the names of the fire commissioners and the architects. Beneath a heavy cornice is an elaborately detailed terra-cotta entablature, below which are two large terra-cotta medallions with foliate patterns. Although it is a midblock structure, the firehouse overlooks the Croton Aqueduct gatehouse (p. 240) immediately to the east, and so the architects were able to echo the appearance of the street facade in the articulation of the visible east elevation.

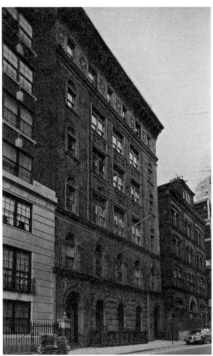

149–151 EAST 67TH STREET

149–151 East 67th Street, formerly the Mount Sinai Dispensary

1889–90

Manhattan

Architects: Buchman & Deisler and Brunner & Tryon

Designated: January 29, 1980

The Mount Sinai Dispensary, or health clinic, reflected Mount Sinai Hospital's pride in its efforts to bring medical care to a large urban population. The hospital was founded in 1852 by eight prominent Jewish citizens. The dispensary began its life in 1875 in two rooms of the hospital basement. It expanded rapidly as the hospital became more specialized, a trend in medicine that was only then beginning. The new dispensary building of 1889–90 was attached to the hospital by a tunnel that ran under 67th Street.

Although the exact contributions of the two architectural firms is uncertain, Buchman & Deisler is generally credited with the iron structural frame because of their prominence in the design of commercial buildings. The Italian Renaissance–style building is distinguished by its handsomely proportioned details in contrasting colors and textures. At the ground floor the central three bays have round-arched windows, and the upper stories are of closely laid pressed brick set off by white terra-cotta trim. The entire building is enframed by a border of vines and medallions. The Kennedy Child Study Center now occupies the building.

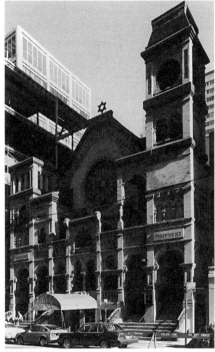

PARK EAST SYNAGOGUE

Park East Synagogue

1889–90

163 East 67th Street, Manhattan

Architects: Schneider & Herter

Designated: January 29, 1980

Park East Synagogue was organized by the Rabbi Bernard Drachman, who aimed to create a place of worship in which the principles of Orthodox Judaism would not bow to the pressures of Reform Judaism. Previously rabbi at Beth Israel Bikkur Cholem, a synagogue at Lexington Avenue and 72nd Street, Drachman resigned rather than vote to have men and women seated together. The Orthodox congregation at the Park East Synagogue was largely German, but

THE WILBRAHAM

THE WILBRAHAM

1889–90; 1934–35

1 WEST 30TH STREET, MANHATTAN

ARCHITECT: D. & J. JARDINE

DESIGNATED: JUNE 8, 2004

"The Wilbraham, built in 1888–90 as a bachelor apartment house, was commissioned by prominent Scottish-American jeweler William Moir as a real estate investment. It was designed by the versatile New York architectural firm of D. & J. Jardine, whose principals, David and John Jardine, were brothers and also of Scottish birth.

The Wilbraham is eight stories high plus basement and penthouse and crowned by a mansard roof. Clad in a handsome combination of Philadelphia brick, Belleville brownstone, and cast iron, the Wilbraham is extraordinary well detailed and reflects the influence of the Romanesque Revival style in the rock-faced stonework and excellent, intricately carved stone detail.

The bachelor apartment hotel, or "bachelor flats," was a multiple dwelling building type that arose in the 1870s to serve the city's very large population of single men. The Wilbraham catered to professional men of means. Each apartment contained a two-room suite with a bathroom but no kitchen; a residents' dining room was provided on the eighth floor. In 1934–35, the apartments were remodeled to include kitchens, and the building ceased to operate solely as bachelor flats."*

included many Polish, Russian, and Hungarian Jews as well. Rabbi Drachman believed in adapting Orthodox practices and traditions to American customs. The style of this synagogue was seen as a link between nineteeenth-century Judaism and Jewish culture in Moorish Spain.

The Moorish style of the building conforms with the late-nineteenth-century notion of appropriate synagogue architecture. The brick and terra-cotta building is distinguished by a central rose window, asymmetrically flanking tower, and rich ornamental detail reminiscent of Byzantine architecture.

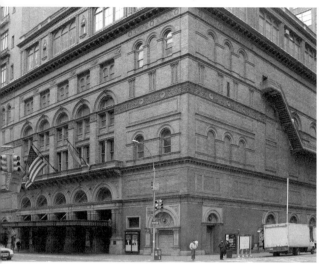

CARNEGIE HALL

Carnegie Hall

1889–91; addition, 1894–96;
restored, 1986, 2003

57th Street at Seventh Avenue,
Manhattan

Architect: William B. Tuthill;
restoration, Polshek Partnership

Designated: June 20, 1967

Andrew Carnegie, one of America's best-known industrialists and philanthropists, was, by the time of his death in 1919, the epitome of the self-made man. From humble origins in Scotland and modest beginnings in America as a bobbin boy in a cotton mill, through his spectacular career as an industrial magnate, Carnegie kept sight of the need for intellectual and artistic self-improvement. Totally self-educated, he frequented theaters and concert halls assiduously and sought out the company of intellectuals such as Matthew Arnold and Herbert Spencer. In order to effect "the improvement of mankind," Carnegie was the founder and benefactor of leading cultural institutions, among them the Carnegie Institute in Pittsburgh, the Carnegie Branch Libraries of the New York Public Library, and Carnegie Hall.

On May 13, 1890, the cornerstone was laid to the strains of music from Wagner's *Das Rheingold*. Carnegie said on that occasion: "Who shall venture to paint its history or its end? It is built to stand for ages, and during these ages it is probable that this hall will intertwine itself with the history of our country. . . . From this platform men may be spurred to aims that end not with the miserable self; here an idea may be promulgated which will affect the world."

Originally called, quite modestly, Music Hall, Carnegie Hall officially opened on the evening of May 5, 1891, with the American premiere appearance of Peter Ilich Tchaikovsky. Today Carnegie Hall continues to be a forum for musical discovery and excellence, at times presenting new artists and works, as well as a classical repertory of world-renowned artists.

Since its opening, the acoustical magic of the hall has been hailed worldwide. William Burnet Tuthill, the architect, made as detailed a study of acoustics as science permitted in 1890. The interior of the hall was painted white and sumptuously adorned with velvet, which would absorb reverberations and echoes; the boxes, laid out in sweeping curves, allowed sound to curve rather than bounce off sharp angles; and an elliptical ceiling avoided the pitfall of collecting and swallowing sound.

The exterior of the six-story building, of less historical importance than the interior, is an excellent example of a modified Italian Renaissance style, with its reddish-brown Roman brick, belt courses, arches, pilasters, and terra-cotta decorations. Originally the building had a mansard roof in the French tradition, but this was removed in 1894 to build the crowning studio floor. A somewhat awkward architectural massing results from the ten-story tower for offices and studios that was added to the building. Carnegie Hall was saved from demolition, when it was purchased by the city in 1960.

Carnegie Hall reopened in December 1986 after the renovation of the Isaac Stern auditorium and the Weill recital hall by the Polshek Partnership. Included in that renovation was the rebuilding of the stage ceiling, whose legendary hole, created during the filming of Carnegie Hall in 1946 and masked by canvas and curtains ever since, had purportedly contributed advantageously to the hall's acoustics. In 2003, the opening of Zankel Hall, also designed by the Polshek Partnership, completed Andrew Carnegie's original vision of three performance halls under one roof.

St. Andrew's Church

1889–90

2067 Fifth Avenue, Manhattan

Architect: Henry M. Congdon

Designated: April 12, 1967

The congregation of St. Andrew's, organized in 1829, grew slowly at first because the church was located so far out of town. Its first church, designed by Congdon in 1872–73, was at Park Avenue and 127th Street. By the late 1880s, the population of the area had grown, as had the congregation. Congdon was hired to dismantle the church and reconstruct and enlarge it on a more prestigious site on Fifth Avenue and 127th Street.

The church is constructed of random quarry-faced granite ashlar in the Gothic tradition. Adjacent to the south transept, on 127th Street, is a clock tower with a slate-covered spire, adorned at each corner with delicate turrets. On each side of the belfry are two pointed-arched openings. The plan of the church follows a cruciform shape, with galleries in the transept and side aisles in the nave. Covering the nave and the transept is a steeply pitched roof sheathed with slate. The west facade is highlighted by buttresses opposite the nave walls, two tall, narrow windows, and a small rose window; the main doorway has its own gable. Another entrance to the church, located on the south facade, is marked by a stone vestibule and slate-covered gable.

Century Association

1889–91; 1992

7 West 43rd Street, Manhattan

Architects: McKim, Mead & White; restoration, Jan Hird Pokorny

Designated: January 11, 1967

One of the purest examples of the Italian Renaissance style built in late-nineteenth-century New York is the Century Association. McKim, Mead & White was well regarded for its interpretation of Renaissance elements, and White in particular was known for masterfully combining textures, materials, and details to create unity and balance in a building.

The Century combines granite, terracotta, and yellow brick in a free and elegant adaptation of an Italian palazzo. Its Renaissance character is expressed by a two-story rusticated masonry base; a monumental arched entrance doorway; four handsomely wreathed round windows above the rectangular ones on the third floor; an elaborate cornice; and a crowning balustrade. The Palladian window above the main doorway was originally an open loggia, and the appearance of the building was weakened when this space was enclosed.

Long considered the city's most prominent cultural club, the Century was founded in 1847 by William Cullen Bryant and Asher B. Durand, among others, as a gathering place mainly for authors and artist. The organization was named the Century because its membership was originally supposed to be lim-

ST. ANDREW'S CHURCH

CENTURY ASSOCIATION

ited to one hundred—a figure long since exceeded. Among its members were many of the city's most important and influential scholars, jurists, and architects. The building also houses a distinguished collection of American art, which includes works by Winslow Homer, Frederic Remington, and Albert Bierstadt. The building was restored in 1992 by Jan Hird Pokorny.

JAMES HAMPDEN ROBB HOUSE

GILBERT KIAMIE HOUSE

JAMES HAMPDEN ROBB HOUSE

1889–92; 1977

23 PARK AVENUE (ALSO KNOWN AS 101–103 EAST 35TH STREET), MANHATTAN

ARCHITECTS: MCKIM, MEAD & WHITE

DESIGNATED: NOVEMBER 17, 1998

Stanford White designed this house for James Hampden Robb, a member of the legislature of New York in 1882 and New York City Parks Commissioner, and his wife, Cornelia, daughter of financier Nathaniel Thayer, one of the wealthiest men in New England. It is the first in a series of Renaissance Revival town houses White designed at the height of his career, drawing on models of ordered symmetry and hierarchical story treatment. The five-story building has a double-story brownstone entry porch, with paired polished granite columns, iron balustrades, balustraded roof parapets, and a two-story oriel on the East 35th Street facade. The tawny-orange, iron spot brick is embellished with Renaissance-inspired terra-cotta ornament and enlivens the simple cubic forms used to structure the facade.

Acquired by the Advertising Club in 1923, the building was combined with the neighboring town house on East 35th Street to serve as the organization's headquarters. In 1977, the building was purchased by a developer and turned into a cooperatively owned apartment building, as it remains today.

GILBERT KIAMIE HOUSE, FORMERLY GROLIER CLUB

1890

29 EAST 32ND STREET, MANHATTAN

ARCHITECT: CHARLES W. ROMEYN

DESIGNATED: AUGUST 18, 1970

The former Grolier Club was designed by Charles W. Romeyn in an imaginative interpretation of the Romanesque Revival style. The three-story building is notable for its restrained use of ornament and its feeling for texture, evident in the skillful juxtaposition of Roman brick and stone. Two linked arches distinguish the first floor, and the top floor has a handsome row of windows with columns between, extending the width of the building and supporting a stone lintel with ornamented cap molding. At the second floor, an arched central window is flanked by high, narrow windows. A slim, molded sill joins them at the base, and a richly ornamented but slender band course divides the two side windows at midheight. The first-floor arches display handsome carving.

The Grolier Club, which derived its name from the sixteenth-century bibliophile Jean Grolier, was formed in 1884 for literary study and promotion of the publishing arts. The club has relocated to 47 East 60th Street, and the house at 29 East 32nd Street is now owned by a New York City real estate concern.

ST. BARTHOLOMEW'S CHURCH

ST. BARTHOLOMEW'S CHURCH

1886–90

1227 PACIFIC STREET, BROOKLYN

ARCHITECT: GEORGE P. CHAPPELL

DESIGNATED: MARCH 19, 1974

St. Bartholomew's Church, near Grant Square in Crown Heights, was designed by the Brooklyn architect George P. Chappell. A Romanesque Revival church executed in red brick with a rough-faced red granite base, its most picturesque features include a wide gable containing a large, round-arched, stained glass window and a curved projection at the west corner with a semiconical roof. Rising from the east corner is a massive square tower with battered brick walls, a belfry, and a low convex tile roof. The nave has a clerestory with stained glass windows above the sloping roofs of the buttressed side aisles. The nave terminates in two projecting sections, each containing a chancel and vestry. Each

of these sections has its own peaked roof and the large round-arched window in the gable echo that of the main facade.

JUDSON MEMORIAL CHURCH AND JUDSON HALL

51–55 WASHINGTON SQUARE SOUTH, MANHATTAN

ARCHITECTS: McKIM, MEAD & WHITE

JUDSON MEMORIAL CHURCH 1888–93

DESIGNATED: MAY 17, 1966

JUDSON HALL, 1895–96

DESIGNATED: APRIL 12, 1966

Judson Memorial Church sits on a corner across from Washington Square Park and adjacent to the ten-story tower of Judson Hall. An architectural composition in the Italian Renaissance style, the church and hall were commissioned by the first pastor, Edward Judson, to complement the Washington Arch.

A raised entrance doorway is set between the buildings; five half-round steps lead gracefully up to a pair of dark, wood-paneled doors, recessed within a richly decorated terra-cotta frame. Terra-cotta ornament continues around the first floor of the north and east elevations of the church, and again at the second, third, and fifth floors of the hall, alternating with horizontal bands of recessed yellow Roman brick. Arches envelop the round-headed windows, while splayed brick lintels span the square-headed windows of the lower three stories.

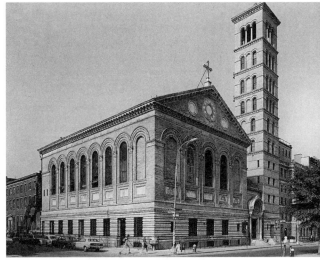

JUDSON MEMORIAL CHURCH AND JUDSON HALL

The stained glass windows of the church are the work of John La Farge, and the altar sculpture is by Augustus Saint-Gaudens. The impressive tower rising above the brick ground floor contains the same masonry work as the walls of the hall and terminates with two slender columns supporting the triple arches of the belfry. The congregation continues to use the church for services; the hall and tower are now part of New York University.

MECHANICS' AND TRADESMEN'S INSTITUTE, FORMERLY THE BERKELEY SCHOOL

1890; ADDITION, 1903–5

20 WEST 44TH STREET, MANHATTAN

ARCHITECTS: LAMB & RICH; ADDITION, RALPH S. TOWNSEND

DESIGNATED: OCTOBER 18, 1988

Originally constructed as a private preparatory school, the building was acquired in 1899 by the General Society of Mechanics and Tradesmen. This organization had fostered building-trades education since 1785, offering free instruction and maintaining one of the city's three subscription libraries. Steel magnate Andrew Carnegie was initiated into the society in 1891, and it was a $250,000 grant from Carnegie that assured the society's survival and made it possible to alter the building significantly. Between 1903 and 1905, two wings were added to the rear and three new upper stories replaced an original fourth-floor gymnasium. The result is a sensitive design solution that blends monumental Beaux-Arts classicism with Renaissance elements.

The exterior is a study in the tension between unifying and stratifying elements. The ten-foot-wide facade of seven symmetrical bays is variously composed of Indiana limestone, yellow Roman brick, and terra-cotta. The rusticated two-story base contrasts with the smooth-faced and elaborately ornamented upper floors. A wide frieze over the three central bays reproduces a portion of the Parthenon frieze, taken from casts

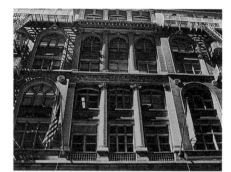

MECHANICS' AND TRADESMEN'S INSTITUTE

at the Metropolitan Museum of Art.

In addition to housing a major collection of architectural books, the building now contains a museum, which features original manuscripts, coins, firearms, and a number of unusual locks.

KREISCHERVILLE WORKERS' HOUSES

c. 1890

71–73, 75–77, 81–83, 85–87 KREISCHER STREET, CHARLESTON, STATEN ISLAND

ARCHITECT/BUILDER: UNKNOWN

DESIGNATED: JULY 26, 1994

The Kreischerville Workers' Houses, located in what is now the neighborhood of Charleston, are part of a group of four identical, two-story double houses. The houses were developed by Peter Androvette, a member of the prominent local shipping family that gave Charleston its original name, Androvetteville. Balthasar Kreischer established a factory in the Staten Island town in 1857 because of its proximity to clay deposits and water transportation.

KREISCHERVILLE WORKERS' HOUSES

As Kreischer's business grew, so did the village and its reliance on the brick industry. By the 1890s, Androvetteville—which by then was known as Kreischerville—was a quasi–company town; most of the population worked in the brick works and resided in rental housing built by either Kreischer or Androvette.

The workers' houses have four-bay facades, side porch entrances, masonry foundations, and stuccoed brick chimneys projecting from flat roofs. Originally, all four shared a single outhouse in back. Typical semi-detached workers' cottages, they evoke the look of a late-nineteenth-century company town. Ironically, the Kreischerville houses, built for brick workers, are constructed from inexpensive wood and shingle.

These four identical pairs of houses are rare surviving examples of their type.

1321 Madison Avenue

1890–91

Manhattan

Architect: James E. Ware

Designated: July 23, 1974

Easily identified by its pyramidal roof among flat cornices, 1321 Madison remains a lively presence on the Upper East Side. This Queen Anne–style house is one of an original row of five commissioned by the developer James V. S. Woolley for this growing middle-class neighborhood, now known as Carnegie Hill.

The three-sided bay window with a paneled parapet on the third floor and three round-arched windows with engaged colonnettes on the fourth floor are typical Queen Anne characteristics. A bracketed cornice with a sheet-metal frieze containing swags and scallops runs just beneath the roofline. Other notable elements include a round-topped attic window with a dormer and, on 93rd Street, an impressive brownstone stairway leading to a wide stoop and arched doorway.

Nicholas C. and Agnes Benziger House

1890–91; 1980; 1989

345 Edgecombe Avenue, Manhattan

Architect: William Schickel

Designated: January 12, 1999

Built at a time when many villas were constructed along the Washington Heights ridge overlooking the Harlem plain, this house is one of the last free-standing mansions in Harlem. Nicholas C. Benziger was a Swiss-born publisher of religious books related to Catholic worship; his firm still operates as a division of McGraw Hill.

Architect William Schickel incorporated medieval forms into the eclectic facade that included a flared mansard roof with gabled dormers, iron-spot brickwork, granite keystones, and brick bull's-eye ornaments. An irregularly shaped schist retaining wall, supporting an original iron fence, surrounds the property.

In 1920, Dr. Henry W. Lloyd bought the house from the Benzigers and used it as an annex to the hospital he operated on St. Nicholas Place. Psychiatrist Henry W. Rodgers purchased the house, also for hospital use. After World War II, the building was turned into a nursery school and kindergarten, and by the 1980s, it was a "short stay" hotel. The Broadway Housing Development Fund Company, a nonprofit organization that provides permanent housing for homeless adults, purchased the building in 1989.

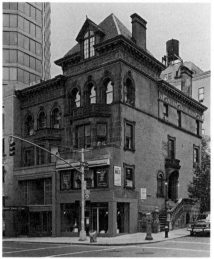

1321 MADISON AVENUE

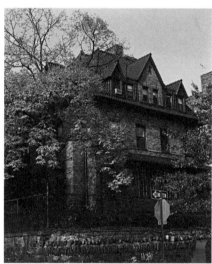

NICHOLAS C. AND AGNES BENZIGER HOUSE

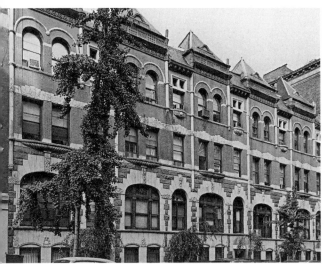

329, 331, 333, 335, 337 WEST 85TH STREET

329, 331, 333, 335, 337 WEST 85TH STREET

1890–91; 1988

MANHATTAN

ARCHITECT: RALPH S. TOWNSEND

DESIGNATED: APRIL 16, 1991

This eclectic group of brownstone and red-brick row houses, originally built as prime single-family residences, demonstrates an unusual combination of divergent stylistic vocabularies. Designed for builder-speculator Perez M. Stuart, the buildings exemplify the architecture of the Aesthetic movement, a progressive trend in England and the United States in the 1880s. The arches, round-headed windows, and rustication recall the Richardsonian Romanesque Revival. These forms are combined with elements of the Queen Anne style: the mullions that cross the broad first-story windows; the smooth-faced basement and first-story arches; and the wide

array of contrasting textures. The horizontal elements and tower-topped silhouettes visually unite the row, although each is distinguished by fanciful carvings of foliage, faces, or masks.

Architect Ralph S. Townsend is known for his row houses and multiple dwellings in Greenwich Village, west Midtown, and the Upper West Side. His appealing designs sold quickly—four out of this group were purchased five days after completion; and the fifth, ten days later. In 1988, the houses were converted into a cooperative apartment complex, entailing only minor modifications to the facades.

DELMONICO'S BUILDING

1890–91; 1999

56 BEAVER STREET (ALSO KNOWN AS 2–6 SOUTH WILLIAM STREET AND 56–58 BEAVER STREET), MANHATTAN

ARCHITECT: JAMES BROWN LORD

DESIGNATED: FEBRUARY 13, 1996

This Renaissance Revival building was the final location of the world-famous Delmonico's Restaurant. Swiss immigrants John and Peter Delmonico opened their first café in 1827 on William Street. During the 1870s and 1880s, the Delmonicos opened more cafés downtown, as well as several in the newly fashionable uptown districts. By 1890, the business was so successful that the present eight-story restaurant and office building was built on the site of an existing Delmonico's restaurant. Delmonico's went out of business in

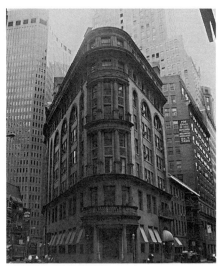

DELMONICO'S BUILDING

1925, and the building has housed several tenants since then. The restaurant space has been renovated, and reopened in 1999 under the Delmonico's name.

The Delmonico's Building was the first major nonresidential work by James Brown Lord. The building's tripartite side facades feature giant arcades made of orange iron-spot brick, brownstone, and terra-cotta. At the intersection of William and Beaver Streets, the rounded corner housing the main entrance stands as an independent facade. The doorway, its flanking columns, and the marble cornice above are said to have come from Pompeii. The columns were considered talismans of good luck for patrons who touched them as they passed through the door.

WILLIAM J. SYMS OPERATING THEATER

1890–92; 1941

400 WEST 59TH STREET, MANHATTAN

ARCHITECT: WILLIAM WHEELER SMITH

DESIGNATED: JULY 11, 1989

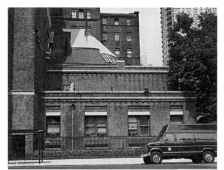

WILLIAM J. SYMS OPERATING THEATER

MACOMB'S DAM BRIDGE

By the late nineteenth century, surgery was established as a medical procedure. Operating theaters were modeled on the anatomical theaters that had been the centers of medical training since the Renaissance. When it opened in 1892, the Syms Operating Theater was the most advanced in the world and one of the first equipped for aseptic surgery. Dr. Charles McBurney, a prominent American surgeon who had achieved international recognition for identifying the diagnostic point on the abdomen for appendicitis, collaborated on its design with William Wheeler Smith, the architect. In an era when modern surgery was taking shape, numerous advances in surgical practice were developed here, including "McBurney's Incision," a method for removing the appendix.

The building is part of Roosevelt Hospital, one of the earliest "pavilion plan" hospitals in America. First proposed in 1788 by the French Academy of Sciences, the pavilion plan emphasizes parallel two-story buildings positioned for maximum light and air to dispel the dirt, dampness, and vapors that were believed to carry infections. The theater was built with a $350,000 endowment from the city's largest gunmaker and

dealer, William J. Syms. The subtly decorated flat brick walls with rounded corners, massive semiconical roof, imposing entranceway, and overall monumentality are all expressive of the unusual functional demands of the building.

Syms remained an operating theater until 1941, and since then has functioned variously as a blood bank, mortuary, temporary emergency room, and office and laboratory space. Today the structure stands as built except for the removal of the south facade, now abutted by the Tower Building, and a few other minor alterations.

MACOMB'S DAM BRIDGE, FORMERLY CENTRAL BRIDGE, AND 155TH STREET VIADUCT

1890–95

FROM JEROME AVENUE AND EAST 162ND STREET, THE BRONX, CROSSING THE HARLEM RIVER TO WEST 155TH STREET AND ST. NICHOLAS PLACE, MANHATTAN

ENGINEER: ALFRED PANCOAST BOLLER

DESIGNATED: JANUARY 14, 1992

Macomb's Dam Bridge is the third-oldest major bridge in New York City (after the Brooklyn and Washington Bridges) and the oldest intact metal-truss swing bridge. At the time of its construction, the central swing span was thought to be the heaviest moveable mass in the world. Alfred Pancoast Boller, an eminent structural engineer, had to overcome daunting obstacles to complete this significant engineering feat. Large obstructing boulders were removed, and foundations varying in depth from twenty-four to one hundred feet were sunk into marshland. The long, sloping 155th Street steel viaduct provided a gradual descent toward the bridge from the heights of Harlem to the west. To decorate the bridge, Boller added steel latticework, shelter towers, and ornamental iron railings and lampposts, several of which are still intact.

Originally built to help spur development in northern Manhattan, Macomb's Dam Bridge continues to provide an elegant and historically valuable connection between Upper Manhattan and the Bronx.

271

PARKSIDE SENIOR HOUSING

PARKSIDE SENIOR HOUSING, FORMERLY PUBLIC SCHOOL 20 ANNEX, FORMERLY THE NORTHFIELD TOWNSHIP DISTRICT SCHOOL 6

1891; 1897–98; 1993–94

160 HEBERTON AVENUE, STATEN ISLAND

ARCHITECTS: 1891, UNKNOWN; 1897–98 ADDITION, JAMES WARRINER MOULTON

DESIGNATED: MARCH 22, 1988

Built in what was in the 1890s the rapidly growing shorefront village of Richmond, P.S. 20 Annex was one of the first schools on Staten Island to have more than one room. While primarily designed in the Renaissance Revival style, this modest, two-story brick structure combines diverse elements and stylistic features.

This stylistic eclecticism predates the 1898 consolidation of Greater New York, which created a metropolis out of the area's scattered cities, towns, and villages and quickly standardized school construction. The tower, for example, with its pyramidal roof atop a round-arched arcade, is in the Romanesque Revival style; its off-center placement, however, evokes Italian villa architecture. Diverse window treatments suggest neo-Renaissance palaces, while decorative terra-cotta panels are drawn from the American Queen Anne style.

A three-story addition, approved in 1897 to handle increasing enrollment, follows the earlier Romanesque Revival style. Symmetrically disposed and simplified in design, the extension is less picturesque than the original, though terra-cotta ornaments—idealized female heads, putti, scrolled acanthus leaves, and reliefs depicting implements associated with learning—lavishly adorn the facade. In 1993–94, the building was converted into low income housing for the elderly by the architecture firm Diffendale & Kubec.

BOYS' HIGH SCHOOL

1891; 1897–98; 2000

832 MARCY AVENUE, BROOKLYN

ARCHITECT: JAMES W. NAUGHTON

DESIGNATED: SEPTEMBER 23, 1975

This splendid Romanesque Revival building represents the mature phase of the style that originated with H. H. Richardson. Richardsonian Romanesque was characterized by a picturesque silhouette, the use of round-arched openings, contrasting smooth- and rough-

BOYS' HIGH SCHOOL

faced stonework, and a strong massing with round bays and towers.

The school faces three streets and each facade incorporates round-arched windows, doors, gables, dormer windows, and a wealth of terra-cotta ornament. The Marcy Avenue facade is the most impressive, with each end terminated by an imposing tower—one crowned with a conical roof and the other extending beyond the roofline in height and crowned by a pyramidal roof. There is a deeply recessed, ribbed round arch at the main entrance. On the first two floors is a projecting section with a three-story bay above framing the windows of the upper floors. The spandrels of this bay and its crowning gable are adorned with terra-cotta ornament.

The building was restored by Beyer Blinder Belle and now serves as the Street Academy, Brooklyn Literacy Center and Outreach Program.

American Fine Arts Society Building, housing the Art Students League of New York

1891–92; addition, 1921

215 West 57th Street, Manhattan

Architect: Henry J. Hardenbergh

Designated: May 10, 1968

AMERICAN FINE ARTS SOCIETY BUILDING

The Arts Students League is a dignified adaptation of a François I town house, a formally balanced and well-proportioned composition that projects an air of restrained elegance that reflects architect Henry J. Hardenbergh's sensibility as much as his historical sources. Four stories high (with a fifth story, not visible from the street, added in 1921), the facade is divided into three major horizontal sections separated by plain and decorated band courses; a heavily decorated cornice with balustrade crowns the composition. The arched main entrance is flanked by tall, ornate candelabra-like spindles, a motif also carried out in the second-floor windows in a way that unifies the decoration. A red-tiled roof adds a touch of color to these formal harmonies.

Hardenbergh also designed an addition on 58th Street, modeled on the Galeries Georges Petit in Paris, originally meant to serve as galleries for George Vanderbilt.

The American Fine Arts Society was founded in 1889 by the Society of American Artists, the Architectural League, and the Art Students League to provide facilities for their activities. The galleries became the venue for virtually all major art exhibitions. In 1906, the Society of American Artists merged with the National Academy of Design; the New York Architectural League moved into its own building in 1927. The National Academy of Design acquired its own building and galleries on Fifth Avenue in 1938. The Art Students League has been the sole occupant of the building ever since.

Bedford Park Congregational Church

1891–92

2988 Bainbridge Avenue (also known as 301 East 201st Street), The Bronx

Architect: Edgar K. Bourne

Designated: June 20, 2000

In 1889, the prominent congregational minister Shearjashub Bourne founded the church in Bedford Park, a recently developed railroad suburb for middle-class families, modeled after the London suburb of the same name. His son, architect Edgar K. Bourne, merged many styles into this rustic building, incorpor-

BEDFORD PARK CONGREGATIONAL CHURCH

ating squat buttresses, round-arched windows with voussoirs, and a timber-framed, Queen Anne-style porch. A Richardsonian Romanesque tower emerges from the rough-dressed fieldstone base and wood shingled roof. The asymmetrically plan, which includes a reception area, a Sunday school room, and an auditorium-plan worship space, is characteristic of congregational churches of this era and is articulated on the church's exterior.

The church congregation continues to meet in the building, which is also used by many community and civic groups.

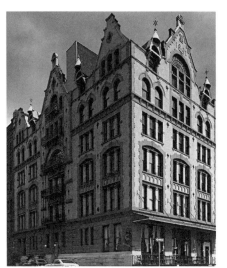
FLEMING SMITH WAREHOUSE

FLEMING SMITH WAREHOUSE

1891–92

451–453 WASHINGTON STREET, MANHATTAN

ARCHITECT: STEPHEN DECATUR HATCH

DESIGNATED: MARCH 14, 1978

Stephen Decatur Hatch's use of Flemish detail—chiefly the stepped gables—reflects the increased interest in Colonial American history at the end of the nineteenth century. While the original use of the building is not recorded, by 1898 it held a shoe factory and a storehouse for wine. The building has been converted to residential use, one of the first in Tribeca restored and adapted for this purpose.

The longer facade on Watts Street is five bays wide, with a slightly projecting central bay marking the entrance. A complex pattern of windows, arches, cornices, and columns, ending in gables, is organized around the central bay. The

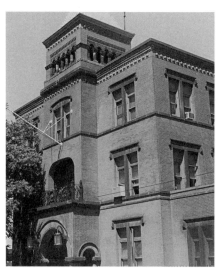
FORMER 19TH PRECINCT STATION HOUSE

Washington Street facade, three bays wide, is similar, except that the first story is more open, with large window bays sheltered by a canopy and protected by an iron fence.

FORMER 19TH PRECINCT STATION HOUSE AND STABLE

1891–92

43 HERBERT STREET (ALSO KNOWN AS 512–518 HUMBOLDT STREET), BROOKLYN

ARCHITECT: GEORGE INGRAM

DESIGNATED: SEPTEMBER 21, 1993

George Ingram, assistant engineer for Brooklyn's Department of City Works, designed this building to house Williamsburgh's newly formed and rapidly expanding 19th Precinct. The sturdy structure, a Richardsonian Romanesque design that stands in sharp contrast to contemporary

Italianate and French Second Empire law-enforcement architecture in New York City, became the model for later Brooklyn precinct houses. In the words of David A. Boody, mayor of Brooklyn in 1892, the 19th Precinct building was part of a broader program to provide Brooklyn with "station houses . . . as commodious and well-equipped as those in any city in the United States." The building is now used by the NYPD for special operations.

Inspired by H.H. Richardson's popular Romanesque civic designs, an arch defines the entrance porch of the complex, and the windows possess bold stone surrounds. The central window on the Humboldt Street facade is detailed with decorative spandrels and an ornamental grille. A two-story stable wing, which housed the cell block and lodging rooms, is connected to the station house by a one-story passageway. A central tower rising above the entrance arch makes the building highly visible along the adjacent stretches of the Brooklyn-Queens Expressway.

HARLEM COURTHOUSE

1891–93

170 EAST 121ST STREET, MANHATTAN

ARCHITECTS: THOM & WILSON

DESIGNATED: AUGUST 2, 1967

While essentially Romanesque Revival in style, this building is infused with romantic overtones from the Victorian Gothic. Red brick, bluestone belt courses, and decorative terra-cotta are

strikingly combined in a variety of forms.

A five-story gabled roof bay projects from both the west and the north facades. Almost symmetrical, each front contains a truck entrance framed by large rectangular windows with metal grilles. Carved figures of cherubs holding scrolls ornament the spandrels of the main entrance. Four deeply set, arched windows on the second floor rest above both entrances with two-story arched windows on the third, or courtroom, floor. Steep gables, dormers, and bold finials complete the design.

At the northwest corner is a round tower with an octagonal belfry. Each portion of the octagonal section contains a steep gable with a semicircular arch that in turn enframes a decorative panel. Two of the arches also enframe clocks, while the remaining arches contain circular windows. Exemplary of the Gothic are the gargoyle animal heads perched on the columns separating each paneled section. Carved figures of cherubs holding scrolls ornament the spandrels of the main entrance. Foliate ornament is displayed in the frieze of the entablature, while a low balustrade caps the classical cornice above the entrance.

Once known as the Fifth District Prison, the structure served as a temporary detention facility, although its primary role was to house one of the many magistrates courts. Today, the structure is occupied by city agencies, including the Department of Air Pollution Control, the Sanitation Department, and the Parole Board.

METROPOLITAN CLUB

1891–94; ADDITION, 1912

1 EAST 60TH STREET, MANHATTAN

ARCHITECTS: McKIM, MEAD & WHITE; ADDITION, OGDEN CODMAN JR.

DESIGNATED: SEPTEMBER 11, 1979

The Metropolitan Club, designed in the Italian Renaissance style by Stanford White, was the largest and most imposing clubhouse of its day. The purpose of the club was to give its members—some of New York's wealthiest citizens, including J. P. Morgan, the club's president, and Cornelius Vanderbilt—a place from which to enjoy a view of Central Park and the procession of society along Fifth Avenue.

A seven-bay facade is balanced asymmetrically on the east by a three-bay, two-story wing fronted by a courtyard. An elaborately modeled marble and copper cornice, projecting six feet beyond the plane of the facade, caps the building. Other prominent features include a restrained rusticated base, horizontal bands, and quoins that strengthen the corners. While the exterior is purposely restrained, the interior is extravagantly decorated, with a vaulted vestibule and monumental entrance hall constructed of book-matched marbles.

The 1912 addition by Ogden Codman Jr. now houses the New York office of the American Academy in Rome. A plan to develop an apartment tower over the Codman addition was rejected by the Landmarks Preservation Commission.

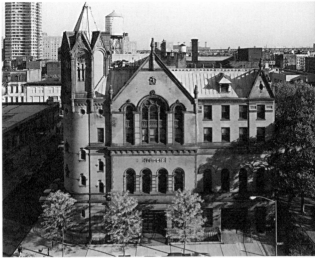
HARLEM COURTHOUSE

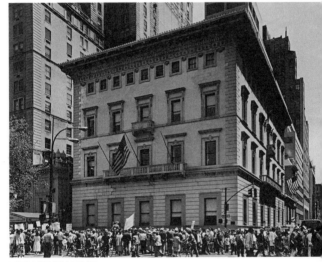
METROPOLITAN CLUB

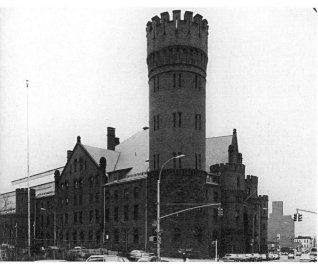

23RD REGIMENT ARMORY

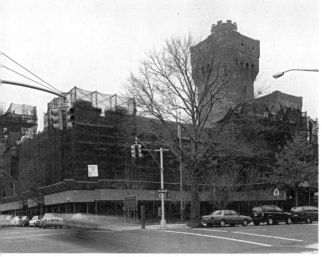

14TH REGIMENT ARMORY

23RD REGIMENT ARMORY

1891–95; 2003

1322 BEDFORD AVENUE, BROOKLYN

ARCHITECTS: FOWLER & HOUGH

DESIGNATED: MARCH 8, 1977

Designed to resemble a medieval fortress, the 23rd Regiment Armory was one of eight armories constructed in Brooklyn before 1900. The 23rd Regiment, part of the Second Brigade of the National Guard, served briefly in the Civil War during the summer of 1863. An armory was constructed on Clermont Street in 1872–73, but as the regiment grew in size and status, plans for the new building were formulated. Colonel John N. Partridge, head of the regiment and president and general manager of the Brooklyn City and Newton Railroad Company, was instrumental in obtaining a state grant of $300,000 for the construction. On November 14, 1891, the cornerstone was laid, and a fair was held to raise funds for furnishing the interior. The Council Room is especially elaborate, with a twenty-four-foot fireplace.

The massive Romanesque Revival structure is composed of an administration building and a vast drill hall. Executed in deep red pressed brick and rough-faced, brownish red Potsdam stone, with red terra-cotta detail, the building has a series of circular corner towers. The main facade has a gabled entrance bay flanked by seventy-foot crenellated towers with rusticated first stories. The round-arched entrance is ornamented by terra-cotta friezes with the regimental motto and coat of arms.

A large plaque on the Bedford Avenue facade honors the soldiers of the regiment who fought in World War I.

The armory was restored by the city in 2003 and now serves as a homeless shelter.

14TH REGIMENT ARMORY

1891–95; 1992

1402 EIGHTH AVENUE, BROOKLYN

ARCHITECT: WILLIAM A. MUNDELL

DESIGNATED: APRIL 14, 1998

Like the 23rd Regiment Armory, this building designed by Brooklyn-based architect William A. Mundell was influenced by medieval architecture with its castellated style and picturesque massing. Consisting of a three-story administration building and a one-and-half story barrel-vaulted drill shed, the building is embellished with asymmetrical central towers and corner bastions, shallow buttresses and a projecting entrance pavilion.

The 14th Regiment, organized in the late 1840s, was known as the Brooklyn Chasseurs and later renamed the "Red-legged Devils," due in part to their red trouser uniforms but also for their fierceness in battle. The regiment suffered heavy casualties during the Civil War, and went on to serve in both World Wars and during the conflict in the Persian Gulf. In 1992, the armory was taken out of service, and is now owned by the City of New York. The building currently houses a homeless shelter and movie sound stages.

276

General Grant National Memorial

1891–97; 1997; 2004–

122ND STREET AND RIVERSIDE DRIVE, MANHATTAN

ARCHITECT: JOHN H. DUNCAN

DESIGNATED (EXTERIOR AND INTERIOR): NOVEMBER 25, 1975

On August 8, 1885, an estimated one million people watched as the funeral procession of Ulysses S. Grant—including some sixty thousand marchers—passed by. Grant was buried in a temporary tomb, but there was a consensus that the former president and hero of the Civil War deserved a more lasting tribute. In 1886 the Grant Monument Association was created, and architect Napoleon LeBrun announced a competition in 1887 for a granite monument with figural sculpture to honor him.

Although the association did not consider any of the designs submitted satisfactory, the judges—LeBrun, George B. Post, William R. Ware, James Renwick Jr., and James F. Ware—awarded top prizes to five memorial columns. A public outcry followed; press and public were united in their objection to what was considered a tired and outmoded type of memorial (virtually all the monuments to Civil War heroes had been in the form of memorial columns). The press suggested a building modeled on two sources—the tomb of King Mausolus at Halicarnassus, which had recently been restored by James Fergusson, and George Kellum's Garfield Memorial, erected in 1884–90 in

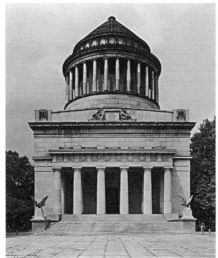

GENERAL GRANT NATIONAL MEMORIAL

Cleveland, Ohio. In 1890, John H. Duncan, who had just received the commission for the Soldiers' and Sailors' Memorial Arch at Grand Army Plaza in Brooklyn, submitted the winning entry to a second competition, a design that drew inspiration from the popular models.

In the disposition of its mass, the monument recalls Kellum's Garfield Memorial; the circular colonnade was inspired by Fergusson's restoration of the Mausoleum at Halicarnassus. The colossal Doric entrance colonnade and pilastrade are based on Viollet-le-Duc's reconstruction of the Doric order from the Temple of Olympian Zeus at Agrigento.

On April 27, 1892, President Benjamin Harrison laid the cornerstone of the memorial. Five years later the bodies of President and Mrs. Grant were moved to the memorial and placed in the crypt, directly beneath the coffered dome. A circular cut in the floor that permits visitors to see the crypt was

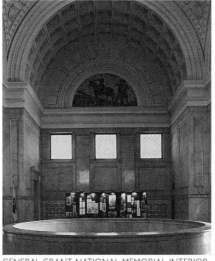

GENERAL GRANT NATIONAL MEMORIAL INTERIOR

inspired by Ludovico Visconti's tomb for Napoleon at Les Invalides. The bronze busts in the crypt were executed in 1938 under the supervision of the WPA. In the pendentives above are low-relief allegorical figures that depict different phases of Grant's life; outside are two recumbent figures representing Peace and Justice. All the figural sculpture is the work of J. Massey Rhind.

In the 1920s, John Russell Pope expanded the plaza and approach, adding two eagles. Pope wanted to complete Duncan's original program, which called for more figural sculpture, but the Depression put an end to further construction. The exterior of the memorial is of Maine granite; the interior is executed in Lee and Carrara marbles. The memorial underwent extensive restoration in 1997. Further work, approved in August 2004, will include the addition of a glass-walled elevator on the north side of the pavilion.

NEW YORK ARCHITECTURAL TERRA-COTTA WORKS

IMPERIAL APARTMENTS

New York Architectural Terra-Cotta Works Building

1892

42–10–42–16 Vernon Boulevard
Long Island City, Queens

Architect: Francis H. Kimball

Designated: August 24, 1982

Built in 1892, this two-story building with stepped gables, round-bottomed roof tiles, and decorative chimneys was the office headquarters for the New York Architectural Terra-Cotta Works. New York's only such firm, the company produced decorative tiles for many New York buildings, including Carnegie Hall, the Ansonia Hotel, and Brooklyn's Venetian-style Montauk Club.

The New York Architectural Terra-Cotta Works was established in 1886 during Manhattan's commercial expansion, shortly after the decorative tiles began to appear in the United States. Strategically located in Queens on the East River, the company enjoyed easy river access to the construction under way in Manhattan.

Shifting architectural tastes and the replacement of terra-cotta by cast concrete slowly eroded the company's success, and the firm declared bankruptcy about 1928. Today the structure awaits restoration and preservation.

RENAISSANCE APARTMENTS

520 WEST END AVENUE

IMPERIAL APARTMENTS

1892

1327–1339 BEDFORD AVENUE AND
1198 PACIFIC STREET, BROOKLYN

ARCHITECT: MONTROSE W. MORRIS

DESIGNATED: MARCH 18, 1986

Located in Grant Square, the Imperial is among several distinguished buildings that recall the area's prestige at the turn of the century. It is one of a number of commissions Morris carried out for Louis F. Seitz, including two other apartment buildings, the Alhambra (p. 261) and the Renaissance. The Imperial was also one of the earliest apartment houses in Brooklyn built for the middle class.

The design of the Imperial is based on sixteenth-century French chateaus, executed in a skillful combination of buff-colored Roman brick, terra-cotta, slate, and metal. Rising from a stone base for four stories, the structure is crowned with a picturesque slate mansard fifth floor. Its three round corner towers with conical roofs create a romantic silhouette. The building is an important element of Grant Square, one of the most prestigious areas in Brooklyn in the early twentieth century.

RENAISSANCE APARTMENTS

1892; 1995–96

140–144 HANCOCK STREET AND 488
NOSTRAND AVENUE, BROOKLYN

ARCHITECT: MONTROSE W. MORRIS

DESIGNATED: MARCH 18, 1986

Like the Imperial, the Renaissance in Bedford-Stuyvesant combines buff Roman brick, terra-cotta, metal, and slate in a design inspired by French chateaus. The building rises four stories from a stone base, with a picturesque slate mansard fifth story; the facade is designed in a striped pattern of continuous bands of terra-cotta separated by five courses of brick. Among its distinguishing features are three round corner towers, classical arches, and a monumental Palladian arch joining the second, third, and fourth stories. The tall pedimented dormers, conical roofs with finials crowning the three towers, and picturesque, steep mansards all recall its French Renaissance antecedents and create a striking contrast to the angular, flat-roofed brownstones of the area. Vacant for many years, the building was restored for housing in 1995–96 by Anderson Associates.

520 WEST END AVENUE

1892

MANHATTAN

ARCHITECT: CLARENCE F. TRUE

DESIGNATED: MARCH 17, 1987

DESIGNATION RESCINDED:
JUNE 9, 1988

DESIGNATION REINSTATED:
AUGUST 2, 1988

The house at 520 West End Avenue, built for cotton broker John B. Leech and his wife, Isabella, is an early and unusual work in the career of architect Clarence F. True. A seminal figure in establishing the initial architectural character of the Upper West Side, True was particularly active in the area west of Broadway.

In the bold form of its rusticated red sandstone, the complex massing of its tan Roman iron-spotted brick upper stories (now painted), and the subtle handling of its carved stone details of Romanesque and Gothic derivation, the Leech residence is a fine example of the picturesque eclectic architecture of the late nineteenth century that once characterized West End Avenue. One of the largest single-family town houses ever constructed on West End Avenue, it is now an apartment building.

Number 520 West End Avenue was designated a landmark on March 17, 1987. On June 9, 1988, Judge Walter M. Schackman of the New York Supreme Court overturned the designation, but it was reinstated on August 2, 1988.

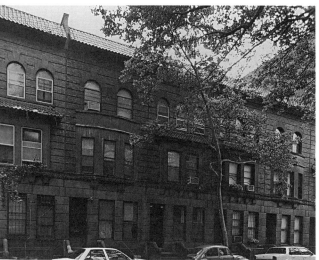

316, 318, 320, 322, 324, 326 WEST 85TH STREET

316, 318, 320, 322, 324, 326 WEST 85TH STREET

1892

MANHATTAN

ARCHITECT: CLARENCE F. TRUE

DESIGNATED: APRIL 16, 1991

Clarence F. True's arrangement of round-arched and rectangular windows, classical ornamentation, and palazzo facades offers an urbane and varied example of the Renaissance Revival style. The restrained facades follow a rhythmic a b a a b a pattern, in a pleasing visual articulation of unity and diversity; an intricately carved sandstone course spans the row, providing a visual like between the six houses. This approach is characteristic of True, who also used diverse polychrome materials in harmonious range of colors: Maynard red standstone, light-orange Roman brick, and red roofing tiles.

Although most of the street on the Upper West Side, once known as Bloomingdale, had been laid out following the Civil War, development crept along at a snail's pace until the 1880s, when improved public transportation stimulated real estate speculation. This group of row houses was one of seven such projects True designed for the speculator-builder Charles G. Judson before entering the speculative housing business himself in 1894.

BROOKLYN FIRE HEADQUARTERS

1892

365–367 JAY STREET, BROOKLYN

ARCHITECT: FRANK FREEMAN

DESIGNATED: APRIL 19, 1966

The Brooklyn Fire Headquarters is one of New York City's finest examples of the Romanesque Revival style. Influenced by the Chicago School, the building is notable for its harmonious blending of tones and interesting juxtaposition of contrasting textures, including red sandstone trim with granite, terra-cotta details against the dark brown, Roman brick walls, and copper edging on the red tile roof. The careful proportioning of the elements is strikingly evident in the balancing of the high, broad, richly decorated arch of the fire engine exit with the imposing solidity of the watchtower that flanks it.

The Jay Street firehouse was used as a headquarters for just six years, until Brooklyn became part of Greater New York in 1898. After the fire headquarters was moved to Manhattan, the Jay Street structure became a neighborhood firehouse. It was subsequently converted into apartments.

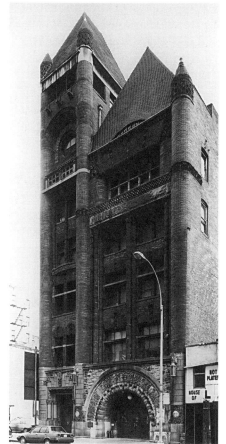

BROOKLYN FIRE HEADQUARTERS

CLAREMONT RIDING ACADEMY, FORMERLY CLAREMONT STABLES

1892

173–177 WEST 89TH STREET, MANHATTAN

ARCHITECT: FRANK A. ROOKE

DESIGNATED: AUGUST 14, 1990

Built just six years before the automobile began to negotiate the city streets, this handsome livery stable was one of 750 commercial stables at the turn of the century. Claremont was then a common building type, but today it is a rare survivor. Conversion to a riding academy in 1927, with easy access to Central Park's bridle trails and boarding facilities for horses, saved it from being turned into a garage. In 1965, the building was rescued a second time when demolition orders levied by the City of New York were canceled.

Built in the Romanesque Revival style that flourished on the Upper West Side in the 1880s, the stable has a dignified, symmetrical design that subtly expresses the utilitarian function. The facade, sheathed in contrasting beige Roman brick, limestone, and terra-cotta and articulated by a central bay with five round-arched openings, is characteristic of the style. Window openings, marked by narrow brick voussoirs with narrow limestone keystones, are outlined by simple brick moldings. Claremont Academy continues to operate as a riding school and stable.

PUBLIC SCHOOL 86, KNOWN AS IRVINGTON SCHOOL

1892–93

220 IRVING AVENUE, BROOKLYN

ARCHITECT: JAMES W. NAUGHTON

DESIGNATED: APRIL 23, 1991

This four-story brick and stone school designed in the Romanesque Revival style is one of the few remaining nineteenth-century schools still being used for its original purpose. Located within the historical boundaries of the town of Bushwick, the school was constructed to meet the needs of a growing immigrant population. Thousands of Germans had fled to America, many settling in Bushwick, following the political upheavals in Europe in 1848.

P.S. 86 was designed by James W. Naughton, superintendent of the Board of Education of the City of Brooklyn from 1879 until his death in 1898. During that time he designed and constructed more than one hundred schools—over two-thirds of the public school buildings erected in Brooklyn in the nineteenth century. Trained at the University of Wisconsin and at Cooper Union in Manhattan, Naughton used an amalgam of popular architectural styles in his school designs—combining, for example, Italianate layered palazzi with French Second Empire flanking pavilions and Gothic detailing. A picturesque silhouette distinguishes the handsome design of P.S. 86: a broad gable embraces a round arch, and prominent dormer windows punctuate the roofline.

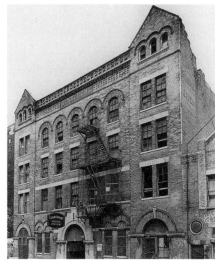
CLAREMONT RIDING ACADEMY

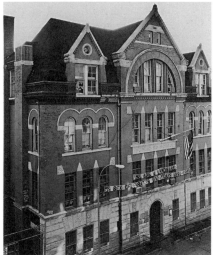
PUBLIC SCHOOL 86 /IRVINGTON SCHOOL

KNICKERBOCKER FIELD CLUB (DEMOLISHED)

351–355 CENTRAL PARK WEST

KNICKERBOCKER FIELD CLUB

1892–93

114 EAST 18TH STREET, BROOKLYN

ARCHITECTS: PARFITT BROTHERS

DESIGNATED: JULY 11, 1978

DEMOLISHED: FEBRUARY 1988

Badly damaged by fire, the Knickerbocker Field Club was demolished with the permission of the Landmarks Preservation Commission. The second clubhouse of the Knickerbocker Field Club, formed in 1889, fifteen years after tennis was introduced to the United States. The building was designed in the Colonial Revival style by Parfitt Brothers, a prominent Brooklyn firm. The clapboard and shingle field house was a long, two-story building with a gambrel roof. A deep porch, carried on Doric columns, extended across the principal facade and around the southern end of the building.

351–355 CENTRAL PARK WEST

1892–93

MANHATTAN

ARCHITECT: GILBERT A. SCHELLENGER

DESIGNATED: NOVEMBER 10, 1987

These five row houses are early survivors of the initial development of Central Park West. Before the 1880s, that avenue was lined with a mixture of wooden shacks, small apartment buildings, and single-family houses. As public transportation became available on the Upper West Side, intense real estate

development began, but progress lagged along Central Park West because of the high price of the land. This block of houses is significant because it was built when large portions of Central Park West were still undeveloped.

The Renaissance-style houses were designed for developer Edward Kilpatrick in light-colored Roman brick, stone, and terra-cotta. The five houses are built in an alternating pattern of two different facades, distinguished by their window placement. Each stands four stories tall with the exception of the corner house, which is five stories. A restrictive agreement with the adjacent Scotch Presbyterian Church prevented the height of the houses from exceeding that of the church tower and ensured their survival. The houses are intact today, and all are still private residences, recalling a time when they were unique in their surroundings.

UNION BUILDING, FORMERLY THE DECKER BUILDING

1892–93; 1995

33 UNION SQUARE WEST, MANHATTAN

ARCHITECT: JOHN EDELMANN

DESIGNATED: JULY 12, 1988

By the mid-nineteenth century, pianofortes had become increasingly popular, and, like many other businesses related to the arts, piano makers had clustered around Union Square. This building was commissioned by John Decker, a founder of Decker Brothers Piano

Company, which appears to have been established in 1856. An important example of the Moorish style, with Venetian touches (such as palazzo-style balconies), the Union Building is profusely embellished with terra-cotta details that enliven the facade. Naturalistic plant motifs ornament its enframements and intradosses (the interior curves of an arch), contributing to the overall impression of animation and movement. The limestone quoins that embellish the shaft and alfiz (the rectangular molding that frames a Moorish arch) and the pattern created by the loggia columns add to the aura of opulence.

Prompted by trade and exploration in the eighteenth and nineteenth centuries, the use of Islamic motifs was the longest-lived of exotic movements in design. In the Western context, Moorish details were often used to suggest relaxation, and they provided an escape from the mundane in the design of smoking rooms, cafés, theaters, and public baths.

Commissioned by John J. Decker as the headquarters of the Decker Brothers Piano Company, the building was one of many related to the arts around Union Square. The pleasures of music may have inspired Edelman to employ this ornate style. The base was attractively restored in 1995.

WEST END COLLEGIATE CHURCH AND SCHOOL

1892–93

WEST 77TH STREET AND WEST END AVENUE, MANHATTAN

ARCHITECT: ROBERT W. GIBSON

DESIGNATED: JANUARY 11, 1967

West End Collegiate Church and School was designed by Robert W. Gibson in his own romantic combination of Dutch and Flemish Renaissance elements—appropriate to a church with deep roots in Dutch New Amsterdam. In fact, the Collegiate Church, an arm of the Dutch Reformed Church, was organized in New Amsterdam in 1628; the Collegiate School, begun in 1638, may be the oldest private secondary school in the country.

Both fresh and flamboyant, the design lends an old-world charm to the surrounding residential area. The yellow-brown brick church is distinguished by the elaborate gable of its facade. Its windows, its doorways, its corners, and the eighteen steps of the central gable are all enriched with stonework, frequently alternating with stripes of brick. The steps of the main gable and the dormer windows that thrust out from the red-tile roof erupt into terra-cotta brackets and pinnacles. Quoins define the corners and underscore the zigzag outlines of the gables. A handsome, lacy spire thrusts up from the center of the high-pitched roof.

UNION BUILDING

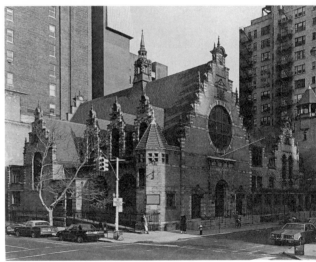
WEST END COLLEGIATE CHURCH AND SCHOOL

283

West End Avenue Town Houses and West 102nd Street Town House

1892–93

854, 856, 858 West End Avenue and 254 West 102nd Street, Manhattan

Architects: Schneider & Herter

Designated: August 14, 1990

This group of four brownstone row houses was built as a speculative venture during a turn-of-the-century boom in residential development on West End Avenue. Highly animated by recessed entrances and balconies, these lively Queen Anne/Romanesque Revival–style houses typify the eclectic residential architecture of West End Avenue in the 1890s. By detailing each building individually, the architects also expressed a reaction against the uniform look of the city's older Italianate row houses.

Featuring a prominent corner house and a house facing the side street behind the avenue, this three-story row house group is the only surviving example of a once-common site plan for corner lots on the avenue. Picturesque rooflines punctuated by gables, pedimented parapets, carved panels, and cornices—distinguish the buildings. The centerpiece corner house, number 858, is dominated by a cylindrical tower that rises an extra story and is capped by a bell-shaped roof. A profusion of ornament, including asymmetrical pilasters with carved capitals and lions-head supports, conveys the architects' distinctive mannerist style.

WEST END AVENUE TOWN HOUSES

HOPE COMMUNITY HALL

Hope Community Hall, formerly 28th Police Precinct Station House

1892–93; 2004–

177–179 East 104th Street, Manhattan

Architect: Nathaniel D. Bush

Designated: February 23, 1999

This precinct house is one of ten surviving station houses designed by Bush and one of a few surviving institutional buildings in East Harlem from the end of the nineteenth century. Here Bush used elements of the *Rundbogenstil*, Renaissance Revival, and neo-Grec styles marking a departure from his earlier, simpler buildings. The five-story midblock station house is clad in red brick with gray granite detailing. The facade, a grid formed by piers and cornices, remains largely intact. Bush, who designed police stations from 1862 to 1895, used this prototype for at least four subsequent designs.

The building served as a police station until 1974. Hope Community, Inc., a nonprofit organization helping to revitalize East Harlem, purchased the building in 1981. Hope Community, Inc., is currently renovating the building, now known as Hope Community Hall, as its headquarters.

253, 256–257 Broadway, formerly the Home Life Insurance Company Building (incorporating the former Postal Telegraph Building)

1892–94

Manhattan

Architects: 253 Broadway, Harding & Gooch; 256–257 Broadway, Napoleon LeBrun & Sons

Designated: November 12, 1991

Founded in Brooklyn in 1860, the Home Life Insurance Company moved its Manhattan branch office here in 1866. In 1890, other insurance companies, including Equitable, New York Life, and

Metropolitan Life commissioned new headquarters buildings nearby. Inspired by these business rivals, Home Life held a competition for the design of a new building.

Pierre LeBrun's winning entry is an early example of the tripartite formula to articulate verticality in a skyscraper. LeBrun visually mimicked the classical column, with its base, shaft, and capital, by concentrating the Renaissance-inspired ornamentation on the base and upper stories. The soaring shaft stands in marked contrast to its neighbor, the former Postal Telegraph Building, purchased by the company in 1947 and connected through its interior. Only two stories lower and in the Renaissance idiom, the building is distinctly horizontal, an impression produced by the prominent sill courses and broad cornice.

LeBrun believed that ornament should reflect a building's function. By using a classical idiom that referred to the Florentine banking houses, he hoped to connect the commercial center of the

Renaissance to the relatively young insurance business of the early twentieth century.

PROTESTANT WELFARE AGENCIES BUILDING, FORMERLY CHURCH MISSIONS HOUSE

1892–94, 1990s

281 PARK AVENUE SOUTH, MANHATTAN

ARCHITECTS: ROBERT WILLIAMS GIBSON AND EDWARD J. NEVILLE STENT

DESIGNATED: SEPTEMBER 11, 1979

The Church Missions House was the joint project of Robert Williams Gibson, an English-born architect who built many Episcopal churches, and Edward J. Neville Stent, who specialized in church decoration. The style is a loose adaptation of Northern European Gothic of the fifteenth and early sixteenth centuries.

Gibson was one of the first New York architects to work in this mode, which is applied here in a very inventive way. Medieval arcading, clustered shafts, corner tourelles, and sculpted tympanum and roof dormers are organized into a rectilinear framework that conceals a steel-frame structure. This treatment accommodates the ample glazing made possible by this structural innovation. The inherently sculptural values of the Gothic shafts and moldings transform the grid's regularity into an animated surface, which is enhanced by Stent's low-relief terra-cotta decoration and modeling. Particularly noteworthy is the

PROTESTANT WELFARE AGENCIES BUILDING

image of Christ the Consoler over the Park Avenue tympanum. The design also marks an early stage in the development of the Gothic cladding applied to a tall building. This cladding can be found on later Gothic "pier" skyscrapers, such as Cass Gilbert's Woolworth Building.

The church missions movement in the United States dates from the early nineteenth century; it received its greatest impetus at the 1821 General Convention of the Episcopal Church in Philadelphia. In 1835, the Missionary Society relocated to New York. Two other charitable organizations, the United Charities and the New York Society for the Prevention of Cruelty to Children, were located nearby. The building was restored in the 1990s and continues to house social service organizations.

THE ARCHIVES APARTMENTS

THE ARCHIVES APARTMENTS, FORMERLY THE U.S. FEDERAL BUILDING; ORIGINALLY UNITED STATES APPRAISERS' STORE

1892–99; 1988

641 WASHINGTON STREET, MANHATTAN

ARCHITECT: W. J. EDBROOKE

DESIGNATED: MARCH 15, 1966

Located far to the west in Greenwich Village, and occupying an entire city block, is the former Federal Building. Built in 1899 as the Appraisers' Store by the federal government, the Archive is ten stories high, with masonry bearing walls; its great arches and massive piers at street level are expressive of the load they carry. This extremely simple yet powerful structure, almost totally devoid of detail, relies on the rhythm and differentiation of its arches to achieve a quality of architectural integrity.

The arches spring from the ground level, embracing both first- and basement-floor windows. Above these arches are paired, square-headed windows beneath a powerful horizontal stone belt course that extends around the structure. Above this, the windows are carried up for five stories and arched at their tops. The immense scale of the building is broken up by paired windows extending up two stories and again arched; the topmost floor has a series of small, arched windows that carry around the curved corners and simulate the effect of the battlements of medieval castles.

After ten years of complex negotiations with city, state, and federal offices, the Rockmore Development Corporation reopened the building in May 1988 as the Archives Apartments, a 479-unit rental complex.

CATHEDRAL CHURCH OF ST. JOHN THE DIVINE

1892–1982

1047 AMSTERDAM AVENUE, MANHATTAN

ARCHITECT: HEINS & LAFARGE (1892–1911); RALPH ADAMS CRAM OF CRAM, GOODHUE & FERGUSON (1916–41); HOYLE, DORAN & BERRY (1979–82)

DESIGNATED: JUNE 17, 2003

DESIGNATION RESCINDED: NOVEMBER 2003

Although unfinished, the Cathedral Church of St. John the Divine is the largest church in the United States, and

CATHEDRAL CHURCH OF ST. JOHN THE DIVINE

the largest cathedral in the world. Its main vault reaches to 124 feet, and the cathedral, at 601 feet in length, offers visitors a one-tenth of a mile view down the nave. At a time when New York City was emerging as an international city, the construction of the cathedral was a part of a wave of new cultural institutions in northern Manhattan, nicknamed "the Acropolis of the New World." The Cathedral Close, an 11.3-acre site with the Synod House and other significant buildings as well as gardens and open space, provides a distinctive setting for this imposing structure.

Now the seat of the Episcopal Diocese of New York, the cathedral was chartered in 1873. Heins & LaFarge, an architectural firm that gained prominence for its ecclesiastical work, won the 1888 design

competition with an eclectic design, drawing from Romanesque, Byzantine and Gothic styles. The first phase of construction, from 1892 to 1911, saw the completion of the crypt, choir, and crossing. Rafael Guastavino, the prominent builder, contributed the saucer dome made of overlapping tiles in 1909.

After Heins's death in 1907, the church hired Ralph Adams Cram of Cram, Goodhue & Ferguson to lead the next phase of construction, which began in 1916. Cram redesigned the building in the French Gothic style, modeled on Notre Dame in Paris as well as the cathedrals at Amiens, Bourges, and Rheims. Cram's most striking contributions were the clever placement of the triforium and clerestory in full-height central aisles and the addition of chapels along the spacious side aisles. During the second phase of construction, the nave was complete and attached to the choir with a rough-finished crossing, the imposing west front was added, and the north transept was partially built.

Dean James Parks Morton began work again in 1979, after a hiatus of nearly forty years, on the west towers and on the ornament of the west facade based on Cram's 1929 designs. He called for a design competition for the south transept, which was won by Santiago Calatrava with a proposal for a contemporary glass-enclosed building. Due to failing funds, construction halted again in 1982, with only fifty feet of the southwest tower built. In 2001, the north transept was substantially damaged in a fire.

Heard for designation in 1966, 1979, and 2003, the Cathedral, but not the

Close and other buildings, was designated in 2003. The cathedral trustees had sought the limited designation in hopes of developing other portions of the site. In a rare move, the City Council overturned the designation, noting that the entire Close and not just the Cathedral in isolation, should have been designated. The Council overrode a mayoral veto, leaving this significant structure undesignated Today the cathedral remains about 60 percent complete, with no immediate plans for construction, although steps are being taken to ensure the preservation of the cathedral.

The Gerard Apartments, formerly Hotel Gerard

1893–94

123 West 44th Street, Manhattan

Architect: George Keister

Designated: July 27, 1982

The Gerard is an exceptionally fine brick, limestone, and terra-cotta residence hotel that marks a transition in the development of the western Midtown area. When it was erected, this thirteen-story building was one of the tallest in a predominantly low-rise residential area, and it heralded the enormous change that the neighborhood was to undergo as it became the heart of the city's theater district.

The Gerard is notable for an unusual combination of Romanesque and Northern Gothic and Renaissance details found on very few other buildings in America, with carefully executed brick

GERARD APARTMENTS

work, curving bays, and striking gables and dormers. Never a luxury hotel, the Gerard catered those who wished to stay in New York for an extended period. When completed, it had 132 suites and twenty-five studio apartments. Named after its manager, William G. Gerard, the hotel included an extremely elegant dining room done in the Italian Renaissance manner, which is now a restaurant. In 1920, the hotel was renamed the Hotel Langwell and later the Hotel 1-2-3. Today the building is a rental apartment building.

UNITED SYNAGOGUE OF AMERICA

JACQUELINE KENNEDY ONASSIS HIGH SCHOOL

UNITED SYNAGOGUE OF AMERICA BUILDING, FORMERLY THE SCRIBNER BUILDING

1893–94

153–157 FIFTH AVENUE, MANHATTAN

ARCHITECT: ERNEST FLAGG

DESIGNATED: SEPTEMBER 14, 1976

This steel-frame Beaux-Arts office building once served as the corporate headquarters of Charles Scribner's Sons and is now owned by the United Synagogue of America. In 1846, Charles Scribner founded a publishing house, Scribner & Baker, and the company soon distinguished itself as the leading publisher of books on theology and philosophy. By 1878, Scribner's sons had taken over the company and renamed it; the company moved to this building in 1894. The architect was Ernest Flagg, Charles Scribner's brother-in-law.

The base of the composition is rusticated limestone, with a wide storefront at the center beneath an entablature supported on brackets. The middle four stories have a tripartite vertical organization; the lowest of the four, like the base, is of rusticated limestone. The sixth story begins with a low parapet, with a slate mansard roof rising behind. The windows of the middle section are divided into three parts by slender colonnettes, set off from the level beneath them by a wide stone belt course with a balustrade carried forward on console brackets with lions' heads.

Charles Scribner's Sons moved uptown to a new building on Fifth Avenue in 1913 (p. 444).

JACQUELINE KENNEDY ONASSIS HIGH SCHOOL FOR INTERNATIONAL CAREERS, FORMERLY HIGH SCHOOL FOR THE PERFORMING ARTS, PUBLIC SCHOOL 67

1893–94; 1991–93

120 WEST 46TH STREET, MANHATTAN

ARCHITECT: C.B.J. SNYDER

DESIGNATED: MAY 19, 1982

The former P.S. 67 is a rare surviving late-nineteenth-century Romanesque Revival school building. It is C.B.J. Snyder's earliest known building; he continued as architect to the New York City Board of Education for thirty years. During World War II, this school housed the U.S. Maritime Commission.

In 1948, Dr. Franklin J. Keller, the principal of the Metropolitan Vocational School, needed a permanent location for the fledgling program for the performing arts; Public School 67 was chosen for its Times Square location. Many famous performers have graduated from the school, including Rita Moreno, Ben Vereen, and Liza Minnelli.

The building is a fine example of Snyder's work. It is a five-story stone and brick structure, symmetrically massed, with a projecting central three-bay pavilion and smaller projecting pavilions at each end. The Romanesque Revival features include an arch above the main entrance flanked by two columns, portrait busts, and an architrave frieze with a curving floral motif.

The High School of the Performing Arts moved in September 1984. The 46th Street building was being used as a special school when it was gutted by fire

on February 13, 1988. The building was restored in 1991–93, and now houses the Jacqueline Kennedy Onassis High School for International Careers.

THE HARVARD CLUB OF NEW YORK CITY

1893–94; ADDITIONS, 1903, 1915, 1946: 2003

27 WEST 44TH STREET, MANHATTAN

ARCHITECTS: MCKIM, MEAD & WHITE ADDITIONS, HENRY COBB, 1946, DAVIS BRODY BOND, 2003

DESIGNATED: JANUARY 11, 1967

The Harvard Club was organized in 1865 and incorporated in 1887 "to advance the interest of the University, and to promote social intercourse among the alumni resident in New York City and vicinity." In 1893–94, the second and present home of the Club was designed by Charles Follen McKim of McKim, Mead & White. Significant additions were made to the club by the same firm in 1903 and 1915. A third expansion, into the adjacent building at 33 West 44th Street, was completed by Henry Cobb in 1946.

The architects—who also designed the Harvard Union in 1902 and the Harvard Business School in 1926—planned a New York club building that would fit comfortably within the scale of its midtown Manhattan site and recall the Georgian architecture of the Harvard campus. Limestone detail accents the red-brick facade; a limestone ledge supports two Ionic columns that in turn

flank a central round-headed window and support a third-floor cornice. The finely carved shield of Harvard surmounts the cornice.

The intimate-looking building is actually quite large and continues through the block to 45th Street. Here, the exterior wall contains three-story round-headed windows set between brick pilasters that illuminate Harvard Hall inside. This room, considered by many architectural historians to be one of America's finest club rooms, rises the height of the entire building. In 2003, a west wing in a contemporary vocabulary was added by Davis Brody Bond.

TRINITY SCHOOL AND THE FORMER ST. AGNES PARISH HOUSE

121–147 WEST 91ST STREET, MANHATTAN

DESIGNATED: AUGUST 1, 1989

SCHOOL, 1893–94

ARCHITECT: CHARLES C. HAIGHT

PARISH HOUSE, C. 1888–92

ARCHITECT: WILLIAM APPLETON POTTER

Trinity School is the oldest continuously operated school in Manhattan. Founded by Trinity Church in 1709 as the only coeducational school in the colonies for children from disadvantaged backgrounds, it became a private preparatory school in 1827. In response to the needs of a growing urban population pushing northward at the end of the nineteenth century, Trinity Church moved its school affiliate to the Upper West Side and

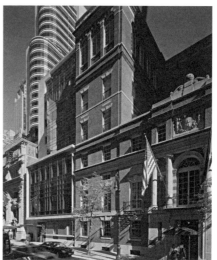

HARVARD CLUB OF NEW YORK CITY

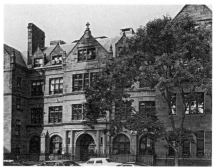

TRINITY SCHOOL

established the St. Agnes Chapel complex next door. Only the Parish House still exists; it was purchased by Trinity School in 1943 and has been remodeled into classrooms. Trinity School's smooth walls, tall bay divisions, and active roofline reflect the English Collegiate Gothic style.

The Parish House, a simply designed, massive three-story structure, was originally attached to the apse of a cruciform church. The wide and narrow courses of brownstone and granite and deeply set windows reveal the influence of H. H. Richardson.

289

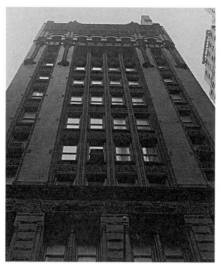
56–58 PINE STREET

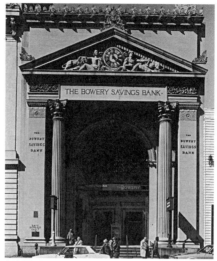
CAPITALE

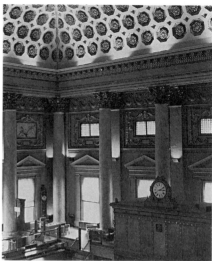
CAPITALE INTERIOR

56–58 PINE STREET, FORMERLY THE WALLACE BUILDING, ALSO KNOWN AS 26–28 CEDAR STREET

1893–94; ADDITION, 1919

MANHATTAN

ARCHITECT: OSWALD WIRZ

DESIGNATED: FEBRUARY 11, 1997

Built as speculative office space in what was then the city's insurance district, 56–58 Pine Street represents the transition between four- and five-story buildings and the massive commercial buildings. At twelve stories, it was among the tallest downtown structures. A two-story addition of 1919 is set back and hardly visible from the street.

56–58 Pine Street was designed by Oswald Wirz, the in-house architect for the construction firm of James G. Wallace, for whom this building was originally named. The elaborate facade is executed in brick, stone, and terra-cotta, and characterized by intricate Romanesque Revival detail, including round-arched openings and deeply set windows linked by groups of truncated, polished granite columns. Set on a raised granite basement, the building is also embellished with highly stylized foliate designs, fantastic visages, and grotesque heads, which merge with the other ornaments to create a unique facade.

CAPITALE, FORMERLY HOME SAVINGS BANK OF AMERICA, ORIGINALLY BOWERY SAVINGS BANK

1893–95;
INTERIOR ALTERATIONS, 1980, 2002

130 BOWERY, MANHATTAN

ARCHITECTS: MCKIM, MEAD & WHITE

DESIGNATED: APRIL 19, 1966; INTERIOR DESIGNATED: AUGUST 23, 1994

With richly articulated entrance facades on Grand Street and the Bowery, the Bowery Savings Bank literally wraps around the old Butchers' and Drovers' Bank—the Bowery's rival—which had refused to sell its lot on the corner. On Grand Street, a sculpted pediment is raised on colossal Corinthian columns with a blank attic story above. The Corinthian order is carried around the building as a shallow pilastrade; the detailing is finely cut, and the architectural elements well articulated.

On the Bowery, Stanford White exploited the narrow frontage, crowding together massive Corinthian columns in antis and a large triumphal arch. A densely carved pediment, floral frieze, and anthemia cover this arrangement. The blank surfaces of the square antae and attic provide an austere and satisfying counterpoint, focusing the energy of this powerful composition.

The interior, principally credited to White, conveys both simplicity and grandeur. It is an early example of the august Roman Revival style, which established the classical temple form as a standard for savings bank buildings.

290

Among the Roman prototypes are the colonnades based on the Basilica Ulpia, giant Corinthian columns derived from the portico of the Pantheon, and a coved and coffered ceiling that refers to the Basilica of Constantine.

The Bowery street entrance opens onto the waiting room, which once provided separate seating areas for men and women adjacent to gender-specific teller counters in the main banking room. This imposing eighty-foot-square space has a pyramidal skylight, and its axially symmetrical arrangement features a prominent bank vault. This public space was innovative in its ventilation system. Fresh air was introduced through open doors and windows, then vented through louvers in the skylight, creating a natural airflow.

Built as the Bowery's headquarters, the building operated for many years as a branch office and was subsequently owned by other financial institutions. New lighting and a reconfigured tellers area, introduced in the 1980s, were removed during an extensive restoration in 2002. The building has been converted to a restaurant and banquet hall.

DOROTHY VALENTINE SMITH HOUSE

1893–95

1213 CLOVE ROAD, STATEN ISLAND

ARCHITECT: UNKNOWN

DESIGNATED: OCTOBER 6, 1987

The Smith house is recognized as a restrained example of the usually ornate Queen Anne style, especially in comparison to similar houses built on Staten Island during the late nineteenth century. Such characteristics as the wraparound porch, tall chimney, ornamental shingles, and decorative window treatment, as well as the L-shaped plan and asymmetrical massing of architectural elements, are integral parts of the Queen Anne style.

The house was constructed for John Frederick Smith, a leading figure in banking and insurance and an active participant in Staten Island cultural and civic life. It eventually became the residence of Dorothy Smith, the younger of his two children, who was deeply involved in the civic affairs and history of Staten Island.

UNIVERSITY HEIGHTS BRIDGE

1893–95; ADDITIONS, 1905–8; 1987–92

HARLEM RIVER FROM WEST 207TH STREET, MANHATTAN, TO WEST FORDHAM ROAD, THE BRONX

CONSULTING ENGINEERS: WILLIAM H. BURR, ALFRED P. BOLLER, AND GEORGE W. BIRDSALL

CHIEF ENGINEER: OTHNIEL F. NICHOLS (ADDITION)

DESIGNATED: SEPTEMBER 11, 1984

The University Heights Bridge is still in use over the Harlem River. This steel-truss bridge, consisting of a central swing (double) span and three deck-truss approach spans, is one of New York City's oldest major bridges and oldest extant swing bridges—a type that was

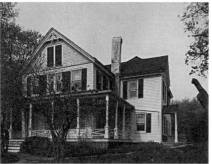

DOROTHY VALENTINE SMITH HOUSE

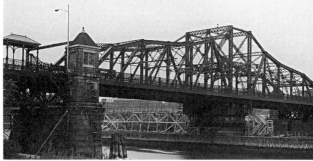

UNIVERSITY HEIGHTS BRIDGE

employed primarily along the Harlem River between 1870 and 1910. The design, construction, move, and reconstruction of the bridge represent the collaboration of a distinguished group of American engineers.

Originally known as the Harlem Ship Canal Bridge, the structure, with a swing span and two flanking spans, bridged the Harlem River at Broadway. Between 1905 and 1908, in a complex bridge flotation operation, these spans were moved to 207th Street to form the University Heights Bridge over the Harlem River. The bridge is distinguished by its ornamental ironwork, handsome truss outline, and steel lattice-work, and its shelters of cast iron, copper, and stone.

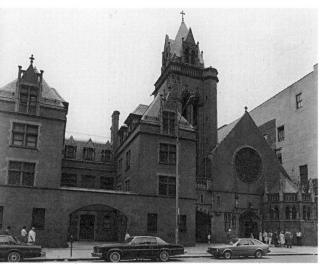

CHURCH OF THE IMMACULATE CONCEPTION

CHURCH OF THE IMMACULATE CONCEPTION AND CLERGY HOUSES, FORMERLY GRACE CHAPEL AND HOSPITAL

1894

406–414 EAST 14TH STREET, MANHATTAN

ARCHITECTS: BARNEY & CHAPMAN

DESIGNATED: JUNE 7, 1966

The Church of the Immaculate Conception is one of only two churches in the city inspired by the François I style. Built in 1894, it was originally a Protestant church known as Grace Chapel and Hospital; the church was intended to provide free pews for those less fortunate financially than the members of Grace Church itself.

A boldly severe building built of stone and Roman brick, the structure is distinguished by a freestanding tower, a steeply pitched gable roof, a large rose window embellishing the plain, asymmetrical facade, and a handsome doorway with a decorated arched portal. To the right of the doorway is a chapel of intimate charm, enriched with beautifully scaled details. Set between six pinnacled buttresses are paired, pointed-arched windows separated by small columns.

Adjacent to and contiguous with the church are the Clergy Houses, a pair of three-and-one-half-story brick and stone structures also designed in the François I style. The two structures are joined by a wide, low, sweeping arch, framing an entranceway to a small courtyard.

What was once a neighborhood

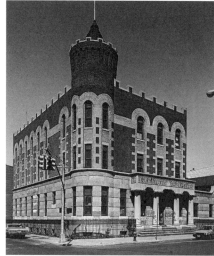

83RD PRECINCT POLICE STATION AND STABLE

church provided much-needed services for immigrant Protestants during the latter part of the nineteenth century. In 1943, when the influx of Protestant immigrants began to subside, the church was reconsecrated as the Roman Catholic Church of the Immaculate Conception.

83RD PRECINCT POLICE STATION AND STABLE, FORMERLY 20TH PRECINCT STATION HOUSE

1894–95; 1996

179 WILSON AVENUE, BROOKLYN

ARCHITECT: WILLIAM B. TUBBY

DESIGNATED: MARCH 8, 1977

The imposing 83rd Precinct Police Station and connecting stable dominates the intersection of DeKalb and Wilson Avenues in the Bushwick section of Brooklyn. A fine Romanesque Revival structure, it was hailed as one of the

best-equipped and handsomest police stations in the world.

The most prominent feature is a corner tower, with small, brick arches carried on a series of corbels below the crenellations. The use of red brick for the walls, with narrower yellow and ocher Roman brick for trim and base, adds rich texture and interest to the facade. The limestone entrance portico is composed of four columns supporting a console-bracketed entablature. Centered in the frieze is the seal of the City of Brooklyn with the Dutch motto "Eendraght Maakt Magt" (Unity Makes Might).

The small stable is connected to the station house by a one-story-cell block wing. Vacant for years, the police station was wonderfully restored in 1996 by Ehrenkrantz & Eckstut and now houses the Brooklyn Task Force.

THE FREE CHURCH OF
ST. MARY-THE-VIRGIN

1894–95

133–145 WEST 46TH STREET AND
136–144 WEST 47TH STREET,
MANHATTAN

ARCHITECTS: NAPOLEON LEBRUN &
SONS

DESIGNATED: DECEMBER 19, 1989

The origins of this church complex can be traced to the Oxford Movement, which began in England in the 1830s. Led by a group of Oxford University theologians, the movement sought to enhance the spiritual lives of industrial workers. Ceremonial rituals were revived, church art and architecture began to follow the medieval style, and mission work in poor neighborhoods was fostered. In North America, the Episcopal Church echoed these developments.

St. Mary's, a complex of five connecting French Gothic–style buildings, was erected in an area of working-class row houses and stables. Faced in limestone, the church is complemented by surrounding buildings of orange Tiffany brick. The group is distinguished throughout by J. Massey Rhind's naturalistic ecclesiastical sculptures and abundant orna-mentation. Keyed limestone surrounds and drip moldings frame doorways and windows. Inside are the long nave, lofty ceilings, side aisles, and deep chancels demanded by a highly ritualistic liturgy.

While St. Mary's looked back intellectually to the ritual and art of pre-Reformation Catholicism, the structure itself was a pioneer in the use of the steel frame in church construction. The steel skeleton, associated at the time only with Chicago skyscrapers, enabled quick construction of the elaborate church complex and earned St. Mary's the nickname "the Chicago Church."

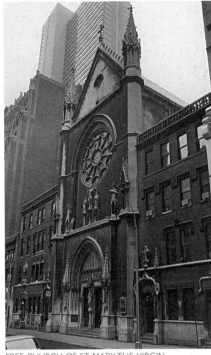

FREE CHURCH OF ST. MARY-THE-VIRGIN

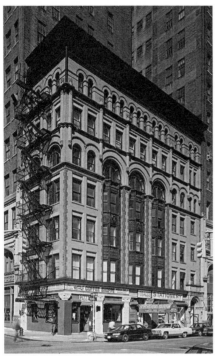

AHRENS BUILDING

AHRENS BUILDING

1894–95

70–76 LAFAYETTE STREET,
MANHATTAN

ARCHITECT: GEORGE H. GRIEBEL

DESIGNATED: JANUARY 14, 1992

The Ahrens Building is an elegant
example of a successful marriage of
state-of-the-art technology and historical
ornamentation. This seven-story struc-
ture takes full advantage of lightweight
armature (thin walls, large windows)
while allowing the facade sophisticated
Romanesque Revival details. Among
the many distinctive features of the
building are the layered arcades of the
two facades, which culminate in a
crowning attic-story arcade, and the
excellent craftsmanship evidenced in
the bold metalwork of the patterned
oriels and deep cornices. This building
provided a handsome answer to the
challenge that absorbed architects of
the late nineteenth century—how to
"dress" the skeleton of modern
commercial buildings.

Griebel ingeniously adapted structural
polychromy (the use of variously col-
ored materials to highlight structural
detail, a practice popularized by John
Ruskin) to a pared-down cladding
appropriate to the steel frame. Buff
brick walls are punctuated by darker,
rock-faced brown brick keys and terra-
cotta moldings. The curved brick profiles
of the windows accentuate the shallow-
ness of the wall surface and gracefully
reveal the underlying construction.

Commissioned by liquor merchant

Herman F. Ahrens, the building was a
speculative investment that coincided
with a municipal project to widen and
improve Lafayette Street. Its original use
was probably as a retail outlet for
Ahrens's liquor business. The building
remained family-owned until 1968,
when it was acquired by Morris and
Herbert Moskowitz. Fortunately, despite
varied uses (upper floors have been
employed for storage, manufacturing,
and office space), the structure has
remained remarkably intact.

AMERICAN TRACT SOCIETY BUILDING

1894–95

150 NASSAU STREET, MANHATTAN

ARCHITECT: R. H. ROBERTSON

DESIGNATED: JUNE 15, 1999

More than twenty stories high, the
American Tract Society Building was one
of the tallest in the city when it was
completed in 1895. Reflecting the style
of its neighbor, the New York Times
Building, Robertson's design features the
Romanesque and Renaissance Revival
styles with a U-shaped plan and exterior
light court. It is one of the earliest steel,
skeleton-frame skyscrapers built partially
of curtain wall construction. Clad in rus-
ticated Westerly granite, Haverstraw
roman brick, and terra-cotta, the two
principal facades are composed as a
base-shaft-capital design, common of
many early skyscrapers. A three-story
open arcade featuring winged caryatids
at street level reappears just below the
tower.

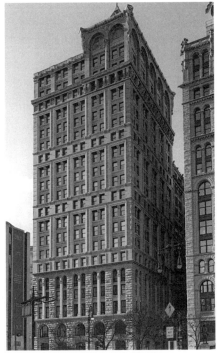

AMERICAN TRACT SOCIETY BUILDING

FORMER SCHEFFEL HALL

1894–95; 1979; 1995

190 THIRD AVENUE, MANHATTAN

ARCHITECT: WEBER & DROSSER

DESIGNATED: JUNE 24, 1997

Originally a German rathskeller, Scheffel Hall is a legacy of Kleindeutschland, the German-American community that flourished on the Lower East Side during the last half of the nineteenth century. Founder Carl Goerwitz emigrated from Germany to the United States in 1873 and named his establishment after Josef Victor von Scheffel, a German poet, novelist, and lawyer.

Designed in German Renaissance Revival style, Scheffel Hall's elaborately detailed, white terra-cotta facade is modeled after the Friedrichsbau at Heidelberg Castle; it is one of the earliest surviving examples of terra-cotta cladding in New York City. The cast-iron storefront is ornamented with intricate strap-and-jewel work, diamond-point rustication, and cartouches. Richly embellished window surrounds and a curved front roof gable contribute to the unique character of the structure.

Though it changed hands a number of times, the building remained a popular gathering place for New Yorkers for over a century. The writer O. Henry, a regular patron, used Scheffel Hall as a setting for his 1909 short story "The Halberdier of the Little Rheinschloss;" from 1979 to 1995 the structure housed Fat Tuesday's, a popular jazz club. The building is now an athletic center.

FORMER SCHEFFEL HALL

Founded in 1825, the American Tract Society was one of the largest publishers of religious tracts and literature in the country prior to the Civil War. Originally operating on this site from a small building, the Society invested in the construction of a skyscraper as a speculative venture. However, due to construction costs and the lack of a stable rental income (partially due to two elevator free-fall accidents), the Society fell into severe debt, losing the building to foreclosure in 1914. Publishers of the *New York Sun* rented the lower floors from 1914 until 1919. After a number of changes in ownership, the building has been converted into condominiums.

WEST 119TH STREET GATEHOUSE, CROTON AQUEDUCT

1894–95

432–434 WEST 119TH STREET (ALSO KNOWN AS 1191–1195 AMSTERDAM AVENUE), MANHATTAN

ARCHITECT: PETER J. MORAN, CONTRACTOR; GEORGE W. BIRDSALL, CHIEF ENGINEER, CROTON AQUEDUCT, FOR NEW YORK CITY DEPARTMENT OF PUBLIC WORKS

DESIGNATED: MARCH 28, 2000

The West 119th Street Gatehouse is a remnant of one of the first major municipal water systems in the United States and the city's first significant supply of fresh water. This formidable structure replaced an older building on Asylum Ridge (named for the Bloomingdale Asylum) in Morningside Heights. Built out of rock-faced granite with round-arched windows with voussoirs and a hipped slate shingle roof, the gatehouse follows the tradition of stone structures for the Croton Aqueduct system. These gatehouses functioned as the southern connection between the cast-iron inverted siphon pipes, laid beneath the Manhattan Valley to the north, and the masonry aqueduct that ran south into the city. The Croton Aqueduct remained the city's principal source of water until 1890, and served the city until 1955. The gatehouse remained in operation until 1990.

WEST 119TH STREET GATEHOUSE

MIDTOWN COMMUNITY COURT

MIDTOWN COMMUNITY COURT, FORMERLY THE AMERICAN THEATER OF ACTORS AND THE ELEVENTH JUDICIAL DISTRICT COURTHOUSE

1894–96; 1995

314 WEST 54TH STREET, MANHATTAN

ARCHITECT: JOHN H. DUNCAN

DESIGNATED: JUNE 6, 1989

The Hell's Kitchen neighborhood served by this courthouse in the late nineteenth and early twentieth centuries was reputed to be the most dangerous and crime-ridden spot in America. A notorious series of street riots in 1900 between Irish and German residents, who represented the majority, and an African American minority contributed to the

exodus of African Americans from the West Side to Harlem. Many of those who participated in the violence were arraigned at the West Side Court, as it was popularly known then.

Proceedings at the courthouse played an integral role in the social history of the densely populated West Side. Senator George W. Plunkitt, a Tammany Hall politician and West Side "boss," was responsible for introducing a bill that enabled the construction of this public building, which housed both the Eleventh District Municipal Court and the Seventh District Magistrates' Court.

The design skillfully adapts the grandeur of the Renaissance Revival style to a small civic structure. A rusticated stone base supports the two brick upper stories, where the tripartite window groups and Corinthian pilasters denote the location of the two court rooms. In 1979, the building was subleased to the American Theater of Actors, which converted the courtrooms into theaters. In 1995, the building was converted back into a courthouse.

FORMER LYCÉE FRANÇAIS DE NEW YORK, ORIGINALLY HENRY T. SLOANE RESIDENCE

1894–96; 2003–

9 EAST 72ND STREET, MANHATTAN

ARCHITECTS: CARRÈRE & HASTINGS

DESIGNATED: JANUARY 11, 1977

By 1900, East 72nd Street was lined with opulent town houses, although only a few of these, such as the former Gertrude Rhinelander Waldo and Oliver Gould Jennings residences (pp. 307, 326), remain today. Henry T. Sloane, a carpet and upholstery merchant, commissioned Carrère & Hastings to construct this Beaux-Arts town house, which the *New York Times* called "one of the handsomest of the newer uptown residences." In 1899, after only two years of marriage, Sloane and his wife, the former Jessie Robbins, divorced. He never again lived at 9 East 72nd Street. Joseph Pulitzer occupied the house briefly before moving to 11 East 73rd Street; James Stillman purchased it in 1901. The building was used as a school by the Lycée Français de New York until 2003; it is currently being restored as a single-family residence.

The four-story limestone facade has four bays, unusually wide for New York, and is elaborately decorated with classical details. Above the rusticated first story, an engaged composite colonnade divides the bays on the upper stories. On the piano nobile tall segmental-arched French windows are set behind low balustrades. Four dormer windows project from the high mansard roof.

The magnificence of the exterior is also reflected in the lavish interior. A porte cochere leads to an arcaded court of honor and main entrance, from which a stairway leads to the Grand Salon, stretching fifty feet across the facade.

9 EAST 72ND STREET

American Surety Company Building

1894–96; additions, 1920–22; 1980s

100 Broadway, Manhattan

Architects: Bruce Price; additions, Herman Lee Meader

Designated: June 24, 1997

Built by one of the leading bond companies in the nation, this was a key building in the evolution of the skyscraper, just as the insurance industry was crucial in the development of this section of Broadway. The second-tallest building in the city at the time it was built, the American Surety Company Building was the first and most important skyscraper designed by Bruce Price. As one of the first to incorporate steel framing, curtain-wall construction, and caisson foundation piers carrying a cantilevered steel foundation structure, the twenty-three-story building was a prototype for the freestanding tower skyscrapers of the early twentieth century. Greek elements such as the Ionic entrance colonnade and classical sculptural figures on the third story—designed by J. Massey Rhind—indicate a neo-Renaissance decorative scheme.

Herman Lee Meader designed modifications to the building between 1920 and 1922, including two penthouse levels, four bays on Broadway, and four bays on Pine Street. The additions match Price's original design in material and articulation.

A group of investors acquired the building in January 1962; in 1973, it was transferred to the Thomson Realty Company, which undertook a major renovation. In the mid-1980s, the interiors of the first thirteen stories were redesigned by the architectural firm of Kajima International for the Bank of Tokyo, and new windows, elevators, and mechanical systems were installed throughout the building.

Bronx Community College, formerly New York University, University Heights Campus

Hall of Fame Terrace at Sedgwick Avenue

The Bronx

Architects: McKim, Mead & White

Hall of Languages, 1894

Designated: February 15, 1966

Gould Memorial Library, 1897–99

Designated: February 15, 1966
Interior designated: August 11, 1981

Hall of Fame, 1900

Designated: February 15, 1966

Cornelius Baker Hall of Philosophy, 1912

Designated: February 15, 1966

In 1890, Henry MacCracken, vice-chancellor of New York University, decided to move the undergraduate students and faculty from the increasingly commercial Washington Square area to a more rustic setting. With funds from the Gould family, the university purchased the forty-acre H. W. T. Mali estate on Sedgwick Avenue in the Bronx, and commissioned McKim, Mead & White to plan and build the new campus.

Stanford White's buff-colored brick and limestone buildings are symmetrically arranged around a cross axis, with the Gould Library at the center. Situated on a steep hillside above the Harlem River, the Gould Library is one of White's greatest achievements. The drum is pushed far back onto an enormous granite and limestone base that supports the building dramatically. The entrance to the library is a portico facing the campus. The transition from the long, low stair to the three-story rotunda of the reading room, with its shallow saucer dome of Guastavino tile, is breathtaking. Sixteen green Connemara marble columns add a rich color accent to the interior.

Surrounding the library and set on a plateau above the Harlem River is the splendid Hall of Fame, an elegant semicircular arcade containing bronze busts of famous Americans. Two symmetrical classical-style buildings, the Hall of Languages and the Cornelius Baker Hall of Philosophy, stand at each end of the Hall of Fame. Each has an imposing flight of steps leading to an Ionic portico at the entrance. The third-floor windows of both are decorated with carved stone garlands; above, an ornate cornice is set on each low roof. The subsidiary buildings, used as dormitories and for individual disciplines, are more modest.

In the 1960s, New York University gradually returned to the Washington Square area. In 1973, Bronx Community College, part of the CUNY system, took over the campus and stewardship of its remarkable buildings.

AMERICAN SURETY COMPANY BUILDING

HALL OF FAME

GOULD MEMORIAL LIBRARY

CLOCK TOWER BUILDING

MCGOVERN-WEIR GREENHOUSE

CLOCK TOWER BUILDING, FORMERLY NEW YORK LIFE INSURANCE BUILDING

1894–98; 1967

346 BROADWAY, MANHATTAN

ARCHITECTS: STEPHEN DECATUR HATCH; MCKIM, MEAD & WHITE

DESIGNATED (EXTERIOR AND INTERIOR): FEBRUARY 10, 1987

A monumental freestanding skyscraper in the Italian Renaissance style, the New York Life Insurance Building has an interesting and complex history. The eastern rear section was designed by Hatch, and it was originally intended to harmonize with the old New York Life building of 1868–70, then located at the western end of the block. When Hatch died suddenly, the commission was turned over to McKim, Mead & White. Under their supervision the project took on new dimensions—the old building was demolished and the new building,

now culminating in a tower on Broadway, was carried to completion.

Built to project an image of prosperity, integrity, and permanence, 346 Broadway is an impressive white marble building that stands twelve stories high at the western end and thirteen at the eastern, following the slope of the site. A long, narrow structure with end pavilions, the Broadway tower pavilion is marked by a monumental portico entrance and crowning clock and bell tower. A thirty-three-foot-tall finial by Philip Martiny topped the tower until about 1928.

The elevations are noted for their handsome cornices and late Italian Renaissance–inspired detail. Crowning the building are four impressive large stone eagles, the emblem of New York Life. The clock tower, now the home of an art gallery, rises two stories. The four-sided striking clock by E. Howard & Co. has twelve-foot faces with Roman numerals—one of the few remaining in the city that have not been electrified.

The interiors of the building were designed using the finest craftsmanship and lavish materials—marble, bronze, mahogany—and incorporating rich classical motifs. Interestingly, the designated spaces bear the personal stamp of the architects—of Hatch most notably in the second-story executive offices, and of McKim, Mead & White in the presidential suite and the magnificent general office, which still contains three enormous walk-in safes.

In 1967, the building at 346 Broadway was acquired by the City of New York, and since then has housed courts and other city agencies.

MCGOVERN-WEIR GREENHOUSE, FORMERLY WEIR GREENHOUSE

1895

SOUTHWEST CORNER OF FIFTH AVENUE AND 25TH STREET, BROOKLYN

ARCHITECT: G. CURTIS GILLESPIE

DESIGNATED: APRIL 13, 1982

The charming McGovern-Weir Greenhouse is the only Victorian commercial greenhouse known to survive in the city. Built by horticulturist James Weir Jr., it was one of several greenhouses to serve visitors to neighboring Green-Wood Cemetery (p. 180).

Although the forms and massing of the greenhouse are bold and impressive, the detailing is simple and straightforward. The building has a rectangular plan enlivened by projecting bays and domes. The greenhouse is a wood-frame

structure enclosing glass panes, and has glass and galvanized-iron roof surfaces. The main entrance takes the form of an octagon. The double entry doors are flanked by wide window expanses with transoms; a cornice separates the transoms from a narrow clerestory. The sloping roof above is capped by an octagonal cupola with a ball finial.

ASSOCIATION OF THE BAR OF THE CITY OF NEW YORK

1895–96

42 WEST 44TH STREET, MANHATTAN

ARCHITECT: CYRUS L.W. EIDLITZ

DESIGNATED: MAY 10, 1966

The Association of the Bar of the City of New York was founded in 1870 "for the purpose of maintaining the honor and dignity of the profession of the Law, of cultivating social relations among its members and increasing its usefulness in promoting the due administration of justice."

This stately limestone building, with its skillful handling of the classical orders, was considered an appropriate symbol of the power and dignity of the law. The imposing facade is centered by a recessed porch and two magnificent fluted Doric columns. A strong horizontal stone band extends the entire width of the building, separating the base from the second floor. Above this, four pairs of well-proportioned Corinthian pilasters form three distinct bays, the center one wider than those on each side. The third-floor windows are small,

but those on the fourth story are wide and flanked by Ionic columns. A Corinthian cornice with beautifully detailed brackets crowns the building.

The building contains one of the largest law libraries in the country. Among the members are distinguished lawyers who have helped to shape the opinions and policies of the Bar Association and the practices of the legal profession in New York and throughout the country.

PUBLIC SCHOOL 108

1895

200 LINWOOD STREET, BROOKLYN

ARCHITECT: JAMES W. NAUGHTON

DESIGNATED: FEBRUARY 3, 1981

An imposing Romanesque Revival building, P.S. 108 is built of brick and Lake Superior sandstone. The structure rises above a rough-faced stone basement for three stories and is crowned by an attic fourth floor pierced with dormers. The building is symmetrical in plan and divided into three parts: the three-bay-wide end pavilions are connected by recessed wings to the seven-bay-wide central entrance section. The pavilions add verticality, plasticity, and a play of light and shadow to the composition. Another picturesque feature is the modillioned roof cornice, broken by gabled dormer windows.

The building still functions as a public school.

ASSOCIATION OF THE BAR

PUBLIC SCHOOL 108

PUBLIC SCHOOL III ANNEX

SQUADRON A ARMORY

PUBLIC SCHOOL III ANNEX, FORMERLY PUBLIC SCHOOL 9 ANNEX

1895

251 STERLING PLACE, BROOKLYN

ARCHITECT: JAMES W. NAUGHTON

DESIGNATED: JANUARY 10, 1978

The annex of P. S. III presents a novel combination of Romanesque and classical ornament. A limestone basement supports three and one-half stories of brick and terra-cotta. The central pavilion contains the main entrance on the first story, marked by a large round arch flanked by paired columns, and a front-facing gable above the cornice line. On each side of the central pavilion are three-bay-wide wings with alternating rows of square and round-arched windows linked vertically by colonnettes. Elaborate terra-cotta panels ornament the spandrels, and large, ornate dormers punctuate the roofs. The terminal pavilions are more classical in detail; their two-bay facades are flanked by colossal fluted Corinthian pilasters, while the windows are ornamented with elaborated terra-cotta columns and lintels carried on brackets.

The annex was built as an extension of P.S. III (originally P.S. 9) across the street, whose facilities were taxed at the turn of the century by the rapid growth of its Prospect Heights neighborhood. The building has since been converted into apartments.

SQUADRON A ARMORY, MADISON AVENUE FRONT

1895; 1969

MADISON AVENUE BETWEEN 94TH AND 95TH STREETS, MANHATTAN

ARCHITECT: JOHN A. THOMAS

DESIGNATED: OCTOBER 19, 1966

A massive wall with towers at each corner is all that remains of the Squadron A Armory on Madison Avenue. The squadron, a volunteer unit that originated as a private group of gentlemen riders called the First New York Hussars or First Dragoons in 1884, the name Troop A in 1889 and Squadron A in 1895. Squadron A was active as a National Guard unit until World War I, when it was called into service; it was reorganized in 1917 as the 105th Machine Gun Battalion.

Reminiscent of a twelfth-century French medieval fortress, the outline of the monumental brick edifice is clearly etched against the sky. Square towers rise alongside round turrets, which are capped by a neatly crenellated parapet wall that continues across the facade. Today the armory is the backdrop for Hunter High School, designed by Morris Ketchum Jr., a former vice-chairman of the Landmarks Preservation Commission, and completed in 1969.

FORMER FIRE ENGINE COMPANY 31

1895; 2000

87 LAFAYETTE STREET, MANHATTAN

ARCHITECTS: NAPOLEON LE BRUN & SONS

DESIGNATED: JANUARY 18, 1966

Fire Engine Company 31 is perhaps the best of the many eclectic firehouses built by the Le Brun firm, at a time when first-class architecture for civic purposes was considered as much of a necessity as fire protection itself. Designed in the early French Renaissance style, the building looks very much like the chateaus of the time of François I. The entire spirit of the building—with its corner tower, its steep roof, its rich and varied dormers, and its stone and iron crestings—recalls a romantic fairy tale. Today it seems almost incredible that such an imaginative design was used for so utilitarian a purpose.

The building was sold in 1986 to two community groups, the Chinatown Planning Council and the Downtown Community TV Center, which plan to use it for community service activities. The exterior was restored in 2000.

FIRE ENGINE COMPANY 253, ORIGINALLY FIRE ENGINE COMPANY 53

1895–96

2429 86TH STREET, BROOKLYN

ARCHITECTS: PARFITT BROTHERS

DESIGNATED: SEPTEMBER 15, 1998

A rare example of the Dutch Renaissance Revival style, Fire Engine Company 253 is a tribute to the neighborhood's roots as New Utrecht, one of the first six towns established by the Dutch in Kings County. Constructed in response to burgeoning development in the area, the two-story building and tower is built of tawny brick with brownstone trim surmounted by stepped gables, a feature common to early-seventeenth-century civic structures in northern Europe and American colonies.

The firehouse is one of the few buildings in the neighborhood predating the consolidation of Greater New York and the introduction of the elevated subway. The lots around the firehouse were not filled in until after 1915. Today, the firehouse continues to serve the surrounding neighborhood.

FORMER FIRE ENGINE COMPANY 31

FIRE ENGINE COMPANY 253

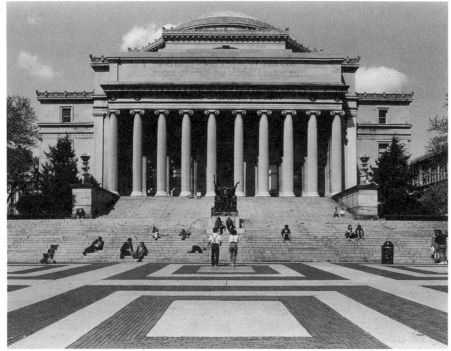

LOW MEMORIAL LIBRARY

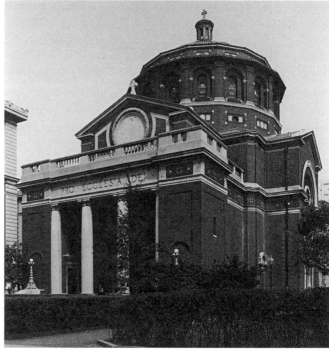

CASA ITALIANA

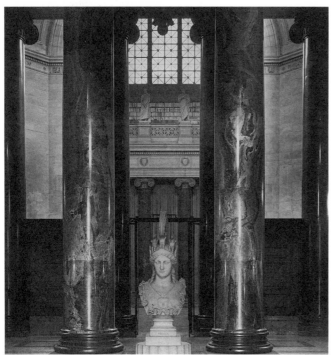

LOW LIBRARY INTERIOR

ST. PAUL'S CHAPEL

COLUMBIA UNIVERSITY

WEST 116 STREET BETWEEN
BROADWAY AND AMSTERDAM AVENUE,
MANHATTAN

LOW MEMORIAL LIBRARY, 1895–97

ARCHITECTS: McKIM, MEAD & WHITE

DESIGNATED: SEPTEMBER 20, 1966;
INTERIOR DESIGNATED: FEBRUARY 3,
1981

ST. PAUL'S CHAPEL, 1904–7

ARCHITECTS: HOWELLS & STOKES

DESIGNATED: SEPTEMBER 20, 1966

CASA ITALIANA, 1926–27; 1996

ARCHITECTS: McKIM, MEAD & WHITE

DESIGNATED: MARCH 28, 1978

Columbia University, chartered in 1754 by King George II as King's College, is the oldest college in New York State. In 1894, Charles Follen McKim of McKim, Mead & White drafted a master plan for the university's new Morningside Heights campus. (The university had been previously housed in a group of buildings on Madison Avenue designed by Charles C. Haight in an academic Gothic mode.) McKim's design was a significant departure from the Collegiate Gothic style that was widely preferred for academic designs in the nineteenth century, and it was chosen precisely for its monumental classical forms derived from principles that he had learned at the Ecole des Beaux-Arts in Paris.

The Low Memorial Library was the first building erected. Situated on a slight rise, this gray Indiana limestone structure is planned as a Greek cross. Compared with Beaux-Arts–inspired

structures, there is little ornament. The chief architectural effect derives from the proportions of the powerful masses. It has one of the finest intact Beaux-Arts interiors in New York, which revolves around a magnificent octagonal hall covered by an imposing dome. The galleries and ambulatories originally contained library stacks and seminar rooms. Though built as the main library, the design proved impracticable, and the building was soon given over to administrative functions. Butler Library (to the south) and almost two dozen specialty libraries around campus now hold the university's collection. Seth Low, who was president of the university from 1890 to 1901 and subsequently mayor of New York, gave the library in honor of his father, Abiel Abbot Low, a merchant in the China Trade.

In 1907, Howells & Stokes completed St. Paul's Chapel, designed as a Greek cross and inspired by Byzantine and early Renaissance forms. The architects combined a variety of materials (red, blue, and burned black brick, Indiana limestone, tile, and terra-cotta) to create a subtly colored combination that moves from mosaic rigidity outside to warm, glowing tones within. Large wooden doors open into a breathtaking space. The dome and transept barrel vaults are made from self-supporting Guastavino tile, a Catalan system introduced into the United States after 1881. The stained glass was executed by Armstrong & Maitland, an English stained- and art-glass manufacturer, after designs by John La Farge.

Facing the apse of St. Paul's across Amsterdam Avenue is the Casa Italiana,

designed by William Mitchell Kendall, the senior partner at McKim, Mead & White after 1915. It was built by the donations primarily from wealthy New Yorkers of Italian descent and the labor of American, Italian, and Italian-American volunteers. Designed as an adaptation of a fifteenth-century Roman palazzo, the building now houses the Italian Academy for Advanced Studies in America. The subtly fenestrated Amsterdam Avenue facade rises six stories from a heavily rusticated base. The wrought-iron window grills and entrance doors and the finely carved stone balustrades are particularly handsome and provide a happy contrast to the severe masonry. The building was restored and adapted for use by the Italian Academy in 1996 by a collaboration of architects Samuel G. White and Italo Rota.

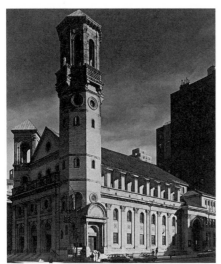

CHURCH OF ST. PAUL AND ST. ANDREW

CHURCH OF ST. PAUL AND ST. ANDREW, FORMERLY ST. PAUL'S METHODIST EPISCOPAL CHURCH

1895–97

540 WEST END AVENUE, MANHATTAN

ARCHITECT: R. H. ROBERTSON

DESIGNATED: NOVEMBER 24, 1981

Church of St. Paul and St. Andrew exemplifies the eclecticism that characterized American architecture in the late nineteenth century. In his design, Robertson merged a particularly unusual combination of forms drawn from German Romanesque, early Christian, and early Italian Renaissance precedents. The church is constructed in pale yellow Roman brick. The front facade on West End Avenue is raised above the street by a short flight of marble stairs; it is dominated by a projecting entrance porch divided into three bays by monumental Corinthian pilasters. Within each bay is a round-arched entrance enframement

with paired rectangular doors and an arched transom filled with intricate grillwork, surmounted by an ornate ocular window flanked by terra-cotta reliefs. At the north end is a low, square tower set at an angle to the street. At the opposite corner a tall octagonal tower anchors the church to its corner site.

The arcade facing 86th Street is extremely regular in the rhythm of its six bays, each composed of a rectangular window and round-arched window separated by a terra-cotta plaque of foliate design. Set back and above the arcade is a tall clerestory with round-arched openings and unusual flying buttresses.

BOHEMIAN NATIONAL HALL

1895–97; 2005

321–325 EAST 73RD STREET, MANHATTAN

ARCHITECT: WILLIAM C. FROHNE

DESIGNATED: JULY 19, 1994

The Bohemian National Hall (Národní Budova) is a rare survivor among the many buildings that housed the benevolent societies organized by New York's immigrant communities. Czechs (Bohemians) and Slovaks, whose native lands were under Austro-Hungarian sovereignty, began immigrating in large numbers following the European revolutions of 1848. They first settled the Tompkins Square area of the Lower East Side, and in the 1880s and 1890s moved uptown to Yorkville.

In the new neighborhood, called "Little Bohemia," they built the

BOHEMIAN NATIONAL HALL

Bohemian National Hall, which served the social, political, and economic needs of the community. The five-story building is organized into six bays and is faced in stone, buff Roman brick, and terra-cotta. The bays are articulated with paired columns and pilasters, and the upper levels have a two-story arcade featuring lion's head bases supporting paired Ionic columns. As part of an agreement to restore the building, the Bohemian Benevolent and Literary Society transferred ownership of the building to the Czech Republic in 2001. The building will house offices of the Consulate General and the Czech Center. The building reopened in 2005.

PUBLIC SCHOOL 27

PUBLIC SCHOOL 27, FORMERLY PUBLIC SCHOOL 154, ALSO KNOWN AS THE ST. MARY'S PARK SCHOOL

1895–97

519 ST. ANN'S AVENUE, THE BRONX

ARCHITECT: C.B.J. SNYDER

DESIGNATED: SEPTEMBER 19, 1995

One of the earliest buildings designed by C.B.J. Snyder, P.S. 27 is adjacent to St. Mary's Park in Mott Haven, in what was, at the time of construction, an Irish-immigrant working-class neighborhood. Snyder, who was New York City superintendent of schools from 1891 to 1923, was very concerned with public health. He created a C-shaped plan that provided ample light and ventilation, as well as created a semi-enclosed play area. The school was also unusual for its small classrooms and modern fire protection.

Not satisfied with simple utilitarianism, Snyder made the building handsome as well. The stepped gables refer to New York's Dutch heritage, while the polygonal bell crowning the center of the roof suggests early American Federal design. The main facade has thirteen bays, the central five composing a projecting pavilion. The five-story building is faced in buff brick with terracotta ornament and is covered with a hip roof. Limestone is used on the keyed window surrounds, the entrances, the corner quoins, and the stringcourses located above each floor. The building has continuously served as a school.

POLO/RALPH LAUREN STORE, FORMERLY GERTRUDE RHINELANDER WALDO MANSION

1895–98; 1984

867 MADISON AVENUE, MANHATTAN

ARCHITECTS: KIMBALL & THOMPSON; NAOMI LEFF

DESIGNATED: JULY 13, 1976

When Polo/Ralph Lauren opened in April 1986, New York was at last given the chance to see the grandeur of the Rhinelander mansion and be reminded of the lavish scale on which wealthy New Yorkers lived in the late nineteenth century. The building had been empty and inaccessible for much of its history.

In 1895, Gertrude Rhinelander Waldo, a leading society matron and member of one of New York's old and established families, commissioned Kimball & Thompson to create an imposing town house in the François I style. Introduced to New York by Richard Morris Hunt, the style was immediately adopted for the most lavish private residences. The Rhinelander Mansion is an exceptionally fine adaptation of this style to American urban domestic architecture.

The mansion's four and one-half

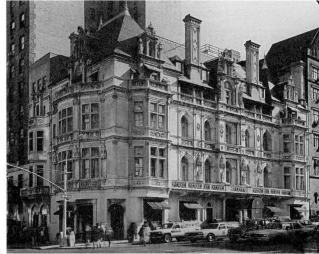

POLO/RALPH LAUREN STORE

stories are constructed in limestone; the red roofs are accented by copper dormers, crestings, and finials. The main facade on Madison Avenue is symmetrically designed in a tripartite composition with projecting end bays and a slightly projecting central bay at the second and third stories. Other features include French Renaissance–style round-arched windows and handsome, elaborate carved ornaments.

The mansion was completed in 1898, but it remained unoccupied; Mrs. Waldo continued to live across the street in her sister's house until her death in 1911. Her sister inherited the property, but the bank foreclosed on the mansion. Olivotti & Co., antique dealers, leased the building in 1920, and became its first occupants. Since that time, the mansion has been occupied by retailers, art auctioneers, and St. James Episcopal Church.

Adapted for use as the Polo/Ralph Lauren shop by Naomi Leff, the interior and exterior were completely and handsomely renovated.

307

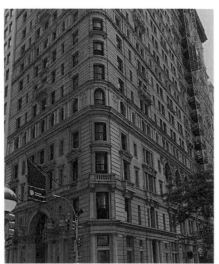

EMPIRE BUILDING

Empire Building

1895–98; addition, 1928–30; 1997

71 Broadway, Manhattan

Architects: Kimball & Thompson; addition, J. C. Westervelt

Foundation Engineer: Charles Sooysmith

Builders: Marc Eidlitz & Son

Designated: June 25, 1996

The Empire Building is generally credited to Francis H. Kimball, "the father of the skyscraper," and it is his earliest extant building. Kimball also designed the nearby Trinity and U.S. Realty buildings (pp. 388, 404). Empire Building became the headquarters of U.S. Steel, a company formed by the merger, financed by J. Pierpont Morgan, of Carnegie Steel and seven other steel companies in 1901. This gigantic steel conglomerate was soon the largest industrial concern in the world, and it dominated all aspects of the American

BOWLING GREEN OFFICES BUILDING

steel industry. In 1919, U.S. Steel bought the Empire Building, which it owned until 1976. The building is now a luxury apartment building.

Typical of early skyscrapers, the Empire's richly ornamented, neoclassical facade is tripartite in its organization. The gray granite base is ornamented with arcades below paired, arched windows; the white shaft is organized horizontally with band courses and vertically with balconies; at the top are colonnaded loggias below a heavy projecting cornice. The building has three articulated facades: polished granite columns capped by eagles on globes frame the two-story arched Broadway entrance; a narrow facade fronts Trinity Street; and the long Rector Street facade forms a backdrop to Trinity Church. Structurally, the building is noteworthy for the early use of pneumatic caissons (sealed concrete cylinders sunk by mechanical means) to create the foundation. The building was converted to apartments in 1997.

Bowling Green Offices Building

1895–98; alterations, 1912–13, 1917–20

5–11 Broadway (also known as 5–11 Greenwich Street), Manhattan

Architects: William James and George Ashdown Audsley; alterations, Ludlow & Peabody

Designated: September 19, 1995

An enormous and beautifully crafted presence at the base of Broadway, the Bowling Green Offices Building was in the vanguard of New York commercial architecture when it was built. Its functional achievements included a large steel frame, a central light court, and provisions for electric service. The sheer mass of the building was also noteworthy—only the shorter Produce Exchange had a comparably large footprint, and only the much narrower Hudson Building was as tall.

The building's Hellenic Renaissance style is expressed in two nearly identical facades. The architects described the building as expressing "a free but pure treatment of ancient Greek architecture," meaning that the austere, rectilinear design avoided using specifically Greek forms, although it incorporated the proportions, spirit, and ornament of Greek architecture. The building is divided into a decoratively carved granite base, a white brick shaft, which solemnly reflects the rhythms of the structural skeleton, and an ornate terra-cotta capital. The bold, straightforward design shows the influence of the innovative

architecture of the Chicago School. The original stoops on Broadway were reconfigured in 1912–13, and a seventeenth story and setback, four-story tower were added in 1917–20.

CHURCH OF ST. IGNATIUS LOYOLA

1895–1900

980 PARK AVENUE, MANHATTAN

ARCHITECTS: SCHICKEL & DITMARS

DESIGNATED: MARCH 4, 1969

This Roman Catholic church is an amalgam of the features of sixteenth- and seventeenth-century Roman Baroque churches. An evocation of Il Gesù, the Jesuit mother church in Rome, the facade is articulated by superposed Tuscan and Corinthian pilastrades whose linear clarity is accented by the rhythm of the rusticated masonry cladding. The Palladian window and shallow pediment above, however, derive from the Federal period. These features place this design squarely in the Colonial Revival of around 1900. The lack of strong sculptural articulation and rather squat proportions, which seem now to mar the design, would have been offset by the twin two-hundred-foot towers that were designed but never executed.

The 84th Street elevation incorporates tantalizing remnants of an earlier structure. The rough-cut masonry at the foot of this elevation was the foundation for the lower chapel of a Gothic Revival church that was begun in 1884 but left unfinished in 1886. This earlier church was dedicated to St. Lawrence O'Toole,

the titular saint of this parish, which was formed in 1851. When the Jesuits took control of the parish in 1866, they petitioned Rome for a new dedication to St. Ignatius Loyola, the sixteenth-century missionary and founder of their order. The interior is richly decorated; particularly noteworthy is the exquisite apse mosaic, made in 1915–16 by Salviati and Co. of Venice.

BROOKLYN MUSEUM

1895–1915; ALTERED, 1934–35, 2004

200 EASTERN PARKWAY, BROOKLYN

ARCHITECTS: McKIM, MEAD & WHITE; ENTRANCE PAVILION AND PLAZA, POLSHEK PARTNERSHIP

DESIGNATED: MARCH 15, 1966

Only the central block of the ambitious McKim, Mead & White design was built during the initial construction completed in 1915. The Eastern Parkway elevation was originally dominated by a monumental staircase, but the stairs were removed in 1935. A new entrance pavilion and plaza designed by the Polshek Partnership as a contemporary interpretation of that form opened in 2004. Sheltered within a glass and steel pavilion, the new lobby fans out in an arc that defines a significant outdoor gathering space. It is a foil to the Beaux-Arts facade, which retains its impressive six-column entrance portico, with a heavy Roman entablature, cornice, steep pediment filled with sculpted figures, and rich ornament. Thirty heroic statues stand on the cornice on each side of the

CHURCH OF ST. IGNATIUS LOYOLA

BROOKLYN MUSEUM

portico, joined by two female figures by Daniel Chester French representing Manhattan and Brooklyn; these were moved to the museum in 1964 from the Manhattan Bridge during a roadway improvement plan.

In the rear is the Frieda Schiff Warburg Memorial Sculpture Garden, designed in 1966 by Ian White. Here pieces of the former Pennsylvania Station are preserved, along with other architectural ornaments salvaged from notable New York City buildings.

1857 ANTHONY AVENUE

1857 ANTHONY AVENUE

1896

THE BRONX

ARCHITECTS: NEVILLE & BAGGE

DESIGNATED: JULY 15, 1986

This handsome French Renaissance
Revival residence, designed for Edwin
Shuttleworth, is a reminder of the
affluent suburban character of the Bronx
at the turn of the century. Occupying a
corner site, the house is constructed in
light gray rough-faced ashlar laid in a
regular pattern of wider and narrower
courses, with contrasting red mortar. The
facade is marked by two full-length cor-
ner towers, each with a conical roof; the
main body of the house is crowned by a
hipped roof with a broad projecting
square central bay at the first and second
stories. The carved detail—griffins,
fleurs-de-lis, and foliate ornament—is
typical of the French Renaissance
chateaus on which this design is based.

PUBLIC SCHOOL 25, ANNEX D

PUBLIC SCHOOL 25, ANNEX D, FORMERLY WESTFIELD TOWNSHIP DISTRICT SCHOOL NO. 7, PUBLIC SCHOOL NO. 4

1896; ADDITION, 1906–7

4210–4212 ARTHUR KILL ROAD,
CHARLESTON, STATEN ISLAND

ARCHITECTS: UNKNOWN; ADDITION,
C.B.J. SNYDER

DESIGNATED: MAY 16, 1995

During the second half of the nineteenth
century, Kreischerville was a small,
quasi-company town centered around
the Kreischer Brick Works. Following
Staten Island's incorporation into New
York City, Kreischerville (present-day
Charleston) experienced a sharp increase
in population. The Westfield School,
built to accommodate the children of
the new residents, is one of the bor-
ough's oldest surviving school buildings.
Intended as an "ornament for the neigh-
borhood," the school was the center of

21 TIER STREET

the town's civic life and its most signifi-
cant institutional building until 1984. It
has since been under the jurisdiction of
the Division of Special Education.

The narrow, gable-framed front
facade prominently features the build-
ing's name and construction date in
light brick. An addition dating from
1906–7 is set apart from the original
structure by a connector with entrances
on the north and south sides. The walls
facing the street feature two tones of
glazed ironspot brick from the factory.

21 TIER STREET

1896

THE BRONX

ARCHITECT: SAMUEL H. BOOTH,
BUILDER

DESIGNATED: JUNE 20, 2000

Constructed as a summer retreat on City
Island, this is a rare surviving shingle
style residence in New York City. Samuel
H. Booth, a local builder, designed and
built this the house on the waterfront
for Lawrence Delmour, a Tammany Hall
politician and real estate investor, and

his wife, Mary Delmour. The shingled surfaces, horizontal lines interrupted by a corner tower capped by a conical roof, interlocking geometrical forms, and broad covered porch make this a classic example of the style. It is still a private residence.

CONGREGATION SHEARITH ISRAEL

1896–97

2 WEST 70TH STREET/99 CENTRAL PARK WEST, MANHATTAN

ARCHITECTS: BRUNNER & TRYON

DESIGNATED: MARCH 19, 1974

Shearith Israel, whose name means "Remnant of Israel," is the oldest Jewish congregation in the United States. It dates from September 12, 1654, when a group of recently landed Spanish and Portuguese Jews held a Rosh Hashanah service in New Amsterdam. The earliest Jewish settlers in New York were mostly descendants of those exiled from Spain and Portugal in 1492. They first took refuge in Holland, and later in Brazil, when the Dutch established colonies there. But by 1654 the Portuguese had moved into Brazil and the Jews fled back to Holland. One ship carrying twenty-three refugees was captured by pirates, who stranded its passengers in the West Indies. The captain of a French ship, the *Saint Charles*, picked up the unfortunate group and brought them to the nearest Dutch settlement—New Amsterdam. Peter Stuyvesant was strongly opposed to the immigration of these refugees

CONGREGATION SHEARITH ISRAEL

from Portuguese Brazil but, because the Jews were successful traders for the Dutch West India Company, he was overruled. In 1672, the Jews were playing an active role in the civic and commercial affairs of the colony, although they were still allowed neither to hold public office nor to build a synagogue.

The first building of the congregation, located on what is today South William Street and built in 1729, provided a permanent house of worship for the Jewish settlers. Parts of this building are preserved in the present synagogue at 2 West 70th Street, the fifth built by the congregation.

The synagogue was the first designed in the monumental neoclassical style used for public and ecclesiastical structures at the turn of the century. Overlooking Central Park, the Central Park West facade is composed of four large engaged composite columns that embrace three round-arched openings, enclosed by elaborate bronze gates and three round-arched windows with

balustrades. The openings, which resemble a loggia, lead to a porch containing the two main entrances. The front columns are crowned by an entablature with a modillioned cornice. Above this is a high attic with smooth-faced pilasters that enframe panels with classical wreath motifs. The attic also supports a handsome low pediment with foliate detail in the tympanum, which is crowned by the conventional anthemion-shaped acroteria. The 70th Street facade is composed of large double doors and a transom with a handsome grille surmounted by a full entablature with foliate consoles and terminates in slightly projecting pavilions. The east pavilion turns the corner to form a part of the main massing on the entrance facade.

311

WEST 54TH STREET HOUSES

WEST 54TH STREET HOUSES

MANHATTAN

DESIGNATED: FEBRUARY 3, 1981

13 WEST 54TH STREET, 1896–97

ARCHITECT: HENRY J. HARDENBERGH

15 WEST 54TH STREET, 1896–97

ARCHITECT: HENRY J. HARDENBERGH

9–11 WEST 54TH STREET, 1896–98

ARCHITECTS: McKIM, MEAD & WHITE

5 WEST 54TH STREET, 1897–99

ARCHITECT: R. H. ROBERTSON

7 WEST 54TH STREET, 1899–1900

ARCHITECT: JOHN H. DUNCAN

These five town houses are examples of the elegant residential architecture that once characterized the West Fifties between Fifth and Sixth Avenues—a neighborhood that developed in style and popularity after the landscaping of Central Park and during the building boom that followed the Civil War.

The house at 5 West 54th Street was built for neurologist Dr. Moses Allen Starr, designed by R. H. Robertson in the Renaissance Revival style using principles of Beaux-Arts composition. Number 7 is an elegant French Beaux-Arts house built for New York banker Philip Lehman, son of Emanuel Lehman, a founder of Lehman Brothers. The six-story twin residence at 9–11 West 54th was designed in the Georgian Revival style by McKim, Mead & White for businessman James Junius Goodwin; it now houses the U.S. Trust Company. Numbers 13 and 15 were built as a pair for businessman William Murray by New York architect Henry J. Hardenbergh in a

Renaissance-inspired style using detail in a picturesque manner.

In the years following World War I, the superb residences of this neighborhood began to give way to commercial and apartment house development. This portion of 54th Street is a rare and fortunate exception to this trend.

BALDUCCI'S, FORMERLY NEW YORK SAVINGS BANK

1896–97; 1994; 2005

81 EIGHTH AVENUE (ALSO KNOWN AS 301 WEST 14TH STREET), MANHATTAN

ARCHITECT: R. H. ROBERTSON

DESIGNATED (EXTERIOR AND INTERIOR): JUNE 8, 1988

Although New York City became the nation's financial capital soon after the Civil War, its commercial banks were often located in unimpressive quarters, including converted residences, because of the high rents in the Wall Street area. Savings banks, restricted by law to a single location, created monumental headquarters to inspire confidence in small private investors.

Located on a prominent corner site, the bank, is a fine example of the classical style popularized by the 1893 World's Columbian Exposition in Chicago. The L-shaped building embodies a classical architectural vocabulary sensitively molded to its institutional functions. The pedimented bay and dome on the 14th Street side suggest the important public space within. The most striking features,

BALDUCCI'S

however, are the copper-sheeted drum and dome and the grand Corinthian portico of the principal Eighth Avenue facade. Inside, rose-gray marble paves the banking hall, which features majestic Corinthian columns on high plinths supporting the entablature and coffered ceiling. Siena marble wainscoting on many of the walls dates from a 1930 remodeling.

In 1940–41 a limestone-faced addition was built to the north of the banking hall to house expanded services. Upon merging with the Bank for Savings in 1964, the bank became the third-largest savings institution in the city. After a second merger, with the Buffalo Savings Bank in 1981, the building was closed to cut costs. In 1994, the building was converted into a carpet and rug emporium. It is now a branch of Balducci's, the well-known gourmet food market.

FIRE ENGINE COMPANY 252, FORMERLY FIRE ENGINE COMPANY 52 AND FIRE ENGINE COMPANY 152

1896–97

617 CENTRAL AVENUE, BROOKLYN

ARCHITECTS: PARFITT BROTHERS

DESIGNATED: OCTOBER 19, 1995

The City of Brooklyn established its professional Fire Department in 1869, four years after New York City did. Between 1870 and 1900, concurrent with the opening of the Brooklyn and Williamsburg Bridges and the elevated trains over the East River, Brooklyn's

population tripled, surpassing one million. Also around this time, the rival New York City Fire Department built a number of handsome and well-outfitted buildings, which led to the construction of twenty new Brooklyn firehouses in the 1890s. Among them was this three-story Flemish Revival building. One of the finest in Brooklyn, this firehouse has been in continuous service since 1897.

The walls are built of brick laid in a common bond, and Lake Superior red sandstone surrounds the windows on the second and third stories. Stepped end gables and a prominent scrolled front gable refer to the seventeenth-century Dutch settlement in Bushwick. Fluted, cast-iron pilasters flank the entrance, where a rolling wood-and-glass door has replaced the original double wooden doors. Above this, a wide stone lintel with intricate botanical carvings incorporates the initials of the Brooklyn Fire Department (B.F.D.), the company's name, the construction date, and shields carved with "52."

BALDUCCI'S INTERIOR DOME

FIRE ENGINE COMPANY 252

HECLA IRON WORKS BUILDING

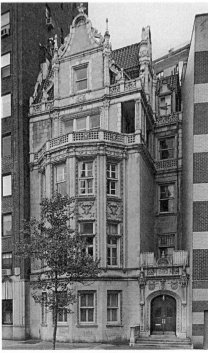

PHILIP AND MARIA KLEEBERG HOUSE

HECLA IRON WORKS BUILDING

1896–97

100–118 NORTH 11TH STREET,
BETWEEN BERRY STREET AND WYTHE
AVENUE, BROOKLYN

ARCHITECT: CHARLES M. EGER

DESIGNATED: JUNE 8, 2004

"The Hecla Iron Works Building, constructed in 1896–97, is located on North 11th Street in Williamsburg, Brooklyn. Four stories tall, the front and rear elevations are faced with cast-iron panels enriched by simple classical details. While most iron fronts incorporate rows of weight-bearing columns, this facade is only a few inches thick, suggestive of skin rather than structure. In combination with metal frame windows, which are all original to the building, it anticipates the decline of masonry fronts and the rise of the modern curtain wall.

Niels Poulson, who co-founded the company with Charles Eger in 1876, is likely to have supervised the building's design and construction. During the 1880s, Hecla pioneered various technologies, most notably the Bower-Barff process which was used to treat the iron. In contrast to most cast-iron facades, which were painted to resemble stone and prevent corrosion, the panels were exposed to super-heated steam that converts rust to magnetite, creating an unusual black, velvety, surface that is unaffected by moisture. As the company's headquarters, the building served as a showpiece for the types of architectural and ornamental metalwork that Hecla produced. Hecla's contribution to New York City's built fabric was extremely significant. Named for an active volcano in Iceland, this versatile firm supplied ornamental work for the exteriors and interiors of many designated New York City Landmarks, most notably the American Surety Building, New York Life Insurance Company Building, B. Altman & Co. Department Store, Macomb's Dam Bridge and 155th Street Viaduct, and Grand Central Terminal. Hecla also produced the 133 original kiosks for the IRT subway system.

Poulson and Eger became major philanthropists; Eger funded the Norwegian Home for the Aged, now the Eger Health Care Center on Staten Island, and Poulson's gifts helped establish the American-Scandinavian Foundation. After their deaths, the works closed, and the building was sold in 1928 to the Carl H. Schultz Mineral Water Company. Since 1989, the lofts have been leased to commercial and residential tenants."*

PHILIP AND MARIA KLEEBERG HOUSE

1896–98

3 RIVERSIDE DRIVE, MANHATTAN

ARCHITECT: C.P.H. GILBERT

DESIGNATED: JANUARY 8, 1991

Situated at the intersection of 72nd Street and Riverside Drive, this refined five-story French Renaissance Revival–style town house is faced in limestone and brick and embellished with classical motifs. Tall, faceted pilasters divide the windows of the three-story, four-sided bay, which projects out to the building

line and is topped by a balustrade decorated with shields. Like the François I style that inspired it, Gilbert's design blends Gothic and Renaissance details, combining picturesque dormers and steeply pitched rooflines with carved putti, gargoyles, shields, shells, wreaths, ribbons, and foliage. The house was considered so noteworthy that an 1899 prospectus put out by architect and developer Clarence F. True, included a photograph of the recently completed building as an example of the high-quality homes to be found in the area. It was the only structure not designed by True's office to be included in the prospectus. Developers also stimulated the demand for houses by emphasizing the beautiful landscape that made the area along Riverside Drive prime real estate. The original drive, designed by Frederick Law Olmsted, had been proposed as a formal park by Parks Commissioner William R. Martin. Today it stretches from 72nd to 129th Streets.

PARK ROW BUILDING

1896–99

15 PARK ROW (ALSO KNOWN AS 13–21 PARK ROW, 3 THEATER ALLEY AND 13 ANN STREET), MANHATTAN

ARCHITECT: R. H. ROBERTSON; NATHANIEL ROBERTS, ENGINEER

DESIGNATED: JUNE 15, 1999

For nearly a decade, the Park Row Building was the tallest building in New York City, and one of the tallest structures in the world, Park Row build

ing rises thirty stories to a height of 391 feet. Robertson departed from past conventions, choosing to concentrate all decoration on the Park Row facade, organizing it vertically, with a slightly recessed and highly ornamented central panel; the side and rear elevations were unadorned. At a time when architects and critics were searching for an appropriate style for the skyscraper, Robertson moved away from his earlier use of the Romanesque style. He employed classical ornament, including pilasters, columns, cornices, and projecting ornamental balconies, as well as four large figures sculpted by J. Massey Rhind. Two ornamental domed towers add a distinctive element to the skyline, even today. While criticized by contemporaries, artists of the period embraced its form, and the facades were highly featured in the photography of Charles Sheeler.

Due to the building's height and irregular plot, Robertson and Nathaniel Roberts, the project engineer, developed innovative construction techniques, including a pile and steel-grillage foundation (similar to the one used on Robertson's American Tract Society Building, p. 294), a fireproof Roebling concrete floor system, and Sprague electric elevators. The building was often described as a small city, with thousands of people traveling within its transportation infrastructure.

Located across from City Hall Park, the office space remained desirable for businesses, which included, among others, August Belmont's Interborough Rapid Transit Company. The center of newspaper publishing in New York

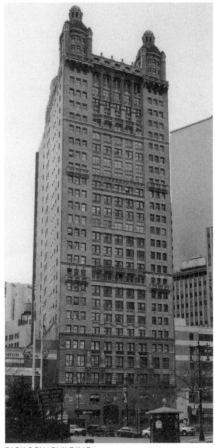

PARK ROW BUILDING

City from the 1840s to the 1920s, the building also housed the Associated Press news agency. The Park Row Building remains in use as a commercial office building, with little alteration to the exterior. It is one of a number of late nineteenth-century office towers located on what was then known as Newspaper Row.

315

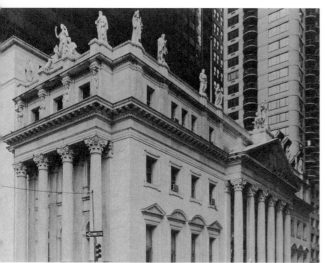

APPELLATE DIVISION, NYS SUPREME COURT

Appellate Division of the Supreme Court of the State of New York

1896–99; 2003

Madison Avenue at 25th Street, Manhattan

Architect: James Brown Lord

Designated: June 7, 1966; interior designated: October 27, 1981

The Appellate Division of the New York State Supreme Court was established in 1894; the justices themselves chose the courthouse site on Madison Square and commissioned James Brown Lord to design the building.

The influence of English Palladian country house designs from the early eighteenth century is apparent in the colossal columns on the 25th Street and Madison Avenue facades, and in the high base and flat, unmolded walls, but the decorative treatment is richer than that of any Palladian Revival building. In this

elaborate decorative ensemble Lord was certainly responding to the vision of public architecture presented at the 1893 World's Columbian Exposition in Chicago.

Like other major cities in the 1890s, New York had artistic societies that promoted classically inspired, highly decorated architecture. In consultation with artists from the newly formed Municipal Art Society, the National Sculpture Society, and the National Society of Mural Painters, Lord worked out the elaborate iconographic scheme of the building, which deals with the attributes and historical development of justice and the law. Daniel Chester French coordinated the sculpture program, and John La Farge oversaw the execution of all the interior paintings, ensuring that the painters adhered to a consistent figure scale and color scheme.

Seated figures of *Wisdom* and *Strength* by Frederick Ruckstuhl flank the main entry on 25th Street. The pediment sculpture by Charles Niehaus is an allegorical representation of the *Triumph of Law*; above is French's *Justice, Power and Study*. The Corinthian portico on Madison Avenue is topped by caryatids representing the four seasons; the large figure group above is Karl Bitter's *Peace*. Above the cornice line, nine overlife-size statues depict figures associated with the historical development of the law.

When the courthouse was renovated in 1954, a tenth figure, *Mohammed*, was removed from above the cornice line at the request of religious leaders. Lord's original translucent Massachusetts marble was replaced with opaque Alabama marble, and a solid marble

APPELLATE COURTROOM

band was substituted for the original open-worked balustrade at street level.

The decorative program on the interior is more complex, but still in keeping with the themes developed outside. The interiors represent a zenith in the synthesis of architecture, decorative arts, and fine arts. The walls of the main hall, are lined with Siena marble and divided into bays by fluted marble piers and Corinthian pilasters. Above the original, Herter Brothers chairs, a bronze and glass chandelier hangs from the gilded coffered and paneled ceiling. At frieze level are murals depicting allegorical figures related to the Law by H. Siddons Mowbray, Robert Reid, and Willard L. Metcalf. Above the entrances on the south wall are Law and Equity by Charles Yardley Turner.

The courtroom is also lined with Siena marble, with piers and pilasters similar to those used in the main hall. A central, stained glass dome, designed by Maitland Armstrong, dominates the gilded coffered and paneled ceiling. A balustered wooden railing separates the spectators from the proceedings in the courtroom. The front of the curved judges' bench has ornamental panels flanked by colonnettes; on the high back

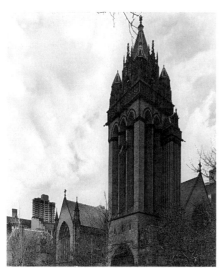

HOLY TRINITY CHURCH

FIRE ENGINE COMPANY NO. 67

scallop-shell tympana mark each judge's seat. As in the main hall, allegorical murals complete the decorative plan with works by Edwin Blashfield, Edward Simmons, Henry O. Walker, Kenyon Cox, and Joseph Lauber. The interior and exterior have been restored by Platt Byard Dovell White.

HOLY TRINITY CHURCH, ST. CHRISTOPHER HOUSE, AND PARSONAGE

1897

312–316, 332 EAST 88TH STREET, MANHATTAN

ARCHITECTS: BARNEY & CHAPMAN

DESIGNATED: FEBRUARY 15, 1967

The Holy Trinity Church complex was built by Serena Rhinelander as a memorial to her grandfather and father. The structures—which occupy a portion of the Rhinelander Farm, purchased in

1798 by the first William Rhinelander— are an outstanding example of late-nineteenth-century brick and terra-cotta ecclesiastical architecture. The church is distinguished by its bell tower, perhaps the most beautiful in the city. The sculptural and decorative features of the entire complex are of terra-cotta, while the bodies of the buildings are Roman brick, mottled golden brown, made especially for the project. All three buildings have red tile roofs.

The tower of the church is accented vertically by open belfry slots consisting of deeply revealed concentric Gothic arches. It terminates in a cluster of turrets, pinnacles, and dormers, crowned by a simple eight-sided spire. The tympanum above the main doors, executed by the nineteenth-century sculptor Karl Bitter, depicts the Trinity and saints.

St. Christopher House looks like an elegant French Renaissance chateau and complements the French Gothic church. Three large arches grace a recessed ground-floor porch. The porch is

repeated on the second story, while steep roofs intersected by pinnacled dormers rise above the third-floor. The three-story Parsonage, also French Renaissance in style, is notable for its relatively plain exterior walls, which contrast with elaborate gabled dormers, pinnacled terminations, elegant main entrance, and orante bronze crestings.

FIRE ENGINE COMPANY NO. 67

1897–98

518 WEST 170TH STREET, MANHATTAN

ARCHITECTS: FLAGG & CHAMBERS

DESIGNATED: FEBRUARY 27, 2001

Fire Engine Company No. 67 is a dynamic and expressive solution to a small midblock firehouse. The striking facade, dominated by a three-story arched opening, reflects the architects' training at the Beaux-Arts. Classical elements, such as the bracketed cornice topped by a row of small anthemia and an elaborate cartouche and hooded round arch in limestone, are juxtaposed to the unadorned brick. The architects utilized a transitional structural system of masonry walls, cast-iron columns, and modern steel framing, allowing for the wall of clustered windows.

Flagg and Chambers further developed these design concepts in a second commission, Fire Engine Company 33 (p. 324). Company No. 67 still serves Washington Heights from this building with exemplary contemporary firefighting standards.

HOTEL MARTINIQUE

1897–98, 1901–3, 1909–11; 2003

1260 BROADWAY, MANHATTAN

ARCHITECT: HENRY J. HARDENBERGH

DESIGNATED: MAY 5, 1998

The luxurious Hotel Martinique catered to wealthy visitors amidst an abundance of shopping and entertainment around Herald Square at the turn of the century. For the sixteen-story hotel, Hardenbergh adapted the French Renaissance-style to create a striking mansard roof, with towers and elaborate dormers, all visible from Greeley Square. The three facades are faced with glazed brick, terra-cotta, and limestone, embellished by rusticated stonework, balconies, and prominent cartouches. Construction took place in three phases, but the hotel was always intended to be a single building.

Developer William R. H. Martin acquired many lots in this area, anticipating its popularity. Rogers, Peet & Co., of which Martin was a founder, operated a store on Broadway, which was demolished for construction of the hotel. By 1970, the neighborhood had lost much of its glamour, but remained a commercial hub. Still under private ownership, the hotel rooms were rented as welfare housing until 1989. The hotel has been restored and reopened as a Holiday Inn.

HOTEL MARTINIQUE

FIRE ENGINE COMPANY NO. 65

FIRE ENGINE COMPANY NO. 65

1897–98

33 WEST 43RD STREET, MANHATTAN

ARCHITECTS: HOPPIN & KOEN

DESIGNATED: OCTOBER 2, 1990

The character of West 43rd Street between Fifth and Sixth Avenues changed dramatically in the late 1890s as an enclave of luxury hotels and social clubs replaced the garages and horse stables of the Sixth Avenue Railroad Company. This firehouse was erected to protect these elite establishments. To complement the majestic neighboring facades and placate prestigious clubs, architects Frances L. V. Hoppin and Terence A. Koen—both classically trained at McKim, Mead & White—constructed a graceful exterior influenced by the Beaux-Arts architecture of the 1893 World's Columbian Exposition in Chicago. Elegant proportions and stately white Roman brick facade embellished with symbolic ornament—the dragon-and-laurel motif signifying the battle between fire and water—clearly express the dignity of the civic function housed within and create an impression of monumentality.

The company started out with horse-drawn engines but it progressed to the forefront of modern fire fighting and distinguished itself in battling such perilous blazes as that of the Ritz Tower Hotel (1932), the Empire State Building (in a 1945 bomber crash), and the Times Tower (1961).

STATEN ISLAND OFFICE OF PUBLIC BUILDING SERVICES, NEW YORK CITY BOARD OF EDUCATION, FORMERLY PUBLIC SCHOOL 15, KNOWN AS DANIEL D. TOMPKINS SCHOOL

1897–98; 1967

98 GRANT STREET, STATEN ISLAND

ARCHITECT: EDWARD A. SARGENT

DESIGNATED: NOVEMBER 19, 1996

In 1897, due to increased enrollment, the Board of Trustees for the Middletown Township school district voted to replace its 1883 schoolhouse with this three-story red-brick structure. New York City took over the school when Staten Island became a borough the following year. In 1916, the school was renamed for Daniel D. Tompkins, the founder of Tompkinsville, who served as governor of New York from 1807 to 1817 and vice president of the United States from 1817 to 1825.

The Tompkins School is the only remaining schoolhouse of the three designed by Edward A. Sargent, an English-born architect who also designed several hundred Staten Island residences. The main entrance on St. Paul's Avenue is flanked by projecting pavilions with hip roofs. Terra-cotta and stone trim accent the rough-textured, burnt red-brick facade. The most noteworthy feature is its four-faced clock tower, which rises a full story above the structure. The school was closed in 1965, but two years later the Board of Education opened administrative offices in the building.

GREATER METROPOLITAN BAPTIST CHURCH, ORIGINALLY ST. PAUL'S GERMAN EVANGELICAL LUTHERAN CHURCH, LATER 12TH CHURCH OF CHRIST SCIENTIST

1897–98

147–149 WEST 123RD STREET, MANHATTAN

ARCHITECTS: SCHNEIDER & HERTER

DESIGNATED: MARCH 8, 1994

Witness to a century of change in Harlem, this church was built to accommodate the growing German-immigrant congregation of St. Paul's German Evangelical Lutheran Church. With economic and social changes in Harlem at the turn of the century, the German community moved away, and the church became home to the 12th Church of Christ, Scientist, the first African-American congregation of its denomination in the city. In 1985, the building was bought by the Greater Metropolitan Baptist Church, which had broken off from the Metropolitan Baptist Church on West 128th Street, one of the oldest African-American churches in Harlem.

At the center of the neo-Gothic facade, executed in blue-gray Vermont marble, is a gabled section with a recessed portal and gabled rose window. This is flanked by two square end towers containing secondary entrances, lancet windows, and finial-capped spires. The symmetrical design projects an architectural grandeur despite the mid-block location. The cornerstone, taken from the St. Paul's Church building, which was demolished to make way for the

S.I. OFFICE OF PUBLIC BUILDING SERVICES

GREATER METROPOLITAN BAPTIST CHURCH

current structure, is inscribed "Christus Unser Eckstein (Christ our cornerstone) / 1865 / 1897." The east entrance now bears a sign including an illuminated cross and the name of the congregation.

PUBLIC SCHOOL 31

SCHOOL OF ARTS AND TECHNOLOGY

PUBLIC SCHOOL 31, KNOWN AS WILLIAM LLOYD GARRISON SCHOOL

1897–99

425 GRAND CONCOURSE, THE BRONX

ARCHITECT: C.B.J. SNYDER

DESIGNATED: JULY 15, 1986

Named for the abolitionist William Lloyd Garrison, P.S. 31 is one of a large number of schools built in the late nineteenth century to accommodate a surge in the population of the Bronx. An early Collegiate Gothic building with Tudor-arched doorways, arched and square-headed windows, stone tracery, and gabled bays, P.S. 31 was a model for academic architecture for many years.

The school is a five-story, light brick and limestone building. Projecting from the center of the main facade is a tower, set off by two octagonal piers, with slit windows, figurehead-carved moldings and belt courses, and turrets on the fifth floor. Snyder included the tower as trib-

ute to a tradition in New York City school building, begun in 1868 when the first tower adorned a school in Manhattan. The main entrance is through the tower base. Flanking the tower on each side are three symmetrically arranged gabled bays; the bays are pierced with groups of five narrow windows on the first four levels and with small double-turret windows on the gables of the fifth floor. Similar fenestration marks the western facade.

MANHATTAN SCHOOL OF ARTS AND TECHNOLOGY, FORMERLY PUBLIC SCHOOL 166

1897–99; 1990S

132 WEST 89TH STREET, MANHATTAN

ARCHITECT: C.B.J. SNYDER

DESIGNATED: JUNE 27, 2000

Built during a period of extremely rapid growth on the Upper West Side, Public

School 166 was one of eight constructed between 1888 and 1899. P.S. 166 also served as a prototype for five schools built in Manhattan and the Bronx at the same time, incorporating Snyder's ideas on fire protection, ventilation, lighting, and classroom size.

Designed in the Collegiate Gothic style, the facade is marked by a turreted central bay with a Tudor-arched entrance, large windows, and prominent gables with steeply pitched roofs. The large number of windows, defined with drip moldings, is made possible by the steel-frame construction. This is one of the early public buildings where terra-cotta is used for the majority of surfaces.

Students who went on to attain international prominence include Dr. Jonas Salk, who developed the first vaccine against polio, Broadway composer Richard Rodgers, and author J.D. Salinger. Still a public school, it was renamed the Manhattan School of Arts and Technology in the 1990s.

ELIZABETH FARRELL SCHOOL, ALSO KNOWN AS PUBLIC SCHOOL 116

1897–99; 1990S

515 KNICKERBOCKER AVENUE, BROOKLYN

ARCHITECT: JAMES W. NAUGHTON

DESIGNATED: JUNE 25, 2002

This four-story Renaissance Revival schoolhouse, with red brick (now painted), terra-cotta reliefs, and an elaborate iron cornice, was one of the last designed by James W. Naughton,

superintendent of buildings for the Brooklyn Board of Education. Financial constraints and the imminent consolidation of Brooklyn into Greater New York dictated a simpler design, with limited classical detailing, than Naughton's earlier schools. The plan reflects the changes in educational attitudes that began in the 1870s, suggesting that the large, undivided assembly spaces should give way to specialized instruction in smaller classrooms.

In the late 1990s, the school was renamed in honor of Elizabeth E. Farrell, a pioneer in special education.

BAYARD-CONDICT BUILDING

1897–99; 2003
65–69 BLEECKER STREET, MANHATTAN
ARCHITECT: LOUIS H. SULLIVAN
DESIGNATED: NOVEMBER 25, 1975

The Bayard-Condict Building is the only New York City project of the great Chicago architect Louis H. Sullivan. Erected as a commercial building on the edge of the city's former printing district, the Bayard-Condict Building is an elegant expression of the most significant feature of a skyscraper, its great height. With the structural innovations of his Chicago School colleagues as a point of departure, Sullivan worked from the multiple-story arcaded buildings of the 1870s to develop a new aesthetic for the skyscraper.

In the Bayard-Condict Building, as in all of Sullivan's mature skyscraper designs, narrow piers rise the full height of the facade without a horizontal break. Here, Sullivan refined this system of structural expression further, making the piers that stand in front of vertical steel elements thicker than those that serve as window mullions. Both elements terminate in stylized Ionic columns at the cornice level, where elegant winged victories are arranged among intertwined geometric and natural forms.

Sullivan's reputation was built, to a certain extent, on his inimitable and inventive ornamentation. His highly stylized decorative elements were abstracted from a variety of sources: classical details, Celtic metalwork, medieval manuscript decoration, the English arts and crafts movement, Art Nouveau, and natural forms. These motifs help to clarify the organization of his skyscraper facades: the horizontal spandrels and vertical elements have different types of ornament, thus differentiating one system from another. The large-scale use of such intricate ornament is possible only with terra-cotta, mass-produced by casting in plaster molds.

After decades of partial occupation and neglect, the Bayard-Condict Building has at last been restored. Because of its architectural importance and its great beauty, the building has attracted many tenants involved in the arts, architecture, engineering, and publishing. The original storefronts were recreated in 2003 by Wank Adams Slavin Architects.

ELIZABETH FARRELL SCHOOL/PUBLIC SCHOOL 116

BAYARD-CONDICT BUILDING

THE UNIVERSITY CLUB

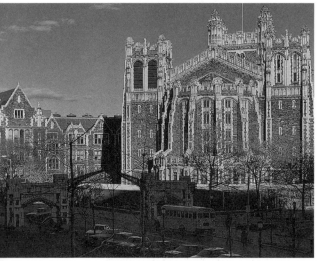

CITY COLLEGE OF NEW YORK

THE UNIVERSITY CLUB

1897–99

1 WEST 54TH STREET, MANHATTAN

ARCHITECTS: McKIM, MEAD & WHITE

DESIGNATED: JANUARY 11, 1967

The University Club was founded in 1865 for "the promotion of Literature and Art." At the time, it was the only New York City club that required its members to have a college degree. In 1894, the club officers considered expanding their quarters in the Jerome Mansion at 26th Street and Madison Avenue. Unable to acquire the adjacent property, they purchased the five lots that make up the present site and hired Charles Follen McKim, himself a member, to design their new building.

McKim turned to a venerable architectural type—the English gentleman's club, which evolved in the early Victorian period in the Pall Mall area of London. Sir Charles Barry, whose Travellers' Club (1829–32) inspired dozens of gentleman's clubs throughout England, had adapted the Florentine palazzo of the sixteenth century for the English clubhouse. His primary innovation was the increased scale of the uppermost cornice. This feature, properly called a cornicione, enhances the effect of the building as a single mass.

McKim picked up this innovation, and then, to reinforce further the cubic form of the building, treated the corners as colossal, rusticated piers rising the full nine stories. He also grouped sets of three stories each between the stringcourses to "disguise" the building as a more typical three-story palazzo. Each grouping consists of a "major" story (actually two stories high, with a mezzanine in the back that does not show on the facade) and a full story above. As a result, the building appears lower than it actually is. The cornice friezes and balconies, with their delicate cast-bronze balustrades, have rich motifs derived directly from Italian Renaissance and Roman sources. McKim also added panels of carved and inscribed Knoxville marble, corresponding to the eighteen colleges and universities whose alumni then made up the majority of the membership; the carvings were designed by Daniel Chester French.

A stone balustrade at the base of the building at street level originally softened the transition from the street to the building. It was removed in 1910 when the street was widened.

Today members from more than 230 American universities and 40 foreign institutions enjoy this beautifully sited, elegant building.

CITY COLLEGE OF NEW YORK, CITY UNIVERSITY OF NEW YORK, NORTH CAMPUS

1897–1930; 1990s

WEST 138TH AND WEST 140TH STREETS, BETWEEN AMSTERDAM AVENUE AND ST. NICHOLAS TERRACE, MANHATTAN

ARCHITECT: GEORGE B. POST; GEORGE B. POST & SONS

DESIGNATED: MAY 26, 1981

The North Campus of City College includes many fine examples of English Perpendicular Gothic style, also known as Collegiate Gothic. Designed as one complete project by George B. Post, these buildings comprised one of the first entire campuses in the United States to be built in this style.

The impressive site at St. Nicholas Terrace was a massive stone outcropping of Manhattan schist, popularly referred to as the Acropolis. Post used schist and terra-cotta in the construction of the buildings, and the contrast created a dramatic effect. The new complex included six halls and three gates, including Townsend Harris Hall, Wingate Hall, Compton Hall, Goethals Hall, Baskerville Hall, Shepard Hall, the main gate, and two other entrance gates. The architecture is distinguished by its dramatic contrast of surface and elaborate Gothic detailing, including more than six hundred terra-cotta gargoyles and grotesques.

City College of New York, founded in 1847 by Townsend Harris as the Free Academy, was originally located on Lexington Avenue between 22nd and 23rd Streets. James Renwick Jr. designed the building—a handsome Gothic Revival edifice that stood for seventy-nine years, until it was demolished in 1928. In 1866, the Free Academy was incorporated as the College of the City of New York.

A major restoration of the North Campus buildings was undertaken in the 1990s.

THE UKRAINIAN ACADEMY OF ARTS AND SCIENCES, FORMERLY THE NEW YORK FREE CIRCULATING LIBRARY, BLOOMINGDALE BRANCH

1898

206 WEST 100TH STREET, MANHATTAN

ARCHITECT: JAMES BROWN LORD

DESIGNATED: AUGUST 29, 1989

Among the wealthy patrons of the New York Free Circulating Library—founded in 1880 to provide "moral and intellectual elevation of the masses"—were Andrew Carnegie, J. Pierpont Morgan, and Cornelius Vanderbilt. Philanthropists were often involved in the management of libraries such as this one, which was devoted to the self-education of the poor. By 1901, the steady expansion of its services had spawned eleven branches. Prior to their consolidation with the New York Public Library, these free libraries were the only alternative to private, fee-charging institutions and the Astor and Lenox research libraries.

Eighteenth-century French design, inspired by Renaissance models, appears to have been a prototype in the development of the urban branch library, as is evident in the Carnegie branch buildings constructed in the early twentieth century. A steel-framed, three-story structure, this library is faced in tan glazed Roman brick enlivened by terra-cotta and limestone. A shallow three-bay portico supported by Tuscan columns projects from a deeply rusticated limestone base featuring five round-arched openings. The architectural prominence

UKRAINIAN ACADEMY OF ARTS AND SCIENCES

of the center bays continues on the second and third stories with colossal Ionic terra-cotta elements framing slightly recessed windows. Since 1961, the building has served as a library and research facility for the study of Ukrainian culture and sciences.

323

THE REGISTER / JAMAICA ARTS CENTER

1898

161–04 JAMAICA AVENUE, QUEENS

ARCHITECT: A.S. MACGREGOR

DESIGNATED: NOVEMBER 12, 1974

The Register / Jamaica Arts Center, an Italian Renaissance Revival building, was erected in 1898, the same year Queens was incorporated into Greater New York. The structure originally served as the office for registering deeds, but it has been adapted for use as a cultural center, with an art gallery, classrooms for York College, and offices of other arts organizations and the Greater Jamaica Development Corporation.

The building stands on a rusticated dark stone base that is separated from the first floor by a rolled molding; the first floor is also rusticated, with smooth stone above. The focal point of the facade is the round-arched doorway, enframed by engaged columns. A classically inspired wrought-iron railing crowns the entrance. Console brackets at the roof support a dentiled stone cornice with egg-and-dart molding.

FIRE ENGINE COMPANY 33

1898

44 GREAT JONES STREET, MANHATTAN

ARCHITECTS: FLAGG & CHAMBERS

DESIGNATED: NOVEMBER 12, 1968

Built in 1898, this flamboyant Beaux-Arts building is four stories high and

THE REGISTER / JAMAICA ARTS CENTER

FIRE ENGINE COMPANY 33

constructed of brick and stone. The facade is dominated by an immense arch; beginning on the second floor, the deep, smooth arch rises from a strong rusticated stone base and swoops up three stories to an elegantly carved keystone above an ornate cartouche. The tall French windows on the second and fourth floors are enhanced by decorative metal railings. Two large doors for vehicles on the ground floor have three centered arches of graceful proportions. Crowning the structure is a very deep metal cornice ornamented with antefixes, fleurs-de-lis, and other

RIVERSIDE DRIVE HOUSES

classical forms. The firehouse is a superb example of rich civic architecture—full of spirit, but possessing dignity and order.

RIVERSIDE DRIVE HOUSES

1898–99

103, 104, 105, 107–109 RIVERSIDE DRIVE, MANHATTAN

ARCHITECT: CLARENCE F. TRUE

DESIGNATED: APRIL 25, 1991

Clarence Fagan True, a prolific architect, whose 1893 and 1899 prospectuses for the Riverside Drive area feature more than 270 houses he designed, began to work as his own developer in 1894. In addition to promoting the Upper West Side, he sought to create designs that would be a departure from repetitive brownstone row houses. The varied architectural elements and materials for each building in this row (the brick is

graduated in hue from tan to orange to red) demonstrate his philosophy of harmonious diversity.

The five extant row houses of an original group of six were built by True's development firm, the Riverside Building Company. They were designed in his signature "Elizabethan Revival" style, a picturesque style based on French and English Renaissance architecture and characterized by contrasting brick and limestone facing, dormers, decorative ironwork, chimneys, and crenellations. All the houses were originally built with prominent projections, such as bowfronts and three-sided bays, but Charlotte Ackerman, a neighbor, sued True for blocking her view, light, and air. In 1903, the New York State Court of Appeals ruled that no permanent encroachments would be allowed on the block. As a result, in 1911, all the facades facing Riverside Drive were removed and rebuilt by other architectural firms to conform to the property lines. Numbers 103 and 104, both altered by Clinton & Russell, and number 107–109, altered by Tracy, Swartwout & Litchfield, were rebuilt with the original materials and retained many of their architectural details; Bosworth & Holden designed a new facade for number 105.

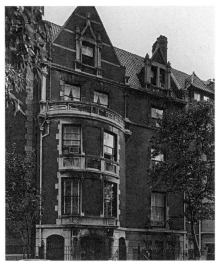

332 WEST 83RD STREET

One of a magnificent ensemble of row houses in True's idiosyncratic "Elizabethan Revival" style—readily identifiable by its asymmetrically placed bowfront, contrasting red Roman brick and limestone, decorative ironwork, and steeply pitched tile roof—this building is the only house in the group that remains unaltered. Unlike the four on Riverside Drive, its picturesque projections were not removed because it faced onto West 83rd Street. The facades facing Riverside Drive were removed and set back after a neighbor brought suit against True for obstructing her view, light, and air.

This house was purchased in 1900 by Robert E. Dowling, president of the real estate firm City Investing Company. Dowling, who negotiated some of New York's largest real estate transactions, lived in the house until his death in 1943. After, the house was sold and converted to a multiple-unit residence.

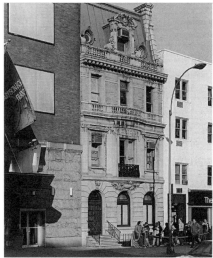

ESTONIAN HOUSE

ESTONIAN HOUSE, FORMERLY THE CIVIC CLUB

1898–99

243 EAST 34TH STREET, MANHATTAN

ARCHITECT: THOMAS A. GRAY

DESIGNATED: MARCH 28, 1978

The Civic Club building was commissioned by Frederick Norton Goddard, a leading social and political reformer who had founded the club to "render personal service as well as pecuniary aid to anybody needing it within the district [the members] regarded as their own, bordered by Fourth Avenue, 42nd Street, the East River and 23rd Street."

The facade of this four-story limestone and brick building is enriched with a variety of decorative detail and distinguished by a rusticated first floor with three round-arched openings—a door and two windows. On the second level is a bowed central window with double French doors.

332 WEST 83RD STREET

1898–99

MANHATTAN

ARCHITECT: CLARENCE F. TRUE

DESIGNATED: APRIL 16, 1991

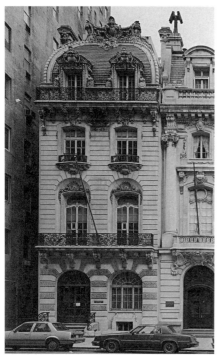

7 EAST 72ND STREET

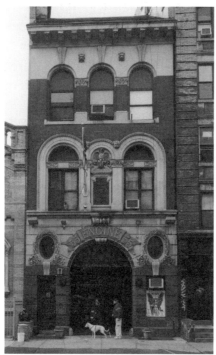

FIRE ENGINE COMPANY 55

Above a modilioned roof cornice crowned by a stone balustrade is a steeply pitched copper mansard roof.

The Civic Club remained in the building until 1946, when the Goddard family sold it to the Estonian Educational Society. The building now serves as a center for Estonian cultural and educational activities.

FORMER LYCÉE FRANÇAIS DE NEW YORK, ORIGINALLY THE OLIVER GOULD JENNINGS RESIDENCE

1898–99; 2003

7 EAST 72ND STREET, MANHATTAN

ARCHITECTS: FLAGG & CHAMBERS

DESIGNATED: JANUARY 11, 1977

The Jennings residence is an especially opulent example of the Beaux-Arts town house. Ernest Flagg and Walter B. Chambers worked to make the house harmonize with the adjoining Sloane house (p. 297) by Carrère & Hastings, which was built three years earlier. Both are constructed of Indiana limestone, and they are further coordinated through the alignment of floor height and similar fenestration.

The Jennings house is three stories high above a basement and crowned by a tall convex mansard roof with ornate copper crestings. The variety of stone finishes of the facade creates visual interest, as do the iron railings. Other decorative elements include carved brackets, corbels, and scallop-shell motifs.

Until 2003, the Jennings and Sloane residences were part of the Lycée Français de New York. Both buildings are now being restored to residential use.

FIRE ENGINE COMPANY 55

1898–99

363 BROOME STREET, MANHATTAN

ARCHITECT: R. H. ROBERTSON

DESIGNATED: OCTOBER 13, 1998

Fire Engine Company 55 is the only firehouse designed by R. H. Robertson. Here he combines the fashionable Romanesque Revival and Beaux-Arts styles, creating a richly detailed composition centered on the immense arched vehicular entrance, which is flanked by garland-draped oval windows, and surmounted by the company banner carved in stone.

The three-story firehouse, faced in red brick and limestone, replaced an earlier firehouse on Elm Street (now Lafayette Street). The structure was one of the first firehouses finished following the consolidation of Greater New York in 1898, and one of many civic improvements constructed in the area at the time.

Five firefighters from Company 55 died in the collapse of the World Trade Center towers during the terrorist attacks of September 11, 2001.

New York Public Library, Aguilar Branch

1898–99; enlarged and refaced, 1904–05; 1993–96

172–174 East 110th Street, Manhattan

Architects: Herts & Tallant; enlargement and new facade, Herts & Tallant

Designated: June 25, 1996

This building is named for Grace Aguilar, a British writer of Spanish-Jewish descent who was known for her popular novels about the Spanish Inquisition. It was originally the East Harlem branch of the broader Aguilar Free Library system, one of several programs that the small but established German-Jewish population created to educate and acculturate the numbers of newly arrived Eastern European Jews.

In 1899, Andrew Carnegie gave the city $5.2 million to establish a library system. Soon after, various independent libraries, including the Aguilar, were consolidated into the New York Public Library. In 1905, the original facade was replaced with a classical design that includes a three-story, three-bay, glass-and-galvanized-iron recessed screen, flanked by monumental fluted limestone piers. These end in Ionic capitals, which support a limestone entablature featuring the inscription "New York Public Library." This institutional building—which has been in continuous use, except for a 1993–96 renovation—is a rarity for Herts & Tallant, a firm renowned for theater designs including

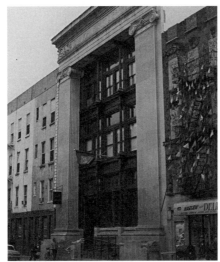

NYPL, AGUILAR BRANCH LIBRARY

the Lyceum, the Shubert, and the Brooklyn Academy of Music. The building was renovated in 1993–96.

Hamilton Fish Park Play Center

1898–1900; 1989–91

130 Pitt Street, Manhattan

Architects: Carrère & Hastings

Designated: December 21, 1982

Among the most notable small civic buildings in the city, the Hamilton Fish Play Center is outstanding example of the Beaux-Arts style favored by Carrère & Hastings. Designed in the manner of a small garden pavilion planned within a formal park, the building reflected the belief of the architects that utilitarian structures deserved a sophisticated architectural treatment. The park was built as part of a movement to add open space to the densely populated slums of the Lower East Side.

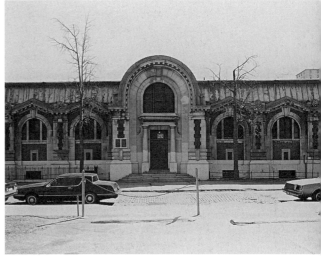

HAMILTON FISH PARK PLAY CENTER

Inspired by Charles Girault's Petit Palais in Paris (1895), the pavilion is a symmetrically massed structure; the main focus is on the projecting centrally placed, round-arched entrance portal, constructed of limestone with brick trim. To each side of the entrance are three brick and stone bays set above a continuous high limestone basement.

The pavilion is used today for locker rooms and as an entrance to the swimming pool, which was added in 1935–36. Although the park has been redesigned twice since it was completed, the pavilion is unchanged and stands as a monument to nineteenth-century notions of "civic betterment"—the belief that great architecture and design could help to endow the citizenry with outstanding moral character. The pavilion was restored in 1989–91.

327

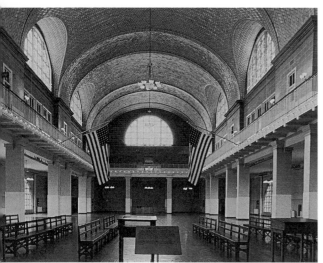

MAIN BUILDING INTERIOR, ELLIS ISLAND

ELLIS ISLAND, MAIN BUILDING INTERIOR, ALSO KNOWN AS THE REGISTRY ROOM

1898–1900; RESTORED 1986–90

ELLIS ISLAND, ISLAND NO. 1, MANHATTAN

ARCHITECTS: BORING & TILTON; RESTORATION, BEYER BLINDER BELLE

DESIGNATED: NOVEMBER 16, 1993

During the three decades between the opening of Ellis Island in 1892 and the restrictive Immigration Act of 1924, approximately twelve million Eastern and Southern European immigrants passed through this huge processing center. Today, the descendants of those who first set foot in the New World at Ellis Island represent more than one in every three Americans. As immigration slowed to a trickle in the 1920s, Ellis Island was adapted to serve a variety of governmental needs. It was finally closed in 1954, and abandoned until the late

1980s. In 1990, the National Park Service opened it as the Ellis Island Immigration Museum. The Ellis Island Historic District, designated in 1993, encompasses the Ellis Island Federal Immigration Station. The island is composed of three land masses: the original island, on which the Main Building stands, and two manmade islands, now connected, made of subway fill. These support medical, administrative, and dormitory buildings.

From 1986 to 1990, much of the Main Building was renovated, and the Registry Room was restored to its 1918–24 appearance; the space is now the centerpiece of the Immigration Museum. Designed in the Beaux-Arts classic style, its floor plan and use of space closely resemble the grand train stations of the era. The Registry Room has a soaring barrel-vaulted ceiling in Guastavino tile, large, arched window openings at the clerestory, a perimeter balcony, and a 2,000-square-foot red Ludowici tile floor. This space offered an impressive—and intimidating—welcome to America to the up to 5,000 immigrants whom the room could accommodate daily. Beyer Blinder Belle completed the restoration in association with Notter Finegold & Alexander.

THE INDONESIAN PAVILION, FORMERLY THE WILLIAM H. MOORE HOUSE

1898–1900; 1986

4 EAST 54TH STREET, MANHATTAN

ARCHITECTS: McKIM, MEAD & WHITE

DESIGNATED: JANUARY 11, 1967

THE INDONESIAN PAVILION

The careful symmetry, order, and unity of structure, combined with the imaginative detail and ornamentation of this building, are typical of the work of McKim, Mead & White. Now the Indonesian Pavilion, this town house was built as a New York residence for William H. Moore, a Chicago industrialist active in the formation of the United States Steel Corporation, the American Can Company, and the National Biscuit Company. For many years, it housed the America-Israel Cultural Foundation.

In a loose adaptation of Italian Renaissance design, the architects established order and stability through simple symmetrical fenestration. They then relieved any rigidity in the arrangement by successively reducing the volumes of the heavy window moldings from the first to the fifth floors. The surface is further enlivened by rustication on the first story and by the inclusion of ornate detail overall. The first-floor windows are graced with voluted keystones, while those of the floors above are adorned

with bracketed cornices; an elaborate dentiled entablature with a scallop-shell frieze rests above the windows of the fifth floor. Intricate carving ornaments an imposing second-floor balcony, and wrought-iron work is added to a smaller balcony above the central window head. Other decorative details include a cartouche carved on the door, a horizontal dentiled belt course between the fourth and fifth floors, and voluted brackets under the main cornice and balustrade.

In 1986, the building was renovated by the firm of Breger Terjesen Bermel.

NEW YORK PUBLIC LIBRARY

1898–1911; RESTORED 1980S–2002; 2004–

476 FIFTH AVENUE AT 42ND STREET, MANHATTAN

ARCHITECTS: CARRÈRE & HASTINGS; RESTORATION, DAVIS BRODY BOND

DESIGNATED (EXTERIOR AND INTERIOR): JANUARY 11, 1967

The New York Public Library was established in 1895, a consolidation of the Astor and Lenox libraries and a generous bequest of Samuel J. Tilden, former governor of New York. An open competition was held in 1898 among the city's most prominent architects to design its building. The rules of the competition were devised by John Shaw Billings (the library's first director), in collaboration with Bernard Green, the engineer who built the Library of Congress, and William R. Ware, founder of the school of architecture at Columbia University.

Thomas Hastings of Carrère & Hastings submitted the winning design, and the cornerstone was laid in 1902.

Hastings's design was selected as much for its striking eighteenth-century French elevations as for its plan. Built of white Vermont marble, the Fifth Avenue facade is characterized by a contrast between finely executed detailing and broad, unrelieved surfaces. This contrast is especially noticeable in the main entrance, which sits atop an ample flight of steps. Corinthian columns stand before three monumental arches, which form a deep porch with transverse barrel vaults. This section is connected to smaller, pedimented pavilions by colossal pilasters, and the whole rides on a massive rusticated base. The heavy masonry corners are the only unresolved elements in a flawless composition.

These and other aspects of the design troubled Hastings, who revised his plan repeatedly; he suggested changes as late as 1927, and reportedly left money in his will to pay for alterations that were never made. The side facades repeat the window-over-arch motif from the main facade, with blank, barely molded piers replacing the Corinthian pilasters. The Bryant Park elevation, which contains the book stacks, is appropriately more modest, with simply molded arches, corner quoining, and piers executed in gray brick and limestone.

Four artists collaborated on the exterior sculpture: George Grey Barnard did the pediment; Paul W. Bartlett, the attic sculpture; Frederick MacMonnies, the fountains; and E. C. Potter, the now celebrated lions. At key points of the interior, many of the same muralists who had

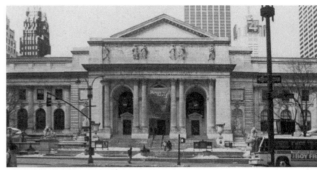

NEW YORK PUBLIC LIBRARY

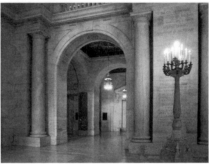

NEW YORK PUBLIC LIBRARY INTERIOR

collaborated on the New York Appellate Court (p. 316) combined their talents with architect and sculptors to create superb decorative ensembles. The four murals and two lunettes in the Central Hall, painted by Edward Laning under the Artists Program of the WPA, were completed in 1940; the ceiling, also by Laning, was finished in 1942.

A restoration and renovation program was begun in the 1980s. The main reading room (78 by 297 feet and 51 feet high) was restored and enhanced with the latest technology through a gift from Sandra Priest Rose and Frederick Phineas Rose. The work was overseen by Davis Brody Bond, which also completed an infill addition in an interior court.

A complete exterior restoration is underway.

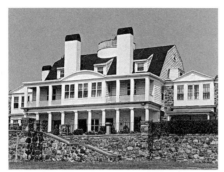
STONE COURT

STONE COURT, ERNEST FLAGG HOUSE, GATEHOUSE, AND GATE

1898–1917; 1980S

209 FLAGG PLACE, STATEN ISLAND

ARCHITECT: ERNEST FLAGG;
ROBERT A.M. STERN

DESIGNATED: APRIL 12, 1967;
EXPANDED LANDMARK SITE
DESIGNATED: JUNE 28, 1983

Born in Brooklyn, Ernest Flagg trained at the Ecole des Beaux-Arts and in the atelier of Paul Blondel in Paris. Among his major works are the Singer Building, the Corcoran Art Gallery in Washington, D.C., and the U.S. Naval Academy at Annapolis, Maryland. Stone Court, his estate at Todt Hill, includes a gatehouse, gardener's cottages, a palm house, swimming pool, stable, storage house, garage, and water towers.

For Stone Court, Flagg initially drew inspiration from local vernacular colonial architecture, although later revisions refer to classical Palladian villa architecture. The main house, constructed of local materials, had whitewashed fieldstone on the ground floor, shingles on the second story (now covered by

aluminum siding), and a shingled gambrel roof, presently somewhat obscured by asphalt. The facade is dominated by a two-level veranda with a Tuscan columned entry porch on the first floor, surmounted by a projecting bay with three large windows on the second. A circular, balustraded widow's walk, twin chimneys with curved ventilator caps, and shed dormers accent the roof.

Surrounding this main house, Flagg arranged the other houses of the estate according to a modular system based upon mathematical principles of Greek architecture. These buildings, completed between 1898 and 1917, are also built of locally quarried fieldstone in the Colonial Revival style.

Stone Court was sold after Flagg's death in 1947, and today it houses the Scalabrini Fathers of Saint Charles. On much of the estate is a group of large suburban homes called Copper Flagg Residential Development, designed by Robert A.M. Stern in the 1980s.

NEW YORK YACHT CLUB

1899–1900; 1990S

37 WEST 44TH STREET, MANHATTAN

ARCHITECTS: WARREN & WETMORE

DESIGNATED: SEPTEMBER 11, 1979

Whitney Warren's Yacht Club building is an expression of Baroque ingenuity adapted to house the country's most prestigious yachting institution, whose members wanted a showcase for their club. J. Pierpont Morgan, commodore of

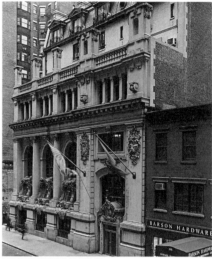
NEW YORK YACHT CLUB

necessary lots on the condition that the building display an impressive, seventy-foot front.

The Beaux-Arts structure includes elaborate decorations and an asymmetrical composition with external divisions that correspond to the internal plan. Grand arched windows mark each of the principal rooms. The entire fine-grained, brick facade displays the base-shaft-capital separations of a classical column. This horizontal arrangement is offset by a vertical entrance pavilion divided into three external sections that in turn correspond to the different levels inside. Decorated with two stanchions and a lighted cartouche, the entrance occupies a single bay of the seven-story, four-bay front. Surrounding each of the arched windows is a sculpted framework of sailing vessel sterns, shells, and seaweed that announces the nautical theme of the club. Grand in scale and romantic in tone, the Yacht Club building suggests the elegance of New York's clubhouse district. During the early 1990s, the

building was restored, bringing the ornate street front back to its original glory.

CITY AND SUBURBAN HOMES COMPANY ESTATES

FIRST AVENUE AND YORK AVENUE, MANHATTAN

DESIGNATED: APRIL 24, 1990

FIRST AVENUE ESTATE, 1898–1915

1168–1190 FIRST AVENUE (ALSO KNOWN AS 401 EAST 64TH STREET), 1194–1200 FIRST AVENUE (ALSO KNOWN AS 402 EAST 65TH STREET), 403–409, 411, 417, 419, 421, 423, 429 EAST 64TH STREET, 404–408, 410, 412, 414, 416, 430 EAST 65TH STREET

ARCHITECTS: JAMES E. WARE, JAMES E. WARE & SON(S), AND PHILIP H. OHM

AVENUE A (YORK AVENUE) ESTATE, 1900–1913

1470 YORK AVENUE (ALSO KNOWN AS 501 EAST 78TH STREET), 1492 YORK AVENUE (ALSO KNOWN AS 502 EAST 79TH STREET), 503–509, 511–517, 519–523, 527–531, 535–539, 541–555 EAST 78TH STREET, 504–508, 510–512, 516–520, 524–528, 530–534, 536–540 EAST 79TH STREET

ARCHITECTS: HARDE & SHORT, PERCY GRIFFIN, AND PHILIP H. OHM

These are the oldest projects executed by the City and Suburban Homes Company, the most successful privately financed company to address the housing problems of the city's working poor at the turn of the century. In the 1880s, more than two-thirds of New York's 3.5 million residents, many of them immigrants, were living in 90,000 tenements. To provide these wage-earners comfortable, safe, and hygienic housing at market rates, the company's investors—mainly wealthy philanthropists, including Cornelius Vanderbilt, Samuel B. Babcock, and Mrs. Alfred Corning Clark—agreed to limit their profits. The company established "a middle ground between pure philanthropy and pure business," said its president, E. R. L. Gould, and encouraged others to invest in model low-income housing. Both estates—each covering a full city block—are high-density developments. The First Avenue Estate has 1,059 apartments and the Avenue A Estate 1,257 plus 410 rooms, the largest low-income housing project in the world at the time of its completion in 1913.

Early Avenue A Estate buildings were executed in neo-Renaissance and Georgian Revival designs. First Avenue Estate and later Avenue A Estate buildings were constructed in contemporary architectural styles, with such details as cartouches, heavy garlands, raised brickwork, and elaborately carved stone doorways. They are the product of the City and Suburban Homes Company's own architectural department, established in 1906 and headed by Philip H. Ohm. Ohm experimented with the configuration of courts, stairs, and halls to produce the most economical and efficient plans. The savings were used to

CITY AND SUBURBAN HOMES COMPANY ESTATES

augment the tenant amenities, adding public bathrooms, children's playrooms, and laundry rooms.

When the federal government began to establish a national housing policy in the 1930s, the large-scale development, management techniques, and financial structure of these model projects were worthy examples for the new programs.

BROADWAY-CHAMBERS BUILDING

BROADWAY-CHAMBERS BUILDING

1899–1900

273–277 BROADWAY, MANHATTAN

ARCHITECT: CASS GILBERT

DESIGNATED: JANUARY 14, 1992

Vibrant, unabashed color differentiates the Broadway-Chambers Building from other contemporary tripartite structures. Architect Cass Gilbert eschewed the light monochrome materials fashionable at the time, preferring instead to use a pale-pink granite with deep-purple overtones for the base of his structure. He chose beige terra-cotta highlighted with brilliant Pompeian red, blue-green, and greenish yellow for the richly embellished capital. The Broadway-Chambers Building exemplifies the classically inspired Beaux-Arts style popularized by the World's Columbian Exposition in Chicago. The three-part vertical structure, which alludes to the three sections of a classical column, and its rich ornamentation—the Tuscan capitals are adorned with Hermes' and lions' heads, garlands, and wreaths—are characteristic of this lush, decorative style.

Still in use today as commercial office space, the Broadway-Chambers Building remains remarkably intact. By and large, changes have been limited to ornamental detail: the copper cheneau was removed from the roof cornice in 1925, and later the decorative transom screen and flanking plinths that once had graced the main entrance were also removed.

WILLIAM E. DILLER HOUSE

1899–1901; 1927

309 WEST 72ND STREET, MANHATTAN

ARCHITECT: GILBERT A. SCHELLENGER

DESIGNATED: JANUARY 8, 1991

Faced in brick and limestone, this Renaissance Revival town house is one of four grand houses remaining at the intersection of 72nd Street and Riverside Drive (opposite and pp. 314, 349). Designed during the resurgence of neoclassicism in America, the building harmonizes with its neighbors, which display similar horizontal divisions, rounded bays, elaborate entrance porticoes, and ornate classical detailing. A low stoop leads to a central entrance framed

WILLIAM E. DILLER HOUSE

by an Ionic portico whose columns and pilasters support a two-story bowed bay and an entablature lavishly adorned with carved vine details and moldings of anthemia, beads, and reels.

In the 1880s, grand mansions were the first dwellings built along Riverside Drive; skyrocketing real estate prices later encouraged the construction of smaller row houses and town houses, such as this one, for greater numbers of less affluent tenants. The owner, William E. Diller, was a physician who, like many other well-to-do New Yorkers at the time, became involved in the real estate market; from 1920 to his death in 1936 he constructed over one hundred single-family homes on the west side of midtown Manhattan. Apparently this house was constructed for investment purposes since the Diller family sold the property only a year after construction was completed. In 1927, it was converted to a multiple dwelling.

Frederick and Lydia Prentiss House

1899–1901; 1957

1 Riverside Drive, Manhattan

Architect: C.P.H. Gilbert

Designated: January 8, 1991

This imposing five-story residence, situated on a large, curved lot, was designed to take advantage of its prominent position at the intersection of West 72nd Street and Riverside Drive. With a dormered, copper-trimmed, slate mansard roof, the building is faced in limestone and features an entrance portico supported by Ionic columns and a turret topped with a conical roof. Curved bays project from the front and side facades. The architect for many prominent members of New York society, Cass Gilbert had attended the Ecole des Beaux-Arts in Paris, where he familiarized himself with interpretations of Renaissance and Baroque prototypes of Italian, French, and German architecture. His studies at the Ecole are evident in his treatment of this facade, which is replete with classical garlands, carved friezes, floral patterns, pilasters, balustrades, columns, and rustication.

In 1957, the building was purchased by the New York Mosque Foundation, which modified the interior to accommodate a mosque on the first and second floors.

FREDERICK AND LYDIA PRENTISS HOUSE

Duke-Semans House

1899–1901; 1980s

1009 Fifth Avenue, Manhattan

Architects: Welch, Smith & Provot

Designated: February 19, 1974

This Beaux-Arts mansion, prominently sited on the southeast corner of Fifth Avenue and 82nd Street, is one of the few survivors of the grand residences that once lined Fifth Avenue. Designed by Alexander M. Welch of the firm Welch, Smith & Provot, the house was built for S.W. Hall and T.W. Hall, speculative builders who specialized in the construction of large private residences.

The six-story limestone and brick mansion has a narrow facade facing Fifth Avenue, dominated by a broad, curved bay extending from the basement through the fourth floor. The roof, with two towers rising above the ends of the main block of the house,

DUKE-SEMANS HOUSE

is covered with red tiling and crowned by handsome, boldly scaled copper crestings and finials. The entrance facade is symmetrically composed with two slightly projecting corner pavilions flanking a central four-story curved bay. The roof cornice is crowned by a balustrade behind which appear dormer windows with richly adorned arched pediments. Rich surface ornamentation, in the form of carved cartouches, wrought-iron railings, belt courses, and carved brackets, embellish the surface.

Shortly after its completion, 1009 Fifth Avenue was bought by the industrialist Benjamin N. Duke. In 1907, Benjamin sold the mansion to his brother and business partner, James B. Duke. After James Duke's new residence at East 78th Street and Fifth Avenue was completed, 1009 was occupied by Angier Buchanan Duke and then by his sister Mrs. A.J. Drexel Biddle. The house has remained in the Biddle family and is now known as the Duke-Semans House.

GRAHAM COURT APARTMENTS

GRAHAM COURT APARTMENTS

1899–1901

1923–1937 ADAM CLAYTON POWELL
JR. BOULEVARD, MANHATTAN

ARCHITECTS: CLINTON & RUSSELL

DESIGNATED: OCTOBER 16, 1984

Commissioned by William Waldorf
Astor, the Graham Court Apartments
were constructed as part of the great
Harlem real estate boom. Designed by
Clinton & Russell, a firm known for
apartment houses, hotels, and early
commercial skyscrapers, Graham Court
was built as luxury apartments, and its
design is one of the signal achievements
in the history of the apartment house in
the city. Graham Court is quadrangular
in plan and built around a central court-
yard—one of the few apartment houses
of this type in New York City. In a
conscious effort to evoke an image of
luxury, the building recalls an Italian
Renaissance palazzo; eight stories high
with a projecting stringcourse, the struc-
ture is divided horizontally into three
parts with a two-story rusticated base.
The whole is characterized by monu-
mentality, symmetry, and restraint.

When Graham Court was built, West
Harlem was developing into a prosper-
ous and fashionable neighborhood; it
attracted affluent people who had lived
in attractive brownstones and luxury
apartment buildings along Seventh and
Lenox Avenues. Graham Court, the
largest and finest of the new buildings,
was also one of the last major apartment
buildings in Harlem to become integrat-
ed: it was not open to black residents
until 1928. The building remained under
the control of the Astor estate until 1933.
It remains one of the most notable
buildings in Harlem, a survivor from
the neighborhood's heyday at the turn
of the century.

CONSULATE GENERAL OF ARGENTINA

CONSULATE GENERAL OF ARGENTINA, FORMERLY THE HARRY B. HOLLINS HOUSE

1899–1901; ADDITION, 1924; 1947

12–14 WEST 56TH STREET,
MANHATTAN

ARCHITECTS: MCKIM, MEAD &
WHITE; ADDITION, J.E.R. CARPENTER

DESIGNATED: JUNE 19, 1984

Designed by Stanford White as a
residence for banker Harry B. Hollins,
12–14 West 56th Street is one of the
most elegant and well-proportioned
Georgian Revival town houses of its
time. Its strikingly simple facade is
distinguished by a rusticated limestone
ground floor; each of the three French
windows on the second floor is fronted

by a low, iron balcony and capped by a carved lunette, and the whole is crowned by a heavy limestone modillioned cornice with a parapet balustrade concealing the shape of the peaked roof. A two-story, brick-faced extension on the east side of the building, added in 1924 by J.E.R. Carpenter, is set back from the street line behind a one-story aedicular entrance framed by fluted Corinthian pilasters; the original entrance is now the central ground-floor window.

The building has housed the Calumet Club, several commercial establishments, the Salvation Army, and, since 1947, the Argentine Consulate General.

MANHASSET APARTMENTS

1899–1901; ENLARGED, 1901–05
2801–2825 BROADWAY, 301 WEST 108TH STREET, AND 300 WEST 109TH STREET, MANHATTAN

ARCHITECTS: JOSEPH WOLF; ENLARGEMENTS, JANES & LEO

DESIGNATED: SEPTEMBER 17, 1996

Around the turn of the century, rising Upper West Side real estate prices—spurred by the 1879 elevated train on Ninth Avenue (renamed Columbus Avenue in 1880) and the Broadway subway line in 1901–04—effectively prohibited single-family dwellings for all but the very wealthy. Meanwhile, the success of the 1880 Dakota Apartments (p. 225) made multiple-unit living desirable for the upper-middle class and led to an apartment construction boom

in the area. The Manhasset is an early example of the type of speculative apartment building that would come to dominate the Upper West Side.

The eight-story Manhasset was originally built as two contiguous buildings with a flat roof. The brick-and-stone building was designed in the Beaux-Arts style by Joseph Wolf. The property was foreclosed before its opening, and the new owners added entrance pavilions in the side street light courts, a ninth story, and a two-story mansard roof—the building's most prominent feature—designed by Janes & Leo. The effect is one large facade, asymmetrically massed, facing Broadway. The building has a two-story limestone base, which is divided from a seven-story brick midsection by a limestone sill. A metal cornice underlines the ninth story at the original roofline. The Manhasset is now a cooperatively owned apartment building.

MANHASSET APARTMENTS

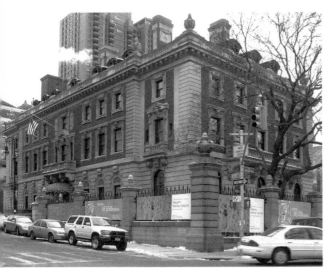

COOPER-HEWITT NATIONAL DESIGN MUSEUM

COOPER-HEWITT NATIONAL DESIGN MUSEUM, SMITHSONIAN INSTITUTION, FORMERLY THE ANDREW CARNEGIE MANSION

1899–1902; RESTORED 1976; 1996–97

2 EAST 91ST STREET, MANHATTAN

ARCHITECTS: BABB, COOK & WILLARD; RESTORATION, HARDY HOLZMAN PFEIFFER; JAMES STEWART POLSHEK & PARTNERS

DESIGNATED: FEBRUARY 19, 1974

Andrew Carnegie's sixty-four-room mansion on upper Fifth Avenue was one of New York's grandest private residences. Carnegie was born in Scotland in 1835 and immigrated to the United States with his family in 1848. He started as a full-time boy in a cotton mill, and over the next fifty years amassed a fortune from steamship and railroad lines, iron, coal, and steel companies. At his death in 1919, Carnegie was one of America's richest men and a noted philanthropist.

In 1898, Carnegie decided to build what he called the "most modest, plainest, and roomiest house in New York." In the 1860s and 1870s, most affluent property owners built their sumptuous places on Fifth Avenue in the sixties and seventies, but Carnegie preferred the open space farther uptown. On his new grounds there was room for a magnificent garden filled with wisteria, azaleas, rhododendron, and ornamental trees. Carnegie's move encouraged other wealthy New Yorkers to follow suit, and the area became known as Carnegie Hill.

The architecture of the mansion is reminiscent of a Georgian-style English country house. In line with Carnegie's "modest" desires, the design is much more restrained than the "chateaus" and "palazzos" of his New York contemporaries. It is one of the few remaining freestanding houses in Manhattan. The symmetrical structure was constructed in red brick with limestone trim, and is typically Georgian in its use of heavy quoins and carved window frames, with a modillioned roof cornice beneath a balustrade. Segmental arches, copper-faced dormers, and tall, red-brick chimneys with limestone ornament add vitality at roof level. The main entrance on 91st Street was sheltered by a Tiffany-style copper and glass canopy.

The building also incorporated several significant engineering techniques, including a heating and ventilation system that brought air inside, filtered it, heated and cooled it, and adjusted the humidity to the proper level. Carnegie

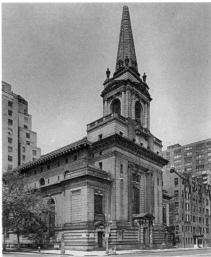

FIRST CHURCH OF CHRIST, SCIENTIST

also installed a water filter system.

Carnegie's widow, Louise, lived in the house until her death in 1946, when it became part of Columbia University. In 1972, the building was given to the Smithsonian Institution to house its National Museum of Design. In 1976, after renovations by Hardy Holzman Pfeiffer, it opened to the public as the Cooper-Hewitt Museum. In 1996–97, James Stewart Polshek & Partners incorporated a skillful addition to the museum, providing handicap access to the main entrance and a connection to the George L. McAlpin house, another historic house on the Carnegie site.

FIRST CHURCH OF CHRIST, SCIENTIST

1899–1903

1 WEST 96TH STREET, MANHATTAN

ARCHITECTS: CARRÈRE & HASTINGS

DESIGNATED: JULY 23, 1974

The Carrère & Hastings design for the First Church of Christ, Scientist, is a synthesis of historical precedents. The plain surfaces of the massive stone walls and the design of the spire are reminiscent of the work of English architect Nicholas Hawksmoor. The rational articulation of the plan on its exterior—giving each aisle its own entrance pavilion, exposing the windows of rooms above the sanctuary—reflect the architects' training at the Ecole des Beaux-Arts. The restrained use of classical forms brings these two traditions together. Colossal engaged Ionic columns frame the stained glass window above the entrance, while smaller engaged columns of the same order are used in the tower. A continuous, complete Ionic cornice ties the sanctuary to the tower, while a secondary cornice unites elements at the roof level of the aisles.

The Christian Science Society had organized a branch in New York by 1887; in 1896 the name changed to First Church of Christ, Scientist, New York. Only the finest resources were used for the congregation's building from the design by the nationally known firm of Carrère & Hastings to the window above the entrance by the noted stained glass artist John La Farge and the best Concord white granite on the exterior.

ANSONIA HOTEL

1899–1904

2101–2119 BROADWAY, MANHATTAN

ARCHITECT: PAUL E. M. DUBOY

DESIGNATED: MARCH 14, 1972

The Ansonia Hotel embodies the standard of luxury applied to turn-of-the-century apartment buildings on the Upper West Side. The hotel was designed by French architect Paul E. M. Duboy in the full flowering of the late Beaux-Arts style—with the purely decorative aspects of the style given full expression in the building. The design was very much under the personal control of the owner-builder, William Earl Dodge Stokes, a real estate developer who was responsible for much of the early growth of Riverside Drive and the Upper West Side. The hotel was named after the town of Ansonia, Connecticut, where Stokes's grandfather, Anson Greene Phelps, founded the Ansonia Brass & Copper Co.

Built with over three hundred suites, the Ansonia rises seventeen stories; its facades are covered with ornament and balconies, marked by splendid corner towers, and topped by mansards in the very best French tradition. The effect is one of lightness, grace, and elegance, and the profuse surface ornament is never overbearing. The most striking features of this vast building are the corner towers, with their domes and railings, which rise slightly above and repeat the theme of the three-story convex mansard roof that tops the building. Another interesting feature is a series of recessed courts—two on the north, two on the south, and one on Broadway—that were intended to maximize light and air. The tiers of windows, recessed courts, and rounded towers establish a sense of verticality that is skillfully modulated by a series of horizontal balconies. The contrast of highly

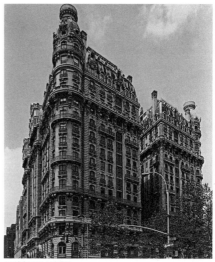

ANSONIA HOTEL

ornamented and delicate ironwork with terra-cotta and massive limestone details, and the contrast of quoins and rustication with smooth-paneled surfaces of brickwork, creates a highly dramatic and elegant surface.

The building, originally planned as a residential hotel, incorporated many of Stokes's own inventive ideas, such as heavy, all-masonry fireproof construction with heavy interior partitions to separate apartments. This construction was also virtually (and unintentionally) soundproof, a factor that has always made the building attractive to musicians. Indeed, it has numbered among its notable tenants Leopold Auer, Enrico Caruso, Bruno Castagna, Yehudi Menuhin, Lily Pons, Antonio Scotti, Igor Stravinsky, and Arturo Toscanini.

The Ansonia was always a highly individual enterprise; when it first opened, it included such unheard-of attractions as shops, in the cellar, two swimming pools, and a roof garden.

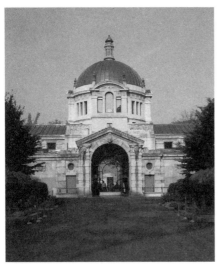
ASTOR COURT

ENID A. HAUPT CONSERVATORY

ROCKEFELLER FOUNTAIN

BRONX PARK

THE BRONX

LORILLARD SNUFF MILL, C. 1840

NEW YORK BOTANICAL GARDEN

ARCHITECT: UNKNOWN

DESIGNATED: APRIL 19, 1966

THE CONSERVATORY, 1899–1902;
1978; 1997

NEW YORK BOTANICAL GARDEN

ARCHITECT: WILLIAM R. COBB FOR
LORD & BURNHAM

DESIGNATED: OCTOBER 16, 1973

ROCKEFELLER FOUNTAIN
ERECTED 1910

BRONX ZOO

ARTIST: ANONYMOUS EIGHTEENTH-
CENTURY ITALIAN CRAFTSMAN

DESIGNATED: FEBRUARY 20, 1968

ASTOR COURT, FORMERLY BAIRD
COURT

1899–1910, ADDITION 1922

BRONX ZOO

ARCHITECTS: HEINS & LAFARGE;
HAROLD A. CAPARN, LANDSCAPE
ARCHITECT; ADDITION, HENRY D.
WHITFIELD

DESIGNATED: JUNE 20, 2000

RAINEY MEMORIAL GATES, 1934

BRONX ZOO

SCULPTOR: PAUL MANSHIP

ARCHITECT: CHARLES A. PLATT

DESIGNATED: JANUARY 11, 1967

Bronx Park, containing the New York
Botanical Garden and the Bronx Zoo of
the Wildlife Conservation Society, is
located on 661 acres purchased by the
City of New York in 1884 from the
Lorillard family and other Bronx
landowners. Among the notable features
of the Botanical Garden are the original
Lorillard Snuff Mill and the Enid A.
Haupt Conservatory. Important features
of the zoo include the Rockefeller
Fountain, the Baird (now Astor) Court,
and the Rainey Memorial Gates.

The Lorillard Snuff Mill was built
about 1840 on the site of an earlier
wooden gristmill. It is one of the few
surviving pre–Civil War industrial build-
ings; the mill was in operation until
about 1870. After the city acquired the
property, the Parks Department used the
mill for a carpentry shop, leaving its
machinery and its waterwheel
unchanged until about 1900. Although
the mill has been altered to serve as a
cafe, its old fieldstone walls, brick trim,
and century-old beams are still intact.

The Enid A. Haupt Conservatory,
named in 1978 for the philanthropist
who provided for its first restoration by
Edward Larrabee Barnes, was construct-
ed in 1899–1902. Inspired by the Royal
Botanic Gardens at Kew, England, and
influenced by London's Crystal Palace of
1851, the structure was designed by
William R. Cobb of the firm of Lord &
Burnham. The structure is C-shaped in
plan, and consists of the central Palm
House (about one hundred feet in diam-
eter) and ten connected houses, all built
with steel posts bolted to stone founda-
tions, which in turn support bowed
steel ribs to form a curved roof. The
second restoration in 1997 by Beyer,
Blinder Belle included the complete
disassembly of the building, the replace-

ment of wooden elements with aluminum, and an upgrading of the technical system.

The eighteenth-century Rockefeller Fountain was acquired in Italy by William Rockefeller in 1902 and donated to the zoo. It was moved to a circle in the garden's concourse in 1910. The marble sculpture is composed of an enormous bowl and a central shaft. Four large shells rest on the bowl, each containing a cherub playfully astride a sea horse. The sculpted shells, which are supported by mermaids and sea gods, alternate with grotesque bronze heads. The central shaft, supported by four sea monsters, is surmounted by a goose, whose beak spouts water skyward to trickle down into the basin thirty feet below.

Baird Court, now Astor Court, is patterned on the Court of Honor at the World's Columbian Exposition of 1893. Built with a classical formality designed to contrast with the park landscaping, the court is one of the few remaining ensembles of the City Beautiful movement, which held that major cultural monuments should be designed in the style of classical antiquity. From the north, an Italian-inspired stairway brings visitors up to the Court. Six detached limestone, brick, and terra-cotta buildings, surrounding a central sea lion pool, define the symmetrically and longitudinally planned terrace. All were designed in a neoclassical style by Heins & LaFarge with realistic stone and terra-cotta sculptures of animals by the sculptors Eli Harvey, Charles R. Knight, and Alexander Phimster Proctor. The National Collection of Heads and Horns

building (now Security, Education, and International Conservation Offices) was added in 1922 by Henry D. Whitfield.

The Rainey Memorial Gates, located at the concourse entrance, were completed in 1934 by sculptor Paul Manship. These monumental, freestanding Art Deco bronze gates with animal and plant motifs, which took five years to design and two to cast, were given to the Zoological Park by Grace Rainey Rogers as a memorial to her brother, Paul J. Rainey, a big-game hunter, who donated a number of exotic animals to the zoo. The central post that separates the two openings is in the form of a tree trunk, modeled in ascending curves filled with figures of birds in profile; the tree is topped by a seated lion enframed by a soaring burst of stylized tree limbs that seem to metamorphose into birds' wings. Smaller trees flank each side of the gate, one topped by a panther and the other by a baboon.

LORILLARD SNUFF MILL

RAINEY MEMORIAL GATES

339

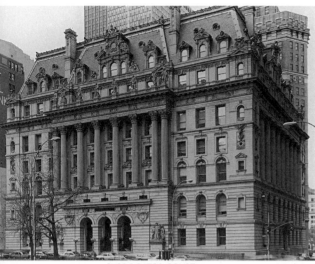

SURROGATE'S COURT

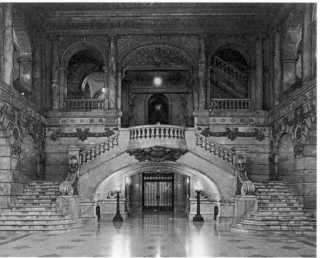

SURROGATE'S COURT INTERIOR

SURROGATE'S COURT, FORMERLY THE HALL OF RECORDS

1899–1907

31 CHAMBERS STREET, MANHATTAN

ARCHITECTS: JOHN R. THOMAS (1899–1901); HORGAN & SLATTERY (1901–11)

DESIGNATED: FEBRUARY 15, 1966; INTERIOR DESIGNATED: MAY 11, 1976

By 1888, the old eighteenth-century "gaol" in City Hall Park, which served as New York's first hall of records, had become too small for the city's needs. The Sinking Fund Commission, formed to study the problem, recommended razing City Hall and erecting a larger building that would combine both functions. An open competition drew over 130 entries; the winner was John R. Thomas, a Rochester-born architect with a wide New York City practice. The public, however, was outraged at the proposal to destroy City Hall, and the plan was abandoned. The current site was chosen in 1897. Thomas retained the commission, but he died in 1901 before its completion. Horgan & Slattery, known for its Tammany Hall connections, finished the work largely according to Thomas's plans.

The building is of white Maine granite. Its high mansard roof and prominent chimneys are characteristic of French Second Empire design, but the pedimented central pavilion, colossal Corinthian colonnade, heavily rusticated base, and the division of the facade into three horizontal sections are all Beaux-Arts features, as is the abundant figural sculpture. The figures in the roof area, representing the stages of man's development from childhood through old age, are the work of Henry K. Bush-Brown. The statues above the colonnade depict notable New Yorkers, from the founding of the Dutch settlement through 1888. These, as well as the Chambers Street groups portraying *New York in Its Infancy* and *New York in Revolutionary Times*, are by Philip Martiny.

Entered from the Chambers Street facade, the foyer and main lobby are among the most impressive interiors from this period in the entire city. The rusticated, polished yellow Siena marble and low-level lighting produce a glistening effect. The elliptical arched ceiling in the entrance foyer is covered with a mosaic by William de Leftwich Dodge, and bears symbols appropriate to a hall of records and the signs of the zodiac. The vault spandrels depict earlier instances of record keeping. The fine, white marble groups by Albert Weinert are allegories of the *Consolidation of Greater New York* on the east, and on the west, *Recording of the Purchase of Manhattan Island*.

The original building was designed to include the Surrogate's Court; the building's name was changed in 1963. In addition to the offices and courtrooms of the surrogate judges of Manhattan, the building is occupied by the New York County Clerk, the City Register, the Office of the Public Administrator, the City Sheriff, and the New York City Department of Records and Information Services.

1261 MADISON AVENUE

1261 MADISON AVENUE

1900–1901

MANHATTAN

ARCHITECTS: BUCHMAN & FOX

DESIGNATED: JULY 23, 1974

This handsome Beaux-Arts apartment house was commissioned by real estate developer Gilbert Brown at a time when wealthy New Yorkers were moving into the neighborhood soon to be known as Carnegie Hill, after Andrew Carnegie's 91st Street mansion. Erected on a site near the crest of the hill, 1261 Madison was intended to house only fourteen families.

The generously proportioned building has a two-story rusticated base and a three-story midsection. A heavy cornice serves as a balcony for the sixth floor, above which is a tiled mansard roof. The ends of the Madison Avenue facade are emphasized by slightly projecting bays flanked by pilasters and topped by arched pediments. At the center is a grand entrance portico with rusticated pilasters supporting a broken pediment beneath a cartouche inset with a marble medallion. The richly detailed exterior,

coupled with the sense of spacious interiors imparted by the large windows and generous floor-to-floor heights, reveals the opulent expectations of the first generation of New York luxury apartment building dwellers.

BRYANT PARK STUDIOS

1900–1901

80 WEST 40TH STREET (ALSO KNOWN AS 1054–1056 AVENUE OF THE AMERICAS), MANHATTAN

ARCHITECT: CHARLES A. RICH

DESIGNATED: DECEMBER 13, 1988

As New York's art community grew during the second half of the nineteenth century, more space was required for studios and for meeting and exhibition rooms. Bryant Park Studios is one of the earliest buildings designed specifically to meet some of these needs, with generous windows facing the northern light preferred by artists and large work areas. Fernand Léger and Edward Steichen worked here, as did numerous other well-known artists. The studios were commissioned by the prominent American portraitist Abraham Archibald Anderson, who had experienced a lonely and difficult life in Paris as a young art student and was anxious to help others once he himself was established. Anderson occupied a penthouse apartment in the building until his death in 1940.

Executed in pink brick with terra-cotta and stone details, the facade displays a tripartite organization.

BRYANT PARK STUDIOS

A banded brick and terra-cotta transitional story above a two-story base, grooved to simulate rusticated stone, leads to the main section, which displays a variety of window treatments and ornament—including some double-height windows grouped vertically in stone enframements for dramatic emphasis.

By locating the building just south of Bryant Park, Anderson felt assured that the desirable northern light would not be blocked by future tall buildings. Although the building is now surrounded by towering skyscrapers, it is still used as studio space; tenants today include several clothing and interior design firms.

WILLIAM AND CLARA BAUMGARTEN HOUSE

WILLIAM AND CLARA BAUMGARTEN HOUSE

1900–1901

294 RIVERSIDE DRIVE, MANHATTAN

ARCHITECTS: SCHICKEL & DITMARS

DESIGNATED: FEBRUARY 19, 1991

This elegant Beaux-Arts-style house harks back to the time when the Upper West Side was the site of intense real estate development. Unlike most of its neighbors, the house was not built on speculation but was commissioned by its owner, William Baumgarten, a successful German immigrant. The son of a master cabinetmaker, Baumgarten had arrived in America in 1865 and entered the field of furnishings and design. From 1881 to 1891, he headed the

prestigious interior design firm Herter Brothers, which is credited with the interiors of houses belonging to J. Pierpont Morgan, William Vanderbilt, and other wealthy clients. By the time he commissioned this residence for himself, Baumgarten had established his own decorating company and had worked with architect William Schickel, another German immigrant, on designs for numerous other New York City private residences.

The Baumgarten home, with its classical details—including an entrance portico supported by Ionic columns— exemplifies the popularity of the Beaux-Arts style at the time, and the building's symmetrical design, slate mansard roof, limestone facade, carved ornament, and decorative ironwork express the affluence and taste of the client.

BROWN BUILDING, ORIGINALLY ASCH BUILDING

1900–1901

23–29 WASHINGTON PLACE (ALSO KNOWN AS 245 GREENE STREET), MANHATTAN

ARCHITECT: JOHN WOOLLEY

DESIGNATED: MARCH 25, 2003

The Asch Building was the site of one of the worst industrial disasters in American history, when 146 sweatshop workers, mostly young women, died in a fire at the Triangle Shirtwaist Factory. At the turn of the century, when the garment industry was the largest employer in New York City, the

BROWN BUILDING

conditions under which garments were being produced steadily worsened. Laborers, usually young immigrant women, were protected by some turn-of-the-century reforms that significantly restricted home production and required a minimum of 250 cubic feet of air for each worker. Employers soon favored loft buildings for their high ceilings, which made it possible to meet the requirement for breathing space, but actually provided less floor space for each employee.

Joseph J. Asch hired John Woolley to construct the ten-story loft building, and the Triangle Waist Company rented the top three floors for its production of shirtwaists, a popular high-necked blouse. Triangle Factory's working conditions were hazardous, and when

workers tried to unionize, Triangle owners Max Blanck and Isaac Harris laid off 150 union sympathizers, spurring the Shirtwaist-makers Strike of 1909. It was the first major attempt at mobilization by garment workers. The thirteen-week, three-city strike ended in improved conditions and pay for garment workers in New York City, Philadelphia, and Baltimore, but while Triangle raised wages, they did so without improving factory conditions and refused to recognize the union.

On March 25, 1911, when a fire broke out on the eighth floor and spread to upper floors, locked doors, inadequate fire escapes, and deficient firefighting equipment trapped the workers, many of whom leapt to their death. When the fire trucks arrived, firefighters found that the ladders could not reach past the sixth floor. Out of this tragedy grew a strong movement for labor reforms and worker protection, as well as an update of the fire codes. The laws adopted by New York City and State were the most advanced and comprehensive in the country; other state and the federal labor legislation followed throughout the United States.

The neo-Renaissance facade remained mostly unharmed by the fire and the building was restored to manufacturing use. In 1916, New York University leased the eighth floor; subsequently the entire building was donated to the school. The Brown Building, as it is now known, houses the university's biology and chemistry department.

BROAD EXCHANGE BUILDING

BROAD EXCHANGE BUILDING

1900–1902; 1995

25 BROAD STREET (ALSO KNOWN AS 25–33 BROAD STREET AND 44–60 EXCHANGE PLACE), MANHATTAN

ARCHITECT: CLINTON & RUSSELL

DESIGNATED: JUNE 27, 2000

When completed, the Broad Exchange Building was the city's largest office building, and had the highest estimated real estate value in Manhattan. The Alliance Realty Company invested in the building as a speculative venture, part of a commercial building boom in lower Manhattan. Paine, Webber & Company had their headquarters in the building for approximately seventy years, and many other bankers and brokers rented offices in the building due to its desirable location near the New York Stock Exchange (p. 352).

The twenty-story structure employed all of the technologies introduced by pioneering skyscraper engineers in the 1890s, including a steel frame, elevator, and caisson construction. The facade is divided into a three-story rusticated granite base, fourteen-stories of buff-colored-brick, and a three-story granite capital, a common tripartite treatment for the turn-of-the-century skyscrapers. The Italian Renaissance–inspired skyscraper is accented with decorative terra-cotta and surmounted by a copper cornice.

The stock market downturn of 1987 blocked plans for rehabilitating the building, and the owners closed it in 1988. Crescent Heights LLC purchased it in 1995, as a part of the Downtown Revitalization Plan, and converted the building to residential use.

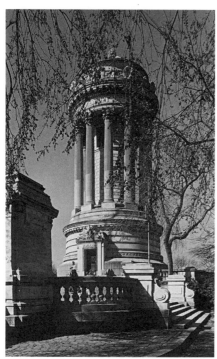

SOLDIERS AND SAILORS MONUMENT

SOLDIERS AND SAILORS MONUMENT

1900–1902; 1961–63

RIVERSIDE PARK AT WEST 89TH STREET, MANHATTAN

ARCHITECTS: STOUGHTON & STOUGHTON, WITH PAUL EMILE MARIE DUBOY

DESIGNATED: SEPTEMBER 14, 1976

The Soldiers and Sailors Monument in Riverside Park pays tribute to the New York regiments that fought in the Civil War. The architects Stoughton & Stoughton won the competition for the design, which was judged by professors William R. Ware and A.D.F. Hamlin of Columbia University and architecture critic Russell Sturgis. The monument was

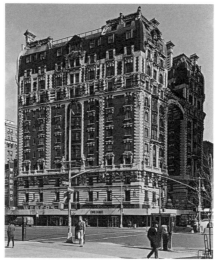

THE DORILTON

originally intended for the site at 59th Street and Fifth Avenue, but this plan was rejected by the Municipal Art Society.

To adapt their design to the new site, the architects invited Paul Emile Marie Duboy to collaborate with them. The cornerstone was laid on December 15, 1900, with Governor Theodore Roosevelt officiating. The unveiling on Memorial Day 1902 was followed by a parade of Civil War veterans.

The simple, white marble structure is based on the Choragic Monument of Lysicrates in Athens. One hundred feet high, it rests on a granite platform above a series of balustraded terraces. Twelve Corinthian columns, thirty-six feet high, form a colonnade that rises from a rusticated marble base adorned with laurel and oak leaves. Above the colonnade is a full entablature with a frieze containing the inscription "To the Memory of the Brave Soldiers and Sailors who Saved the Union." A low conical roof decorated by an elaborate marble finial tops the

building. The single entrance has a marble enframement crowned by a cornice supporting an eagle. Between 1961 and 1963, the monument was extensively rehabilitated.

THE DORILTON

1900–1902

171 WEST 71ST STREET, MANHATTAN

ARCHITECTS: JANES & LEO

DESIGNATED: OCTOBER 8, 1974

Located diagonally across Broadway from the Ansonia Hotel (p. 337), this French Second Empire–style apartment house was equally popular among local artists and musicians. Like the Ansonia, it has large, soundproof rooms; it displays an exceptionally decorative exterior.

The base, topped by a balustrade, consists of two stories of rusticated limestone. The large main portion is accentuated by limestone quoins and alternating limestone brick bands; it also contains an impressive five-story bay window flanked by female figures at its base. This central shape is echoed on the 71st Street facade by the immense triple gateway, complete with high iron gates, leading to a deep entrance courtyard. The side portions of the gateway once served as a U-shaped carriage access drive, while the lower central portion was reserved for pedestrians. Deep voussoirs and an elaborate keystone compose the arch, nine stories over the gateway. The entire structure is capped by a two-and-one-half-story convex mansard roof with copper cresting.

Capital Cities/ABC, Inc. Studios, formerly the First Battery Armory

1900–1903; 1980s

56 West 66th Street, Manhattan

Architects: Horgan & Slattery

Designated: August 1, 1989

This looming, castle-like structure was designed by the firm of Horgan & Slattery, which achieved great commercial success through its close relationship with the administration of Mayor Cornelius Van Wyck. Following its refurbishing of the Democratic Club interior in 1897, the firm—commonly referred to as the Tammany architects—was awarded almost every contract for the Board of Health, the Department of Corrections, the Charities Department, and the Tax Department, ranging from landscaping and interior renovations to barge construction and machinery overhauling on city-owned boats.

Most of Horgan & Slattery's designs conformed to accepted principles of classical composition, planning, and vocabularies. Not surprisingly, their handling of the First Battery Armory adhered to the general architectural consensus that the medieval castle was the appropriate model for an armory, symbolizing military power and control in an urban environment. Indeed, the First Battery Armory was the seventh of ten armories built by the New York Armory Board as part of a general campaign—initiated with the State Armory Law of 1884—conducted in response to growing concern about urban riots.

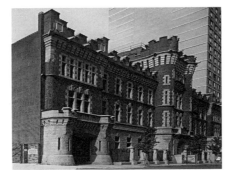

CAPITAL CITIES/ABC, INC. STUDIOS

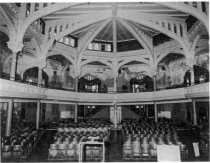

GOUVERNEUR MORRIS HIGH SCHOOL INTERIOR

Gouverneur Morris High School Interior

1900–1904; 1991

East 166th Street and Boston Road, The Bronx

Architect: C.B.J. Snyder

Designated: December 21, 1982

Gouverneur Morris High School, designed by C.B.J. Snyder in the Collegiate Gothic style, contains one of New York's most elaborate interiors designed for an educational facility. The Bronx's first major public secondary school, it occupies the area originally known as Morrisania, after the Morris family that included Lewis Morris, signer of the Declaration of Independence, and Gouverneur Morris, ambassador to France. In 1900, when construction began on the school building, it was called the Peter Cooper High School, but residents argued that the deeds of Gouverneur Morris were indelibly stamped on the minds of Morrisanians; in 1903, the name was officially changed to Morris High School.

The ornament of the Morris High School auditorium is consistent with Snyder's Gothic facade. The high-vaulted space is dominated by two-story Art Nouveau stained glass windows that light the vast space. The interior surfaces are covered in elaborate Gothic plaster elements, including column capitals, foliate forms, and human masks. The monumental historical mural by Auguste F. M. Gorguet, entitled *After Conflict Comes Peace*, which hangs over the stage, was completed in 1926. Together the windows, mural, organ, and architectural detail evoke the unity of the arts.

In 1956, the auditorium was renamed Duncan Hall in honor of Edith Duncan, who served as a teacher and principal of the school. Well-known Morris alumni include Dr. Herman Joseph Muller, who won the Nobel Prize for the discovery of the production of mutations by means of X-ray irradiation in 1946, the cellist Wallinger Riegger, and the playwright Clifford Odets. The School Construction Authority restored the auditorium in 1991.

IRT Broadway Line Viaduct, formerly Manhattan Valley Viaduct

1900–1904

West 122nd Street to West 135th Street, Manhattan

Engineer: William Barclay Parsons

Designated: November 24, 1981

The Broadway Line Viaduct represents an elegant solution to the challenges that Manhattan's uneven topography presented to the construction of the city's transit system. While most of the Interborough Rapid Transit (IRT) was built by the "cut-and-cover" method—entailing an open excavation, installation of the subway corridor, and replacement of surface ducts and fill—the topography of some locations made other construction techniques more practical. Routes, like that beneath Central Park between 104th Street and 110th Street at Lenox Avenue, required tunneling.

The sloping Manhattan Valley, on the other hand, necessitated an elevated structure. William Barclay Parsons, Columbia University–trained and the Rapid Transit Commission's chief engineer in 1894, designed this viaduct, which was incorporated into the IRT system during its construction.

The structure not only carries the subway lines over 125th Street, but also supports the steel- and wood-sheathed station centered above its arch. The granite-faced brick foundations extend thirty feet below street level and support the steel towers, flanked by plate girders,

IRT BROADWAY LINE VIADUCT

INTERNATIONAL COMMERCIAL BANK OF CHINA

that carry the tracks as the ground rises toward 125th Street. Standard viaduct construction would have entailed costly realignment of the angled intersection of Broadway and 125th Street, but Parsons's design used a double-hinged parabolic braced arch for the viaduct's center portion.

Decorative elements, including iron lampposts and scrolled railings, preserve the station's turn-of-the-century spirit. New escalators (the originals having been replaced) extend beyond the station, which is used by more than 6,600 passengers daily on both sides of the

viaduct. The imposing masonry and elegant curves of the Broadway Line Viaduct and West 125th Street Station demonstrate the skill and ingenuity of the engineers who designed New York's first subway system.

International Commercial Bank of China, formerly New York Chamber of Commerce and Industry Building

1901; 1990–91

65 Liberty Street, Manhattan

Architect: James B. Baker

Designated: January 18, 1966

The New York Chamber of Commerce and Industry, founded in 1768, never had its own building until the architect James B. Baker was commissioned to design this massive marble Beaux-Arts structure, on the former site of the Real Estate Exchange. The building housed both the Chamber's meeting room and its remarkable picture collection, which includes portraits of business leaders such as John Jacob Astor and a famous painting of the Atlantic cable crossing.

The front of the building is marked by a row of Ionic columns set on heavy masonry, surmounted by a handsome copper mansard roof with dormer windows. Originally, the columns framed three sculpture groups by Daniel Chester French—one of which depicted DeWitt Clinton standing next to a crouched worker, representing his support of the Erie Canal. Erosion and pollution damaged the figures and they were removed.

At the center of the facade, an arched entrance flanked by two arched windows permitted entry to a bank on the ground floor; a side entrance gave chamber members access to a large vestibule, where elevators and a monumental stairway led up to the main meeting room.

The chamber has moved to new headquarters on Madison Avenue. The current owners, the International Commercial Bank of China, restored the building in 1990–91.

REPUBLIC NATIONAL BANK, FORMERLY THE KNOX BUILDING

1901–2; ALTERATIONS, 1964–65

452 FIFTH AVENUE, MANHATTAN

ARCHITECT: JOHN H. DUNCAN; KAHN & JACOBS

DESIGNATED: SEPTEMBER 23, 1980

The Knox Building is one of the finest Beaux-Arts-style commercial buildings in the city. Built as the headquarters of the Knox Hat Company, the structure occupies an especially prominent midtown Manhattan location on Fifth Avenue at 40th Street, opposite the New York Public Library.

The ten-story facade is distinguished by full-height limestone rustication, large-scale ornament, and a two-story mansard roof—features carried over from Duncan's residential designs and skillfully applied to a large commercial building. Originally, the hat store was located on the first floor.

In 1964–65, the Knox Building was converted for use as the headquarters of the Republic National Bank. The architectural firm of Kahn & Jacobs altered the retail space into banking facilities. The overall effect is sensitive and compatible with the original character of the building.

KINGSBRIDGE HEIGHTS COMMUNITY CENTER, FORMERLY THE 40TH POLICE PRECINCT STATION HOUSE

1901–2; 1981; 1999

3101 KINGSBRIDGE TERRACE, THE BRONX

ARCHITECTS: HORGAN & SLATTERY

DESIGNATED: JULY 15, 1986

One of Horgan & Slattery's best surviving works, this station house was headquarters first of the 40th Precinct and subsequently of the 50th Precinct. The building successfully integrates brick, terra-cotta ornament, tin, and stone. The U-shaped building, derived in plan from the fifteenth-century Italian palazzo, suggests security and monumentality—ideas appropriate to a police station headquarters.

The police moved to another Kingsbridge building in 1974. In 1975, the Kingsbridge Heights Community Center was established here and soon initiated major renovations, which were completed in 1981. For safety reasons, the cornices were removed in early 1987. After raising funds, the center recast the cornices and reinstalled them in 1999.

REPUBLIC NATIONAL BANK

KINGSBRIDGE HEIGHTS COMMUNITY CENTER

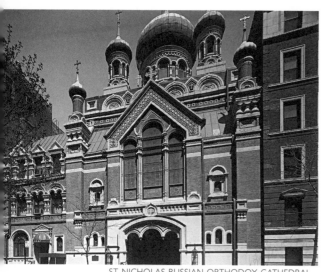
ST. NICHOLAS RUSSIAN ORTHODOX CATHEDRAL

ST. NICHOLAS RUSSIAN ORTHODOX CATHEDRAL

1901–2

15 EAST 97TH STREET, MANHATTAN

ARCHITECT: JOHN BERGESEN

DESIGNATED: DECEMBER 18, 1973

St. Nicholas Russian Orthodox Cathedral was built from the designs of John Bergesen, a New York City architect of Russian origin. Modeled after Muscovite Baroque architecture, the church was erected by the St. Nicholas congregation, which had formed in 1894. Unable to finance the building, the congregation was aided by the Synod of Russia, which was given Imperial permission to collect funds throughout the Russian Empire.

The cathedral and attached rectory present an impressive facade on East 97th Street. The broad front entrance to the sanctuary is contained within a central two-story gabled bay. Pendants with cherubs are set into the spandrels of the wide, segmental-arched entranceway. Above this, three tall, round-arched windows fill the gable. A terra-cotta frieze embellished by Greek crosses within linked circles ornaments the entablature. Wide brick pilasters, each surmounted by a small turret topped with an onion dome, flank this facade, which is trimmed by a blue and gold diamond-patterned band at the eaves. A flat platform, embellished by colorful panels, is set back from the sloping front roof. A dominant central onion dome, with ogee arches at the base and round-arched windows above, rises from the platform, surrounded by four smaller cupolas at the corners.

COLLECTORS CLUB, FORMERLY THE THOMAS B. CLARKE HOUSE

1901–2; 1980s

22 EAST 35TH STREET, MANHATTAN

ARCHITECTS: MCKIM, MEAD & WHITE

DESIGNATED: SEPTEMBER 11, 1979

Located in the fashionable Murray Hill section, the Clarke House is an especially notable example of Georgian Revival architecture, looking both to English and American precedents.

Thomas Benedict Clarke was a prominent New York City art collector, dealer, and decorator. His collection of American art was among the finest in the world in private hands. For a residence that would be a suitable showcase for his varied collections, Clarke turned to the McKim, Mead & White; the design of the house has long been

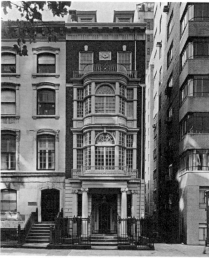
COLLECTORS CLUB

attributed to Stanford White, a friend of Clarke's. In designing the new residence, White altered an existing brownstone row house, adding an entirely new facade, extending the rear, and building an additional story.

The five-story building is faced with red and gray brick laid up in Flemish bond, with contrasting stone and metal detail. The rusticated ground floor is dominated by a classically inspired entrance portico, above which is a graceful two-story projecting bay window—the dominant feature of the facade. In 1937, the house was purchased by the Collectors Club, an organization founded in 1896 and devoted to philately. Its library contains one of the world's largest and most comprehensive collections of philatelic literature. In the 1980s, the organization undertook major repair and restoration of the facade and interior.

John and Mary Sutphen House

1901–2

311 West 72nd Street, Manhattan

Architect: C.P.H. Gilbert

Designated: January 8, 1991

This is one of four remaining grand town houses designed for a notable site—the intersection of Riverside Drive and 72nd Street (pp. 314, 332, 333). Ionic columns at the entrance portico support a lavishly ornamental entablature decorated with egg-and-dart molding, volutes, and foliate carving. Curved bays grace the limestone front and side facades; the roof is an elaborately dormered mansard. Gilbert was known for lavish detail and generous interior spaces in his opulent residences.

Sutphen's father, John S. Sutphen Sr., owned all the property along Riverside Drive between West 72nd and West 73rd Streets and established the restrictive covenants under which this neighborhood was developed. These codes stipulated the type of building that could be constructed—including the materials to be used—and prohibited the construction of slaughterhouses, nail factories, breweries, stables, or any other business "which may be in anywise dangerous, noxious, or offensive to the neighboring inhabitants." Through these restrictions, Sutphen and other developers sought to ensure the future value and character of the neighborhood. An additional stipulation required the selection of Gilbert as the architect for three of the four town houses at this corner.

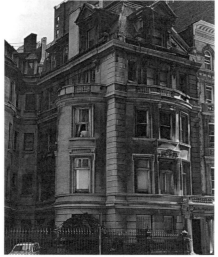

JOHN AND MARY SUTPHEN HOUSE

Wadleigh School, formerly the Wadleigh High School for Girls

1901–2; restoration and addition, 1989–93

215 West 114th Street (also known as 203–249 West 114th Street and 226–250 West 115th Street), Manhattan

Architect: C.B.J. Snyder

Designated: July 26, 1994

School construction was brisk at the turn of the century, due to mandatory children's education and increasing immigration. The Wadleigh School, designed by C.B.J. Snyder, the prominent superintendent of school buildings, was the first public girls' school in New York City. In 1953–54, it was converted into a coeducational junior high school and reopened in 1956 as I.S. 88. The school was named for women's education pioneer Lydia Wadleigh, who founded

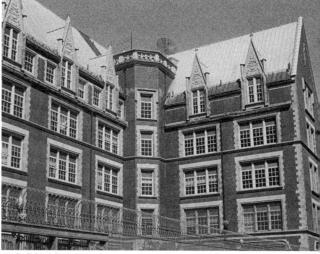

WADLEIGH SCHOOL

the 12th Street Advanced School for Girls (p. 160) in 1856 and achieved the position of Lady Superintendent at the New York Normal College (now Hunter College).

The school is set on an H-plan and is framed in steel, allowing for large banks of windows, which give good light and ventilation. On a relatively small plot of land, the five-story school has classrooms, laboratories, offices, gymnasiums, and study halls, all accessible by some of the earliest electric elevators in a New York City public school. Inspired by the Collegiate Gothic style, the red-brick and sandstone school has gabled dormers and is ornamented with decorative terra-cotta shields. A 125-foot corner tower with a pyramidal roof gives the building a commanding presence despite its midblock location. Between 1989 and 1993, the school was renovated, restored, and enlarged with a two-story gymnasium annex.

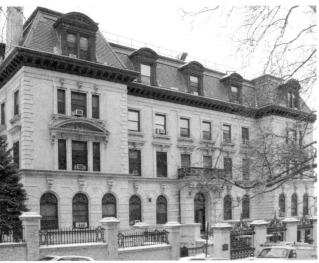

HIGHBRIDGE-WOODYCREST CENTER

HIGHBRIDGE-WOODYCREST CENTER, FORMERLY AMERICAN FEMALE GUARDIAN SOCIETY AND HOME FOR THE FRIENDLESS

1901–2; 1991

936 WOODYCREST AVENUE, THE BRONX

ARCHITECT: WILLIAM B. TUTHILL

DESIGNATED: MARCH 28, 2000

This skillfully designed turn-of-the-century building disguises its institutional use with a richly decorated facade and massing typical of a large mansion. The American Female Guardian Society, founded in 1834 to assist impoverished women, and later children, operated the Home for the Friendless in Manhattan. By the end of the nineteenth-century, pressured by rising real estate values and the need for more adequate facilities, the enterprise was moved to the Bronx, which was newly accessible via Macomb's Dam Bridge (p. 271).

William B. Tuthill designed this building on a pavilion plan, popular for hospitals at the time. The complex plan, terracing, and fashionable Beaux-Arts decorations disguised the building's size. The facade is a mix of gray brick, stone, and terra-cotta, highlighted by boldly massed classical details, including a rusticated base and quoins. It features an arched entrance, elaborate aedicular window surrounds, molded cornices, garland brackets, and a mansard roof pierced by dormers and chimneys.

The Society and Home occupied the building until 1974. In 1989–91, the interiors were restructured to create private apartments for one hundred residents. The Highbridge-Woodycrest Center, a health care facility for families and individuals with AIDS, opened in 1991 and continues to operate in the building.

JAMES F.D. LANIER HOUSE

1901–3

123 EAST 35TH STREET, MANHATTAN

ARCHITECTS: HOPPIN & KOEN

DESIGNATED: SEPTEMBER 11, 1979

At the turn of the century, the rows of brownstone houses in the Murray Hill district attracted wealthy and socially prominent New Yorkers such as James F.D. Lanier, A.T. Stewart, and J. Pierpont Morgan. Lanier, a sportsman, pioneer automobile driver, and banker with one of the oldest private banking houses in the country, commissioned this particularly handsome Beaux-Arts structure.

JAMES F.D. LANIER HOUSE

Built on the site where two houses previously stood, the five-story building is a generous thirty-three feet wide. Its rusticated stone base creates an imposing ground floor with three arched openings—two window bays and an entrance—constructed from swagged and bracketed voussoirs. Carved paneled doors set beneath a bull's-eye window ornament the entranceway. Other decorative details include paneled newel posts topped by stone urns, which intersect both a stone balustrade and an elegant wrought-iron fence.

Colossal pilasters with Ionic capitals mark the three bays on the second and third floors. The openings on the second story have shallow cornices and French doors; those on the third, projecting sills and central keystones. On the fourth floor, the windows are screened by a lacy wrought-iron balustrade that echoes the stone balustrade on the second floor. The structure is balanced by a copper-covered mansard roof with pedimented dormers.

YESHIVA CHOFETZ CHAIM SCHOOL, FORMERLY THE ISAAC L. RICE MANSION

1901–3; ADDITIONS AND ALTER-
ATIONS, 1908; 1954

346 WEST 89TH STREET, MANHATTAN

ARCHITECTS: HERTS & TALLANT;
ADDITIONS, C.P.H. GILBERT

DESIGNATED: FEBRUARY 19, 1980

YESHIVA CHOFETZ CHAIM SCHOOL

The Isaac L. Rice Mansion and the Morris Schinasi House (p. 413) are the last freestanding mansions that survive on Riverside Drive. While the Rice mansion features elements of Georgian Revival and Beaux-Arts design, the design displays the highly individualistic touch that Herts & Tallant brought to residential architecture.

Four stories high and faced with red brick laid up in Flemish bond with contrasting marble detail, the house is crowned by a hipped roof with broad eaves. Perhaps the most handsome features of the West 89th Street facade are a curved projection, two stories high, and a porte cochere, which was very unusual for Manhattan residences. The Riverside Drive facade is dominated by a series of broad entrance steps; a grand entrance at the second-floor level, encompassed by a bold arch that rises to the full height of the third story, gives vertical emphasis to the facade.

In 1907, Rice sold the house to tobacco importer Solomon Schinasi, brother of Morris Schinasi, who commissioned C. P. H. Gilbert to make several compatible additions to the structure. Because the house was long occupied by the Schinasi family, it survived while others on the drive were lost. Since 1954, it has housed the Yeshiva Chofetz Chaim School.

HOTEL BELLECLAIRE

1901–3

2171–2179 BROADWAY, MANHATTAN

ARCHITECTS: STEIN, COHEN & ROTH

DESIGNATED: FEBRUARY 10, 1987

The Hotel Belleclaire was built by architect Emery Roth of Stein, Cohen & Roth. Still a relatively unknown architect at this time, Roth would play an important role in shaping the Manhattan skyline. During his career of more than forty years, he completed more than two hundred projects. The Belleclaire was one of a new breed of apartment hotels providing dwellings for both permanent and transient residents in single- or multiple-room units. These fashionable apartments were built without kitchen facilities or servants' quarters: all staff and services were provided by the hotel.

The owner, Albert Saxe, awarded Roth the Belleclaire commission after their

HOTEL BELLECLAIRE

successful collaboration on the Saxony Apartments at 250 West 82nd Street. The Belleclaire is ten stories high and executed in red brick with limestone, terra-cotta, and metal detailing. It is composed of three symmetrically massed pavilions with an entrance court on West 77th Street and two deeply recessed light courts on the south facade; the eastern pavilion conforms to the angle of Broadway.

In designing the Belleclaire, Roth combined Beaux-Arts principles with his own Art Nouveau–Secessionist style, seen in the profuse surface ornamentation. The strong horizontal design is dramatically counterbalanced by the verticals of the tower and the monumental pilasters in the main and side elevations. On Broadway, the pilasters enframe bays containing tripartite metal oriel windows that rise from the third to sixth stories, and also from the eighth to tenth stories. At the seventh story, the pilasters enframe elliptically arched windows with curvilinear mullions. The stone pilasters are ornamented with pendants and stylized Indian heads.

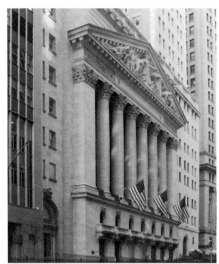

NEW YORK STOCK EXCHANGE

NEW YORK STOCK EXCHANGE

1901–3

8–18 BROAD STREET, MANHATTAN

ARCHITECT: GEORGE B. POST

DESIGNATED: JULY 9, 1985

Since the early eighteenth century, Wall Street has been the focus of financial activity in New York City. The New York Stock Exchange, constituted March 8, 1817, as the New York Stock & Exchange Board, has been in its present location at 8–18 Broad Street since the completion of this building in 1903. This Greek Revival temple symbolizes the strength and security of the nation's financial community, and the position of New York at its center.

Post's exchange building is the second to stand on Broad Street. The Civil War had triggered a burst in securities trading, and with the growth of industrialization, the New York Stock & Exchange Board decided in 1863 to move out of rented quarters (at the Merchants Exchange Building on Wall Street) and commission its own building. That building, designed by John Kellum, was a four-story, marble-faced Italianate structure sited at 10–12 Broad Street. By the turn of the century, even larger quarters were necessary for a rapidly expanding market. The adjacent land was bought, and construction began on the present Exchange Building in 1901.

The demands of the brokers and the site presented Post with a difficult challenge. The brokers wanted more space, greater convenience for business transactions, more light on the trading floor, and better ventilation. The site itself was irregular in both contour and incline, being located on a hill that rose to the north and northeast. Post anchored the structure on a two-story podium with a granite water table to overcome the incline, and set the activities of the exchange behind a massive facade of colossal Corinthian columns and pediment. He enhanced the interior lighting by designing the glass curtain wall that opens into the trading room just behind the bank of columns. A similar but simpler facade faces New Street, surmounted by a cornice rather than a pediment.

The sculpture in the Broad Street pediment was designed by John Quincy Adams Ward and executed by Paul Wayland Bartlett. The eleven figures represent American commerce and industry; at the center stands Integrity with arms outstretched, protecting the works of men. On her left are Agriculture and Mining, on her right Science, Industry, and Invention—the products of the earth versus the means of invention.

Post's design continues to impart a sense of austerity, power, and security, and the building remains a potent symbol of one of this country's most important financial institutions.

ST. REGIS HOTEL

1901–4; 1927; 1987–91

699–703 FIFTH AVENUE, MANHATTAN

ARCHITECTS: TROWBRIDGE & LIVINGSTON; 1927 EXTENSION, SLOAN & ROBERTSON

DESIGNATED: NOVEMBER 1, 1988

The most ambitious of John Jacob Astor's New York hotels, the St. Regis was constructed in the heart of what was then the most fashionable residential neighborhood in New York. The eighteen-story hotel was to be a home away from home for wealthy visitors, good enough to house the overflow of Astor's own guests. Named for the French monk who had been canonized for his hospitality to travelers, the St. Regis offered elegance and service that matched the grand European hotels Astor had visited and surpassed them in modern conveniences and technological inventions.

Distinctively Beaux-Arts and reminiscent of the French apartment buildings of the period, the elegant limestone facade follows the model of a classical column, with the shaft of the building rising from a rusticated base and ending in a richly decorated capital.

Equally lavish interiors offered forty-seven Steinway pianos for the use of the guests; the library, with its English oak paneling and three thousand leather-bound, gold-embossed volumes, was attended by a librarian who assisted guests with their selections. Even the engine and boiler rooms, sixty feet below Fifth Avenue, were lined in marble.

The first major renovation occurred in 1927, when the hotel was sold by Vincent Astor, John Jacob's son, to Duke Management. An extensive addition increased the number of guest rooms to 520, and two floors were added, including the famous St. Regis roof. The hotel was sold again in 1959 and subsequently changed hands several times until 1966, when it was purchased by the Sheraton Corporation. The most recent renovation of the St. Regis (1987–91) included an upgrade of the operating systems, enabling the management to accommodate new demands for plumbing, electricity, and air circulation and integration of new technologies. In 2005, a limited number of Hotel Condominium Suites were offered for sale.

HIGH PUMPING STATION

1901–6

JEROME AVENUE, SOUTH OF THE MOSHOLU PARKWAY, THE BRONX

ARCHITECT: GEORGE W. BIRDSALL

DESIGNATED: JULY 28, 1981

The High Pumping Station was built to pump water from the Jerome Reservoir to consumers throughout the Bronx. Constructed by George W. Birdsall, engineer for the Department of Water Supply, Gas and Electricity, the building is a major example of the contemporary belief that utilitarian structures were worthy of careful and sophisticated design treatment. The station also exhibits the technology that allowed water to be pumped to multistory buildings and other areas with poor service structures.

The pumping station is a long and narrow red-brick building crowned by a steeply pitched roof. Its facade is divided into a series of bays, each consisting of two arched windows flanked by shallow brick buttresses. This arrangement relieves the dominant horizontality of the design and creates a sense of rhythm. Capping each window is a semicircular corbeled brick lintel that adds texture and variety to the wall surface. Austerity of form coupled with a sensitive handling of detail, a hallmark of the Romanesque Revival style, characterize the High Pumping Station.

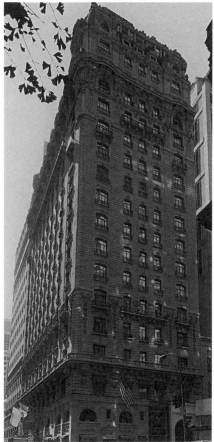

ST. REGIS HOTEL

HIGH PUMPING STATION

ASTOR PLACE STATION

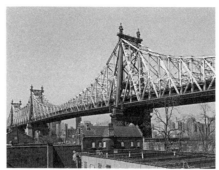

QUEENSBOROUGH BRIDGE

IRT Subway System Stations

1901–8

Manhattan

Architects: Heins & La Farge

Interiors designated:
October 23, 1979

Twelve of the original forty-five underground IRT subway stations are designated as interior landmarks, including portions of the stations at Borough Hall, Wall Street, Fulton Street, City Hall, Bleecker Street, Astor Place, 33rd Street, 59th Street–Columbus Circle, 72nd Street, 79th Street, 110th Street –Cathedral Parkway, and 116th Street –Columbia University. This status applies only to the walls. The system engineer, William B. Parsons, a graduate of Columbia University School of Mines, planned each station. He studied Boston's subway and European underground systems in London and Vienna and combined what he felt were the best features of each. He devised two types of stations: the local stop, with platforms on either side of the tracks; and the express stop, with the platform between two tracks. In the spring of

1901, the Rapid Transit Commission selected Heins & La Farge to design the subway kiosks and control houses as well as the platform interiors.

George L. Heins and Christopher Grant La Farge had studied together at MIT under the French architect Eugene Letang. The firm is best known for the winning submission for Cathedral Church of St. John the Divine (p. 286), which they designed in 1891. All of the subway interiors followed a similar pattern. A coved, glazed terra-cotta molding serves as the wall base. Above this is a wainscoting of buff-colored Roman brick or rose-colored marble. White glazed or glass tiles cover the walls, which are divided into panels, usually by deep blue tiles. The panels correspond to the station columns, spaced fifteen feet apart. The decorative treatment is used at the cornice level, where terra-cotta or faience plaques illustrate a local landmark or recall a historical event.

Many station interiors have lost their original splendor through insensitive modernization, poor maintenance, or vandalism. Fortunately, several stations have been restored, including 66th Street–Lincoln Center, 72nd Street, and 86th Street.

Queensborough Bridge

1901–8

East River from 11th Street and Bridge Plaza North and Bridge Plaza South Queens, to Second Avenue and East 59th and 60th Streets, Manhattan

Architect: Henry Hornbostel

Engineer: Gustav Lindenthal

Designated: April 16, 1974

The Queensborough Bridge was the first built between Manhattan and Queens and the second between Manhattan and Long Island, after the Brooklyn Bridge. Completed in 1908, the bridge contributed significantly to the growth of Queens, whose population tripled in the first two decades of this century.

While emblematic of New York's growth and development, the Queensborough Bridge also represents an engineering accomplishment. It is one of the largest cantilever bridges in the world with no suspended spans. Engineered by Gustav Lindenthal, the bridge was designed by Henry Hornbostel; he appears to have been influenced by Jean Resal's Pont Mirabeau in Paris, which was completed while Hornbostel was a student at the Ecole des Beaux-Arts in 1895.

Today, the bridge's heavy steel frame contrasts with the more graceful suspension bridges. The piers are composed of rough-faced masonry with smooth quoins; spiky pinnacles crown its steel towers. Four of the original entrance kiosks still stand at the Manhattan entrance; the fifth, formerly in Queens,

has been removed and now stands at the entrance to the Brooklyn Children's Museum.

NEW YORK PUBLIC LIBRARY, YORKVILLE BRANCH

1902

222 EAST 79TH STREET, MANHATTAN

ARCHITECT: JAMES BROWN LORD

DESIGNATED: JANUARY 24, 1967

One of the Carnegie branches, the Yorkville Public Library is an elegant adaptation of the Palladian style, characterized by symmetrical ordering and a restrained use of ornament. The three-story structure has a limestone facade divided into three bays. Ionic columns separate the windows, each containing another small oblong window framed with decorative garlands and resting above a triangular pediment. The round-arched opening of the first floor, crowned by lion's-head keystones, are set in rusticated stonework surmounted by a cornice. The low, second-floor balustrade is echoed by a simple baluster along the edge of the roof.

THE ALGONQUIN HOTEL

1902

59–61 WEST 44TH STREET, MANHATTAN

ARCHITECTS: GOLDWIN STARRETT

DESIGNATED: SEPTEMBER 15, 1987

While the design of the Algonquin is representative of architectural tastes at the turn of the century, it is the building's social history that distinguishes it from its contemporaries. Since its opening in 1902, the Algonquin has been associated with New York's literary and theatrical worlds. Under the proprietorship of Frank Case, the hotel was host to such notables as Sinclair Lewis, Douglas Fairbanks, Orson Welles, Tallulah Bankhead, Noel Coward, and dozens of other artists. After World War I, as home to the Round Table—a daily luncheon gathering of some of the city's brightest wits—the Algonquin's fame became national.

The twelve-story building is five bays wide, with a lightly rusticated, two-story limestone base. Above it are eight stories of brick with terra-cotta trim below a projecting cornice. Two stories at the top work together to function as an attic. The ten top stories have three sash windows in the center flanked by a pair of projecting bays on each side, except for the twelfth story where the bays are replaced with simple sash windows. The building was originally capped by a metal cornice, which has been removed.

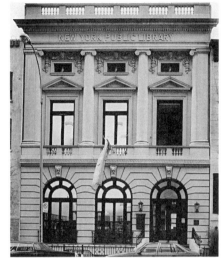

NYPL, YORKVILLE BRANCH LIBRARY

THE ALGONQUIN HOTEL

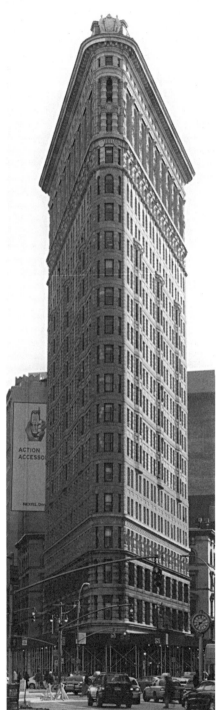

FLATIRON BUILDING

FLATIRON BUILDING

1902; 1991; 2002

BROADWAY AND FIFTH AVENUE AT
23RD STREET, MANHATTAN

ARCHITECTS: D. H. BURNHAM & CO.

DESIGNATED: SEPTEMBER 20, 1966

The Flatiron Building is one of New York's most distinguished and eccentric skyscrapers. Designed by D. H. Burnham & Co. of Chicago, it was originally known as the Fuller Building. Because of its triangular shape—determined by its site at the confluence of Broadway and Fifth Avenue—the building soon became widely known as the Flatiron. It was one of the earliest buildings in the city to be supported by a complete steel cage; the non-visibility of its advanced structural support system, coupled with its soaring 285-foot height, created much skepticism among New Yorkers, who feared that high winds would topple it. When the building was viewed from uptown, the impression of fragility was increased by the remarkable, six-foot-wide apex at the crossing of Broadway and Fifth.

The building has a wonderful sense of drama. Its lyrical, romantic, and often haunting quality has provided inspiration to such photographers as Edward Steichen and Alfred Stieglitz. In comparison with other decorative skyscrapers of the period, such as the ornate Singer Building by Ernest Flagg, the Flatiron's restrained and relatively uninterrupted wall treatment induces a sense of lightness and height. Its twenty-one stories are divided along classical columnar lines of base, shaft, and capital, creating a visual impression of strength. The base, more heavily rusticated than the shaft, gives the building a solid, well-anchored appearance. The more ornate treatment of the crowning four stories, accentuated by two-story rusticated pilasters and a heavy cornice, provides a satisfying visual stop to the upward sweep. The underlying steel frame made this kind of shoring up superfluous, but a combination of aesthetic and public prejudices made it necessary.

Despite initial public resistance, the Flatiron Building was an immediate success. Legend has it that the downdrafts generated by the tower and its location (supposedly the windiest corner in the city) created an even more agreeable spectacle—the billowing skirts of female passersby; the expression "twenty-three skiddoo" reputedly derived from the shouts of policemen posted at the corner to clear the gawkers. Whatever the attraction, the Flatiron Building became a symbol of the New York City skyline in its time. The light coloration of the building was once again revealed after a 1991 cleaning and restoration. To celebrate its centennial, the sculptural group on the roof was recreated.

George S. Bowdoin Stable

1902; 1944

149 East 38th Street, Manhattan

Architect: Ralph S. Townsend

Designated: June 17, 1997

Until the early twentieth century, horse-drawn vehicles were the primary mode of transportation in New York City, and horses were a vital part of city life. This structure was built in 1902, during the last phase of stable construction in the city, for William H. Martin, a real estate developer and senior partner in the clothing firm of Rogers, Peet & Company. The stable was purchased in 1907 by George S. Bowdoin, a partner in J. P. Morgan & Company, who lived at Park Avenue and East 36th Street.

The two-and-a-half-story Dutch Revival-style building alludes to New York City's history as the Dutch colony of New Amsterdam. Its configuration is typical of private stables of the era, with space for the carriage and horses on the ground floor and living quarters for the coachmen above. Bold ornamentation and a strong roofline distinguish this building from others around it. Each of the three arched entries is defined by overscaled stone quoins and voussoirs. Sculpted stone horse heads accentuate each end of the narrow spandrel above the entryways, and in the center is a shield inscribed with the address number "149." Between the two square windows on the second story is a large stone panel with a shield with the date "A.D. 1902."

An elaborate stepped gable rises from

GEORGE S. BOWDOIN STABLE

a mansard roof, with stone quoins marking each vertical edge of the gable, and a stone volute capping each step. A semicircular stone pediment tops the structure. In the center of the gable is an oval window with an ornate stone surround, above which sits a carved bulldog's head.

In 1918, Edith Bowdoin inherited the stable from her father and converted it into a garage. She owned it until 1944; since then various owners have reconfigured the upper floors to house one or two families. It is currently a single-family residence.

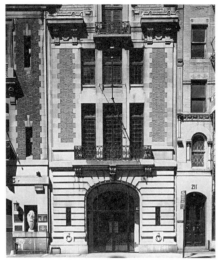

HELEN MILLER GOULD CARRIAGE HOUSE

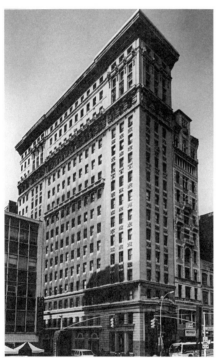

J.P. MORGAN CHASE & CO.

HELEN MILLER GOULD CARRIAGE HOUSE

1902–3

213 WEST 58TH STREET, MANHATTAN

ARCHITECTS: YORK & SAWYER

DESIGNATED: AUGUST 29, 1989

This elegant French Renaissance-influenced stable was built by the eldest daughter of transportation and communications tycoon Jay Gould. In contrast to her father's reputation as a "robber baron," Helen Miller Gould was widely known for her generosity and unflagging support of worthy causes. When she died in 1938, the *New York Times* called her "the best-loved woman in the country." At the time the stable was constructed, the stretch of 58th Street between Fifth Avenue and Broadway resembled a mews. Area residents stabled their horses here, while those who enjoyed driving through nearby Central Park appreciated the convenience of liveries. Miss Gould, who lived in the Fifth Avenue mansion bequeathed to her by her father, demolished an existing stable to make way for this carriage house.

Architect Phillip Sawyer had studied for a year at the Ecole des Beaux-Arts in Paris, and elements of this Parisian-style facade suggest the uniform, symmetrical elevations of the Place des Vosges. A suave, dignified effect is achieved by the building's subtle verticality, the attenuated hipped slate roof and tall flanking chimneys, and the limestone tethering rings at the arched entrance. Ornamentation, like the flat voussoirs of the

third-story windows and the triglyph brackets supporting the cornice, imbue this chiefly utilitarian building with an unmistakable air of luxury.

J.P. MORGAN CHASE & CO., FORMERLY CHASE MANHATTAN BANK, ORIGINALLY BANK OF THE METROPOLIS

1902–3

31 UNION SQUARE WEST (ALSO KNOWN AS 19–23 EAST 16TH STREET), MANHATTAN

ARCHITECT: BRUCE PRICE

DESIGNATED: JULY 12, 1988

To attract the support of leading publishers and jewelry and other merchants located around fashionable Union Square, the board of directors of the Bank of the Metropolis included such powerful neighborhood businessmen as Louis Comfort Tiffany and publisher Charles Scribner. Occupying a commanding corner location, the building superbly demonstrates Bruce Price's ability to use the requirements of function, the dictates of site, and a classical vocabulary to create a skyscraper that emanates authority. The neo-Renaissance limestone tower is enhanced by classical elements traditionally associated with American bank architecture—most notably, a bowed two-story portico with monumental polished-granite columns, lions' heads, consoles, and foliated spandrels.

The site demanded a long, thin building, and Price's vision related the skyscraper to a classical column. The tripar

tite scheme—a rusticated base, a nine-story midsection, and a capital topped by a prominent copper cornice—is a commanding visual, rather than functional, solution to organizing a tall structure. Price, an influential architect of skyscrapers, once remarked that "their aerial aspect [is] of more value to the city as a whole than the distorted partial values . . . we can obtain from the street." His neoclassical vocabulary fuses well here with the dictates of skyscraper construction to create a distinctly modern, urban building. Price also transformed the narrow facade into an imposing entrance with a two-story portico and classical ornament.

The bank was absorbed by the Bank of the Manhattan Company in 1918; the resulting entity merged with Chase in 1955 to become the Chase Manhattan Bank. Today the banking floor is a restaurant, and many of the upper floors are apartments.

NEW AMSTERDAM THEATER

1902–3; RESTORED 1996–97

214 WEST 42ND STREET, MANHATTAN

ARCHITECTS: HERTS & TALLANT; RESTORATION, HARDY HOLZMAN PFEIFFER ASSOCIATES

DESIGNATED (EXTERIOR AND INTERIOR): OCTOBER 23, 1979

The New Amsterdam Theater, built for the theatrical producers Klaw and Erlanger, was for many years the most prestigious theater in Times Square and home of the famous Ziegfeld Follies.

Designed by the theatrical architects Herts & Tallant, it is one of the rare examples of art nouveau architecture in New York City.

At the request of the owners, the building was intended to be more than a theater. It incorporates two theatrical spaces—the auditorium and the Aerial Theater above—and an office tower for the administrative needs of the producers. The theaters are located on West 41st Street, but Klaw and Erlanger wanted the entrance on 42nd Street, sharing a facade with the office tower above. To meet the dual requirements of theater and offices, the architects made use of the relatively new structural steel frame.

The main ten-story facade united architecture and sculpture with an appropriate sense of drama. The entrance, modified drastically in 1937, spanned three floors, and was the most lavish feature of the exterior. A segmented triumphal arch entranceway was flanked by rusticated piers that supported paired marble columns at the second floor. Sculpture by George Grey Barnard, who probably also designed the various figures at roof level, rested on the cornice. Virtually all but the triumphal arch was removed to make way for a movie marquee and vertical electric sign. The second- and third-story windows are framed by art nouveau bronze flower motifs.

The interior is among the most sumptuous surviving from the turn of the century. It expands on the restrained art nouveau sinuousness of the exterior entrance. It is distinguished by a synthesis of architecture, mural painting, sculpture, decorative panels, and

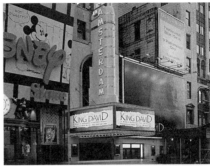

NEW AMSTERDAM THEATER

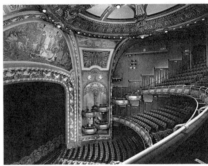

NEW AMSTERDAM THEATER INTERIOR

continuous plaster and carved oak moldings. The auditorium is elliptical in plan and section, a form pioneered in theaters by Herts & Tallant to enhance acoustical properties. The firm also introduced cantilevered balconies, which allowed an unobstructed view from all seats and contributed to the effect of a merging and flowing of space and architecture in keeping with art nouveau theories. The theater closed in 1985. In 1996–97, the Walt Disney Company with Hugh Hardy of Hardy Holzman Pfeiffer Associates undertook a major restoration of the magnificent interior.

LYCEUM THEATRE INTERIOR

LYCEUM THEATRE

1902–3

149–157 WEST 45TH STREET,
MANHATTAN

ARCHITECTS: HERTS & TALLANT

DESIGNATED: NOVEMBER 26, 1974;
INTERIOR DESIGNATED:
DECEMBER 8, 1987

The oldest playhouse in New York City still serving the legitimate stage, the Lyceum Theatre opened on November 2, 1903, under the management of Daniel Frohman. The Lyceum staged long-running productions rather than repertory; such performers as Ethel Barrymore, Leslie Howard, Judy Holiday, and Basil Rathbone starred here.

The facade is dominated by a row of tall, ornate columns rising above a soaring canopy that protects the entrances at street level. The columns terminate in composite capitals and support a massive entablature decorated with theatrical

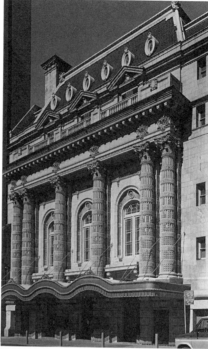

LYCEUM THEATRE

masks. A balustrade serves as a balcony for the three central pedimented windows of the penthouse. The sloping mansard roof with six oval dormer windows encloses a former rehearsal hall.

The interior continues the Beaux-Arts themes of the exterior. The lobby contains a vaulted, domed ceiling and murals on canvas by James Wall Finn portraying actors Sarah Siddons and David Garrick. The auditorium has an elaborate proscenium arch decorated with figures representing Athena, music, and drama. Decorative plasterwork in a variety of motifs covers the boxes, balconies, and ceiling.

The Lyceum's modest size, with seating for about 900, promoted a sense of intimacy that Frohman felt was best suited to the realism in drama that

HUDSON THEATER

was evolving at the time of the theater's construction.

HUDSON THEATER

1902–4; 1990

139–141 WEST 44TH STREET,
MANHATTAN

ARCHITECTS: J. B. MCELFATRICK &
SON AND ISRAELS & HARDER

DESIGNATED (EXTERIOR AND
INTERIOR): NOVEMBER 17, 1987

The Hudson Theater was built by Henry B. Harris, one of the top Broadway producers of the turn of the century. The design was begun by theater specialists J. B. McElfatrick & Son and completed by

the firm of Israels & Harder. The reason for the change is unknown, but it is clear that both firms were involved.

Four stories high and five bays wide, the dignified composition focuses on the slightly projecting pavilion created by the three central bays. Medusa-head capitals decorate the pilasters on this inner segment, and an elaborate cartouche adorns the balustrade at the top.

In contrast to the relatively simple exterior is the extraordinarily lavish interior. The ticket lobby has a grand coffered ceiling and elaborate plasterwork, and the inner lobby has a classical arcade and a ceiling embellished with domes of Tiffany glass. The ceiling of the auditorium has oval sections of plaster ornament, while floral reliefs and Corinthian columns enhance the walls.

The Hudson served as Harris's headquarters until his untimely death in the *SS Titanic* disaster of 1912. The building was restored in 1990 and is now part of the adjacent hotel.

OUR LADY OF LOURDES ROMAN CATHOLIC CHURCH

1902–4

467 WEST 142ND STREET, MANHATTAN

ARCHITECTS: O'REILLY BROTHERS

DESIGNATED: JULY 22, 1975

Washington Heights consisted mainly of open fields when Our Lady of Lourdes was built. The church, however, was not entirely new; instead of obtaining freshly quarried stone, Father Joseph H. McMahon, the founding pastor, purchased ("at a bargain") stones salvaged from three of New York City's most famous nineteenth-century buildings: the National Academy of Design, the old St. Patrick's Cathedral, and the A. T. Stewart mansion—all of which were being demolished to make room for new structures.

From the outset, the superstructure of the new church was regarded as a notable artistic endeavor. Imaginatively combining the salvaged stones, the firm of O'Reilly Brothers of Paterson, New Jersey, reproduced in modified form the Academy of Design, a Venetian Gothic-style building that dominated the corner of 23rd Street and Park Avenue South until its demolition in 1901. The rear of the church, built with stones from St. Patrick's, was adorned with brilliant late Gothic stained glass windows. The elaborately carved pedestals that flank the steps leading up to the entrance were taken from the Stewart mansion.

With its handsome and bluestone Gothic facade, Our Lady of Lourdes is a magnificent and regrettably rare example of urban rescue and reuse. The structure harmonizes well with the surrounding limestone houses, and the church continues today to serve its congregation.

HUDSON THEATER IINTERIOR

OUR LADY OF LOURDES ROMAN CATHOLIC CHURCH

361

CURTIS HIGH SCHOOL

CURTIS HIGH SCHOOL

1902–4; ADDITIONS, 1922, 1925, 1937

HAMILTON AVENUE AND ST. MARK'S PLACE, STATEN ISLAND

ARCHITECT: C.B.J. SNYDER

DESIGNATED: OCTOBER 12, 1982

Curtis High School was Staten Island's first public secondary school. The campus—a broad lawn dotted with trees and shrubs—provides the setting for C.B.J. Snyder's Collegiate Gothic-style buildings.

The original four-story building of brick and limestone is rectangular in plan, with a central tower and gabled end pavilions. Ornamentation is concentrated in the upper portions of the building; a crenellated parapet wall adorns the roofline of the main block. The centrally placed five-story English medieval–style tower contains the main entrance, which is formed by a compound Tudor arch.

A south wing with workshops and classrooms, completed in 1922, demonstrates an evolving Gothic sensibility in Snyder's school designs. The brick and limestone construction and the Gothic Revival ornament harmonize with the earlier building. The north auditorium wing, with its tall, closely set windows and abundant ornament, was completed in 1925. Later additions of 1937—the swimming pool to the rear of the main building and the new gymnasium wing—simplify and repeat the forms of the earlier buildings.

THE WHITEHALL BUILDING

1902–4, EXTENSION 1908–10; 2000

17 BATTERY PLACE (ALSO KNOWN AS 1–17 WEST STREET), MANHATTAN

ARCHITECT: HENRY J. HARDENBERGH; EXTENSION, CLINTON & RUSSELL

DESIGNATED: FEBRUARY 8, 2000

The Whitehall Building was named after Dutch governor Peter Stuyvesant's mid-seventeenth-century residence, White Hall, which had been sited nearby. A visually prominent structure by virtue of its location at the edge of Battery Park, the Whitehall was built as a speculative venture by Robert A. and William H. Chesebrough, the real estate developers responsible for popularizing the southern tip of Manhattan as an important office locale. The building was such a success that the Chesebrough brothers planned an addition, a 31-story building with a tower, overlooking the original

THE WHITEHALL BUILDING

structure. Built on a landfill and attaining an impressive height, Great Whitehall, as the addition was called, required innovative construction techniques, including a system of caissons and cofferdams below the waterline to support its foundation.

Hardenburgh, knowing that no other building could block the Battery Park facade, used bold red brick with matching mortar for the central panel of the facade, flanked by yellow and pink brick in a Renaissance motif. Greater Whitehall, while five times larger, is visually more subdued than its mate, using modest tan and yellow brick, embellished with elaborate arcades and crowned with a rounded pediment. In 2000, the top 19 floors were converted into luxury apartments, while the tower floors continue to be used as office space.

La Quinta Manhattan Hotel, formerly Aberdeen Hotel

1902–4; 2003

17 West 32nd Street (also known as 17–21 West 32nd Street), Manhattan

Architect: Harry B. Mulliken

Designated: January 30, 2001

During the first decade of the twentieth century, when Herald Square was an entertainment center and Fifth Avenue was developing as a major shopping district, the Aberdeen Hotel was built as an apartment hotel. Designed for the Old Colony Company, a real estate firm, the hotel was reconfigured during the 1920s to accommodate transient guests. Notably, it was one of the first hotels in New York City that did not enforce curfews and restrictions on female guests unaccompanied by men.

The Beaux-Arts facade, with its elaborate entranceway amid ornate three-dimensional sculptures and a projecting bay of windows with decorative metal spandrel panels, is evidence of the American preoccupation with Parisian architecture at the turn of the century. The exterior of the twelve-story limestone and brick hotel remains largely intact. After a renovation, the hotel, now owned by the Apple Core chain, was reopened as the La Quinta Manhattan in 2003.

Consulate of the Polish People's Republic, formerly the Raphael De Lamar Mansion

1902–5; 1973

233 Madison Avenue, Manhattan

Architect: C.P.H. Gilbert

Designated: March 25, 1975

This imposing Beaux-Arts edifice was built for Dutch-born Raphael De Lamar, who amassed a fortune in Colorado's gold strike of the late 1870s. After De Lamar's death in 1918, the house was sold to the National Democratic Club; in 1973, the Polish People's Republic acquired the property for use as a consulate.

Conspicuous and dramatic on its Madison Avenue site, the De Lamar Mansion exhibits a towering and elegant mansard roof embellished by copper crestings with shell motifs. The main facade, which faces onto 37th Street, is designed in a tripartite organization, both vertically and horizontally. One of the building's most impressive features is the recessed entrance with double oak doors, crowned by a stone balcony with an imposing elliptical arched window, and capped by a handsome wrought-iron balcony.

LA QUINTA MANHATTAN HOTEL

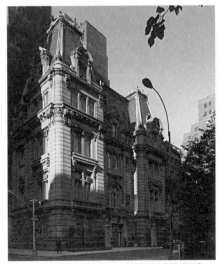

CONSULATE OF THE POLISH PEOPLE'S REPUBLIC

363

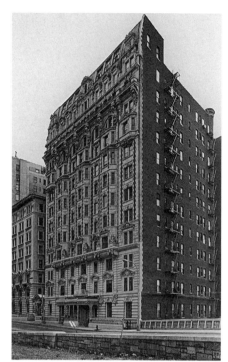

CHATSWORTH APARTMENTS AND ANNEX

CHATSWORTH APARTMENTS AND ANNEX

340–344 WEST 72ND STREET, MANHATTAN

ARCHITECT: JOHN E. SCHARSMITH

DESIGNATED: SEPTEMBER 11, 1984

CHATSWORTH APARTMENTS, 1902–4

ANNEX, 1905–6

The Chatsworth Apartments and Annex were constructed in the Beaux-Arts style as luxury "housekeeping apartments" for an affluent clientele. The original building consisted of two twelve-story blocks that shared a common base and entry. The annex was a separate, eight-story tower, linked to the original apartments at its base by a pavilion. At the beginning of the century, apartment houses had to overcome the middle-class belief that associated multiple-family dwellings with poverty and immorality. Naming an apartment house conferred upon it an appealing identity. Modern conveniences such as central heating, elevators, built-in bath and kitchen equipment, and services, including a sun parlor, billiard parlor, café, barbershop, valet, and tailor, satisfied the desire for comfort and created the impression that the apartment was a private home.

The Chatsworth exemplifies the inflated dimensions of classically inspired designs that had originally evolved for three- to five-story buildings. The rusticated limestone base rises three stories to a convex frieze and cornice. The midsection consists of seven stories faced in russet-colored brick with limestone trim. The attic and slate mansard roof occupy three stories, with the conservatory at the top.

The horizontal detail of the Annex works against its eight-story height to create the impression of a lower building. It is entered through a small, rusticated one-story pavilion, faced in limestone, that separates it from the main building.

EAST 91ST STREET HOUSES
MANHATTAN

CONSULATE GENERAL OF THE RUSSIAN FEDERATION, FORMERLY THE JOHN HENRY HAMMOND HOUSE, 1902–3

9 EAST 91ST STREET

ARCHITECTS: CARRÉRE & HASTINGS

DESIGNATED: JULY 23, 1974

CONVENT OF THE SACRED HEART, FORMERLY THE JAMES A. BURDEN HOUSE, 1902–5

7 EAST 91ST STREET

ARCHITECTS: WARREN & WETMORE

DESIGNATED: FEBRUARY 19, 1974

CONSULATE GENERAL OF THE RUSSIAN FEDERATION, FORMERLY THE JOHN B. TREVOR HOUSE, 1909–11

11 EAST 91ST STREET

ARCHITECTS: TROWBRIDGE & LIVINGSTON

DESIGNATED: JULY 23, 1974

CONVENT OF THE SACRED HEART, FORMERLY THE OTTO KAHN HOUSE, 1913–18

1 EAST 91ST STREET

ARCHITECTS: J. ARMSTRONG STENHOUSE AND C.P.H. GILBERT

DESIGNATED: FEBRUARY 19, 1974

Financier and banker Otto Kahn bought the site at 1 East 91st Street from Andrew Carnegie and had the architects C.P.H. Gilbert and J. Armstrong Stenhouse design a mansion that comes as close to a true Italian Renaissance palace as there is in the city, complete with a drive-through porte cochere and an interior

courtyard, and the highest order of Renaissance-style detailing throughout. The house is now part of the Convent of the Sacred Heart, which cleaned and restored the facade in 1994.

Mr. and Mrs. William Sloane commissioned the architects Warren & Wetmore to design a palace at number 7 as a wedding present for their daughter when she married James Burden. Sloane had number 9 built for his second daughter, when she married John Henry Hammond. Number 7, which is also today part of the Convent of the Sacred Heart, is an Italian Renaissance–style town house, noted for its circular marble staircase. Number 9 is an Italian Renaissance–style mansion designed by Carrère & Hastings, notable for its perfect symmetry and balance. Since 1976, the house has been the property of the Consulate General of the Russian Federation, which restored the building. John B. Trevor commissioned the firm of Trowbridge & Livingston to design his Beaux-Arts–style town house at number

11, which is also part of the Consulate General of the Russian Federation.

647 FIFTH AVENUE, FORMERLY THE GEORGE W. VANDERBILT HOUSE

1902–5; ADDITION, 1917; 1995–96	
MANHATTAN	
ARCHITECTS: HUNT & HUNT	
DESIGNATED: MARCH 22, 1977	

In 1902, just a year after the architectural firm of Hunt & Hunt was formed, brothers Richard H. and Joseph Hunt began building the "Marble Twins," a pair of town houses at 645 and 647 Fifth Avenue, for George Washington Vanderbilt. The commission reflected both the longstanding patron-architect relationship between the Vanderbilts and the Hunts, and a continuation of the trend to build in the opulent French Renaissance style introduced to New

York in 1879 by the architects' father, Richard Morris Hunt. Today, only number 647 remains.

The town house is executed in the style of Louis XV. The first floor was originally rusticated, with round-arched openings; today a wide plate-glass window has been installed for a storefront. One of the most handsome features of the facade is a composite order of finely carved, fluted pilasters linking the second and third stories. The two top stories above the entablature were skillfully added in 1917.

When 647 was completed, the neighborhood was an area of Beaux-Arts splendor—with the University Club two blocks away, the Plaza nearing completion up the street, and the handsome Union Club (now demolished) adjacent to the twins. One of the last reminders of the lavish mansions that once enhanced Fifth Avenue, 647 Fifth Avenue now houses the designer store Versace, which undertook a major restoration of the facade in 1995–96.

HOTEL MARSEILLES

PENINSULA HOTEL

HOTEL MARSEILLES

1902–5

2689–2693 BROADWAY, MANHATTAN

ARCHITECT: HARRY ALLAN JACOBS

DESIGNATED: OCTOBER 2, 1990

A handsome example of the wave of grand hotels that swept up Broadway in the first decade of the twentieth century, the Hotel Marseilles was built during a development boom that struck the Upper West Side when the IRT subway line opened in 1904. With its brick-and-limestone facade, terra-cotta and wrought-iron detail, and sloping mansard roof, this gracious apartment hotel illustrates the rise of "modern French" commercial and hotel architecture in New York. The fashionable style reflects the French influence on American architecture through the large number of important architects who attended the Ecole des Beaux-Arts.

The apartment hotel was America's answer to space-conscious European-style apartment living without the intrusive presence of servants, to which well-to-do New Yorkers objected. Like its famous counterparts the Ansonia (p. 337) and the Hotel Belleclaire (p. 351), the Marseilles provided a full-service staff, central kitchens, and restaurants for its residents (both permanent and transient) so that personal servants could be dispensed with. Its six upper stories were divided into single rooms and suites, while the ground floor was rented out to retailers, an integral element of the apartment hotel design, in keeping with Broadway's early image

as a flourishing residential boulevard dotted with storefronts.

Architect Harry Allan Jacobs, who specialized in elegant residences, adorned the Hotel Marseilles with Beaux-Arts flourishes—wrought-iron balconies and spandrel panels carved with foliage and keystones.

Since 1980, the building has been used as subsidized housing for the elderly.

PENINSULA HOTEL, FORMERLY THE GOTHAM HOTEL

1902–5

696–700 FIFTH AVENUE, MANHATTAN

ARCHITECTS: HISS & WEEKES

DESIGNATED: JUNE 6, 1989

The Gotham is among the oldest and finest "skyscraper" hotels erected at a time when Fifth Avenue was being transformed from an exclusive residential street to a fashionable commercial thoroughfare. This boldly rendered neo–Italian Renaissance rocket, rising twenty stories (with a modern rooftop addition), is a stylistic counterpart to the flamboyant Beaux-Arts St. Regis Hotel (p. 352) directly across Fifth Avenue.

As former employees of McKim, Mead & White, Philip Hiss and H. Hobart Weekes brought many of the firm's stylistic concepts to their design. Yet they demonstrated originality in adapting Renaissance structures to the skyscraper form and enhancing the result with sculptural detail—the ornate

main entrance is adorned with foliate-patterned architrave molding, swags, and crowning figures of Ceres and Diana. Faced in limestone, the Gotham was configured like a classical column with a monumental, rusticated base, a smooth-faced shaft, with balconies at the end bays, and a capital. The capital boasts a garlanded cornice, scroll brackets, and wreathed corbels supporting a two-story arcade that echoes the arcade at the base. The Gotham's architectural lines harmonize with the Renaissance lines of McKim, Mead & White's University Club (p. 322), which adjoins it to the south.

KNICKERBOCKER HOTEL

1902–6

1462–1470 BROADWAY, MANHATTAN

ARCHITECTS: MARVIN & DAVIS AND BRUCE PRICE; 1906 ANNEX, TROWBRIDGE & LIVINGSTON

DESIGNATED: OCTOBER 18, 1988

When the Knickerbocker Hotel opened on October 24, 1906, it was deemed a great success, attracting such dignitaries as Woodrow Wilson, George M. Cohan, Enrico Caruso, and others to the theater district. All were eager to see its elegantly furnished bars and restaurants featuring electric fountains by Frederick MacMonnies and murals by American artists Maxfield Parrish and Frederic Remington. One of several luxury hotels financed by John Jacob Astor at the turn of the century, the Knickerbocker, executed in red brick with French Renaissance ornament and a spectacular

copper mansard roof, could accommodate nearly one thousand guests; the public rooms could serve two thousand.

Beginning with the Astor House of 1836 near City Hall, the Astor family enjoyed a reputation for building costly and well-appointed hotels. John Jacob's cousin William Waldorf Astor's many ventures included the Waldorf Hotel (1895), built on a site adjacent to John Jacobs Astoria Hotel (also 1895). (The Waldorf and Astoria were eventually joined to form the Waldorf-Astoria, considered among the first rank of American hostelry.)

Touted as "a Fifth Avenue hotel at Broadway prices," the success of the Knickerbocker abruptly ended with the onset of the Depression. The hotel was then converted to commercial and office use. The current owners plan to return the upper floors to hotel use.

KNICKERBOCKER HOTEL

CULTURAL SERVICES OF THE FRENCH EMBASSY

EAST 79TH STREET HOUSES

CULTURAL SERVICES OF THE FRENCH EMBASSY, FORMERLY THE PAYNE WHITNEY HOUSE

1902–6; 1987; 1998

972 FIFTH AVENUE, MANHATTAN

ARCHITECTS: MCKIM, MEAD & WHITE

DESIGNATED: SEPTEMBER 15, 1970

This exquisite town house was commissioned by Oliver Payne as a wedding present for his nephew, financier Payne Whitney and his wife, Helen, a poet and patron of the arts. Designed in a high Italian Renaissance style, the curved granite front, covered with rich classical ornament, rises five stories. Entablatures delineate each story. The central doorway has an ornately carved marble enframement and double entrance doors of openwork bronze grills with an intricate floral motif. Winged cherubs fill the spandrels of the round-arched parlor-floor windows, which are flanked with Ionic pilasters. The Renaissance treatment of the upper stories, with Corinthian pilasters and carved classical figures in low relief, is particularly handsome. The structure is topped by a pitched tile roof with a deep overhanging stone cornice supported by paired stone brackets.

Helen Hay Whitney lived in the house until her death in 1944. Since 1952, the house has been owned by the French government. During an extensive restoration in 1987, a stained glass window designed especially for the house by John La Farge was discovered. In 1998, the Whitney family reinstalled the Venetian room—a gilded and mirrored confection—in its original position on the first floor.

EAST 79TH STREET HOUSES

MANHATTAN

63 EAST 79TH STREET

1902–03; ADDITIONS, 1904

ARCHITECTS: ADAMS & WARREN

DESIGNATED: MAY 19, 1981

67–69 EAST 79TH STREET

1907–08

ARCHITECTS: CARRÈRE & HASTINGS

DESIGNATED: MAY 19, 1981

59 EAST 79TH STREET

1908–09

ARCHITECTS: FOSTER, GADE & GRAHAM

DESIGNATED: MAY 19, 1981

53 EAST 79TH STREET

1916–17

ARCHITECTS: TROWBRIDGE & LIVINGSTON

DESIGNATED: FEBRUARY 15, 1967

The Upper East Side of Manhattan developed as a residential neighborhood in the 1860s, when simple brownstone row houses were constructed on speculation and sold to middle-class families. But during the period between 1890 and the beginning of World War I, more opulent town houses, such as these on East 79th Street, replaced the older brownstone, reflecting the move uptown of the city's most elite families.

Number 53 was the residence of John S. Rogers until 1937, when the New York Society Library purchased the building; the association still occupies it today. This limestone structure, designed by Trowbridge & Livingston in 1916, has a front facade four stories high and three bays wide, terminating in a rich stone frieze and cornice topped by a balustrade. The fifth floor, set back a few feet behind this balustrade, has a tile roof with a wide overhang over an open terrace. Number 59 was designed for John H. Iselin by the firm of Foster, Gade & Graham in an eclectic mix of Northern Renaissance and French styles. The five-story structure is faced with buff brick enlivened by limestone detailing. Number 63, designed by architects Adams & Warren in an English neoclassical style, is a five-story house with an Ionic entrance portico shading a Federal-style entranceway. The original mansard roof was removed when two stories were added in 1945. Number 67–69 was designed in 1907 by Carrère & Hastings in a late French Baroque style. The building now serves as the Greek Consulate and the offices of the Greek Orthodox Diocese of America.

EAST 90TH STREET HOUSES

MANHATTAN

DESIGNATED: JULY 23, 1974

11 EAST 90TH STREET

1902–3

ARCHITECTS: BARNEY & CHAPMAN

15 EAST 90TH STREET

1927–28

ARCHITECT: MOTT B. SCHMITT

17 EAST 90TH STREET

1917–19

ARCHITECT: F. BURRALL HOFFMAN JR.

These three dignified and elegant residences add considerable charm to the Carnegie Hill area of the Upper East Side. Number 11 is a handsome four-and-one-half-story limestone building designed in the best tradition of the French Beaux-Arts and the eighteenth-century *hôtel particulier*. Number 15 is a charming Federal Revival house designed by Mott B. Schmidt, who was responsible for some of the most refined examples of this style in the city. Three and one-half stories high and of red brick laid in Flemish bond, its most notable feature is a handsome entrance portico composed of Corinthian columns supporting a full entablature that accents the paneled double doors. Number 17 combines a modified Georgian Revival style with an arcaded loggia in the continental tradition; its most distinguishing features are the keystones of the arches of the loggia, embellished by decorative human masks, and the handsomely carved and paneled double doors.

EAST 90TH STREET HOUSES

NYPL, CHATHAM SQUARE BRANCH LIBRARY

574 SIXTH AVENUE

RED HOUSE

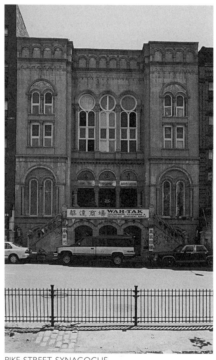

PIKE STREET SYNAGOGUE

NEW YORK PUBLIC LIBRARY, CHATHAM SQUARE BRANCH

1903

31 EAST BROADWAY (ALSO KNOWN AS 31–33 EAST BROADWAY), MANHATTAN

ARCHITECT: McKIM, MEAD & WHITE

DESIGNATED: NOVEMBER 13, 2001

In 1901, Andrew Carnegie donated $5.2 million to establish a branch library system in New York City. This was the first of twelve Carnegie library commissions for McKim, Mead & White. All were executed in the neoclassical style, which became the model for Carnegie libraries by other architects and later for libraries across the country.

The three-story library is faced in limestone with a rusticated base and has large arched windows that provide ample light to all three floors. The symmetrical facade includes a row of double height Ionic columns supporting a classical cornice with carved ornament. The Chatham Square branch, the third of sixty-seven Carnegie libraries built throughout the five boroughs of New York City, has been serving the community for more than a century.

RED HOUSE

1903–4

350 WEST 85TH STREET, MANHATTAN

ARCHITECTS: HARDE & SHORT

DESIGNATED: SEPTEMBER 14, 1982

Red House, an exceptionally handsome apartment house, was one of the earliest buildings designed by the architects Harde & Short. The lively six-story building takes its name from the color of the brick facing, which is set off by an abundant use of light-colored terra-cotta ornament. The facade is organized into two pavilions, each with angled sides, flanking a slightly recessed central window bay. The detailing of the facade, which displays the concern for historicism typical of much of the firm's work, is enhanced by a strong contrast between the red brick and the cream-colored terra-cotta ornament. Recalling the sixteenth-century style of François I in its combination of French Gothic and Renaissance elements, the detailing includes the use of the salamander and crown motifs, baldachin canopies, and windows with multipaned sashes organized in bays.

The facade is crowned by an entablature composed of a corbeled frieze supporting a projecting cornice and an architrave broken by diamond-shaped panels that repeat the pattern of the window spandrels. Elongated brackets terminate in terra-cotta pendants, which display foliate motifs and the crown of François I.

574 SIXTH AVENUE BUILDING

1903–4

574 AVENUE OF THE AMERICAS (ALSO KNOWN AS 57–59 WEST 16TH STREET), MANHATTAN

ARCHITECT: SIMEON B. EISENDRATH

DESIGNATED: AUGUST 14, 1990

The Knickerbocker Jewelry Company built this four-story retail store during a resurgence of commercial activity in the Ladies' Mile area around the turn of the century. Located two blocks from where such prestigious stores as B. Altman and Siegel-Cooper once stood, the building is modeled on larger commercial structures of the period, featuring large display windows around the base and mezzanine. Rusticated and smooth brick piers that project beyond the plane of the spandrels and lintels were allusions to the steel-frame construction of taller commercial buildings. The flamboyant sheet-metal cornice—falling forward in a scroll—and the baroque spandrels and window arches on the upper two stories were intended to attract the attention of passengers on the Sixth Avenue elevated train.

Despite the effort to present the building as a commercial palace, the jewelry store was a short-lived venture; in 1905, it was taken over by a cloak maker and has since been repeatedly remodeled.

PIKE STREET SYNAGOGUE, CONGREGATION SONS OF ISRAEL KALWARIE

1903–4

13–15 PIKE STREET, MANHATTAN

ARCHITECT: ALFRED E. BADT

DESIGNATED: MAY 20, 1997

One of the few Lower East Side synagogues remaining from the era of Jewish immigration and settlement at the turn of the twentieth century, the Pike Street Synagogue served as a house of worship for the Congregation Sons of Israel Kalwarie. Strongly influenced by Romanesque and German *Rundbogenstil* architecture, the three-story limestone building is distinct and impressive, with a columned portico above a raised basement. Its double lateral staircase leads to a recessed entrance with a small, round-arched corbel table above the windows, and a round-arched blind arcade encircles the top of the building.

The Pike Street Synagogue was one of the few designed specifically as a synagogue. Its congregation continued to worship in the synagogue well into the 1970s, when membership declined significantly. Abandoned, the building was vandalized and then fell into disrepair. Congregation members disagreed over whether to sell it, and only after a court battle was it sold in 1994. Today, the ground floor is used as commercial space, its main floor as a Buddhist temple, and its upper levels as apartments.

New York Public Library, Tottenville Branch

1903–4

7430 Amboy Road, Tottenville, Staten Island

Architects: Carrère & Hastings

Designated: May 16, 1995

The Tottenville Branch dates back to 1899, when the Tottenville Free Library was established by the Tottenville Library Association. The village prospered from shipbuilding, oystering, and seaside resort tourism, and its Free Library was the first modern public library on Staten Island. The building housed a collection built around the Free Library's small holdings. It was the first of four Staten Island branch libraries funded by Andrew Carnegie's gift. This coincided with a larger trend that brought rural Staten Island into the realm of New York City's civic culture.

The one-story, classically inspired building is articulated in brick, stucco, and wood. It sits on a raised basement and its classical references include a Tuscan portico, quoins, and a modillioned raking cornice. The classical facade is softened by a hip roof, giving the building a graceful harmony with its landscaped site and village setting.

NYPL, TOTTENVILLE BRANCH LIBRARY

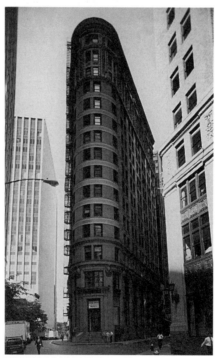

NEW YORK COCOA EXCHANGE BUILDING

New York Cocoa Exchange Building, formerly the Beaver Building

1903–4

82–92 Beaver Street (also known as 129–141 Pearl Street and 1 Wall Street Court), Manhattan

Architects: Clinton & Russell

Designated: February 13, 1996

This flatiron-shaped, fifteen-story structure was called the Beaver Building because of its address and the ornamental carved beaver-head decorations above the entrance. The building sits at the intersection of Beaver and Pearl streets, where an elevated railway line once curved around the Pearl Street facade. The neo-Renaissance palazzo facade followed the convention of designing skyscrapers in a tripartite manner, using different materials to define the base, shaft, and capital. The three-story base is of granite and Indiana limestone, the middle section has alternating rows of tan and buff brick, and the top three stories are highlighted with polychromatic glazed terra-cotta of bright green, buff, and red.

Its first prominent tenant, the Munson Steamship Company, established in 1899 immediately after the United States occupied Cuba in the Spanish-American War, transported Cuban sugar. From 1931 to 1972, the building housed the world's first cocoa exchange, with a trading room on the first floor. Since 1979, the Cocoa Exchange has been part of the New York Coffee, Sugar & Cocoa Exchange, located at 127 John Street.

CARTIER, FORMERLY THE MORTON F. PLANT HOUSE

1903–05

651–653 FIFTH AVENUE AND 4 EAST 52ND STREET, MANHATTAN

ARCHITECTS: ROBERT W. GIBSON AND C.P.H. GILBERT

DESIGNATED: JULY 14, 1970

This elegant, six-story Italian Renaissance–style building was designed for Morton F. Plant, a banker and yachtsman, and owner of two baseball teams. The East 52nd Street facade is dominated by an ornately carved balcony, supported by heavy console brackets at the second floor; four fluted Doric pilasters rise two stories above the balcony and support the low-pitched pediment. The fifth-floor attic windows are set in a profusely decorated frieze.

In 1917, Cartier acquired the building in an extraordinary manner: Mrs. Plant swapped the house for a necklace of perfectly matched, giant Oriental pearls that had been the pride of Pierre Cartier's collection. The jewelers have been located here ever since.

PERMANENT MISSION OF SERBIA AND MONTENEGRO TO THE UNITED NATIONS, FORMERLY THE R. LIVINGSTON BEEKMAN HOUSE

1903–5

854 FIFTH AVENUE, MANHATTAN

ARCHITECTS: WARREN & WETMORE

DESIGNATED: JANUARY 14, 1969

The finest of the extant small town houses on Fifth Avenue, this elegant building is a superb example of Louis XV style, executed with vigor and authority. Capped with a mansard roof containing two floors of dormers, the grand masonry facade is three stories high and two windows wide. The base of the house has two graceful round-arched openings with molded frames; the second-floor windows, pedimented at the top with balustraded balconies, are tall and dignified. The facade contains superior foliate ornamental detail in the Beaux-Arts tradition. A low, open parapet, with a railing in front of the two fourth-floor dormers, rises above the cornice. The high mansard roof is covered with copper and has a richly molded cresting that crowns the house.

CARTIER

MISSION OF SERBIA AND MONTENEGRO

BROOKLYN PUBLIC LIBRARY, WILLIAMSBURGH BRANCH

1903–5

240 DIVISION AVENUE (ALSO KNOWN AS 226–246 DIVISION AVENUE, 197–213 MARCY AVENUE, AND 241–251 RODNEY STREET), BROOKLYN

ARCHITECT: WALKER & MORRIS

DESIGNATED: JUNE 15, 1999

The Williamsburgh Branch of the Brooklyn Public Library, opened in 1905, is the largest and finest of the Brooklyn Carnegie branches. Located on a triangular lot formed by intersection of three streets, the Y-plan building is visible on all sides with its two spreading wings and circular rear pavilion. Clad in red brick, the expansive library employs French-inspired planning and detail with its central projecting archway defined by limestone keystones and quoins, and emphasized by double-height arched windows on both wings.

Richard A. Walker, a Beaux-Arts trained architect, designed this, the second and largest, of twenty-one Carnegie Branch libraries in Brooklyn; later work included three more branches. Brooklyn was allotted $1.6 million of the Carnegie gift. Williamsburgh was chosen first to receive a new library because of huge population growth in the area, due in part, to the anticipated opening of the Williamsburgh Bridge.

THE PIERPONT MORGAN LIBRARY

29 EAST 36TH STREET, MANHATTAN

1903–6; 2002–2006

ARCHITECTS: McKIM, MEAD & WHITE; RENZO PIANO BUILDING WORKSHOP

DESIGNATED: MAY 17, 1966; INTERIOR DESIGNATED MARCH 23, 1982

ANNEX, 1928

ARCHITECT: BENJAMIN WISTAR MORRIS

DESIGNATED: MAY 17, 1966

PHELPS STOKES–J.P. MORGAN JR. HOUSE

1852–53

231 MADISON AVENUE

ARCHITECT: UNKNOWN; ENLARGED BY R. H. ROBERTSON, 1888

DESIGNATED: FEBRUARY 26, 2002

In 1900, the great financier J. Pierpont Morgan began to make plans for a building to house his vast collection of paintings, sculpture, objets d'art, and rare books. He acquired land adjacent to his house on East 36th Street and hired the architect Whitney Warren to draw up plans. In 1902, however, he decided he wanted the firm of McKim, Mead & White to take over the project. With an enthusiasm that matched Morgan's sizable financial commitment, Charles McKim designed the Pierpont Morgan Library, considered by many to be his masterpiece.

Drawing stylistically upon the Italian Renaissance villa, the uncomplicated, classical library is the result of a close collaboration between client and architect. Morgan studied the plans for two years, often over breakfast meetings with McKim, working out details of structure and ornamentation. In the final version, three rooms open off a central rotunda. To the east is a library, and to the north a librarian's office; on the west is Morgan's personal office, the repository of his most prized objects. The project also included a house on the same property for Morgan's daughter, Louisa Satterlee.

The main library entrance employs the Palladian motif of an archway with three openings. The four paired Ionic columns (instead of the usual two) are backed by a deep porch with a beautifully decorated groin-vaulted ceiling. On each side of the doorway the side wings, flush with the entrance, are defined by pilasters and niches with sculpted figures. The exterior marble walls were assembled without mortar, and the blocks are set together so tightly that a penknife cannot be inserted into the joints. McKim had studied this technique at the Erechtheum on the Acropolis; this proof of structural longevity was enough to convince

Morgan to spend an additional $50,000 on blocks of Tennessee marble.

The interior, richly turned out in materials and coverings from European sources, shows the same attention to detail. The rotunda, based on Renaissance prototypes, is distinguished by an allegorical vault painting by H. Siddons Mowbray. The marble floor is laid in a pattern modeled on a design in the Villa Pia in the Vatican.

The Pierpont Morgan Library is an influential example of studied form and consummate workmanship. In its careful design, which integrates sculpture, painting, and architecture, the library exemplifies the turn-of-the-century ideal of unity of the arts and creates a splendid showcase for Morgan's collection.

The adjoining Florentine Renaissance–style Annex, designed by Benjamin Wistar Morris and built in 1928 when the Library opened to the public, exists in simple, subordinate harmony with the McKim building. The Library acquired the Phelps-Morgan house at 37th Street and Madison Avenue in 1998, creating a three-building campus. In 2002, the Landmarks Preservation Commission approved major expansion and renovation plans for the library complex by Renzo Piano, scheduled for completion in 2006.

THE PIERPONT MORGAN LIBRARY AND ANNEX

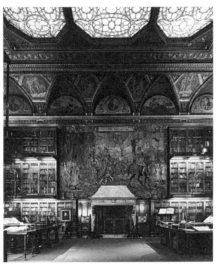

MORGAN LIBRARY, EAST ROOM INTERIOR

PHELPS STOKES–J.P. MORGAN JR. HOUSE

FORMER TIFFANY & CO. BUILDING

NEW-YORK HISTORICAL SOCIETY

FORMER TIFFANY & CO. BUILDING

1903–6; 2003

397–409 FIFTH AVENUE, MANHATTAN

ARCHITECTS: McKIM, MEAD & WHITE; BEYER BLINDER BELLE

DESIGNATED: FEBRUARY 16, 1988

When Tiffany & Co., America's premier jewelers, moved uptown from Union Square, it almost single-handedly established Fifth Avenue as the city's most exclusive shopping street. In April 1903, Charles Cook, Tiffany's president, instructed McKim, Mead & White to "build me a palace." The firm modeled the lavish new quarters on the majestic sixteenth-century Palazzo Grimani in Venice. Sheathed in white marble, the building creates the illusion of being a three-story structure, although it is actually seven stories tall. Large plate-glass windows, Corinthian-order piers and columns, and an imposing entablature distinguish the facade; the result is one of the most elegant and sophisticated commercial buildings in New York.

The Tiffany building illustrates the success of McKim, Mead & White in the reintroduction of classical design in America, particularly in this prestigious retail district. Despite major ground-floor alterations, the former Tiffany & Co. store's exquisite proportions testify to the firm's enduring legacy of innovation. In 2003, the facade was restored by Beyer Blinder Belle.

NEW-YORK HISTORICAL SOCIETY

CENTRAL SECTION 1903–8; WINGS, 1937–38

170 CENTRAL PARK WEST, MANHATTAN

ARCHITECTS: YORK & SAWYER (CENTRAL SECTION); WALKER & GILLETTE (WINGS)

DESIGNATED: JULY 19, 1966

In 1804, a score of prominent New York City residents established the New-York Historical Society. In the words of the society's first president, John Pintard, its purpose was to "collect and preserve whatever may relate to the natural, civil or ecclesiastical history of the U.S. in general, or of this state in particular." From 1804 until 1857 the society's collections changed location seven times, starting out at City Hall (1804–11) and finally settling at Town & Davis's New York University Building (1841–57). By 1857, charitable donations enabled the society to erect its first permanent building, at the corner of Second Avenue and East 11th Street.

In addition to holding conventional historical records, the society—as the only such public institution in the city—soon began to serve as the repository for several major art collections. Many of these collections were dispersed as various museums were established, but the society retains a strong collection of American art.

The 1857 building became hopelessly overcrowded. As art accumulated in the tightly packed quarters, society members called for the creation of a public

museum in Central Park and became the first group to suggest the founding of the Metropolitan Museum of Art.

The fund-raising drive for a larger building began in 1887; the current site was chosen in 1891. The financial panic of 1893, however, postponed construction. In October 1901, the firm of York & Sawyer won the commission for the current building in a sealed-bid competition. The central section was completed in 1908. With ample exhibition galleries planned from the very beginning, the society could provide free public access to the collection, as well as scholarly research facilities.

The 1901 design also allowed for the erection of two identical wings to the north and south as funds became available. A building extension fund was established in 1920 and York & Sawyer contracted to complete their original designs. Once again, economic distress frustrated construction plans. In 1935, thanks to an enormous bequest from Mary Gardiner Thompson, Walker & Gillette received the commission to complete the building, adhering to Philip Sawyer's original designs fairly closely. Sawyer had designed colossal semidetached colonnades for the wings, identical to the one on the center block. Ralph T. Walker preferred flat pilasters set into shallow spandrels and stylized Sawyer's heavily rusticated base. Walker did match the original gray granite perfectly, and his additions are sensitive to the original design.

72ND STREET SUBWAY KIOSK

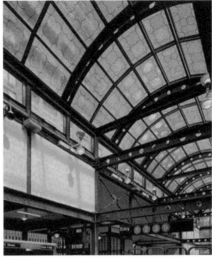

72ND STREET SUBWAY KIOSK, CEILING MOSAIC

72ND STREET SUBWAY KIOSK AND CONTROL HOUSE

1904; 2003

WEST 72ND STREET AND BROADWAY, MANHATTAN

ARCHITECTS: HEINS & LA FARGE

DESIGNATED: JANUARY 9, 1979; INTERIOR DESIGNATED OCTOBER 23, 1979

Heins & La Farge developed two types of aboveground structures for the IRT: control houses and kiosks. Of the 130 original kiosks, each made of cast iron and glass, none remains, but one has recently been reconstructed at the Astor Place station. The six original control houses—at West 103rd Street, West 116th Street, West 149th Street, Atlantic Avenue, Bowling Green, and this station—were of buff-colored Roman brick with limestone and terra-cotta trim. Their vaguely Flemish Renaissance style is an appropriate reference to New York's earliest Dutch settlement at Bowling

Green. Two of the remaining three, this and the one at Bowling Green are designated landmarks.

The West 72nd Street Control House occupies the triangular site where Broadway crosses Amsterdam Avenue. The wrought-iron fence that surrounds it is original. The foundation is of granite; the trim is limestone, and the Flemish scroll gable coping and ball finials are terra-cotta. The brick is laid in the Flemish bond pattern. A louvered glass roof monitor and wrought-iron grills admit light and air. A restoration by Gruzen Sampton and Richard Dattner, completed in 2003, included the installation of a ceiling mosaic comprising more than one million pieces of glass, interpreting Verdi's *Rigoletto* in a visual pattern by the sculptor Robert Hickman.

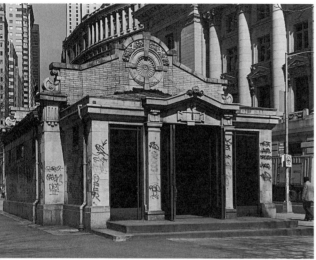

BATTERY PARK CONTROL HOUSE

NYPL, TOMPKINS SQUARE BRANCH LIBRARY

BATTERY PARK CONTROL HOUSE

1904–5

STATE STREET AND BATTERY PLACE,
MANHATTAN

ARCHITECTS: HEINS & LA FARGE

DESIGNATED: NOVEMBER 20, 1973

The Battery Park Control House is an
entrance and exit for the Bowling Green
Station of the Lexington Avenue IRT. The
yellow-brick building has limestone
quoins at each corner and a granite base.
Smooth limestone banding encircles the
building, above the plain brick walls
pierced by simple high windows. The
gable ends of the building are decorated
with a central bull's-eye with elaborate
moldings. The northern facade has a
projecting limestone porch with
engaged square columns supporting a
stylized pediment on brackets. The
southern facade has a brick extension,
edged by plain stone quoins and topped
with a copper entablature and roof.

NEW YORK PUBLIC LIBRARY,
TOMPKINS SQUARE BRANCH

1904

331 EAST 10TH STREET, MANHATTAN

ARCHITECTS: MCKIM, MEAD & WHITE

DESIGNATED: MAY 18, 1999

Characteristic of the Carnegie libraries,
this classically inspired mid-block, three-
story building is organized along a
vertical plan, symmetrical design, and
with an offset entryway. Tall arched
window openings on the lower floors,
and rectangular windows on the third,
punctuate the limestone facade, allowing
ample light into the interior.

This building was the second of
twelve branch libraries designed by
McKim, Mead & White, and the third
of twenty branches built in Manhattan
with Andrew Carnegie's gift. McKim
was responsible for the firm's branch
library designs, assisted by William
Mitchell Kendall.

During the early twentieth century,
the Tompkins Square Branch was known
throughout the city for its Polish book
collection, becoming a center of Polish
intellectual life during World War II. It
remains an active lending library and
important community institution.

QUEENS BOROUGH PUBLIC LIBRARY,
POPPENHUSEN BRANCH

1904; 2004

121–123 14TH AVENUE (ALSO KNOWN
AS 121–127 14TH AVENUE AND 13–16
COLLEGE POINT BOULEVARD),
QUEENS

ARCHITECTS: HEINS & LAFARGE

DESIGNATED: MAY 30, 2000

One of five surviving Carnegie libraries
in Queens, the Poppenhusen Branch is
unlike any other in the city because of
its unusual ornament. Set back from the
street on a grassy corner lot, the free-
standing library is designed in the
classical style. The arched entrance
portico is topped by a broken pediment
and heavy decorative stone banding,
surmounted by a hipped roof embel-
lished with a modillioned-stone cornice;
broad flat stone-trimmed windows light
an interior reading room.

The Queens Library Board sought to
extend the money received from
Carnegie, intended for three branch
libraries; instead they built seven less
expensive buildings. The community of
College Point donated the land, and the
Poppenhusen Institute (p. 196), a local
civic institution founded by the

neighborhood's most influential employer, supplied the books. The Queens Borough Public Library has the largest circulation of any urban library system in the United States. The Poppenhusen Branch, closed for a year of renovations, reopened on February 12, 2004, one hundred years after it was first constructed.

52ND POLICE PRECINCT STATION HOUSE

1904–5

3016 WEBSTER AVENUE, THE BRONX

ARCHITECTS: STOUGHTON & STOUGHTON

DESIGNATED: JUNE 18, 1974

The 52nd Police Precinct Station House was built to serve the growing Norwood and Bedford Park neighborhoods following the 1898 consolidation of New York City. In detail and form, the three-story red-brick and terra-cotta building recalls Tuscan precedents. The south facade is governed by a centrally placed engaged tower. The base of the tower is a porte cochere where prisoners were delivered; its top is marked by polychromed terra-cotta clock faces beneath recessed arches on the three free sides. The first-floor walls are laid in Flemish bond and pierced by round-arched windows with square frames whose spandrels are decorated with blue terra-cotta panels. The second and third stories are separated by terra-cotta panels and distinguished by diaper-pattern brickwork. The main entrance to the building on Webster

QBPL, POPPENHUSEN BRANCH LIBRARY

Avenue is marked by an Italianate porch. Above the porch is a terra-cotta plaque, embossed with the seal of the City of New York and the precinct number.

The precinct's former stable and patrol wagon garage remain behind the main building. This building, too, received careful detailing in the form of a belt course and diapered brickwork on the top story.

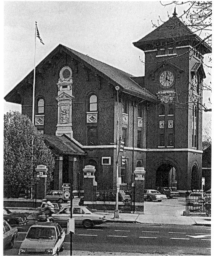

52ND POLICE PRECINCT STATION HOUSE

379

SCHOMBURG CENTER FOR RESEARCH IN BLACK CULTURE, NEW YORK PUBLIC LIBRARY, FORMERLY WEST 135TH STREET BRANCH

1904–5; 1990

103 WEST 135TH STREET, MANHATTAN

ARCHITECTS: MCKIM, MEAD & WHITE; DAVIS BRODY BOND

DESIGNATED: FEBRUARY 3, 1981

This three-story limestone library became a center of cultural, social, and political activity in Harlem. Franz Boas, W.E.B. DuBois, and Carl Van Doren lectured here; actors Harry Belafonte and Sidney Poitier made their acting debuts with the American Negro Theater on the basement stage. The library's collection of books about black literature and history was initially compiled by Ernestine Rose in the early 1920s; it increased dramatically with the acquisition of the Schomburg Collection, pur-

chased in 1926 with the aid of a $10,000 Carnegie Corporation gift.

The symmetrically structured building has a rusticated ground floor pierced by square-headed openings. A wide belt course ornamented with a richly carved pattern of alternating wreaths and books divides the first story from the floors above. The second and third floors are broken into three bays by tall pilasters. Large double-hung windows with tiny windows above create the outer bays; the central bay is lit by a handsome Palladian window. The entire structure is topped by a broad, modillioned over-hanging cornice containing a simple entablature, ornamented with round plaques and the inscription "New York Public Library."

The building was restored in 1990 by Davis Brody Bond. The firm also designed the handsome new building that houses the research collections.

THE LAMBS, FORMERLY THE LAMBS CLUB

1904–5

128 WEST 44TH STREET, MANHATTAN

ARCHITECTS: MCKIM, MEAD & WHITE

DESIGNATED: SEPTEMBER 24, 1974

This handsome Georgian Revival club-house was built to house the Lambs Club, founded in 1874 for "the social intercourse of members of the dramatic and musical professions with men of the world." Henry J. Montague, one of the founders, had belonged to the Lambs Club in London and suggested

the name for the New York group. The club became well known for its "Gambols"—satirical revues—that began in 1888. McKim, Mead & White, all members of the Lambs, were given the commission for the new building when the club outgrew its former quarters at 70 West 36th Street.

Stanford White was in charge of the design for the six-story brick, marble, and terra-cotta clubhouse. Its ground floor is faced with marble, while the upper stories are faced with red Flemish bond brickwork and flanked by stone quoins. A projecting cornice tops the fifth floor; a classical attic with a second-ary cornice above the sixth floor is crowned by a roof balustrade. The fine decorative details include a belt course with Greek fret motif and identical doorways with Doric columns support-ing full entablatures. At the second floor, graceful loggias with French doors are separated by Ionic columns and enclosed by wrought-iron balcony rail-ings. There are stylized lambs' heads

between the spandrels of the windows, and a wall plaque flanked by lambs.

The club has moved to new quarters at 3 West 51st Street; the Manhattan Church of the Nazarene, also called "The Lambs," currently occupies the clubhouse on West 44th Street.

NEW YORK PUBLIC LIBRARY, PORT RICHMOND BRANCH

1904–5

75 BENNETT STREET, STATEN ISLAND

ARCHITECTS: CARRÈRE & HASTINGS

DESIGNATED: OCTOBER 13, 1998

The Port Richmond Branch of the New York Public Library is one of four Carnegie branches on Staten Island. Designed as a freestanding and distinctly civic structure, the building is prominently located on a corner lot, set back behind a lawn and trees. The brick and stone library is a symmetrical composition, with a columned portico framing the entrance, large arched windows providing a light-filled reading room and a hipped roof with bracketed, overhanging eaves.

Influenced by the community that it served, the branch was known for its extensive collection of Danish and Norwegian books. During World War I, the library amassed books on shipbuilding, in response to the growing industry on Staten Island.

FIRE ENGINE COMPANY 7 AND HOOK & LADDER COMPANY 1

1904–5

100–104 DUANE STREET, MANHATTAN

ARCHITECTS: TROWBRIDGE & LIVINGSTON

DESIGNATED: SEPTEMBER 21, 1993

While typical firehouses are composed of one bay on narrow lots, this Beaux-Arts-style building has three bays, one for the hook and ladder company and two for engine company. In this neighborhood of tall buildings, engines were required to generate sufficient pressure for throwing water above eight stories. The companies, housed together since 1851, are among the oldest in New York (Hook & Ladder Company 1 was founded before the War of Independence), and together have protected both the City Hall area and the Financial District in Lower Manhattan. The west bay became a museum in 1920 and then the Bureau of Fire Communications offices in 1987; the eastern bays still house Companies 7 and 1.

The symmetrically massed facade is unified by superimposed elements of an Anglicized Italian palazzo. The building behind it is actually two distinct structures separated by a firewall. The ground floor, above a granite base, is boldly rusticated Indiana limestone ashlar with arched apparatus doorways, and the upper stories are gray brick with raised limestone bands. The building is topped by an entablature cornice and paneled parapet.

NYPL, PORT RICHMOND BRANCH

FIRE ENGINE COMPANY 7

BROOKLYN PUBLIC LIBRARY, DeKALB BRANCH

1904–5

790 BUSHWICK AVENUE, BROOKLYN

ARCHITECT: WILLIAM B. TUBBY

DESIGNATED: MAY 18, 2004

"The Brooklyn Public Library's DeKalb Branch, located in Bushwick, was constructed in 1904–5 as one of the first branch libraries built in the Borough of Brooklyn with the money provided by Andrew Carnegie's multi-million dollar gift. The neighborhood's tremendous population growth during the last decade of the nineteenth and first decade of the twentieth century necessitated a variety of civic services including a public library.

The DeKalb Branch was the first of five library designs by noted architect William B. Tubby, who served on the Architects' Commission for the Brooklyn Carnegie branches. This building followed the stylistic guidelines agreed upon by that group: a freestanding, brick and limestone building in the Classical revival style. Its double-height windows provided much light and air for the users of the building while the rounded apse at the rear allowed for a spacious two-story area for book stacks.

Except when closed for renovations, the library has served this densely populated area of Brooklyn for a century, and, with its recent refurbishing, continues to contribute a distinguished civic presence to the neighborhood."*

BPL, DEKALB BRANCH LIBRARY

STATEN ISLAND BOROUGH HALL

1904–6

RICHMOND TERRACE, STATEN ISLAND

ARCHITECTS: CARRÈRE & HASTINGS

DESIGNATED: MARCH 23, 1982

The borough of Staten Island commissioned Carrère & Hastings to design a new borough hall as a symbolic demonstration of the island's importance in the recently consolidated Greater New York. When completed, the building rivaled the borough halls of Brooklyn and the Bronx as a significant public structure.

The exuberant nature of the Louis XIII style is tempered by the rational planning inculcated by Beaux-Arts training. The building is organized symmetrically on a five-part plan consisting of a five-bay central section, two recessed hyphens each one bay wide, and two projecting wings, each two bays wide. The ground floor is limestone; above it are two stories of brick with limestone trim, surmounted by a two-story mansard roof. In the central section, the main entrance is recessed below a round arch flanked by four segmental arched windows. The base of the central section

STATEN ISLAND BOROUGH HALL

carries an engaged Doric colonnade between limestone piers. In the wings, the Flemish bond brickwork is further animated by limestone window enframements, spandrels, and an elaborate cornice. In the mansard, a variety of window styles is seen above the cornice; smaller shed dormers light the top floor.

When the building opened, the *New York Times* lamented that it had "to hobnob with wooden and brick structures of no distinction whatever." Today it stands at the political center of a borough that is an increasingly vital element of New York City.

PUBLIC BATHS

1904–6; 1989–90

EAST 23RD STREET AND ASSER LEVY PLACE, MANHATTAN

ARCHITECTS: ARNOLD W. BRUNNER AND WILLIAM MARTIN AIKEN

DESIGNATED: MARCH 19, 1974

In the late nineteenth century, charitable organizations and social reformers lobbied strongly for city governments to provide public sanitation and recreation

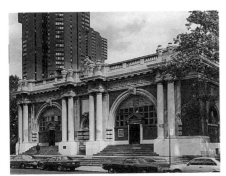

PUBLIC BATHS

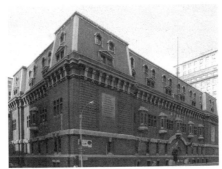

69TH REGIMENT ARMORY

69TH REGIMENT ARMORY

1904–6

68 LEXINGTON AVENUE, MANHATTAN

ARCHITECTS: HUNT & HUNT

DESIGNATED: APRIL 12, 1983

facilities to help improve living conditions in densely populated slums. The sanitation facilities in tenements were often inadequate or nonexistent. Reformers blamed overcrowded and filthy conditions for everything from periodic outbreaks of cholera and typhus to what was perceived as the decline of domestic values and morality.

Private organizations had provided bathing facilities based on contemporary European establishments since the 1850s, but these facilities proved insufficient by the 1890s. Lobbyists argued that only municipal funding for a citywide system could serve slum dwellers' needs. In 1894, the New York City Tenement House Commission, a special advisory board, concurred. The Panic of 1893, however, delayed appropriation of funds; these were allocated only through the intervention of newly elected Mayor Seth Low in 1901. Between 1902 and 1915, thirteen bathhouses were built for $2 million, making New York City's system the largest in the country. Today, nine bathhouses remain.

Arnold W. Brunner, who was associated with earlier sanitation reform movements and who also built community

hospitals and public schools, based his design for the East 23rd Street baths on ancient Roman models. The East 23rd Street bathhouse was one of the first to provide both recreational and bathing facilities. It is a one-story brick and limestone building with four pairs of freestanding columns articulating three internal divisions. Men and women had separate waiting rooms and shower areas, marked by the large thermal windows facing 23rd Street. A fountain, whose stonework simulates falling water, announces the building's function and marks the interior glazed pool area used by both sexes. A large swag-decorated shield, bearing the seal of New York City, rises above the balustrade.

Following the restrictive immigration laws of 1923 and the increasing number of tenements built with sanitation facilities, use of public baths dropped off; by the 1950s, the baths had been converted to community facilities or demolished. Restored in 1989–90 by the Department of Parks and Recreation, the East 23rd Street baths serve now as a recreation and community center.

The 69th Regiment Armory was the first building of its type to reject the medieval fortress prototype used for Manhattan armories built between 1880 and 1906. Instead, this armory synthesizes the classically inspired design principles of the Ecole des Beaux-Arts with a clear expression of military function. The armory, occupying much of the block bounded by 25th and 26th Streets and Lexington and Park Avenues, is an unadorned brick structure, composed of two standard elements of armory design: an administrative building and a drill hall rising behind.

The armory served as a training and marshaling center for the National Guard. It is also the home of "The Fighting 69th," an Irish regiment that distinguished itself in the Civil War and the two World Wars. In 1913, the 69th Regiment Armory was the site of the *International Exhibition of Modern Art*, popularly known as the Armory Show. The exhibition changed the course of American art by introducing then-revolutionary European and American art forms to a wider public.

GORHAM BUILDING

1904–6

390 FIFTH AVENUE (ALSO KNOWN AS
2–6 WEST 36TH STREET),
MANHATTAN

ARCHITECTS: MCKIM, MEAD & WHITE

DESIGNATED: DECEMBER 15, 1998

The Gorham Building was among the first and most elegant commercial palaces built on Fifth Avenue north of 34th Street. This building housed show-rooms, offices and workshops for the Gorham Manufacturing Company, an internationally renowned silversmith. Stanford White was praised for the careful detailing and artistry of the eight-story building, itself an adaptation of an early Florentine Renaissance style palazzo. The tripartite composition juxtaposes the elaborately decorated base and capital with the muted midsection. The base, an elaborate two-story arcade, today is only visible on the West 36th Street facade due to alterations on the Fifth Avenue storefronts. Crowning the facade is a copper cornice (originally polychromed and gulded on the underside) that projects eight feet from the building. Notable facade elements include a bas-relief sculpture carved by Andrew O'Connor and ornamental bronze balconies and friezes, designed by White and executed by Gorham. Since the Gorham Company moved uptown in 1923, tenants of the building have continuously used the space for commercial purposes.

GORHAM BUILDING

ST. LUKE'S–ROOSEVELT HOSPITAL CENTER

ST. LUKE'S–ROOSEVELT HOSPITAL CENTER, FORMERLY PLANT AND SCRYMSER PAVILIONS FOR PRIVATE PATIENTS

1904–6, 1926–28

401 WEST 113TH STREET AND 400
WEST 114TH STREET, MANHATTAN

ARCHITECT: ERNEST FLAGG

DESIGNATED: JUNE 18, 2002

St. Luke's Hospital is one of a number of institutions that moved north to Morningside Heights at the turn of the

century, joining Columbia University and the Cathedral of St. John the Divine on the "Acropolis" of Manhattan. Ernest Flagg was awarded the St. Luke's com-mission by Cornelius Vanderbilt II, chairman of the hospital's executive committee and husband of Flagg's cousin.

Flagg designed the building with a French inspired Renaissance Revival plan, consisting of nine pavilions sym-metrically arranged around a central domed administrative building. This popular pavilion plan was used by hos-pitals to hinder the spread of germs and increase light and fresh air in the build-ing. During the first phase of construc-tion from 1893 to 1896, only five of the nine pavilions were built. The Plant and Scrymser Pavilions, two of the six sur-viving buildings by Flagg, were added in 1904–6 and 1926–28, respectively.

Margaret J. Plant, who inherited her husband's railroad, steamship, and hotel fortune, was a major philanthropist and generously donated to the hospital. From her bequest, the eight-and-a-half-story Plant Pavilion was built to provide facilities for wealthy private patients and helped to subsidize other hospital pro-grams. In keeping with the master plan, the C-shaped pavilion and its French Renaissance Revival facades are similar to the early buildings with variations in ornamental detail and the addition of wrought-ironwork.

The nine-story Scrymser Pavilion was named in honor of James A. Scrymser, who was responsible for laying of the telegraph cable lines that connected North and South America, was the eighth and last building designed by

TREMONT BAPTIST CHURCH

Flagg for the hospital. Scrymser's widow, Mary Catherine, inherited his fortune and in turn bequeathed a large sum to St. Luke's. The Scrymser pavilion is simpler in design, without much of the French Renaissance Revival ornament; it featuresupper terraces and a loggia instead of a mansard roof.

The hospital became affiliated with Columbia University in 1971 and merged with Roosevelt Hospital in 1979; it now operates as St. Luke's–Roosevelt Hospital Center.

TREMONT BAPTIST CHURCH

1904–6; 1911–12

324 EAST TREMONT AVENUE, THE BRONX

ARCHITECT: WILLIAM H. BIRKMIRE

DESIGNATED: FEBRUARY 8, 2000

The Tremont Baptist Church is a distinctive example of a neo-medieval auditorium church in the Mt. Hope section of the Bronx, its picturesque composition taking advantage of the unusual site. Built in response to a population influx and an increased Baptist presence in

New York City, the church is a rare ecclesiastical project by William Birkmire, who specialized in commercial buildings. The foundation and basement of the church were built in 1904–6 and services were held there until the rest of the church was completed in 1912. Polygonal in plan, Birkmire's design for the church drew on the early English Gothic style with its imposing gray marble facade and intersecting gables offset by a crenellated tower at the southeast corner. Five buttressed bays follow the curve of East Tremont Avenue and are embellished with pointed arched window openings, stained glass, tracery and cusping in smooth marble surrounds. With few changes to the facade and an established and vital congregation, the church remains an important civic and architectural presence in the neighborhood.

SUPREME COURT OF THE STATE OF NEW YORK, QUEENS COUNTY, LONG ISLAND CITY BRANCH

1872–76; REBUILT, 1904–8; 1970S

25–10 COURT SQUARE, QUEENS

ARCHITECTS: GEORGE HATHORNE; RECONSTRUCTION, PETER M. COCO

DESIGNATED: MAY 11, 1976

Constructed between 1872 and 1876 and rebuilt shortly after the turn of the century, the Long Island City Courthouse is a monument to the years when Long Island City served as the seat of Queens County. The building was also the setting

SUPREME COURT OF THE STATE OF NEW YORK, QUEENS COUNTY

for many sensational trials, notably the murder trial of Ruth Snyder and her lover, Henry Judd Gray, in 1927, and the trial of the notorious bank robber Willie Sutton. Characterized by a bold fenestration and firm symmetry, the present English Renaissance–style building replaced a French Second Empire–style one designed by George Hathorne. After a fire in 1904, the building was remodeled by the architect Peter M. Coco. He replaced its mansard roof with two additional stories, razed the two central towers, and removed the exterior detail. A huge stained glass skylight, reputed to be the largest in New York State, decorates the third-floor courtroom. The Queens County Court was located in the courthouse until 1932, when it moved to accommodate the State Supreme Court. In addition, the building housed other judiciary services until the 1970s, when the Supreme Court took over the entire structure.

385

AMERICAN ACADEMY OF DRAMATIC ARTS

AMERICAN ACADEMY OF DRAMATIC ARTS, FORMERLY THE COLONY CLUB

1905

120 MADISON AVENUE, MANHATTAN

ARCHITECTS: McKIM, MEAD & WHITE

DESIGNATED: MAY 17, 1966

The first private women's club in New York to build a clubhouse, the Colony Club was primarily a social club, with overtones of good works—namely, patronage of the arts. It was founded in 1901 by Anne Morgan (sister of J. Pierpont Morgan), Mrs. J. Borden Harriman, and Helen Barney.

The clubhouse at 120 Madison Avenue, designed by Stanford White, opened in 1906. It was built to accommodate a swimming pool, assembly rooms, a gymnasium, dining quarters, a roof garden, bedrooms, and a tea room—all within a six-story building that retains its domestic character. The graceful Federal Revival facade is constructed of grayish red brick with white limestone trim. The whole is dominated by five tall windows on the second floor, set within recessed arches. The beautiful stone cornice is crowned by a perforated railing separating the lower floors from the roof with its five small dormers.

In an admirable example of sympathetic reuse, the clubhouse has served since 1963 as the home of the American Academy of Dramatic Arts. Founded in 1884, the academy is the oldest school of professional dramatic training in the English-speaking world. For over a century it has produced some of this country's most illustrious actors and actresses, among them Spencer Tracy, Kirk Douglas, Lauren Bacall, Rosalind Russell, and Edward G. Robinson.

NEW YORK PUBLIC LIBRARY, HAMILTON GRANGE BRANCH

1905–6; ALTERATIONS, 1973–76

503–505 WEST 145TH STREET, MANHATTAN

ARCHITECTS: McKIM, MEAD & WHITE

DESIGNATED: MARCH 31, 1970

In true Italian Renaissance style, the facade of the Hamilton Grange Branch is symmetrical. The central entryway is emphasized by a cartouche bearing the seal of the City of New York, and the central second-floor window is surmounted by an arched pediment. The large, round-arched openings of the first floor give way to rectangular, pedimented windows on the second story; on

NYPL, HAMILTON GRANGE BRANCH LIBRARY

both floors, the large windows alternate with narrower windows. On the third floor are five small windows of equal size. The strong verticality created by the narrow windows is balanced on the upper floors by the horizontal belt courses and on the first floor by the illusion of weightiness in the rustication.

The library was extensively rehabilitated between 1973 and 1976. Although the exterior remained largely unchanged, the main entrance was lowered to street level to provide easier access for the elderly and handicapped. The Hamilton Grange library has a particularly strong collection of books on black history and culture, and also holds many volumes in Spanish.

35-34 BELL BOULEVARD

35-34 BELL BOULEVARD

1905

QUEENS

ARCHITECT: UNKNOWN

DESIGNATED: OCTOBER 19, 2004

"35-34 Bell Boulevard is a rare example of a house built from cobblestones in New York City. Located on a commercial street in Bayside, Queens, construction of the 2-story structure began in late 1905 and was completed in 1906. The architect, who has yet to be identified, adopted various features associated with both the Colonial Revival style and the Arts and Crafts movement. Composed in a symmetrical manner, the front and rear facades are divided by three arched bays, each crowned with a pedimented window. The walls consist of tan or gray stones that are neither cut, shaped, nor sized. The use of such rugged materials, set in concrete, is one of the building's most distinguishing characteristics.

Residential subdivisions began to slowly replace farms in this area during the 1870s. These changes were closely tied to transit improvements and in 1904 the Rickert-Finlay Realty Company acquired the last one hundred acres of the Abraham Bell farm. Stone walls were frequently used to mark property boundaries and it is possible that cobblestones were chosen to evoke Bayside's fleeting agricultural past. To honor the former owners, the development was named Bellcourt and pairs of cobblestone pillars were erected along what is now Bell Boulevard. Only the pair on the west side of the intersection at 36th Avenue survives and the north pillar is located within the landmark site. The house, among the earliest built in Bellcourt, was owned by Elizabeth A. Adams, of Yonkers, New York, from 1905 to 1922. In subsequent years, it was leased for commercial use and converted to apartments in the early 1930s. The building is well maintained and aside from alterations to the front porch on the ground floor, this unusual house retains many of its original features, most notably the cobblestone walls, arched elevations, recessed porches, and a red tiled roof."*

ERASMUS HALL HIGH SCHOOL, IN THE COURTYARD OF ERASMUS HALL

1905–6, 1909–11, 1924–25, 1939–40

899–925 FLATBUSH AVENUE (ALSO KNOWN AS 2212–2240 BEDFORD AVENUE), BROOKLYN

ARCHITECTS: C.B.J. SNYDER, WILLIAM GOMPERT, ERIC KEBBON

DESIGNATED: JUNE 24, 2003

ERASMUS HALL HIGH SCHOOL

Erasmus Hall High School, originally founded as Erasmus Hall Academy by Dutch settlers in 1786, is the oldest secondary school in New York State. The school was originally housed in a clapboard-sided building, built in 1787 (p. 73), which was later donated to the Brooklyn Board of Education and converted to a public school in 1896. At the beginning of the century, the school attempted to keep up with the rapid growth of Brooklyn, many of whom were immigrants, by adding several wings and purchasing nearby buildings. By 1904, C.B.J. Snyder had drawn up plans for a series of buildings arranged around the old school building on a grassy quadrangle; each building was to be built as needed.

Erasmus Hall, designed in Snyder's trademark collegiate Gothic style, was meant to invoke Oxford and Cambridge Universities. The buff brick facades are trimmed with limestone and terra-cotta, and the building features a central tower with a Tudor arched entry and oriel windows, stone tracery and crenellated parapets. Constructed in four sections, the two later buildings were supervised by William Gompert and Eric Kebbon.

Less ornamentation was used, but general characteristics of Snyder's buildings were employed in order to maintain the visual unity of the campus.

Alumni from New York City's oldest high school include Barbra Streisand, Beverly Sills, Bobby Fisher, Bernard Malamud, Neil Diamond, and many others. The campus is still active, although in 1995, the building was internally sectioned off into specialized high schools—High School for the Humanities and High School for Business and Technology— sharing common facilities. The Academy building was renovated a few years ago, but it is in deteriorating condition. A group of alumni are trying to raise funds for restoration, including replacing the dormers, repairing damaged plaster, and replacing exterior siding.

FIRE ENGINE COMPANY NO. 23

1905–6

215 WEST 58TH STREET, MANHATTAN

ARCHITECT: ALEXANDER H. STEVENS

DESIGNATED: AUGUST 29, 1989

This limestone and red-brick Beaux-Arts–style firehouse served as a model for later firehouse design. Although the Fire Department continued to commission individual architects, by 1904 a program of in-house construction was instituted by the superintendent of buildings, Alexander H. Stevens. His plans for No. 23 became a prototype for future firehouses constructed through the 1920s. The building's symmetry, the

FIRE ENGINE COMPANY NO. 23

height of its windows, and Stevens's choice of materials work together to suggest a sober, official structure.

Fire Engine Company No. 23 has been on West 58th Street for more than one hundred years; it moved from 69th Street to a new firehouse at 233 West 58th Street (now demolished) in 1884. The company has helped to put out some of the most notable fires in New York history: the oceanliner *Normandie* (1940); the Empire State Building airplane crash (1945); the Times Tower and the Mayflower Hotel (1960); and Trump Tower, during its construction (1980).

AVENUE H SUBWAY STATION

1905–6

802 EAST 16TH STREET, BROOKLYN

ARCHITECT: UNKNOWN

DESIGNATED: JUNE 29, 2004

"The Avenue H station on the BMT line,

AVENUE H SUBWAY STATION

originally the Brooklyn, Flatbush & Coney Island Railroad, built in 1906, is the city's only shingled wooden cottage turned transit station house. Often compared to a country train stop, it originally served as a real estate sales office for developer Thomas Benton Ackerson to sell property in the adjacent neighborhood of Fiske Terrace, an early twentieth century example of planned suburban development. The structure, with a hipped and flared roof and wraparound porch, evokes in miniature the area's Colonial Revival and Queen Anne houses. After nearly a century of commuter traffic, the Avenue H station remains in service and retains much historic fabric, from a corbelled chimney to peeled-log porch columns. It is one of a very small number of wood-frame station houses surviving in the modern subway system, the only station adapted from a structure built for another function, and the only surviving station from Brooklyn's once-extensive network of surface train lines."*

TRINITY BUILDING

TRINITY BUILDING

1905–7

111 BROADWAY, MANHATTAN

ARCHITECT: FRANCIS H. KIMBALL

DESIGNATED: JUNE 7, 1988

The Trinity Building's picturesque roofline, together with Trinity Church next door, the United States Realty Building, and the Woolworth Building, creates a striking Gothic silhouette on lower Broadway. The building extends the full length of the block between Broadway and Trinity Place. The United States Realty and Construction Company commissioned this skyscraper to use as speculative office space at a time when major American businesses were establishing themselves in Lower Manhattan.

While the Gothic style suggested scholasticism and spirituality—both thought incompatible with the image of capitalism—a few massive, Gothic skyscrapers like this one made a great impact on Manhattan's skyline. The cathedral-type tower this building anticipated emerged a few years later, in 1911, with Cass Gilbert's soaring Woolworth tower (p. 434).

Architect Francis Kimball, a Gothic revivalist, decided the ecclesiastical style best suited a commercial building that would flank one side of Trinity Church (p. 120). The steel-framed, twenty-one-story building sheathed in Indiana limestone exemplifies Kimball's innovative engineering techniques. Most impressive is the fact that the tower is set on fifty concrete caissons sunk into bedrock using a pneumatic process in order to avoid disturbing the soil. The building and its companion, the United States Realty Building (built by Kimball two years later, p. 404) set world records for construction time and were, at a cost of over $15 million, the most expensive commercial buildings of their era.

131–135 EAST 66TH STREET

1905–7

MANHATTAN

ARCHITECTS: CHARLES A. PLATT AND SIMONSON, POLLARD & STEINAM

DESIGNATED: MARCH 31, 1970

Eleven stories high, this distinguished apartment house was skillfully designed to make a relatively tall building seem

131–135 EAST 66TH STREET

hardly taller than its five-story neighbors. The heavily rusticated base is actually three stories high, and the fifth- and sixth-story windows are framed in stone to make them look as though they were one story. A series of horizontal bands and cornices break up the remaining height of the building, while the windows of the entablature are lost within the shadows of the overhanging cornice. This building is considered one of the finest examples of the Italian Renaissance palazzo style adapted to a New York apartment house. This cooperative was the first design by Charles A. Platt in association with the firm that specialized in the design of buildings with double-height artist's studios and duplex living quarters. Platt moved into this building upon its completion.

389

THE PLAZA

The Plaza

1905–7

FIFTH AVENUE AND WEST 59TH
STREET, MANHATTAN

ARCHITECT: HENRY J. HARDENBERGH

DESIGNATED: DECEMBER 9, 1969

The celebrated Plaza hotel sits majestically at the corner of Fifth Avenue and 59th Street overlooking Central Park and Grand Army Plaza. When it opened on October 1, 1907, the Plaza was described quite simply as "the greatest hotel in the world"; imposing, elegant, and opulent, it was destined to attract a fashionable and affluent clientele.

The Plaza was built at a cost of $12.5 million—an amazing sum at the time; it replaced a smaller (400-room) hotel designed by George W. DeCunha. Hardenbergh's new Plaza was much grander, with 800 rooms, 500 baths, private fourteen- to seventeen-room apartments (whose tenants included the George Jay Gould family and the Alfred Gwynne Vanderbilt family), two floors of public rooms, ten elevators, five marble staircases, and a two-story ballroom.

The Plaza is based stylistically on the French Renaissance chateau. The main facades, one facing Central Park and the other Fifth Avenue, are organized along the lines of a classical column. A three-story marble base supports the ten-story white brick shaft. The capital, or crown, of the building, demarcated by a horizontal band of balconies and a heavy cornice, consists of a mansard slate roof of five floors with gables and dormers and a cresting of green copper. The facades are unified vertically by recessed central bays and projecting corner towers. Hardenbergh claimed that the site on the park helped to determine the simplicity of his design.

To attract and impress its illustrious visitors and tenants, the Plaza was outfitted in rich woods and lavish ornamentation. Much of the interior decoration and furnishing came from Europe. Although the hotel has since undergone a series of renovations and refurbishings, most of its original grandeur remains. The Palm Court (formerly the Tea Room), just off the Fifth Avenue entrance, still has its four Italian caryatids representing the four seasons, and its mirrored walls, but the splendid Tiffany leaded-glass domelight was removed in the 1940s.

In early 2005, new owners announced a plan to convert the Plaza to condominium apartments and retail space, retaining only a small percentage of the rooms for hotel use.

Former Stuyvesant High School

1905–7

354 EAST 15TH STREET (ALSO KNOWN
AS 331–351 EAST 15TH STREET AND
326–344 EAST 16TH STREET),
MANHATTAN

ARCHITECT: C.B.J. SNYDER

DESIGNATED: MAY 20, 1997

Originally a "manual training" school for boys, the former Stuyvesant High School was one of the first built after the consolidation of the New York City boroughs in 1898 and the subsequent creation of a citywide system of public education. The five-story, H-plan building has two side courts that provide light and ventilation. Designed in a Beaux-Arts style with distinctive classical and secessionist detail, the main facade on East 15th Street is clad in tan brick and limestone with stone ornament, and is dominated by a pedimented entrance pavilion flanked by three bays of windows. The East 16th Street facade is red brick above a limestone

FORMER STUYVESANT HIGH SCHOOL

base, with "Stuyvesant High School" inscribed above the entrance.

Stuyvesant quickly became one of the most prestigious high schools in the city, noted for mathematics, technology, and especially the sciences. Since the 1930s, admission has been based on a competitive entrance examination. In 1967, a Brooklyn girl sued the Board of Education to gain admission to Stuyvesant, and the subsequent court decision opened the school to girls in 1969. In 1992, Stuyvesant High School relocated to a new facility in Battery Park City. The original building remains in use by the High School for Health Professionals, the Institute for Collaborative Education, and P.S. 226, a special-education program.

DARRYL ROTH THEATRE, FORMERLY AMERICAN SAVINGS BANK, ORIGINALLY UNION SQUARE SAVINGS BANK

1905–7; 1998

20 UNION SQUARE WEST (ALSO KNOWN AS 101–103 EAST 15TH STREET), MANHATTAN

ARCHITECT: HENRY BACON

DESIGNATED: FEBRUARY 13, 1996

This bank, originally the Institution for Savings of Merchants' Clerks, was founded in 1848 to "encourage clerks . . . to take care of their earnings." Half a century later, the bank realized that its name was no longer suitable to an institution that had depositors of all professions, and so it changed its name to the Union Square Savings Bank.

The bank building is one of the largest and best-known banks designed by Henry Bacon, who also designed the Lincoln Memorial in Washington, D.C. The Union Square Bank is a flat-roofed building covered in Troy white granite. The main facade design is a freestanding portico on four fluted Corinthian columns supporting the entablature and parapet. Above the columns is a cornice with dentils, egg-and-dart moldings, and carved faces of lions.

In 1998, the building underwent exterior restoration and interior redesign. The bank now houses the Daryl Roth Theatre with the 99-seat DR2 Theatre in the adjacent garage.

A contemporary sign that features the current production now covers the frieze, which bore the original bank name, carved wreaths, and a beehive.

DARRYL ROTH THEATRE

WEST STREET BUILDING

West Street Building

1905–7; 2003

90 West Street and 140 Cedar
Street, Manhattan

Architect: Cass Gilbert

Designated: April 14, 1998

Significantly damaged in the terrorist
attacks on September 11, 2001, this
building was once considered a
transition between the early "base-shaft-
capital" skyscraper designs of the late
nineteenth century and the romantic
towers exemplified by the Woolworth
Building. Cass Gilbert, one of New York
City's most renowned skyscraper archi-
tects, designed it, as well as the ornate
Woolworth Building (p. 434), which
marks the end of this transition.

Gilbert's pioneering design includes
Gothic influences, which are also con-
sidered unusual for this time period, but
foreshadow his later masterpiece for
F. W. Woolworth. Clustered piers in the
middle section anticipate exploration of
vertical elements in future skyscraper
design.

Appropriately, the building, which
had been conceived as a center for the
shipping and railroad industries, was
highly visible from the Hudson River.
Atop the building, The Garret Restaurant
offered diners panoramic river and city
views, billing itself as the highest
restaurant in New York.

Much of the north facade was gouged
by flying steel debris from the collapse
of the South Tower of the World Trade
Center. The building burned for twenty-
four hours, but the original construc-
tion, including structural steel columns
encased in thick clay tile, are credited
with saving the building from complete
destruction. Covered in a 23-story
shroud and scaffoldings for over than
two years after the attack, 90 West Street
is being brought back to life. Most of
the interior was gutted, followed by a
painstaking restoration. Working from
historic photographs, original elements
discovered in the debris were incorpo-
rated in the lobby, including the 1907
decorative frieze, and cast-iron embel-
lishments. Israeli-based Brack Capital
Real Estate purchased the building in
2003 with plans to restore the property
as an apartment building.

MESSIAH HOME FOR CHILDREN

Messiah Home for Children

1905–8; restoration, 1978

1771–1777 Andrews Avenue South,
The Bronx

Architects: Charles Brigham;
restoration, Castro-Blanco,
Piscioneri & Feder

Designated: June 24, 1997

Constructed for the Messiah Home for
Children, an orphanage, this building
occupies a site donated by Standard Oil
magnate Henry H. Rogers in 1902. The
construction was underwritten by
Rogers and designed by Charles
Brigham, a prominent Boston architect.
Brigham chose a Jacobethan Revival
style marked by towers and turrets,
numerous dormers, including some
with Flemish gables, and an array of
deep-set, transomed windows for the
elaborate structure.

The term "Jacobethan" is a combina-
tion of the terms Elizabethan and
Jacobean. This architectural style is a
nineteenth-century revival of the
Jacobean design style developed during
the reign of King James I (1603–25),
which was essentially a later version of

the style from the reign of Elizabeth. Originally developed during the High Renaissance in Italy, the Jacobethan style was revived in England in the 1830s, becoming more elaborate toward the century's end. Around this time, American architects were searching for design precedents for large institutional structures in the United States, and the large estates of Europe proved useful as models. Bingham referred to these manor houses for his symmetrically composed and elaborately embellished early-twentieth-century designs.

The Salvation Army purchased the building in 1920 for use as a training college for cadets, adding a temporary lecture hall in 1921. In 1958–60, the Salvation Army also constructed a five-story brick-and-concrete dormitory building, connected by a one-story passageway, to the east of the original structure. (This addition is not included in the designation.) The organization occupied the building until 1975.

In 1978, the City of New York and the U.S. Department of Labor joined forces to rehabilitate the structure for use as a Job Corps training center. Restoration, which included the repair and cleaning of the masonry, the replacement of window sashes and roof shingles, and the re-creation of the original copper trim with a new copper substitute, was executed by the architectural firm of Castro-Blanco, Piscioneri & Feder. The City of New York still owns the building.

POLICE BUILDING APARTMENTS

1905–9; 1987

240 CENTRE STREET, MANHATTAN

ARCHITECTS: HOPPIN & KOEN; EHRENKRANTZ & ECKSTUT

DESIGNATED: SEPTEMBER 26, 1978

On May 6, 1905, Mayor George B. McClellan laid the cornerstone of the new police headquarters during a ceremony filled with marching bands and mounted troops. Hailed by the press as the most up-to-date building of its kind, it was the result of police reform and reorganization begun in the late nineteenth century.

The Municipal Police Act of 1884 had abolished the antiquated "night watch" system and established the police force as we now know it. Under this act, the seventeen wards of the city were divided into precincts, each with its own station house, captain, and sergeant. Officers received a manual that outlined their duties and legal powers. They did not, however, accept the role of "public servant"; the officers refused to wear the proposed blue uniform, which was reminiscent of servants' livery. A star-shaped copper badge (from which the expression "cop" derives), was worn over the left breast, and identified the early police force.

By 1900, the New York City police force had become the most sophisticated and largest in the country, and clearly required new headquarters. In 1903, Francis L. V. Hoppin and Terence A. Koen designed the new headquarters for a wedge-shaped site, bounded by Grand,

POLICE BUILDING APARTMENTS

Centre Market Place, Centre, and Broome Streets. The building is a monument both to the growing municipal consciousness of New York and the new, professional police force. The main facade is reminiscent of the English Baroque of Sir Christopher Wren. The colossal Corinthian columns in the main portico and end pavilions, the rustication carried through the attic story, and the vigorously plastic central dome produce lively contrasts of highlight and shadow.

In 1973, the Police Department left the building for new headquarters at 1 Police Plaza. The city tried to find new uses for the old structure through the late 1970s, but met with little success. Finally, in 1987, Fourth Jeffersonian Associates acquired the property, and the firm of Ehrenkranz & Eckstut extensively restored and renovated the building into luxury apartments.

B. ALTMAN ADVANCED LEARNING SUPERBLOCK

B. ALTMAN ADVANCED LEARNING SUPERBLOCK, FORMERLY B. ALTMAN & CO. DEPARTMENT STORE

1905–13; 1999

355–371 FIFTH AVENUE, MANHATTAN

ARCHITECTS: TROWBRIDGE & LIVINGSTON; GWATHMEY SIEGEL & ASSOCIATES

DESIGNATED: MARCH 12, 1985

Located on the northeast corner of East 34th Street and Fifth Avenue, the B. Altman & Co. department store building is a stately and elegant example of American commercial design and a landmark in the cultural history of New York City.

B. Altman & Co. began as a mid-nineteenth-century storefront dry-goods shop operated on Third Avenue and East 10th Street by Benjamin Altman and his father. In 1874, the family store moved to Sixth Avenue, at West 18th Street—the city's newly fashionable retail location. By the turn of the century, B. Altman & Co. had established itself as a world leader in fine dry goods, especially as a purveyor of exquisite silks, satins, and velvets. In a trend-setting move, the store acquired land in a newly commercial area—34th Street and Fifth Avenue—and Altman commissioned Trowbridge & Livingston to design a new home for his company. Within a few years of the building's opening, B. Altman was joined by such distinguished commercial establishments as W. & J. Sloane, Arnold Constable & Co., and Bergdorf Goodman. Fifth Avenue

was quickly transformed from a street lined with town houses to a world-renowned commercial boulevard.

Trowbridge & Livingston employed an Italian Renaissance palazzo design that echoed the style of many of the residences that lined the avenue. The facade of French limestone, a material previously used only on residential buildings, blended well with those of neighboring structures. The two-story base is punctuated with tall, recessed-arch window bays separated by Corinthian pilasters; the entrances on Madison and Fifth Avenues are marked by impressive projecting portals, each articulated by elegantly fluted Corin-thian columns.

In 1989, B. Altman closed. Under the direction of Gwathmey Siegel, the exterior was restored and the interior reconfigured to house three institutions, the New York Public Library, Science, Industry and Business Library; Oxford University Press; and the City University of New York, Graduate School and University Center, including WNYC-TV.

BRONX BOROUGH COURTHOUSE

1905–15

EAST 161ST STREET BETWEEN BROOK
AND THIRD AVENUES, THE BRONX

ARCHITECT: MICHAEL J. GARVIN

DESIGNATED: JULY 28, 1981

Designed by local architect Michael J. Garvin, the Bronx Borough Courthouse was erected to serve various borough courts. The building was officially opened in January 1914, when the Bronx assumed the powers and responsibilities of a county in New York State.

The four-story granite Beaux-Arts building occupies an entire block and can be seen from all sides. Its symmetrical classical design includes central pavilions that project from the north and south elevations; these are punctuated by deeply recessed windows and double-height arched entrances.

The two-story base is faced with stone rustication; stylized voussoirs surmount the first-story windows, becoming archivolts at the arched entrances. The upper stories form a single architectural unit and are faced with smooth granite bands. Two-story pilasters flank the window bays and form corner piers. On the East 161st Street elevation, two window bays flank monumental columns, which in turn frame a recessed central section with an arched window opening. An allegorical figure of Justice, by the French-born sculptor J. E. Roine, sits in this alcove over the entrance. The courthouse has been restored by the New York City Department of General Services.

VERDI SQUARE

1906; 1996–97

BROADWAY AT WEST 72ND STREET,
MANHATTAN

DESIGNATED: JANUARY 28, 1975

Verdi Square, a triangular lot in the northern part of Sherman Square, is a charming green that once lay within the old village of Harsenville—one of the many hamlets that arose along the old Bloomingdale Road, which was widened and renamed Broadway in 1849.

This small green honors the great Italian composer Giuseppe Verdi. The centrally located statue, sculpted by Pasquale Civiletti—brother of the noted Sicilian sculptor Benedetto Civiletti—was unveiled on October 12, 1906. The heroic Verdi, executed in Carrara marble, stands on a fifteen-foot base encircled by four lifesize figures from Verdi's operas: *Aïda*, *Falstaff*, *Otello*, and *La Forza del Destino*. The statuary was restored in 1996–97.

BRONX BOROUGH COURTHOUSE

VERDI SQUARE

395

20 VESEY STREET

BPL, PARK SLOPE BRANCH LIBRARY

20 VESEY STREET, FORMERLY THE NEW YORK EVENING POST BUILDING

1906

MANHATTAN

ARCHITECT: ROBERT D. KOHN

DESIGNATED: NOVEMBER 23, 1965

The former New York Evening Post Building is one of the few outstanding art nouveau buildings constructed in America, and more striking than Kohn's better-known Society for Ethical Culture (p.418) on West 64th Street. The fourteen-story steel-frame structure, veneered with stone, is more Continental than American, reminiscent of the buildings that line the boulevards of Paris. Its ornamentation includes three gently bowed cast-iron bays framed by tall limestone piers, an elaborate patinated copper mansard roof two stories high, and four elongated sculpted figures on the front of the building. Two of these figures are the work of Gutzon Borglum, who is also noted for his heroic busts of presidents at Mount Rushmore.

The building originally served as the headquarters of the New York Evening Post during Oswald Garrison Villard's ownership. The New York Landmarks Preservation Commission was headquartered here from 1980 to 1987.

BROOKLYN PUBLIC LIBRARY, PARK SLOPE BRANCH

1906

431 SIXTH AVENUE, BROOKLYN

ARCHITECT: RAYMOND F. ALMIRALL

DESIGNATED: OCTOBER 13, 1998

This is one of four branches designed by Raymond F. Almirall, who also planned the original central Brooklyn Public Library building. He served as secretary of the Architects' Advisory Commission, a group that assured consistency of individual design for Brooklyn branches, without restricting the architect's creative influence. Almirall's design takes advantage of the corner site, and the projecting columned entrance portico, oversized tripartite windows, and literary-themed stone ornaments make for an impressive, welcoming facade.

By the second half of the nineteenth century, Park Slope had become a popular residential area for middle- and upper-class professionals, as a result of the development of Prospect Park and the Brooklyn Bridge, which provided quick access to Manhattan. The original local library, a traveling library consisting of only books on natural history, was housed in Litchfield Villa in Prospect Park. Today the library collection remains housed in Almirall's building, and both are active parts of the Park Slope community.

NYPL, MUHLENBERG BRANCH LIBRARY

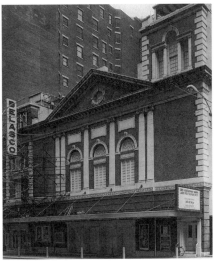

BELASCO THEATER

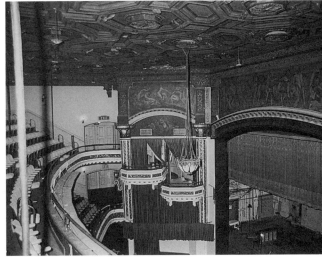

BELASCO THEATER INTERIOR

New York Public Library, Muhlenberg Branch

1906

209-211 West 23rd Street, Manhattan

Architect: Carrère & Hastings

Designated: June 30, 2001

The Muhlenberg branch was one of thirteen designed by Carrère & Hastings, also the architects of the Main Building of the New York Public Library (p. 329). The three-story masonry structure features an arched entrance, offset to one side, in line with two sizeable arched windows on the ground floor, attracting passers-by and bringing ample light into the reading room. At the upper stories, its symmetrical composition, featuring large rectangular window openings, are marked by carved pediments in the classical style.

The Muhlenberg Branch, the eleventh to be built, was named for William Augustus Muhlenberg, the first rector of the Church of the Holy Communion on West 20th Street. Today, the library collection includes works on the history of Chelsea and the local fashion industry.

Belasco Theater

1906–7; addition, 1909

111–121 West 44th Street, Manhattan

Architect: George Keister

Designated (exterior and interior): November 4, 1987

The sixth-oldest theater on Broadway, the Belasco is a monument to the genius and vision of its founder, David Belasco. One of the most important figures in the development of the American stage, Belasco was an actor, dramatist, manager, and director. He developed the Little Theater movement, which emphasized a close actor-audience contact best served in intimate, comfortable surroundings, and experimented with advanced methods of staging and lighting design that have had enduring significance in the modern theater.

Designed by architect George Keister under Belasco's close supervision, the theater was built in the Georgian Revival style, more commonly seen in residences and civic buildings than in the typical, classical theater designs of the day. The pedimented facade has towers with Palladian windows. Also included were a four-story pavilion for offices, and a ten-room rooftop duplex, added in 1909, which became Belasco's personal residence.

The interior of the theater featured an entrance lobby and doors by John Rapp, light fixtures by the Tiffany Studios, and eighteen mural panels by Ash Can School artist Everett Shinn. Adding to the opulence of the interior was the colored glass ceiling, illuminated from behind to create the effect of daylight.

FIRE ENGINE CO. 84 AND HOOK & LADDER CO. 34

FIRE ENGINE COMPANY 84 AND HOOK AND LADDER COMPANY 34

1906–7

513–515 WEST 161ST STREET, MANHATTAN

ARCHITECT: FRANCIS H. KIMBALL

DESIGNATED: JUNE 17, 1997

This monumental, double-company firehouse was built in Washington Heights at a time when Manhattan's expansion northward was transforming the area from a rural retreat to a residential neighborhood. The double-company firehouse was introduced in the early twentieth century, after New York City and its boroughs were consolidated in 1898 and municipal services were centralized.

The brick-and-limestone facade is an example of Beaux-Arts civic architecture. Its grand scale, clearly articulated sections, and heavy ornamentation reflect the rational planning and urban-design principles of the City Beautiful movement that influenced American urban planning at the turn of the century. Elaborate sculptural detail, overscaled window surrounds, and the use of rich materials create the firehouse's strong physical and symbolic presence. The two companies shared the building but operated separately, so the interior is divided by a firewall. Two separate vehicular entrances reflect this division, while the second- and third-story three-bay organization unites the facade. Limestone panels inscribed with the name of each company are placed above the entrances.

BANCA COMMERCIALE ITALIANA BUILDING, FORMERLY J.&W. SELIGMAN & COMPANY BUILDING AND LEHMAN BROTHERS BUILDING

1906–7; ALTERATIONS, 1929; ADDITION, 1982–86

1 WILLIAM STREET (ALSO KNOWN AS 1–9 WILLIAM STREET, 1–7 SOUTH WILLIAM STREET, AND 63–67 STONE STREET), MANHATTAN

ARCHITECTS: FRANCIS H. KIMBALL AND JULIAN C. LEVI

DESIGNATED: FEBRUARY 13, 1996

Originally the headquarters of J. & W. Seligman & Company, a prestigious investment-banking firm, this building is a rusticated, richly sculptural neo-Renaissance–style structure, drawn from the contemporary Baroque Revival in England. It was designed by Francis H. Kimball in association with Julian C. Levi, a graduate of the Ecole des Beaux-

BANCA COMMERCIALE ITALIANA BUILDING

Arts and a nephew of the Seligmans. Viewed from Wall Street, this building's vertical focus is on the tempietto-form tower rising from an awkward, quadrilateral base atop the building.

Beginning in 1929, Lehman Brothers, another distinguished investment-banking firm, used this building as its headquarters. A new corner entrance was added, and the original arched South William Street entrance was replaced with windows matching the William Street facade. The current owner, Banca Commerciale Italiana, one of Italy's largest banks, built an eleven-story addition clad in banded limestone and black granite. The addition, completed in 1986, complements the original structure in a streamlined contemporary style, and is marked by an ornamental, round, openwork metal turret, echoing the tempietto tower on the opposite corner of the original building.

HOOK AND LADDER COMPANY 17, ALSO NOW FIRE ENGINE COMPANY 60

1906–7

341 EAST 143RD STREET, THE BRONX

ARCHITECT: MICHAEL J. GARVIN

DESIGNATED: JUNE 20, 2000

This firehouse was constructed to provide a larger fire protection facility for this thickly populated neighborhood, and housed one of its first professional firefighting companies. In 1874, the year that the Bronx was annexed by New York City, Hook and Ladder Company 17 replaced the volunteer J. & L. Mott Ladder 2 Company and served the Mott Haven community from a small stationhouse on Third Avenue.

Architect Michael J. Garvin, Bronx County's first Commissioner of Buildings, also designed the Bronx County Courthouse (p. 395). Incorporating elements of the classical style, Garvin created a solid structure with rusticated end piers, carved stone ornament, and a strong cornice, all of which convey a sense of civic identity for the Bronx. The brick and stone facade of this firehouse features stone band courses, carved stone shields, swags, and brick-trimmed arches over the windows.

Fire Engine Company 60, organized in 1895 at 352 East 137th Street, was reassigned to this location in 1948, and continues to share the facility with Ladder 17.

APTHORP APARTMENTS

1906–8

2201–2219 BROADWAY, MANHATTAN

ARCHITECTS: CLINTON & RUSSELL

DESIGNATED: SEPTEMBER 9, 1969

The Apthorp Apartments, one of the Upper West Side's great central courtyard apartment buildings, reminiscent of Florence's Pitti Palace, was designed for the Astor Estate in the popular Italian Renaissance style.

The most conspicuous feature of this handsome, limestone-clad building is the use of rustication contrasted with the smooth ashlar masonry of the wall planes. Notable also is the adaptation of the three-story Renaissance palazzo design to a block-long, twelve-story edifice. The large wall planes of the facade are divided vertically into a three-story rusticated base, a smooth center portion, and two stories at the top with pilasters and windows just below the bold cornice. Instead of using quoins, the architects emphasized each corner by a wide band of rustication for its entire height. The monumental entrance archway, complete with ornate iron gateway and coffered ceilings and flanked by paired Corinthian pilasters capped with statues, creates a dramatic and commanding passageway to the drive-in courtyard. William Waldorf Astor named this apartment house after the very fine old Apthorp mansion that stood at West 91 Street and Columbus Avenue until 1892. At the time it was constructed, the building set a standard for luxury in apartment houses.

HOOK AND LADDER CO. 17, AND FIRE ENGINE CO. 60

APTHORP APARTMENTS

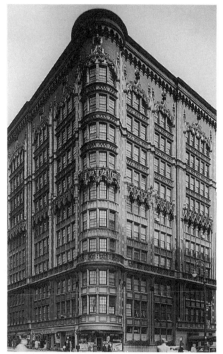

45 EAST 66TH STREET

45 EAST 66TH STREET

1906–8; 1987–88

MANHATTAN

ARCHITECTS: HARDE & SHORT

DESIGNATED: NOVEMBER 15, 1977

45 East 66th Street is a fine example of the luxury apartment houses that began to replace the opulent private mansions that lined the Upper East Side during the first decades of the twentieth century.

The picturesque building, with its distinctive corner tower, is among the earliest and most beautiful of its type to be built in the city. It rises ten stories with a penthouse above, and the ornate redbrick facade is trimmed with light-colored, Gothic-inspired terra-cotta details. The structure has an almost medieval quality that stands out in the neighborhood. The facades were restored in 1987–88.

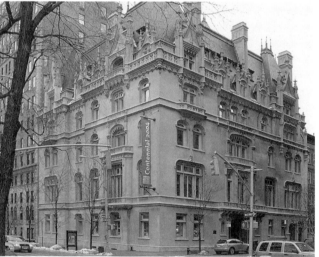

JEWISH MUSEUM

JEWISH MUSEUM, FORMERLY THE FELIX M. WARBURG MANSION

1906–8; ADDITION, 1993

1109 FIFTH AVENUE, MANHATTAN

ARCHITECT: C.P.H. GILBERT; ADDITION, KEVIN ROCHE

DESIGNATED: NOVEMBER 24, 1981

By the early 1900s, Fifth Avenue was known as "Millionaires' Row." The epitome of the Gilded Age, the avenue was lined with mansions that proclaimed the owners' unabashed enthusiasm for the beauty money can create.

Among the few surviving mansions, the Warburg Mansion is among the finest—an exceptionally handsome example of a "château" in the French Renaissance style. Constructed for Felix and Frieda Schiff Warburg, the house was designed by C.P.H. Gilbert, who had designed a house for Felix's brother Paul. Felix Warburg admired the Isaac D. Fletcher house, an elaborate François I–style mansion by Gilbert at East 79th Street and Fifth Avenue. Over the objections of his father-in-law, Jacob Schiff, who thought such an ostentatious style would encourage anti-Semitism, Warburg commissioned Gilbert to design a similar mansion.

The grand, lavishly ornamented building is faced in Indiana limestone, which allows for smooth wall surfaces and sharply defined ornate detailing. Above the five principal floors are steeply pitched slate roofs encircled by pinnacled stone gables, tall chimneys, copper cresting and finials, and a sixth story with small copper dormers. The windows are of various types, including square-headed and "basket-handle" arched, with ogee-arched enframements. Projecting bays and balconies further enliven the facades.

Members of an internationally renowned German banking family, the Warburg brothers emigrated from their native Hamburg to this country and joined the New York banking firm of Kuhn, Loeb & Co. While Paul devoted himself to banking, Felix's achievements were more diversified. A highly capable financier, he was also a bon vivant, art collector, philanthropist, and leader of

the Jewish community. In fact, the entire family played an important role in Jewish causes in America. Mrs. Warburg donated the family mansion as a permanent home for the Jewish Museum, which opened in 1947. An addition, designed by architect Kevin Roche, was completed in 1993, replicating the original building and more than doubling the size of the museum.

DIME SAVINGS BANK

1906–8; ADDITION, 1918; ENLARGED, 1931–32

9 DEKALB AVENUE (ALSO KNOWN AS 9–31 DEKALB AVENUE AND 86 ALBEE SQUARE), BROOKLYN

ARCHITECTS: MAWBRAY & UFFINGER; ADDITION, RUSSELL TRACY WALKER & LEROY P. WARD; ENLARGEMENT, HALSEY, McCORMACK & HELMER

DESIGNATED (EXTERIOR AND INTERIOR): JULY 19, 1994

Founded in 1859, Dime Savings Bank was named for its minimum required opening balance—one dime. In 1994, Dime merged with the Anchor Savings Bank, becoming Dime Bancorp, the nation's fourth-largest thrift institution. Dime's five-story "Greek temple"–style building was the first structure in the United States to be clad in Pentelic marble, known to the ancient Greeks for its translucent quality. The main entrance, located on a chamfered corner, features a portico with fluted Ionic columns bearing a frieze with the bank's name. On the pediment above is a clock and two figures, one depicting a youthful "Morning" anticipating work, and the other an older "Evening" reaping the fruits of his labor. A carved Mercury dime, the bank's symbol, is also above each entrance.

The neoclassical interior remains remarkably intact. The coffered ceiling and marble floor feature stars and hexagons, and six bronze chandeliers illuminate the marble teller counters. A central rotunda is composed of twelve marble Corinthian columns, an elaborate entablature, and a fifty-two-foot-diameter dome, which rises to 110 feet. In the 1931 enlargement, the use of a lightweight steel frame allowed an increase in floor space, from 14,000 to 29,000 square feet.

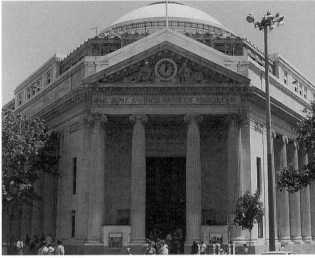

DIME SAVINGS BANK

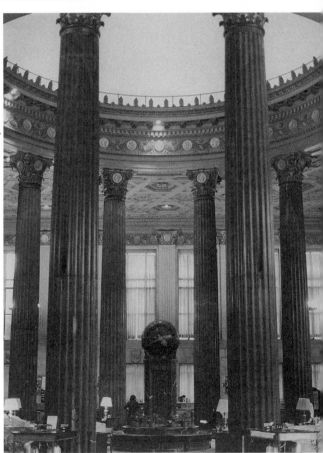

DIME SAVINGS BANK INTERIOR

401

BROOKLYN LYCEUM

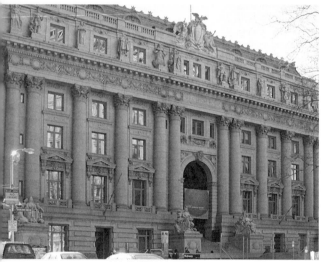

U.S. CUSTOM HOUSE

BROOKLYN LYCEUM, FORMERLY PUBLIC BATH NUMBER 7

1906–10

227–231 FOURTH AVENUE, BROOKLYN

ARCHITECT: RAYMOND F. ALMIRALL

DESIGNATED: SEPTEMBER 11, 1984

Public Bath Number 7 is a survivor of what was once the largest system of public baths in the world. The bath system was an outgrowth of the mid-nineteenth-century tenement reform movement, whose goal was to improve slum conditions and to promote cleanliness in areas where only minimal sanitary facilities were provided. Bathing was viewed with some trepidation by many tenement dwellers so the architectural expression of the bathhouses was of particular importance. The classical style chosen for many of these buildings, of which this is an especially flamboyant example, equated the bathhouses stylistically with banks, libraries, and other important public institutions.

The main facade has three large round arches, with a men's entrance on one side, a women's on the other, and a window in the center. The base of the building is a terra-cotta imitation of rusticated limestone; the upper portion of the facade is executed in white glazed brick. Raymond F. Almirall's signature use of color appears in the terra-cotta ornament of the building, much of which has aquatic themes. In the parapet, blue urns spill out green water; in the spandrels, blue T-shaped panels contain images of Triton and a trident.

Converted to a gymnasium in 1930

and abandoned briefly in the 1950s, the building is now a performance space known as the Brooklyn Lyceum.

U.S. CUSTOM HOUSE, NOW THE NATIONAL MUSEUM OF THE AMERICAN INDIAN AND FEDERAL BANKRUPTCY COURT

1907; RESTORED 1980S

BOWLING GREEN, MANHATTAN

ARCHITECT: CASS GILBERT; RESTORATION, EHRENKRANTZ & ECKSTUT

DESIGNATED: OCTOBER 14, 1965; INTERIOR DESIGNATED: JANUARY 9, 1979

The Custom House, built at the lowest point of land in Manhattan, on what was once the shore of the Battery, has no difficulty in dominating the soaring contemporary towers that surround it. Though only seven stories high, the building is vast and monumental, enclosing a volume of space said to be fully a quarter of that of the Empire State Building.

Cass Gilbert's building was erected on the site of a much earlier custom house, destroyed by fire in 1814. Tariffs on imported goods were a major source of revenue for the federal government in the days before taxes on income and corporations. As New York developed into America's largest port, the U.S. Custom Service acquired increasingly larger buildings; both Federal Hall (p. 111) and the Merchant's Exchange (p. 125) once served as custom houses. In 1892, due to the increasing demand

for a new and larger building, the U.S. Treasury acquired the large plot of land at Bowling Green, and Gilbert was chosen over twenty other architects in a competition for the design of the new Custom House.

Gilbert said that a public building like the Custom House should encourage "just pride in the state, [be] an education to oncoming generations . . . [and] a symbol of the civilization, culture and ideals of our country." The Custom House was designed and constructed with these lofty purposes in mind. Indeed, the building—a granite palace executed in a monumental Beaux-Arts style—is a paean to trade, to the city's role as a great seaport, and to America's status as one of the leading commercial nations in the world.

The building was designed to turn its back upon the harbor, but its symbolic ornament is unquestionably marine: shells, snails, and dolphins embellish the walls of the facade. On the capitals of the forty-four stout columns that encircle the building is carved a head of Mercury, the Roman god of commerce; masks of different races decorate the keystones over the windows and a head of Columbus stares out from above the cavernous main entrance. On the broad stone sill of the sixth-story cornice rest twelve immense figures in white Tennessee marble, representing twelve of the most successful commercial nations and city-states in history: Greece, Rome, Phoenicia, Genoa, Venice, Spain, Holland, Portugal, Denmark, Germany, England, and France. The central cartouche at the top of the facade is the shield of the United States, supported by two winged figures. The Continents, four enormous limestone sculptures by Daniel Chester French, rest on pedestals on the ground-floor level.

The interior of the Custom House is as majestic as its exterior. The main entrance leads to a grand, symmetrically designed two-story hall, finished in marbles of varying textures and colors with a spiral staircase rising the full height of the building at each end. Off the hall is one of the most splendid rooms in the city, paneled from floor to ceiling in oak and with a richly worked ceiling. Perhaps the most impressive feature of the interior is the rotunda, 135 feet long, 85 feet wide, and 48 feet high. The ceiling skylight is one of the curious tile-and-plaster vaulted masterpieces of Rafael Guastavino. Of special note in the rotunda are the sixteen frescoes by Reginald Marsh, executed in 1937; the small murals depict early explorers, while the larger panels follow the journey of a passenger liner through New York Harbor. By engaging the services of many nationally known artisans, Gilbert created a design that is unparalleled in public buildings of the period.

In 1973, the U.S. Custom Service left the building for larger quarters. An extended period of restoration under the direction of Ehrenkrantz & Eckstut followed. On October 30, 1994, one of three locations of the Smithsonian National Museum of the American Indian opened at the U.S. Custom House as the George Gustav Heye Center. The museum features exhibitions that present the diversity of the native peoples of the Americas.

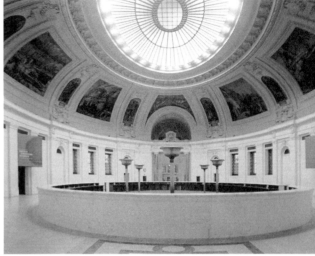

U.S. CUSTOM HOUSE ROTUNDA

U.S. CUSTOM HOUSE ENTRANCE HALL

130–134 EAST 67TH STREET

1907

MANHATTAN

ARCHITECT: CHARLES A. PLATT FOR
ROSSITER & WRIGHT

DESIGNATED: JANUARY 29, 1980

This apartment house was designed to complement the nearly identical adjoining apartment house by Charles Platt at the corner of Lexington Avenue and East 66th Street (p. 389). The building is an important example of the luxury cooperative apartment house, then a relatively new type of residence for wealthy urban dwellers.

Faced in finely worked limestone, 130–134 East 67th Street reflects the adaptation of the tripartite facade organization of the Italian Renaissance palazzo to tall urban buildings in the late nineteenth and early twentieth centuries. The first three of the eleven stories are treated as a base, articulated by a smooth-faced and shallow pattern of very regular rustication and crowned by a bold ovolo molding. Molding courses also articulate the upper stories into distinct horizontal bands. Among the most prominent features are the twin porticoes that mark the main entrances. Their baseless Doric columns support a full entablature with crisply carved triglyphs and alternating lions' heads and anthemia on the cornice. Above the third story, the facade is of very closely laid smooth-faced limestone, and the window arrangement is asymmetrical. A bold cornice crowns the structure.

UNITED STATES REALTY BUILDING

1907

115 BROADWAY, MANHATTAN

ARCHITECT: FRANCIS H. KIMBALL

DESIGNATED: JUNE 7, 1988

Among the first Gothic-inspired skyscrapers in New York, the United States Realty Building and its near twin, the Trinity Building (p. 388), were constructed at a time when insurance companies, conscious of public mistrust of monopolies and big business, were attempting to create positive images of prosperity. "Commercial Gothic," as the style came to be known, with its spiritual connotations, provided visual allusions to tradition, respectability, and integrity and suggested that big business was there to serve, rather than to sell. The vertical thrust of the Gothic cathedral was also viewed as an appropriate predecessor to a modern, vertical style.

Kimball wanted to produce "a broad effect in stone, in one plane, unbroken by vertical lines of projection." The modeling along Gothic lines was no doubt also determined by Kimball's sensitivity to the site, adjacent to Trinity Church (p. 120). In fact, Kimball adjusted the scale of the decorative ornament and arcaded windows of the lower stories to avoid overwhelming one of New York City's outstanding landmarks.

The United States Realty and Trinity buildings set world records for speed of construction and were considered the costliest commercial structures ever, together totaling more than $15 million dollars (including land). A graceful finishing touch was applied in 1912, when Kimball erected a handsome footbridge of ornamental wrought iron to join the roofs of the two structures.

NEW YORK COUNTY NATIONAL BANK

NEW YORK COUNTY NATIONAL BANK, FORMERLY MANUFACTURERS HANOVER TRUST BUILDING

1907; 2002

77–79 EIGHTH AVENUE, MANHATTAN

ARCHITECTS: DE LEMOS & CORDES AND RUDOLPH L. DAUS

DESIGNATED: JUNE 7, 1988

Built for the New York County National Bank and situated on a prominent corner across the street from the New York Bank for Savings, this refined structure is typical of bank design following the 1893 World's Columbian Exposition in Chicago. Stirred by the exposition's spectacular "White City," American architects strove to create a style characterized by order, clarity, and sobriety—qualities considered particularly appropriate for the design of banks. The siting and stylistic connection between the two banks on this important and busy intersection is also in keeping with late-nineteenth-century urban ideals, which valued the interplay of types and forms within the classical idiom.

Though small in scale, the elegant white marble-clad building reflects the gravity and importance of the bank's financial operations through a dignified classicism, superimposing two treatments of the orders—trabeated and arcuate—in a unified and structurally expressive manner. The narrow facade forms a pedimented portico, while the four-bay, 100-foot side elevation reflects the large banking room behind it.

In 1921, New York County National Bank merged with Chatham and Phoenix National Bank; three years later, this institution merged with the Metropolitan Trust Company. The bank was subsequently acquired in 1932 by the Manufacturers Trust Company—later named the Manufacturers Hanover Trust Company—which continued to own and occupy the bank until the building was sold. It was converted into a spa in 2002.

GAINSBOROUGH STUDIOS

1907–8

222 CENTRAL PARK SOUTH, MANHATTAN

ARCHITECT: CHARLES W. BUCKHAM

DESIGNATED: FEBRUARY 16, 1988

Built during the heyday of artists' cooperative housing, the Gainsborough is a rare surviving example of this type of structure. While cooperatively owned buildings had existed in European cities since the early nineteenth century, it was not until one hundred years later that the idea was accepted in New York. Construction of cooperative studio buildings was spurred by the return of

GAINSBOROUGH STUDIOS

young American artists from their studies abroad, which increased the already soaring demand for adequate living and working spaces. Mindful of artists' requirements, architect Charles W. Buckham designed the apartments so that the double-height studios on 59th Street faced the coveted northern light, and the smaller apartments were located to the rear of the building.

The project was the brainchild of portrait painter August Franzen, a well-established member of the New York art world who cited Thomas Gainsborough's work as a model for his own. The building's most distinctive feature is the terra-cotta frieze *Festival Procession* by the Austrian-born sculptor Isidore Konti, which depicts people of all ages carrying gifts to the altar of the arts. Located above the first story, the frieze, in conjunction with the colorful tiles above the sixth story, the bust of Gainsborough, and the artist's palette over the entrance, effectively announces the building's purpose.

405

NEW YORK PUBLIC LIBRARY, 115TH STREET BRANCH

1907–8

203 WEST 115TH STREET, MANHATTAN

ARCHITECTS: McKIM, MEAD & WHITE

DESIGNATED: JULY 12, 1967

This three-story Italian Renaissance style structure was built with funds from the Carnegie gift to establish branch libraries in New York City. The gray limestone facade is animated by deep rustication for its full height and organized by three widely spaced window bays. On the first and second floors, the round-headed windows are set beneath a belt course. On the first floor, a cartouche above the central window showing the city's coat of arms is supported by two cherubic angels bearing garlands. A projecting stone cornice, carried on ornate brackets, effectively terminates the facade at the top.

HENRI BENDEL, FORMERLY RIZZOLI BUILDING

1907–8

712 FIFTH AVENUE, MANHATTAN

ARCHITECT: ALBERT S. GOTTLIEB

DESIGNATED: JANUARY 29, 1985

Among the finest of the commercial buildings erected on Fifth Avenue in the early twentieth century is 712 Fifth Avenue, once known as the Rizzoli Building for the bookstore and publishing company that occupied the premises from 1964 to 1985. It was designed by Albert S. Gottlieb, an architect trained at the Ecole des Beaux-Arts in Paris.

Gottlieb's beautiful limestone building resembles an eighteenth-century neoclassical town house with its balanced and restrained massing and elegantly executed detail. The ground floor has a rusticated base cut by the round-arched entrance to the upper floors. This entry is ornamented with a carved wreath set within a fanlight. Arched openings on the second floor have French doors and balustrade railings, above which are set Corinthian pilasters and delicately carved garland panels. A balustrade railing capped by urns runs above the cornice and shields a mansard attic.

The facades of this building and the adjoining Coty Building (below) have been incorporated into a mixed-use high-rise building, whose bulk is set back from Fifth Avenue. Both are now part of the Henri Bendel store. The building remains one of the few surviving deluxe commercial establishments of the early twentieth century on this world-famous avenue.

HENRI BENDEL, FORMERLY COTY BUILDING

1907–8; 1989–90

714 FIFTH AVENUE, MANHATTAN

ARCHITECTS: WOODRUFF LEEMING; RESTORATION, BEYER BLINDER BELLE

DESIGNATED: JANUARY 29, 1985

The six-story limestone former Coty Building incorporates three stories of windows designed by the internationally acclaimed French craftsman René Lalique for the perfumer François Coty. The building survives from the earliest period of commercial development on Fifth Avenue south of 59th Street.

The history of the building extends back to 1871, when architect Charles Duggin designed group of row houses for the west side of Fifth Avenue between 55th and 56th streets. In 1907

HENRI BENDEL

the building and its neighbor at 712 became the first commercial structures on this section of Fifth Avenue. The house at 712 was soon demolished and replaced by a French neoclassical structure. Number 714 was only partially demolished; the original facade was removed and rebuilt. Architect Woodruff Leeming's design incorporated French design detail that linked the building to its residential neighbors, but its large, multipaned windows clearly proclaimed its commercial function.

In 1910, François Coty, whose business had recently grown from a small concern into one of international renown, leased the building. Soon thereafter, he transformed the space into an elegant French shop. Interior designer L. Alavoine created a glamorous interior; René Lalique's workshop was commissioned to design and manufacture the windows for the facade.

The six-story facade consists of three floors unified within a single design concept. The horizontal window bands on each level are divided by vertical metal mullions into five sections, each filled by small panes of semi-opaque glass. Four strands of intertwining poppies link each level to the next. These forms were created in three-dimensional molded glass with the flowers and vines on the exterior, recalling Lalique's early Art Nouveau work.

Coty remained at 714 Fifth Avenue until François Coty's death in 1934. In 1941 the City Investing Co. purchased the property, and it was used by a succession of commercial tenants. The Coty Building and the adjoining Rizzoli Building are now incorporated into a mixed-use high-rise building. The Coty facade, including the glass, was restored in 1989–90 by Beyer Blinder Belle and is now part of the Henri Bendel store.

SARA DELANO ROOSEVELT MEMORIAL HOUSE

1907–8; 1942
47–49 EAST 65TH STREET, MANHATTAN
ARCHITECT: CHARLES A. PLATT
DESIGNATED: SEPTEMBER 25, 1973

The Sara Delano Roosevelt Memorial House is a superb example of an early-twentieth-century Georgian Revival town house. In 1905, Sara Roosevelt, Franklin Delano Roosevelt's mother, commissioned Charles A. Platt to design, as a wedding present for her recently married son, a double house that she could share with him. Sara Delano Roosevelt lived at number 47. Franklin

SARA DELANO ROOSEVELT MEMORIAL HOUSE

and Eleanor Roosevelt moved into number 49 in 1908, and stayed there whenever they were in New York City, where he was a lawyer and an officer of an insurance firm. It was in this house in 1921 that he began his convalescence from his crippling attack of polio. After 1928, the year he was first elected governor of New York, Roosevelt spent only brief periods at number 49. His mother, Sara, continued to live at number 47 until her death in 1941. The following year, a group of citizens bought the double house for use by the students of nearby Hunter College as an interfaith social center.

TRAFFIC CONTROL DIVISION

130 WEST 57TH STREET STUDIO BUILDING

TRAFFIC CONTROL DIVISION, FORMERLY 23RD POLICE PRECINCT ("TENDERLOIN") STATION HOUSE

1907–8

134–138 WEST 30TH STREET, MANHATTAN

ARCHITECT: R. THOMAS SHORT

DESIGNATED: DECEMBER 15, 1998

Originally part of the larger 19th Precinct, this station house served the infamous "Tenderloin" district of Manhattan. The area required a larger police force to patrol the city's densest concentration of brothels, saloons, gambling parlors, sex shows, dance halls, and "clip joints." The district spread between 23rd and 42nd Streets, and Park/Fourth and Seventh Avenues, and was guarded by the city's first exclusively automobile patrol.

One of the first station houses to be constructed in Manhattan after the consolidation of Greater New York in 1898, the building was designed by R. Thomas Short, a partner in the firm of Harde & Short, known for intricately decorated apartment buildings (p. 400). He employed the unconventional Medieval Revival style to convey the authority of the police force. The four-story plus mezzanine structure features a bracketed cornice and crenellated roof parapet above the iron-spot Roman brick of the upper stories. Cut through the rusticated granite base, designed to simulate towers, is a central automobile entrance, with a Guastavino tile vault, giving way to the recessed arched doorway, and an interior courtyard beyond.

130 WEST 57TH STREET STUDIO BUILDING

1907–8

MANHATTAN

ARCHITECT: POLLARD & STEINAM

DESIGNATED: OCTOBER 19, 1999

Catering to the live/work spaces preferred by artists in the early twentieth century, this brick and limestone studio building (and its identical neighbor, number 140,) placed artists in the creative center of New York. Built on a busy, cross-town street, this studio building was within walking distance of the Art Students League, Carnegie Hall, and many other organizations promoting the arts and the artists. The double-height rooms with expansive projecting bay windows, enframed within geometrically ornamented cast iron, provided spacious areas for visual artists to work and large amounts of north light. Well-known residents include writer William Dean Howells, and his son, the architect John Mead Howells; Childe Hassam included the building's distinctive windows in several of his paintings. While intended for artist use, the tenants were teachers, lawyers and stockbrokers as well, showing the growing acceptance of apartment living for prosperous New Yorkers.

Apart from the recent installation of a storefront at the street level, the rest of the building has remained remarkably intact. The building was cooperatively owned until 1937, when it became a rental property, which it remains today.

140 WEST 57TH STREET STUDIO

the front, including full kitchens and servants quarters, while the back of the building offered twelve-stories of smaller studios with kitchenettes. The tall, projecting bay windows in cast-iron frames mirror exactly those of 130 West 57th Street, as does the ornamented terra-cotta cornice above the base of the building. Number 140 has seen some changes to its ground story, and the removal of its cornice, but remains otherwise well preserved. It remained a cooperative until 1944, when it was converted into rental units.

HOTEL RIVERVIEW

140 West 57th Street Studio Building

1907–8

Manhattan

Architect: Pollard & Steinam

Designated: October 19, 1999

Pollard & Steinam had previously experimented with studio cooperatives on West 67th Street, stepping out as clear pioneers in its development and its acceptance within the upper classes. Cooperatively owned apartment buildings attracted wealthier residents with the exclusivity and the opportunity to choose one's neighbors. As single-family homes became increasingly expensive, Pollard & Steinam found huge success with their double-height studios, which enticed all professions, not just artists, but also teachers, stockbrokers, and lawyers, with ample light and space.

The duplex plan allowed for seven double-height studios and apartments in

Hotel Riverview, formerly American Seaman's Friend Society and Sailor's Home and Institute

1907–8

505–507 West Street (also known as 113–119 Jane Street), Manhattan

Architect: William A. Boring

Designated: November 28, 2000

Attempting to improve the social and moral welfare of seamen, the American Seaman's Friend Society opened this, the second of its hotels, as an alternative to the waterfront "dives" and boarding-houses frequented by sailors. The building was operated as a hotel with amenities for seamen, as well as a home for impoverished sailors. Surviving crewmembers of the luxury liner *Titanic* were brought here after the ship sank in April 1912. During the Depression and World War II, destitute seamen were housed here.

William A. Boring, known for his work on many Ellis Island buildings, designed this social and residential center. Construction, however, would not have been possible without the financial assistance of Olivia Sage, the widow of financier Russell Sage, one of the world's wealthiest, and more important, philanthropic women.

Designed in the neoclassical style, the brick and cast stone building features a polygonal corner tower, entrance portico, and nautical ornament. It stands on a prominent corner next to the once busy waterfront that brought in half a million seamen each year at its peak. The larger shipping ports of New Jersey, and advances in airplane technology, severely reduced activity on the waterfront. In 1946, the building became a residential and transient hotel. The hotel has changed owners many times since and currently operates as the Hotel Riverview.

AVILDSEN BUILDING

NYPL, MORRISANIA BRANCH LIBRARY

AMERICAN BANK NOTE COMPANY BUILDING

Avildsen Building, formerly 94–100 Lafayette Street Building

94–98 Lafayette Street, 1907–8;
100 Lafayette Street, 1909–10;
1999

Manhattan

Architect: Howells & Stokes

Designated: December 18, 2001

While the facades appear to be continuous, these two buildings, built for the same owner, were not joined internally until 1952. Faced in tan brick, the facade has limited but carefully placed neoclassical details of limestone and terra-cotta; the original metal frames and spandrels of the windows remain intact, as do most of the ground floor showrooms.

Two of the country's leading hardware manufacturing firms were long-term tenants in the separate buildings, and the buildings became known as a premiere location for hardware in New York City. From the early 1980s until 1999, the tenants were predominantly garment manufacturers; subsequently, the loft interiors were converted to office space.

New York Public Library, Morrisania Branch, originally McKinley Square Branch

1907–8; 1995–96

610 East 169th Street, The Bronx

Architects: Babb, Cook & Willard

Designated: June 16, 1998

This was the fourth Carnegie branch library built in the Bronx, designed by the architects of Andrew Carnegie's own mansion (now the Cooper-Hewitt National Design Museum, p. 336) after residents petitioned to receive a branch from Carnegie funds.

The freestanding, two-story building is unique among the many Carnegie branches. Built on a narrow, thickly developed site, historic wrought-iron fences define small lawns in front of the two side wings. The red brick facade is embellished with handsome neoclassical details executed in limestone. It has a central entrance surrounded by a projecting stone portico. Arched window openings light the interior. In 1995–96, the interiors were remodeled, improving the services the library could offer to the community that it continues to serve.

American Bank Note Company Building

1907–8; 1995

70 Broad Street, Manhattan

Architects: Kirby, Petit & Green

Designated: June 24, 1997

This neoclassical structure was constructed to house the corporate, administrative, and sales headquarters of the American Bank Note Company. Formed by a merger of seven banknote engraving firms in 1858, the American Bank Note Company became a prominent producer of banknotes, stamps, stock certificates, and letters of credit by the late nineteenth century; the firm began producing the American Express Company's new "Travelers Cheques" in 1891. When the company outgrew several smaller quarters, the administrative and sales functions were separated from the production facilities. This narrow Broad Street lot was chosen to house the

administrative headquarters because of its proximity to the financial institutions of lower Manhattan.

Banking institutions often favored monumental buildings in classical styles to portray a solid and trustworthy image. The five-story building is distinguished by two overscaled, fluted Corinthian columns rising three stories above the entrance, which is capped with a carved eagle atop a medallion, the corporate symbol of the company.

In 1988, the company offices moved to Blauvelt, New York, and the 70 Broad Street building was sold. After serving several years as a fast-food facility, the building was again sold in 1995 and reopened as a restaurant.

STATEN ISLAND HISTORICAL SOCIETY, FORMERLY PUBLIC SCHOOL 28

1907–8; 1981

276 CENTER STREET, STATEN ISLAND

ARCHITECT: C.B.J. SNYDER

DESIGNATED: SEPTEMBER 15, 1998

As superintendent of school buildings, C.B.J. Snyder had few opportunities to design for rural settings; this building alone survives of three that he built during his three decades of service to the Board of Education. Located in the historic community of Richmondtown, the Tudor-style, brick building features a set of tall windows situated between twin porches with tapered wood columns and masonry stairways. A prominent gable marks the Center Street facade, treated with timbers and rough plaster,

STATEN ISLAND HISTORICAL SOCIETY

brackets, a bargeboard, and finial. On the sides, eyebrow windows emerge from the low-hipped roof; a small, octagonal cupola marks the apex.

Made redundant by the opening of the larger P. S. 23, the former school building served various purposes for the Board of Education. Acquired by the Staten Island Historical Society in 1981, the building currently houses the society's education department, library, and archives.

ALWYN COURT APARTMENTS

1907–9

182 WEST 58TH STREET, MANHATTAN

ARCHITECTS: HARDE & SHORT

DESIGNATED: JUNE 7, 1966

The Alwyn Court Apartments is the finest of all of the turn-of-the century apartment houses to be decorated with terra-cotta. The entire building is embellished with decorative detail, leaving virtually no surface unadorned. Such rich ornamentation, which would have been impossible in stone, could be achieved with terra-cotta molds used

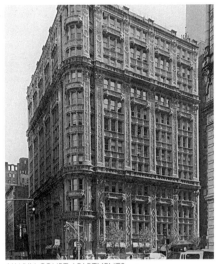

ALWYN COURT APARTMENTS

repeatedly to produce intricate designs in great quantity.

In its departure from the design formula for apartment houses of the time (base, plain shaft, and top story ornamented and crowned by a projecting cornice), the Alwyn Court was quite radical. The first four floors were treated as the base, the next five as the shaft, and the final three as the crown. The tripartite divisions were separated horizontally by strong projecting decorative bands. Corinthian pilasters divide the Seventh Avenue elevation into four bays and the West 58th Street elevation into five. In the best Parisian tradition, a rounded bay marks the corner of the building. The shafts of the pilasters, the belt courses, and all the windows are richly decorated with intricate French Renaissance–inspired detail, including the crowned salamander, symbol of François I of France. Today the apartments provide a pleasing and refreshing contrast to the neighboring glass and steel buildings of Seventh Avenue.

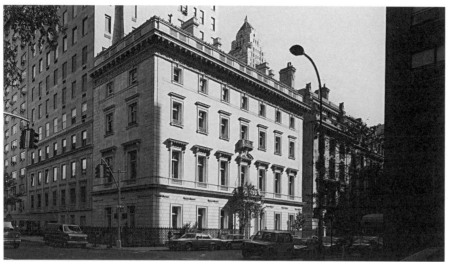

COMMONWEALTH FUND

COMMONWEALTH FUND, FORMERLY THE EDWARD S. HARKNESS HOUSE

1907–9; 1987

1 EAST 75TH STREET, MANHATTAN

ARCHITECT: JAMES GAMBLE ROGERS

DESIGNATED: JANUARY 24, 1967

This marble mansion was commissioned by Edward S. Harkness, the son of Stephen Harkness, one of the founding partners of Standard Oil. In contrast to many of the mansions built on upper Fifth Avenue for wealthy clients, James Gamble Rogers's design is notable for its combination of luxury and restraint. In 1910, the *Architectural Record* declared, "If there is any facade on upper Fifth Avenue which gives an effect of quiet elegance by worthier architectural means it has not been our good fortune to come across it." Rogers achieved this effect by turning to Renaissance models, and his design shows a profound instinct for their sense of proportion.

The facade is divided into a rusticated ground story, finely dressed ashlar upper stories with quoins, and a top floor disguised by a stone balustrade. A full cornice with an elaborate frieze articulates the transition from the body of the building to the top floor. The main entrance on 75th Street features Tuscan columns supporting a balustraded balcony. In the tradition of the Renaissance palazzo, the important reception rooms form a piano nobile, expressed on the facades by large windows on the second story. In addition to the finely executed detail of the exterior, the house is also distinguished by the understated luxury of its rooms, which preserve the ambience of elegant life around the turn of the century.

In 1918, Edward Harkness's mother established the Commonwealth Fund, "to do something for the welfare of mankind." Edward and his wife, the former Mary Stillman, devoted most of their lives to the philanthropic programs of the fund. In 1950, the house became the headquarters of the Commonwealth Fund, which today supports planning in the field of health and medical research and provides fellowships to graduate students from the United Kingdom, Australia, and New Zealand. In 1987, the fund restored the house and its interior.

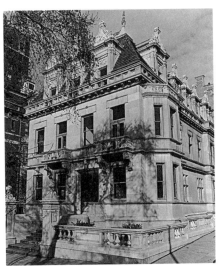

MORRIS AND LAURETTE SCHINASI HOUSE

MORRIS AND LAURETTE SCHINASI HOUSE

1907–9

351 RIVERSIDE DRIVE, MANHATTAN

ARCHITECT: WILLIAM B. TUTHILL

DESIGNATED: MARCH 19, 1974

A relatively small, freestanding mansion, the Schinasi house was designed by architect William B. Tuthill, who also designed Carnegie Hall (p. 264). Schinasi was a member of the well-known tobacco-processing family and a partner in the firm of Schinasi Bros., Inc., which manufactured Natural brand cigarettes.

Tuthill designed an exquisite French Renaissance–style jewel box executed in pristine white marble, with a pitched roof of deep-green tiles and bronze grills on the balconies and at the main entrance. Two and one-half stories high, the facade is accented by an interplay of projecting and recessed wall sections.

Among its more distinctive features are high French windows on the second floor, a paneled frieze at the roofline, and boldly projecting dormer windows set above the modillioned roof cornice.

Schinasi so prized the whiteness of the facade that a special system of pumps was installed to allow every part of the exterior to be cleaned. On the interior, rich materials, wood paneling, mosaics, and stencil patterns contributed to a precious refinement unsurpassed on the Upper West Side, while mirrors and vistas between rooms enhanced the apparent spaciousness of the house.

METROPOLITAN LIFE INSURANCE COMPANY TOWER

1907–9; RENOVATION, 1960–64

1 MADISON AVENUE, MANHATTAN

ARCHITECTS: NAPOLEON LEBRUN & SONS; RENOVATION, LLOYD MORGAN AND EUGENE V. MERONI

DESIGNATED: JUNE 13, 1989

Realizing the value of corporate architectural imagery, John Rogers Hegeman, Metropolitan Life's third president, took an avid interest in the construction of his company's home office. Indeed, it is Hegeman who is credited with conceiving the idea of a tower. During his tenure, from 1891 to 1919, the company expanded its complex to eight buildings, including the tower, all connected by corridors running east-west between avenues and north-south across streets. The vast complex covered two city blocks near Madison Square Park.

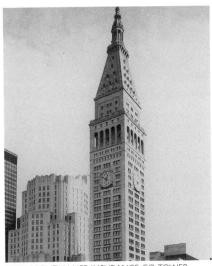

METROPOLITAN LIFE INSURANCE CO. TOWER

Recalling the famous campanile at the Piazza San Marco in Venice, this 700-foot tower was the world's tallest building for four years after its completion. Architect Pierre LeBrun modeled its proportions on those of a Doric column, which was then translated by engineers into a fifty-story steel frame. The structure is distinguished by an arcaded capital that rises to a setback capped with a pyramidal spire, cupola, and glazed lantern. A major renovation by Morgan & Meroni in the early 1960s replaced the original white marble facing with limestone and eliminated much of the ornamental detail in order to harmonize with a new home office building. However, LeBrun's four great clock faces, featuring seventeen-foot-long minute hands weighing a thousand pounds each, continue to decorate the shaft.

MUNICIPAL BUILDING

1907–14

CHAMBERS AND CENTRE STREETS,
MANHATTAN

ARCHITECTS: McKIM, MEAD & WHITE

DESIGNATED: FEBRUARY 1, 1966

In undertaking the design of the
Municipal Building, McKim, Mead &
White departed substantially from its
usual practice. McKim in particular
disliked designing tall buildings, which
he felt were inevitably clumsy; more-
over, their size conflicted with his vision
of the city as a continuum of low-rise
development punctuated by large public
spaces and grand civic structures. The
Municipal Building was the firm's first
skyscraper; it reflects not so much a
change in the original partners' attitudes
as the influence of younger partners,
particularly William Mitchell Kendall,
who designed this structure.

It was also unusual for the firm to
enter competitions. McKim agreed to
submit to the Municipal Building com-
petition as a personal favor to Mayor
George B. McClellan. The firm won the
commission over designs by Carrère &
Hastings, Clinton & Russell, and Howells
& Stokes.

Kendall's first studies date from
1907–8, and the design changed very
little over the course of development
and construction. The turrets and dome
at the top derive from three of the firm's
earlier projects: the Rhode Island State
Capitol, White's towers for Madison
Square Garden (now demolished), and
their Grand Central Terminal project,

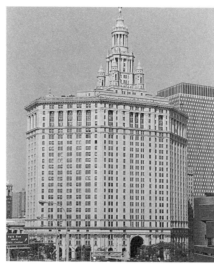

MUNICIPAL BUILDING

which was never built. The Federal style
refers to Mangin & McComb's nearby
City Hall (p. 86). The Municipal Build-
ing influenced many later twentieth-
century designs, including Albert Kahn's
General Motors Building in Detroit,
Carrère & Hastings's Tower of Jewels at
the Panama Pacific Exposition in San
Francisco (1915), and the main building
at Moscow University (1949).

The roadway through the base, now
closed, and the plaza that joined the new
IRT subway station to the entrances
demonstrated sensitivity to the require-
ments of the modern city. Several archi-
tects of the time—among them Cass
Gilbert, whose Woolworth Building
(p. 434) is diagonally across City Hall
Park—tried to provide direct or shel-
tered entrances to buildings from the
growing underground mass transit sys-
tem, and this practice became common
in large office buildings through the
1920s. Since 2001, the offices of the
Landmarks Preservation Commission
have been located in this building.

LOUIS A. AND LAURA STIRN HOUSE

LOUIS A. AND LAURA STIRN HOUSE

1908; 1962

79 HOWARD AVENUE, STATEN ISLAND

ARCHITECT: KAFKA & LINDENMEYR

DESIGNATED: JANUARY 30, 2001

Prominently sited on Grymes Hill, with
a spectacular view of New York Harbor,
the Stirn House is one of the few of its
size and type extant on Staten Island.
Grymes Hill, originally developed in the
1830s, had become a fashionable resi-
dential neighborhood for wealthy
German-Americans in the early 1900s.

Composed of a symmetrical center
block and flanking dependencies, the
house was modeled after an Italian
Renaissance villa, carefully decorated
with simple arts and crafts details,
including iron balconies, polychrome
terra-cotta details, and several windows,
with stained glass roundels. Dormers
and bracketed eaves are distinctive fea-
tures of the red clay tile roof. Ionic
porticos on the front and rear facades
and a gabled porch/conservatory relate
the house to the surrounding gardens.
Innovative materials include glazed
polychrome terra-cotta, Portland cement

stucco facing, and concrete window surrounds.

Louis A. Stirn was a German immigrant who became a prominent silk merchant and importer. His wife, Laura, granddaughter of pioneer bridge builder John Augustus Roebling, was an expert in botany and horticulture, known for her collection of rare plants. Following Stirn's death in 1962, the house was sold to Reuben Gross, a prominent attorney, and his wife, Blanche. The Estate of Blanche Gross now owns the house.

RICHMOND HILL REPUBLICAN CLUB

1908

86–15 LEFFERTS BOULEVARD, QUEENS

ARCHITECT: HENRY E. HAUGAARD

DESIGNATED: DECEMBER 17, 2002

The Richmond Hill Republican Club served a significant local political organization and became an important part of downtown Richmond Hill, hosting many neighborhood events, including public lectures, rallies, parades, and dinners. The basement and part of the ground floor were also used as a post office until 1918, when it was converted into a dormitory. During World War I, the building became the Soldiers' and Sailors' Club of Richmond Hill. The club hosted many political figures, including Theodore Roosevelt, Richard Nixon, and Ronald Reagan and remained a strong political and social voice for Queens into the 1980s.

The Colonial Revival–style building is constructed of Roman brick with wood

RICHMOND HILL REPUBLICAN CLUB

trim. Four expansive, semicircular steps lead to the main entrance; double doors with large side windows are capped by a classical pediment and flanked by paired Ionic columns. Although the building has been vacant since the mid-1980s, the bold bracketed cornice and a roofline balustrade maintain its visual prominence within the community.

EVERETT BUILDING

1908

45 EAST 17TH STREET (ALSO KNOWN AS 200–218 PARK AVENUE SOUTH), MANHATTAN

ARCHITECTS: GOLDWIN STARRETT & VAN VLECK

DESIGNATED: SEPTEMBER 6, 1988

Built for the Everett Investing Company, this is a quintessential example of the commercial building type defined by A. C. David in the *Architectural Record* of 1910: "functional, fireproof, and quickly constructed while demonstrating a concern for architectural decency." Prominently situated on a corner site at Union Square, the building, together

EVERETT BUILDING

with the monumental Germania Life Insurance Company Building (p. 428), forms an imposing terminus to Park Avenue South.

In its frank expression of function, the tower recalls the Chicago style of commercial architecture. The appearance of a grid on the facade demonstrates the major tenet: to articulate the interior structure on the exterior. Here, the juxtaposition of verticals and horizontals, such as the crossings of ribbed mullions and textured panels on the story shaft, are surrogates for the concealed skeletal frame.

While a portion of the two upper stories appears to have been resurfaced, the structure remains largely unchanged. It continues to serve as an office building with retail stores on the ground floor.

415

TOURO COLLEGE

BELNORD APARTMENTS

TOURO COLLEGE, FORMERLY NEW YORK SCHOOL OF APPLIED DESIGN FOR WOMEN

1908–9

160 LEXINGTON AVENUE, MANHATTAN

ARCHITECT: HARVEY WILEY CORBETT

DESIGNATED: MAY 10, 1977

A highly imaginative neoclassical design and a skillful combination of varied materials and textures in a unified composition, this building is a veritable temple to the arts. Designed by Harvey Wiley Corbett, the structure is five stories high and built of terra-cotta and stone. The main facade on 30th Street is distinguished by a low-relief frieze composed from casts of portions of the Parthenon frieze. Four polished, unfluted granite Ionic columns rise above the frieze, emphasizing the strong verticality of the building. The boldly plastic entablature is executed in terra-cotta and ornamented with rich classical moldings. The steep gabled roof, of galvanized iron and tin painted green to imitate copper, continues the vertical emphasis. On the Lexington Avenue facade is a witty, polished gray column.

The school was founded in 1892 with the purpose "of affording to women instruction which may enable them to earn a livelihood by the employment of their taste and manual dexterity in the application of ornamental design to manufacture and the arts." It was quite advanced for its time, demanding high-quality education for women. In 1944 the school merged with the Phoenix Art Institute, and in 1974 merged again with the Pratt Institute of Brooklyn. The building is now occupied by Touro College.

BELNORD APARTMENTS

1908–09

201–225 WEST 86TH STREET, MANHATTAN

ARCHITECT: H. HOBART WEEKES

DESIGNATED: SEPTEMBER 20, 1966

The end of pre–World War I development of the Upper West Side was marked by two large and very similar luxury apartment houses: the Apthorp at 79th Street (p. 399) and the Belnord, begun a year later by H. Hobart Weekes. Both are in the style of sixteenth-century Italian Renaissance palazzi, with heavy rustication and elaborate wrought-iron grillwork; both are hollow squares in plan.

The central court of the Belnord was accessible to traffic from the south and to pedestrians from the east through monumental arched entries. Instead of the conventional light court used in many contemporary apartment houses, this lovely courtyard with a fountain at the center lent a princely character to an already luxurious multiple dwelling.

One of the Belnord's most distinctive features is the unusual treatment of the windows, which vary in size, enframement, and embellishment. Decorative panels link the corner windows vertically. This sense of monumental verticality on the four long horizontal facades is

enhanced by rusticated brickwork. An elaborate, overscaled, projecting cornice terminates the elevations. Each courtyard entry has a coffered barrel vault. The building andcourtyard have recently been renovated.

UNION THEOLOGICAL SEMINARY

MANHATTAN

ARCHITECTS: ALLEN & COLLINS

DESIGNATED: NOVEMBER 15, 1967

BROWN MEMORIAL TOWER, 1908–10

3041 BROADWAY AT REINHOLD
NIEBUHR PLACE
(WEST 120TH STREET)

JAMES TOWER AND JAMES
MEMORIAL CHAPEL, 1908–10

CLAREMONT AVENUE BETWEEN
REINHOLD NIEBUHR PLACE AND
SEMINARY ROAD (WEST 120TH
AND 122ND STREETS)

Union Theological Seminary, an independent, ecumenical graduate and professional school, was established in 1836. The seminary's first building, dedicated in 1838, was located near Washington Square at 9 University Place. In 1884, the seminary moved to its second home on Lenox Hill, with the central entrance at what is now 700 Park Avenue. The current seminary site is a complex of buildings between West 120th and 122nd streets, completed in 1910—a rectangle enclosing two city blocks and surrounding a landscaped inner quadrangle. Brown Memorial Tower, James Tower, and James Memorial

Chapel were designed by the architects Allen & Collins, who won the commission in a competition.

Rising high above the adjacent lower buildings, Brown Memorial Tower and James Tower are among finest examples of the English Perpendicular Gothic in New York City. At the base of these square towers, buttresses project from the corners, terminating at the top in pinnacles with delicate finials. Parapets at the roofline are paneled and ornately decorated. In the upper half of the Brown Memorial Tower, the tall windows are topped with handsome, intricate tracery.

The James Memorial Chapel extends south from the James Tower. The walls of the east and west facades are evenly divided into seven bays, separated by stepped buttresses. Clerestory windows in both elevations are enframed within pointed arches, divided by two millions that terminate in handsome tracery. On the Claremont Avenue side, buttresses rise above the crenellated parapet wall and teminate in finials.

UNION THEOLOGICAL SEMINARY

LUNT-FONTANNE THEATER

NEW YORK SOCIETY FOR ETHICAL CULTURE

LUNT-FONTANNE THEATER, FORMERLY THE GLOBE THEATER

1909; 1958

203–217 WEST 46TH STREET, MANHATTAN

ARCHITECTS: CARRÈRE & HASTINGS

DESIGNATED: DECEMBER 8, 1987

The Lunt-Fontanne Theater represents the theatrical vision of Charles Dillingham, who produced over two hundred musicals and plays in his thirty-eight-year career on Broadway. Dillingham built the Globe as his headquarters and named it for Shakespeare's theater to honor to his central inspiration. Converted to a movie house in 1932, the Globe was renamed the Lunt-Fontanne in 1958 and returned to use as a legitimate theater. Characteristics of the facade include a five-bay arcade of double-height Ionic columns, a deep cornice, and sculpted theatrical figures and masks. The extravagant design also included a large oval panel in the roof that could be removed to create an open-air auditorium. The lavish interior was rebuilt in 1958, and none of the original remains. The Lunt-Fontanne is one of the oldest surviving Broadway theaters and the only survivor of four designed by Carrère & Hastings.

NEW YORK SOCIETY FOR ETHICAL CULTURE

1909–10

2 WEST 64TH STREET, MANHATTAN

ARCHITECT: ROBERT D. KOHN

DESIGNATED: JULY 23, 1974

The New York Society for Ethical Culture was founded in 1876 by Dr. Felix Adler, who intended the Ethical Culture Movement to bring together people interested in improving social morality. In 1897, after moving from Standard Hall to Chickering Hall and then to Carnegie Hall, the society decided to find a permanent location. Kohn was a close friend of Adler's and served as a leader of the congregation and president of the society from 1921 to 1944. His building reflects the Austrian Secession designs of Otto Wagner and Josef Hoffmann.

A quotation by Dr. Adler, engraved above the speaker's platform in the auditorium, articulates the philosophy of the institution: "The Place where Men meet to seek the Highest is Holy Ground." In keeping with this ideal, the prominent Central Park West front combines large undecorated spaces with recessed openings to create a tremendous sense of scale. Each window group contains a shallow niche intended to hold sculptures of the *Servants of Humanity*. Estelle Rumbold Kohn, the artist's wife, sculpted the figures in the pedimented panel above the main entrance on 64th Street.

FIRST PRECINCT POLICE STATION

1909–11

SOUTH STREET AND OLD SLIP, MANHATTAN

ARCHITECTS: HUNT & HUNT

DESIGNATED: SEPTEMBER 20, 1977

Old Slip, the site of the first official marketplace in New Amsterdam, was home to the First Precinct from 1884 to 1973. Among the subsequent tenants was the Landmarks Preservation Commission. The building now houses the New York City Police Museum.

Despite its massive scale, this building is simple in detail. Nine windows wide with narrow ends, it follows the style of the Italian Renaissance Revival. The horizontal divisions include a molded granite base, a rusticated center section, and a smooth-faced attic story. A rhythmic series of arches pierces the facade on the first floor with square windows above. The central entrance has a recessed double door with leaded glass panels, Doric columns, and a pediment supported by ornate brackets. A deep cornice with console brackets crowns the building.

NEW YORK UNIVERSITY INSTITUTE OF FINE ARTS, FORMERLY THE JAMES B. DUKE MANSION

1909–1912; 1958; 1977

1 EAST 78TH STREET, MANHATTAN

ARCHITECTS: HORACE TRUMBAUER; ROBERT VENTURI

DESIGNATED: SEPTEMBER 15, 1970

The Institute of Fine Arts is the southern cornerstone of the Metropolitan Museum Historic District. Designed by the Philadelphia architect Horace Trumbauer, the building is one of the last of the freestanding mansions that once lined "Millionaires' Row." James Buchanan Duke and his older brother amassed a fortune in the tobacco industry. The Dukes were major benefactors of Trinity College in their native Durham, North Carolina. The college was renamed Duke University in their honor in 1925.

James Duke moved to New York in 1884. His mansion is designed in the Louis XV style Trumbauer preferred for residential commissions and made of unusually fine-grained limestone that resembles marble. After Duke's death in 1925, his widow and daughter continued to live in the house until 1958. Doris Duke donated the house to New York University for use as the Institute of Fine Arts, a graduate program in the history of art and architecture, archaeology, and conservation. Robert Venturi renovated the building in 1958. In 1977, Richard Foster and Michael Forstel restored the interiors to their original splendor.

FIRST PRECINCT POLICE STATION

NYU INSTITUTE OF FINE ARTS

419

ST. MARY'S PROTESTANT EPISCOPAL CHURCH (MANHATTANVILLE), PARISH HOUSE AND SUNDAY SCHOOL

517–523 WEST 126TH STREET, MANHATTAN

DESIGNATED: MAY 19, 1998

ST. MARY'S PROTESTANT EPISCOPAL CHURCH, 1908–9

ARCHITECTS: CARRÈRE & HASTINGS

PARISH HOUSE (ORIGINALLY THE RECTORY), 1851

ARCHITECT: UNKNOWN

SUNDAY SCHOOL, 1890

ARCHITECT: GEORGE KEISTER

ST. MARY'S PROTESTANT EPISCOPAL CHURCH

THOMSON METER COMPANY BUILDING

St. Mary's Protestant Episcopal Church has occupied its original Manhattanville site for more than 175 years. In deference to the poor constituents of its parish, the church abolished pew rentals in 1831, becoming the city's first "free pew" church. Several generations of Manhattanville's founding families have worshipped at St. Mary's, including Elizabeth Schuyler Hamilton, the widow of Alexander Hamilton, Daniel F. Tiemann, mayor of New York City from 1858 to 1860, and Jacob Schieffelin, a town planner and donor of the plot on which the first church building was erected in 1824–26.

The original building, a white, wood frame church with steeple, was replaced in 1908 by this English Gothic-style brick church designed by Theodore E. Blake of Carrère & Hastings. A pointed-arch window, with traceries, infill and leaded glass, dominates the main facade, and a bell tower rises from the roof.

The parish house was erected as a parsonage in 1851, housing the village's first resident clergyman. In 1890, St. Mary's commissioned architect George Keister to design a Sunday school building behind the church. This complex of buildings, sited around a garden, evokes the rural origins of this historic neighborhood.

THOMSON METER COMPANY BUILDING, LATER NEW YORK ESKIMO PIE CORPORATION BUILDING

1908–9

100–110 BRIDGE STREET (ALSO KNOWN AS 158–166 YORK STREET), BROOKLYN

ARCHITECT: LOUIS E. JALLADE; GENERAL CONTRACTOR: HENNEBIQUE CONSTRUCTION CO.

DESIGNATED: FEBRUARY 10, 2004

This factory building reflects the debate between architects about the use of exposed concrete. Some argued for honesty in materials while others insisted on aesthetic consideration, advocating that it be clothed in decorative materials. In this four-story industrial structure, the arcaded facades are enlivened with elaborate polychromed terra-cotta details and colored, patterned brickwork inlaid at the spandrels. The exposed concrete, poured on site, was modeled after contractor-engineer François Hennebique's own reinforced-concrete system, first employed in Belgium and France. Louis E. Jallade, an architect and engineer, encountered this technique while studying at the Ecole des Beaux-Arts. Reinforced concrete emerged as a significant structural building material at the turn of the century.

The building was used to manufacture John Thomson's patented water meters until his death in 1927. A subsidiary of the Eskimo Pie Corp. then purchased the building and manufactured the first American chocolate-covered ice cream bar there. It served as a milk-bottling

distribution plant until 1966 and is currently used for commercial and industrial purposes.

2ND BATTERY ARMORY

1908–11; ADDITION, C. 1928

1122 FRANKLIN AVENUE, THE BRONX

ARCHITECTS: CHARLES C. HAIGHT; ADDITION, BENJAMIN W. LEVITHAN

DESIGNATED: JUNE 2, 1992

The first permanent armory built in the Bronx, this medieval-looking building originally housed the 2nd Battery, a field artillery unit of the National Guard. The unit served during a number of major New York strikes and riots (including the Abolition Riot of 1834 and the draft riots of 1863) as well as in the Civil and Spanish-American Wars. Located in the Morrisania section of the Bronx, the armory reflects the rapid growth of the borough at the turn of the century, when it was formally annexed to the City of New York.

Designed by Charles C. Haight, a former member of the New York State militia, the armory is notable for its bold massing, expressive brick forms, picturesque asymmetry, and restrained Gothic vocabulary. Haight's design is in keeping with the tradition of medieval imagery in earlier New York armory buildings, but refers also to the collegiate Gothic of educational institutions. In 1917, the *Architectural Record* considered this armory the best building in the entire borough.

In addition to office space, the

2ND BATTERY ARMORY

structure included a rifle range, stables, a gun room, and a drill hall with 167-foot-wide iron roof trusses. Today the structure is managed by the Human Resources Administration of the City of New York as a homeless shelter.

CHURCH OF NOTRE DAME

MANHATTAN

DESIGNATED: JANUARY 24, 1967

CHURCH OF NOTRE DAME, 1909–10

MORNINGSIDE DRIVE AND WEST 114TH STREET

ARCHITECTS: DANS & OTTO (SANCTUARY); COMPLETION, CROSS & CROSS

RECTORY, 1913–14

409 WEST 114TH STREET

ARCHITECTS: CROSS & CROSS

The Dans & Otto firm designed and built the original section of this church—the sanctuary, which survives

CHURCH OF NOTRE DAME

as an unusual grotto in the apse. In 1914, Cross & Cross continued the original plans for the chancel, but completed the church according to their own designs. In plan, the church is square, with a shallow Greek cross superimposed upon it. The cross is expressed in the portico on the east facade and slightly projecting pilastrade on the south elevation. A Corinthian portico dominates the facade. At the cornice level on the main body of the church is an elegant band of swags. The architects originally intended to raise a large dome over the crossing in a design closely based on Jacques-Germain Soufflot's dome on the Panthéon in Paris. The carving and proportions seem inspired by French nineteenth-century architecture.

The gray brick and limestone rectory on West 114th Street resembles a sixteenth-century Renaissance palazzo. The broad building is fitted onto a cramped site around the church. The most notable architectural features are the rounded corners, inset windows, and a two-story window set in a slightly projecting quoined central section. The wrought-iron fence surrounding the church creates a lively pattern against the austere facade.

SIDEWALK CLOCKS

SIDEWALK CLOCKS

DESIGNATED: AUGUST 25, 1981

CLOCK AT 753 MANHATTAN AVENUE

BROOKLYN, C. 1895

MAKER: UNKNOWN

CLOCK AT 522 FIFTH AVENUE

MANHATTAN, 1907

MAKER: SETH THOMAS CLOCK
COMPANY

CLOCK AT 200 FIFTH AVENUE

MANHATTAN, 1909

MAKER: HECLA IRON WORKS

CLOCK AT 30–78 STEINWAY STREET

QUEENS, 1922

MAKER: UNKNOWN

CLOCK AT 783 FIFTH AVENUE

MANHATTAN, C. 1927

MAKER: E. HOWARD CLOCK COMPANY

Although they enhance the cityscape and provide a public convenience, cast-iron street clocks were generally installed for advertising purposes. Introduced in the 1860s, these elegant timepieces were available from catalogues and sold for about $600. A merchant often painted his store name on the clock face and installed the timepiece in front to attract passersby. When a business moved, its clock was generally taken along. Originally, street clocks were operated by weights that descended gradually, and thus kept the clock running for about eight days. Today, they are mechanized and have secondary movements. Master clocks inside the buildings operate the clocks outside.

Though many were casualties of traffic mishaps and sidewalk ordinances, three clocks in Manhattan, one in Brooklyn, and one in Queens are designated city landmarks.

Manufactured in 1907 by the Seth Thomas Clock Company, the clock at 522 Fifth Avenue originally stood on Fifth Avenue and 43rd Street in front of the American Trust Company. When that bank and the Guaranty Trust Company merged in the 1930s, the clock was moved one block north to its present location. The nineteen-foot clock features a fluted post and classically inspired ornamented base that support foliate scroll brackets. The faces are marked with Roman numerals and rimmed with wreaths of acanthus. A pineapple motif crowns the clock.

The Hecla Iron Works (p. 314) manufactured the clock at 200 Fifth Avenue, which was installed in 1909 with the construction of the Fifth Avenue Building and features the building's name on its face. A stylish advertisement, the ornate cast-iron clock is composed of a rectangular, classically ornamented base and a fluted Ionic column with a Scammozzi capital. Its dials are marked with Roman numerals, framed by wreaths of oak leaves, and crowned by a cartouche.

The classically designed clock at 783 Fifth Avenue features a high, rectangular, beveled base with gilded panels that support the clock's slender fluted column and double-faced dial. Possibly installed in 1927 when the Sherry-Netherland Hotel was built, the clock was manufactured by the E. Howard Clock Company, a Massachusetts-based firm founded by Aaron L. Dennison and Edward Howard, creators of the first mass-produced pocket watch. The company introduced sidewalk clocks about 1870 and continued to produce them until 1964.

The cast-iron street clock at 753 Manhattan Avenue in Brooklyn was bought by Bomelsteins Jewelers and has a rectangular, beveled base, fluted column, and double-sided face. The

clock surround has been obscured by a contemporary sign.

The tall cast-iron street clock at 30–78 Steinway Street in Queens has a large, round, double-faced dial, surmounted by an inverted triangular sign bearing the name Wagner Jewelers, and supported by a narrow, scroll-topped, fluted column on a beveled base. Erected in 1922, the clock was purchased secondhand in Manhattan by Edward Wagner, owner of the jewelry concern.

BATTERY MARITIME BUILDING, FORMERLY MUNICIPAL FERRY PIERS TO SOUTH BROOKLYN

1909

11 SOUTH STREET, MANHATTAN

ARCHITECT: WALKER & MORRIS

DESIGNATED: MAY 25, 1967

Ferry service, concentrated on the lower tip of the island, played an essential part in the life of early Manhattan. At the peak of the ferry era, seventeen lines ran between terminals in Manhattan and Brooklyn alone. Today, only the Municipal Ferry Terminal remains standing. In operation since 1909, it is used by the Coast Guard for service to Governors Island and houses offices for the Bureau of Transit Operations.

Contrasting with the angular cityscape, arched three-hundred-foot openings mark the water side of the terminal. Embellished with latticework, raised moldings, and a variety of rivets and rosettes, these decorative arches are examples of Beaux-Arts structural

BATTERY MARITIME BUILDING

A.T. DEMAREST & COMPANY

expressionism. They are set between colossal pilasters that appear to rise from the water's edge, their capitals transformed into scroll brackets.

An open promenade supported by low steel arches between piers resting on granite bases marks the land side of the terminal. Paired, tapered columns, also decorated with unusual capitals and scroll brackets, support the roof and cornice. Other features include a balcony ornamented with marine forms, a three-story curtain wall made of tall, tripartite framed windows, and swinging gates protecting the entrances to two of the ferry slips. The overall style, inclusive of these structural details, is reminiscent of turn-of-the-century French Exposition architecture.

A. T. DEMAREST & COMPANY AND PEERLESS MOTOR CAR COMPANY BUILDINGS, LATER GENERAL MOTORS CORPORATION BUILDING

1909

224–228 WEST 57TH STREET (ALSO KNOWN AS 1758–1770 BROADWAY), MANHATTAN

ARCHITECTS: FRANCIS H. KIMBALL

DESIGNATED: DECEMBER 19, 2000

In the heart of "Automobile Row," architect Francis H. Kimball constructed buildings for two independent car manufacturing businesses, but unified them through analogous facades and an entwined floor plan. The Cleveland-based Peerless Motor Car Co. occupied the L-shaped building, and A. T. Demarest & Co., originally a carriage manufacturer, occupied the corner building, pocketed inside the other. Subtly different ornamental schemes on each of the facades related to the Broadway Tabernacle, the imposing neo-Gothic church located next door (demolished in 1970). The facades are composed almost entirely of matte white terra-cotta. Kimball employed steel-frame construction above concrete piers for these nine-story buildings based on his extensive knowledge of contemporary skyscraper design.

The structures were combined into single office building when the General Motors Corporation, acquired the building in 1918 for its first major corporate headquarters. It is now owned by the Hearst Corporation.

LIBERTY TOWER

1909–10; 1979

55 LIBERTY STREET, MANHATTAN

ARCHITECT: HENRY IVES COBB;
JOSEPH PELL LOMBARDI

DESIGNATED: AUGUST 24, 1982

Located at 55 Liberty Street in Lower Manhattan, Liberty Tower is a magnificent Gothic Revival skyscraper. When it was built, it had the distinction of being the "World's Tallest Building on so Small a Plot." Designed by Henry Ives Cobb, the thirty-three-story building was erected shortly before the Woolworth Building (p. 434). Although only half as tall as its more famous contemporary, Liberty Tower anticipated much of its revolutionary character by being almost entirely freestanding, clad largely in terra-cotta, and designed in a Gothic style.

Liberty Tower was one of the first early buildings to adapt a historic style to the newly emerging steel-cage method of construction, and it broke free, somewhat, of the tripartite system of skyscraper composition. The high, sloping copper roof acquired a dull green patina that was intended to contrast with the white-glazed terra-cotta of the three main elevations. The prolific surface ornament is an adaptation of English Gothic. Pilasters at the corners of the roof are topped by pinnacles and crowned with finials. The dormers are flanked by small piers surmounted by terra-cotta animals.

The building was constructed according to the latest technological achieve

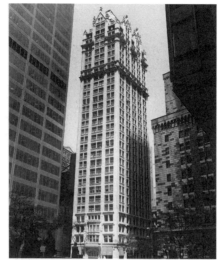

LIBERTY TOWER

GUATEMALAN PERMANENT MISSION TO THE U.N.

ments of its time: The foundation was laid on caissons, resting on bedrock ninety feet below the curb, and the skeletal steel construction was fully fireproofed. The building was originally equipped with five high-speed elevators with wire glass enclosures.

The Garden City Company of Long Island bought Liberty Tower in 1916 and resold it to the Sinclair Building

Company in 1919 for the main offices of the Sinclair Oil Company. From 1945 to the mid 1970s, the building was owned by a real estate company and rented out as offices. In 1979, architect Joseph Pell Lombardi bought the building; he restored the exterior and public areas and converted it to a cooperative residential building. The space was sold unimproved so that each of the eighty-nine apartments had its own architect, design, style, and layout.

GUATEMALAN PERMANENT MISSION TO THE UNITED NATIONS, FORMERLY THE ADELAIDE L. T. DOUGLAS HOUSE

1909–11

57 PARK AVENUE, MANHATTAN

ARCHITECT: HORACE TRUMBAUER

DESIGNATED: SEPTEMBER 11, 1979

This elegant Louis XVI–style town house was designed for New York socialite Adelaide L. Townsend Douglas in 1909, a year after her divorce from William Proctor Douglas, a vice-commodore of the New York Yacht Club. The architect, Horace Trumbauer, had earned great prominence for his commissions from Peter A. B. Widener, including the Widener Memorial Library at Harvard University. He favored the stylistic prototypes of seventeenth- and eighteenth-century France, and the Adelaide Douglas House belongs to this mode.

The ground floor of the six-story granite and limestone structure is heavily rusticated. An impressive cornice, which also serves as a balcony, sets off

the main portion of the facade at the second and third stories. The fourth story rises above a modillioned cornice with a grooved frieze decorated with bellflowers. A dentilled cornice and parapet sets off the slate-covered mansard roof that forms the fifth story. Shielded by a wrought-iron railing, only the parapet of the sixth floor, which is set back from the building line, is visible from the street. Wrought-iron railings also shield the windows, and a wrought-iron fence encloses the basement entryway. The Guatemalan Permanent Mission to the United Nations currently occupies the house.

NEW YORK CITY PARKING VIOLATIONS BUREAU, FORMERLY THE EMIGRANT INDUSTRIAL SAVINGS BANK BUILDING

1909–12

51 CHAMBERS STREET, MANHATTAN

ARCHITECT: RAYMOND F. ALMIRALL

DESIGNATED (EXTERIOR AND INTERIOR): JULY 9, 1985

Organized under the auspices of Bishop John Hughes and the Irish Emigrant Society, the Emigrant Industrial Savings Bank was incorporated in 1850 to protect the savings of people newly arrived in the United States. The bank grew rapidly with New York's growing immigrant population. In 1907 it acquired, for the second time, additional adjoining space and commissioned architect Raymond F. Almirall to design a new building for the expanded lot.

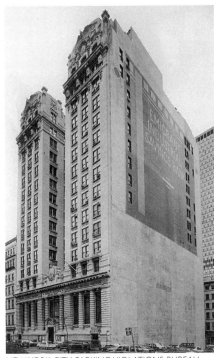

NEW YORK CITY PARKING VIOLATIONS BUREAU

Intended as a backdrop to City Hall, Almirall's seventeen-story commercial building represents an early version of the New York skyscraper. The diffusion of sufficient interior light was a major preoccupation of the building's designers, who believed that a well-illuminated interior was crucial to healthy banking activity.

These goals were complicated by the strictures of Beaux-Arts design, which called for heavy cornices to balance blocklike towers; these towers prevented light from reaching the building's upper stories. Some architects solved the problem by telescoping their towers to create a narrow main shaft that would permit light to reach a building's interior. Some developers responded by purchasing surrounding buildings to

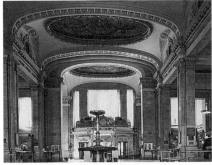

PARKING VIOLATIONS BUREAU INTERIOR

prevent the erection of light-blocking "spitescrapers."

Almirall's solution lay in his innovative H plan. Here, a series of double-height rusticated piers and engaged columns form nine bays that rest on a basement story and support an entablature. The long windows of these light bays illuminate the two-story banking halls within. Adorned with copper-framed, double-sash windows recessed behind limestone piers, the building's twin towers create an unbroken line that emphasize the buildings daring height. Although the solution was praised in the *Real Estate Record and Guide*, a 1916 zoning law requiring setbacks to admit light to city streets prevented further use of the plan.

The majestic hall on the first floor remains one of New York's best banking rooms. Unlike better-known spaces, this formal hall achieves a gentle spaciousness through its repeated elliptical decorative motifs, which hint at the art nouveau style. Four stained glass oval skylights portray figures that represent facets of the economy. The building now houses municipal offices.

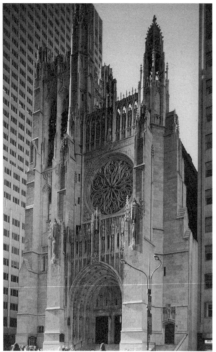

ST. THOMAS CHURCH

MANHATTAN BRIDGE APPROACH

ST. THOMAS CHURCH AND PARISH HOUSE

1909–14; 1997

1–3 WEST 53RD STREET, MANHATTAN

ARCHITECTS: CRAM, GOODHUE & FERGUSON; BEYER BLINDER BELLE

DESIGNATED: OCTOBER 19, 1966

The first church structure to house the St. Thomas parish, at Broadway and Houston Streets, burned in 1851, and a second structure at the same location was closed in 1866 as the neighborhood around it deteriorated. The third church building, erected on this Fifth Avenue site, was built in 1870 and burned in 1905, to be replaced by the present church.

This massive limestone structure, although influenced by Gothic prototypes, is original in its design. The architectural firm of Cram, Goodhue & Ferguson won the commission with their plan for an asymmetrical single corner tower and an off-center nave. This plan was a sensitive response to the problem of the corner site. Though the elevations are highly ornamented, the buttresses of the square tower are extremely simple and balance the elaborate main entrance and rose window above it. The delicate reredos, designed by Bertram G. Goodhue and the sculptor Lee Lawrie, offer relief from the massive solidity of the rest of the church. In 1997, the church underwent a major restoration by Beyer Blinder Belle.

MANHATTAN BRIDGE APPROACH

1909–16

MANHATTAN BRIDGE PLAZA, BOUNDED BY THE BOWERY AND CANAL, FORSYTH, AND BAYARD STREETS, MANHATTAN

ARCHITECTS: CARRÈRE & HASTINGS

DESIGNATED: MAY 10, 1968

The Manhattan Bridge was the fourth to span the East River. The monumental arch and colonnades on the Manhattan side were designed by Carrère & Hastings. The arch is of light gray rusticated granite and its semicircular vaulting is richly coffered with rosettes and carved borders. The heavy cornice is surmounted by a balustrade with classical motifs, as is the colonnade. Originally, the approach had ornate sculptural decoration by Carl A. Heber and a frieze panel—called *The Buffalo Hunt*—by Charles Gary Rumsey. On the Brooklyn side were pylons with statues representing New York and Brooklyn by Daniel Chester French; these are now installed at the Brooklyn Museum.

In 1913, the commissioner of the Department of Bridges proposed building a grand boulevard to link the Brooklyn and Manhattan Bridges in Manhattan. This boulevard was never developed; the arch and colonnades are all that remain of the original approach plan.

680–690 PARK AVENUE

This Park Avenue block, known as Pyne–Davison Row, is composed of four Federal Revival town houses. Built between 1909 and 1926, these residences have been adapted to serve as the headquarters of the Americas Society (formerly the Center for Inter-American Relations), the Spanish Institute, the Italian Cultural Institute, and the Consulate General of Italy.

Although the buildings were designed individually, the four present a uniform appearance: each house is red brick laid in Flemish bond, with rusticated limestone ground floors and stone cornice balustrades. Numbers 680 and 684 were designed by McKim, Mead & White, 686 is the work of Delano & Aldrich, and 690 was designed by Walker & Gillette.

Built for Percy R. Pyne, financier and philanthropist, number 680 achieved notoriety in 1960 when Soviet Premier Nikita S. Khrushchev gave a news conference from the iron balcony on the second floor. At the time, the building housed the Soviet Mission to the United Nations. The restoration of the house was begun by the Marquesa de Cuevas in 1965. The second-floor drawing room has an Adam ceiling panel by Angelica Kauffmann, the eighteenth-century decorative painter. On the ground floor, an exhibition space has replaced servants quarters and the kitchen.

Oliver D. Filley, Pyne's son-in-law, commissioned McKim, Mead & White to design his house on the site of the Pyne family's garden. The building was renovated in the 1960s to adapt it to its current function as headquarters of the Spanish Institute. The classic interior detail—a center staircase, an eighteenth-century paneled room, carved marble mantelpieces, vaulted ceilings, and plaster cornices—was retained. The rugs and furnishings from Spain are in the Spanish neoclassical style, which parallels the Federal style of architecture.

Number 686 was built in 1916–19 for William Sloane. Some of the interior detailing was taken from Belton House, in Grantham, England, which was designed by Christopher Wren. The Italian Cultural Institute has occupied the building since 1959. Number 690, built for Henry B. Davison, is now the Consulate General of Italy.

427

SHELTER PAVILION AND ATTACHED BUILDINGS, 1910

MONSIGNOR McGOLRICK PARK, NASSAU AND DRIGGS AVENUES, MONITOR AND RUSSELL STREETS, BROOKLYN

ARCHITECTS: HELMLE & HUBERTY

DESIGNATED: FEBRUARY 8, 1966

This handsome, gently curving pavilion provides the focal point for this small park in the Greenpoint section of Brooklyn. Originally called Winthrop Park, it was officially renamed in 1941 to honor Monsignor Edward J. McGolrick, then pastor of St. Cecilia's Church. It was designed by Helmle & Huberty in the mode of seventeenth- and eighteenth-century French gardens, most notably the gardens of the Grand Trianon at Versailles.

The crescent-shaped pavilion consists of an open arcade with a small building at each end. In the buildings, a central arched window is framed by engaged columns flanked by smaller, square-headed windows. The corners are accented by paired pilasters, and a handsome balustrade surmounts each of the two end buildings, while their cornices are carried through the full sweep of the colonnade—a strong unifying feature.

The park shelter controls the landscape plan around it. This type of radial landscaping— determined by the form of a building—is typically French and rarely encountered in America.

SHELTER PAVILION

LOUIS ARMSTRONG HOUSE

1910; 2003

34–56 107TH STREET, QUEENS

ARCHITECT: ROBERT W. JOHNSON

DESIGNATED: DECEMBER 13, 1988

Louis Armstrong, born in New Orleans in 1901, began his musical career at the age of ten as the tenor in a children's street quartet, singing ragtime and comic songs. On New Year's Eve 1912, he was arrested for firing a pistol in celebration and sent to the Colored Waifs' Home for eighteen months; there he learned to play the cornet. After his release, he continued to play with various New Orleans bands while working odd jobs. In 1930, Armstrong moved to New York, traveling widely as he became increasingly well known.

In 1942, Armstrong married his third wife, Lucille Wilson; the following year she purchased and furnished this home in Corona, Queens. The modest, brick-clad frame structure was home to Armstrong from 1943 until his death in 1971. According to Lucille, when Louis first went to see it, he wasn't ready to settle down. "He left his bags in the cab

LOUIS ARMSTRONG HOUSE

and told the driver to wait for him. But, to his surprise, he fell in love with the house," she recalled.

Lucille Armstrong bequeathed the house and its contents to the City of New York to serve as a museum and study center devoted to Armstrong's career and the history of American jazz. The house opened to the public in 2003.

W HOTEL, FORMERLY GUARDIAN LIFE BUILDING AND THE GERMANIA LIFE INSURANCE COMPANY BUILDING

1910–11; 2000

50 UNION SQUARE EAST, MANHATTAN

ARCHITECTS: D'OENCH & YOST

DESIGNATED: SEPTEMBER 6, 1988

The founder of the Germania Life Insurance Company was Hugo Wesendonck, a former member of the Frankfurt parliament who fled a death sentence in Germany when the Revolution of 1848 failed and the parliament was disbanded. After dabbling in the silk business in Philadelphia, he decided "to bring the benefits of life

CHEROKEE APARTMENTS

W HOTEL

insurance to the 'little people' of German extraction" in New York. Regarded highly for its ethical conduct and economical practices, the company flourished in the second half of the nineteenth century. The cost of this building, Germania's fourth headquarters, was $1 million. (Anti-German sentiment during World War I led the owners to change the company's name to Guardian Life in 1918.)

While the building displays traditional European design elements—the Second Empire–style mansard roof and the masonry exterior—it also reflects the practical considerations of modern design. The architects provided the maximum amount of usable floor space, flooded with natural light, using a sophisticated system of fireproof floor

construction. The ornamentation of the building, including garlanded keystones, links it with the "cartouche" style, which distinguished Parisian architecture of the 1890s. References to sixteenth-century German architecture, such as the interesting variety and arrangement of the dormer windows, can also be seen. The building was cleaned and restored in 2000 when it was converted into the W Hotel.

CHEROKEE APARTMENTS, FORMERLY SHIVELY SANITARY TENEMENTS

1910–11; 1989–90

507–515 AND 517–523 EAST 77TH STREET AND 508–514 AND 516–522 EAST 78TH STREET, MANHATTAN

ARCHITECT: HENRY ATTERBURY SMITH

DESIGNATED: JULY 9, 1985

The Shively Sanitary Tenements, also known as the East River Homes, were conceived by Dr. Henry Shively, a prominent physician, and funded by philanthropist Mrs. William K. Vanderbilt. They were intended to house tuberculosis patients and their families in a sanitary environment and to provide the city's poor and sick with the light and open space for recovery. Purchased by Mrs. Vanderbilt for $81,000, the site was selected for its proximity to the East River and consequent fresh air.

The architect chosen to design these four adjoining buildings was Henry Atterbury Smith, who in the early 1900s had developed the "open-stair" plan as a healthful and economic form of housing

for the working class. He made use of other innovative architectural elements as well, including interior courtyards entered through Guastavino-tiled, barrel-vaulted passageways, roof gardens fitted with windbreaks and tiled floors, and such sensitive details as seats built into the outside stair railing at each level so that those ascending the stairs could rest along the way. The stairwells, rising to roof level from the interior corners of the courtyards, were shielded from inclement weather by glass canopies.

On the facades, Smith used a blend of materials—light stone, terra-cotta, and tan brick inset with green terra-cotta ornament—all topped by a projecting green tile roof. The triple-hung windows, intended to increase airflow to the rooms, were carefully and symmetrically arranged across each facade. They were fronted by cast-iron balconies supported by large curving brackets, which allowed people to sit or sleep outside.

The buildings were sold to the City and Suburban Homes Company for apartments in 1924. In 1989–90, the buildings underwent extensive exterior restoration.

ST. PHILIP'S PROTESTANT EPISCOPAL CHURCH

ST. PHILIP'S PROTESTANT EPISCOPAL CHURCH

1910–11

210–216 WEST 134TH STREET, MANHATTAN

ARCHITECTS: VERTNER W. TANDY & GEORGE W. FOSTER JR.

DESIGNATED: JULY 13, 1993

This neo-Gothic building is the fourth home of New York's oldest African American Protestant Episcopal congregation, established as a parish in 1818. The congregation's original site, near the intersection of Chrystie and Stanton Streets, was given by the Trinity Parish to be used as a burying ground for Trinity's African American worshipers. In 1818, St. Philip's was recognized as an independent Episcopal parish. St. Philip's was the first black church to move to central Harlem, and its relocation from Lower Manhattan reflects the residential patterns of the African American popu-

lation in New York City. Its membership has included Thurgood Marshall, W.E.B. Du Bois, and Langston Hughes.

St. Philip's was designed by Vertner W. Tandy and George Washington Foster Jr., who were among the first African-American architects to practice in the United States. The church's only true facade faces 134th Street and is laid in orange Roman brick. It is symmetrically massed and dominated by an enormous stained glass, pointed-arch window, below which are three small, street-level windows flanked by buttressed doorways. Gargoyles and a high-gabled roof complete the Gothic detail.

14 WALL STREET, FORMERLY BANKER'S TRUST BUILDING

1910–12; ADDITION, 1931–33

14 WALL STREET (ALSO KNOWN AS 8–20 WALL STREET, 1–11 NASSAU STREET, AND 7–15 PINE STREET), MANHATTAN

ARCHITECTS: TROWBRIDGE & LIVINGSTON; ADDITION, SHREVE, LAMB & HARMON

DESIGNATED: JANUARY 14, 1997

As monopolistic trusts grew in America's turn-of-the-century economy, New York City's financiers defended their interests by forming the Banker's Trust. Closely associated with J. Pierpont Morgan, the firm was organized in 1903 with $1 million. By 1912, the year in which its new building was completed, the Banker's Trust was the second-largest trust in the country. It controlled $168

14 WALL STREET

million, and its board members held 113 interlocking directorships in fifty-five of the nation's largest banking, insurance, transportation, manufacturing, trading, and utility companies. In the same year, Congress discovered that more than three-quarters of all American capital and credit was controlled by this small Wall Street banking clique.

Capped by a seven-story, stepped pyramidal roof, this 539-foot building—modeled on the campanile of San Marco in Venice—is a distinctive element of the lower Manhattan skyline. Its much imitated profile became a symbol of American capitalism, while its pointed top set a more general precedent in skyscraper design. In the early 1930s, a twenty-five-story, L-shaped addition articulated with a blend of Modern Classic and Art Deco motifs was added north of the original tower. Banker's Trust held the building until 1987, and it is currently owned by General Electric.

430

998 FIFTH AVENUE

998 FIFTH AVENUE

1910–12

MANHATTAN

ARCHITECTS: McKIM, MEAD & WHITE

DESIGNATED: FEBRUARY 19, 1974

The first large apartment house built north of 59th Street on the Upper East Side, 998 Fifth Avenue dominated a neighborhood of smaller private homes. To promote the transition of potential occupants from single-family houses to apartments, the building was filled with amenities, among them a refrigerated wine cellar, central vacuum cleaning, and three wall safes with combination locks for each apartment. In addition, the apartments were large, either seventeen-room single-floor apartments or slightly larger duplexes. The appeal of the building can be judged by the earliest tenant lists, which included such notables as Senator Elihu Root, former Governor Levi P. Morton, and Mr. and

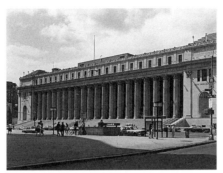

JAMES A. FARLEY BUILDING

Mrs. Murray Guggenheim.

This building has long been recognized as the finest Italian Renaissance Revival apartment house in New York. The limestone exterior is divided into three superimposed, four-story sections separated by wide belt courses and balustrades. The base is heavily rusticated, while the upper two sections are more finely dressed ashlar with quoins. At the roofline, a large cornice with a deep overhang terminates this emphatically horizontal composition.

JAMES A. FARLEY BUILDING, FORMERLY THE U.S. GENERAL POST OFFICE

1910–13; ADDITION, 1935

EIGHTH AVENUE BETWEEN 31ST AND 33RD STREETS, MANHATTAN

ARCHITECTS: McKIM, MEAD & WHITE

DESIGNATED: MAY 17, 1966

On Labor Day 1914, a new post office at Eighth Avenue between 31st and 33rd Streets was opened to the public. Named Pennsylvania Terminal, it was designed by William Mitchell Kendall, who joined the firm of McKim, Mead & White in

1906. On July 1, 1918, the facility became the U.S. General Post Office. The building was renamed in honor of James A. Farley, the 53rd postmaster general of the United States, in 1982.

A dignified and imposing urban structure, the building mirrored the neoclassical magnificence of Pennsylvania Station across the street—until Penn Station was destroyed. An addition—the West Building—was opened in December 1935. Together, the buildings cover an area of 1,561,600 square feet.

The portico of twenty colossal Corinthian columns at the main entrance on 8th Avenue is anchored at each end by massive, niched pavilions and approached by a grand sweep of thirty-one steps. The scheme of the main colonnade is repeated with pilasters on the other elevations. An attic story surmounts a distinctive cornice.

The now-famous inscription occupying the entire height and length of the 280-foot frieze of the entablature was adapted by Kendall from the Eighth Book of Herodotus. The motto, which has come to be associated with the U.S. Post Office, reads: "Neither snow nor rain nor heat nor gloom of night stays these couriers from the swift completion of their appointed rounds." Although couriers carry out their tasks differently today, the Farley Building, continues to be both functional and elegant. It creates a ceremonial public architecture related to its urban environment and reflecting the union of past and present. There are plans to convert it to a transportation center named for the late New York Senator Daniel Patrick Moynihan.

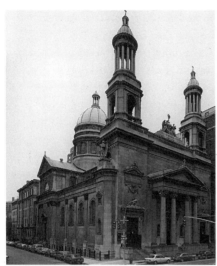

ST. JEAN BAPTISTE CHURCH

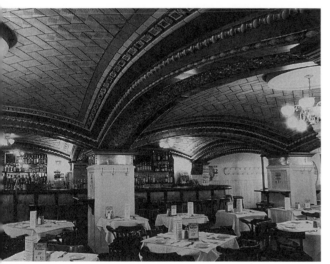

VANDERBILT STATION INTERIOR

ST. JEAN BAPTISTE CHURCH

1910–13; 1995–96

1067–1071 LEXINGTON AVENUE, MANHATTAN

ARCHITECT: NICHOLAS SIRRACINO

DESIGNATED: NOVEMBER 19, 1969

The St. Jean Baptiste Church, built to serve the French-Canadian community of New York, was funded by the noted financier Thomas Fortune Ryan. Nicholas Sirracino, an Italian architect, designed the church in the Italian Renaissance style.

Renaissance and Baroque elements embellish the facade. Two slightly projecting bell towers, capped with small domes, are situated on each side of the front facade, and one large dome is situated over the crossing. A portico with four Corinthian columns marks the front entrance. Each of the towers is adorned with scrolls, swags, small pediments, and the heads and wings of cherubs. A globe, supported by angels, is located on the parapet between the bell towers; other angels are found just to the sides of the towers, standing on pedestals below the cornice. A major restoration campaign for the church was completed in 1995–96.

VANDERBILT STATION INTERIOR, FORMERLY FIORI RESTAURANT, ORIGINALLY THE DELLA ROBBIA BAR AND GRILL, ALSO KNOWN AS THE CRYPT

1910–13

4 PARK AVENUE, MANHATTAN

ARCHITECTS: WARREN & WETMORE

VAULT CONSTRUCTION: R. GUASTAVINO COMPANY

ARCHITECTURAL TERRA-COTTA: ROOKWOOD POTTERY COMPANY

DESIGNATED: APRIL 5, 1994

A survivor from an opulent era, this restaurant was housed in the Vanderbilt Hotel, which was designed by Warren & Wetmore, also the architects of Grand Central Terminal (p. 452). The hotel was a personal project of Alfred Vanderbilt, who occupied its luxurious penthouse apartment. Along with 127 other Americans, Alfred Vanderbilt met an early death aboard the *Lusitania*, a British passenger ship that was torpedoed by a German U-boat in 1915; the incident contributed to America's decision to enter the World War I. Today the Vanderbilt Hotel building is office and storage space, and its facade has been stripped of ornament.

The restaurant interior, however, remains largely unchanged. The bar (now the front dining room) and two adjacent bays (now the rear dining room) have vaulted ceilings. Elaborate terra-cotta dominates the decor, including flowers, keys, ropes, and grotesque heads. The significance of ceramics is indicated by the fact that the restaurant

took its name from Luca della Robbia, a celebrated fifteenth-century terra-cotta craftsman. Once frequented by such celebrities as Enrico Caruso, Rudolph Valentino, and Diamond Jim Brady, the grotto-like ambience gave the fashionable Della Robbia its nickname, "the Crypt."

EAST 70TH STREET HOUSES

MANHATTAN

DESIGNATED: JULY 23, 1974

11 EAST 70TH STREET, 1909–10

ARCHITECT: JOHN H. DUNCAN

15 EAST 70TH STREET, 1909–10

ARCHITECT: CHARLES I. BERG

17 EAST 70TH STREET, 1909–11

ARCHITECT: ARTHUR C. JACKSON

19 EAST 70TH STREET, 1909–10

ARCHITECT: THORNTON CHARD

21 EAST 70TH STREET, 1918–19

ARCHITECT: WILLIAM J. ROGERS

Built between 1909 and 1919, these houses on East 70th Street were inspired by the French classical and Italian Renaissance modes; although they were designed by five different architects, the buildings are unified by their splendid limestone facades. The properties on this block were held by the estate of James Lenox until 1907, when they were transferred to the New York Public Library. In 1909, the library began to sell the property to affluent New Yorkers, who bought these lots and erected elaborate houses for themselves.

The first house was number 11,

designed by John H. Duncan; number 15 was built in the same years and was designed by Charles I. Berg. Number 17, noted for its rusticated ground floor and boldly enframed central window, was designed by Arthur C. Jackson. Number 19, now occupied by the Knoedler Gallery, is an imposing house, designed by Thornton Chard in a simplified early Italian Renaissance style—complete with arched loggia, balconies, and prominent roof cornice. The simple yet elegant house at number 21, now Hirschl & Adler Galleries, was designed by William J. Rogers; the smooth ashlar limestone facade is pierced with two deeply recessed openings at each floor, which give the building its crisp and distinctive character.

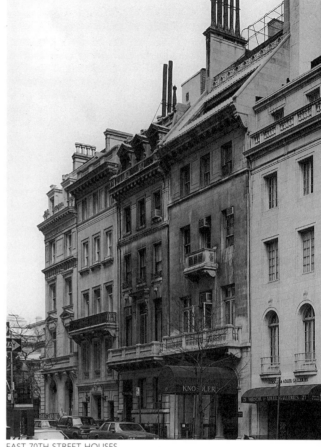

EAST 70TH STREET HOUSES

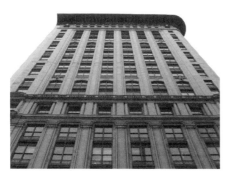

FORMER UNITED STATES RUBBER COMPANY

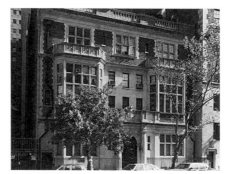

1025 PARK AVENUE

FORMER UNITED STATES RUBBER COMPANY BUILDING

1911–12

1790 BROADWAY (ALSO KNOWN AS 234 WEST 58TH STREET), MANHATTAN

ARCHITECTS: CARRÈRE & HASTINGS

DESIGNATED: DECEMBER 19, 2000

Pioneers in the design and attitude towards the skyscraper, Carrère & Hastings were one of the first firms to reveal the steel skeleton of the contemporary skyscraper, making the marble veneer apparent as a non-load-bearing element of the building. The delicately carved facades, connected by a rounded corner, each feature vertically grouped windows, adorned by metal spandrels and slender, continuous piers topped by a broad cornice.

Constructed at the beginning of the era of automobile, this striking Beaux-Arts-style building contributed to the development of a section of Broadway known as "Automobile Row." Lower floors originally provided tire retail-space, while United States Rubber occupied eight floors of office space above.

In 1951, the company moved to offices in Rockefeller Center. The building is still used as office space, and the ground floor houses a bank.

1025 PARK AVENUE

1911–12

MANHATTAN

ARCHITECT: JOHN RUSSELL POPE

DESIGNATED: OCTOBER 7, 1986

The house at 1025 Park Avenue was designed for Reginald DeKoven, a composer of light opera and popular music, and his wife, Anna. The building is a rare survivor of the private houses built on Park Avenue after the enclosure and electrification of its railroad tracks.

DeKoven established his reputation in the music world with *Robin Hood*, a light comic opera written in 1890 that included the favorite "O Promise Me." As a music critic, DeKoven joined with the Shuberts to build the Lyric Theater on West 42nd Street.

Pope's design took the DeKovens' musical lifestyle into consideration, providing a large, double-height front room

to accommodate musical entertainments; this music room also served as a ballroom. The design also reflected Mrs. DeKoven's love of early English design. The dominating, symmetrically arranged bay windows and solid brick facade with stone trim are reminiscent of British manor houses of the late sixteenth and early seventeenth centuries. Other features include three-sided bay windows with casements of leaded glass and stone mullions. The round-arched, classical doorway of Jacobean character supports a shield bearing the arms of the DeKoven family.

WOOLWORTH BUILDING

1911–13; 1980s

233 BROADWAY, MANHATTAN

ARCHITECT: CASS GILBERT

DESIGNATED (EXTERIOR AND INTERIOR): APRIL 12, 1983

The Woolworth Building is one of the most famous skyscrapers in the United States. Designed by Cass Gilbert and completed in 1913, it was the tallest building in the world until the Chrysler Building topped it in 1929. In terms of height, profile, corporate symbolism, and romantic presence, this graceful, Gothic-style tower became the prototype for the great skyscrapers that permanently transformed the skyline of New York City after World War I.

The Woolworth Building was commissioned in 1910 by Frank Winfield Woolworth, proprietor of a multimillion-dollar international chain of five-

and-ten-cent stores. For the headquarters of his vast empire, Woolworth wanted a building that reflected not only his personal success but also the new twentieth-century phenomenon of mass commerce. Gilbert's building attained these goals, and at its inauguration, Woolworth nicknamed the building the "Cathedral of Commerce."

Gilbert objected to the frequently ecclesiastical association made between the Woolworth Building and a Gothic cathedral. He had great respect for the aesthetic significance of architectural historicism; but as a Midwesterner aware of the technological advances of the Chicago School, Gilbert was a keen advocate of the modern aesthetic of functionalism. He held that a building's surface should express its structure, and, in the case of the skyscraper, its construction around a steel cage.

The Woolworth Building is massive yet elegant in its soaring verticality. Unlike most earlier tall buildings, it avoids the traditional subdivision into base, shaft, and capital, presenting instead a silhouette based on two setbacks, creating three sections of progressively smaller dimensions culminating in a pyramidal roof (originally gilded) and four tourelles. Gilbert emphasized the skyscraper structure in three ways. The elevations of the thirty-story base and the narrower thirty-story tower are divided into continuous vertical bays of windows and Gothic-traceried spandrels, set off from one another by projecting piers that emphasize the underlying construction. Gilbert chose to cover the building in a skin of ornamental terra-cotta rather than masonry

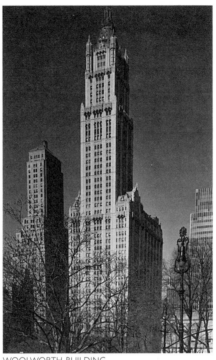

WOOLWORTH BUILDING

(except for the first four stories, which are limestone), to stress the fact that the walls themselves were not load-bearing. He used polychromy to enhance the shadows and accent the main structural lines. The overall color is cream, with highlights in buff, blue, and gold; the colors become stronger higher up on the tower.

The interior, designed as a monumental civic space, is divided into an arcade, a marble staircase hall in the center, and, beyond that, a smaller hall. The decoration continues the Gothic motif of the exterior. Rich in marble, bronze Gothic filigree, sculpted relief, mosaic vaults, glass ceilings, and painted decoration, the Woolworth Building has one of the most handsome publicly accessible interiors in the city.

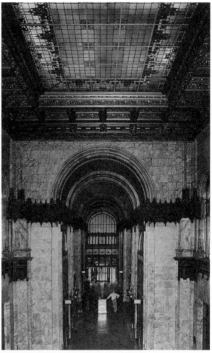

WOOLWORTH BUILDING INTERIOR

The Woolworth Building is a key monument in the creation of New York as a skyscraper city because it established the basic principles for such construction after 1920. The tower continues to serve as the national company headquarters, celebrating both the Woolworth empire and the gilded age of New York City commerce. During the 1980s, the F. W. Woolworth Company undertook a major restoration of the building's exterior, replacing much of the terra-cotta with cast stone.

435

CHURCH OF THE INTERCESSION

CHURCH OF THE INTERCESSION AND VICARAGE

1911–14

540–550 WEST 155TH STREET, MANHATTAN

ARCHITECTS: CRAM, GOODHUE & FERGUSON

DESIGNATED: AUGUST 16, 1966

In 1906, the Church of the Intercession —which was then located at 158th Street and Grand Boulevard (now Broadway) —found itself in financial peril. The rector, Dr. Milo Hudson Gates, was aware that Trinity Church wished to establish a chapel near its uptown cemetery. Gates negotiated a solution whereby the Church of the Intercession would become a chapel of Trinity, which, in turn, would build a new church building for the congregation on part of the cemetery land. The cemetery had been landscaped by Calvert Vaux in the 1870s; a bridge designed by Vaux spanned Grand Boulevard at the time, and connected two halves of the cemetery.

In designing the new church, Bertram Grosvenor Goodhue took advantage of the dramatic site at the crest of a hill to create a wonderfully picturesque composition. A large western gable, emerging from buttresslike forms in Goodhue's characteristic manner, dominates the western facade. The design is reminiscent of English fourteenth-century Gothic, called Perpendicular, especially in the use of a tower with parapet, reticulated tracery, shallow buttresses, and generally broad proportions. The present steeple, installed in the 1950s, replaces the original, which was damaged. The tower is in an unusual position, and provides a smooth transition from church to vicarage, chapter house, and small cloister to the east. The random ashlar masonry (the stones were excavated on the site) is continued in this section; combined with Tudor hood moldings, windows, bays, and segmental arches, it creates a more secular image.

In plan, the church is a long rectangle with suppressed transepts and shallow aisles. The nave gives the impression of a single, sweeping space. The buff-colored, rough-cast plaster finish on the interior elevations is unusual. Against it, the stone arcades, window trim, and wall shafts stand out in strong relief. The most exciting interior feature is the brightly polychromed, wood hammer-beam roof. The church furnishings are exceptionally fine and worth a good look. Goodhue felt this was one of his greatest New York commissions and

asked to be interred here. His tomb, carved by Lee Lawrie, is in the north transept. Buried in the adjacent cemeteries are many other prominent New Yorkers, including Clement Clarke Moore, John James Audubon, and various members of the Astor family.

The vicarage is an integral part of the church complex. It is connected to the chapel by a cloister; the three elements surround a small courtyard. The vicarage is constructed of the same combination of rock-faced and ashlar stone as the chapel, and although its Tudor style differs from the Perpendicular Gothic of the chapel, the similarity in materials allows the two buildings to function as a unified whole.

FORMER LONG DISTANCE BUILDING OF THE AMERICAN TELEPHONE & TELEGRAPH COMPANY

1911–14; 1914–16; 1930–32; 2000

32 SIXTH AVENUE, MANHATTAN

ARCHITECTS: CYRUS L. W. EIDLITZ AND MCKENZIE, VOORHEES & GMELIN; 1930–32, VOORHEES, GMELIN & WALKER

DESIGNATED (EXTERIOR AND FIRST FLOOR INTERIOR): OCTOBER 1, 1991

This massive, brick Art Deco skyscraper was the result of three building campaigns, each undertaken in response to the remarkable growth of the long-distance communications industry. The first structure, a seventeen-story Romanesque Revival office building and telephone exchange, was prudently designed with

a foundation and steel skeleton that would be able to accommodate additional stories. Only two months after completion, plans were filed to enlarge the structure to twenty-four stories; the seven-story addition extended the exterior architectural features of the original design. Still, within the next decade, the company required even more space. The last design added a multistory penthouse and two large twenty-seven-story extensions. In its final state, the building—which was in use twenty-four hours a day—contained dormitories, a kitchen, three cafeterias, a five-hundred-seat auditorium, recreation spaces, and a medical department.

This "small city," with its overall sculptural quality and linear ornamentation, is united by the continuous polished Texas pink-granite water table, the vertical bands of brick, coherent fenestration patterns, and the faceted parapet of lighter colored brick. The earlier sections are faced in red-brown brick; the portions dating from the 1930–32 alteration are faced in a distinctive blend of red, orange, gray, brown, and dark-brown brick.

As he had done in the Barclay-Vesey building (p. 490), architect Ralph Walker united the lobby with the exterior by echoing the building's architectural elements in his interior decorative program: the exterior brick curtain walls are reflected in the earth-colored tiles of the lobby, and the exterior vertical piers are recalled in the red tile pilasters set in the umber tile wall. Although broken into disjointed spaces because of the irregular building plan, the lobby is unified by a harmonious scheme of colors

and textures and the consistent use of indirect lighting. Walker also used linear decorative motifs throughout to represent modern technology: patterns of terrazzo, tile, and glass are suggestive of the long-distance telephone lines and wires in a less abstract fashion, the ceiling decoration includes allegorical figures of Australia, Asia, Africa, and Europe, reminding visitors of the building's function as a main hub of international communication: it was the crossroads of all main trunk routes in the Northeast, serving 360 cities and handling all transoceanic calls.

In December 1999, the Rudin Organization bought the building from AT & T, and undertook major renovation work. The Rudins continue to own, operate, and manage the building, known as the Global Connectivity Center, as a telecommunications hub and as a Tribeca office space.

FORMER AT&T LONG DISTANCE BUILDING

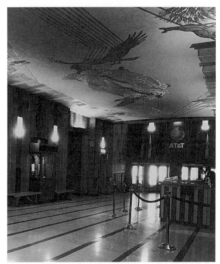

FORMER AT&T LONG DISTANCE BLDG. INTERIOR

ADMINISTRATION BUILDING

FORWARD BUILDING

ADMINISTRATION BUILDING AT EAST 180TH STREET

1912; 1940S

481 MORRIS PARK AVENUE,
THE BRONX

ARCHITECTS: FELLHEIMER & LONG
AND ALLEN H. STEM

DESIGNATED: MAY 11, 1976

Originally designed as a railroad station serving the New York, Westchester & Boston Railroad, this building was constructed of concrete and operated by electricity—reflecting the trend toward modernized stations designed to serve the expanding suburban communities of the early twentieth century. Free from the heavy ornamentation of its wooden prototypes, the structure followed the simple style of an Italian villa.

The Morris Park facade contains a three-story central section with an arcaded loggia at the street level. It is flanked by four-story projecting end pavilions, resembling towers and marked by balustraded balconies. A narrow belt course with small square windows directly above it separates the first story from the upper portion of the facade. This rhythm is repeated on the third floor by paired arched windows set within blind arches. Round plaques, recalling Tuscan originals, surround the street-level loggia. Other ornamentation includes the winged head of Mercury centered in the crowning broken pediment and picturesque red roof tiles.

The station was closed when service terminated in 1937. Since the 1940s, the building has functioned as an entrance to the East 180th Street subway station, with offices on the upper floors.

FORWARD BUILDING

1912

173–175 EAST BROADWAY,
MANHATTAN

ARCHITECT: GEORGE A. BOEHM

DESIGNATED: MARCH 18, 1986

The Forward Building was erected in 1912 to house the *Jewish Daily Forward*, a Yiddish paper founded in 1897 by a dissenting faction of the Socialist Labor Party. The editors argued for pragmatic socialism in the United States and called for cooperation among the labor left toward this common goal. The *Jewish Daily Forward* also published sensationalist stories similar to those printed in Joseph Pulitzer's *New York World*, and Yiddish literature by Morris Rosenfeld and Isaac Bashevis Singer, among others. More generally, the *Jewish Daily Forward* was one of several papers serving the large Eastern European Jewish community that grew rapidly from 1870 until 1925, when a federal law slowed immigration.

The newspaper offices occupied only four floors of the building; the rest were leased to labor organizations, including the Workmen's Circle and United Hebrew Trades. The staff and publishers decided to turn the building into a labor center, determined to erect a more imposing building than Josef Yarmalofsky's nearby twelve-story bank

at Canal and Allen streets. Appropriately, the decoration in the first-floor frieze includes portraits of Karl Marx, Friedrich Engels, and Central European labor leaders, Ferdinand Lassalle and Friedrich Adler. Unfortunately, contemporary shop signs cover these portraits.

Not enough is known about the architect George Boehm to determine how and why he received this large commission from a socialist client early in his career. In the 1930s and 1940s, however, Boehm criticized architects who catered to landlords and developers and argued for the introduction of public policy courses in architecture schools. He carried his social commitment further as a committee member for the Citizens Housing and Planning Council and the Housing Section of the Welfare Council of New York.

The overall design follows that of the former Evening Post Building (p. 396) at 20 Vesey Street, completed in 1906 by Robert Kohn. Boehm trained in the Beaux-Arts system, first at Columbia University and then in Paris and Rome; the Forward Building's classical detailing reflects this background. The seven-story central section, clad in white terra-cotta and generously glazed, expresses the building's height. The low structures on each side convey the difference in height and design between construction from the 1870s and early 1880s and the first generation of tall buildings.

STATEN ISLAND LIGHTHOUSE

1912

LIGHTHOUSE HILL, EDINBORO ROAD, STATEN ISLAND

ARCHITECT: UNKNOWN

DESIGNATED: JANUARY 17, 1968

From Lighthouse Hill above historic Richmondtown, the Staten Island Lighthouse illuminates one of New York Harbor's many channels. Commonly known as the Richmond Light, this 350,000-candlepower beacon operates under the jurisdiction of the U.S. Coast Guard, in conjunction with the Ambrose Light Tower, to guide ships into the busy port.

The tall, octagonal, yellow-brick tower rises above a rusticated limestone base. Alternate faces of the shaft are set with rectangular stair windows framed by smooth stone beneath stepped lintels. From the cornice above, large ornate brackets support an octagonal widow's walk. Following the perimeter of the tower, this narrow walk is enclosed by a simple wrought-iron rail and is lined with bull's-eye windows. At the lighthouse's summit, glass-faced walls, beneath a low-pitched roof supporting a large ball and lightning rod, surround the powerful light. A small cantilevered balcony at this level echoes the widow's walk below.

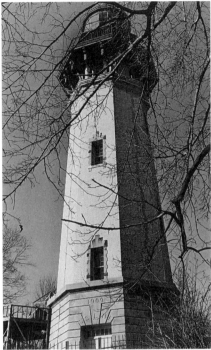

STATEN ISLAND LIGHTHOUSE

439

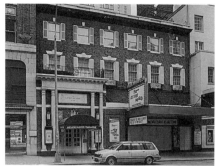
HELEN HAYES THEATER

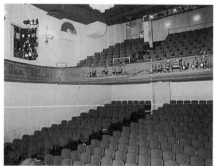
HELEN HAYES THEATER INTERIOR

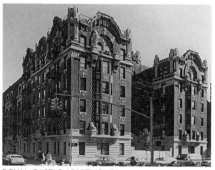
ROYAL CASTLE APARTMENTS

HELEN HAYES THEATER, FORMERLY THE LITTLE THEATER

1912; ADDITIONS, 1917–20

238–244 WEST 44TH STREET, MANHATTAN

ARCHITECTS: INGALLS & HOFFMAN; ADDITIONS, HERBERT J. KRAPP

DESIGNATED: NOVEMBER 17, 1987

As part of his plan to popularize drama on an intimate scale in America, producer Winthrop Ames, along with architects Harry C. Ingalls and Francis B. Hoffman Jr., built the Little Theater in 1912. When it opened, the theater had only 299 seats; in 1917–20 it was enlarged by the addition of a balcony according to a plan by the theater architect Herbert J. Krapp. With 499 seats, the Helen Hayes is the smallest of the Broadway theaters.

The red brick and limestone exterior resembles a home more than an ornate Broadway theater. The refined Georgian Revival exterior was paired with an equally refined Adamesque interior. The auditorium is enhanced by elaborate paneled wainscoting halfway up the walls, with tapestries above framed by Corinthian pilasters. The wood paneling not only aided the acoustics of the theater but also suggested the warmth and intimacy of a drawing room, thus realizing Ames's goal.

ROYAL CASTLE APARTMENTS

1912–13

20–30 GATES AVENUE, BROOKLYN

ARCHITECTS: WORTMANN & BRAUN

DESIGNATED: DECEMBER 22, 1981

An imposing Beaux-Arts-style apartment house, the Royal Castle Apartments were built for the development firm of Levy & Baird. Six stories high with stone details, the Royal Castle is an imposing composition complementing the dignified and exclusive nature of Clinton Avenue, which was once known as Brooklyn's "Gold Coast."

The design of the Royal Castle was in keeping with the architectural character of the avenue. The flavor of the neighborhood was established by the free-standing mansions built in the latter half of the nineteenth century, spurred by oil magnate Charles Pratt's decision to erect his mansion here in 1875. The Beaux-Arts style was associated with wealth and luxury; the name of this building was chosen to convey an image of luxury and social standing.

Built of brick above a rusticated limestone base, the structure commands the intersection of Gates and Clinton Avenues. A deep central court on Gates Avenue marks the main entrance and divides the building into two pavilions; the building is entered through a one-story stone portico pierced by a broad, round arch with drip molding. The most dramatic feature is the striking silhouette of the sixth floor and roofline. The central bay at the sixth floor of each pavilion is designed as a large Venetian

round-arched window with radiating keystones and a voussoir arrangement echoing the pilasters below. Ornate round pediments crown each pavilion.

SHUBERT THEATER

1912–13; 1996

221–233 WEST 44TH STREET, MANHATTAN

ARCHITECT: HENRY B. HERTS

DESIGNATED (EXTERIOR AND INTERIOR): DECEMBER 15, 1987

The Shubert Theater was built as the headquarters of the Shubert Organization and a memorial to Sam S. Shubert, the leader of the business until his death. Designed to stage the organization's large musicals, the elaborate Shubert was built jointly with the smaller and more intimate Booth Theater in Shubert Alley.

Herts masterfully integrated the exteriors of both theaters into one design. Curved corner entrance doors are the most dramatic elements of the facade. Within, painted panels by J. Mortimer Lichtenauer represent classical figures; set in frames of various shapes and sizes, they create a sense of grandeur in the auditorium. Renaissance-inspired plasterwork outlines the main architectural elements of the interior. The Shubert Organization still has its offices in this theater. In 1996, the original color scheme and painted murals were restored on the interior.

BOOTH THEATER

1912–13

222–232 WEST 45TH STREET, MANHATTAN

ARCHITECT: HENRY B. HERTS

DESIGNATED (EXTERIOR AND INTERIOR): NOVEMBER 4, 1987

Named for Edwin Booth, the great nineteenth-century Shakespearean actor (and brother of John Wilkes Booth), this theater was built for the Shubert brothers and independent producer Winthrop Ames. The city had stipulated that a space must exist between the theaters and the Astor Hotel to the east. The creation of Shubert Alley allowed the theater to have two fully designed facades, making it a showcase for the Shubert Organization. The two facades are joined by a projecting curved pavilion, which contains the central doorway, and decorated with Venetian Renaissance details, including low-relief sgraffito decoration below the cornice. The Booth and the Shubert contain the only known surviving examples of sgraffito in New York.

Ames was a proponent of intimately scaled theaters. With the Booth—as with the Little Theater—he hoped to sell audiences on the style of drama that he had seen in Europe. The Booth contained just 785 seats—half as many as the Shubert Theater next door. The design is similar to the Tudor-style theaters that Ames had seen in England, complete with wood paneling to enhance the acoustics and multipaned casement windows. The ceiling is decorated with latticework bands executed in plaster.

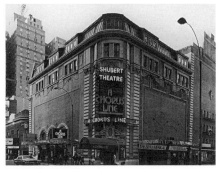

SHUBERT THEATER

SHUBERT THEATER INTERIOR

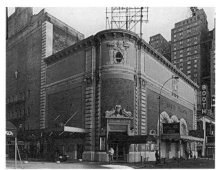

BOOTH THEATER

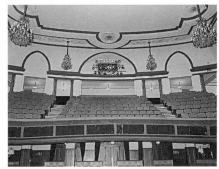

BOOTH THEATER INTERIOR

441

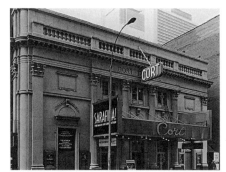

CORT THEATER

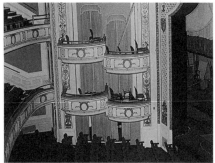

CORT THEATER INTERIOR

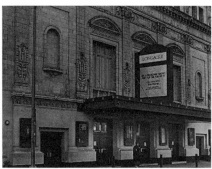

LONGACRE THEATER

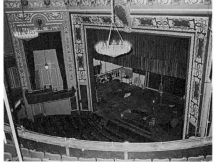

LONGACRE THEATER INTERIOR

CORT THEATER

1912–13

138–146 WEST 48TH STREET, MANHATTAN

ARCHITECT: THOMAS LAMB

DESIGNATED (EXTERIOR AND INTERIOR): NOVEMBER 17, 1987

In the course of his career, architect Thomas Lamb designed more than three hundred theaters throughout the world. The Cort is one of his oldest remaining New York theaters, built for producer and theater owner John Cort. Lamb's theaters, designed in historical styles popular with the wealthy, were accessible to the masses for the price of a ticket.

The facade of the Cort Theater is an adaptation of the Petit Trianon—the "playhouse" of Marie Antoinette at Versailles. This little house was a well-worn source of inspiration to architects of Lamb's generation. Although the theater is not an exact copy—Lamb used round-arched doors rather than square windows, and engaged columns instead of pilasters—the Cort still reflects the essence of its model.

The French theme is continued in the opulent interior. A replica of a bust of Marie Antoinette stands in a niche overlooking the ticket lobby, and plasterwork displaying French motifs, such as panels with cameos, decorates the entire interior. A mural above the proscenium arch depicts a garden dance that might have taken place during the reign of Louis XVI. The arch itself is the theater's most unusual feature; made of plaster and

detailed with art glass, it was lit during performances.

The Shubert organization purchased the palatial Cort in 1927 and continues to maintain it today.

LONGACRE THEATER

1912–13

220–228 WEST 48TH STREET, MANHATTAN

ARCHITECT: HENRY B. HERTS

DESIGNATED (EXTERIOR AND INTERIOR): DECEMBER 8, 1987

The Longacre Theater was designed to house the productions of Harry H. Frazee, a Broadway producer and owner of the Boston Red Sox. Frazee had worked his way up from a movie-house usher to an influential Broadway producer in a very short time, and he opened the Longacre when he was only thirty-three years old.

Herts was one of Broadway's foremost theater architects and a longtime partner of Hugh Tallant, another theater architect. Herts and Tallant had met in Paris at the Ecole des Beaux-Arts, where Herts developed his French neoclassical design; the Longacre is an outstanding example of this style. The facade has five bays, framed by six fluted pilasters. The three center bays form a large casement window, and the two outer bays are round-headed niches. Ornamentation includes carved fountains at the base of each pilaster, each topped by a personification of drama. A foliate cornice with projecting carved lion heads, foliate

vases, and strapwork escutcheons spans the top of the facade. In contrast to its architectural success, the Longacre had a history of failed productions and financial hardship.

PALACE THEATER INTERIOR

1912–13; 1965

1564–1566 BROADWAY, MANHATTAN

ARCHITECTS: KIRCHHOFF & ROSE

DESIGNATED: JULY 14, 1987

The Palace era began when Sarah Bernhardt appeared on its vaudeville-style stage in 1913. She was immediately followed by a succession of famous entertainers, including Jack Benny, Ethel Barrymore, the Marx brothers, Mae West, and the great illusionist Harry Houdini.

Designed specifically for vaudeville, the grand lobby and spacious foyer were built to handle large crowds for several daily shows. Boxes, loggias, a high proscenium arch, and a large stage were all commonly found in such production spaces. Twenty tiered boxes were originally located at the ends of the double balconies that wrapped around the Palace's deeply splayed orchestra walls. While lavish ornamental plasterwork in high relief announced the entertainment in a boisterous fashion, the near-perfect sight lines and fine acoustics created an intimate relationship between the audience and the performers. Other interior decorations include Pavanzzo marble in the main lobby and an inner lobby constructed of Siena marble and containing

bronze screen doors with stained glass. The building is L-shaped, with an eleven-story office complex connected to the theater.

Soon after its opening, the Palace began to feel the effects of the rapidly growing motion-picture industry; in 1932, the bill changed to include movies. Structural changes soon followed; the auditorium was renovated and modernized in the late 1930s and early 1940s. Until its purchase in 1965 by the Nederlanders, the Palace fluctuated between a policy of mixed bills and straight film. The new owners, under the direction of designer Ralph Alswang, successfully restored the structure.

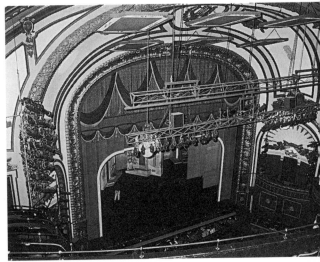
PALACE THEATER INTERIOR

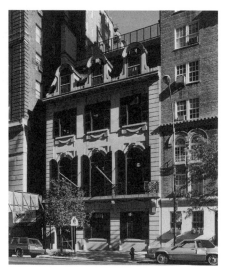
MANHATTAN COUNTRY SCHOOL

MANHATTAN COUNTRY SCHOOL, FORMERLY THE OGDEN CODMAN JR. HOUSE

1912–13; 1966	
7 EAST 96TH STREET, MANHATTAN	
ARCHITECT: OGDEN CODMAN JR.	
DESIGNATED: MAY 25, 1967	

This Louis XVI house was designed by the architect Ogden Codman Jr. for his own use. Codman was a talented architect and decorator who practiced mainly in Boston, Newport, and New York from the 1890s through the first decades of the twentieth century. His work consisted mostly of interior decoration, although he designed twenty-two houses, creating stylish and elegant settings notable for their human scale and lack of excessive opulence.

His house at 7 East 96th Street, as well as the buildings at 12 and 15, were based on eighteenth-century French sources, and the facades are taken directly from plates from César Daly's *Motifs Historiques d'Architecture* (1880). The circular dining room was inspired by one taken from an eighteenth-century mansion in Bordeaux, now at the Metropolitan Museum of Art. The rooms of Bordeaux houses were particularly useful models, because the houses occupy lots the same size as those of New York City town houses.

The four-story structure with a limestone facade is distinguished by wrought-iron balconies, dormer windows, many shutters, a mansard roof, and a porte cochere leading to a courtyard and garage. Above a strong, rusticated first floor rests a second-floor stone balcony supported on carved brackets, with an exquisitely detailed wrought-iron railing extending the width of the entire facade. Completing the composition is a well-proportioned stone cornice, behind which rises a slate mansard roof with three unusual dormer windows.

After passing through the hands of several owners, including the Nippon Club, the mansion was bought by the Manhattan Country School in 1966.

SEPHORA, FORMERLY CHARLES SCRIBNER'S SONS

1912–13	
597 FIFTH AVENUE, MANHATTAN	
ARCHITECT: ERNEST FLAGG	
DESIGNATED: MARCH 23, 1982; INTERIOR DESIGNATED: JULY 11, 1989	

This Beaux-Arts building was the second

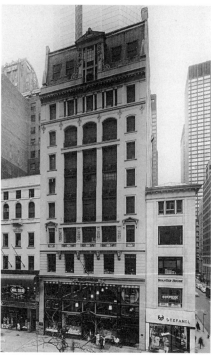
SEPHORA

Ernest Flagg designed for the prominent publishing firm of Charles Scribner's Sons, and it incorporated many of the design features of the earlier work, expanding and elaborating them for this new, more fashionable midtown location at Fifth Avenue near 48th Street.

The facade is divided into a base, midsection, and top and is crowned by a mansard roof with a large central dormer. Following Flagg's interpretation of the Beaux-Arts dictum, the building is symmetrical from side to side: the three central bays form a distinct group, more elaborately decorated than the two end bays. The facade is dominated by the extensively glazed two-story storefront.

Inside, Flagg's two-story, plaster-paneled vaulted space—graced with a mezzanine, balconies, and a clerestory—

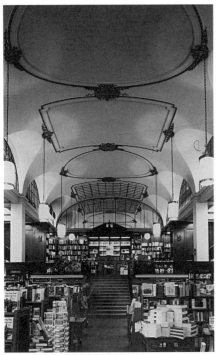

CHARLES SCRIBNER'S SONS INTERIOR

RUSSELL SAGE FOUNDATION
BUILDING AND ANNEX

1912–13; PENTHOUSE 1922–23; 1973
ANNEX 1930–31

122–130 EAST 22ND STREET (ALSO
KNOWN AS 4–8 LEXINGTON AVENUE),
MANHATTAN

ARCHITECT: GROSVENOR ATTERBURY;
ANNEX WITH JOHN A. TOMPKINS II

DESIGNATED: JUNE 20, 2000

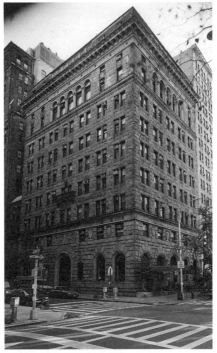

RUSSELL SAGE FOUNDATION

resembles nothing so much as the library of a private home. The flamboyant ironwork framing the first-floor interior, and continuing in the staircase and balcony railings, exemplifies some of the best design and craftsmanship of the early twentieth century. Flagg's eye for spatial complexity and beautiful detail is apparent in the mirrored end wall, the graceful central staircase, and the iconography of the ceiling, which illustrates the world of publishing.

The Scribner Building was for many years an appropriate corporate symbol for the distinguished publishing firm of Charles Scribner's Sons. Edizone Realty Corporation, a subsidiary of the Benetton family, owns the building. The store is leased to Sephora, a leading retailer of perfumes and cosmetics.

Olivia Sage, one of the world's wealthiest women and most important philanthropists, launched the Russell Sage Foundation in 1907 with an unparalleled ten-million-dollar donation, creating one of the leading reform social service organizations of the Progressive era. Since the new headquarters building was planned as a memorial to her husband, great attention was given to the design and construction, and funds for the project were ample. Architect Grosvenor Atterbury adapted the sixteenth-century Florentine palazzo form to a twentieth-century office building. The principal facades are clad in rough-cut, red sandstone, punctuated by a patterned assembly of openings.

In 1922–23, a tenth-floor penthouse was added, and granite sculpture panels were added in 1922–26. These carvings express the ideals and goals of the foundation; each in the form of a shield, they represent health, work, play, housing, religion, education, civics, and justice. Modeled by sculptor Rene Chambellan, these are some of his earliest known architectural sculptures.

In 1930–31, an Annex was built, designed by Atterbury with John A. Tompkins II.

The foundation sold its headquarters in 1949 to the Catholic Charities of the Archdiocese of New York, which held the property until 1973. The building was later converted into apartments.

445

HAMILTON PALACE

NEW YORK TIMES BUILDING

HAMILTON PALACE, FORMERLY HAMILTON THEATER

1912–13

3560–3568 BROADWAY (ALSO KNOWN AS 559–561 WEST 146TH STREET), MANHATTAN

ARCHITECT: THOMAS W. LAMB

DESIGNATED: FEBRUARY 8, 2000

Constructed at the height of vaudeville's popularity in the United States prior to World War I, this structure was designed by theater architect Thomas W. Lamb. His portfolio featured three hundred theaters around the world, including the Regent and Hollywood Theaters. The Hamilton's neo-Renaissance style facades feature large, round-arched windows with centered oculi, and is embellished by cast-iron and terra-cotta details, including caryatids, brackets, and Corinthian engaged columns.

Entertainment developers, B.S. Moss and Solomon Brill, operated the vaudeville theater in Harlem, until 1928, when the newly created Radio-Keith-Orpheum (RKO) Radio Pictures, Inc., bought it and installed a sound system, allowing the screening of "talking pictures," one of New York City's first such theaters. After RKO closed the Hamilton in 1958, an evangelical church owned the building from 1965 until the mid-1990s. The original terra-cotta cornice was removed in the 1930s and the theaters marquee in the 1990s. The building has been converted into a department store selling adult and children's clothing and furniture.

NEW YORK TIMES BUILDING, ORIGINALLY THE TIMES ANNEX

1912–13, 1922–24, 1930–32

217–247 WEST 43RD STREET, MANHATTAN

ARCHITECT: BUCHMAN & FOX; LUDLOW & PEABODY, 1922–24; ALBERT KAHN, INC., 1930–32

DESIGNATED: APRIL 24, 2001

This building marks the entwined history of Times Square and the newspaper for which it is was named. The New York Times Company first moved its production to a skyscraper on West 42nd Street in 1905, from its building on Printing House Square. The newspaper enjoyed tremendous growth, and without any option to develop lots around the tower, an annex was constructed two hundred feet away, on West 43rd Street, with the intention of shifting all production and offices into the new building. Mortimer J. Fox's eleven-story building, known as the Times Annex, which mimicked the company's existing neo-Gothic tower, is now mostly occupied by tenants. It was retained as a company icon until 1961 (now altered).

In 1922, an eleven-story addition, designed by Ludlow & Peabody in the French Renaissance style, doubled the building's capacity. Also constructed at that time was a five-story attic level addition, with a hipped roof that extended to the original building, unifying the structures, and featuring a seven-story tower capped by a pyramidal roof and lantern. The building became a beacon within the entertainment

district, providing the company with a solid street presence.

Officially renamed the New York Times Building in 1942, it houses the editorial and business offices, although printing has moved outside Manhattan. The company is constructing a new headquarters, designed by Italian architect Renzo Piano. Occupancy is expected in 2007, and the company expects to sell the West 43rd Street building.

THERESA TOWERS, FORMERLY THE HOTEL THERESA

1912–13

2082–2096 ADAM CLAYTON POWELL JR. BOULEVARD, MANHATTAN

ARCHITECTS: GEORGE & EDWARD BLUM

DESIGNATED: JULY 13, 1993

The Hotel Theresa opened in 1913 and maintained a policy of segregation. It was not until 1940 that the whites-only policy ended, and the Theresa—which came to be known as "the Waldorf of Harlem"—became the preferred hotel for prominent African-American writers, labor and business leaders, athletes, and bandleaders. The March on Washington Movement and Malcolm X's Organization of Afro-American Unity convened here. Fidel Castro stayed at the Theresa in 1960, receiving such luminaries as C. Wright Mills, Allen Ginsberg, and Nikita Khrushchev. The father of Ron Brown, former U.S. Secretary of Commerce, was the manager.

The Theresa was constructed as a residence hotel, although the suites did not have full kitchens; residents could eat in the hotel dining room or have their meals delivered. When built, it was the tallest structure in Harlem, affording views of New Jersey and Long Island. The building's three facades have projecting bays, arched surrounds, and prominent gables. Using a variety of geometric shapes that create complex and ingenious patterns, the white facade exemplifies George & Edward Blum's singular approach to ornamentation and inventive use of terra-cotta. The Theresa is now an office building.

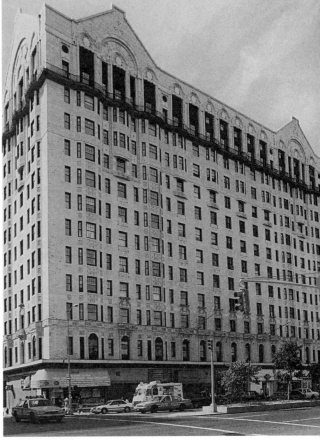

THERESA TOWERS

447

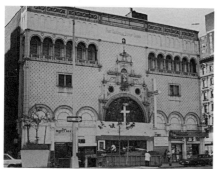
FIRST CORINTHIAN BAPTIST CHURCH

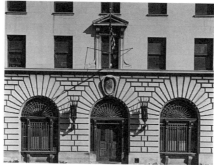
41ST POLICE PRECINCT STATION

FIRST CORINTHIAN BAPTIST CHURCH, FORMERLY THE REGENT THEATER

1912–13; 1964

1960–1916 ADAM CLAYTON POWELL JR. BOULEVARD (ALSO KNOWN AS 200–212 WEST 116TH STREET), MANHATTAN

ARCHITECT: THOMAS LAMB

DESIGNATED: MARCH 8, 1994

One of New York City's first—and most significant—motion-picture theaters, the Regent Theater building is among the few surviving local examples of the form, with one balcony and more than 1,800 seats. It was built during the motion-picture industry's transition from nickelodeons, which showed short silent pictures, to much larger theaters for viewing longer films. One critic remarked that the Regent initiated "an altogether new era in the moving picture world." Thomas Lamb, who was well known for his theaters and was responsible for many of the movie houses in Times Square, created the design. Among Lamb's extant theaters are the Mark Hellinger Theater, the Empire Theater, and Loew's 175th Street

Theater and Ballroom.

The Regent followed the architectural example of existing dramatic theaters. It included a notable multicolored, terra-cotta facade and street-level commercial space that originally housed six stores. The exotic facades incorporate Italian, neo-Renaissance, and mannerist motifs. The Regent operated for fifty years as a venue for motion pictures and vaudeville, providing musical accompaniment ushers, and an ornate and comfortable decor. In 1964, the First Corinthian Baptist Church, an African-American congregation formed twenty-five years earlier, bought the building.

41ST POLICE PRECINCT STATION HOUSE, FORMERLY THE 62ND POLICE PRECINCT STATION HOUSE

1912–14

1086 SIMPSON STREET, THE BRONX

ARCHITECTS: HAZZARD, ERSKINE & BLAGDEN

DESIGNATED: JUNE 2, 1992

Built in the West Farms area of the Bronx at a time of rapid development—

due to the construction of the elevated portion of the subway—the station reflects the vision of the City Beautiful movement. Evoking the fifteenth- and early-sixteenth-century palaces of Florence and Rome, the Renaissance style was considered appropriate for civic architecture. The three-story Simpson Street facade is faced with limestone ashlar—the ground story rusticated and the second and third stories smooth—and five large arches spring from the building's granite base. The structure is crowned with a richly ornamented terra-cotta cornice and a broad-eaved, hipped roof, originally covered in green tile.

When the station house first opened, the area still boasted the vestiges of gardens and orchards. World War II, however, drew thousands who had found employment in the war-related industries nearby. By the 1960s many of these industries had relocated, causing unemployment to increase, housing maintenance to decline, and poverty to escalate. By the 1970s, the majority of arrests made in the area were drug related, and for many residents the station house had become less a refuge and more a fortress; it was even nick-named "Fort Apache" by the press. A new station house is under construction for the 41st Precinct, and the once-admired station on Simpson Street will become a branch office of the Safe Streets program.

REGIS HIGH SCHOOL

1912–14

55 EAST 84TH STREET, MANHATTAN

ARCHITECTS: MAGINNIS & WALSH

DESIGNATED: NOVEMBER 19, 1969

Early in 1912, a group of Jesuit Fathers decided to erect a liberal-arts high school for gifted young men—a pilot project in Catholic education. When Regis High School opened two years later, the Catholic News reported that the school was "intended only for graduates from the parochial schools and is the first of its kind to be built in this city." The article also stated, "The general and private offices of the prefect of discipline will be given a commanding situation in reference to the entrances and stairways."

Designed by Maginnis & Walsh of Boston, and constructed of limestone, the school was built to harmonize in scale with St. Ignatius Loyola Church (p. 309) directly across the street. The five-story building is characterized by monumental Ionic columns on the East 84th Street facade. On East 85th Street an exterior wall, designed in the classical manner, encloses a large auditorium on the first three stories; the style is enhanced by two stairways in slightly projecting end bays with imposing doors at street level and by a large blank wall that serves as the base for a row of Ionic columns on the two upper floors. The entablature carries the inscription "Ad Maiorem Dei Gloriam" (To the Greater Glory of God). The architects made maximum use of the available space and

provided the seclusion desirable for effective education. Most of the classrooms open onto a central courtyard, which was once a playground.

FIRE ENGINE COMPANY 289, LADDER COMPANY 138

1912–14

97–28 43RD AVENUE, QUEENS

ARCHITECTS: SATTERLEE & BOYD

DESIGNATED: JUNE 22, 1999

This station was erected as part of a campaign to bring professional fire service to Queens, after a long history of volunteers serving the community, following the 1898 consolidation of Greater New York. The building was one of the earliest to anticipate automobile use in its design. The French Renaissance–style facade incorporates arched limestone apparatus bays designed exclusively for motorized vehicles, a mansard roof with limestone dormers, tapestry brick, bronze and marble medallions, decorative ironwork and wrought-iron balconies. Now located among single family residences and small industrial buildings, this active fire station remains one of Corona's most prominent public buildings.

REGIS HIGH SCHOOL

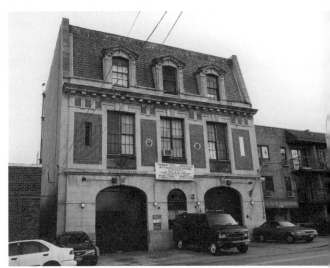

ENGINE COMPANY 289, LADDER COMPANY 138

449

FLUSHING COUNCIL ON CULTURE AND ARTS, FORMERLY FLUSHING HIGH SCHOOL

1912–15; 1991	
35–01 UNION STREET, QUEENS	
ARCHITECT: C.B.J. SNYDER	
DESIGNATED: JANUARY 8, 1991	

FLUSHING COUNCIL ON CULTURE AND ARTS

Flushing High School, the city's oldest public high school, is located in one of the three colonial settlements that now comprise Queens. During the seventeenth century, this neighborhood began to develop into one of the most important centers for horticulture in the country. Nurseries in Flushing provided many of the trees in Central and Prospect Parks. The grounds of the school contain many rare trees and plants that recall the area's history. Less than a block from the high school are the offspring of the landmark weeping beech tree of 1847.

Following the consolidation of New York City in 1898, Flushing residents, aware of the potential for rapid development in the area due to the proposed construction of the Queensborough Bridge and the extension of the subway into Queens, began to lobby for a new high school. This brick and gray-speckled terra-cotta building in its campus-like setting was the outstanding response of the newly formed city government. The monumental square entrance tower, picturesque silhouette, asymmetrical massing, and assorted Gothic-inspired details—crenellation, grotesque corbels, and heraldic statues of unicorns and griffins—echo the fanciful conjoining of styles typical of English universities. This so-called collegiate Gothic style was introduced to New York public school architecture by C. B. J. Snyder, superintendent of buildings for the Board of Education from 1891 to 1923. In 1991, the Flushing Council on Culture and Arts acquired the building.

KINGSBRIDGE ARMORY, 8TH REGIMENT ARMORY

1912–17	
29 WEST KINGSBRIDGE ROAD AND JEROME AVENUE, THE BRONX	
ARCHITECTS: PILCHER & TACHAU	
DESIGNATED: SEPTEMBER 24, 1974	

The Kingsbridge Armory, with its massive and crenellated parapets, gives the appearance of a medieval Romanesque fortress. Officially the home of the 258th Field Artillery (8th Regiment), it is reputedly the largest armory in the world, covering an entire city block. Designed by the firm of Pilcher & Tachau, which gained acclaim for their competition design of 1901 for the Squadron C Armory in Brooklyn, the

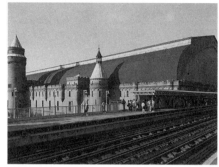

KINGSBRIDGE ARMORY

Kingsbridge Armory was built on the site of the proposed eastern basin of the Jerome Park Reservoir. Excavation had begun for the eastern basin in the early 1900s, but the state legislature authorized the site for a National Guard Armory in 1911. A number of military relics were exposed during the excavation, reflecting the site's proximity to the sites of Fort Independence and Fort Number Five of the American Revolution.

The red-brick walls are trimmed with stone and punctuated at regular intervals by slit window openings. Two semi-engaged, round towers crowned by conical roofs flank the main entrance. A stone stairway leads up to the round-arched doorway, where massive iron gates protect paneled doors. A metal and glass roof spans the enormous drill hall.

BROOKLYN CENTRAL OFFICE

Brooklyn Central Office, Bureau of Fire Communications

1913

35 Empire Boulevard, Brooklyn

Architects: Helmle & Huberty

Designated: April 19, 1966

The Brooklyn Central Office, Bureau of Fire Communications, was designed by the prominent Brooklyn architect Frank J. Helmle of Helmle & Huberty. Erected in 1913, the building serves as the central communications office for the Brooklyn Fire Department. This brick and limestone pavilion is simple and utilitarian, and reminiscent of the magnificent Morgan Library in Manhattan. Both are Italian Renaissance–style structures that, for quite different reasons, required more wall space than windows. The architectural solution in both cases was to dramatize the contrast between the blank flanking wings and an open central loggia. The Brooklyn building is elegantly scaled and crowned by a plain cornice and tile roof. Three graceful arches with slender columns and a low balustrade frame the deep porch, or loggia, creating a fine entranceway.

Grand Army Plaza

1913; 1988–90

Fifth Avenue and 59th Street, Manhattan

Architect: Carrère & Hastings

Designated: July 23, 1974

In the Greensward Plan of 1858, Frederick Law Olmsted and Calvert Vaux projected a plaza running from 58th to 60th Street along Fifth Avenue, in addition to "cuts" along Central Park South. These were to serve as standing areas for carriages, surrounded by trees and enclosed within railings. Several members of the City Board in Charge of Central Park were dissatisfied with this solution, and in 1863 a special committee selected designs for four plazas and gateways by Richard Morris Hunt, who had just returned from the Ecole des Beaux-Arts in Paris. Olmsted and Vaux were outraged by the monumental urban character of the gates, which they felt were foreign to their image of the park as a picturesque retreat.

Although Hunt's designs were rejected, the idea for an urban plaza—inspired by Napoleon III's reorganization of Paris—remained. Later, in the 1890s, Karl Bitter, a noted sculptor and member of the City Arts Council, returned to Hunt's ideas, which now found a wider audience thanks to the efforts of the City Beautiful Movement. No funds were available, however, until 1912, when Joseph Pulitzer bequeathed $50,000 to the city for the erection of a fountain "like those in the Place de la Concorde in Paris." Bitter then invited the Pulitzer

GRAND ARMY PLAZA

estate to hold a limited competition, won by Thomas Hastings of Carrère & Hastings.

All parks, Hastings felt, should reflect their urban context by articulating the terminations and intersections of major arteries. He also felt that New York City's grid was too rigid and did not provide sufficient public areas. His plaza reflects these ideas. For the southern end, he designed a fountain rising in five concentric rings to Bitter's figure of Abundance. The architect took great care to align the fountain with Augustus Saint-Gaudens's statue of William Tecumseh Sherman in the northern half of the plaza. The area was officially named Grand Army Plaza in 1923. In 1988–90, the fountain was restored by architect Samuel G. White and the Sherman statue regilded.

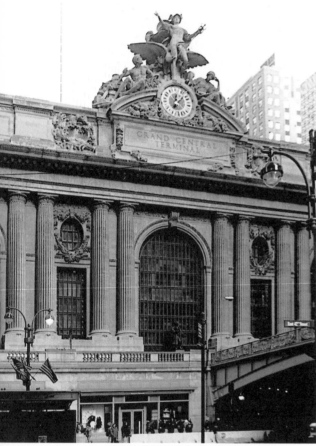

GRAND CENTRAL TERMINAL

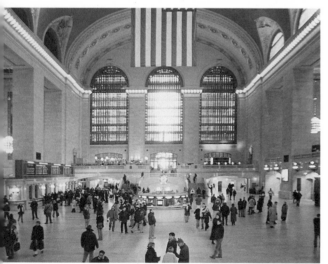

GRAND CENTRAL TERMINAL INTERIOR

GRAND CENTRAL TERMINAL

COMPLETED 1913; RESTORED, 1994–98

71–105 EAST 42ND STREET, MANHATTAN

ARCHITECTS: REED & STEM AND WARREN & WETMORE; RESTORATION, BEYER BLINDER BELLE

DESIGNATED: SEPTEMBER 21, 1967; INTERIOR DESIGNATED: SEPTEMBER 23, 1980

Grand Central Terminal, one of the great buildings in America, has been a symbol of New York City since its completion in 1913. It combines distinguished architecture with a brilliant engineering solution to the problem of accommodating under one roof a vast network of merging railway lines and the needs of the 400,000 people who pass through each day. This monumental building functions as well in the twenty-first century as it did when built. Its style represents the best of the French Beaux-Arts—generously scaled spaces, imposing architecture, and grandly conceived sculptural decoration. Grand Central also operates as a modern urban nerve center. So extensive is the series of connections to nearby office buildings that many commuters can go to work without going outdoors. Grand Central has come to be associated with the mobility and nobility of New York City—the sometimes frenzied, but usually dignified, energy of its people.

The terminal was designed by two architectural firms. Reed & Stem devised the daring concept of using ramps to connect the various levels of the complex, as well as the separation of automobile, pedestrian, subway, and train traffic. The subsequent plans of Warren & Wetmore produced the rich Beaux-Arts architectural details. The facade, largely the work of Whitney Warren, is based on a triumphal arch motif with three great windows, colossal columns grouped in pairs, and a dramatic sculptural group by Jules Coutan surmounting the cornice and clock over the central entranceway.

The interior of Grand Central, reminiscent of the huge vaulted spans of Roman baths, is truly a spatial triumph in the Beaux-Arts tradition. It is 275 feet long, 120 feet wide, and 125 feet high, and displays a remarkable unity of order, clarity, amplitude, and grandeur. The plan is characterized by a series of axially aligned spaces connected by ramps and passageways that create a movement forward and downward, leading to the train platforms. The lateral ancillary spaces contribute to a sense of spatial flow and freedom within the tight, symmetrical plan. Covering the vault of the central hall is a magnificent zodiac mural by Paul Helleu.

Fortunately the U.S. Supreme Court upheld the city's right to declare the building a landmark in 1978, thereby ending plans to place a huge tower over the concourse. Grand Central Terminal will continue, in its original state, to monitor and mirror the pulse of New York City. The spectacular building was restored in 1994–98 by Beyer Blinder Belle.

J. William Clark House, formerly Richard L. Feigen & Co. Gallery and Automation House

1913–14; 2000

49 East 68th Street, Manhattan

Architects: Trowbridge & Livingston; Wendy Evans Joseph

Designated: November 10, 1970

The J. William Clark House is part of an outstanding group of Federal Revival red-brick town houses known as Pyne-Davison row, which extends along Park Avenue between East 68th and 69th streets (p. 427). The Clark house relates to 680 Park Avenue, the house on the corner: on both, the roof cornice, the belt course, and the height of the first story base are set at approximately the same level.

Four stories high and only two bays wide, the house has a red-brick facade laid up in English bond and a twin-arched loggia at the street level. Entry to the ground floor is gained through a doorway behind the right arch of the loggia. The arch on the left leads to the basement door, which is shielded by a low iron railing and gate. An effect of simplicity is created by the undecorated limestone cornice. The gambrel roof is clad in copper.

The house was built for J. William Clark, whose grandfather invented a form of cotton sewing thread that was first produced in Paisley, Scotland, in 1812. Clark's sewing thread was introduced to America in 1818, but during the Civil War, when importing became difficult, William Clark and his brother opened a thread mill in Newark, New Jersey; their six-cord thread, trade-marked "O.N.T." (Our New Thread), soon became famous. It has now been restored as a private residence by architect Wendy Evans Joseph.

Morgan Guaranty Trust Company of New York, formerly J.P. Morgan & Co.

1913

23 Wall Street, Manhattan

Architects: Trowbridge & Livingston

Designated: December 21, 1965

This elegant building is an austere, four-story marble structure of massive strength and solidity that displays handsome classical details and proportions. The building is located where the north end of Broad Street widens to create the illusion of a small square. The building's chamfered corner enhances this illusion of openness, and the main entrance, with its heavy bronze grills, adds to the dignity of this intersection at the heart of New York City's financial district. The building served as the headquarters of J. P. Morgan & Co. and played a vital role in the commerce of New York City. It is now the home of the internationally renowned Morgan Guaranty Trust Company of New York.

J. WILLIAM CLARK HOUSE

MORGAN GUARANTY TRUST COMPANY

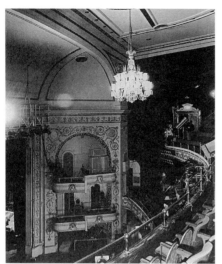
APOLLO THEATER INTERIOR

APOLLO THEATER INTERIOR, FORMERLY HURTIG AND SEAMON'S NEW THEATER

1913–14; 2002–

235 WEST 125TH STREET, MANHATTAN

ARCHITECT: GEORGE KEISTER

DESIGNATED: JUNE 28, 1983

Located on Harlem's main street and centered in the community's commercial district, the Apollo Theater is distinguished for having provided one of America's most important centers for the nurture of black talent and entertainment.

The theater spanned the two eras of Harlem's rich entertainment history; its construction reflected the appeal that vaudeville and burlesque held for Harlem's middle-class white population in the late nineteenth century. The theater's later role as a center for black entertainment reflects the talent that blacks brought to Harlem as they settled in the community in the first decades of the twentieth century.

Hurtig and Seamon's New Theater still catered to white audiences in the early 1920s. In 1924, the theater installed a runway and featured some of the livelier "shimmy-shakers," including "Queen of the Runway" Erin Jackson, and Isabelle Van and her dancing Dolls. Billy Minsky, well-known the proporietor of several of New York's burlesque houses, bought the theater in 1928, by which time the name had been changed to the Apollo. In an effort to quell mounting competition, Minsky negotiated an arrangement with neighboring theaters; they agreed not to schedule live performances, and Minsky promised not to show motion pictures.

In the 1930s, the Apollo changed hands twice. At Minsky's death in 1932, the theater was sold to Sidney Cohen, who presented black vaudeville. In 1935, after Cohen's death, Leo Brecher and Frank Schiffman assumed the theater's operation and instituted a permanent variety-show format that featured leading black entertainers. The Apollo thus presented a rich opportunity for black performers who, even as late as the 1950s, were excluded from many downtown establishments.

Throughout its history, the Apollo displayed every form of popular black entertainment, including comedy, drama, dance, gospel, blues, jazz, swing, bebop, rhythm and blues, rock and roll, and soul music. Bessie Smith, Billie Holiday, Louis Armstrong, Duke Ellington, Gladys Knight, and Bill Cosby are only a few of the distinguished entertainers who have performed here.

A comprehensive renovation of the Apollo began in 2002 with upgrades to the lighting, sound, and mechanical systems. Restoration of the facade and the famous blade sign was undertaken as well. The Apollo is working in cooperation with the Landmarks Preservation Commission.

EQUITABLE BUILDING

1913–15

120 BROADWAY (ALSO KNOWN AS 104–124 BROADWAY, 70–84 CEDAR STREET, 15–25 NASSAU STREET, AND 2–16 PINE STREET), MANHATTAN

ARCHITECTS: ERNEST R. GRAHAM WITH PEIRCE ANDERSON

DESIGNATED: JUNE 25, 1996

New York City's concerns about unregulated skyscraper construction and shadows created by building mass culminated in the 1916 zoning law, which mandated setbacks to create "stepped facade" towers and stipulated that a building's total floor space could not exceed twelve times the area of its lot. The Equitable Building, whose commission predates the law, boldly illustrates what this regulation was designed to prevent: the massive structure rises forty-two stories from its property lines and is thirty times the area of its lot. It is capped by a two-story penthouse, which is not visible from the street. Upon completion, it was the largest office building in the world at 1.2 million square feet, and it

EQUITABLE BUILDING

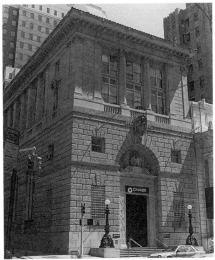

J.P. MORGAN CHASE

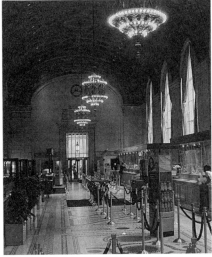

J.P. MORGAN CHASE INTERIOR

could accommodate 16,000 workers.

The six-story base and four-story capital are clad in granite and terra-cotta, and both feature Beaux-Arts ornamentation with classical details. The H-plan, buff-brick shaft allows light and air to reach the offices. Double-height triumphal arches, flanked by three-story pilasters, define the main entrances on Broadway and Nassau Street. Although Equitable Life left the building in 1960, it continues to provide major office space in the financial center of Lower Manhattan. In 1978 it was named a National Historic Landmark.

J.P. MORGAN CHASE, FORMERLY BROOKLYN TRUST COMPANY

1913–16

177–179 MONTAGUE STREET AND 134–138 PIERREPONT STREET, BROOKLYN

ARCHITECTS: YORK & SAWYER

DESIGNATED (EXTERIOR AND INTERIOR): JUNE 25, 1996

In the chaotic post–Civil War economy, America needed stable banks to help convey strong public images. One such bank was the Brooklyn Trust Company, founded in 1866. The bank occupied a former private residence from 1873 until 1913, when the trustees agreed a larger headquarters building was required. The Brooklyn Trust Company grew to thirty-one branches located throughout the city during the 1930s and, after a series of mergers, became Chase Manhattan Bank in 1996.

York & Sawyer designed this five-story urban palazzo in the sixteenth-century Italian High Renaissance style, reminiscent of the great banking houses of Florence and Verona. The building is composed of two limestone-clad sections: a rusticated and vermiculated base, and piano nobile with a smooth facade and a double-height colonnade of Corinthian columns. The bank has three facades but only two entrances. Mirror images of each other, the three-bay northern and southern elevations feature heavy, wrought-iron, double-height doors sided by torcheres. The west elevation's seven-bay arcade lights the single-vaulted banking hall, whose fine materials and craftsmanship include a coffered ceiling and polychromatic marble mosaic floor. The building remains a bank, with only minimal alterations resulting from modern changes in banking procedures.

455

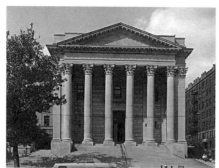
RICHMOND COUNTY COURTHOUSE

KNICKERBOCKER CLUB

RICHMOND COUNTY COURTHOUSE

1913–19
RICHMOND TERRACE, STATEN ISLAND
ARCHITECTS: CARRÈRE & HASTINGS
DESIGNATED: MARCH 23, 1982

This courthouse was built at the urging of Staten Island's first borough president, George Cromwell, as part of a grand scheme of civic buildings.

Reflecting the influence of Roman, Italian Renaissance, and Northern Renaissance architecture, the structure's classical details are derived from the Panthéon—the symbol of justice. In addition to the Corinthian front, these include alternating bands of wide and narrow rustication, upper-story pilasters, and rusticated wall surfaces with rhythmically placed pedimented windows. The rusticated rear facade, which is an impressive thirteen windows wide, now serves as the entrance. Its massive entry enframement contains a Northern Renaissance–inspired portico with banded columns, Doric frieze, and bracketed cornice. Wooden and bronze doors, framed by a round arch, are set into the rusticated wall surface directly

behind the portico. Each side of the building is seven windows wide with a smooth limestone base. The windows mark the first floor of each side elevation; they appear in alternation with pedimented windows on the second story. A balustrade runs along the roofline.

Designed to enliven the long stretch of municipal buildings, a French garden lies along the harbor front. A melange of parterres, paved walks, sculpted elements, and fountains, it is geometrically arranged on three raised levels.

KNICKERBOCKER CLUB

1913–15
2 EAST 62ND STREET, MANHATTAN
ARCHITECTS: DELANO & ALDRICH
DESIGNATED: SEPTEMBER 11, 1979

This building, the third home of the Knickerbocker Club, has long been recognized as one of the finest Federal Revival buildings in New York. Designed by William A. Delano, a distinguished architect as well as a club member, the structure was carefully scaled to a

neighborhood then characterized by expansive single-family homes.

Organized on Halloween in 1871, the Knickerbocker Club was founded in reaction to a perceived relaxation of membership standards at the Union Club following the Civil War. Long a bastion of old New York families, the Union Club had begun to accept members whose family fortunes were more recently acquired. In an effort to retain their longstanding exclusivity, eighteen members of the Union Club, among them Alexander Hamilton, Jr., John. L. Cadwalader, and John Jacob Astor, founded this new organization, which is still active in the city today.

Delano displayed a profound understanding of the tenets of Federal design in his composition of this three-story clubhouse. The seven-bay facade is divided into a rusticated limestone base surmounted by three stories of English bond brick, which are further divided by a stone belt course. The first and second stories are of approximately equal height, while the third story is diminished, suggesting an attic. Limestone lintels surmount all of the windows.

FORMER INTERNATIONAL CENTER OF PHOTOGRAPHY, ORIGINALLY THE WILLARD DICKERMAN STRAIGHT HOUSE

1913–15; 2005
1130 FIFTH AVENUE, MANHATTAN
ARCHITECTS: DELANO & ALDRICH
DESIGNATED: MAY 15, 1968

The former Willard Dickerman Straight House at Fifth Avenue and 94th Street is one of the last remaining examples of the great private houses that once lined upper Fifth Avenue. Occupying a prominent corner lot, the house was built for Straight, a diplomat, financier, and publicist, and his wife, Dorothy Payne Whitney, daughter of William C. Whitney, the Wall Street financier. They chose Delano & Aldrich, who also designed the Knickerbocker Club and the Colony Club, to design their residence.

William A. Delano, the chief architect, spoke of the building in his memoirs: "If I do say so, it's a well-planned and lovely house; once inside it seems much larger than it is." Delano was greatly influenced by both the Georgian and Federal styles of architecture, and used certain characteristics of each to create a highly individual style. The overall symmetry of the design and the use of red brick in a Flemish bond pattern are the key Georgian features. The house shows the influence of the Federal style in its decorative elements.

The Straight family lived in the house until 1927, and it was here that they founded *The New Republic*. Judge Elbert H. Gary was the second owner, but he died soon after making the purchase, and the mansion became the home of the legendary hostess Mrs. Harrison Williams, who maintained the city's most fashionable "salon." Subsequently, the International Center for Photography occupied the building, converting the public rooms to exhibition space, but its days as an elegant private house have resumed. An elaborate and thorough restoration has returned the building to one of the finest private residences; the restored house maintains the floor plan of the first and second floor public rooms. It was reoccupied in 2005.

FORMER LYCÉE FRANÇAIS DE NEW YORK, ORIGINALLY THE MRS. AMORY S. CARHART HOUSE

1913–21; 2005

3 EAST 95TH STREET, MANHATTAN

ARCHITECT: HORACE TRUMBAUER

DESIGNATED: JULY 23, 1974

Executed in the best tradition of eighteenth-century French classicism, the Mrs. Amory S. Carhart House resembles the residences of Louis XVI's Paris. The house, begun in 1913, was named for Mrs. Carhart, who commissioned its construction but never occupied it; both she and her husband died before its completion in 1921. Architect Horace Trumbauer, noted for his fine town houses, including the James B. Duke Mansion (p. 419) was chosen to design the structure.

Ordered and formal in appearance, the building is a straightforward expression of the best of eighteenth-century French architecture. The facade is divided horizontally into a one-story base, a two-story main section, and a crowning mansard roof. The boldly rusticated ground floor contains three tall, graceful arches that frame a central doorway with symmetrically placed windows on both sides. Among other distinguishing features are a balcony with wrought-

1130 FIFTH AVENUE

3 EAST 95TH STREET

iron railings supported by large ornamental brackets on the second floor, and tall French doors with arched transoms enframed by arched openings.

The building was occupied as a school by the Lycée Français de New York until 2003. It is being adapted for use as condominium apartments by the English architect John Simpson in association with Zivkovic Associates.

457

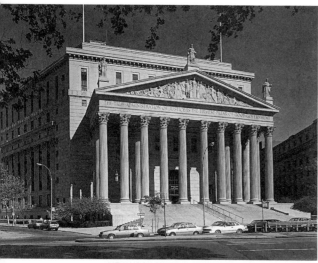

NEW YORK STATE SUPREME COURT

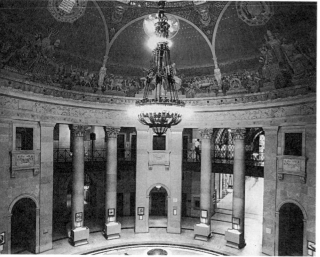

NEW YORK STATE SUPREME COURT INTERIOR

NEW YORK STATE SUPREME COURT, FORMERLY THE NEW YORK COUNTY COURTHOUSE

1913–27; 1992

FOLEY SQUARE, MANHATTAN

ARCHITECT: GUY LOWELL

DESIGNATED: FEBRUARY 1, 1966; INTERIOR DESIGNATED: MARCH 24, 1981

The New York State Supreme Court is a fine structure built on a grand scale, but it is in fact smaller and less ornate than the building called for in the original plan. Its long building history began in 1903, when the state legislature created a Courthouse Construction Board to oversee the construction of a new building to replace the Tweed Courthouse (p. 182). Six different sites were considered through 1913, when Guy Lowell, a Boston architect, won a limited competition with a design for an enormous round building twice the size of the structure actually built. This design recalled the Coliseum in Rome and the work of the French visionary architects Etienne-Louis Boullée and Claude-Nicholas Ledoux. During excavation, however, engineers discovered underground springs that made the site unworkable, and the board then purchased this smaller site.

A giant, fluted Corinthian portico dominates the main facade of the hexagonal building. The temple front is attached to a wall of rusticated masonry facing. Above this rustication is a stylized attic area, two stories high, and a service area recessed behind the simply carved cornice. The side elevations are identical: a colossal pilastrade is isolated by the rusticated wall. The heavy, almost blank corners mark the stairwells and elevators. This vigorous austerity is moderated inside by Tiffany-designed light fixtures, colored marbles, and murals by Attilio Pusterla on the theme of law and justice.

Critics here praised the structure on its completion. Europeans admired the building as well, less for its grandeur than for its innovative planning, which allows easy circulation of the public to specific courtrooms, and at the same time eliminates the crowd and street noise. The public enters by a rotunda placed at the center of six wings. From here each corridor leads to a specific courtroom. Each wing contains a single court and all the facilities relating to it, including separate entrances for the judges. Administrative offices are located above, and accessible by corner elevators. This arrangement is less interesting to the casual viewer, who is more likely to admire the simple nobility of the structure and the powerful urban space formed by this building, the state courthouse to the north, and the federal courthouse to the south. Restoration work on the murals in the rotunda and on the vestibule ceiling began in 1992.

FRICK COLLECTION AND FRICK ART REFERENCE LIBRARY

MANHATTAN

DESIGNATED: MARCH 20, 1973

FRICK COLLECTION, 1913–14; RENOVATION 1931–35; ADDITION, 1977

1 EAST 70TH STREET

ARCHITECTS: CARRÈRE & HASTINGS; RENOVATION: JOHN RUSSELL POPE; ADDITION: HARRY VAN DYKE, JOHN BARRINGTON BAYLEY, AND G. FREDERICK POEHLER

FRICK ART REFERENCE LIBRARY, 1931–35

10 EAST 71ST STREET

ARCHITECT: JOHN RUSSELL POPE

Occupying the entire blockfront along Fifth Avenue between East 70th and 71st Streets, where the Lenox Library once stood, the Frick Collection was constructed as the residence of coke and steel magnate Henry Clay Frick.

The building was designed in a restrained style reminiscent of that popular during the reign of Louis XVI. The Fifth Avenue facade is set back from street level behind a broad, raised terrace. Centered on the eleven-bay-wide main block is a slightly projecting portico marked by four colossal Ionic pilasters with arched entrances between them. To the north of this block is a one-story loggia that extends forward along the 71st Street edge of the terrace to Fifth Avenue, where it ends in a small, three-bay-deep, Ionic pavilion. A projecting two-story wing balances the composition on the south side of the terrace.

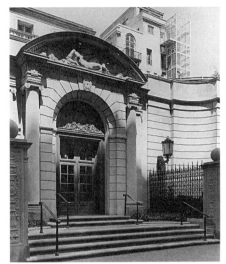

FRICK COLLECTION

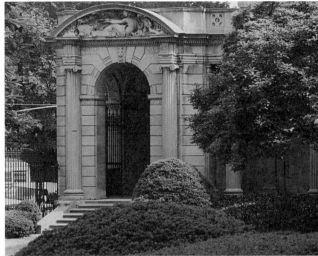

FRICK COLLECTION

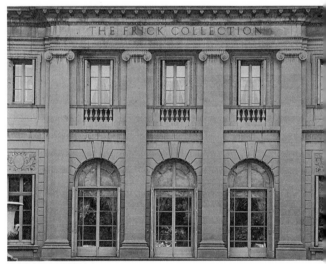

FRICK COLLECTION

The Frick House was always intended to serve ultimately as a museum. Following the death of Frick's widow in 1931, John Russell Pope was hired to modify the original house and to design a new building to house the Frick Art Reference Library. Pope, one of the leading institutional architects of the twentieth century, created a library building that was stylistically very much in keeping with the original house.

In 1977, the P.A.B. Widener house, 70th Street, was demolished (without permission from the Landmarks Preservation Commission) to make way for a wing designed by Harry van Dyke, John Barrington Bayley, and G. Frederick Poehler. The addition shares stylistic characteristics with the original building, and both are complemented by an adjoining garden designed by Russell Page.

NEW WORLD FOUNDATION

NEW WORLD FOUNDATION, FORMERLY THE LEWIS G. MORRIS HOUSE

1914

100 EAST 85TH STREET, MANHATTAN

ARCHITECT: ERNEST FLAGG

DESIGNATED: APRIL 19, 1973

Although Ernest Flagg was best known for his commercial buildings, the Beaux-Arts-trained architect demonstrated his versatility with the design for this Federal Revival town house. The building appears to be two independent structures separated by a courtyard—a novel solution to the problem of building a house on a long, narrow lot.

The house rises three stories above a raised basement, with the larger western portion presenting the gable end of its slate roof to Park Avenue. Flagg used a variety of flat-arched lintels in the body of the house; five hipped-roof dormers above the modillioned cornice light the attic. The extra height required by the

garage in the eastern wing necessitated raising the floor level half a story above that of the main house. Atop the garage, the first two stories are united behind superimposed bay windows, while the third story has the double-hung sash found in the western side. The two sections are connected by a staircase crossing the courtyard, which also contains the main exterior entrance stair and an elevator tower capped by a cupola.

The building was commissioned by Lewis Gouverneur Morris, whose family had been active in politics since before the Revolution. His daughters sold the house to the New World Foundation, hoping to preserve the structure. The foundation provides financial aid to groups working on education, civil rights, and peace issues.

HOUSE OF THE REDEEMER, FORMERLY THE EDITH FABBRI HOUSE

1914–16; 1949

7 EAST 95TH STREET, MANHATTAN

ARCHITECT: GROSVENOR ATTERBURY

DESIGNATED: JULY 23, 1974

This elegant house was the home of Edith Shepard Fabbri, great-granddaughter of Commodore Cornelius Vanderbilt and wife of Ernesto Fabbri. The house is stylistically derived from Italian Renaissance sources and has many characteristics of Italian palazzo design.

Five stories high, its distinguishing features include an L-shaped plan (with a rear wing at the western side of the main section of the house, forming a

HOUSE OF THE REDEEMER

courtyard), fine architectural features such as rusticated pilasters set within a heavy rusticated stone frame comprising the impressive entrance, and elegant window treatment, in which the sizes and ornament vary at each floor level.

In 1949, Mrs. Fabbri transferred the building to the House of the Redeemer, and since that time it has been used continuously for religious retreats and operated by an independent Episcopal board of trustees.

555 EDGECOMBE AVENUE APARTMENTS, ALSO KNOWN AS ROGER MORRIS APARTMENTS

1914–16

MANHATTAN

ARCHITECTS: SCHWARTZ & GROSS

DESIGNATED: JUNE 15, 1993

Facing Roger Morris Park and the historic Morris-Jumel Mansion (p. 68), this

555 EDGECOMBE AVENUE APARTMENTS

are faced in gray granite. This portion of the building also contains the arched main entrance. Above this, it is faced in beige and yellow brick, and the upper stories are separated from the lower storie by a terra-cotta beltway. Although the area has declined, 555 remains well maintained.

LUCY D. DAHLGREN HOUSE

1915; 2004–

15 EAST 96TH STREET, MANHATTAN

ARCHITECT: OGDEN CODMAN JR.

DESIGNATED: JUNE 19, 1984

LUCY D. DAHLGREN HOUSE

thirteen-story building, known as "555" or "Triple Nickel," is one of the most impressive structures in Washington Heights. Created by the same firm that designed the 409 Edgecombe building (p. 464), the prestigious 555 was often considered to be part of the adjacent— and at one time more exclusive—neighborhood of Sugar Hill. Although much of the area around 555 was populated by African-Americans, the owners of the apartments refused to rent to them until 1939. One year after the race restriction was lifted, however, no white tenants remained in 555. Once available, the sizable apartments and fine views attracted a cross section of African-American professionals, as well as celebrities, including performer and activist Paul Robeson, social psychologist Kenneth Clark, and jazz musician Count Basie.

The apartments occupy a rectilinear, block-like building with a central court. Because of the slope of the plot, the building's Edgecombe Avenue facade has an exposed basement and cellar, which

Built in 1915 for the socially prominent and wealthy Lucy Drexel Dahlgren, the house at 15 East 96th Street was designed by the well-known architect Ogden Codman Jr., whose own house was up the street at number 7 (p. 444). Codman, a Boston-born architect raised in France, practiced in Boston from the 1890s through the first decades of the twentieth century and then returned to France. A respected society decorator, he espoused a design philosophy that stressed the integration of architecture and interior decoration; he collaborated with Edith Wharton on *The Decoration of Houses*, published in 1897.

The New York town houses of Ogden Codman are based on French and English eighteenth-century sources. The five-story Dahlgren house is a decorative, thirty-room Beaux-Arts-style mansion, faced with rusticated limestone and ornamented with carved swags and an intricate wrought-iron balcony. Beaux-Arts details include

segmental-arched pediments crowning the second-floor window of the center bay and dormers, a slate mansard roof, Louis XIV–style volutes supporting the balcony, and original wooden casement windows with transoms. Elegantly detailed double-leaf wooden doors lead to a porte cochere and an interior court; the main entrance is off the court. Inside are a grand marble staircase and an octagonal dining room with two marble fountains.

The handsome mansion, with its seven fireplaces and eleven bathrooms, was bought in 1922 by the jeweler Pierre Cartier, who owned it until 1945. It was then sold to the St. Francis de Sales Convent, a Roman Catholic religious order. Once again a private residence, the house is currently being restored.

HADLEY HOUSE

HADLEY HOUSE

BUILT EIGHTEENTH CENTURY; FRAME ADDITION SECOND QUARTER OF THE NINETEENTH CENTURY; REMODELED C. 1915–16

5122 POST ROAD, THE BRONX

ARCHITECT: DWIGHT JAMES BAUM

DESIGNATED: JUNE 20, 2000

The central stone portion of the house, built in the eighteenth century, survives as one of the oldest residences in the Bronx. That portion was probably built by a tenant farmer of the Philipsburg Manor Estate, of which this site was originally a part. Local farmer William Hadley, from whom the property acquired its name, bought the property in 1786. Major Joseph Delafield, an amateur antiquarian with a strong interest in the preservation of old farmhouses, later acquired the Hadley farm in 1829, and probably added its large frame wing. It survived the 1909 subdivision of the Delafield estate due to its recognized age, and around it grew the garden suburb of Fieldston.

The house assumed its present form in 1915, when it was extensively remodeled and enlarged by Dwight James Baum, who worked successfully in a range of historical styles. Adding another wing and porch, Baum created a modern suburban home. Baum found authenticity by incorporating various aspects of Colonial architecture in the remodeling, creating a garden facade in the formal Georgian style, retaining the vernacular farmhouse's nature on the road facade. Built over the course of

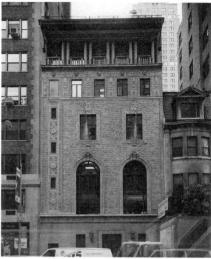

COLUMBIA ARTISTS MANAGEMENT INC.

three centuries, the house remains in use as a private residence.

COLUMBIA ARTISTS MANAGEMENT INC. (CAMI) BUILDING, FORMERLY LOUIS H. CHALIF NORMAL SCHOOL OF DANCING

1916

163–165 WEST 57TH STREET, MANHATTAN

ARCHITECT: G. A. & H. BOEHM

DESIGNATED: OCTOBER 19, 1999

Built in a neighborhood rich in performing and fine arts, the Louis H. Chalif Normal School of Dancing was a major influence on dance education in America and one of the earliest schools to instruct teachers in dance. In 1916, the school moved into this building on West 57th Street across from Carnegie Hall. Louis H. Chalif, a Russian-born ballet master, immigrated to the United

States in 1904; the following year he began dancing with the Metropolitan Opera Ballet, and founded this school.

Designed by G. A. & H. Boehm, the asymmetrical facade of the five-story building, inspired by the Italian Renaissance and Mannerism, is topped by a colonnaded loggia with an imposing copper cornice. The tan-gray brick of the upper stories is laid in a diamond pattern, and embellished by polychrome terra-cotta featuring theatrical and classical references such as masks, lyres, scrolls, and urns.

The school moved out of the building in 1933, later renting rooms in Steinway Hall, just down the block. Later tenants included Carl Fischer, Inc., an important figure in American music publishing, which operated a retail store and concert hall in the building. In 1959, Columbia Artists Management, Inc. purchased the building for use as its headquarters and recital hall, where it continues to function as one of the world's largest and most influential management and booking firms, representing artists of classical music, opera, theater, and dance.

RODIN STUDIOS

1916–17

200 WEST 57TH STREET, MANHATTAN

ARCHITECT: CASS GILBERT

DESIGNATED: FEBRUARY 16, 1988

Like many of the studio buildings constructed in the 1880s, Rodin Studios was

a cooperative venture undertaken by a group of artists who raised the necessary capital, elected officers, and formed a corporation. In return, each became an owner with the exclusive right to occupy or sublet one of the studio apartments in the building. The corporation chose as architect Cass Gilbert, whose patronage of artists for his own commissions perhaps influenced the selection.

Named for the French sculptor considered by many to be the greatest living artist at the time, the Rodin Studios included stores on the first floor, offices on the second and third floors, and apartments and studios on the remaining eleven floors. The base of the building is comprised of five broad bays containing shop windows and a central entrance. The exterior is distinguished by rough-faced brick in richly colored hues ranging from buff to burnt-gold. As was also true of Gilbert's Woolworth Building (p. 434), the Rodin had an extensive terra-cotta decorative program.

The design managed to combine the best contemporary technology with a graceful French Renaissance style. The studios are placed across the northern facade of the building, providing the maximum light necessary for a painter's work. The addition of handsome cast-iron canopies suspended between studio windows is another example of Gilbert's ability to marry elegantly form and function.

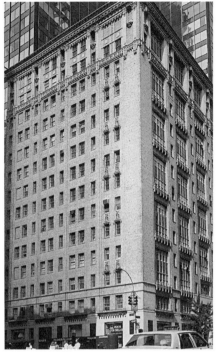

RODIN STUDIOS

HOWARD E. AND JESSIE JONES HOUSE

1916–17

8200 NARROWS AVENUE, BROOKLYN

ARCHITECT: JAMES SARSFIELD KENNEDY

DESIGNATED: MARCH 8, 1988

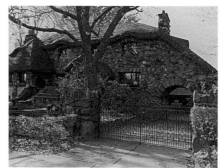

HOWARD E. AND JESSIE JONES HOUSE

One of the finest examples of the arts and crafts style in New York City, the Jones House is built of large, randomly laid, uncut rocks and boulders in assorted colors. One of the most unusual and appealing features of the house is the original asphalt roof; its tiles are scattered unevenly across the surface, and its sensuous curves and smooth molded edges are reminiscent of the thatched roofs of rural English cottages. Irregular terraced steps form a path to the main entrance through a central peak-roofed vestibule with a round-arched front. The varied heights of the house lead upward to a massive end-wall chimney, calling attention to the symbolic importance of the hearth as the center of the home.

The architect, James Sarsfield Kennedy, specialized in freestanding residences and worked in a variety of styles, frequently combining modern and historic sources. In this house, designed for shipping merchant Howard Jones, the architect created a late, yet sophisticated, version of the arts and crafts style, which advocated the hand-made as a humanizing influence in the rising tide of nineteenth-century industrialization. Kennedy's choice of rugged materials and avoidance of exact, crisp finishes reflect the architectural "savagery" that John Ruskin, an early

proponent of the movement, called for. Kennedy's finishing touch—a simple iron fence punctuated with widely spaced newels of roughly hewn stone—echoes and encloses this structure.

409 EDGECOMBE AVENUE APARTMENTS, ALSO KNOWN AS COLONIAL PARKWAY APARTMENTS

1916–17

409 EDGECOMBE AVENUE, MANHATTAN

ARCHITECTS: SCHWARTZ & GROSS

DESIGNATED: JUNE 15, 1993

Sugar Hill, the neighborhood between 145th and 155th Streets and Edgecombe and Amsterdam Avenues, became home to many affluent African-Americans in the 1930s. This thirteen-story, E-shaped, neo-Georgian and neo-Renaissance apartment building, known simply as "409," was considered the most prestigious address in the area. The main entrance is marked by a stone enframement topped by a pedimented window surround. Faced in red-brown brick, the exterior has a tripartite design with

409 EDGECOMBE AVENUE APARTMENTS

terra-cotta detail at the base and capital. Set on the rocky ridge known as Coogan's Bluff, 409 overlooks Jackie Robinson Park—previously known as Colonial Park—which ensures an unobstructed view of the Harlem River and the Bronx.

During the late 1930s, some of the most well known and influential African-Americans resided in this building. As *Ebony* magazine put it, "Legend, only slightly exaggerated, says bombing 409 would wipe out Negro leadership for the next 20 years." Residents included Jules Bledscoe, singer and actor; William Stanley Braithewaite, poet and critic; Aaron Douglas, painter and illustrator; W.E.B. Du Bois, scholar and activist; Thurgood Marshall, civil libertarian and the first African-American U.S. Supreme Court justice; Lucky Roberts, jazz musician; Walter White, executive secretary of the NAACP; and Roy Wilkins, White's successor.

AMERICAN EXPRESS COMPANY BUILDING

AMERICAN EXPRESS COMPANY BUILDING

1916–17

65 BROADWAY (ALSO KNOWN AS 63–65 BROADWAY AND 43–49 TRINITY PLACE), MANHATTAN

ARCHITECT: RENWICK, ASPINWALL & TUCKER

DESIGNATED: DECEMBER 12, 1995

This building served as American Express headquarters from 1874 until 1975, and continues to house its travel services. The American Express Company was formed in 1850 as a parcel-post business, transporting the mail and packages that the U.S. Post Office would not handle. The company made several major innovations involving the transfer of funds, initiating the money order in 1882, the travelers cheque in 1891, and the credit card in 1958. The building at 65 Broadway has also housed the headquarters of other prominent firms, including the investment bank of J. W. Seligman & Co. and the American Bureau of Shipping, a maritime concern.

The twenty-one-story (plus basement), neoclassical, concrete and steel-framed structure, set on an H-plan, has light courts facing the street—an arrangement popularized by architect George B. Post. The design provides offices with ample light and air, and was widely employed from the 1880s through the 1910s. The facades, which are executed in white brick and terra-cotta above a granite base, are divided into a tripartite base-shaft-capital scheme. The massive stone walls are consistent with the masonry wall of its blockfront, contributing to the "canyon effect" that now characterizes lower Broadway, long known as "Express Row."

BUSH TOWER

1916–18

130–132 WEST 42ND STREET AND 133–137 WEST 41ST STREET, MANHATTAN

ARCHITECTS: HELMLE & CORBETT

DESIGNATED: OCTOBER 18, 1988

Designed prior to the adoption of the 1916 zoning law that mandated setbacks for skyscrapers, the Bush Tower incorporated setbacks as an aesthetic solution—the rooftop water tank and elevator housing unit were concealed on the recessed top story. And it soon became the prototype for the stepped-back buildings of the future.

The thirty-story buff brick and terra-cotta tower was named for Irving T. Bush, an oil company executive who established Brooklyn's Bush Terminal Company in 1902. The company later

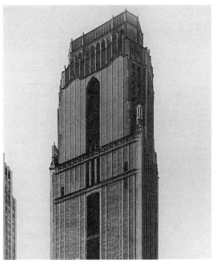

BUSH TOWER

grew to occupy thirty city blocks of extensive lofts, warehouses, and piers for manufacturing, storing, and shipping goods. Bush Tower, in a prime location between the two major railroad terminals and readily accessible to out-of-town buyers, was created as a centralized merchandise showroom. While an unpartitioned display area was not an entirely new idea, the Bush project was much broader in scope than any other existing facility in New York. Lower floors housed a luxurious Buyers' Club decorated in an "Old English" style.

The Bush Terminal Company lost this property to the Metropolitan Life Insurance Company in 1938 foreclosure proceedings. Subsequent alterations to the building have been limited to changes in the street-level facade—reflecting the changing uses of the building—and the insertion of windows in the side walls between Corbett's handsome trompe l'oeil piers.

465

RACQUET AND TENNIS CLUB

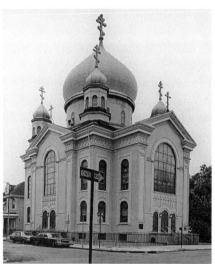

RUSSIAN ORTHODOX CATHEDRAL

RACQUET AND TENNIS CLUB

1916–18

370 PARK AVENUE, MANHATTAN

ARCHITECTS: MCKIM, MEAD & WHITE

DESIGNATED: MAY 8, 1979

This building was erected as the third home of the Racquet and Tennis Club, first organized in 1875 to "encourage all manly sports among its members"; from its beginnings, it was considered one of the most exclusive of New York's social and athletic organizations. Dominating the blockfront of Park Avenue between East 52nd and 53rd Streets, the structure is a notable essay in Italian Renaissance Revival style, as taught at the Ecole des Beaux-Arts in Paris.

Based on sixteenth-century Italian palazzi, the Racquet and Tennis Club Building is an imposing structure noted for its refined and restrained detail and for the clarity with which its detail is expressed. A powerful rectangular block, fully visible on three sides, the building rises five stories on a rusticated granite base pierced by large arched openings. Stone quoins mark the corners of the building, contrasting with the smooth beige brick of the upper walls. A central loggia is recessed behind three arched openings on the piano nobile. The major courts for sports are located on the upper floors, indicated on the exterior by the large blind arches at the fourth-floor level. The terra-cotta frieze at the fifth floor incorporates racquets into the pattern. A balustraded roof parapet above a decorative cornice provides a fitting termination to the handsome design.

RUSSIAN ORTHODOX CATHEDRAL OF THE TRANSFIGURATION OF OUR LORD

1916–21

228 NORTH 12TH STREET, BROOKLYN

ARCHITECT: LOUIS ALIMENDINGER

DESIGNATED: NOVEMBER 19, 1969

Monumental in scale and a striking example of eclectic ecclesiastical architecture, this church is a scholarly reproduction of the Byzantine style so characteristic of Russian churches, with a strong Renaissance flavor. A Greek cross is surmounted by a great central onion dome on a drum. The four corners made by the arms of the cross are topped by small towers, each capped with a domed octagonal cupola housing the church's bells. The combination of the five copper-covered domes, each surmounted by a gilded patriarchal cross, makes a very picturesque silhouette against the sky. The main mass of the church is extremely severe; its light yellow-brick walls are pierced by simple round-arched windows and doors. The composition is tied together by a massive cornice that runs continuously around the entire structure.

Although the building, at North 12th Street and Driggs Avenue, is claimed by residents of Greenpoint, Williamsburg, and Northside, it is technically in Williamsburg, by twenty-five feet.

TODT HILL COTTAGES

STONE COURT, STATEN ISLAND

ARCHITECT: ERNEST FLAGG

DESIGNATED: MAY 23, 1985

BOWCOT, 1916–18

95 WEST ENTRY ROAD

WALLCOT, 1918–21

285 FLAGG PLACE

MCCALL DEMONSTRATION HOUSE

1924–25

1929 RICHMOND ROAD

Ernest Flagg constructed three remarkable small stone houses on the grounds of Stone Court, his country estate (p. 330). Now known as the Todt Hill Cottages, they expressed his aesthetic theories, as outlined in his widely regarded book *Small Houses: Their Economic Design and Construction*, published in 1922. Flagg considered these cottages to be of no less importance than his Singer Tower, which was the world's tallest building when completed in 1911. Employing the architect's inventive cost-saving design and construction techniques, they demonstrate Flagg's conviction that economy and good design are not mutually exclusive.

Bowcot was the first of the experimental stone cottages, built in 1916–18. Flagg observed that ". . . as the wall bends with the road, the house bends too": thus was Bowcot named. The cottage appears to nestle into the slope and surrounding landscape; this harmony of structure and topography is one of the most significant aspects of Bowcot's

design. Constructed of mosaic rubble with an irregular rectangular plan, the cottage is distinguished by picturesque chimneys and gables.

Wallcot, known also as House-on-the-Wall, was built in 1918–21. Also of mosaic rubblestone, but with a less picturesque design than Bowcot's, the house consists of two rectangular sections, one and one-half stories high. The facade has an imposing main entrance with a wide, round-arched opening topped by a large gabled hood roof carried on enormous ornamental brackets. Wide-spreading roofs cover both sections of the house, and there is a lively variety of window types used.

The McCall Demonstration House was built in for *McCall's* magazine; in 1923, the publication asked the foremost architects of the country to design "a series of small houses planned not for beauty of design alone, but for the convenience of the homemaker, as well." Flagg wrote many articles, discussing his proposed design. The house illustrates his experimentation with building technology, and incorporates such features as a combination slate/rubberoid roof and window frames flush with the walls, representing a pioneering example of passive solar design.

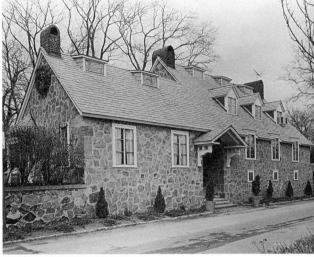

TODT HILL COTTAGES, WALLCOT

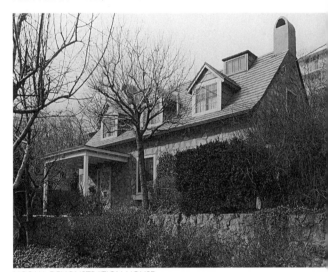

MCCALL DEMONSTRATION HOUSE

467

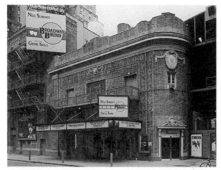

BROADHURST THEATER

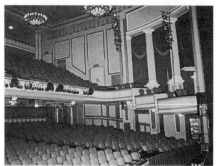

BROADHURST THEATER INTERIOR

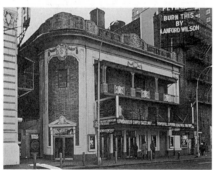

SCHOENFELD THEATER

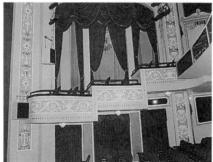

SCHOENFELD THEATER INTERIOR

BROADHURST THEATER

1917–18

235–243 WEST 44TH STREET, MANHATTAN

ARCHITECT: HERBERT J. KRAPP

DESIGNATED: NOVEMBER 10, 1987; INTERIOR DESIGNATED: DECEMBER 15, 1987

The Broadhurst Theater and its twin, the Plymouth (now Schoenfeld), are among the earliest theaters built by the prominent architect Herbert J. Krapp, and the first of many theaters he built for the Shubert Organization. The Broadhurst was part of Shubert Alley, which marked the heart of the Broadway theater district and already included two earlier Shubert theaters, the Booth and the Shubert. In an effort to maintain architectural consistency within the alley, Krapp incorporated many features of the other theaters into the Broadhurst.

The Broadhurst has a rounded corner that faces Broadway, the most accessible route for the audience. This corner includes an entrance with a broken-pediment enframement and an oval cartouche. The exterior is marked with diaper-patterned brickwork and neoclassical details such as stone and terra-cotta trim—features that Krapp frequently employed.

The interior of the Broadhurst is designed in the Adamesque style. The walls are enframed by tall pilasters, and a plaster entablature covers the length of the wall above the proscenium arch. Relief panels based on the Parthenon frieze decorate the boxes, the front of the balconies, and the proscenium arch. The seating arrangement is flexible; a movable barrier and a false platform in the back of the theater permit expansion from 550 seats to 680, depending on the type of production. A single balcony is divided into two sections by means of a cross-over aisle.

The theater was leased by the prolific playwright George Broadhurst while it was still under construction. He named the building after himself, with the intention of staging chiefly his own productions, although he did put on other plays throughout the years.

GERALD SCHOENFELD THEATER, FORMERLY PLYMOUTH THEATER

1917–18

234–240 WEST 45TH STREET, MANHATTAN

ARCHITECT: HERBERT J. KRAPP

DESIGNATED: DECEMBER 8, 1987; INTERIOR DESIGNATED: DECEMBER 15, 1987

The Plymouth and the Broadhurst share many architectural characteristics. The facades, in diaper-patterned brickwork with neoclassical detail, set the tone for Krapp's later designs based on a similar style. The interior of the Plymouth is in the Adamesque style. The low-relief plasterwork and friezes depict wreaths, urns, and classical figures holding musical instruments. These friezes outline all major elements in the theater—the balconies, ceiling, and proscenium arch.

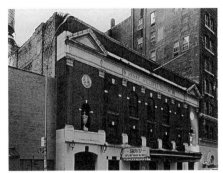

HENRY MILLER THEATER

After its construction, the Plymouth was leased to manager/producer Arthur M. Hopkins, renowned for his pioneer productions of Ibsen plays and his production of *Anna Christie*. Hopkins was strongly identified with the Plymouth until his death in 1950. The theater is still a successful playhouse.

On October 10, 2004 it was renamed the Gerald Schoenfeld Theater.

HENRY MILLER THEATER

1917–18; 2004–

124–130 WEST 43RD STREET,
MANHATTAN

ARCHITECTS: ALLEN, INGALLS &
HOFFMAN

DESIGNATED: DECEMBER 8, 1987

The Henry Miller Theater was the creation of one of the most prominent figures of Broadway in the early twentieth century. First known as an actor, Miller eventually wrote and produced plays; after considerable success, he decided to build his own theater.

The building was designed according to Miller's idea that the theater should be an intimate and accessible environment in which to see drama. The structure is based on the Georgian Revival style, which was popular for smaller theaters at the time. The brick and terra-cotta facade features a classical colonnade, a terra-cotta entablature, and windows at the second and third stories.

In 2004, the Durst Organization began construction of a $1 billion, 945-foot skyscaper for the Bank of America on the site of the Henry Miller Theater. The historic facade will be kept intact, and a new state-of-the-art stage will be incorporated in the building.

EAST 93RD STREET HOUSES, FORMERLY THE GEORGE F. BAKER JR. HOUSE COMPLEX

MANHATTAN

ARCHITECTS: DELANO & ALDRICH

SYNOD OF BISHOPS OF THE RUSSIAN ORTHODOX CHURCH OUTSIDE OF RUSSIA

1917–18; ADDITION, 1928

69–75 EAST 93RD STREET

DESIGNATED: JANUARY 14, 1969

67 EAST 93RD STREET, 1931

DESIGNATED: JULY 23, 1974

Although each portion of the George F. Baker Jr. House Complex was designed and built at a different time, the architectural firm of Delano & Aldrich was able to create an elegant, cohesive architectural unit. The earliest portion of the complex is the five-story brick house built in 1917–18 for Francis F. Palmer.

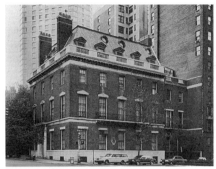

EAST 93RD STREET HOUSES

The house is almost square with five evenly placed windows facing Park Avenue and four facing East 93rd Street. The decorative elements on the facade are spare and create an effective contrast with the plain brick walls.

In 1928, banker George F. Baker Jr. purchased the Palmer house and commissioned Delano & Aldrich to add a ballroom wing and a garage. A courtyard was created between the original house and the additions, which were similar to the original design.

In 1931, Baker again asked Delano & Aldrich to add to the complex by building a four-story house at 67 East 93rd Street for his father. This house is carefully designed to harmonize with the earlier buildings. A broad belt course separates the two lower floors from the upper ones and links the structure to the rest of the complex. The classical details and the carefully executed masonry of all three structures is exemplary of the Federal Revival style that Delano & Aldrich popularized.

In 1958 the Synod of the Bishops of the Russian Orthodox Church Outside of Russia purchased the original Palmer house and the ballroom addition to serve as its headquarters.

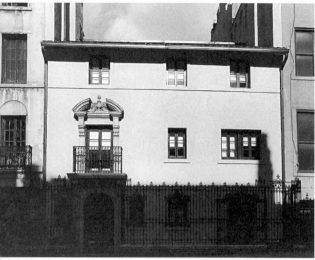

BARBARA RUTHERFORD HATCH HOUSE

PERSHING SQUARE VIADUCT

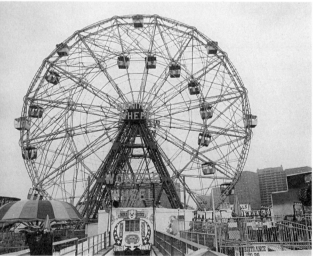

THE WONDER WHEEL

BARBARA RUTHERFORD HATCH HOUSE

1917–19

153 EAST 63RD STREET, MANHATTAN

ARCHITECT: FREDERICK J. STERNER

DESIGNATED: JANUARY 11, 1977

The house at 153 East 63rd Street is unusual and picturesque, adapting Spanish Colonial and Italian Renaissance styles to a sophisticated urban setting. Commissioned by Barbara Rutherford Hatch, a young socialite married to Cyril Hatch, the house was designed by the town-house architect Frederick J. Sterner. The stucco walls, red tile roof, and ornate iron railings and grills of this three-story residence are all typically Spanish. U-shaped in plan, the house has two main wings parallel to the street that allowed for a spacious interior courtyard—a Mediterranean feature and a rarity in New York town houses.

Following the Hatches' divorce in 1920, the town house passed into the hands of a succession of illustrious owners, including Charles B. Dillingham, a prominent figure in the Broadway theater; Charles Lanier Lawrence, a pioneer aviation engineer; Gypsy Rose Lee, the entertainer; and more recently the artist Jasper Johns.

PERSHING SQUARE VIADUCT

1917–19

PARK AVENUE FROM 40TH STREET TO GRAND CENTRAL TERMINAL AT 42ND STREET, MANHATTAN

ARCHITECTS: WARREN & WETMORE

DESIGNATED: SEPTEMBER 23, 1980

The Pershing Square Viaduct links upper and lower Park Avenue by way of elevated drives that make a circuit around Grand Central Terminal and descend to ground level at East 45th Street. Designed in 1912 by Warren & Wetmore, it was conceived as part of the original 1903 plan for the station by the firm of Reed & Stem. The square was named in honor of General John J. Pershing.

In plan, the Pershing Square Viaduct reflects Beaux-Arts design and planning: the overall design of Grand Central Terminal, including the connecting viaduct, was created with concern for monumental scale, axial planning, and a clearly defined system of circulation. French in character, the viaduct, almost 600 feet long, has three low, broad spanning arches and substantial granite supporting piers. Originally, all three arches were left open, with the trusses exposed, and at one time a trolley line ran underneath. The central arch was enclosed in 1939, when the New York City Convention and Visitors' Bureau was opened under the central section of the bridge. Today it houses the Pershing Square restaurant.

THE WONDER WHEEL

1918–20

3059 WEST 12TH STREET, BROOKLYN

INVENTOR: CHARLES HERMAN;
MANUFACTURED AND BUILT BY THE
ECCENTRIC FERRIS WHEEL
AMUSEMENT COMPANY

DESIGNATED: MAY 23, 1989

The Wonder Wheel opened on Memorial Day 1920, in "Sodom by the Sea," as Coney Island was known—a place synonymous with fantasy, and fun for over one hundred years. Sigmund Freud said it was "the only place in the United States" that interested him.

The modern Ferris wheel is named for George W. G. Ferris, a civil engineer and head of the Pittsburgh Bridge Company. His giant, 264-foot-high wheel, erected for the 1893 Chicago World's Columbian Exposition, was developed from European and Oriental swing-like prototypes developed centuries ago at fairs and festivals. Though smaller (150 feet high), the Wonder Wheel's more sophisticated design was an improvement on the Ferris wheel. Of the twenty-four passenger cars, sixteen are swinging cars that slide along a serpentine track that leads each car either toward the hub or, as the wheel turns, toward the circumference. The wheel accommodates 160 passengers, weighs 200 tons, and is operated by a forty-horsepower motor. Since opening day, the Wonder Wheel has carried approximately thirty million pleasure seekers. Offering panoramic views of Brooklyn, it is an important feature of the borough's skyline and, happily, has never caused an injury.

AMBASSADOR THEATER

1919–21

215–223 WEST 49TH STREET, MANHATTAN

ARCHITECT: HERBERT J. KRAPP

DESIGNATED (EXTERIOR AND INTERIOR): AUGUST 6, 1985

The very simple exterior of the Ambassador is ornamented only by textured brick—a common building material in New York between the wars. A series of pilasters, shallow panels, and segmental arches articulate the facade; there is a rounded corner above the entrance—an element that Krapp also used at the Booth and Plymouth theaters. The unpretentious exterior hardly prepares us for the rich interior, an explosion of Adamesque fans, cameos, and swags—the mode in which nearly all Krapp's Shubert work is designed.

The Ambassador stage has a venerable history, and has featured such diverse talents as Claudette Colbert, Jason Robards Jr., Sandy Duncan, Maureen Stapleton, and George C. Scott.

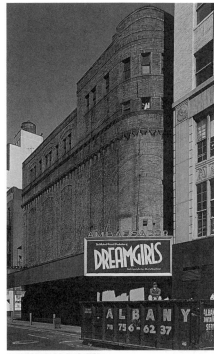

AMBASSADOR THEATER

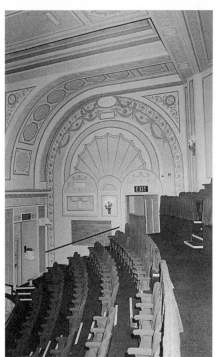

AMBASSADOR THEATER INTERIOR

471

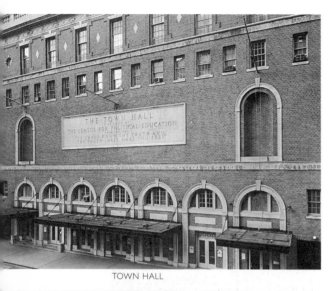

TOWN HALL

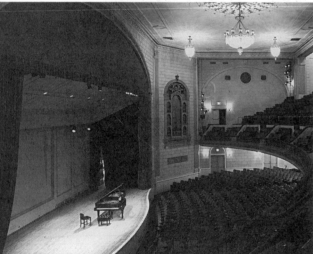

TOWN HALL INTERIOR

TOWN HALL

1919–21; 1958

113–123 WEST 43RD STREET, MANHATTAN

ARCHITECTS: MCKIM, MEAD & WHITE

DESIGNATED (EXTERIOR AND INTERIOR): NOVEMBER 28, 1978

Characterized by one contemporary observer as "an idea with a roof over it," Town Hall was built as a meeting hall for the City of New York. The League for Political Education, founded by six prominent suffragettes in 1894, commissioned McKim, Mead & White to design a structure versatile enough to accommodate a speaker's auditorium, a concert hall, a movie theater, and a clubhouse.

Town Hall began as a forum to educate men and women in political issues. From its inception, it became a popular arena for airing the nation's most pressing and controversial issues, and over the years attracted such international speakers as Theodore Roosevelt, Winston Churchill, Thomas Mann, and Jane Addams. The building attained national importance in 1935 when its weekly Thursday evening meetings were broadcast by radio in a program entitled "America's Town Meeting of the Air."

Town Hall has also become known for the excellent acoustics of its concert hall. McKim, Mead & White had become aware of the science of acoustics through their collaboration with Wallace C. Sabine on Boston Symphony Hall. Sabine, a Harvard professor of physics, developed a formula to predict reverberation time based on the relationship between the volume of the space and the relative absorbency of its materials. Although Sabine died in 1919, his work certainly influenced the design of this auditorium.

Centrally located on the north side of West 43rd Street, Town Hall is a four-story adaptation of a Federal Revival design, a style frequently employed by McKim, Mead & White. Laid up in Flemish bond brick with contrasting limestone trim, the facade is punctuated by a seven-bay blind arcade, with theatrical canopies suspended over the double doors. In the middle of the facade is a large inscribed limestone plaque.

Inside, the semicircular auditorium with cantilevered balcony has walls of rusticated artificial stone. The angles of the hall are accented by monumental gilded pilasters, and crystal chandeliers hang from a paneled plaster ceiling. Perhaps the most decorative features of the hall are the arched organ grills that flank the stage on the diagonal walls.

In 1958, Town Hall, Inc. merged with New York University, which for twenty years managed the hall and leased the auditorium for a variety of purposes. Town Hall is now used for various musical events.

ST. BARTHOLOMEW'S CHURCH AND COMMUNITY HOUSE

109 EAST 50TH STREET, MANHATTAN

DESIGNATED: MARCH 16, 1967

ST. BARTHOLOMEW'S CHURCH, 1914–19

PORCH (FROM OLD ST. BARTHOLOMEW'S CHURCH), 1902

ARCHITECTS: BERTRAM G. GOODHUE; McKIM, MEAD & WHITE (PORCH)

COMMUNITY HOUSE, 1926–28

ARCHITECTS: BERTRAM G. GOODHUE AND MAYERS, MURRAY & PHILIP

Flanked by the Waldorf-Astoria Hotel and the General Electric Building, St. Bartholomew's Church occupies a prominent Park Avenue site. The congregation was originally formed in a church at the corner of Lafayette Place and Great Jones Street; from 1872 until the early twentieth century, it occupied a Lombardic Revival structure by James Renwick Jr. at the corner of Madison Avenue and 44th Street. The Romanesque porch from that church was commissioned by Mrs. Cornelius Vanderbilt in her husband's memory and designed by Stanford White; it was removed from the old church and incorporated by Goodhue into his design for this building.

Goodhue was a noted church architect who preferred the Gothic style; St. Bartholomew's was his first church based exclusively on Byzantine forms. The design, both inside and out, shows the influence of John Francis Bentley's Westminster Cathedral in London. Stanford White's famous porch bears

sculpture by gifted Americans: Henry Adams designed the north portal, and Philip Martiny the south portal; the central portal is the work of Daniel Chester French and Andrew O'Connor. Goodhue also reused marble columns from Renwick's church in the chapel to the south of the main nave.

St. Bartholomew's has a domed crossing resting on four reinforced concrete piers faced with stone. The shallow transepts and choir are barrel-vaulted with Rumford tile. The interior, completed in 1929, is a multicolored combination of brilliant mosaics and marble inlays. The gilded exterior of the dome adds a bright accent to skyscraper-lined Park Avenue.

The vestry of St. Bartholomew's had proposed that the Community House be removed and the land leased to a realtor for development. The Landmarks Preservation Commission opposed the plan, and the litigation that ensued was turned down by the United States Supreme Court in the 1980s. Currently, St. Bartholomew's plans an extensive repair and restoration of the existing building and its interior systems.

St. Bartholomew's functions as did cathedrals of earlier times—as an open sacred space with civic purpose and welcome. In addition to its renowned music and liturgy, the church operates a public café (al fresco in summer), the oldest continuously operating community theater in New York, and an innovative public interfaith education program, the Center for Religious Inquiry. Strong growth in congregational size and support has made possible a campaign for preservation work beginning in 2005.

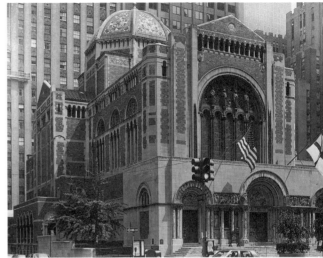

ST. BARTHOLOMEW'S CHURCH

473

United States Postal Service, formerly Cunard Building

1917–21

25 Broadway (also known as 13–27 Broadway, 13–39 Greenwich Street, and 1–9 Morris Street), Manhattan

Architect: Benjamin Wistar Morris

Consulting Architects: Carrère & Hastings

Designated (exterior and interior): September 19, 1995

Architect Benjamin Wistar Morris designed the twenty-two-story Cunard Building to conform to the zoning law of 1916, which mandated setbacks to create "stepped facade" towers and stipulated that a building's total floor space could not exceed twelve times the area of its lot. This building has subtle setbacks, and it is arranged on an H-plan with unusually long exposures to allow for ample light and ventilation. The neo-Renaissance exterior has projecting end pavilions, but the facade is more noticeably separated into a rusticated base, central plane, and colonnaded crown, the tripartite division characteristic of Lower Manhattan's "canyon" walls. Nautically inspired details—representing sea horses, the four winds, and Neptune's head—animate the otherwise austere facade. The design conveys the prestige of the Cunard Steamship Line Ltd., then the premier transatlantic passenger line.

The Cunard Building housed a ticket office comparable in size to grand rail way stations rather than steamship offices. The interiors are monumental public spaces modeled on Italian Renaissance and ancient Roman prototypes. Grandly proportioned and skylighted, the Great Hall consists of a central, domed octagonal space with square vault areas on either side, and a five-bay entrance lobby. Nautical iconography dominates the reliefs, ornaments, and painted surfaces. The U.S. Postal Service currently occupies the space.

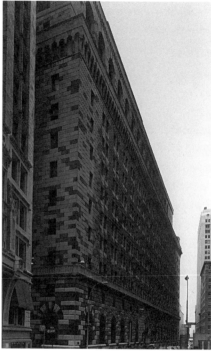

FEDERAL RESERVE BANK OF NEW YORK

UNITED STATES POSTAL SERVICE

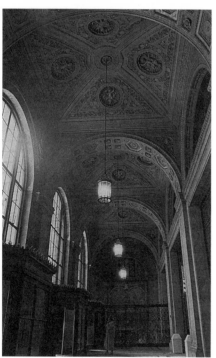

UNITED STATES POSTAL SERVICE INTERIOR

FEDERAL RESERVE BANK OF NEW YORK

1919–24

33 LIBERTY STREET, MANHATTAN

ARCHITECTS: YORK & SAWYER

DESIGNATED: DECEMBER 21, 1965

Fourteen stories high with five stories below ground, the Federal Reserve Bank of New York is an enormous building occupying an entire city block. Designed by York & Sawyer and completed in 1924, the "Fed" building freely adapts Italian Renaissance precedents to twentieth-century demands. The stonework, arches, and ironwork recall the Strozzi Palace of 1489; the sheer monumentality suggests the Pitti Palace of the early 1400s; and the arching and facade molding closely follow the details of the Palazzo Vecchio. The size and shape of the building are unusual, as the building narrows to conform to an irregular site.

Among the finest features are the fortresslike rusticated facade, wrought-iron window grills and lanterns, fine proportions, and superb quality of construction. This building, worthy of the Federal Reserve Bank's preeminent position in the financial life of the city and the nation, set a precedent for many other banks.

MUSIC BOX THEATER

1920

239–247 WEST 45TH STREET, MANHATTAN

ARCHITECTS: C. HOWARD CRANE AND E. GEORGE KIEHLER

DESIGNATED (EXTERIOR AND INTERIOR): DECEMBER 8, 1987

The Music Box Theater was built for the prolific producer Sam H. Harris and the legendary songwriter Irving Berlin. The theater was a rarity in the 1920s because it was not built by a large organization, but by an individual producer. Harris and Berlin asked architects C. Howard Crane and E. George Kiehler to design a theater that would stand out as the home of Berlin's famous "Music Box Revues."

The most prominent feature of the facade is the limestone Ionic colonnade screening a gallery. A mansard roof tops the theater, and a decorative wrought-iron balustrade runs the length of the roof. A mixture of Georgian Revival and Palladian elements on both the exterior and interior suggests an opulent country manor.

The auditorium, embellished with Adamesque ornament in a color scheme of antique ivory and soft green, is one of the most handsome on Broadway. Elaborate boxes framed by Corinthian columns project into the auditorium, with murals of bucolic classical ruins decorating the half-domes above.

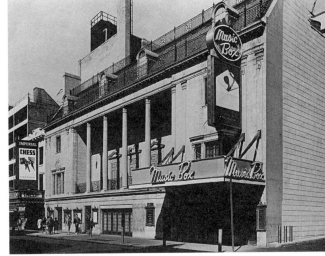

MUSIC BOX THEATER

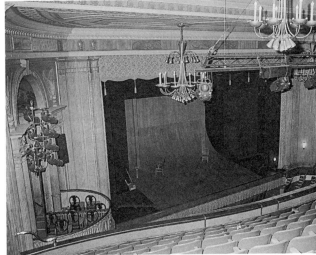

MUSIC BOX THEATER INTERIOR

475

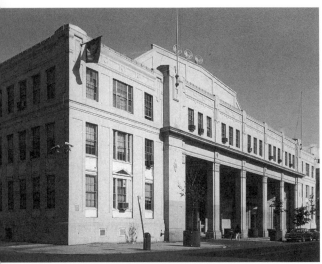

KAUFMAN ASTORIA STUDIOS

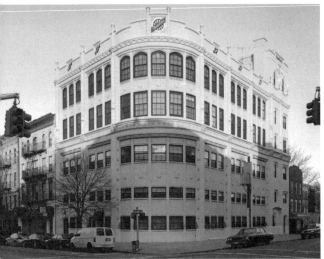

STUDEBAKER BUILDING

KAUFMAN ASTORIA STUDIOS, FORMERLY FAMOUS PLAYERS–LASKY CORPORATION STUDIOS AND PARAMOUNT STUDIOS, BUILDING NO. 1

1919–21

35–11 35TH AVENUE, ASTORIA, QUEENS

ARCHITECTS: FLEISCHMAN CONSTRUCTION COMPANY

DESIGNATED: MARCH 14, 1978

The Kaufman Astoria Studios were built as the eastern production head-quarters for the Famous Players–Lasky Corporation, the forerunner of Para-mount Pictures. More than 110 feature silent films were produced here between 1921 and 1927, with such stars as Gloria Swanson, Rudolph Valentino, W. C. Fields, and Dorothy Gish. In 1929, the studio produced its first sound feature, *The Letter*, starring Jeanne Eagels. Soon such actors as the Marx brothers, Claudette Colbert, Tallulah Bankhead, George Burns, and Gracie Allen were associated with the studios. In 1932, Paramount moved all studio operations to California, and the Astoria studios were turned over to independent pro-ducers. A Works Progress Administration film, *One Third of a Nation*, was the last major motion picture produced at the studios before World War II.

In 1942, the buildings were trans-ferred to the U.S. Army's Pictorial Center, and until 1970 the studios served as the production headquarters for army films. The building was then turned over to the City of New York. From the original government parcel of 5.3 acres, the complex has grown to over 14 acres. Building No. 1 has been rehabilitated and is in active use as a film production facility, handling an average of eight to twelve feature films each year. *The Cosby Show* was filmed there from 1986 to 1993 and *Sesame Street* from 1969 to the present.

The Fleischman Construction Company of New York designed and built the studios. Made of reinforced and cast concrete, with terra-cotta and masonry block used for decorative and facing materials, the main facade of Building No. 1 is three stories high, monumentally scaled, and distinguished by modified classical detail. The central portion is highlighted by a striking dou-ble-height porte cochere, five bays wide and flanked by end pylons. The building was designed around one large interior space—the Main Stage—that is spanned by a series of roof trusses. It is report-edly one of the four largest sound stages in the world, and was the largest on the East Coast, historically important for its early use of such technological features as sound insulation and readily adapt-able ceiling modules.

STUDEBAKER BUILDING

1920; 2000

1469 BEDFORD AVENUE (ALSO KNOWN AS 737–745 STERLING PLACE), BROOKLYN

ARCHITECTS: TOOKER & MARSH

DESIGNATED: DECEMBER 19, 2000

The Studebaker Building is an excellent example of a terra-cotta clad commercial structure and a rare reminder of Brooklyn's "Automobile row," a stretch of Bedford Avenue once lined with car showrooms. Originally a wagon manufacturer, Studebaker constructed their showroom at the height of their prominence in the industry, marketing to an increasing clientele of automobile users in suburban Brooklyn.

Designed by the firm Tooker & Marsh, the neo-Gothic-style brick and concrete building is clad in white terra-cotta manufactured by the Atlantic Terra-Cotta Works, the largest supplier at the time. The four-story building housed a showroom and salesroom on the ground floor with large windows (now removed) for displaying cars and attracting clients; offices were located on the upper levels and a garage in the rear. A rounded corner connects the primary facades. Notable elements of the building include segmental arched openings on the fourth floor, battlement parapets with black and white terra-cotta wheel emblems, and neo-Gothic details including moldings, colonettes, and figural sculpture. The showroom, which served as a company icon, retains its original logo, "Studebaker" on a diagonal banner across the wheel emblem, an image used on Studebaker buildings across the country.

Closed by Studebaker in 1939, the building was used for a variety of offices and small manufacturers. In 2000, a developer divided the ground and second floors into three floors of residential units. The twenty-seven apartments are now rented to homeless, disabled, and low-income families.

MAGEN DAVID SYNAGOGUE

1920–21

2017 67TH STREET, BROOKLYN

ARCHITECT: MAURICE COURLAND

DESIGNATED: APRIL 24, 2001

The Magen David Synagogue is a visual reminder of the vibrant culture brought to the United States by Syrian Jews at the beginning of the twentieth century and a testament to their strong ethnic and community ties. Designed by Maurice Courland, a native of Palestine, the brick neo-Romanesque Revival style building features Middle Eastern motifs including colorful, round-arched windows, and brick pattern work, and distinctive roof-line, all reminders of the homeland.

Having first settled the Lower East Side and Williamsburg, the community earned enough as peddlers, and later shopkeepers, to move to suburban Bensonhurst, Brooklyn. Built in 1920–21, the synagogue continues to function as the "mother" synagogue within the Syrian Jewish community, which has now spread into Midwood and Gravesend in Queens, and the Jersey shore. It is not uncommon for members of the dispersed community to hold funerals in the synagogue.

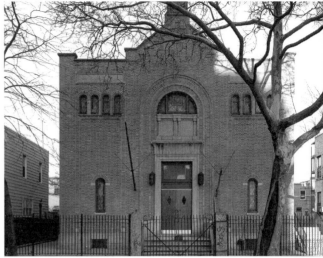

MAGEN DAVID SYNAGOGUE

NEWTOWN HIGH SCHOOL

NEWTOWN HIGH SCHOOL

1920–21, 1930–31, 1956–58

48–01 90TH STREET; NON-ADDRESS-
ABLE BUILDING FRONTAGE ON 50TH
AVENUE; 90–14 48TH AVENUE,
QUEENS

ARCHITECTS: C. B. J. SNYDER,
1920–21; WALTER C. MARTIN,
1930–31; MAURICE SALO &
ASSOCIATES

DESIGNATED: JUNE 24, 2003

Newtown High School, one of the most
distinguished buildings in Queens, rests
on a site that has been devoted to
education since 1866, when a small
wooden schoolhouse was first built.
Due to the rapid population growth of
Elmhurst, the school required more
space, and a much larger brick building,
designed by Boring & Tilton in 1898,
was added. Less than twenty-five years
later, this building and the original 1866
building were demolished to make way
for a new structure. Built by C.B.J.
Snyder, Superintendent of Buildings for
the New York City Board of Education,
the building was designed in a Flemish
Renaissance Revival-style to reflect the
area's Dutch roots. The building features
stepped gables, a hipped roof with
gabled dormers, terra-cotta embellish-
ments, and a dramatic five story tower
above the entrance, topped by a cupola
and turrets.

Two additional wings, more simply
executed, were added by architect Walter
C. Martin in 1930–31, again adopting a
building style that evoked Dutch
Colonial roots. Queens continued to
grow due to an influx of immigrants.
In 1956–58, Maurice Salo & Associates,
a Manhattan firm, designed a new bold,
International Style wing. The largely
intact high school currently enrolls
4,500 students, and has more than 200
teachers.

120TH POLICE PRECINCT STATION HOUSE, FORMERLY 66TH POLICE PRECINCT STATION HOUSE AND HEADQUARTERS

1920–23

78 RICHMOND TERRACE,
STATEN ISLAND

ARCHITECT: JAMES WHITFORD SR.

DESIGNATED: JUNE 27, 2000

The 120th Police Precinct Station House,
influenced by the City Beautiful move-
ment at the turn of the century, was
designed as part of an ensemble of
classically inspired civic buildings on
Richmond Terrace in Staten Island.
American architects and city planners
at the time worked to create these urban
clusters of corresponding buildings,
relying on the Classical Revival forms.

120TH POLICE PRECINCT STATION

In 1898, when Richmond County
was consolidated into the Greater City
of New York, George Cromwell, the
first Borough President of Staten Island,
moved the government seat from
Richmondtown, to this location. An
active supporter of the City Beautiful
movement, Cromwell hired John
Carrère, of Carrère & Hastings to design
the master plan for a series of new
governmental and cultural buildings.
Between 1898 and 1919, the firm built
four buildings from the plan. James
Whitford Sr., who designed approxi-
mately two thousand buildings, many
of them on Staten Island, followed the
design guidelines set out by Carrère for
the headquarters of the Richmond
County Police. To create a unique build-
ing that harmonized with its immediate
neighbors, Whitford took inspiration
from an Italian Renaissance palazzo,
cladding the building in terra-cotta
treated to resemble limestone with a
rusticated base and two entrances,
surmounted by bracketed cornices and
wrought iron balconies. The building,
which retains the sculptural figures
carrying city seals, is still used as a
station house.

STANDARD OIL BUILDING

1920–28

26 BROADWAY (ALSO KNOWN AS 10–30 BROADWAY, 1–11 BEAVER STREET, AND 73–81 NEW STREET), MANHATTAN

ARCHITECTS: CARRÈRE & HASTINGS

ASSOCIATE ARCHITECTS: SHREVE, LAMB & BLAKE

DESIGNATED: SEPTEMBER 19, 1995

A fine example of the new setback style of skyscraper that emerged during the early 1920s, the Standard Oil Building supports one of the southernmost spires in the Manhattan skyline. The huge sixteen-story base is articulated with neo-Renaissance window bays and entrance portals, above which a thirteen-story, pyramid-capped tower rises at slight angles to both the Broadway and Beaver Street facades. The structure is clad in buff Indiana limestone. Its complex massing served to incorporate the earlier Standard Oil Building and fit into the irregular, five-sided site, while also allowing for subsequent building expansions. The Broadway entrance is ornamented with carved panels, above which is a glazed screen framed by spandrels, featuring the corporate iconography of triple torches merging into a single flame. Other images include globes showing both hemispheres, suggesting Standard Oil's powerful position in world commerce.

From this site, John D. Rockefeller and his associates saw Standard Oil monopolize the American oil industry. In 1911, the company withstood an antitrust decision that stripped it of its subsidiaries, although it managed to retain its dominant role in the international oil business. The building, constructed as the company approached its fiftieth year, reinforced its physical presence in New York City's center of commerce. In 1956, Standard Oil's successor sold the building, which remains an office tower.

STANDARD OIL BUILDING

POMANDER WALK

1921

3–22 POMANDER WALK, 261–267 WEST 94TH STREET, AND 260–274 WEST 95TH STREET, MANHATTAN

ARCHITECTS: KING & CAMPBELL

DESIGNATED: SEPTEMBER 14, 1982

Pomander Walk extends from West 94th to West 95th Street in the middle of the block bounded by Broadway and West End Avenue; sixteen two-story buildings that face the private walk, and eleven buildings that face the cross streets, make up the complex. Secluded from the street, Pomander Walk is an oasis of picturesque dwellings ornamented with Tudor Revival details. The romantic atmosphere reflects the intentions of restaurateur Thomas Healy, who commissioned King & Campbell to design a complex that evoked the village atmosphere of Lewis Parker's play *Pomander Walk*, which was then enjoying great success on Broadway.

The interiors and exteriors of the buildings in this recreated English village have remained essentially unchanged since their completion.

POMANDER WALK

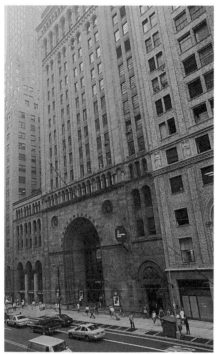

CIPRIANI'S

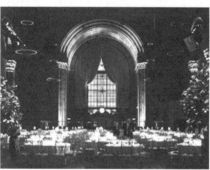

CIPRIANI'S INTERIOR

CIPRIANI'S, FORMERLY GREENPOINT BANK, ORIGINALLY BOWERY SAVINGS BANK

1921–23; ADDITION, 1931–33; 2002
110 EAST 42ND STREET, MANHATTAN
ARCHITECTS: YORK & SAWYER,
W. LOUIS AYRES DESIGN PARTNER;
ADDITION, W. LOUIS AYRES
DESIGNATED (EXTERIOR AND
INTERIOR): SEPTEMBER 17, 1996

As one of New York's largest banks at the turn of the century, the Bowery Savings Bank opened a Midtown branch in the early 1920s, following the center of commerce as it shifted north from Lower Manhattan. The building was designed by York & Sawyer, a firm known for its bank designs. The firm had inherited many of its aesthetic traditions—not to mention its staff—from McKim, Mead & White, which designed the first Bowery Savings Bank (p. 290).

The 42nd Street property was too valuable to be occupied solely by a bank, so the planners created a dual-purpose building: a fourteen-story office tower superimposed over the monumental banking hall. The Romanesque facade, with its simple arches and expansive surfaces, breaks with the typical "Greek Temple" bank design. A deeply cut, four-story arched entrance on 42nd Street is the major element of the base, and the tower has a pier-and-spandrel system of four double bays. Immediately east of the original building, a six-story addition repeats the tower's motifs above an arcade.

Ayres's interior design is Italian Roman-Byzantine, recalling a basilica with apse-like areas along the side walls; the space celebrates thrift as a quasi-religious virtue. The simple Romanesque forms are constructed from a variety of lavish materials, including polished marble, limestone, sandstone, plaster, bronze, gold leaf, and wood.

In 1991, the Bowery Savings Bank was acquired by Home Savings of America, and in 1995 the banking spaces were transferred to GreenPoint Bank. The banking hall is now used for special events.

EAST 80TH STREET HOUSES

MANHATTAN
116 EAST 80TH STREET, 1922–23
ARCHITECTS: CROSS & CROSS
DESIGNATED: JANUARY 24, 1967
130 EAST 80TH STREET, 1927–28
ARCHITECT: MOTT B. SCHMIDT
DESIGNATED: APRIL 12, 1967
120 EAST 80TH STREET, 1929–30
ARCHITECTS: CROSS & CROSS
DESIGNATED: NOVEMBER 12, 1968
124 EAST 80TH STREET, 1930
ARCHITECT: MOTT B. SCHMIDT
DESIGNATED: JANUARY 24, 1967

This block of East 80th Street, between Park and Lexington Avenues, was one of the earliest in this neighborhood to have houses built upon it. The earliest town house is the Lewis Spencer Morris House, at number 116, which architects Cross & Cross designed in 1922–23 in

the simple red brick of the Federal Revival style. In 1927–28, architect Mott B. Schmidt designed number 130 for Vincent Astor; it is now the clubhouse of the Junior League of New York. This neoclassical building is carried out entirely in a mellow-toned limestone. Its sophistication suggests the Regency period in England.

The gap between the two houses was subsequently filled in by two more: the George Whitney House at number 120, designed by Cross & Cross, and the Clarence Dillon House at number 124, by Schmidt. Both were completed in 1930 and were considered the most elegant town houses of their day. The Whitney House, while still basically Federal Revival, is more elaborate than its neighbor at 116; the pedimented central window and the raising of the balustrade to the top of the slate roof above the dormers are Georgian features. The Dillon House, with its brick quoins, splayed lintels and keystones, and heavy pedimented doorway, is pure Georgian Revival. The two architects managed to achieve a handsome unity among the buildings, yet each one retains its own individual stamp.

116 EAST 80TH STREET

130 EAST 80TH STREET

120 EAST 80TH STREET

124 EAST 80TH STREET

369TH REGIMENT ARMORY

ABYSSINIAN BAPTIST CHURCH

369TH REGIMENT ARMORY DRILL SHED AND ADMINISTRATION BUILDING

2360 FIFTH AVENUE, MANHATTAN

DESIGNATED: MAY 14, 1985

369TH REGIMENT ARMORY DRILL SHED, 1921–24

ARCHITECTS: TACHAU & VOUGHT

ADMINISTRATION BUILDING, 1930–33

ARCHITECTS: VAN WART & WEIN

The 369th Regiment Armory, like other armories built in the city in the late nineteenth and early twentieth centuries, is a highly specialized structure built to serve as a training and marshaling center for the National Guard. The structure consists of two sections—the drill shed and the administration building—which were designed in two stages. The design of the building combines the medieval forms of earlier armories with contemporary Art Deco elements. In the drill shed, the reddish-brown brick walls are articulated with regularly spaced simulated buttresses with stone copings; they flank narrow window openings set within brick arches. The square-headed entrances are set in stone enframements below foliate spandrels and marked by overscaled, red sandstone pediments. The parapet terminates in a crenellated motif; a gabled roof rises above the parapets.

The forms and massing of the administration building also recall medieval prototypes, but the setbacks and details are in the Art Deco mode, accented with appropriate military touches.

The 369th Regiment Armory is

particularly noted as the home of the "Harlem Hell Fighters," New York's official African American regiment, whose efforts in World War I brought military success and well-deserved accolades.

ABYSSINIAN BAPTIST CHURCH AND COMMUNITY HOUSE

1922–23

CHURCH

136–142 WEST 138TH STREET (ODELL M. CLARK PLACE), MANHATTAN

COMMUNITY HOUSE

132–134 WEST 138TH STREET (ODELL M. CLARK PLACE), MANHATTAN

ARCHITECTS: CHARLES W. BOLTON & SON

DESIGNATED: JULY 13, 1993

The Abyssinian Baptist Church was formed in 1808, when a small group of African American worshipers broke with the predominantly white First Baptist Church on Gold Street. The church moved northward, following the residential patterns of the African American community.

The Abyssinian Church and community house are constructed in the neo-Gothic style, with a central gabled section serving as the focal point of the facade. The symmetrically massed church is faced with blocks of Manhattan schist in random ashlar with white terra-cotta trim. East of the church is the community house, faced with the same materials and designed to complement the style of the church.

In 1923, during the tenure of the

Reverend Adam Clayton Powell Sr., the church moved to its present Harlem location. Reverend Powell initiated the social-activist doctrine for which the church is known. His son, Adam Clayton Powell Jr., took over the ministry in 1937, broadening the church's social mission in New York and in Washington, D.C. He served as a United States congressman from 1945 to 1970, advocating civil rights legislation, federal aid for education, a minimum wage scale, and better unemployment benefits. In recent years, the church has supported social programs including AIDS awareness, economic aid to African communities, and the "Billboard Campaign," which has removed outdoor advertising for liquor and tobacco from the central Harlem area.

SAKS FIFTH AVENUE

1922–24; 1989

611 FIFTH AVENUE, MANHATTAN

ARCHITECTS: STARRETT & VAN VLECK; LEE HARRIS POMEROY

DESIGNATED: DECEMBER 20, 1984

Representative of midtown Manhattan's premier shopping district, the handsome Saks Fifth Avenue building was an up-to-the-minute melange of the latest in fashion design and Renaissance Revival architecture at the time of its construction. This dignified and elegant structure was the result of Horace Saks's timely decision to move from his father's original Herald Square site. The building's opening—part of the boom of the

1920s—created quite a stir, as throngs of patrons stampeded through the store.

In compliance with the city's strict new zoning resolution and the Fifth Avenue Association's neighborhood requirements, the upper stories were set back from the main portion of the building. The restrained facades were sheathed in traditional stone and brick. Chamfered corners mark the transition from the main to the side-street facades. The ground floor of this ten-story structure is a rusticated granite base with entrances flanked by display windows. Carved spiral moldings decorate the entrances, which are topped by a plain cornice. Windows, set behind elegant detailed metal grills, surmount the doors.

Above the entrance level rises the main portion of the facade, with fluted pilasters supporting an architrave of Indiana limestone. Between the third and seventh floors the facade is brick with rectangular windows. The seventh-story level is set off by a sill molding; here, narrower windows alternate with stone roundels. Above the seventh floor are a series of setbacks. Their successive arrangement, marked by cornices and balustrades at the eighth through the tenth stories, completes the structure.

Immediately behind the 1929 building is a 36-story, mixed-use office tower designed by Lee Harris Pomeroy. The first nine stories provide additional retail and support space for Saks Fifth Avenue and the balance are occupied as the North American headquarters of Swiss Bank. The contextual design of the tower continues the classic motifs of the store on the street facades while

SAKS FIFTH AVENUE

acknowledging Rockefeller Center with its own modern front. The chamfered corners recall those of the store and the smooth Indiana limestone cladding is compatible with the materials of the historic building. The rusticated limestone base of the new building carrries the theme of composite order pilasters and the proportions of the punched shed windows of the Renaissance-style facade of the store.

ANDREW FREEDMAN HOUSE

CROSSLAND FEDERAL SAVINGS BANK

Andrew Freedman Home

1922–24; wings, 1928–31

1125 Grand Concourse,
The Bronx

Architects: Joseph H. Freedlander
and Harry Allan Jacobs; wings,
David Levy

Designated: June 2, 1992

Successfully combining the manner of
an urban Italian Renaissance palazzo
with the setting and terraces of a rural
villa, this home was built as a result of
an unusual bequest in the will of
wealthy capitalist Andrew Freedman.
Best-known as the owner of the Giants,
the New York baseball club, Freedman
asked that a home be established for
"aged and indigent persons of both
sexes" who were once wealthy.

This project was the only collabora-
tion of Joseph Freedlander and Harry
Allan Jacobs, who both had attended the
Ecole des Beaux-Arts and were well-
known members of New York's architec-
tural establishment. Joseph Freedlander
was one of the first three Americans to
actually complete the Ecole curriculum
and receive a diploma. His affinity for
the Beaux-Arts philosophy is obvious in
the monumental massing of the build-
ing and its references to several tradi-
tions of European architecture. The
design features a recessed loggia, a
balustraded terrace, fine stonework, and
beautiful wrought-iron detail. While the
design relies on historical sources, the
building is a steel-frame, fireproof struc-
ture, with concrete floors and terra-cotta
and brick partitions.

The Freedman Home was referred to
as a retreat for millionaires by the press,
but the early residents were actually
doctors, dressmakers, and teachers. In
the years before the home closed in
1983, many residents were German and
Austrian Jewish refugees. The Mid-Bronx
Senior Citizens Council bought the
building in 1983, and the elegant rooms
continue to serve the elderly.

Crossland Federal Savings Bank, formerly the Greenwich Savings Bank

1922–24

1352–1362 Broadway (also known
as 985 Sixth Avenue), Manhattan

Architects: York & Sawyer

Designated (interior and
exterior): March 3, 1992

One of the finest examples of the aca-
demic classical tradition in the country,
this new facility marked the success of
the Greenwich Savings Bank in
Greenwich Village and the decision of its
trustees to move the headquarters to a
more prominent Midtown location.

Edward Palmer York and Philip Sawyer
had both worked for McKim, Mead &
White, and they carried the senior firm's
monumental classicism into their
designs. The Greenwich Savings Bank
design was doubtless influenced by the
two-story, Italian Rennaisance Revival
Herald Building, designed by McKim,
Mead & White, that once stood across
the street, to the south. York was once
Stanford White's assistant, and Sawyer

studied at the Ecole des Beaux-Arts in Paris; together they designed many hospital, college, and government buildings, although they are best known for their bank buildings.

Sawyer's knowledge of ancient Roman architecture is manifest in the manner in which the three facades are articulated by a monumental Corinthian colonnade and a rusticated podium. His knowledge and appreciation of eighteenth- and nineteenth-century French planning and design are expressed in the elliptical plan of the main banking room. The continuous elliptical screen, faced with Indiana limestone and Ohio sandstone, conceals the fact that between this and the exterior wall there are six stories of offices and a basement. For all of the building's historicism, the banking room is lit by a twentieth-century light diffuser that hangs seventy-two feet above it.

Other than the signage on the exterior, the building has undergone few changes since the day it opened. In 1981, it became the Metropolitan Savings Bank and two years later, the Crossland Federal Savings Bank. Currently vacant, the beautiful interior is used on occasion for special events.

IMPERIAL THEATER INTERIOR

1923

249 WEST 45TH STREET, MANHATTAN

ARCHITECT: HERBERT J. KRAPP

DESIGNATED: NOVEMBER 17, 1987

Located in Shubert Alley, the Imperial was intended to be a premier showcase for the Shubert Organization's revues and musicals.

In contrast to the plain and modest exterior, Herbert Krapp's Adamesque interior is elegant. Shallow pilasters line the walls, and the triple boxes are decorated with highly ornamental, low-relief plasterwork. Ornaments are placed on the ceiling, and the walls contain friezes, floral and geometric motifs, and fairy figures holding the masks of comedy and tragedy.

In 1925, the Shuberts planned to add a fifteen-story residential hotel designed by Krapp on top of the Imperial, but the plan was never executed. The Shubert Organization fell on hard times during the Depression, but was able to maintain management of the Imperial and make it into one of Broadway's most legendary musical theaters. It has housed successes such as *Gypsy*, *Carnival*, and *Fiddler on the Roof*.

CROSSLAND FEDERAL SAVINGS BANK INTERIOR

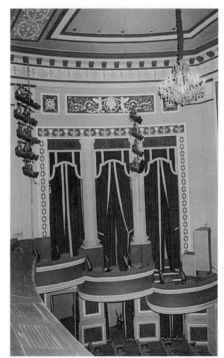

IMPERIAL THEATER INTERIOR

485

RICCI CANDY MANUFACTURING CO., FORMERLY CHILDS RESTAURANT BUILDING

1923

2102 BOARDWALK (ALSO KNOWN AS 3053–3078 WEST 21ST STREET), BROOKLYN

ARCHITECT: DENNISON & HIRONS

DESIGNATED: FEBRUARY 4, 2003

Designed in a florid resort style with Spanish Revival influences, the Childs Restaurant Building is a reminder of Coney Island's heyday. With the subway opening in 1920 and the Boardwalk construction in 1923, crowds of one million visitors could be expected on a summer day. The restaurant attracted patrons with its seaside atmosphere and wholesome foods, which could be enjoyed on its rooftop pergola and open arcade. The masonry building was far sturdier than the wooden stalls that lined the Boardwalk, surviving and even halting the spread of a fire that destroyed many of its neighbors in 1932.

The Beaux-Arts-trained architects Dennison & Hirons embellished the white stucco walls with elaborate polychrome terra-cotta ornament, full of nautical motifs with images of fish, seashells, ships, and the god Neptune. The Spanish Revival style, rarely seen in New York City, is atypical of the firm's designs, which tended toward the classical or Art Deco style. The style and elaborate ornamentation was also rare for the Childs Restaurant chain, which favored tile, mirrors, and marble to emphasize cleanliness. The Coney Island

RICCI CANDY MANUFACTURING CO.

restaurant is one of their earliest attempts to adapt their design to a specific location. Begun in 1889 by brothers Samuel and William Childs, the chain owned more than one hundred restaurants in the United States and Canada. The Coney Island restaurant closed in the early 1950s, when the area began to decline. The Ricci family then purchased the building, and today they continue to operate their candy manufacturing plant at the site.

BRYANT PARK HOTEL, FORMERLY THE AMERICAN STANDARD BUILDING, ORIGINALLY AMERICAN RADIATOR BUILDING

1923–24; 2001

40 WEST 40TH STREET, MANHATTAN

ARCHITECT: RAYMOND M. HOOD

DESIGNATED: NOVEMBER 12, 1974

Raymond M. Hood established himself as one of the foremost architects in the United States with this, his first major commission in New York. Although the massing, setbacks, and Gothic ornament were not unusual architectural features

BRYANT PARK HOTEL

in the 1920s, the black brick and gilded terra-cotta ornament startled both the profession and the public. This color combination was not present in the original design, and was added only after ground had been broken in early 1923. The black brick is particularly successful, giving the skyscraper a unified, slablike effect, much admired at the time of its completion. This effect had been achieved best by Louis Sullivan in his use of unbroken vertical piers; Hood created the same result through color and unaccented mass. Hood set the main body of the tower back from the east and west party walls, thus ensuring that the structure would always appear as a lone tower despite later construction of tall buildings in the area.

The entire ground floor was a showroom for American Radiator products: it then served American Standard, Inc., in the same way. Hood's original display floor was distributed over three levels, with an almost unobstructed view from the front to the rear of the building,

made possible by an advanced form of the portal-braced steel frame. At the back of the showroom was a wrought-iron grill, based loosely on late Gothic metalwork, that led down to the boiler room where gleaming American Radiator heating equipment worked quietly and efficiently.

Every aspect of the structure was meant to attest to the high quality of the company's products. Dramatic nighttime lighting was added soon after the building's completion at the company's own initiative. The company was so pleased with its headquarters that Hood received the 1928 commission for its European headquarters in Argyll Street, London. The building was restored, and it reopened in 2001 as the Bryant Park Hotel.

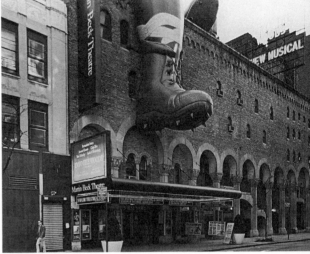

AL HIRSCHFELD THEATER

AL HIRSCHFELD THEATER, FORMERLY MARTIN BECK THEATER

1923–24

302–314 WEST 45TH STREET, MANHATTAN

ARCHITECT: C. ALBERT LANSBURGH

DESIGNATED (EXTERIOR AND INTERIOR): NOVEMBER 4, 1987

The Martin Beck is a monument to the man who conceived and built it. A Czech immigrant, Beck began his career in a vaudeville company. Eventually, he became involved in the Orpheum circuit, rising in 1920 to succeed his father-in-law as president of more than fifty Orpheum theaters.

The Orpheum merged with the East Coast–based Keith Circuit, and Beck was ousted in 1923. At this point, he decided to build his own theater. He hired G. Albert Lansburgh, whose designs for many of the Orpheum Circuit theaters had brought him national acclaim. Lansburgh regarded the Martin Beck Theater as his most notable accomplishment.

One of the most lavishly appointed theaters on Broadway, it met with immediate critical praise and success. The theater is done in a Moorish style, marked chiefly by a three-story arcade on West 45th Street. With its recessed entrances, exotically carved capitals, and angled piers, the arcade contrasts sharply with the more common flat facades and neoclassical style of many other Broadway theaters.

The interior design echoes the elaborate facade, with an abundance of ornamentation, and the vaulted Romanesque ticket lobby; an inner lobby features three domes with mural paintings. One of the highlights of the interior is the ceiling designed by painter and illustrator Albert Herter. As a tribute to the renowned illustrator, the theater was renamed the Al Hirschfeld Theater in 2002.

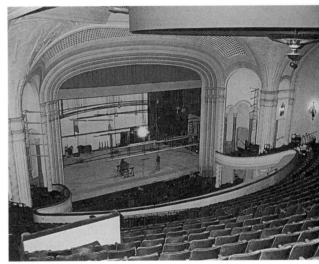

AL HIRSCHFELD THEATER INTERIOR

B.P.O.E. LODGE NUMBER 878

REFORMED CHURCH OF HUGUENOT PARK LIBRARY

BENEVOLENT AND PROTECTIVE ORDER OF ELKS, LODGE NUMBER 878

1923–24; 2001

82–10 QUEENS BOULEVARD, QUEENS

ARCHITECT: THE BALLINGER COMPANY

DESIGNATED: AUGUST 14, 2001

Remarkably intact and well preserved, the Benevolent and Protective Order of Elks, Lodge Number 878 is one of the most prominent buildings on Queens Boulevard. The Lodge was featured in a 1926 issue of *Architectural Forum* as one the nation's largest, and best equipped, fraternal buildings. Modeled after an Italian Renaissance palazzo by the Philadelphia-based Ballinger Company, the Lodge is distinguished from the other buildings in Elmhurst by its formidable mass. Other features include a full-width front terrace, ornate round-arched entryway, flanked by Doric half columns, bronze and glass clock and giant bronze elk statue, designed by prominent sculptor Eli Harvey. Clad in brick, limestone and granite, the three-story structure encloses a series of recreational and social spaces. In the 1960s, the Queens Lodge counted membership of well over six thousand, and their annual "Elks Bazaar" was considered the borough's social event of the year. Due to a severe decline in membership, the building was sold to the New Life Fellowship Church in 2001. The Lodge's remaining members continue to meet in the building.

REFORMED CHURCH OF HUGUENOT PARK

1923–24; 1980s

5475 AMBOY ROAD, STATEN ISLAND

ARCHITECTS: ERNEST FLAGG; 1955 ADDITION, JAMES WHITFORD JR.

DESIGNATED: NOVEMBER 20, 1990

LIBRARY

906 HUGUENOT AVENUE, C. 1903–5

ARCHITECT: UNKNOWN

This church was built to commemorate the three-hundredth anniversary of the Huguenots settling on Staten Island after fleeing religious persecution in France. It stands on farmland that originally belonged to Benjamin T. Prall, a direct descendant of Pierre Billiou, leader of the first Huguenots to arrive. Stylistically the church recalls medieval Romanesque and vernacular Norman architecture found in France and England. It is faced in concrete and mosaic serpentine stone quarried from Stone Court, Flagg's estate (p. 330). Staten Island's rich-hued native serpentine stone—combined with Beaux-Arts craftsmanship and technological innovations—is Flagg's trademark. Other features include a long nave articulated by a steeply pitched roof, gabled entrance pavilions on each side of the south end, a large square tower topped by a pyramidal roof at the north end, and a polygonal spire rising from the northwest corner. The massing of pared-down, abstract forms is Flagg's personal interpretation of medievalism. A one-story assembly hall with a peaked roof, sympathetic in style to the original

building, was added to the west side of the church by architect James Whitford Jr. in 1955.

At the northeast corner of the site stands a diminutive, one-story frame building that was moved to its present location in the early twentieth century. It served as the smallest branch of the New York Public Library until 1985.

In the mid-1980s an extensive restoration program repaired the asphalt shingle roof (originally seam metal strips) and replaced approximately twenty percent of the original crumbling stone with the same native serpentine stone Flagg had used.

MOTHER AFRICAN METHODIST EPISCOPAL ZION CHURCH

1923–25

140–148 WEST 137TH STREET, MANHATTAN

ARCHITECT: GEORGE W. FOSTER JR.

DESIGNATED: JULY 13, 1993

This church is the sixth home of New York City's first African American congregation and the founding church of the African Methodist Episcopal Zion Church. It was established in 1796, when the black members of the predominantly white John Street Methodist Congregation broke with their church, which refused to allow integrated communions. The new congregation withdrew from the Methodist Church denomination and formed the Conference of A.M.E. Zion Churches in 1820.

During the nineteenth century, the A.M.E. Zion, known as the "Freedom Church," was noted for its outspoken abolitionism. It counted among its members Harriet Tubman, Sojourner Truth, and Frederick Douglass. Many of the Zion Churches were part of the Underground Railroad, which smuggled African Americans out of the South. The A.M.E. Zion Church Conference continued its social activism in the twentieth century, and its membership included Langston Hughes, Marian Anderson, Joe Louis, and Paul Robeson.

Designed by one of the first African American architects to be registered in the United States, this neo-Gothic church is symmetrical, with a gray stone facade laid in random ashlar and trimmed in terra-cotta. Flanking a tall, central gable are pairs of narrow buttressed wings. A pointed-arch window dominates the center of the facade, above the entrance.

REFORMED CHURCH OF HUGUENOT PARK

MOTHER AFRICAN METHODIST CHURCH

489

BARCLAY-VESEY BUILDING

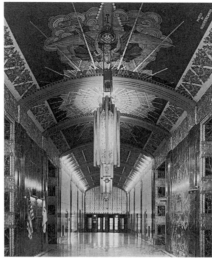

BARCLAY-VESEY BUILDING INTERIOR

BARCLAY-VESEY BUILDING

1923–27

140 WEST STREET, MANHATTAN

ARCHITECT: RALPH WALKER OF
MCKENZIE, VOORHEES & GMELIN

DESIGNATED (EXTERIOR AND FIRST
FLOOR INTERIOR): OCTOBER 1, 1991

This stunning example of American Art Deco was built for the New York Telephone Company as their new central headquarters. Designed to be "as modern as the telephone activity it houses" and to symbolize the size and technological advances of the company, the building program mandated a facility large enough for six thousand employees serving 120,000 telephone lines. Hailed in its day as the ultimate modern skyscraper, the thirty-two-story building was awarded the Architectural League of New York's Gold Medal of Honor in 1927 and became a model for telephone headquarters later built throughout New York.

The company selected architects McKenzie, Voorhees & Gmelin, a firm that had a long history with New York Telephone. The critical success of the building quickly elevated Ralph Walker to partnership, even though this was his first major project in association with the firm. Subsequent corporate commissions brought Walker recognition as a designer of Art Deco skyscrapers, earning him in 1957 the title "architect of the century" from the American Institute of Architects.

Walker's approach to design was based on two precepts—that economy was the key to good design and that machine technology was the road to modern style. His pragmatism is evident in both the design and the choice of building materials. Most of the facade is brick, which was selected for its texture and subtle color, with ornament for the upper stories fashioned in machine-cast stone. The building occupies a parallelogram-shaped, 52,000-square-foot site.

Its massive base was determined by the fact that many of the internal operations required only artificial light, thus eliminating the need for an interior court.

The dramatic first-floor interior is an integral component of the building. Serving as a long corridor between the two entrance vestibules, the space establishes continuity between exterior and interior by mirroring external elements, such as vertical piers, in the program of internal ornaments, like the marble pilasters. Walker also attempted to eliminate handwork in his interior design, choosing instead such materials as veneer, which celebrated machine technology. This machine-age emphasis was further underscored by a series of painted ceiling panels and bronze floor plaques that illustrate advancements in communications through the ages and, specifically, New York Telephone's role in these developments.

Many of the windows were blown out by the attacks of September 11, 2001; the facade required much repair, but no structural damage occurred.

CITY CENTER 55TH STREET THEATER, FORMERLY THE MECCA TEMPLE

1924

131 WEST 55TH STREET, MANHATTAN

ARCHITECT: H. P. KNOWLES

DESIGNATED: APRIL 12, 1983

The Mecca Temple began as an entertainment hall for New York City Shriners. The exterior reflects the organization's adopted heritage and

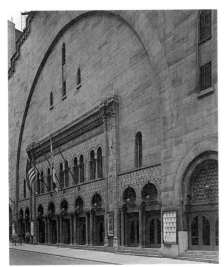

CITY CENTER 55TH STREET THEATER

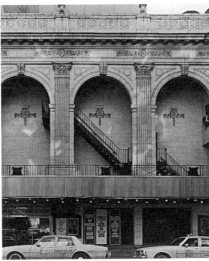

RICHARD RODGERS THEATER

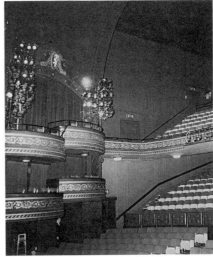

RICHARD RODGERS THEATER INTERIOR

includes elements from the Alhambra and Egyptian mosques, as well as Templar Church facades. Four main interior spaces—a lodge and club rooms, a stage, a large auditorium, and a banquet hall—are organized within a concrete-encased structural steel frame. Together, they form a massive cube covered in sandstone and surmounted by a tile dome.

The West 55th Street front, in a style deemed "modified Arabian" by the Shriners, is actually composed of two facades. One structurally merges with the upper dome, while the other is scaled to the pedestrian below. The facade on West 56th Street appears more classical and restrained than its Moorish counterpart. It is composed of five arches: the outer and central arches provide access to the stage, while those in between serve as public entrances. The large, decorative dome houses an exhaust fan eight feet in diameter.

The building changed hands several times during the Depression; the City of

New York acquired it in 1942. A year later, Mayor Fiorello LaGuardia was instrumental in reopening the temple as the City Center of Music and Drama, dedicated to the production of cultural events at affordable prices. Once home to the New York City Ballet and the New York City Opera, the theater has remained a center for dance and theater under the 55th Street Dance Theater Foundation, Inc. The Jeffrey, Alvin Ailey, and Paul Taylor dance companies have performed here on a regular basis.

RICHARD RODGERS THEATER,
FORMERLY CHANIN'S 46TH STREET
THEATER

1924

226–236 WEST 46TH STREET,
MANHATTAN

ARCHITECT: HERBERT J. KRAPP

DESIGNATED (EXTERIOR AND
INTERIOR): NOVEMBER 17, 1987

The 46th Street Theater was Irwin S. Chanin's first theatrical venture. Its brick and terra-cotta Renaissance-style facade is more elaborate than those of theaters that Herbert Krapp had previously designed. A triple-arched loggia placed between five Corinthian pilasters is the main design element. Terra-cotta embellishes the arches and on each side there are panels with theatrical masks.

The interior is designed in what Chanin called a stadium plan, which he believed would make theater-going more democratic. All seats were reached through the same lobby, whether they were in the orchestra or in the balcony. The 1,500-seat auditorium was detailed with Adamesque plasterwork. The walls are decorated with pilasters and shell moldings that form arches, and the boxes are enhanced by wave friezes.

ARTHUR HAMMERSTEIN HOUSE

ARTHUR HAMMERSTEIN HOUSE

1924; ADDITIONS, 1924–30

168–11 POWELL'S COVE BOULEVARD,
QUEENS

ARCHITECT: DWIGHT JAMES BAUM

DESIGNATED: JULY 27, 1982

Upon his marriage to film star Dorothy
Dalton, and after the year-long success
of his 1923 musical comedy *Wildflower*,
Arthur Hammerstein, son of Oscar
Hammerstein, built this mansion, which
he named Wildflower. Located in the
Beechhurst-Whitestone neighborhood,
Hammerstein's residence is a fine model
of Tudor Revival architecture.

Dwight James Baum designed an
asymmetrically massed, two-and-one-
half-story brick structure with peaked
roofs and gables, steep chimneys, and
projecting bays. Personal touches added
by Hammerstein include a tile inscrip-
tion in the entrance hall reading "AH.
Thys Hovse was Bvilt in the Yere of owre
Lorde MCMXXIV" and leaded stained
glass windows by J. Scott Williams that
depict Shakespearean characters.
Modifications to the house, probably
executed by Baum and finished between

1924 and 1930, include a stone bay,
gable, one-story addition on the north
elevation, a regrouping of gables and
openings on the south. Since 1930, the
garage has been modified and the
entrance set back into a vestibule, but
the house remains largely unchanged.
With the onset of the Depression,
Hammerstein was forced to sell Wild-
flower to raise funds to sustain his
Hammerstein Theater, now the Ed
Sullivan Theater (p. 505). The house
then served as the Clearview Yacht Club
headquarters, and later as a restaurant.

VIRGINIA THEATER, FORMERLY
THE GUILD THEATER

1924–25; 1982

243–259 WEST 52ND STREET,
MANHATTAN

ARCHITECTS: CRANE & FRANZHEIM

DESIGNATED: AUGUST 6, 1985

The Virginia Theater was constructed for
the Theater Guild as a subscription play-
house named the Guild Theater. The
founding members—including actors,
playwrights, designers, attorneys, and
bankers—formed the Theater Guild to
present plays of high quality, which they
believed would be artistically superior to
the offerings of the commercial Broad-
way houses. The Guild Theater was
designed to be a resource center as well,
with classrooms, studios, and a library.
The theater itself included the most
up-to-date staging technology.

The exterior, designed by theater
architect C. Howard Crane with Kenneth

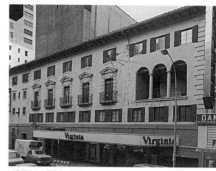

VIRGINIA THEATER

Franzheim, drew inspiration from fif-
teenth-century Tuscan villas. Differing
markedly from the neoclassicism of
other theaters of the period, the build-
ing provoked as much admiration as the
company's planned operations. Among
its notable features are the stuccoed
walls framed by rusticated stone quoins,
a tiled roof overhanging the facade, and
a small arched loggia.

In the 1930s, the Theater Guild was
forced to give up its theater; in 1950 the
building was taken over by ANTA, a sim-
ilar theater group that had evolved from
the Federal Theater Project. In 1981,
ANTA moved to Washington and became
the American National Theater Company.
The building was purchased by the
Jujamcyn Corporation in 1982 and
renamed the Virginia Theater.

STEINWAY HALL

1924–25

109–113 WEST 57TH STREET (ALSO
KNOWN AS 106–116 WEST 58TH
STREET), MANHATTAN

ARCHITECT: WARREN & WETMORE

DESIGNATION: NOVEMBER 13, 2001

STEINWAY HALL

Steinway Hall has been an international center of cultural and artistic influence since 1925, when it was built for Steinway & Sons, New York City's only remaining piano maker. Originally located in the 1866 Steinway Hall, near Union Square, the company has occupied the first four floors of the building, as well as the legendary basement showroom, since 1925. The Columbia Broadcasting System had its beginnings in the penthouse, where William Paley set up a radio studio and broadcast CBS concerts from the recital hall downstairs. The penthouse is also home of one of the oldest recording studios in the city, used by jazz legends Charlie Parker and Miles Davis. The Manhattan Life Insurance Company owned the building between 1958 and 1980, maintaining their headquarters there until 2001. Steinway and Sons, which continued to rent space throughout this period, reacquired the building in May 1999.

Warren & Wetmore designed the L-shaped, sixteen-story building in the neoclassical style. A four-story colonnaded tower tops the building, peaking in a central campanile-like tower with a pyramidal roof and large lantern. The limestone facade features music-themed ornamentation including a sculptural group by Leo Lentelli and a frieze with portraits of distinguished classical composer-pianists.

A. PHILIP RANDOLPH CAMPUS HIGH SCHOOL, FORMERLY THE NEW YORK TRAINING SCHOOL FOR TEACHERS/NEW YORK MODEL SCHOOL

1924–26

443–465 WEST 135TH STREET, MANHATTAN

ARCHITECT: WILLIAM H. GOMPERT

DESIGNATED: JUNE 24, 1997

The New York Training School for Teachers/New York Model School was the first building constructed expressly for the Training School, one of three facilities maintained by the Board of Education. The facility, designed by William H. Gompert, architect and superintendent of school buildings for the Board of Education, was divided between the training school and its "model school" for practice teaching. The building was designed in an abstracted, contemporary Collegiate Gothic style, and the dual interior functions of the facility are differentiated by the exterior articulation. The L-shaped building is divided vertically by pavilions, buttresses, and square towers.

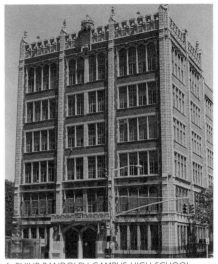
A. PHILIP RANDOLPH CAMPUS HIGH SCHOOL

Adjoining the training school portion of the building is a wing housing a two-story auditorium beneath a two-story gymnasium.

The Training School became the New York Teachers Training College from 1931 to 1933, after which it was abolished due to a surplus of teachers during the Depression. In 1933, the model school portion of the building was used by Public School 193, followed in 1936 by the High School of Music and Art, established by Mayor Fiorello H. La Guardia. This was considered to be the first public high school in the United States that specialized in the study of music and art. The school merged with the High School of Performing Arts in 1984, becoming the Fiorello H. La Guardia High School of Music and Art and Performing Arts, and relocated to a building west of Lincoln Center. The 135th Street building has since housed the A. Philip Randolph Campus High School.

EMBASSY I THEATER INTERIOR

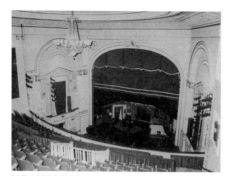
BILTMORE THEATER INTERIOR

EMBASSY I THEATER INTERIOR

1925

1556–1560 BROADWAY, MANHATTAN

ARCHITECT: THOMAS LAMB

DESIGNATED: NOVEMBER 17, 1987

The interior of the Embassy I is a reminder of the grandeur that was once part of the movie-going experience. It was built in 1925 for the Metro-Goldwyn-Mayer corporation, and no expense was spared: paintings were commissioned from the noted muralist Arthur Crisp and the lighting fixtures and decorative elements were created by the Rambusch Studio.

The lobbies were decidedly French in style, with marble detailing in the outer lobby and rich blond wood paneling and Louis XV furniture—since removed—in the inner lobby. The French motifs were continued in the auditorium with floral reliefs and oval insets, each in a different color and type of marble. The lighting fixtures are in the shape of vases supported on the backs of mermaids. These details were originally accompanied by tapestry-covered chairs and silk damask curtains.

The Embassy I was not a movie theater for the masses; it was designed for those wealthy enough to pay for reserved seats. The manager was Gloria Gould, an early feminist and darling of New York society, and the theater was staffed entirely by women, from the projectionists to the musicians.

The novelty of an exclusive movie theater run by women soon wore off, and the Embassy I was transformed into the first newsreel movie house in America in 1929. With the advent of television news, the newsreel became obsolete. In 1949, the Embassy I began once more to show feature films, and now houses the Times Square Visitors Center.

BILTMORE THEATER INTERIOR

1925–26; 2003

261–265 WEST 47TH STREET, MANHATTAN

ARCHITECTS: HERBERT J. KRAPP; POLSHEK PARTNERSHIP

DESIGNATED: NOVEMBER 10, 1987

Through its various theater projects, of which the Biltmore Theater is a fine example, the Chanin organization created much of the feeling of the Broadway district.

The interior of the Biltmore differs from other Broadway theaters in the design of its auditorium which is horseshoe-shaped, with a single aisle. The interior is Adamesque, featuring highly ornamental, low-relief plasterwork. The auditorium is decorated with shallow pilasters, and its false boxes are adorned with neoclassical aedicules. The ceiling is adorned with low-relief plasterwork, as are the panels on the walls. The Biltmore interior was restored in 2003 by the Polshek Partnership. The auditorium, stairs, and mezzanine hall are designated interiors, and these existing forms and primary finishes were restored or replicated. Other public and back-of-house areas were finished in a modern idiom designed to complement the restoration.

EUGENE O'NEILL THEATER, FORMERLY THE FORREST THEATER, INTERIOR

1925–26; 1994

230-238 WEST 49TH STREET, MANHATTAN

ARCHITECT: HERBERT J. KRAPP

DESIGNATED: DECEMBER 8, 1987

The Eugene O'Neill is significant for being part of the first hotel-theater complex in Times Square. At that time, the buildings were known as the Forrest Hotel and Theater, after Edwin Forrest, one of the greatest actors of the nineteenth century.

494

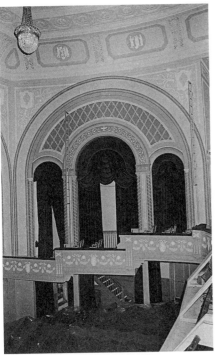

EUGENE O'NEILL THEATER INTERIOR

An unusual aspect of the building is the use of a structural steel skeleton, unheard of, until then, in theater construction. The most significant feature of the Eugene O'Neill, however, is its Adamesque interior, with ornamental low-relief plasterwork based on ancient Roman decoration. The decor includes panels depicting classical scenes, cartouches with classically robed figures, and theatrical masks. Bands of plasterwork outline the ceiling and boxes.

The theater has had a succession of owners throughout its history, including playwright Neil Simon. In 1953, it was renamed the Eugene O'Neill by Lester Osterman, who was the owner at the time. In 1994, the ornamental interiors were restored.

BROOKS ATKINSON THEATER, FORMERLY THE MANSFIELD THEATER

1925–26

256–262 WEST 47TH STREET, MANHATTAN

ARCHITECT: HERBERT J. KRAPP

DESIGNATED (EXTERIOR AND INTERIOR): NOVEMBER 4, 1987

This was the third theater designed by Herbert J. Krapp for Irwin S. Chanin. Originally named for Richard Mansfield, one of America's most famous nineteenth-century actors, the theater was renamed for critic Brooks Atkinson in 1960, when—after a ten-year stint as a radio and television studio—it reopened as a theater. The building is markedly different from the first two theaters that Krapp built for Chanin. The architect chose Spanish motifs, instead of the neoclassical themes that were popular at the time. On the exterior, Palladian arches and windows, spiral Corinthian columns, a tiled roof, and flanking towers are combined with rich terra-cotta detailing to create a romantic effect.

The elaborate interior design echoes the Spanish exterior. Chanin brought in Roman Meltzer, a former decorator and architect to Czar Nicholas II, as a consultant for the interior. The audience is brought close to the stage by an auditorium that is wider and shallower than usual. Once seated, the audience is surrounded by ornate details, including murals depicting figures from the commedia dell'arte, muses by A. Battisti and G. Troombul, and ornamental low-relief plasterwork by sculptor Joseph F. Dujat.

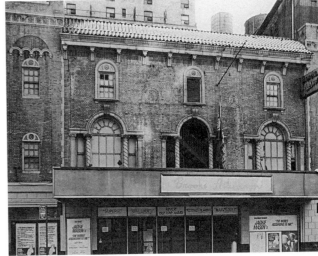

BROOKS ATKINSON THEATER

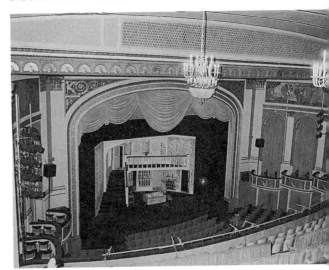

BROOKS ATKINSON THEATER INTERIOR

CITY CINEMAS VILLAGE EAST, FORMERLY PHOENIX THEATER, LOUIS N. JAFFE ART THEATER, YIDDISH ART THEATER

1925–26

181–189 SECOND AVENUE, MANHATTAN

ARCHITECT: HARRISON G. WISEMAN

CONSULTANT FOR INTERIOR DECORATION: WILLY POGANY

DESIGNATED (EXTERIOR AND INTERIOR): FEBRUARY 9, 1993

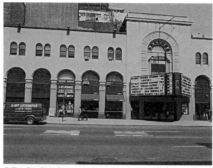

CITY CINEMAS VILLAGE EAST

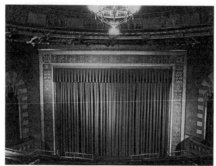

CITY CINEMAS VILLAGE EAST INTERIOR

By the 1920s, the Yiddish theater—arguably the most important part of Jewish immigrant culture—had begun a slow decline as a second generation of Jews came of age and their linguistic particularity eroded. During this time, the Yiddish theater district moved from Grand Street ("the Yiddish Broadway") and the Bowery to Second Avenue.

Originally the Yiddish Art Theater, this building housed Yiddish productions until 1945 and staged Yiddish revivals in the 1970s and 1980s. The Phoenix Theater occupied the building in the 1950s, where, for affordable prices, audiences could see such well-known performers as Jessica Tandy, Hume Cronyn, Montgomery Clift, and Uta Hagen. Younger actors such as Larry Storch, Joel Grey, Carol Burnett, and Peter Falk also performed here. Over the next three decades, the building housed debut productions of *Grease*, *Oh Calcutta!*, *The Best Little Whorehouse in Texas*, and *Joseph and the Amazing Technicolor Dreamcoat*.

The exterior is a 1920s Moorish

Revival style that uses Judaic references such as half menorahs in its ornate entrance pavilion arch. The interior has lavishly ornamented tile and plaster ceilings containing six-pointed stars. In 1991, the building was converted into the seven-screen Village East cinema. Although the main room has been subdivided, much of the elaborate decor remains.

RITZ TOWER

1925–27

465 PARK AVENUE, MANHATTAN

ARCHITECT: EMERY ROTH WITH THOMAS HASTINGS

DESIGNATED: OCTOBER 29, 2002

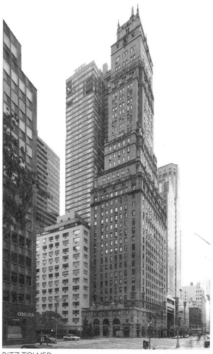

RITZ TOWER

At the time of its completion, this luxury apartment hotel was the tallest residential building in New York City, and the first to employ the latest skyscraper construction techniques. The hotel provided centralized meal preparation, but no individual kitchens, and therefore was not held to the height restrictions of apartment buildings. Emery Roth, the innovative architect, enlisted the help of Thomas Hastings, who had previously practiced with the late John M. Carrère, creating an Italian Renaissance–inspired facade. The building, constructed of tan brick with a limestone base, is highlighted by terracotta ornament. A series of setbacks emphasize its verticality, and it is capped by a slender obelisk.

Arthur Brisbane, a popular journalist, funded the venture, and hired the Ritz-

Carleton Company to manage the building, hoping to add cachet. Soon after opening, Brisbane was forced to sell the hotel to William Randolph Hearst. Kitchens have been added to the suites, and it is now a cooperatively owned apartment building. For many years, it housed Le Pavillion, one of America's earliest and most successful French haute cuisine restaurants, owned by the legendary Henri Soulé.

ELIZABETH ARDEN BUILDING, FORMERLY AEOLIAN BUILDING

1925–27

689–691 FIFTH AVENUE (ALSO KNOWN AS 1 EAST 54TH STREET), MANHATTAN

ARCHITECTS: WARREN & WETMORE

DESIGNATED: DECEMBER 10, 2002

Warren & Wetmore combined neoclassical elegance and French Renaissance detailing in the limestone facades of this building. The upper stories, featuring set backs, some with concave corners, are highly ornamental, with decorative bronze, carved garlands, large urns, an impressive lantern, and a copper pyramidal roof.

Commodore Charles A. Gould, a prosperous steel and iron manufacturer, commissioned this building. He died before its completion, and later his daughter took ownership. The Aeolian Co., a manufacturer of roll-operated musical instruments, made the building its headquarters in 1927. In a 1930 column, in *The New Yorker*, George S.

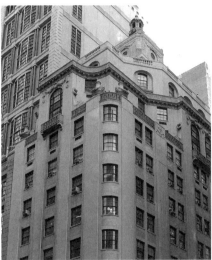
ELIZABETH ARDEN BUILDING

I. MILLER BUILDING

Chappell attributed the design of the Aeolian Building to Whitney Warren, and called it "one of his most successful achievements." In 1930, the flagship Elizabeth Arden Red Door Salon opened here. Elizabeth Arden (the professional name of Florence Nightingale Graham) emerged as one of the most successful female entrepreneurs in American history, and the Red Door Salon continues to operate here. The ground-floor space was occupied for many years by the I. Miller Shoe Store. It was later known as the home of Gucci, and is currently a shop of the European chain Zara.

I. MILLER BUILDING

REDESIGNED AND RECLAD 1926; 1978

1552–1554 BROADWAY, MANHATTAN

ARCHITECT: LOUIS H. FRIEDLAND

DESIGNATED: JUNE 29, 1999

This Times Square branch of the I. Miller shoe chain pays tribute to the theatrical profession through a series of four statues designed by the sculptor Alexander Stirling Calder. The statues portray Ethel Barrymore as Ophelia (representing drama), Marilyn Miller as Sunny (musical comedy), Rosa Ponselle as Norma (opera), and Mary Pickford as Little Lord Fauntleroy (film). The public was invited to nominate performers to become models for the sculpture. In addition, an inscription on the frieze refers to Miller's early career making footwear for the theater industry.

Louis H. Friedland redesigned and reclad two existing buildings in the modern classical style inspired by several historical periods. Executed in limestone, marble, and mosaic, the store also features an arcaded entrance and double height round-arched window openings. The I. Miller shoe store remained in this building until the early 1970s. In 1978, companies associated with the Riese family purchased the building, and a chain restaurant, owned by the family, operates in the former shoe store.

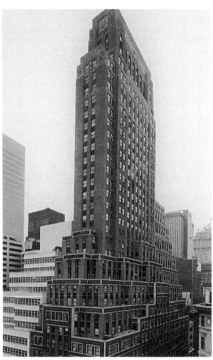

FRED F. FRENCH BUILDING

FRED F. FRENCH BUILDING

1926–27

551 FIFTH AVENUE, MANHATTAN

ARCHITECTS: H. DOUGLAS IVES AND SLOAN & ROBERTSON

DESIGNATED (EXTERIOR AND INTERIOR): MARCH 18, 1986

Located on the northeast corner of 45th Street and Fifth Avenue, the Fred F. French Building was constructed as the corporate headquarters of the prominent real estate firm of the same name. The building—once described as an exotic "business palace"—was a collaborative design by H. Douglas Ives, the French company's head architect, and Sloan & Robertson, a firm responsible for some of the most distinguished skyscrapers in New York, including the Chanin Building (p. 510) and the Graybar Building. The architects chose to work in an eclectic blend of Near Eastern, Egyptian, ancient Greek, and early Art Deco forms.

The Near Eastern allusion is enhanced by a dramatic series of setbacks. Although mandated by the building code of 1916, these wedding-cake-like tiers had a romantic corollary in the ziggurats, or step pyramids, of ancient Assyria. The building has a tripartite configuration: a three-story limestone base, a pyramidal midsection with numerous setbacks, and a rectangular tower that rises straight to the thirty-fifth floor before setting back with a triplex penthouse. The tower terminates with a water tower, elaborately masked by large faience bas-reliefs depicting a

rising sun flanked by griffins and bees— symbols, respectively, of progress, integrity, and watchfulness, and industry and thrift. On the ground floor, two entrances and fifteen commercial bays are crowned by a segmented bronze frieze whose metopes carry winged Assyrian beasts. The bronze and poly- chromatic decorative details throughout contrast to splendid effect with the limestone trim and russet-colored brick walls.

Inside, a similar Near Eastern effect is produced in the vaulted lobby and the enclosed vestibule on East 45th Street through the use of polychromatic ceil- ing ornament, decorative cornices of ancient inspiration, and elaborate wall fixtures. Most splendid of all are the twenty-five gilt-bronze doors, where inset panels of women and bearded Mesopotamian genies symbolize various aspects of commerce and industry.

The building was innovative from a technical standpoint as well, with such modern devices as an electric plumbing system, excellent lighting and ventilation systems, and, most notably, an automatic self-leveling elevator system. As one of the earliest and loftiest towers on Fifth Avenue above 42nd Street, the Fred F. French Building is important for its cre- ative response to the new building ordi- nance, its accomplished blend of linger- ing historicism and vanguard mod- ernism, and its use of architecture to establish a distinctive corporate image.

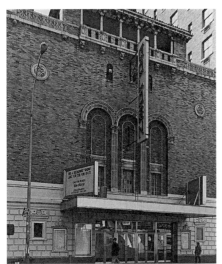

GOLDEN THEATER

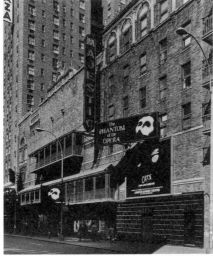

MAJESTIC THEATER

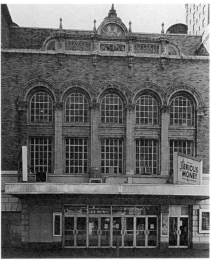

JACOBS THEATER

BERNARD B. JACOBS, MAJESTIC, AND GOLDEN THEATERS

MANHATTAN

ARCHITECT: HERBERT J. KRAPP

BERNARD B. JACOBS THEATER, FORMERLY ROYALE THEATER, 1926–27

242–250 WEST 45TH STREET

DESIGNATED (EXTERIOR AND INTERIOR): DECEMBER 15, 1987

MAJESTIC THEATER, 1926–27

245–257 WEST 44TH STREET

DESIGNATED (EXTERIOR AND INTERIOR): DECEMBER 8, 1987

GOLDEN THEATER, FORMERLY THE THEATER MASQUE, 1926–27

252–256 WEST 45TH STREET

DESIGNATED (EXTERIOR AND INTERIOR): NOVEMBER 17, 1987

Herbert J. Krapp designed the Royale Theater, the Majestic Theater, and the Golden Theater for the Chanin Construction Company as part of a complex that included the Lincoln Hotel (now the Milford Plaza). For this group, Krapp opted for a romantic and eclectic look, which he called "modern Spanish." The facades all shared a rusticated terra-cotta base with a Roman-brick wall above, and Spanish Renaissance–inspired ornamentation.

Each of the theaters was designed for a different purpose. The Royale was intended for musical comedy, it has a seating capacity of 1,200. The interior was designed by Roman Meltzer, who had once served as architect to Czar Nicholas II of Russia. The groin-vaulted ceiling is supported by arches with lunettes, which are decorated with murals by Willy Pogany entitled Lovers of Spain. Plasterwork in the style of Joseph F. Dujat outlines the major interior architectural elements. In 1937, the Royale became a broadcast studio for CBS, but three years later the Shubert Organization took over the building and converted it back to a legitimate theater. On October 10, 2004, the Royale became the Bernard B. Jacobs Theater.

The Majestic, with 1,800 seats, was the largest theater in the complex, intended for the production of musicals and revues. The highlights of the interior include a single entrance for ticket holders and the use of a stadium design, which allowed for a clear view of the stage from all seats. The lobby and auditorium are decorated with classically inspired ornament. During its heyday, the Majestic was considered one of the most desirable places to stage a show.

The Golden, originally the Theater Masque, was intended for intimate drama, seating only 800. In 1937, the theater was turned over to director and producer John Golden, who managed it for almost a decade and renamed it for himself.

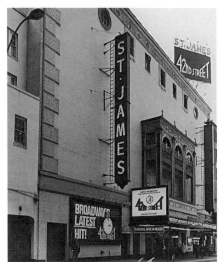
ST. JAMES THEATER

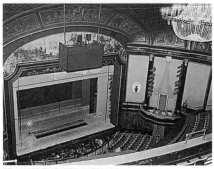
ST. JAMES THEATER INTERIOR

ST. JAMES THEATER, FORMERLY THE ERLANGER THEATER

1926–27	
246–256 WEST 44TH STREET, MANHATTAN	
ARCHITECTS: WARREN & WETMORE	
DESIGNATED (EXTERIOR AND INTERIOR): DECEMBER 15, 1987	

The St. James Theater was originally known as the Erlanger in tribute to its builder, producer Abraham Erlanger. The theater was the first designed by the

prestigious firm of Warren & Wetmore, which underscores Erlanger's determination to make the house named for him as handsome as possible.

The St. James was the last theater to be built in the two-block cluster known as Shubert Alley. The facade is done in relatively simple finished stucco with a cornice decorated by theatrical masks; the visual highlight is an elaborate wrought-iron loggia located above the main entrance.

The interior of the theater is also simple in comparison to some of its neighbors. The ornamentation, which is mainly applied to the ceiling area and the side boxes, was executed in paint rather than plasterwork. Each box is framed by fluted Corinthian columns and topped by a lunette adorned by murals. The ceiling is decorated with trompe l'oeil paintings of swags and musical instruments.

The Erlanger was renamed the St. James when it was sold in 1932, shortly after Erlanger's death. It is now owned by the Jujamcyn Corporation.

NEIL SIMON THEATER, FORMERLY THE ALVIN THEATER

1926–27	
244–254 WEST 52ND STREET, MANHATTAN	
ARCHITECT: HERBERT J. KRAPP	
DESIGNATED (EXTERIOR AND INTERIOR): AUGUST 6, 1985	

The Alvin Theater was built to stage the productions and house the offices of

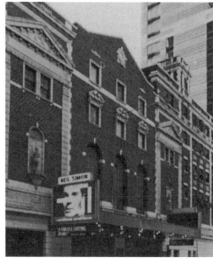
NEIL SIMON THEATER

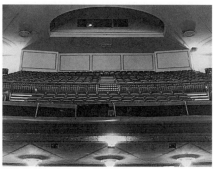
NEIL SIMON THEATER INTERIOR

producers Alex Aarons and Vinton Freedley, from whose names the acronym "Alvin" was derived. The theater opened on November 22, 1927, with George and Ira Gershwin's *Funny Face*, featuring Fred and Adele Astaire. It has since been home to countless plays and musicals.

Krapp designed a Georgian Revival facade, asymmetrically divided into two sections: a five-story auditorium section and a six-story stage section. The floors above the auditorium contain offices, and those above the stage contain dressing rooms. The red-brick facade is

highlighted by terra-cotta elements: seashell niches, urns, quoins, pediments, pilasters, panels, belt courses, and window hoods. A small, one-story tower with arched openings and a balustraded parapet rises above the roofline.

Krapp's interior is as elegant as his facade. The exquisite Adamesque plasterwork on the ceiling, boxes, and walls features sunbursts, wreaths, urns, and fluted pilasters. Characteristic of Krapp's theaters is the single balcony divided into tiers and walls that curve in toward the proscenium.

FORMER EAST RIVER SAVINGS BANK

1926–27, ADDITION 1931–32

743 AMSTERDAM AVENUE, MANHATTAN

ARCHITECTS: WALKER & GILLETTE

DESIGNATED: FEBRUARY 10, 1998

This was the first branch of the East River Savings Bank, built shortly after the State Legislature passed a law legalizing the operation of savings bank branches in 1923. Walker & Gillette planned the original building and the 1931–32 addition that doubled the Amsterdam Avenue facade. They employed the conservative classical style, widely used by banks since the nineteenth century, though their subtle design reflects the modernist influences of the time. A line of Ionic columns gives the building an imposing presence on the corner of Amsterdam Avenue and 96th Street, and it is crowned by a grand entablature and parapet.

TEACHERS INSURANCE AND ANNUITY ASSOCIATION, FORMERLY WILLIAM AND HELEN MARTIN MURPHY ZIEGLER JR. HOUSE

1926–27

116–118 EAST 55TH STREET, MANHATTAN

ARCHITECT: WILLIAM L. BOTTOMLEY

DESIGNATED: MAY 1, 2001

William L. Bottomley successfully adapted the neo-Georgian style to this unusually wide town house, which is considered one of his best urban residential works. The beautifully detailed facade of Flemish bond brickwork features a bowed-arched pediment entryway, separated from the sidewalk by a wrought-iron fence with brick pillars. The roof is a steeply pitched gray slate, with dormers, chimneys, and modillioned cornice.

William Ziegler Jr., a successful businessman and head of several organizations for the blind, and his wife, Helen Martin Murphy, lived here until William's death in 1958. The house has since been converted to office space and is owned by the Teachers Insurance and Annuity Association. TIAA-CREF offered the property, which is particularly suited for a public institution, for sale and expects it to be sold in early 2005.

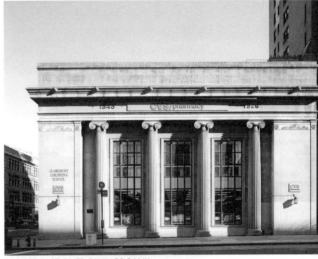

FORMER EAST RIVER SAVINGS BANK

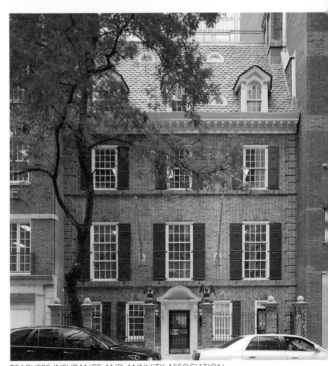

TEACHERS INSURANCE AND ANNUITY ASSOCIATION

NEW YORK LIFE INSURANCE COMPANY BUILDING

1926–27; 1994

51 MADISON AVENUE, MANHATTAN

ARCHITECT: CASS GILBERT

DESIGNATED: OCTOBER 24, 2000

As much a part of the New York Life Insurance Company identity as their logo, this building was designed to communicate corporate values and stability, and is highly recognizable on the urban skyline. A triumph for architect Cass Gilbert, it is third in a trio of skyscrapers that explore the neo-Gothic style and stepped cubic massing. This marked a general departure from historical revival-style skyscrapers that proliferated in the 1900s, and push towards Art Deco styled towers of the late 1920s. It is fully clad in stone featuring granite, round arched bays at its base and a six story pyramidal tower which caps the forty-story building.

New York Life, founded as the Nautilus Insurance Company in 1841, constructed an annex at 63 Madison Avenue in 1958–62 and continues operations in both buildings. In 1994, a major renovation project, which included the recladding of the octagonal crown with new gold-toned ceramic tiles, was carried out in preparation for the company's 150th anniversary.

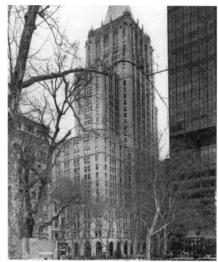

NEW YORK LIFE INSURANCE COMPANY BUILDING

UNITED WORKERS' COOPERATIVE COLONY

UNITED WORKERS' COOPERATIVE COLONY ("THE CO-OPS")

THE BRONX

DESIGNATED: JUNE 2, 1992; MID 1980S

2700–2744 BRONX PARK EAST
1926–27

ARCHITECTS: SPRINGSTEEN & GOLDHAMMER

2846–2870 BRONX PARK EAST
1927–29

ARCHITECT: HERMAN JESSOR

These two residential complexes were erected by the United Workers' Cooperative Association (a group largely comprised of idealistic Jewish immigrant garment workers) in response to the appalling living conditions that many new immigrants faced on arrival in New York. Both projects were carefully sited and planned to maximize light, air, and privacy. Inspired in part by communist teachings, the colony encouraged cooperative activity in all aspects of life and was equipped with classrooms, a library, a gymnasium, and other facilities for social interaction. The workers organized their colony so that all residents shared equally in ownership and management and were prohibited from selling apartments at a profit.

The first complex, while incorporating neo-Tudor elements—such as pointed arches and half-timbering—also reflects a political view, with hammer-and-sickle motifs, symbols of learning, and smoking factories depicted in the spandrels of several of the pointed-arch entrances. The second complex was

502

designed in an avant-garde Expressionist mode reminiscent of the progressive housing complexes that had recently been erected in northern Europe, especially in Amsterdam. Brick was used to create texture and pattern, a hallmark of the Amsterdam school of architecture.

The cooperative failed financially early in the Depression and became a rental complex in 1943. During McCarthy's "witch-hunts" of the immediate post–World War II era, all residents became suspect. By the late 1970s, almost all of the original residents were gone, and in the mid-1980s, a new owner, Allerton Associates, rehabilitated the project.

PARAMOUNT BUILDING

1926–27; 1997; 2001

1493–1501 BROADWAY, MANHATTAN

ARCHITECTS: RAPP & RAPP

DESIGNATED: NOVEMBER 1, 1988

Situated in the heart of Times Square, this brick-clad setback skyscraper originally housed the Paramount Theater and served as the eastern headquarters for the Famous Players–Lasky Corporation, the forerunner of Paramount Pictures. Brothers George and Cornelius Rapp became famous for their theater designs, which became the model for the opulent "movie palace" type of the era. George Rapp also served as consulting architect for New York's beloved Radio City Music Hall (p. 538).

Headed by Adolph Zukor and Jesse Lasky in the 1920s and 1930s, Paramount could boast a roster of stars that included Rudolph Valentino, Clara Bow, Gloria Swanson, Gary Cooper, William Powell, Mae West, and Claudette Colbert.

The Paramount Building occupies the entire 200-foot block front on the west side of Broadway between 43rd and 44th Streets and extends 207 feet on the side streets. Rising thirty-three stories, including a clock tower, it was the tallest structure north of the Woolworth Building on Broadway at the time it was built. Although the building's ornamental details are classical in style, its massing and setbacks were characteristic of the modern trend in 1920s office-building design.

Paramount Pictures, committed to creating a symbol of the company's role in the motion picture industry, added a number of aggrandizing elements. The setbacks were floodlit at each level; a globe was placed atop the clock tower to advertise the worldwide activities of Paramount; and the clock faces featured five-pointed stars, the Paramount trademark, to mark the hour. Not surprisingly, a film record of the construction was also made by the enthusiastic clients. The clocks and globe were restored in 1997 and the marquee in 2001.

PARAMOUNT BUILDING

APPLE BANK FOR SAVINGS

APPLE BANK FOR SAVINGS INTERIOR

APPLE BANK FOR SAVINGS, FORMERLY CENTRAL SAVINGS BANK

1926–28

2100–2114 BROADWAY, MANHATTAN

ARCHITECTS: YORK & SAWYER

DESIGNATED: JANUARY 28, 1975; INTERIOR DESIGNATED: DECEMBER 21, 1993

This powerful structure of gray Indiana limestone is a welcome transition from the open area at the West 72nd Street subway kiosk to the high-rise apartment houses immediately to the north. The most striking feature of the six-story elevations is the rusticated facing, which is quite heavy at the ground story but becomes lighter above the fourth-story cornice. Large, arched windows with pointed voussoirs mark the main banking hall within. A Tuscan pilastrade applied over shallow rustication and a loggia above terminate the composition. The whole is capped by a roof of Spanish clay tile. The interior is richly ornamented and dramatically lit from four sides.

An outstanding example of the academic classical architectural tradition, this interior presents an early-twentieth-century design fusion of Roman, Baroque, and High Renaissance prototypes, which are complemented by the decorative ironwork designs of Samuel Yellin. The accommodation of the great banking hall and its accessory areas to the irregular four-sided site reflects the overall Beaux-Arts organization and planning of the space. The brilliance and monumentality of the banking hall are emphasized by the skillful manipulation of scale between the low entrance sequence, the lofty banking hall, and the mezzanine loggia. Outside, the Broadway entrance vestibule and foyer are walled with simple sandstone. Inside, the banking hall is finished with rich materials and fine interior details, highlighted by the polished polychromatic marbles of the floor. The main banking room is dominated by the vast barrel-vaulted, coffered ceiling, from which hang enormous chandeliers above a central tellers' cage.

In designing the bank, the architect—probably Philip Sawyer—retained the form, but altered the proportions of an Italian Renaissance palazzo. The result is unique and highly expressive; the scale of the windows to the surrounding masonry is particularly successful. The appropriately massive wrought-iron grills and gates are also the work of Samuel Yellin. During the 1920s, York & Sawyer established themselves as specialists in bank design. In this as in their other work, the fortresslike quality projects an image of reassuring stability.

DUNBAR APARTMENTS

1926–28

WEST 149TH STREET TO WEST 150TH STREET, BETWEEN FREDERICK DOUGLASS AND ADAM CLAYTON POWELL JR. BOULEVARDS, MANHATTAN

ARCHITECT: ANDREW J. THOMAS

DESIGNATED: JULY 14, 1970

The Dunbar Apartments, named for the African American poet Paul Laurence Dunbar, was the earliest cooperative garden apartment complex in the city. The project, financed by John D. Rockefeller Jr., was immediately recognized for architectural excellence with the award in 1927 of first prize, for walk-up apartments, by the New York Chapter of the American Institute of Architects. An average room rented for $14.50 a month and attracted such famous tenants as W.E.B. Du Bois, Countee Cullen, and Bill ("Bojangles") Robinson. The complex, with a total of 511 apartments, consists of six independent U-shaped buildings clustered around a large interior garden court. The buildings alternate in height between five and six stories, with adjoining units projected and recessed. The varicolored Holland brick, decorative limestone, wrought-iron balconies, and terra-cotta roof ornament complete the decoration.

ED SULLIVAN THEATER INTERIOR, FORMERLY HAMMERSTEIN'S

1927; 1993

1697–1699 BROADWAY, MANHATTAN

ARCHITECT: HERBERT J. KRAPP

DESIGNATED: JANUARY 5, 1988

Originally named Hammerstein's, the Ed Sullivan Theater was built by Arthur Hammerstein as a monument to his father, opera impresario Oscar Hammerstein.

Herbert J. Krapp designed the theater in the Gothic style, which established

the building as architecturally unique among New York's theaters. The interior is based on a Gothic cathederal: the ceiling is vaulted, with panels bearing brightly colored heraldic designs. The theater vestibule and lobby are finished with bronze grills and imitation travertine stone. The floors are of rich marble, and stained glass panels depict scenes from Oscar Hammerstein's operas. A large organ was built for the orchestra pit. A lifesize sculpture of Oscar Hammerstein by Pompeo Coppini occupies the central foyer.

After the initial excitement of the opening, Arthur Hammerstein met with financial trouble and was forced to sell the theater in 1931. After a number of failed ownerships, the theater was converted into a casino and nightclub in 1934, and renamed Billy Rose's Music Hall, after the well-known producer of the period. In 1949, CBS converted the building into a television studio, which became the set for the Ed Sullivan Show. On December 10, 1967, the theater was renamed the Ed Sullivan, marking the first time a Broadway theater had been named for a television figure. In 1993, CBS repurchased and refurbished the theater to accommodate David Letterman's late-night television talk show.

DUNBAR APARTMENTS

ED SULLIVAN THEATER INTERIOR

THE CYCLONE

KEHILA KADOSHA JANINA SYNAGOGUE

THE CYCLONE

1927

834 SURF AVENUE AT WEST 10TH
STREET, BROOKLYN

INVENTOR: HARRY C. BAKER

ENGINEER: VERNON KEENAN

DESIGNATED: JULY 12, 1988

By the time the Cyclone was introduced to Coney Island—New York's seaside Disneyland of the early twentieth century—the amusement park entertained nearly a million visitors every Sunday afternoon. While Irving Berlin and Mae West captivated the crowds in Coney Island's theaters, many were tempted to ride this thrilling coaster, a descendant of eighteenth-century Russian ice slides.

The world's first modern roller coaster was built at Coney Island in 1884, and the ride became popular here. The Cyclone is a rare species of wooden-track, twister-type coaster (resting on a steel framework) that is irreplaceable today. The building code of the City of New York prohibits the construction of timber-supported roller coasters. The Cyclone hits a record-breaking speed of 68 miles per hour in order to maintain velocity over the course of its three thousand feet of looping, hilly track. The tremendous weight of the old-fashioned cars allows the Cyclone to reach its high speeds. A chain carries the cars to the first plunge of ninety feet, after which they travel on their own momentum over six fan turns and eight more drops. Aviator Charles Lindbergh called the ride a "greater thrill than flying an airplane at top speed."

Today the Cyclone, one of the country's premier roller coasters, stands in Astroland amusement park—the only survivor of nearly two dozen roller coasters that once could be found in Coney Island.

KEHILA KADOSHA JANINA SYNAGOGUE

1926–27

280 BROOME STREET, MANHATTAN

ARCHITECT: SYDNEY DAUB

DESIGNATED: MAY 11, 2004

"The Kehila Kadosha Janina Synagogue was constructed in 1926–27 for a small group of Romaniote Jews who had emigrated from the town of Ioannina in northwestern Greece. They had begun moving to the United States in 1905 and established a small community on New York's Lower East Side, alongside numerous other recent Jewish immigrants. Adhering to neither the Ashkenazy nor the Sephardic traditions, this group came with their own religious and social customs developed in Greece over the course of many centuries. In New York, they established their own synagogue, first meeting in rented quarters, until they were able to construct their own building. The Kehila Kadosha Janina Synagogue, designed by architect Sydney Daub, is a two-story, brick-faced structure embellished with symbolic ornament, such as Tablets of the Law, Stars of David and a cusped arch, suggestive of the middle-eastern origin of the congregation. As the only surviving Romaniote synagogue in the Western hemisphere,

Kehila Kadosha Janina continues to have an active congregation, despite its small numbers, with few members living nearby"*

BEACON THEATER INTERIOR

1927–28

2124 BROADWAY, MANHATTAN

ARCHITECT: WALTER W. AHLSCHLAGER

DESIGNATED: DECEMBER 11, 1979

The Beacon, which took its name from the airplane beacon on its roof, is one of the last grand movie palaces from the first generation of motion pictures. Earlier movie houses were simple structures, often inserted into spaces designed for a different purpose. In the 1920s, as improvements in film technology and the advent of sound attracted larger audiences, movie-house owners and film distributors began to compete with the live theater. Movie houses became more elaborate, emulating the ornate interiors of live theaters and often increasing their decorative richness beyond what conventional theater owners deemed appropriate.

In the Beacon, Walter W. Ahlschlager, a Chicago architect, combined a wide variety of classicizing motifs into an overwhelming decorative ensemble, using deliberate spatial manipulations such as the contrast between the low ceiling in the ticket lobby and the high-ceilinged rotunda beyond. This visual drama was crucial to the mer-

chandising approach of the Beacon's manager, Samuel L. Rothafel (known as "Roxy"), who felt that "the patron must begin to feel what might be called the spell of the theater before he reaches his seat." Roxy also managed the Rialto, Rivoli, and Capitol movie houses. In association with the Chanin Construction Company, Roxy elaborated movie-house programs by introducing music and dancing, novel lighting effects, hundred-piece orchestral accompaniment, and up-to-the-minute technical devices such as elaborate systems of stage elevators. All this contributed to the Beacon's enormous success and set the pattern for the grand movie palace through the 1930s.

Patrons enter the theater through an open-air ticket lobby, under multicolored, Renaissance-inspired moldings and ornate light fixtures. Inside the three-level auditorium, the proscenium arch is flanked by thirty-foot statues of armed Greek women. The ceiling simulates a brightly colored tent, while above the side wall exits are large murals that depict caravans of elephants, camels, and traders. The theater is now used for concerts.

BEACON THEATER INTERIOR

507

RKO KEITH'S FLUSHING THEATER INTERIOR

1927–28

135–29 TO 134–45 NORTHERN BOULEVARD, QUEENS

ARCHITECT: THOMAS LAMB

DESIGNATED: FEBRUARY 28, 1984

Part of the vaudeville circuit founded by B. F. Keith, later the Radio-Keith-Orpheum circuit (RKO), Keith's Flushing Theater opened in 1928 to an audience of subscription holders. Thomas Lamb, who designed hundreds of theaters, movie palaces, and auditoriums in almost every major American city, as well as in Canada, Europe, and Australia, designed the Keith's. This building is one of a handful of Lamb designs in the "atmospheric style" aimed at producing an illusion of open, outdoor spaces.

The grandeur of the 3,000-seat theater is seen not just in the auditorium, but also in the grand foyer, ticket booth hall, mezzanine promenade, and lounges. The walls of the auditorium were built up as stage sets representing a Spanish-style townscape in the "Mexican-Baroque" or so-called "Churrigueresque" style, an eighteenth-century modification of the Italian Baroque with Moorish and Gothic decorative elements. Among the Keith's elaborate "atmospheric" features are its murals, gilded wood and plasterwork, a blue ceiling with electric "stars," and a machine projecting "clouds" moving across the ceiling—completing the illusion of a Spanish outdoor garden.

RKO KEITH'S FLUSHING THEATER INTERIOR

HEARST MAGAZINE BUILDING

1927–28; 2006

951–969 EIGHTH AVENUE, MANHATTAN

ARCHITECTS: JOSEPH URBAN AND GEORGE B. POST & SONS; FOSTER AND PARTNERS

DESIGNATED: FEBRUARY 16, 1988

Planned as the centerpiece of William Randolph Hearst's Plaza, this building is the sole surviving component of a grand scheme that collapsed because of the Depression and Hearst's own speculative and extravagant real estate ventures. Hearst had moved to New York in 1895, seeking national prominence in politics. Initially he leased two floors in the Tribune Building in Printing House Square, but as other papers moved uptown, he began to envision a Midtown headquarters in the Columbus Circle area, a rapidly developing section of Manhattan close to Carnegie Hall, the

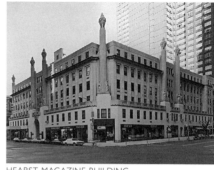

HEARST MAGAZINE BUILDING

Art Students League, and numerous art galleries that he frequented.

Encouraged by expectations for Columbus Circle's future as an extension of the theater district, Hearst, as early as 1895, purchased a small block between Columbus Circle and 56th Street. Plans for this block were abandoned in 1903 when Hearst bought a larger block immediately south. He followed this pattern of buying blocks and abandoning plans until 1921, when he finally bought the largest lot in the area "for the headquarters of his eastern enterprises." Originally intended to hold a two-story structure housing stores, offices, and an auditorium, it ultimately became the site of the International Magazine Building.

Hearst's eventually ruinous pattern of speculative real estate purchases and lack of follow-through may explain the unusual appearance of the building. It was created by noted architect and theater and stage designer Joseph Urban as a base for a projected, but never-completed, skyscraper. Hearst had been introduced to Urban by the noted impresario Florenz Ziegfeld, beginning a close association between the two lovers of spectacle. Urban's design is itself a

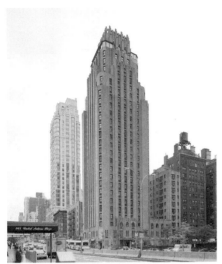
BEEKMAN TOWER HOTEL

theatrical tour de force, recalling the grandiosity of World's Fair architecture. Placed atop pylons, figures by German sculptor Henry Kreis dramatically break through a continuous second-story balustrade and are further accentuated by columns rising behind them. A 36-story addition on top of the building, designed by Lord Norman Foster and Partners, is scheduled for completion in 2006.

BEEKMAN TOWER HOTEL, FORMERLY PANHELLENIC TOWER

1927–28; ANNEX 1928–29

3 MITCHELL PLACE, MANHATTAN

ARCHITECT: JOHN MEAD HOWELLS

DESIGNATED: FEBRUARY 3, 1998

Members of national collegiate sororities were provided housing in this pioneering residential and social center, located in this prominent Art Deco tower in

Midtown. Its striking vertical design was widely published and lauded as a dramatic transition in urban skyscraper design. The twenty-six-story tower, characterized by simplified forms and dramatic massing, has chamfered corners, deeply recessed window-and-spandrel bays, and is distinguished by its orange-tan brick and bold vertical striping. At the entrances there are intricate, Gothic-inspired Art Deco style carvings by the premier architectural sculptor of the time, Rene Chambellan.

This successful enterprise, catering to the masses of college-educated women entering the work force in the 1920s, encountered financial difficulties during the Depression and men were then accepted as residents. Today the Beekman Tower Hotel is operated by the Manhattan East hotel chain, owned by the Denihan family.

130 WEST 30TH STREET

1927–28; 2003

130 WEST 30TH STREET, MANHATTAN

ARCHITECT: CASS GILBERT; CMA DESIGN STUDIO

DESIGNATED: NOVEMBER 13, 2001

This loft building is a strong example of Cass Gilbert's stylistic versatility and ability to distinguish his buildings within the streetscape. The terra-cotta ornament, imprinted with winged beasts, chariots, hunting scenes, and palm trees, is repeated around the entire building, drawing attention to the setbacks and the geometric motifs of the spandrels

130 WEST 30TH STREET

highlight the gridded composition of the central section. The stylized designs that decorate the entryway are adapted from ancient Assyrian designs. The eighteen-story building, which held space for offices, showrooms, and manufacturing use, was then referred to as the S.J.M. Building. It was constructed by M & L Hess, Inc, a real estate developer, for Salomon J. Manne, a fur trader who started in the industry as a laborer. Manne was a Polish immigrant who fought for workers' rights, who also shared part interest in a box at the Metropolitan Opera with Cass Gilbert. In 2003, the developer Henry Justin, renamed the manufacturing building the "Cass Gilbert," and divided it into 45 condominium lofts designed by Alfredo Carballude and Michele Morris of CMA Design Studio.

HELMSLEY BUILDING

HELMSLEY BUILDING, FORMERLY THE NEW YORK CENTRAL BUILDING

1927–29; 1977; 2002

230 PARK AVENUE, MANHATTAN

ARCHITECTS: WARREN & WETMORE

DESIGNATED (EXTERIOR AND INTERIOR): MARCH 31, 1987

This skyscraper counterpart to Grand Central Terminal was part of the Terminal City project, Cornelius Vanderbilt's scheme to rid Park Avenue of the exposed railroad tracks whose smoke, noise, and cinders made the neighboring real estate uninhabitable. With the electrification of the rail lines, trains could be submerged below ground and the reclaimed acreage used for revenue-producing structures. The New York Central Building was erected to house the offices of the railroad companies that used Grand Central.

The design of the building was guided by circulation requirements.

The terminal was built in the center of Park Avenue, with the Pershing Square Viaduct (p. 470) connecting the northern and southern segments of the boulevard. A system of ramps and winding one-way roads provided circulation around the terminal and through the base of this building, which includes two pedestrian walkways as well.

The New York Central Building added a distinctive accent to the skyline and provided a royal setting for the railroad barons, its lobby lavishly ornamented with industrial imagery. Harry B. Helmsley bought the building in 1977 and restored much of the its ornate splendor. In 1998, the building was sold to Richard Kalikow and, as a condition of sale, it retains the Helmsley name. In 2002, most of the gilding was removed in the restoration that renovated the pedestrian tunnels as well as the 46th Street entrance.

CHANIN BUILDING

1927–29

122 EAST 42ND STREET, MANHATTAN

ARCHITECTS: SLOAN & ROBERTSON

DESIGNATED: NOVEMBER 14, 1978

The Chanin Building was erected as the headquarters of the Chanin Construction Company, a well-known New York development firm. It is an excellent example of Art Deco architecture and was the first major skyscraper to be built in the area around Grand Central Terminal, anticipating a major shift in the business district of the city. Other

CHANIN BUILDING

notable skyscrapers such as the Chrysler and Daily News Buildings soon followed. Built in 1927–29 by the Chanin Construction Company, it was thought to be an efficient, up-to-date, progressive structure that would attract businessmen of its day.

Designed by the architectural firm of Sloan & Robertson, the Chanin Building stands at the corner of Lexington Avenue and 42nd Street. It rises fifty-six stories in a series of setbacks culminating in a tower in accordance with the 1916 building code. As was customary in skyscraper design, the architects were concerned with establishing a clearly defined base, which here is marked by terra-cotta plant forms. Major setbacks begin above the seventeenth story, forming a pyramidal base for the tower, which rises uninterrupted from the thirtieth to the fifty-second floor. The upper four stories are further recessed and accented with buttresses. The steel frame is clad with buff brick, terra-cotta, and limestone.

The lobby contains remarkably intricate detail, designed by Jacques Delamarre; he collaborated with the architectural sculptor Rene Chambellan on the design of the sculptural reliefs and bronze grills adorning the vestibules inside the building entrances. Expressing the theme of New York as "the city of opportunity," they tell the story of the success and achievements of Irwin S. Chanin, who founded the company. The Chanin Building continues to function as an office building.

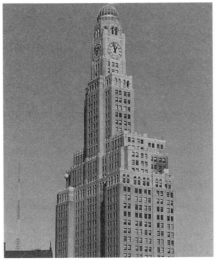
HSBC

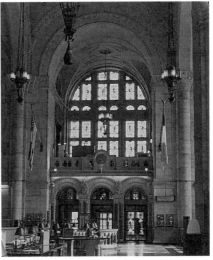
HSBC INTERIOR

HSBC, FORMERLY REPUBLIC NATIONAL BANK, ORIGINALLY WILLIAMSBURGH SAVINGS BANK

1927–29

1 HANSON PLACE, BROOKLYN

ARCHITECTS: HALSEY, MCCORMACK & HELMER

DESIGNATED: NOVEMBER 15, 1977; INTERIOR DESIGNATED: JUNE 25, 1996

Soaring more than five hundred feet above Hanson Place, the former Williamsburgh Savings Bank, with its striking silhouette and famous four-faced clock, is the most prominent feature of the Brooklyn skyline. It was the tallest building on Long Island for many years. It is situated at the intersection of the two main thoroughfares, Flatbush and Atlantic Avenues. The building is the third erected by the Williamsburgh Savings Bank—one of the oldest financial institutions in Brooklyn.

The setback and the fine ornamental details and rich carving of the lower two stories are the Byzantine building's most striking features. The base of the building is polished rainbow granite, the first floor is Indiana limestone laid up in random-coursed ashlar, and the shaft is buff-colored brick and terra-cotta, rising in a series of setbacks. The crowning gilded copper dome was intended to recall the dome of the bank's first building, at 175 Broadway in Brooklyn, designed by George B. Post (p. 203). The setbacks are accented by contrasting limestone trim, with the thirteenth and the twenty-sixth floors set off by the use of round arches and a continuous decorative terra-cotta band. Beneath the dome is the famous illuminated four-faced dial clock, one of the largest in the world.

The interior, a simple and elegant Romanesque Revival space, imagines banking as a quasi-religious act. The great banking room—112 by 73 feet, and 63 feet high—is a basilica-like, three-bay space set on a nave-and-aisles plan. The inclusion of a ladies' lounge in the original plan attested to the growing role of women as depositors in the early twentieth century. Due to the prominence given to the banking space, the elevators are located in the southeast corner, not in the center as one would expect in a skyscraper. The walls and floors of the banking room are finished in polished exotic marbles, and it is highlighted with golden mosaic vaults and enameled steel. A mosaic by the painter Angelo Magnanti depicts the stars and the signs of the zodiac with their mythological figures. On the north wall is a mosaic giving the bank a prominent place in Brooklyn's skyline, reinforcing its general prominence in the borough.

The bank has remained in continuous use and is currently operated by HSBC.

FORMER BANK OF NEW YORK & TRUST COMPANY BUILDING

1927–29

48 WALL STREET, MANHATTAN

ARCHITECT: BENJAMIN WISTAR MORRIS

DESIGNATED: OCTOBER 13, 1998

Easily recognizable in the Lower Manhattan skyline, this thirty-two story skyscraper is known for its Federal-style cupola, topped by a dramatic, bald eagle with its wings spread. The Bank of New York, established in 1784 as the first financial institution in the state (and second in the country), originally built on this site in 1796. The bank was the first financial institution to erect a head-quarters on Wall Street, helping to devel-op the area as a business district. This tower, and others built by the banking industry, played a significant part in the 1920s redevelopment of Lower Manhattan, creating a soaring district of skyscrapers that remains today.

The limestone structure has grand neo-Georgian details, including pedimented entrances accented with decorative bronze panels and double-height, arched window openings. The bank maintained headquarters here until the late 1990s, moving to 1 Wall Street after merging with the Irving Trust Bank Corporation.

FORMER BANK OF NEW YORK BUILDING

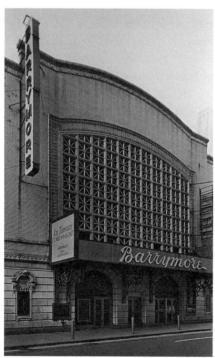

BARRYMORE THEATER

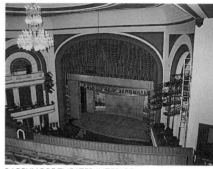

BARRYMORE THEATER INTERIOR

BARRYMORE THEATER

1928

243–251 WEST 47TH STREET, MANHATTAN

ARCHITECT: HERBERT J. KRAPP

DESIGNATED: NOVEMBER 4, 1987; INTERIOR DESIGNATED: NOVEMBER 10, 1987

The Barrymore Theater was erected to honor the Shuberts' star performer, Ethel Barrymore It is the latest of the surviving theaters built for the Shubert Organization in the Broadway district. The Shuberts were the dominant force in theatrical production and ticket sales in the country in the 1920s.

Built during the pre-Depression pros-perity, the Barrymore was a lavish and decorative theater. The facade features an enormous terra-cotta grillwork screen; at the base were two large bronze and glass canopies, which unfortunately no longer exist. The interior is designed in a mock-Elizabethan style. Raised plaster-work in a strapwork pattern, elaborate ornamental treatment of the theater boxes, and a coved ceiling with a thirty-six-foot-wide dome and cut-glass

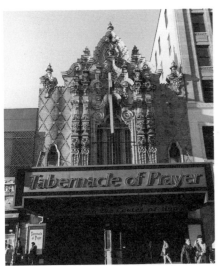

TABERNACLE OF PRAYER FOR ALL PEOPLE

chandelier are the outstanding features.

The theater opened to rave reviews—both of the architecture and the initial production, *The Kingdom of God*, starring Ethel Barrymore.

TABERNACLE OF PRAYER FOR ALL PEOPLE, FORMERLY LOEW'S VALENCIA THEATER

1928; 1977

165–11 JAMAICA AVENUE, QUEENS

ARCHITECT: JOHN EBERSON

DESIGNATED: MAY 15, 1999

The Valencia Theater was one of five "Wonder Theaters" built by the Loew's Corporation, in a venture to bring fanciful movie houses to the urban outer boroughs and Jersey City. John Eberson, who produced many influential theater designs and helped to redefine the American movie experience with the creation of the "atmospheric" theaters,

designed the elaborately decorated building. Combining Spanish and Mexican influences from the Baroque or "Churrigueresque" period, he created a patterned yellow brick and glazed terra-cotta facade that is embellished with spiral and curving forms as well as with cherubim, half-shells, floral swags, wreaths and decorative finials. In 1977, Loew's donated the theater to the Tabernacle of Prayer for All People, and the playful facade—yellow brick encrusted with elaborate terra-cotta reliefs—remains a prominent component of the community fabric.

BEAUX-ARTS INSTITUTE OF DESIGN

1928

304 EAST 44TH STREET, MANHATTAN

ARCHITECT: FREDERIC C. HIRONS OF DENNISON & HIRONS

DESIGNATED: AUGUST 23, 1988

Chartered in 1916 by the Society of Beaux-Arts Architects, the Beaux-Arts Institute of Design served as the national headquarters for architectural instruction modeled after the Ecole des Beaux-Arts in Paris. In this atelier system, where students were trained in the studio of a practicing architect, the basis of the curriculum was a series of competitions treating different design problems and increasing in difficulty as the student progressed. The institute established a nationwide standard of excellence in architectural education.

Appropriately, in 1927, when a new building was needed to meet the

BEAUX-ARTS INSTITUTE OF DESIGN

institute's growing enrollment, the board of trustees organized a competition open to all members of the institute and Society of Beaux-Arts Architects who were practicing architects. Participants included noted architects Frederic C. Hirons, Raymond Hood, Ralph Walker, Arthur Loomis Harmon, William Lamb, and Harvey Wiley Corbett.

Hirons's winning design combined modern, streamlined Art Deco elements with Beaux-Arts principles of symmetry, axial planning, use of ornament to highlight important areas in the design, and the integration of architecture and the other fine arts. Vivid polychrome terracotta spandrel plaques by noted sculptor and model-maker Rene Chambellan depict the Parthenon, St. Peter's Church, and the Ecole des Beaux-Arts, recalling the institute's classical and architectural tradition. A series of allegorical figures in the relief panels alludes to the architectural profession, and bold block lettering dramatically surmounts the double-height entrance. The Atlantic Terra-Cotta Company, then one of the largest and best-known manufacturers of terracotta in the world, executed the spandrel plaques on the facade.

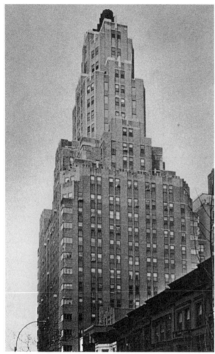

MASTER BUILDING

MASTER BUILDING

1928–29

310—312 RIVERSIDE DRIVE,
MANHATTAN

ARCHITECTS: HARVEY WILEY CORBETT
OF HELMLE, CORBETT & HARRISON
AND SUGARMAN & BERGER

DESIGNATED: DECEMBER 5, 1989

Originally designed as a combination apartment hotel and museum, this Art Deco skyscraper was commissioned by foreign exchange broker Louis L. Horch and his wife, Nettie. They were both followers and patrons of the Russian artist and mystic Nicholas Roerich, to whom the museum was dedicated. The building has always played an important cultural role in New York City, housing first the Roerich Museum, in 1929, and later the Riverside Museum; an art school, the Master Institute of United Arts; and, since 1961, the Equity Library Theater, a showcase for New York artists.

One of the tallest residential structures on Riverside Drive, the building expresses its dual function in the design of the lower two stories—fewer windows and dramatically exaggerated entrances indicate their public character. The design also incorporates significant Art Deco elements, such as patterned brickwork that varies in color from dark at the base to light at the tower, setbacks, regular and faceted massing of the upper stories, and an ornamental cap. The most distinctive features are the corner windows, derived from modern European architecture. Cited in contemporary accounts as the first use of this feature in a New York City skyscraper, they are particularly appropriate for a building with views of Riverside Park and the Hudson River.

BERESFORD APARTMENTS

1928–29

211 CENTRAL PARK WEST,
MANHATTAN

ARCHITECT: EMERY ROTH

DESIGNATED: SEPTEMBER 15, 1987

In 1929, when the Beresford was completed, Emery Roth was at the height of his career as a master of apartment house architecture. The prominently sited building, across 81st Street from the American Museum of Natural History, takes full advantage of its location with two monumental facades crowned by corner towers.

Executed in brick, with limestone and terra-cotta trim, the Beresford is distinctively ornamented with sculpture derived from late Renaissance precedents. Animating the walls are winged cherubs, angels, dolphins, rams' heads, cartouches, and rosettes. Its vast scale and dramatic profile make the Beresford one of the most important elements of the Central Park West skyline, as well as a provocative reminder of the heights speculative building could reach in Manhattan.

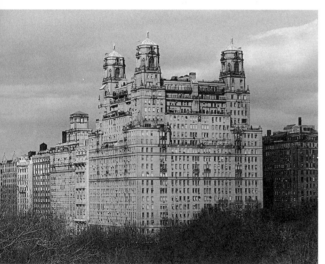

BERESFORD APARTMENTS

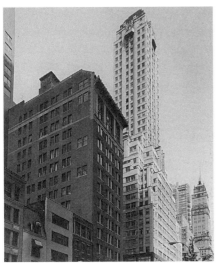

FULLER BUILDING

FULLER BUILDING

1928–29

593–599 MADISON AVENUE,
MANHATTAN

ARCHITECTS: WALKER & GILLETTE

DESIGNATED (EXTERIOR AND
INTERIOR): MARCH 18, 1986

A fine example of the Art Deco sky-scraper, the Fuller Building was built as the home office for one of the largest and most important construction firms in America. Of the many office towers erected in Midtown during the late 1920s and early 1930s, the Fuller Building was one of the first to be located as far north as 57th Street.

In an unusual arrangement respond-ing to the character of the neighbor-hood, the first six floors were designed to house high-quality shops and art gal-leries. The mixed-use is reflected in the design. Black granite cladding surrounds large display windows for retail shops,

while the office floors above are faced in light stone with smaller window open-ings. In a modernistic interpretation of classical forms, bold geometric patterns at the setbacks and at the top of the building take the place of cornices; these forms are complemented by a large sculpture over the front doors by the sculptor Elie Nadelman.

The richly decorated first-floor interi-or enhances this elegant Art Deco sky-scraper. To symbolize the client's position in the construction field, as well as this building's place in the building boom, the architects used the theme of con-struction in their design of the magnifi-cent lobby. Stylized classical motifs are joined with modernistic geometric patterns, executed in bronze and marble. On the floor of this elegant interior are promotional mosaics representing major monuments of the Fuller Company.

FILM CENTER BUILDING INTERIOR

1928–29

630 NINTH AVENUE, MANHATTAN

ARCHITECT: ELY JACQUES KAHN

INTERIOR: NOVEMBER 9, 1982

The Film Center Building's interiors are among the most colorful and inventive surviving Art Deco ensembles in New York City. Walls and ceilings are treated as woven plaster tapestries, a motif that the architect Ely Jacques Kahn used. He may have been influenced by Frank Lloyd Wright's California textile block houses, which were built in the mid-1920s; both shared an interest in

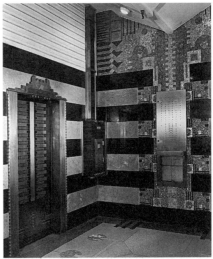

FILM CENTER BUILDING INTERIOR

Mayan architecture, which seems evident in their work.

In the outer vestibule, an ornamental plaster band runs across the ceiling and down the two side walls in a stepped, upside-down triangle articulated in low-relief panels. The lobby is beyond a sec-ond set of doors. The ceiling is animated with a geometric pattern that also con-tinues partway down the walls. The walls in this area are horizontally banded with light and dark stone; this design is repeated on the elevator doors, directory board, and mailbox. The mosaic work is particularly noteworthy.

While New York has lost most of its Art Deco interiors, the Film Center Building lobby has survived largely intact, and is one of Kahn's most splendid productions. The exterior is less exciting, although the small touches of colored terra-cotta produce a subtle coloristic effect. Although much film industry activity has now left New York, this building continues to function in its original capacity.

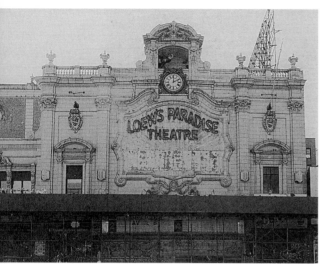

LOEW'S PARADISE THEATER

LOEW'S PARADISE THEATER

1928–29; 1973

2401–2419 GRAND CONCOURSE
(ALSO KNOWN AS 2394–2408
CRESTON AVENUE), THE BRONX

ARCHITECT: JOHN EBERSON

DESIGNATED: APRIL 15, 1997

Marcus Loew, an Austrian-Jewish immigrant who settled on Manhattan's Lower East Side, began his company in 1909 with a single theater. By 1919, Loew's was a major nationwide chain. In 1920, Loew bought Louis B. Mayer's Metro Studio, which in turn acquired Samuel Goldwyn's studio in 1924, becoming Metro-Goldwyn-Mayer (MGM). Loew's Paradise Theater exemplifies the grand and eclectically themed movie palaces of the 1920s. It was one of five Loew's theaters built concurrently outside of midtown Manhattan: the others were in Flatbush, Brooklyn; Jamaica, Queens; Jersey City, New Jersey; and East 175th Street, Manhattan.

The 4,000-seat Loew's Paradise is housed in a steel-framed structure. The facade is organized into three sections: a three-story lobby with an elaborate Italian Baroque terra-cotta frontispiece; a long, two-story section housing storefronts and office space; and a three-story stage house. The theater opened with a characteristically diverse program that included the national anthem, two musical performances, three short films, a stage presentation, and the feature-length talkie *The Mysterious Dr. Fu Manchu*; ticket prices ranged from twenty-five cents to one dollar. The interior

space has been subdivided several times since 1973, but the theater continued to show films until 1994. Since then, the theater's future use has been the topic of contentious debate.

CHRYSLER BUILDING

1928–30; 1979; 1999

405 LEXINGTON AVENUE,
MANHATTAN

ARCHITECT: WILLIAM VAN ALEN

DESIGNATED (EXTERIOR AND
INTERIOR): SEPTEMBER 12, 1978

The Chrysler Building, a stunning statement in the Art Deco style embodies the romantic essence of the New York skyscraper. Built for Walter P. Chrysler, it was "dedicated to world commerce and industry." For a few months after it was built—until the completion of the Empire State Building in 1931—the 1,046-foot structure was the tallest building in the world.

Van Alen originally designed an office building on this site for William H. Reynolds, a real estate developer and former New York state senator. Publicized as embodying the newest principles in skyscraper design, the Reynolds building was to rise sixty-seven stories (808 feet) and "to be surmounted by a glass dome, which when lighted from within, will give the effect of a great jewelled sphere."

In 1928, Chrysler, who was aggressively expanding his company and seeking to break into real estate, took over the project and lease. No corporate

funds were used to finance the project, which Chrysler said he built so that his sons would have something for which to be responsible. Work began on October 15 of that year, and construction proceeded rapidly.

During construction, Van Alen altered the original design, doing away with the "jewelled sphere" and substituting a spire, which he called a "vertex." Chrysler himself took credit for suggesting that the building be taller than the 1,024 1/2 foot Eiffel Tower; he also allegedly urged Van Alen to win the race to build the world's tallest building. It is suspected, however, that Van Alen had his own reasons for achieving this goal. His rival and former partner, H. Craig Severance, was constructing the Bank of Manhattan (40 Wall Street, p. 526) with the aim of making that the world's tallest building. Thinking that the Chrysler Building would be only 925 feet high, Severance added a 50-foot flagpole to his project, making it 927 feet. Meanwhile, Van Alen had kept secret his design for the 185–foot Chrysler spire, which was delivered to the building in five sections and clandestinely assembled on the 65th floor. In November 1929 it was finally raised into position by a 20-ton derrick through a fire tower in the center of the building, then riveted into place; the whole operation took about ninety minutes.

The 77-story building, constructed in a series of setbacks in compliance with the building code of 1916, quickly captured the popular imagination. Some observers rejected it—Lewis Mumford criticized its "inane romanticism . . .

meaningless voluptuousness, . . . [and] void symbolism." But most saw it as Eugene Clute described it in the magazine *Architectural Forum*—as an "expression of the intense activity and vibrant life of [their] day . . . teeming with the spirit of modernism."

The ornamentation of the Chrysler Building is justly famous. A procession of idealized automobiles in white and gray brick, with mudguards, hubcaps, and winged radiator caps of polished steel, spans the frieze above the twenty-sixth floor of the facade. Other levels of the building also show automobiles, eagles, acorns, and gargoyles, all made of stainless steel. The walls and floor of the lobby are patterned in multicolored marble and granite from around the world. On the ceiling, a mural by Edward Trumball depicts the building itself, airplanes of the period, and scenes from the Chrysler Corporation's factory assembly line. There are thirty passenger elevators, with doors of wood veneer on steel; the interiors are decorated with wood inlays.

The Massachusetts Mutual Life Insurance Company purchased the Chrysler Building in 1975. The company invested $23 million in beginning a renovation that was completed by Jack Kent Cooke, the cable television and sports magnate, who bought the building in 1979. Then Tishman Speyer acquired the property and completed a major restoration in 1999. Once again, the Chrysler Building is the supreme Art Deco skyscraper, an aesthetic as well as commercial beacon of progress.

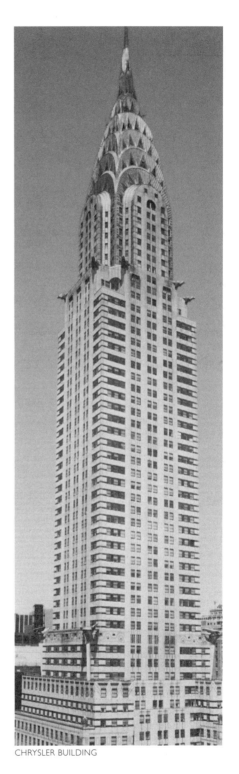

CHRYSLER BUILDING

The Riverside Church

1928–30

490–498 Riverside Drive and 81 Claremont Avenue, Manhattan

Architects: Henry C. Pelton and Allen & Collens

Designated: May 16, 2000

RIVERSIDE CHURCH

WESTERN UNION BUILDING

The skyline of Morningside Heights is marked by Riverside Church's distinctive tower, one of New York's best known religious structures. Harry C. Pelton and Allen & Colleens, the team of architects that constructed the congregation's previous building on the Upper East Side, designed the church, which was funded by its wealthy congregation, primarily John D. Rockefeller Jr. The design combines modern building techniques with French-Gothic styling, loosely based on Chartres Cathedral. Steel-frame construction, which quickened the construction pace, and gave the 392-foot tower enough strength to hold the 72-bell carillon, is concealed behind a limestone facade. Founding pastor, Henry Emerson Fosdick, was known for his modernist religious theology and, today, the congregation continues to follow his teachings.

Western Union Building

1928–30; 1983

60 Hudson Street, Manhattan

Architect: Ralph Walker, of Voorhees, Gmelin & Walker

Designated (Exterior and first floor interior): October 1, 1991

This dramatically massed Art Deco skyscraper is characteristic of a group of communications buildings designed by Ralph Walker in the late 1920s. Like New York Telephone and other affiliates of AT&T, Western Union commissioned a modernistic skyscraper to both consolidate operations and establish a corporate identity compatible with advanced technology. Because of complex technical requirements, the "Telegraph Capitol of America," which housed seventy million feet of wire and thirty miles of conduit, took two years to complete. In addition to the operating telegraph rooms, the building contained training rooms for operators, classrooms for high school study and mechanical trades, a library, and a gymnasium.

Walker's preference for brick as the material is here fully indulged in a graded color scheme. Employing nineteen shades, from a deep rose-red at the base to a light, delicate yellowish pink at the top, the curtain walls of the facades part near street level to become a series of large proscenium-like openings, with fanned, pleated forms suggesting the folds of a drawn stage curtain.

Walker's style is also evident in the striking cliffed forms of the building and its faceted, vertical treatment.

A close visual connection between exterior and interior is seen in the incorporation of a setback skyscraper shape in exterior doorway openings, a mailbox, and interior door designs. The all-brick exterior is recalled in the unusual, patterned brick corridor (which even contains a brick reception desk) that stretches between two entrance vestibules. Indirect lighting, the barrel-vaulted Guavastino tile ceiling, and corbel-arched doorways underscore the design's Expressionist aspects.

Sold in 1947, the building continued to be occupied by Western Union until 1983. The building now houses a variety of offices and firms.

TIMES SQUARE CHURCH, FORMERLY MARK HELLINGER THEATER AND THE HOLLYWOOD THEATER

1929

217–239 WEST 51ST STREET, MANHATTAN

ARCHITECT: THOMAS LAMB

DESIGNATED: JANUARY 5, 1988
INTERIOR DESIGNATED:
NOVEMBER 17, 1987

The Times Square Church, formerly the Mark Hellinger Theater, and the Hollywood Theater, was built by Warner Brothers at the advent of sound movie production. The last of the grand movie palaces constructed in Times Square in the 1910s and 1920s, the Hellinger is the only surviving theater of its type.

Designed by Thomas Lamb in a grand, opulent style, the Hellinger—and other movie palaces like it—was intended to evoke the glamour of the world's most exotic locales and to create an atmosphere of luxurious fantasy that would enhance the make-believe world of the cinema. The interior is based on Baroque church design. The grand foyer includes eight fluted Corinthian columns, gilded plasterwork, an oversized chandelier, and a ceiling mural of nymphs and clouds. The main auditorium is an extension of the foyer, also with elaborate plasterwork, murals, and chandeliers.

The exterior of the Hellinger shares no stylistic similarities with the Baroque interior; it is, instead, a reflection of the modernistic architectural trends of the period. Lamb used elements of early-twentieth-century buildings to construct a unique facade. The monumental paired sculptural figures at the entrance and the corbeling effect in the brick pattern of the facade are similar to those of Finnish architect Eliel Saarinen's Helsinki Railroad Station. The flat, projecting overhang and ribbed corbels of the western wing are reminiscent of Frank Lloyd Wright's Unity Temple in Oak Park, Illinois, plans of which were published in architectural magazines in the late 1920s.

TIMES SQUARE CHURCH

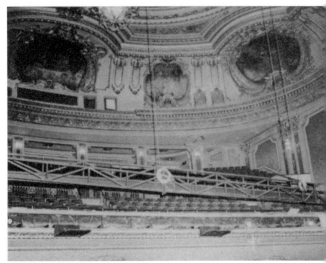

TIMES SQUARE CHURCH INTERIOR

The theater, originally named the Hollywood, opened in 1930 and was converted to a legitimate stage theater in 1934. It was renamed in 1949 in honor of the columnist, playwright, and former Warner Brothers producer, Mark Hellinger. The building no longer functions as a theater and was sold to the Times Square Church in 1991.

GREATER JAMAICA DEVELOPMENT CORPORATION, FORMERLY SUFFOLK TITLE AND GUARANTEE COMPANY BUILDING

1929

90-02–90-04 161ST STREET, QUEENS

ARCHITECT: DENNISON & HIRONS

DESIGNATED: MARCH 6, 2001

This small office building, designed with an Art Deco skyscraper treatment, makes a distinctive stylistic statement. Setbacks, purely decorative on this eight-story building, create a varied roofline that can be appreciated from the street. Rene Chambellan's colorful terra-cotta friezes, tiled above the second story and larger ones adorning the crown, add texture to the composition. Dennison & Hirons used thin vertical piers, and decorative spandrels with patterned brick designs to emphasize the height of the building.

The Suffolk Title Guarantee Company, an insurer of mortgages and bank loans, went bankrupt during the Depression, leaving the building unoccupied for many years. The building was donated to the Greater Jamaica Development Corporation in the 1980s; their offices, along with those of other not-for-profit agencies, occupy the building today.

SAN REMO APARTMENTS

1929–30

145–146 CENTRAL PARK WEST, MANHATTAN

ARCHITECT: EMERY ROTH

DESIGNATED: MARCH 31, 1987

SAN REMO APARTMENTS

One of the last grand apartment houses of the pre-Depression era, the San Remo is a distinctive feature of the Central Park West skyline. The Multiple Dwelling Act of 1929 allowed apartment houses of large ground area to rise to a greater height and permitted the use of setbacks and towers. The San Remo, the first of the vast twin-towered West Side apartment houses, was designed in response to this law.

Emery Roth had received a number of important commissions prior to World War I, but it was the prosperity of the

1920s that carried him into a period of great achievement. Developers such as the Bing Brothers and Harris H. Uris retained Roth to design medium-height structures that the architect dubbed "skyscratchers." Originally designed to conceal water towers, Roth's towers evolved into a major element of his designs.

The main block of the San Remo is seventeen stories high, with terraced setbacks from the fourteenth to seventeenth floors. Two symmetrical towers, each ten stories high, are surmounted by elaborate structures that culminate in circular temples with lanterns to give the building a dramatic profile. The building is executed in light brick, over a three-story base of rusticated limestone. The architectural detailing in stone, terra-cotta, and metal is late Italian Renaissance in character. Balustrades, pilasters, engaged columns, broken pediments, garlands, urns, cartouches, scrolls, consoles, and rondoles are all employed to highlight entrance and window configurations.

ELDORADO APARTMENTS

1929–30

300 CENTRAL PARK WEST, MANHATTAN

ARCHITECTS: MARGON & HOLDER; EMERY ROTH (CONSULTANT)

DESIGNATED: JULY 9, 1985

The northernmost of the four twin-towered apartment houses that give Central Park West its distinctive skyline, the Eldorado is one of the finest and most dramatically massed Art Deco residential buildings in the city. The form of the building, with its massive base and twin towers set at the Central Park West corners, closely resembles the massing of Roth's San Remo, which was also completed in 1930.

The Eldorado towers rise free of the base—seventeen stories, of which the bottom three are yellow cast stone—for twelve stories; each is six bays wide on Central Park West and faced with tan brick. Futuristic rocketlike pinnacles crown each tower, and an angular frieze runs above the third floor. There are stylized brick spandrel panels below many of the windows, and angular balconies with zigzag panels. The tripartite entrance on Central Park West consists of three faceted portals with bronze frames, each surmounted by a pair of ornamental plaques embossed with geometric and floral Art Deco motifs.

Construction of the Eldorado coincided with the stock market crash of 1929, which led to the collapse of the real estate market. Despite financial and labor problems, the building was completed in 1930, but the owners experienced rental problems and finally defaulted on loan payments. The Eldorado has attracted many residents of note, particularly people associated with the arts, such as Milton Avery, Richard Dreyfuss, Faye Dunaway, Carrie Fisher, Tuesday Weld, Richard Estes, Groucho Marx, and Marilyn Monroe.

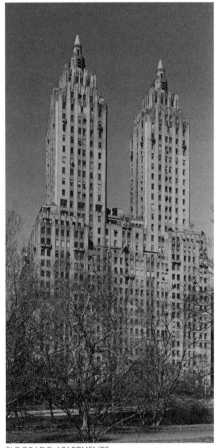

ELDORADO APARTMENTS

SOFIA APARTMENTS

SOFIA APARTMENTS, FORMERLY KENT AUTOMATIC PARKING GARAGE

1929–30; 1983–84

34–43 WEST 61ST STREET, MANHATTAN

ARCHITECTS: JARDINE, HILL & MURDOCK

DESIGNATED: APRIL 12, 1983

This impressive brick and terra-cotta building was one of two Kent Automatic Parking Garages that used a patented automatic parking system. An electrical "parking machine" engaged cars by their rear axles and towed them from the elevator platform to parking spots.

Designed by the firm of Jardine, Hill & Murdock, the Kent Automatic Parking

MUSEUM OF THE CITY OF NEW YORK

Garage is a splendid Art Deco building. The client most likely chose the style, with its implications of modernity, to indicate the innovative nature of the new parking garage within the building.

Twenty-four stories high with set-backs on the fifteenth, twenty-first, and twenty-third stories of its main Columbus Avenue facade, the building has a two-story entrance decorated with Aztec-inspired motifs in polychromatic terra-cotta. The upper stories are simply articulated with orange brickwork, black horizontal brick bands delineating the stories, and slightly projecting vertical brick piers defining the central window bays. The crenellated parapet areas of each setback, including the roof, are capped by cream and royal blue terra-cotta and cast-stone ornament, echoing the ornament of the main entrance.

The garage operated until 1943, when the Sofia Brothers Warehouse purchased the building. In 1983–84, the building was converted into co-op apartments.

MUSEUM OF THE CITY OF NEW YORK

1929–30

1220–1227 FIFTH AVENUE, MANHATTAN

ARCHITECT: JOSEPH H. FREEDLANDER

DESIGNATED: JANUARY 24, 1967

Inspired by the Musée Carnavalet, which presents the history of Paris, the Museum of the City of New York was founded in 1923. The purpose of the museum was to create a love for, and interest in, all things particular to New York. Gracie Mansion was the first home of the museum, but the organization did not flourish there. So after more $2 million was raised—from such New Yorkers as John D. Rockefeller Jr. and Edward S. Harkness—a new building was proposed on Fifth Avenue.

Joseph H. Freedlander's design for a five-story building in a modern adaptation of Georgian Colonial architecture was selected from a competition of

proposed designs. The finished building opened for inspection on December 17, 1930, and attracted a great deal of publicity. After receiving many gifts and collections, the museum opened to the public on January 11, 1932.

A short entrance walk leads up a few steps from the street to a landscaped garden forecourt. A projecting four-story facade with a four-columned Ionic portico contains the main doorway. The columns support a low-pitched pediment containing the sculpted shield of the City of New York. White marble cornerstones accent the joints between the main building and its wings. The central portico is also distinguished from the surrounding brick mass by the use of elegant, white marble facing. Bronze sculptures of Alexander Hamilton and De Witt Clinton set into niches ornament the Fifth Avenue entrance of the building.

The Museum of the City of New York is a first-rate museum of urban history and culture. It offers a wide variety of public programs, including walking tours and gallery displays of its extensive permanent collection.

NEWS BUILDING, FORMERLY DAILY NEWS BUILDING

1929–30; ADDITION, 1958	
220 EAST 42ND STREET, MANHATTAN	
ARCHITECTS: HOWELLS & HOOD; ADDITION, HARRISON & ABRAMOVITZ	
DESIGNATED: JULY 28, 1981	

Commissioned by the newspaper's founder, Captain Joseph Patterson, the Daily News Building is home to this country's first successful tabloid. Dubbed the "servant girl's Bible" by competitors, the paper's circulation passed the one million mark in 1925, making it New York's best-selling paper.

Raymond M. Hood claimed that his design for the Daily News Building was almost entirely determined by utility, but the facade is ornamented. The pattern of reddish-brown and black bricks in the horizontal spandrels evokes pre-Columbian art as well as contemporary Art Deco style. The white-brick piers echo those on earlier Gothic-style skyscrapers, such as the Woolworth Building (p. 434). Unlike the designs of these and other tall buildings—which treat the elevation in three stages corresponding to the base, shaft, and capital of a classical column—the Daily News Building rises in a sequence of monolithic slabs. The termination of each setback is abrupt, without any cornice to interrupt the soaring vertical planes. As a result, the whole appears almost weightless, especially from a distance. Henry-Russell Hitchcock and Philip Johnson admired this effect and included the building in the 1932 exhibition *The*

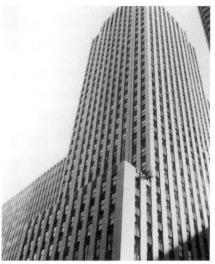

NEWS BUILDING

International Style at the Museum of Modern Art with the more radically reductivist works of European modernists like Mies van der Rohe and Walter Gropius. The main entrance is set in a limestone slab, incised in low relief and lit up at night by neon light bars on each side.

The printing annex, added by Harrison & Abramovitz in 1958, is a sympathetic response to the older building. While the original building remains in excellent condition, Harrison & Abramovitz dramatically altered the splendid chrome and faceted black glass lobby in 1958. Inside, the large, slowly revolving globe and glass dome give some idea of Hood's futuristic concept. The original Art Deco decor of the elevator lobby was replaced.

The Daily News remained a primary tenant until the company vacated the premises in 1995. Now known as the News Building, the building is owned by the realtor S.L. Green, who acquired it in 2003 for $265 million.

BEAUX-ARTS APARTMENTS

1929–30

307 AND 310 EAST 44TH STREET,
MANHATTAN

ARCHITECTS: KENNETH M.
MURCHISON AND RAYMOND HOOD
OF RAYMOND HOOD, GODLEY &
FOUILHOUX

DESIGNATED: JULY 11, 1989

In 1928, facing a scheduled move to new headquarters at 304 East 44th Street, the board of the Beaux-Arts Institute of Design formed the Beaux-Arts Development Corporation with the intention of financing, designing, building, and managing its own real estate venture, the Beaux-Arts Apartments. These apartments were intended to serve as adjuncts to the new institute, providing residential and studio accommodations for architects and artists.

Composed of some of the most prominent and well-connected architects of the day, the corporation included Raymond Hood and Kenneth Murchison. The two sixteen-story structures were among the first in New York City to reflect the horizontal emphasis of modernist European architecture and incorporate an Art Moderne convention of using industrial materials in a residential rather than commercial context—hence the bold massing, streamlined geometric metal railings, and corner windows. Originally constructed as "apartment hotels," the interiors, designed by Murchison, were fitted with such space-saving features as Murphy beds, custom-designed

BEAUX-ARTS APARTMENTS

DOWNTOWN ATHLETIC CLUB BUILDING

refrigerators, and smaller-than-standard bathroom fixtures.

The paired Beaux-Arts Apartments created a harmonious residential streetscape, even after the transformation of the Turtle Bay area by the construction of the United Nations and its many international agencies and missions.

DOWNTOWN ATHLETIC CLUB BUILDING

1929–30; 2005–

19 WEST STREET (ALSO KNOWN AS
28–32 WASHINGTON STREET),
MANHATTAN

ARCHITECT: STARRETT & VAN VLECK

DESIGNATED: NOVEMBER 14, 2000

The Downtown Athletic Club is famous as the home of the coveted Heisman Trophy, (originally called the DAC Trophy,) which is awarded to the most outstanding player of the year in college football. A boldly shaped skyscraper, this building was designed to house the activities of a prestigious athletic club for executives and lawyers, organized in 1926. The building, with its boxy silhouette punctuated by setbacks, is faced in mottled orange brick, with proscenium-like entrances at both street. The repeated chevron designs were common motifs of the Jazz Age, preoccupied with speed and energy. The constrained site dictated the need for vertical organization with each floor serving a different function, including a the first swimming pool, built above a ground-level floor.

FORMER L. P. HOLLANDER & COMPANY BUILDING

For over seventy years, the club provided athletic facilities and other services, but it encountered financial difficulties and closed after September 11, 2001. The Heisman Trophy ceremony has been moved to a hotel. AAL Realty currently owns the building and plans to convert it to condominiums.

FORMER L. P. HOLLANDER & COMPANY BUILDING

1929–30	
3 EAST 57TH STREET, MANHATTAN	
ARCHITECTS: SHREVE, LAMB & HARMON	
DESIGNATED: JUNE 17, 2003	

Set in a row of exclusive shops, the distinctive design of the Hollander store advertised its modernity, employing popular Art Deco ornamentation for its exteriors, and modern interiors, that emphasized the freshness of European

fashions for sale. Attracting pedestrians, bronze-framed display windows (now altered) housed the latest offerings. The sleek black polished granite facade contrasts with the narrow vertical stone piers and rows of embossed aluminum spandrels separating the casement windows, creating a striking image. The handling of the windows here, closely grouped, set nearly flush with the facade and separated by only spandrels as opposed to masonry, is a technique that architects Schreve, Lamb & Harmon would further develop on their famed Empire State Building.

L. P. Hollander & Company, a retailer of exclusive women's fashions, was recognized by a local community development group for the modern and attractive facade. Although the two lower stories have since been modernized, the building continues to house an upscale clothing establishment.

YESHIVA OF THE TELSHE ALUMNI, FORMERLY THE ANTHONY CAMPAGNA ESTATE

1929–30; 2006	
640 WEST 249TH STREET, THE BRONX	
ARCHITECT: DWIGHT JAMES BAUM	
DESIGNATED: NOVEMBER 16, 1993	

Built as the home of Italian-born builder and philanthropist Anthony Campagna, this twenty-eight-room Italianate villa is an example of 1920s American architectural eclecticism. Dwight James Baum was commissioned for the project because he specialized in "historical"

YESHIVA OF THE TELSHE ALUMNI

and European styles. The design suggests a Tuscan model. A rusticated limestone entrance portico is the central focus of the two-story facade, the remainder of which is faced in stucco. The frontal exposure includes an off-center stair tower and a projecting east wing. The roof is handmade Italian tile.

The mansion is surrounded with formal landscape elements. A drive, starting at the stone-and-iron entrance on West 249th Street, leads into a walled forecourt with a center fountain. The grounds have a sunken garden area, a reflecting pool, fountains, and terraces. Secluded and forested in the Riverdale section of the Bronx, the estate has views of the Hudson River and the New Jersey Palisades. Campagna lived in the house until 1941, after which it had several owners. It is currently owned by an Orthodox Jewish boarding school. The school plans to add a wing in the rear, which is expected to be completed by 2006.

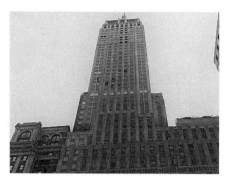

MANHATTAN COMPANY BUILDING

MANHATTAN COMPANY BUILDING

1929–30

40 WALL STREET (ALSO KNOWN AS
34–42 WALL STREET AND 25–39 PINE
STREET), MANHATTAN

ARCHITECT: H. CRAIG SEVERANCE

ASSOCIATE ARCHITECT:
YASUO MATSUI

CONSULTING ARCHITECTS:
SHREVE & LAMB

CONSULTING ENGINEERS:
MORAN & PROCTOR

BUILDERS: STARRETT BROTHERS &
EKEN

DESIGNATED: DECEMBER 12, 1995

Commissioned during the speculative
real estate boom of the 1920s and con-
structed in less than one year, this build-
ing was intended by H. Craig Severance
to be the tallest in the world. Its rival
was the Chrysler Building (p. 517),
designed by Severance's former partner,
William Van Alen. The Manhattan
Company Building soared to 927 feet,
but Van Alen's addition of a 185-foot
spire to the Chrysler Building—installed
in sections under the cover of a single

night—raised it to a total of 1,046 feet.
One year later, the 1,250–foot Empire
State Building (p. 532) exceeded both
their heights, and decisively ended the
record-setting height competition until
the World Trade Center's twin towers
were completed in 1973.

The overall massing of the Manhattan
Company Building is characteristic of
Art Deco-style skyscrapers. Consistent
with the traditions of the Financial
District, its base, which occupies almost
the entire lot, is faced with granite and
limestone and is articulated by a tradi-
tional classical colonnade. The midsec-
tion is defined by a series of setbacks as
it rises into a freestanding tower, and
spandrels with abstract Art Deco designs
separate the windows. Topped by a
seven-story, pyramidal steel roof and
spire, the structure remains a distinctive
element of the Manhattan skyline.

GENERAL ELECTRIC BUILDING, FORMERLY RCA BUILDING

1929–31; 1995

570 LEXINGTON AVENUE,
MANHATTAN

ARCHITECTS: CROSS & CROSS

DESIGNATED: JULY 9, 1985

The General Electric Building, famous
for its pinnacled tower, is one of the
monuments of the Art Deco style in
New York City. Its design, in the Gothic
mode of the style, is expressive of its
function as the headquarters of the
Radio Victor Corporation of America
(RCA), which by the late 1920s was at

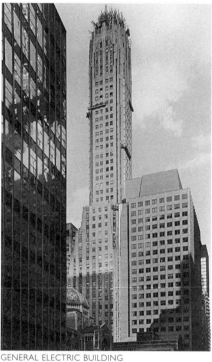

GENERAL ELECTRIC BUILDING

the forefront of the radio and communi-
cations industry.

The fifty-story building is an eight-
sided tower, articulated with piers and
recessed spandrels, rising from a base
that completely fills the relatively small
site. The symbolic signature of Cross &
Cross, in imagery tailored to RCA, is
found in the bolts and flashes that crack-
le from the surface and the monumental
allegorical deities—expressing the
power of radio—found just below the
tower's pinnacled crown of gold-glazed
tracery.

The primary material of the exterior
is orange and buff brick, which harmo-
nizes gracefully with the adjacent St.
Bartholomew's Church (p. 473). The
streamlined piers, commencing at the
base, send the eye upward. Patterns of

electrical bolts adorn the spandrels, and the buttresses, pinnacles, tracery, and repeated Gothic features are executed in a streamlined Art Deco mode.

For nearly sixty years, the building was a striking corporate symbol—as appropriate to the General Electric Company as it was to RCA. In 1995, the building was donated to Columbia University, which carried out an extensive restoration.

PARK PLAZA APARTMENTS

1929–31

1005 JEROME AVENUE, THE BRONX

ARCHITECTS: MARVIN FINE (ELEVATIONS); HORACE GINSBERG (LAYOUT)

DESIGNATED: MAY 12, 1981

The Park Plaza is one of the finest Art Deco apartment houses in the Bronx. Its designers, Marvin Fine and Horace Ginsberg, knew of and synthesized the major elements of the new skyscraper style being developed in Manhattan by Raymond M. Hood and William Van Alen, and adapted them to the low-rise apartment houses of the city's residential neighborhoods. The Park Plaza was a pioneering work, representing a major departure in scale and design from the surrounding buildings.

The eight-story building is divided into five sections, each six bays wide; the blocks are separated by recessed courtyards and connected by a continued section at the rear. Each block is defined by its window arrangement, brick patterns, small towerlike massings at the roofline, and terra-cotta banding.

PARK PLAZA APARTMENTS

The Art Deco influence is apparent in the arrangement of brick and window bays as vertical shafts and in the use of polychromatic terra-cotta friezes with geometric decorative motifs. Traces of earlier building styles include the monochrome brick and the flat surface facade—with none of the later Art Deco curved wall surfaces or polychrome brick patterns. Large terra-cotta scenes under the windows show an architect presenting a model of his building to the Parthenon, as if to ask, "What do you think?" These scenes suggest that for the architect, the final judge was still classical antiquity.

101 WILLOUGHBY STREET

1929–31

BROOKLYN

ARCHITECT: RALPH WALKER

DESIGNATED: SEPTEMBER 21, 2004

"Built in 1929-30, the Long Island Headquarters of the New York Telephone Company, is an example of architect Ralph Walker's long and productive association with the communications

101 WILLOUGHBY STREET

industry. Walker was a prominent New York architect whose expressive tall buildings, prolific writings and professional leadership made him one of the foremost representatives of his field during his lifetime. In this dramatically massed, orange brick skyscraper, Walker illustrates his exceptional ability to apply the Art Deco style to a large office tower. The structure is faced with multiple sizes of brick laid in a variety of patterns and planes to create a rich facade design. Horizontal panels of patterned brick enhance each setback leading to the central tower. At the same time, the verticality of the structure is emphasized by narrow sections of the facade that soar upward.

The location of this large, important structure in downtown Brooklyn enforced the commitment of the New York Telephone Company to the growth and advancement of the most modern telephone service to the expanding area of Brooklyn and Long Island. The building is currently owned by Verizon New York and used as a commercial space."*

21 WEST STREET BUILDING

21 West Street Building

1929–31; 1997

21 West Street (also known as 11–21 Morris Street, and 34–38 Washington Street), Manhattan

Architect: Starrett & Van Vleck

Designated: June 16, 1998

During the Jazz Age, architects attempted to convey the period's attitudes and technological developments as wholly different from anything that had come before. Forty-five new office skyscrapers were erected in New York City between 1925 and 1931, creating an urgency to gain prominence. Starrett & Van Vleck sought inspiration from North German Expressionist architects who incorporated distinctive texture and coloration into their design. Orange, tan, and purple brick, set in varying patterns that reflect light at different angles, and complimented its neighbor, the Downtown Athletic Club (p. 524), also designed by Starrett & Van Vleck. The architects responded to the 1916 Zoning Resolutions with innovative massing techniques, and undulating layers of setbacks at the very top of the building. Also notable are the recessed ground floor arcade and corner windows without piers. The building was used as a commercial space for many years, before being bought in 1997 by Rose Associates, Inc., and converted to apartments.

Bank of New York, formerly Irving Trust Company

1929–31

1 Wall Street (also known as 70–80 Broadway, and 1–11 New Street), Manhattan

Architect: Voorhees, Gmelin & Walker

Designated: March 6, 2001

Irving Bank, named after the author and diplomat Washington Irving, was founded in 1851, serving Washington Market's farmers and vendors. The bank, now known as Irving Trust, having grown through series of mergers sought to construct its own Wall Street headquarters.

On one of Manhattan's Art Deco masterpieces, Ralph Walker achieved a design that stood out on the increasingly populated skyline, and created a strong corporate symbol for the bank. The imposing verticality emphasized by fluted wall surfaces, tapers to a slim tower topped by a faceted roofline. Thinly scored ornamental designs and concavely faceted windows are layered on top of smooth limestone facades, combining to create a masterful composition, an unbroken whole rarely achieved in skyscraper design.

In 1988, the Bank of New York acquired Irving Trust, and the larger corporation remains in the building at 1 Wall Street.

BANK OF NEW YORK

HERMAN RIDDER JUNIOR HIGH SCHOOL

1929–31

1619 BOSTON POST ROAD, THE BRONX

ARCHITECT: WALTER C. MARTIN

DESIGNATED: DECEMBER 11, 1990

The 1920s saw dramatic changes in the design of American school buildings as the popularity of the Collegiate Gothic style declined and the specialization and standardization of classroom design increased. The result of a 1927 initiative to erect facilities specifically designed for junior high school programs, Herman Ridder Junior High School, named for the prominent newspaper publisher and philanthropist, is the first Art Deco public school building in New York. It was also the first junior high school to recognize the need for specialized classrooms and equipment for academic, industrial, athletic, and music curricula.

American school-building designers, seeking an efficient, modern aesthetic, turned to industrial and commercial buildings for inspiration—and to the machine. The design for Herman Ridder follows the Machine Age concept, suggesting—through its structural emphasis, the pier and window treatment, and the entrance tower—an industrial or commercial building. The square tower is modeled after a setback skyscraper and displays a sculptural program of academic iconography, with terra-cotta panels express allegories of the ideals of knowledge, music, and art.

NEW YORK COUNTY LAWYERS' ASSOCIATION BUILDING

1930

14 VESEY STREET, MANHATTAN

ARCHITECT: CASS GILBERT

DESIGNATED: NOVEMBER 23, 1965

The New York County Lawyers' Association Building is one of the lesser-known works of Cass Gilbert. The "Home of Law," this Georgian Revival building was built on land acquired from the Astor family.

The symmetry and bas-relief ornament of the front facade lend an imposing quality to the four-story structure. Above the smooth ashlar masonry base are five bays decorated by panels that incorporate garlands and classical figures. These bays are separated by pilasters with flattened capitals. The fourth story roof deck and attic are surrounded by a cornice crowned with a balustrade. Due to its proximity to the World Trade Center site, the building was temporarily closed for several months, but it was not damaged.

HERMAN RIDDER JUNIOR HIGH SCHOOL

NEW YORK COUNTY LAWYERS' ASSOCIATION BUILDING

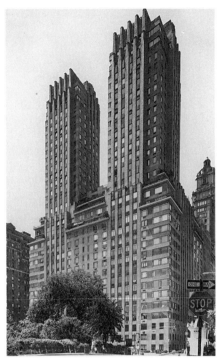

MAJESTIC APARTMENTS

MAJESTIC APARTMENTS

1930–31

115 CENTRAL PARK WEST, MANHATTAN

ARCHITECT: IRWIN S. CHANIN OF CHANIN CONSTRUCTION COMPANY

DESIGNATED: MARCH 8, 1988

In the mid-nineteenth century, Central Park West was a rural outpost of run-down shanties and wandering goats. With the creation of Central Park and improvements in mass transportation, the Upper West Side experienced a period of major development, but real estate prices on Central Park West rose to such heights that speculators were deterred from investing. Even in the 1890s more than half the blockfronts along the park from 60th to 96th streets were vacant or contained modest frame houses.

The prosperity of the 1920s brought to Central Park West an influx of aspiring Jewish immigrants, who, from their modest beginnings in the tenements of the Lower East Side or the cramped apartments of the other boroughs, viewed the Upper West Side as a cultural and architectural haven. By the mid-1930s, more than half of the residents of the Upper West Side were Jewish, and more than one-third of these families were headed by a parent born in Europe. Architect Irwin Chanin, born in Bensonhurst, Brooklyn, was himself the son of Ukrainian Jewish immigrants, a Cooper Union graduate, and an Upper West Sider who developed a real estate and construction empire.

At thirty-one stories, the Majestic

Apartments building reflects the 1929 regulations permitting taller residential buildings with setbacks and towers. Although this is Chanin's first Art Deco residential design (he considered it "experimental"), the building is a sophisticated rendering of the later Art Deco style, eschewing elaborate decoration and relying on profile, tower terminations, and the interplay of vertical and horizontal elements for its impact.

CENTURY APARTMENTS

1930–31

25 CENTRAL PARK WEST, MANHATTAN

ARCHITECT: IRWIN S. CHANIN OF CHANIN CONSTRUCTION COMPANY

DESIGNATED: JULY 9, 1985

The Century Apartments, between 62nd and 63rd Streets, is one of four twin-towered apartment houses built along Central Park West between 1929 and 1931. Together these give the avenue its distinctive silhouette. Irwin S. Chanin of the Chanin Construction Company developed two of them: the Century, and the Majestic at 71st Street.

Known as Eighth Avenue until 1880, Central Park West was first developed as a residential area after the building of Central Park; larger apartment houses were erected on the avenue, and row houses on the side streets. Building stopped around 1910. The second generation of Upper West Side apartments was erected in the 1920s; by 1931, the Depression had ended this boom. The Century was the last grand

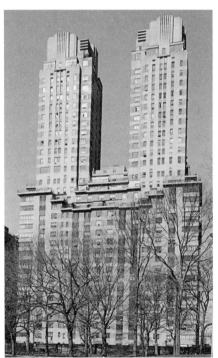

CENTURY APARTMENTS

apartment house built.

In 1925, Chanin visited the Paris Exposition Internationale des Arts Décoratifs et Industriels Moderns—where the Art Deco style had its first major unveiling. On his return, he became one of the first American architects to apply the design sensibility espoused at the Exposition. The earliest Art Deco buildings by Chanin were commercial skyscrapers; the style was applied to apartment towers late in the 1920s. The Century was among the first.

The thirty-story building shows a complex balance of horizontal and vertical elements. The horizontal banding of tan and light brown brick, the long corner windows, and the cantilevered balconies contrast with the vertically articulated bowed window bays in the towers. The sparse exterior ornament is used to highlight major points of emphasis in the design, such as the entrance, setbacks, and crowns.

FORMER LYCÉE FRANÇAIS DE NEW YORK, ORIGINALLY THE MRS. GRAHAM FAIR VANDERBILT HOUSE

1930–31; 2003

60 EAST 93RD STREET, MANHATTAN

ARCHITECT: JOHN RUSSELL POPE

DESIGNATED: JUNE 12, 1968

Designed in the manner of Louis XV, the building at 60 East 93rd Street is reminiscent of the maisons particulières at Versailles. Designed by John Russell Pope, the house is built entirely of finely detailed stone and is completely symmetrical except for the arched doorway, finished in rustic style and set back at the right side of the house. Details to note include the three high French windows crowned by keystones, each bearing the face of a different woman.

Virginïa Graham Fair Vanderbilt, the former wife of William K. Vanderbilt, Jr., occupied the house for a number of years before selling it in the late 1940s to Mrs. Byron C. Foy, née Thelma Chrysler. For a time, it served as the Romanian Permanent Mission to the United Nations, and was later used as a school by the Lycée Français de New York until 2003. The building is now owned by the English antiques dealer Carleton Hobbs.

60 EAST 93RD STREET

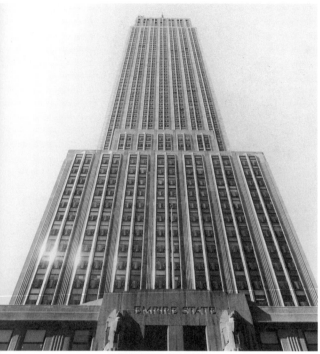

EMPIRE STATE BUILDING

EMPIRE STATE BUILDING INTERIOR

EMPIRE STATE BUILDING

1930–31

350 FIFTH AVENUE, MANHATTAN

ARCHITECTS: SHREVE, LAMB & HARMON

DESIGNATED (EXTERIOR AND INTERIOR): MAY 19, 1981

Its name, its profile, and the view from its summit are familiar around the world. The final, and most celebrated product, of the skyscraper frenzy, the Empire State Building was completed in 1931 on the former site of the Waldorf-Astoria Hotel; it marked the transformation of midtown from an affluent residential area into the commercial center of the metropolis. Its design, engineering, and construction were remarkable accomplishments. Although it was in many ways shaped by constraints of time, cost, and structure, the Empire State Building is the finest work of architect William Lamb, designer for Shreve, Lamb & Harmon.

At 1,250 feet, the Empire State Building was the world's tallest tower until 1973 when the World Trade Center was erected. The Empire State was planned by John J. Raskob, multimillionaire executive of General Motors, as a speculative office building. Unlike the Woolworth Building or the Chrysler Building, it was not meant to symbolize one man or one company, but simply to be a conglomerate of rentable commercial spaces. Raskob named Al Smith, four-time governor of New York State, as president of the Empire State Company —an appointment that aroused extensive journalistic attention. The race to build the world's tallest structure had become somewhat of a publicity stunt in itself by the late 1920s, and the aggressive campaign created further sensation with the announcement that the mast atop the tower would be used as a mooring for dirigibles.

By the 1920s, commercial architecture was being shaped largely by economic and engineering considerations. The aim was to have the maximum amount of rentable space. The spareness and economy of design of the Empire State Building reflected this new practicality. Its eighty-six-story elevation (the tower and mast add another fourteen) is organized around a series of setbacks whose general massing was determined by the elevator system. The exterior facade is covered in limestone, granite, aluminum, and nickel, with a minimum of Art Deco ornament.

The lobby, entrance halls, and elevator concourses are covered in restrained gray and red marble, heightened by bright metal and simply decorated silver ceilings. At the end of the main entrance hall on Fifth Avenue, an aluminum image of the Empire State Building with a rising sun behind it is superimposed on a map of New York State.

The Empire State Building is immensely imposing, epitomizing the enormous surge of skyscraper construction in New York City in the early part of the twentieth century. For much of the world, the Empire State Building remains the quintessential skyscraper.

STARRETT-LEHIGH BUILDING

1930–31

601–625 WEST 26TH STREET,
MANHATTAN

ARCHITECTS: RUSSELL G. AND WALTER
M. CORY

ASSOCIATE ARCHITECT:
YASUO MATSUI

CONSULTING ENGINEERS:
PURDY & HENDERSON

DESIGNATED: OCTOBER 7, 1986

STARRETT-LEHIGH BUILDING

The Starrett-Lehigh is a massive factory building that occupies the entire block bounded by 26th and 27th Streets and Eleventh and Twelfth Avenues. A cooperative venture of the Starrett Investing Corporation and the Lehigh Valley Railroad, the building originally served as a freight terminal for the railroad, with manufacturing and warehouse space above.

The Starrett-Lehigh Building is considered New York's great monument of Modernism. A structurally complex feat of engineering with an innovative interior arrangement, the nineteen-story building is most notable for its exterior design of horizontal ribbon windows alternating with brick and concrete spandrels. An irregular open framing system of steel columns and girders was used on the ground floor to accommodate curving railroad spurs and loading docks for trucks. Above the mezzanine level, the framing system consists of a regular arrangement of concrete mushroom columns carrying concrete floor slabs; these slabs are cantilevered beyond the outer columns, creating largely

unobstructed spaces. Direct access was provided to each floor by truck elevators that exit to loading platforms. The specially designed, multipane steel sash windows provide maximum sunlight.

The railroad ended its association with the building in 1944, following the decline of freight railroads in the Northeast. The building continues to be used for warehousing, manufacturing, and office space.

533

GROUP HEALTH INSURANCE BUILDING

GROUP HEALTH INSURANCE BUILDING, FORMERLY THE McGRAW-HILL BUILDING

1930–31

330 WEST 42ND STREET, MANHATTAN

ARCHITECTS: HOOD, GODLEY & FOUILHOUX

DESIGNATED: SEPTEMBER 11, 1979

Sometimes affectionately referred to as the "jolly green giant," the McGraw-Hill Building is one of New York's great modern buildings, and one of the very few structures in the city to have been included in Henry-Russell Hitchcock and Philip Johnson's 1932 exhibition *The International Style* at the Museum of Modern Art.

McGraw-Hill, the huge publishing company, decided to build its headquarters on 42nd Street west of Eighth Avenue partly in the hope of seeing land values rise there and partly out of the need to be in a neighborhood zoned for industrial use. Skyscrapers never caught on in the neighborhood, and the green tower has commanded the skyline of the West Forties virtually alone for most of the building's life.

Raymond M. Hood designed the building with numerous setbacks on the north and south sides. From the east and west, the setbacks produce a stepped tower profile, but from the north and south they are invisible, creating the illusion that the building is a slab. Each story has a horizontal band of windows that look like "ribbon windows," but which are actually composed of seven sets of four double-hung windows each,

separated by painted metal strips. The window bands are separated by continuous courses of blue-green terra-cotta blocks, the varying size and tone of which produce a somewhat shimmering effect.

The color of the terra-cotta sheathing was completely without precedent. The shade finally selected was said to be John Herbert McGraw's own choice. Above the thirty-fourth-story windows are eleven-foot-high terra-cotta letters spelling out the name McGraw-Hill. The top two stories have horizontal ribs that form a distinctive pylonlike crown.

Apparently, Hood had no intention of designing a modern building. His emphasis on the practical, on utility and function, worked well given the building code of 1916 that applied to setbacks and towers on broad bases; the resulting masterpiece combines two separate profiles—one a graceful Art Deco tower and the other an International Style slab. Indeed, the building is a blend of Art Deco and the International Style, a transitional step between two approaches to architectural design.

McGraw-Hill moved to new headquarters at Rockefeller Center in 1970. The building was empty for four years, before being taken over by Group Health Insurance in 1974. It was, for five years, the location of the New York Landmarks Conservancy offices.

STATEN ISLAND FAMILY COURTHOUSE

STATEN ISLAND FAMILY COURTHOUSE, ORIGINALLY STATEN ISLAND CHILDREN'S COURTHOUSE

1930–31

100 RICHMOND TERRACE, STATEN ISLAND

ARCHITECTS: SIBLEY & FETHERSTON

DESIGNATED: JANUARY 30, 2001

A handsome neoclassical building, prominently sited atop a hill, the courthouse sits within the harmonious ensemble of buildings that create the impressive civic center of Staten Island in St. George. The City Beautiful Movement, espousing unity of governmental buildings, was encouraged in Staten Island. The borough's first president, George Cromwell, and architect John Carrère, created a master plan for the civic center at St. George; each building would be freestanding and, while unique, would be consistent with the forms of the classical revival style.

Sibley & Fetherston abided by Carrère's guidelines, creating a restrained neoclassical Georgian facade in terra-cotta made to look like limestone. The pedimented Ionic portico,

rusticated quoins, and pedimented window surrounds define the Children's Courthouse as a separate unit within the whole.

Built during a rush of courthouse construction, which occurred in a push to decentralize the city court system during the 1920s and 1930s, this courthouse was established to hear spousal and child support cases. Today it is the only family courthouse still in use in the city, and the building fabric is largely intact.

CITY BANK-FARMERS TRUST COMPANY BUILDING

1930–31

20 EXCHANGE PLACE (ALSO KNOWN AS 14–28 EXCHANGE PLACE, 61–75 BEAVER STREET, 6 HANOVER STREET, AND 16–26 WILLIAM STREET), MANHATTAN

ARCHITECTS: CROSS & CROSS

DESIGNATED: JUNE 25, 1996

This building was built as the new headquarters for City Bank-Farmers Trust Company, the predecessor of Citibank. The bank had been formed by a merger of Farmers Loan and Trust Company and National City Bank. The latter had been the largest bank in the country since 1894, as well as the first bank to offer interest on savings accounts. The building was one of several skyscrapers intended to secure the title of "world's tallest building" during the early 1930s. When it was completed in 1931, however, the sixty-story structure achieved

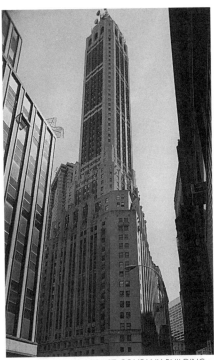

CITY BANK-FARMERS TRUST COMPANY BUILDING

only the uncertain distinction of being the tallest building with a predominantly stone facade.

Despite its massive base, the building achieves a vertical emphasis with two elements: widely spaced piers that rise to freestanding, stylized heroic figures believed to represent the "giants of finance," and a square tower that emerges at an angle slightly shifted from the base. Stylized coins, representing the countries in which City Bank had offices, surround the round-arched main entry on Exchange Place. The building lacks the profusion of Art Deco ornamentation characteristic of the period. Instead, the classic modern design emphasizes silhouettes, and the fine quality of the materials and ornaments.

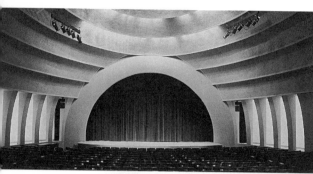

NEW SCHOOL UNIVERSITY AUDITORIUM

NEW YORK CITY POLICE DEPARTMENT

NEW SCHOOL UNIVERSITY, FORMERLY NEW SCHOOL FOR SOCIAL RESEARCH, FIRST FLOOR INTERIOR

1930–31; RESTORATION, 1992

66 WEST 12TH STREET (ALSO KNOWN AS 66–70 WEST 12TH STREET), MANHATTAN

ARCHITECTS: JOSEPH URBAN; RESTORATION, PRENTICE, CHAN & OHLHAUSEN

DESIGNATED: JUNE 3, 1997

The New School for Social Research was founded in 1919 by a group of academics that included Charles Beard, John Dewey, James Harvey Robinson, and Thorstein Veblen. Beard and Robinson had resigned from the faculty of Columbia University to protest the school's ban on antiwar demonstrations on the eve of World War I. The New School was designed to provide expanded learning opportunities for adults, and since its founding has been an important part of the intellectual life of New York City. In the 1930s and 1940s, the New School's "University in Exile" program provided employment for more than 150 European scholars who had fled the Nazis.

In 1928, the New School acquired four lots on West 12th Street and commissioned Joseph Urban, an architect born and trained in Vienna, to design a structure that would reflect the progressive ideals of the school. The seven-story brick-and-glass building, characterized by spare, simple forms and geometric patterns, was the first example of the International Style of architecture built in New York City. The first-floor interior houses a dramatic yet intimate auditorium. The oval plan of the room, as well as the color scheme of gray tones accented with red, give the space a sense of warmth and unity. At the center of the rounded ceiling is a flat, oval panel, from which a series of concentric rings made of perforated plaster fan outward. This configuration, intended to improve acoustics, influenced the design of Radio City Music Hall, which was built in 1932. In the lobby, graceful curves and hard, sleek materials such as polished stone and bronze complement the softer forms and materials of the auditorium.

The auditorium was restored in 1992 and has since been named the John L. Tishman Auditorium. It provides an impressive setting for New School lectures, seminars, symposiums, film screenings, and theatrical productions.

NEW YORK CITY POLICE DEPARTMENT, FORMERLY SUNSET PARK COURT HOUSE

1930–31

4201 FOURTH AVENUE, BROOKLYN

ARCHITECT: MORTIMER DICKERSON METCALFE

DESIGNATED: JUNE 26, 2001

This former courthouse is a remarkable neoclassical building, one of the few historic municipal buildings remaining in Sunset Park. Built during a period of judicial expansion, many small, local courts were formed. It is one of only two known buildings in New York City

designed by Mortimer D. Metcalfe during his service as New York State Deputy Architect under Franklin B. Ware. The elegant porticos on each facade compliment the well-balanced limestone building, detailed with Ionic columns, pediments, and quoins, creating a pleasing neoclassical structure. Few exterior alterations have been made to the building, which now serves the New York City Police Department.

SWISS CENTER, FORMERLY THE GOELET BUILDING

1930–32

606–608 FIFTH AVENUE, MANHATTAN

ARCHITECT: VICTOR L. S. HAFNER; ENGINEER: EDWARD HALL FAILE

DESIGNATED (EXTERIOR AND FIRST FLOOR INTERIOR): JANUARY 14, 1992

Upon learning of the proposed development of Rockefeller Center, financial expert Robert Goelet decided to demolish his gracious home, which stood adjacent to the Rockefeller property, and erect a retail and office building in its place. Goelet insisted that the new commercial structure be as elegant and architecturally worthy as the mansion it replaced.

Goelet, a cofounder of the the Chemical Bank, was determined to offset the exorbitant real estate taxes by maximizing his building's profit. Since retail stores were more lucrative than office space, he stipulated that the plate-glass windows be as expansive as possible.

SWISS CENTER

At the time the building was being designed, the show-window space was worth $3,000 a foot. To meet this exacting requirement, the engineer devised a cantilevered, third-story platform to support the eight stories of office space above; he was thus able to conceal all supporting columns and provide uninterrupted show-window frontage.

It fell to the architect Victor Hafner to give this remarkable skeletal frame aesthetic distinction. To complement a design reflective of the transition between Art Deco and the International Style, he chose a polychromatic scheme using two contrasting marbles—deep-green antique and white Dover cream. The colors and patterns distinguish the functions; the first two floors are faced with green marble, and eight horizontal bands of cream-colored marble distinguish the upper stories devoted to office space. Hafner's decorative flourishes include corbels with stylized Art Deco elements and an elegantly fluted, bronzed-aluminum frieze.

SWISS CENTER INTERIOR

The entrance vestibule, outer lobby, and elevators all bear further witness to Hafner's discriminating use of color and his careful attention to the moods and uses of lobby space. The dark entrance vestibule—its walls are made of thinly veined black marble—was designed to suggest a transition between the frenzied pace of Fifth Avenue and the stately, serene interior. The illumination of the vestibule is dramatic: electric light glows through four vertical aluminum grills punctuated by stylized flowers and leaves. By way of contrast, the center of the outer lobby is designed with bands of variously colored marble that visually direct the visitor around and back to the elevator lobby. No surface left unfinished, each pair of elevator doors bears an octagonal medallion portraying two maidens, each attended by a gazelle, who part as the doors open. The structure stands little altered today—an enduring monument to one man's demanding aesthetic and pragmatic vision.

ROCKEFELLER CENTER

MANHATTAN

ARCHITECTS: HOOD, GODLEY & FOUILHOUX; CORBETT, HARRISON & MACMURRAY; REINHARD & HOFMEISTER; CARSON & LUNDIN

DESIGNATED (EXTERIOR OF ENTIRE COMPLEX): APRIL 23, 1985

RADIO CITY MUSIC HALL, 1931–32

1260 AVENUE OF THE AMERICAS

INTERIOR DESIGNATED: MARCH 28, 1978

RCA BUILDING, 1931–33

30 ROCKEFELLER PLAZA

INTERIOR (GROUND FLOOR) DESIGNATED: APRIL 23, 1985

1270 AVENUE OF THE AMERICAS, FORMERLY THE RKO BUILDING, 1931–33

PROMENADE AND CHANNEL GARDENS, 1931–34

SUNKEN PLAZA WITH SKATING RINK AND STATUE OF PROMETHEUS 1931–34

BRITISH BUILDING, FORMERLY THE BRITISH EMPIRE BUILDING, 1932–33

620 FIFTH AVENUE

RCA BUILDING WEST, 1932–33

1250 AVENUE OF THE AMERICAS

MAISON FRANÇAISE, 1933

610 FIFTH AVENUE

INTERNATIONAL BUILDING, INCLUDING STATUE OF ATLAS IN COURTYARD, 1933–34

630 FIFTH AVENUE

INTERIOR (GROUND FLOOR) DESIGNATED: APRIL 23, 1985

1 ROCKEFELLER PLAZA BUILDING, FORMERLY THE TIME & LIFE BUILDING, 1936–37

ASSOCIATED PRESS BUILDING, 1938

50 ROCKEFELLER PLAZA

10 ROCKEFELLER PLAZA BUILDING, FORMERLY THE EASTERN AIRLINES BUILDING, 1939

SIMON & SCHUSTER BUILDING, INCLUDING ADDITION, FORMERLY THE U.S. RUBBER COMPANY, 1939, 1954–55

1230 AVENUE OF THE AMERICAS

INTERIOR (GROUND FLOOR) DESIGNATED: APRIL 23, 1985

WARNER COMMUNICATIONS BUILDING, FORMERLY THE ESSO BUILDING, 1946–47

75 ROCKEFELLER PLAZA

Rockefeller Center is the single greatest civic gesture of twentieth-century New York architecture. Its unprecedented scope, visionary plan, and brilliant integration of art and architecture have never been equaled. Initiated as a project to create a new home for the Metropolitan Opera Company, it was completed as an exclusively commercial project by John D. Rockefeller Jr. after the stock market crash of 1929 forced the opera's withdrawal. Throughout the Depression, the construction of Rockefeller Center provided jobs for hundreds of laborers in the building industries.

The complex originally extended just over three full city blocks, from 48th to 51st Streets between Fifth and Sixth Avenues. Within this area, three major axes define the circulation patterns. The first is along Fifth Avenue, and the second is the Promenade and Channel Gardens that run east to west from Fifth Avenue to Rockefeller Plaza. This planted alley slopes gently downhill to culminate in the Sunken Plaza with the statue of Prometheus. The intersection of these two axes forms the main facade of the complex and interacts with neighboring buildings to create a notably human-scaled space; the focus at one end is on the RCA Building and at the other on St. Patrick's Cathedral. The third important axis is Rockefeller Plaza, a private north-south street that was one of the first attempts (and the only successful one) to circumvent the grid system.

Rockefeller Plaza intersects the center at midblock, providing functional access to the buildings at the heart of the complex. Minor axes run along 49th and 50th Streets and define the perimeter of Rockefeller Center at 48th and 51st Streets and the Avenue of the Americas.

Rockefeller Center is asymmetrical. Its buildings were designed to conform to the needs of the original tenants. Yet the control of materials and stylistic expression ensured that even the most recent additions bear some contextual resemblance to the rest of the complex. This was Raymond M. Hood's triumph, a vindication of his belief in an expressive modern aesthetic that did not refer to styles of the past. The refinement of the slab style of skyscraper hinted at in his American Radiator and McGraw-Hill Buildings. The structures are all sheathed in limestone with aluminum trim.

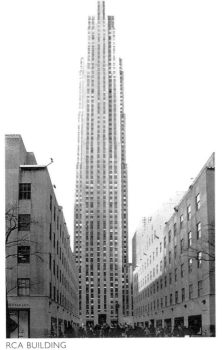

RCA BUILDING

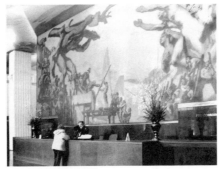

RCA BUILDING LOBBY

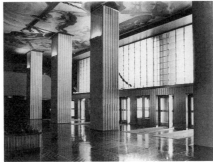

RCA BUILDING GROUND FLOOR

WARNER COMMUNICATIONS BUILDING

RADIO CITY MUSIC HALL

PROMENADE AND CHANNEL GARDENS

INTERNATIONAL BUILDING LOBBY

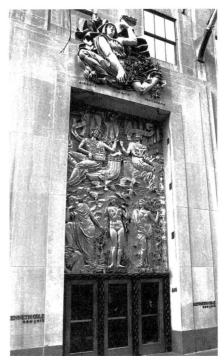

MAISON FRANÇAISE

539

The windows are grouped vertically in slightly recessed strips that emphasize the soaring quality of even the lowest building in the group. On the RCA Building, this soaring quality was enhanced by an elaborate series of setbacks and terraces, which allowed the building to conform to zoning regulations while giving it a profile distinct from those of its more Baroque contemporaries.

The architecture and the public spaces of Rockefeller Center are further enhanced by the works of art that were incorporated from the start. The statues of Atlas at the International Building and Prometheus in the Sunken Plaza, the tympanum panel of Wisdom at 30 Rockefeller Plaza, and the sculptural elements that terminate the vertical stone piers at the bases all combine to animate the exteriors of what might otherwise be austere compositions.

162–24 JAMAICA AVENUE, FORMERLY J. KURTZ & SONS STORE BUILDING

1931

QUEENS

ARCHITECTS: ALLMENDINGER & SCHLENDORF

DESIGNATED: NOVEMBER 24, 1981

The old Kurtz Store is a striking Art Deco–style commercial building in downtown Jamaica, Queens. It was erected in 1931 as a retail store for the furniture chain of J. Kurtz & Sons, which occupied it until 1978. The company commissioned Allmendinger &

162–24 JAMAICA AVENUE

Schlendorf to create a thoroughly modern and colorful building designed to arrest the eye of those passing by on the elevated train, and to reflect the contemporary quality of the furniture displayed there. A compact six stories high, the building bears decorative motifs in the form of tapered pylons in contrasting colors and materials that rise on the two main facades. These, and the skyscraper-like designs originally painted on the windows, show a clear connection to the Art Deco skyscrapers constructed in Manhattan at the same time. Despite the presence of strong horizontal lines, the vertical emphasis of the decoration dominates the facade, creating a building that is impressive beyond its size.

HARLEM BRANCH, YMCA/YWCA

YOUNG MEN'S CHRISTIAN ASSOCIATION (YMCA) BUILDING, 135TH STREET BRANCH, NOW HARLEM BRANCH

1931–32

180 WEST 135TH STREET, MANHATTAN

ARCHITECT: JAMES C. MACKENZIE JR. FOR ARCHITECTURAL BUREAU OF THE NATIONAL COUNCIL OF THE YMCA

DESIGNATED: FEBRUARY 10, 1998

The successor to the "Colored Men's Branch" of the YMCA on West 53rd Street, the West 135th Street Branch was originally constructed in 1918–19 on the opposite side of the street. Construction of this branch began in 1931; receiving funding from many New York philanthropists, it was hailed as the largest and best equipped facility of its kind for African American men and boys.

The neo-Georgian brick building, C-shaped in plan, features a four-story

base, separated by setbacks from the upper seven-stories, and an impressive pyramidal roof atop the tower. There are two main entrances, each with brick and cast-stone enframements and broken-scroll pediments adorned with the triangular YMCA logo. A recreational and cultural center that influenced the neighborhood, it was also a provider of affordable housing for black men and, after 1964, women. The branch hosted a number of community groups, including the Harlem Writers Workshop (founded in 1945) and the National Coordinating Committee on Civil Rights (1940s). Known as the Harlem YMCA, the center continues to serve the men and (since 1955) women of the community.

BRONX COUNTY COURTHOUSE

1931–34

851 GRAND CONCOURSE, THE BRONX

ARCHITECTS: JOSEPH H. FREEDLANDER AND MAX HAUSLE

DESIGNATED: JULY 13, 1976

The Bronx County Courthouse is a handsome example of government-funded architecture commissioned during the New Deal. Architects Max Hausle and Joseph H. Freedlander, in cooperation with sculptors and artisans, designed this building, which combines bold, modern massing with neoclassical elements.

The nine-story courthouse stands on a massive, rusticated granite platform, which elevates it dramatically. A broad

BRONX COUNTY COURTHOUSE

balustraded terrace surrounds the building on all sides. A monumental hexastyle portico is located in the center of each facade. The building is notable for its integration of a twentieth-century architectural style with figural sculpture. A frieze by Charles Keck celebrates the activities of the universal working man. Flanking each entry are two freestanding figural groups, carved in pink marble, by Adolf A. Weinman. The building was restored by the New York City Department of General Services.

FORT TRYON PARK

1931–35

MANHATTAN

ARCHITECTS: OLMSTED BROTHERS

LANDSCAPE ARCHITECT: FREDERICK LAW OLMSTED, JR.

DESIGNATED SCENIC LANDMARK: SEPTEMBER 20, 1983

Fort Tryon Park, an outstanding example of landscape architecture in the English Romantic tradition, represents a continuation of the picturesque New York City public park legacy initiated with the

FORT TRYON PARK

construction of Central Park. The property was given to the city, along with the Cloisters (p. 547), by philanthropist John D. Rockefeller Jr. Fort Tryon Park, which has some of the highest open public land in the city, overlooking the Hudson River and the Palisades, was the last park in the city designed by Frederick Law Olmsted Jr., son of the designer of Central Park.

The site is rich in history. It was named for General William Tryon, the last British colonial governor of New York. During the Revolution, the British built Fort Tryon here, clearing the hills for firewood. Evacuated in 1783, its military history came to an end, but the name remained. In the nineteenth century, several prominent persons built large estates on the land; Rockefeller purchased many of these in 1917 and donated them to the city.

Fort Tryon Park is a excellent response to the geographical difficulties of its rocky site and represents a skillful integration of its various elements, including views of the Hudson River and the Palisades and remnants of nineteenth-century estates.

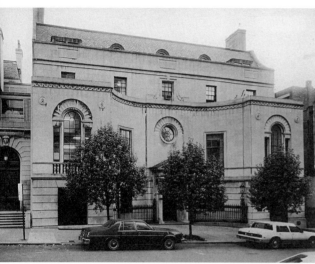

THE SPENCE SCHOOL

EMBASSY'S NEW METRO TWIN

THE SPENCE SCHOOL, FORMERLY SMITHERS ALCOHOLISM TREATMENT AND TRAINING CENTER AND BILLY ROSE HOUSE, ORIGINALLY WILLIAM GOADBY LOEW HOUSE

1932, 2003

56 EAST 93RD STREET, MANHATTAN

ARCHITECTS: WALKER & GILLETTE

DESIGNATED: MARCH 14, 1972

Erected during the Depression, the Loew residence was the last of the large private town houses to be built in the city. Once home to wealthy socialite stockbroker William Goadby Loew, its restrained but elegant use of ornament recalls the English Regency style.

Although framed in steel, the three-story structure displays a smooth ashlar masonry facade with a rusticated English basement. Joined to the house are two-story projecting wings with arched Palladian windows. Together, they create a shallow forecourt at the center surrounded by an ornamental stone wall.

Tall windows and an entrance portico accentuate the first floor, above which rests a slightly projecting central bay with a high, recessed arch. Within this arch, radial fluting enframes a bull's-eye window—a motif echoed in the Palladian windows as well. On the third floor, the smooth plane of the main mass contrasts strikingly with the sparse use of decorative detail. Four of the five rectangular windows have no ornament; the central window contains a crossetted frame and keystone. Set behind a parapet, a roof with dormer windows completes the structure.

In 2003, the building was adapted for use as a classroom building for the Spence School by Platt Byard Dovell White.

EMBASSY'S NEW METRO TWIN, FORMERLY METRO THEATER, ORIGINALLY THE MIDTOWN THEATER

1932–33

2624–2626 BROADWAY, MANHATTAN

ARCHITECTS: BOAK & PARIS

DESIGNATED: JULY 11, 1989

After closing and reopening and closing again from 2002 through 2004, the Embassy's New Metro Twin reopened in December 2004 as an independent cinema with 292 seats in the upstairs auditorium and 188 seats downstairs. Situated between 99th and 100th Streets, the theater is a showcase for foreign and independent films. The small Art Deco movie theater is one of the four still open to the public out of eighteen that in 1934 lined Broadway between 59th and 110th Streets. Constructed during the Depression, at a time when more than five hundred films were produced annually in the United States and a visit to the movie theater—costing only a nickel—was the most popular form of entertainment, the Midtown shows elements of both the Art Moderne and Art Deco styles.

The theater exemplifies the impact of the 1925 Paris Exposition Internationale on architects in New York City. Though the Exposition primarily influenced the design of skyscrapers, smaller commer-

542

cial structures also began to boast vertical accents, colorful terra-cotta, stylized figures, and flat, patterned surfaces characteristic of the new mode. The most impressive theater to be designed with the modernistic motifs of the new style was Radio City Music Hall (p. 538), also constructed in 1932.

With an original capacity of 550 moviegoers, the Midtown's economy of design was particularly appropriate to the Depression-era construction budget. However, its ornate decorative program—a highly colored terra-cotta facade and bas-relief medallion enclosing figures representing comedy and tragedy—sets it apart from this period's more typical movie theater design, a marquee above a simple storefront.

EMIGRANT SAVINGS BANK, FORMERLY DOLLAR SAVINGS BANK BUILDING

1932–33, 1937–38, 1949–52

2516–2530 GRAND CONCOURSE, THE BRONX

ARCHITECT: ADOLF L. MULLER OF HALSEY, McCORMACK & HELMER

DESIGNATED (EXTERIOR AND INTERIOR): JULY 19, 1994

This bank was built in three separate building campaigns spanning twenty years, yet it followed a single, coherent plan and retains its design integrity throughout. The easternmost bay was built in 1932–33; five years later, a one-hundred-foot expansion along the Grand Concourse completed the symmetrically massed, classicized Art Deco

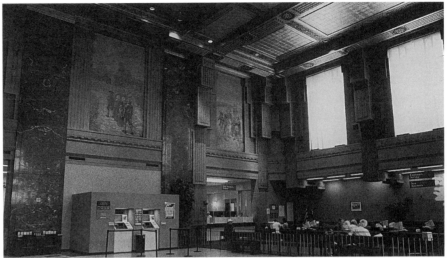

EMIGRANT SAVINGS BANK INTERIOR

facade. Between 1949 and 1952, a ten-story office tower with a fifty-foot clock tower was added to the left of the existing facade, completing the building. It is still a bank, although the neighboring office tower was sold and converted into condominium space.

Twin entrances into the banking room, separated by three double-height windows, are the main features of the facade. The exterior is clad in polished pink Texas granite ashlar, with red brick and terra-cotta on the upper tower stories. The attic is decorated with representations of "Liberty Head" silver dollars—now covered by the logo of the Emigrant Savings Bank, which acquired Dollar in 1992—and four tablets inscribed with advice on saving money. Inside, classical proportion and trabeation prevail in the monumental, unobstructed space, but the details and surfaces are Art Deco. Five murals by painter and mosaicist Angelo Magnanti, depicting the early history of the Bronx, further enhance the space.

EMIGRANT SAVINGS BANK

543

JAMAICA BUSINESS RESOURCE CENTER

JAMAICA BUSINESS RESOURCE CENTER, FORMERLY LA CASINA, ALSO KNOWN AS LA CASINO

C. 1933; 1994–95

90–33 160TH STREET, JAMAICA, QUEENS

ARCHITECTS: UNKNOWN; LI-SALTZMAN ARCHITECTS

DESIGNATED: JANUARY 30, 1996

New York City nightclubs, once the romantic symbol of the city's nightlife, began growing in popularity as enforcement of Prohibition eased in the late 1920s, and continued to proliferate after Repeal in 1933. Built at the twilight of the Jazz Age, La Casina supper club is one of the few surviving Streamlined Moderne buildings in the city. The style, which used dynamic massing and sleek, stripped forms, was a popular means of highlighting commercial structures in the 1930s, and was particularly successful in attracting attention to this small midblock structure.

Horizontal bands of metal form a ziggurat cap over the smooth stucco plane, and the bright, projecting vertical neon sign helped attract business from nearby Jamaica Avenue. La Casina, one of the many clubs that made Jamaica an entertainment and commercial hub in the 1930s, served the traditional supper club mix of dining, dancing, and entertainment. By 1940, the club had closed, and it has since housed a church and a swimsuit and brassiere manufacturer. Since 1989, the Jamaica Business Resource Center, which provides information and capital access for small busi-

LESCAZE HOUSE

nesses, has owned and operated the building. It was restored in 1994–95 by Li-Saltzman Architects.

LESCAZE HOUSE

1933–34

211 EAST 48TH STREET, MANHATTAN

ARCHITECT: WILLIAM LESCAZE

DESIGNATED: JANUARY 27, 1976

Known as the first truly "modern" residence in New York City, the Lescaze House incorporated many elements indicative of later trends in residential design. These include central air-conditioning, the use of glass bricks, and a large skylight to admit light to the living room, as well as the extension of outdoor living space to both the rooftop and rear of the house. Simplicity remains the dominant feature throughout; Lescaze was a devout follower of the French architect Le Corbusier, whose

geometric precision, sharp edges, and smooth surfaces had a deep influence on his work.

Set between deteriorating brownstones of the post–Civil War period, this building retains their modest scale and cornice line but little else. Huge glass-block panels dominate the third and fourth floors; separated only by a narrow strip of wall, they encompass almost the entire width of the building. Ribbon windows with casements accentuate the elegant curve of an otherwise austere stucco front. On the ground floor, a solid glass-brick wall designates Lescaze's office. Designed to serve as both workplace and residence, the building reflects the architect's basic philosophy—to meet the needs of the individual from the inside out.

U.S. COURTHOUSE

1933–36

FOLEY SQUARE, MANHATTAN

ARCHITECT: CASS GILBERT

DESIGNATED: MARCH 25, 1975

The U.S. Courthouse was the last building designed by Cass Gilbert. He died in 1934 while the courthouse was under construction, and his son Cass Gilbert Jr. completed it.

The thirty-one-story building is divided into three parts, reflecting the principal features of a column: base, shaft, and capital. The base of the building is irregularly shaped, expressing the shape of the lot. The back of the structure, facing Cardinal Place, is rounded.

Ten four-story-high unfluted Corinthian columns make up the colonnaded portico on Foley Square. The square main tower is set back from the base and rises twenty stories above it. Surmounting the seventeenth story, a dentiled cornice sets three stories that are treated as a unit, and topped by a pierced stone parapet with urns at the corners, emphasizing the setback. A shallow cornice and low attic story crown the topmost section supporting the pyramidal roof, with eagles at the corners connected by low parapets.

Unfortunately, Gilbert died before the interior details were designed and the materials specified; thus there are few spaces reflecting the sensitive use of color that appears in his watercolors, sketchbook, or previous buildings. Noteworthy, however, is the bronzework on the entry doors and elevators, which is compatible with the plaster and wood details.

One of the last neoclassical office buildings erected in New York, and also one of the earliest skyscrapers built by the federal government, the U.S. Courthouse at Foley Square illustrates an important turning point in American architectural history.

U.S. COURTHOUSE, FOLEY SQUARE

BRYANT PARK

BRYANT PARK

1934; 1988–91

BOUNDED BY WEST 42ND STREET, AVENUE OF THE AMERICAS, WEST 40TH STREET, AND NEW YORK PUBLIC LIBRARY, MANHATTAN

ARCHITECTS: LUSBY SIMPSON; HARDY HOLZMAN PFEIFFER ASSOCIATES; HANNA-OLIN, LTD.

DESIGNATED SCENIC LANDMARK: NOVEMBER 12, 1974

Located just west of the New York Public Library, the land where Bryant Park is now has had a colorful history. The city used it during the 1820s as a potter's field. The Crystal Palace—which housed the New York Exhibition of 1853—was built on the site and burned spectacularly in 1858. During the Civil War, the site was used as a drilling and tenting ground. In 1847 the land was designated a park. In 1884, its name was changed from Reservoir Square, after the adjoin-

ing Croton Reservoir, to Bryant Park in honor of editor and abolitionist William Cullen Bryant. In the late 1890s the reservoir was removed from the adjacent plot and replaced with the New York Public Library, which opened in 1911. Thomas Hastings, one of the building's architects, designed the apselike structure that covers Herbert Adams's 1911 statue of Bryant and stands today at the park's east end.

Disturbance of the park by the construction of the subways prompted calls in the 1920s for its renovation. In 1933, the Architects' Emergency Commission sponsored a competition for a new park design. Lusby Simpson was awarded the $100 prize, and his design was implemented within six months. The park was dedicated on September 15, 1934.

Simpson's design included moving Lowell Fountain, which had been dedicated to the memory of Josephine Shaw Lowell by her sister in 1912, across the park to its present location at the west entrance. The fountain, which was designed by architect Charles A. Platt, is New York's first great public monument to a woman.

Bryant Park underwent an extensive rehabilitation and redesign from 1988 to 1991. It now has two restaurant pavilions and four kiosks, as well as new lighting and perennial gardens. The architects of the renovation were Hardy Holzman Pfeiffer Associates and Hanna-Olin Ltd. Bryant Park is once again a place where New Yorkers can find respite from the towering structures and traffic of midtown Manhattan. An ice-skating facility is being planned.

F.W. I.L. LUNDY BROTHERS RESTAURANT

F.W.I.L. LUNDY BROTHERS RESTAURANT

1934; 1945; 1996

1901–29 EMMONS AVENUE, BROOKLYN

ARCHITECTS: BLOCH & HESSE

DESIGNATED: MARCH 3, 1992

Built during a government-sponsored renewal project in Sheepshead Bay, an area famous among fishermen and wildlife enthusiasts, this popular seafood restaurant could seat 1,700 people; it was thought to be the biggest restaurant in the country when it first opened. It was owned by Frederick William Irving Lundy, whose grandfather, father, and uncle were all partners in the Lundy Brothers fish market, at the time the longest-operating (since 1880) and most successful seafood wholesaler in Brooklyn.

The restaurant is a freestanding structure designed in the Spanish Colonial Revival style, with sand-colored stucco walls, sloping tile roofs, and an arcaded second story (now concealed by enclosed porches). Details include arched corbeling on the Ocean Avenue

side; carved wooden door lintels decorated with modillions (horizontal enscrolled brackets), anthemia, volutes, scallops, and dolphins; and large leaded-glass fanlights decorated with crabs and seahorses crowning the entrances.

During its heyday in the 1950s, Lundy's was the place of choice for Sunday dinner with the family, a first date, or even Sunday morning after church. A typical Sunday brought in ten thousand people, and a typical weekday, two thousand. In 1945, a one-story addition was constructed at the rear of the building. It was named the Theresa Brewer Room, after the popular singer who married Irving Lundy's nephew. Lundy's family continued to operate the restaurant for two years after his death in 1977. In 1996, the restaurant proudly reopened after extensive restoration.

THE CLOISTERS

1934–38

FORT TRYON PARK, MANHATTAN

ARCHITECT: CHARLES COLLENS

DESIGNATED: MARCH 19, 1974

The Cloisters, which opened to the public in May 1938, is a division of the Metropolitan Museum of Art, housing a portion of the museum's medieval art collection. The noted sculptor George Grey Barnard acquired what would become the core of this collection on his travels through Europe. He assembled, in addition to works in the decorative and fine arts, a large number of medieval architectural fragments. In

1925, John D. Rockefeller Jr. made a donation to the Metropolitan Museum of Art to purchase this collection, and five years later he obtained the entire area that now forms Fort Tryon Park (p. 541). After having set aside a four-acre site at the northern end for a museum building dedicated to medieval art, he gave all this property to the city.

Rockefeller hired Charles Collens, of the Boston firm of Allen, Collens & Willis, to design a structure that would integrate Barnard's collection within a sympathetic architectural setting. Earlier, Collens had designed Riverside Church for Rockefeller, as well as the additions to the adjacent Union Theological Seminary.

The Cloisters is not a copy of a particular medieval building. It is planned around the architectural elements of various buildings from the cloisters of five French monasteries that date from the twelfth to fifteenth centuries. At the center of the museum is the largest cloister, reconstructed with fragments from the monastery of St. Michel-de-Cuxa in southwestern France. The high tower overlooking this cloister is the most prominent feature of the entire complex; it was modeled after the tower at the same monastery. In May 1988, the Cloisters celebrated its fiftieth anniversary with the opening of the Treasury.

The modern construction elements fit seamlessly with the ancient work: the finish and pattern of each new stone block were copied from medieval examples. The massive exterior walls are made of millstone granite from New London, Connecticut; the interior from Doria limestone, quarried outside Genoa, Italy.

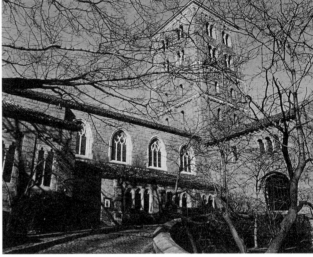

THE CLOISTERS

The rocky outcrop on which the Cloisters stands is reminiscent of the remote and wild locations of many medieval monasteries. The plantings in the adjacent gardens and within the Cloisters are also based on medieval precedents. The museum's terraces provide excellent views of the Hudson River and the Palisades. The park and museum together create one of the most beautiful spots in all of Manhattan.

FIRST HOUSES

THE BRONX POST OFFICE

The *Letter* by Henry Kreis and *Noah* by Charles Rudy—flanking the three central arched entranceways are the facade's only ornamentation.

In contrast to the simple exterior, the interior lobby is richly decorated with thirteen murals of scenes with American workers, painted in 1939 by Ben Shahn and his wife, Bernarda Bryson.

FIRST HOUSES

1935–36

29–41 AVENUE A, 112–138 EAST 3RD STREET, MANHATTAN

ARCHITECT: FREDERICK L. ACKERMAN

DESIGNATED: NOVEMBER 12, 1974

First Houses was the first municipal housing project undertaken by the New York City Housing Authority and the first low-income, public housing project in the nation. Begun as a rehabilitation program to abolish the long-standing problems of the slums of the Lower East Side, First Houses was an experiment in the partial demolition of existing tenements on the site.

Originally planned for 122 families, First Houses consists of eight four-and five-story brick buildings, largely rebuilt, laid out in an L-shaped plan around an inner yard. The apartments were designed to maximize light and air, and all had steam heat, hot water, and modem amenities. The minimal ornamentation is in a simplified Art Deco style. The paved courtyard is enlivened by freestanding and applied animal sculpture, designed by artists

associated with the Federal Artists Program. Today, the First Houses continue to be a great source of pride to the city. The project attracts an ethnically and demographically mixed tenantry, and the rentals are still priced according to income.

THE BRONX POST OFFICE

1935–37

560 GRAND CONCOURSE, THE BRONX

ARCHITECT: THOMAS HARLAN ELLETT

DESIGNATED: SEPTEMBER 14, 1976

Thomas Harlan Ellett's design for the Bronx Post Office combines classical simplicity with the sleekness of Modernism. The approach to the building is marked by a broad, shallow staircase, flanked by bronze flagpoles, that mounts to a granite, balustrade-enclosed terrace. The smooth exterior is lined with tall, elegant arched windows and doors in a manner that suggests a classical arcade. White marble enframes the openings, and a pale stone belt course crowns the structure to provide subtle contrast to the cool gray brick of the facade. Two monumental sculptures—

ROCKEFELLER APARTMENTS

1935–37; 1997

17 WEST 54TH STREET AND 24 WEST 55TH STREET, MANHATTAN

ARCHITECTS: HARRISON & FOUILHOUX; WILLIAM LEGGIO ARCHITECTS

DESIGNATED: JUNE 19, 1984

The Rockefeller Apartments are a major example of the International Style, an architecture that synthesized the new currents in Europe—the functional aesthetic, new building techniques, and the use of industrial materials—with a concern for public housing.

Commissioned by John D. Rockefeller Jr. and Nelson Rockefeller, the Rockefeller Apartments represent architect Wallace K. Harrison's first independent venture after the death of his former partner, Raymond M. Hood. The building is also the first of Harrison's many architectural collaborations with Nelson Rockefeller.

The apartments were built to provide accommodation near Rockefeller Center for well-to-do executives and professionals; their design displayed a concern

ROCKEFELLER APARTMENTS

THE BRONX GRIT CHAMBER

the most significant features. All of the steel casement windows are placed on the outer edge of the bond to ensure the continuity of the wall surface. The structural steel skeleton of these buildings is enclosed by smooth, tawny-colored bricks. The only adornment is the shadow cast by the unconventional vertical bows.

The Rockefeller Apartments changed the standards in New York City apartment house planning. The buildings allowed 15 percent more space for light and air than required by law and set a precedent of integrity and simple elegance in apartment design.

In 1997, the cooperative organization with William Leggio Architects undertook a major restoration of the building, including the refurbishment of its exceptional windows.

THE BRONX GRIT CHAMBER OF THE WARD'S ISLAND SEWAGE TREATMENT WORKS

1935–37

158 BRUCKNER BOULEVARD, THE BRONX

ARCHITECTS: MCKIM, MEAD & WHITE

ENGINEERS: FULLER & MCCLINTOCK

DESIGNATED: JUNE 8, 1982

The Bronx Grit Chamber is a primary component of the Ward's Island Sewage Treatment Works, New York City's first major project to alleviate the pollution of local waters. By the early twentieth century, pollution of the region's waters had become a serious problem, and in

for light and air unprecedented in apartment house design. The midblock site, stretching from 54th to 55th Streets, is linked by a landscaped courtyard intended to ensure that sunlight reached all apartments. The complex is made up of two separate buildings, each eleven stories high; the buildings were designed to work as a unit, with slight variations in the facades creating a dramatic symmetry. The two facades differ in the number and height of the vertical cylindrical bows and in the orientation of these bows' glazed surfaces.

Harrison's window detailing is one of

1914 the Metropolitan Sewerage Commission recommended a sewage plant on Ward's Island in the East River. In 1928, the engineering firm of Fuller & McClintock, using the new technology of activated sludge, began the design for the sewage treatment plant, which was subsequently completed by the city. Construction commenced in 1931, was temporarily halted by the Depression, and resumed in late 1935 with a federal Public Works Administration grant.

The care and attention devoted to the exterior design of the grit chamber make it one of the most unusual industrial structures in the city. Hired as architectural consultants, McKim, Mead & White created an exterior within the tradition of monumental public buildings, for which the firm is best known. Four colossal rusticated pilasters flanking each side of a monumental arch dominate the symmetrical front facade on Bruckner Boulevard. The pedimented main entrance contains the seal of the City of New York.

The Grit Chamber still serves its original function, today under the jurisdiction of the New York City Bureau of Water Pollution Control.

WILLIAMSBURG HOUSES

WILLIAMSBURG HOUSES

WILLIAMSBURG HOUSES

WILLIAMSBURG HOUSES

1935–38; 1990s

142–190 LEONARD STREET, 163–213 MANHATTAN AVENUE, 202–254 GRAHAM AVENUE, 215–274 HUMBOLT STREET, 122–192 BUSHWICK AVENUE, 83–221 SCHOLES STREET, 86–226 MAUJER STREET, 88–215 STAGG WALK, AND 88–202 TEN EYCK WALK, BROOKLYN

ARCHITECTS: RICHMOND H. SHREVE, CHIEF ARCHITECT; WILLIAM LESCAZE, DESIGNER

DESIGNATED: JUNE 24, 2000

This public housing development, one of the earliest influenced by the modern architectural movement, was designed by a group of ten architects, including William Lescaze, who introduced the International Style to the East Coast, and Richmond H. Shreve, whose firm designed the Empire State Building (p. 532). The twenty buildings, occupying only thirty percent of their 23.3-acre site, are offset from the street grid at fifteen-degree angles, creating numerous small open spaces. Entrances, marked by blue tiles and stainless steel canopies, compliment the subdued tones of the tan brick facade with exposed concrete floor plates. This project was one of the first undertaken by the New York City Housing Authority, in conjunction with the Federal Public Works Administration. When it opened to tenants in 1938, rent was under seven dollars per week, and over 25,000 people applied for 1,622 apartments. The buildings underwent

thorough restoration in the mid-1990s, and continue to house residents around tree-shaded squares.

BROOKLYN PUBLIC LIBRARY, CENTRAL BUILDING

1935–41; 1964; 1990s

GRAND ARMY PLAZA, ALSO KNOWN AS 2 EASTERN PARKWAY AND 415 FLATBUSH AVENUE, BROOKLYN

ARCHITECTS: ALFRED MORTON GITHENS AND FRANCIS KEALLY

DESIGNATED: JUNE 17, 1997

Initially proposed in 1888, when Brooklyn was still an independent city, plans for the municipally financed Central Building of the Brooklyn Public Library took more than fifty years to complete. The site was chosen in 1905 and ground was broken in 1911 for architect Raymond F. Almirall's Beaux-Arts design. However, due to problems related to city politics and finances, the original plan was stalled and eventually abandoned. In 1935, Alfred Morton Githens and Francis Keally were commissioned to redesign the building, while retaining the existing foundation and steel skeleton from Almirall's original plan. The library finally opened to the public in 1941.

Set back on a terraced plaza at the intersection of Eastern Parkway and Flatbush Avenue, the three-story, limestone-clad library is a classic modern structure. The building is shaped like an open book, and the impressive Art Deco detailing created by the sculptors

BROOKLYN PUBLIC LIBRARY

Thomas Hudson Jones and C. Paul Jennewein includes inscriptions and figures that express the institution's educational mission. One such inscription reads "The Brooklyn Public Library through the joining of municipal enterprise and private generosity offers to all people perpetual and free access to knowledge and the thought of the ages." A dramatic, fifty-foot entry portico is set into a concave facade, which reflects the elliptical configuration of Grand Army Plaza. The pylons flanking the entry are decorated with a series of gilded, curved bas-reliefs depicting the evolution of science and art. Above the triple doors is a forty-foot bronze screen with fifteen panels, each framing a figure from American literature, including *Tom Sawyer*, *The Raven*, and *Moby Dick*, as well as a portrait of Walt Whitman.

A book-loading area and a garage added in 1964 mask the original rear exterior, and a two-floor addition was built in the early 1990s on top of the windowless extension that originally housed the Branch Distribution Room. However, the main facade of the library remains virtually unchanged. This library endures as one of Brooklyn's best known and frequently used civic buildings.

HARLEM RIVER HOUSES

1936–37

WEST 151ST TO 153RD STREETS, MACOMB'S PLACE TO HARLEM RIVER, MANHATTAN

ARCHITECTS: ARCHIBALD MANNING BROWN, WITH CHARLES F. FULLER, HORACE GINSBERG, FRANK J. FOSTER, WILL RICE AMON, RICHARD W. BUCKLEY, JOHN LOUIS WILSON AND MICHAEL RAPUANO. LANDSCAPE ARCHITECT: HEINZ WARNECKE, ASSISTED BY SCULPTORS T. BARBAROSSA, R. BARTHE, AND F. STEINBERGER

DESIGNATED: JULY 22, 1975

Harlem River Houses were the first housing project in New York City to be funded, built, and owned by the federal government. Erected in 1936–37, the complex consists of three complexes of four- and five-story buildings grouped around open, serpentine landscaped courts embellished with sculpture. It was made possible by the collaborative efforts of the New York City Housing Authority and the federal government, and was described as "a recognition in brick and mortar of the special and urgent needs of Harlem." Lewis Mumford exuberantly reported that the project offers "the equipment for decent living that every modern neighborhood needs: sunlight, air, safety, play space, meeting space, and living space. The families in the Harlem Houses have higher standards of housing, measured in tangible benefits, than most of those on Park Avenue."

HARLEM RIVER HOUSES

Occupying nine acres, two-thirds of which were kept open, the simple, straightforward red-brick buildings are unornamented save for raised brick belt courses at the bases of the buildings and broad, steel framed casement windows. The community-oriented project included a nursery school, health clinic, wading pool, stores, social rooms, and play areas. In the summer of 1937, more than 11,000 people applied for the 574 apartments available in the new project. About a dozen of the original tenants still live there. After fifty years, the Harlem River Houses are still a remarkably gentle oasis.

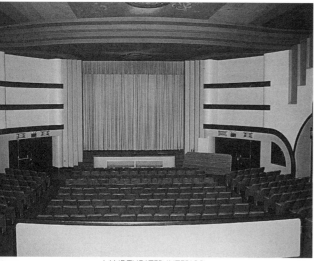

LANE THEATER INTERIOR

LANE THEATER INTERIOR

1937–38

168 NEW DORP LANE, STATEN ISLAND

ARCHITECT: JOHN EBERSON

INTERIOR DESIGNATED:
NOVEMBER 1, 1988

The Lane Theater is one of the few surviving examples of Depression-era, Art Moderne–style theaters, and, in its size and decor, it typifies theater design of that period. While the extravagant movie palaces of the 1920s and early 30s accommodated between two and six thousand people, the Lane seats just under six hundred. Restrained in style as well as size, the Lane departed from the renditions of Moorish palaces, Egyptian temples, Italian villas, and French boudoirs that characterized movie palaces in their heyday. Rather than mimicking exotic locales, Art Moderne detailing suggested the excitement of travel and contemporary life through intimations of speed, efficiency, and technological advancements. Streamlined surfaces, curved planes, geometric forms, and horizontal bands or "speed lines" replaced gilded plasterwork; these simple and relatively inexpensive ornamental elements were also appropriate for the straitened budgets of the time.

Architect John Eberson, one of the most prominent designers of theaters and opera houses in the 1920s, had also introduced the popular "atmospheric theater" (a ceiling with a blue plaster "sky" was dotted with electric lightbulbs simulating stars, and a hidden machine projected "clouds" across the ceiling).

His design for the Lane Theater interior is a variation of these earlier atmospheric theaters, but in a more abstract mode, complete with stylized murals that evoke the night sky.

NORMANDY APARTMENTS

1938–39

140 RIVERSIDE DRIVE, MANHATTAN

ARCHITECTS: EMERY ROTH & SONS

DESIGNATED: NOVEMBER 12, 1985

The Normandy Apartments, overlooking the Hudson River, is one of Emery Roth's last works and the last of the distinguished monumental apartment houses built prior to World War II.

The design of the Normandy shows the combined influence of the Italian Renaissance Revival and Art Deco styles of the 1930s. Occupying an entire blockfront on Riverside Drive, the nineteen-story Normandy is twin-towered (a Roth signature) and is characterized by streamlined curves and sweeping horizontal lines. The building is further defined by large, horizontally arranged rows of windows set close to the facade surfaces. The Renaissance-inspired detail includes a limestone base articulated with horizontal striations suggesting the rusticated stonework typical of Italian palazzi, flat pilasters with decorative capitals, and balustraded parapets. Original steel casements survive in most of the windows, and the placement of the corner windows follows the curve of the building.

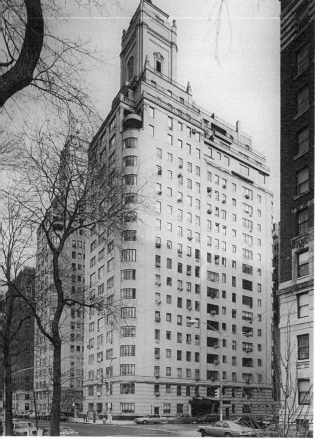

NORMANDY APARTMENTS

Highly visible, meticulously designed, and still largely intact, the Normandy symbolizes the grand era of twentieth-century urbanism.

THE PARACHUTE JUMP

1939; 2003

SOUTHWEST CORNER OF THE BLOCK BETWEEN SURF AVENUE, THE RIEGELMANN BOARDWALK, WEST 16TH STREET, AND WEST 19TH STREET, BROOKLYN; MOVED TO PRESENT SITE BY ARCHITECT MICHAEL MARIO AND ENGINEER EDWIN W. KLEINERT, 1941

INVENTOR: COMMANDER JAMES H. STRONG

ENGINEERS: ELWYN E. SEELYE & COMPANY

DESIGNATED: MAY 23, 1989

Originally erected for the 1939–40 New York World's Fair held in Flushing Meadows, Queens, the Parachute Jump was inspired by the growing popularity of civilian parachuting in the 1930s. It was invented by Commander James H. Strong, who received a patent for his design in 1936. Although intended for military purposes, enthusiastic civilian interest during testing prompted Strong to adapt his device for amusement: he added auxiliary cables to hold the chutes open and prevent them from drifting. At 262 feet, the Parachute Jump was surpassed in height only by the Trylon, the famous 610-foot, needle-like symbol of the fair.

Following the close of the fair in October 1940, the jump was purchased by the Tilyou Brothers and moved to their Steeplechase Park at Coney Island. A fire had damaged the park in September 1939, providing space for the new attraction. During World War II the jump was extremely popular, its double seats allowing couples to make the one-minute ascent and ten-second descent together. However, Coney Island's popularity waned after World War II, and Steeplechase Park closed in 1964. Leased to an amusement operator, the jump continued to operate until 1968. The 262-foot steel tower, reinforced and repainted in 2003, still has "significant challenges," making the possibility of resuming the parachute rides unlikely, according to the Coney Island Development Corporation. A design competition for its reuse is underway: the plan is to build a small restaurant, souvenir shop, and space for exhibitions and events.

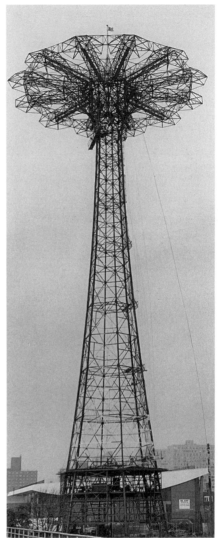

THE PARACHUTE JUMP

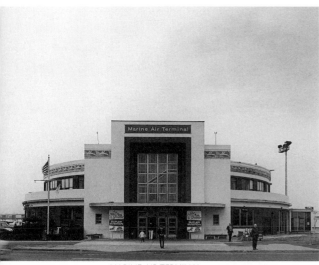

MARINE AIR TERMINAL

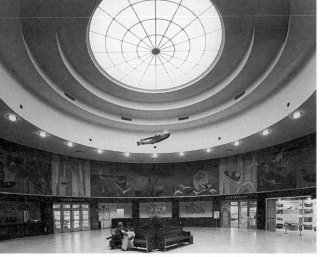

MARINE AIR TERMINAL IINTERIOR

MARINE AIR TERMINAL

1939–40; 1980; 1996

LA GUARDIA AIRPORT, QUEENS

ARCHITECTS: DELANO & ALDRICH;
BEYER BLINDER BELLE

DESIGNATED (EXTERIOR AND
INTERIOR): NOVEMBER 25, 1980

The Marine Air Terminal and its accompanying hangar (now demolished) were built specifically to serve the Pan American Clippers—large seaplanes that made the first transatlantic flights from La Guardia after 1939. This explains the site, close to the water's edge, as well as the imagery of the exterior frieze of stylized flying fish. The airfield and terminal together were one of the most ambitious and expensive projects of the Works Progress Administration, which worked here in conjunction with the New York City Department of Docks and the architectural firm of Delano & Aldrich.

William A. Delano, an artist and architect, was responsible for the design. A member of the U.S. Commission of Fine Arts (1924–28), he was involved in planning and design in Washington, D.C., and restored the White House during the Truman administration (1949–51).

Delano specialized in Federal and Renaissance Revival buildings, but for such a thoroughly new building type, he turned to a newer style. The use of colored terra-cotta, steel, abstract classical elements such as cornices, and a symmetrical plan and entrance facade are all typical of the Art Deco style. The simplified glazing bars and the austere, unmolded brick surfaces reflect tendencies commonly called Moderne; this style was particularly popular for transportation facilities and roadside architecture.

The main entrance to the south is the most monumental and stylish of the three projecting pavilions. At the rear, in a Y arrangement, are two lower wings that link the waiting room with the Clippers' boarding ramps. The waiting room, the central core of the building's circular plan, is decorated with rich materials: dark green marble walls, patterned gray marble floors, stainless-steel doors, and handsome wooden benches inlaid with a propeller blade motif lend this room extraordinary elegance. The uninterrupted span and curved walls produce the feeling of space greater than the room's actual size.

A magnificent mural, entitled *Flight*, rings the entire room; it is the work of James Brooks, the well-known WPA muralist and later Abstract Expressionist. The curved canvas panels depict the genesis of modern aviation in mythology and history, from Icarus and Daedalus to Leonardo da Vinci, the Wright Brothers, and the Pan Am Clippers themselves. The mural was covered over during a refurbishment in the 1950s. In 1980, the mural was beautifully restored and rededicated. Beyer Blinder Belle continued restoration on the interior and exterior in 1996.

240 CENTRAL PARK SOUTH APARTMENTS

1939–40

240 CENTRAL PARK SOUTH, MANHATTAN

ARCHITECT: MAYER & WHITTLESEY

DESIGNATED: JUNE 25, 2002

One of the largest luxury apartment complexes built at the time, this building marked a shift in design presaging the post–World War II era. Almost totally lacking in applied ornament, the facade was a clear step away from the Art Deco style, embracing the modernist apartment house. The steel casement windows and concrete, cantilevered balconies are the only interruptions to the orange-brick facade. The elongated rooflines and Amédée Ozenfant's mosaic, *The Quiet City*, which covers the front entrance, are the only decorative elements added to the otherwise purely structural composition. A twenty-story building, with a central twenty-eight-story tower, faces Central Park at Columbus Circle, and is connected to a fifteen-story building facing 58th Street. These buildings only cover half of the lot, and the open space between, as well as many terraces and a central courtyard, are tastefully landscaped to make this high-traffic site more comfortable for residential use. Noted residents have included author Antoine de Saint-Exupery, actress Sylvia Miles, creator of "60 Minutes" Don Hewitt, and the fictive Lois Lane from the movie *Superman*.

RIDGEWOOD SAVINGS BANK, FOREST HILLS BRANCH

1939–40

107-55 QUEENS BOULEVARD, QUEENS

ARCHITECTS: HALSEY, McCORMACK & HELMER

DESIGNATED: MAY 30, 2000

Founded in 1921, the Ridgewood Savings Bank became very popular in the community, and opened a branch in Forest Hills in 1940, hiring noted bank architects Halsey, McCormack & Helmer to design the new structure. The striking classic modern building sits on a triangular lot on the neighborhood artery, Queens Boulevard. The building employs simplified aspects of the Art Deco style, a common trend in this country after 1925. The broad panels of the building are interrupted by convex and concave wall sections. The light-colored limestone facade and bronzed windows highlight the unusual shape of this highly prominent building that remains an active bank.

240 CENTRAL PARK SOUTH APARTMENTS

RIDGEWOOD SAVINGS BANK, FOREST HILLS

555

GEORGE AND ANNETTE MURPHY CENTER FOR SPORTS AND ARTS, FORMERLY MUNICIPAL ASPHALT PLANT

1941–44; 1972; 2002

FRANKLIN D. ROOSEVELT DRIVE AT EAST 90TH TO 91ST STREETS, MANHATTAN

ARCHITECTS: KAHN & JACOBS

DESIGNATED: JANUARY 27, 1976

Constructed of reinforced concrete in the form of a parabolic arch, the Municipal Asphalt Plant was an innovative and radical design in its day—the first of its kind built in the United States.

The plant was built to produce asphalt for the streets of Manhattan and replaced another that had opened on the same site in 1914. Although it was to be an industrial structure, a standard industrial design was not desired; the Manhattan borough president wanted the new plant to be given an architectural treatment that would blend harmoniously with the East River Drive and the residential developments in the area. The architects Ely Jacques Kahn and Robert Allan Jacobs began with the idea of a conventional rectangular building but the parabolic arch proved to be more economical. The four arched ribs are spaced twenty-two feet apart, each rising to a height of eighty-four feet and with a span of ninety feet. These support a barrel vault constructed of concrete panels. The side walls are pierced by steel sash windows about a third of the way up.

In 1968 when asphalt production for all five boroughs was consolidated at a plant in Queens, operations ceased at the

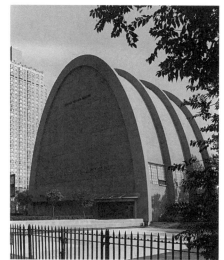

MURPHY CENTER FOR SPORTS AND ARTS

ROCKEFELLER GUEST HOUSE

plant. In 1972, the site—through the efforts of a community group called the Neighborhood Committee for the Asphalt Green—was converted into a much-needed youth center for sports, arts, and recreation. The plant was renamed the George and Annette Murphy Center for Sports and Arts, and the outdoor area, including an artificial-turf playing field, running track, and basketball courts, is called the Asphalt Green. In 2002, the Murphy Center reopened after an extensive renovation, housing five multi-purpose spaces, including two gyms and a theater.

ROCKEFELLER GUEST HOUSE

1949–50

242 EAST 52ND STREET, MANHATTAN

ARCHITECTS: PHILIP C. JOHNSON, WITH LANDIS GORE AND FREDERICK C. GENZ

DESIGNATED: DECEMBER 5, 2000

This simple yet elegant house reflects the early influence of Mies van der Rohe, an icon of modern architecture. The facade, organized into two distinct sections, incorporates structural steel, which creates a grid of six unpolished glass panels, above a wall of iron-spot brick bisected by a polished wood door. Built for Blanchette Rockefeller, the wife of John D. Rockefeller 3rd and a major patron of the Museum of Modern Art, it was intended for use as a guest house and gallery for her art collection. Johnson's only private residence in New York City, it was donated to the Museum of Modern Art in 1955, and has had many owners since, including the architect, who lived in the house during the 1970s. In 1989, it became the first architectural work to be sold at auction by Sotheby's. The house sold again, at auction, in 2000, for $11 million.

MANUFACTURERS HANOVER TRUST COMPANY BUILDING

1950–52

600 FIFTH AVENUE, MANHATTAN

ARCHITECTS: CARSON & LUNDIN

DESIGNATED: APRIL 23, 1985

The Manufacturers Hanover Trust Building, the last addition to the Rockefeller Center complex, replaced the Collegiate Reformed Church of St. Nicholas. Designed by the firm of Carson & Lundin, this structure takes the form of a nineteen-story tower set on an L-shaped, seven-story base. In scale, use of materials, detail, and setbacks, the architects created a design that is compatible with Rockefeller Center. The first major tenant was the Sinclair Oil Co., and the building was also known for many years as the Sinclair Building. Its purchase by Rockefeller interests in 1963 rounded out the center's site.

LEVER HOUSE

1950–52; 2003

390 PARK AVENUE, MANHATTAN

ARCHITECTS: GORDON BUNSHAFT FOR SKIDMORE, OWINGS & MERRILL

DESIGNATED: NOVEMBER 9, 1982

Lever House was the first skyscraper to use the postwar International Style in corporate architecture. Designed by Gordon Bunshaft of Skidmore, Owings & Merrill for the Lever Brothers Company, the building set a new standard for the modern steel and glass skyscraper.

Lever House is comprised of a vertical tower of steel and glass rising from a horizontal base of the same material; the overall effect is of a streamlined, minimal structure. Proponents of the International Style—including Le Corbusier, Walter Gropius, and Mies van

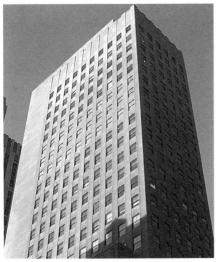

MANUFACTURERS HANOVER TRUST COMPANY

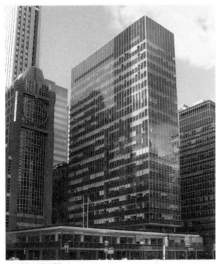

LEVER HOUSE

der Rohe—stressed volume (as opposed to mass), sought regularity in design, and shunned the use of architectural ornamentation. The fixed window/walls of the building make up almost its entire exterior. Their horizontal direction, offset by the vertical stainless-steel mullions, creates a regular, boxlike pattern across each facade and achieves an

exposed, skeletal effect. Because so much surface area is taken up by windows, the building is completely transformed from an opaque structure in daylight to a transparent one at night. Another innovative feature is the colonnaded space that extends from the sidewalk, creating open space for public use. The building was one of the first with a window-washing system that uses a small gondola suspended from miniature railroad tracks on top of the building.

In addition to its architectural interest, Lever House was significant for other reasons. Its construction marked the beginning of the transformation of Park Avenue from a boulevard of small masonry buildings to an imposing street of large glass and steel office buildings. Lever House is also a corporate symbol: Lever Brothers produced soaps and detergents, and the building was intended to convey an image of cleanliness characteristic of the company's products. Finally, Lever House also brought fame to Skidmore, Owings & Merrill, who were credited with developing a building both architecturally innovative and tailored to the needs of the client. In 2003, SOM completed the replacement of the deteriorated curtain wall and installed sculpture and seating designed by Isamu Noguchi. A restaurant that required a new entrance on 53rd Street opened in August 2003.

J.P. MORGAN CHASE BUILDING, FORMERLY MANUFACTURERS TRUST COMPANY BUILDING

1953–54

510 FIFTH AVENUE (ALSO KNOWN AS 2 WEST 43RD STREET), MANHATTAN

ARCHITECTS: GORDON BUNSHAFT FOR SKIDMORE, OWINGS & MERRILL

DESIGNATED: OCTOBER 21, 1997

The former Manufacturers Trust Company Building, a five-story glass box, was an early instance of the International Style design for a bank building. Attempting to communicate the bank's dedication to customers and modern image, the transparent skin invites the casual onlooker inside. Within the first week of operation, the building drew 15,000 visitors and a barrage of press, confirming that good architecture was an attraction to customers. Other banks followed suit, and glass-fronted bank buildings were a national trend by the 1960s.

Gordon Bunshaft led a team of architects for Skidmore, Owings & Merrill, producing the design for the building's clear glass walls, visibly anchored by thin polished aluminum mullions. The sheer facade includes gray-glass spandrel panels, polished granite facings, and a recessed penthouse for executive offices. Manufacturers Trust Company merged with Chase Manhattan Bank in 1988; on July 1, 2004, J.P. Morgan Chase was created by the merger of J.P. Morgan Chase & Co. with BancOne Corporation.

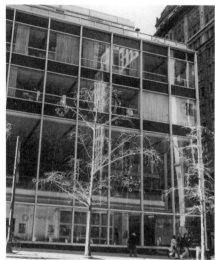

J.P. MORGAN CHASE BUILDING

SOCONY-MOBIL BUILDING

SOCONY-MOBIL BUILDING

1954–56; 2002

150 EAST 42ND STREET (ALSO KNOWN AS 130–170 EAST 42ND STREET, 375–391 LEXINGTON AVENUE, 640–658 THIRD AVENUE, 131–155 EAST 41ST STREET), MANHATTAN

ARCHITECTS: HARRISON & ABRAMOWITZ AND JOHN B. PETERKIN

DESIGNATED: FEBRUARY 25, 2003

The striking combination of opaque blue glass and embossed stainless steel panels makes this tower a one of a kind addition to New York City architecture. These panels were offered at a reduced cost by their manufacturer to encourage their use in urban construction and had rarely been seen on buildings before. The building encouraged the growth of midtown Manhattan as a premier business venue, particularly surrounding Grand Central Terminal. Socony-Mobil Oil Company, previously headquartered in the financial district, initially occupied half of the building. Architects Harrison & Abramowitz worked with John B. Peterkin on the International and Modern-style building, organizing the office space into two 13-story wings, flanking a sleek 42-story tower with no additional setbacks, all resting on a three story base. The Hiro Real Estate Company now owns the building and funded major renovation work on the facades.

Seagram Building

1956–58

375 Park Avenue, Manhattan

Architects: Ludwig Mies van der Rohe, Philip Johnson, and Kahn & Jacobs

Designated (exterior, including the plaza, and first floor interior): October 3, 1989

The only building in New York City designed by the renowned German-born architect Ludwig Mies van der Rohe, the Seagram Building embodies the quest of a successful corporation to enhance its public image through architectural patronage. The president of Joseph E. Seagram & Sons, Inc., Samuel Bronfman, guided by his daughter and architect-to-be Phyllis Lambert (who served as director of planning for this project), selected Mies van der Rohe to design a company headquarters in commemoration of the corporation's centennial anniversary.

At the end of the 1920s, Mies van der Rohe had emerged as one of Germany's leading architects, noted for his visionary skyscraper projects. After serving as director of the Bauhaus design school prior to its closure by the Nazis in 1933, he emigrated to the United States. In 1938, he was made a professor of architecture at Armour Institute (now Illinois Institute of Technology); the following year he designed a master plan and a complete new campus for the institute.

Mies became known as a proponent of the International Style, a style that was rooted not in earlier vernacular or "national" vocabularies but in modern

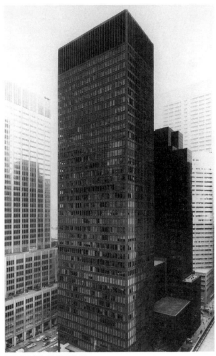

SEAGRAM BUILDING

technological advances in construction. In its early manifestations, this style was characterized by asymmetrical composition, geometric shapes, absence of applied decoration, and large windows often in horizontal bands. In his work in the United States, Mies conceived of the steel frame as a skeleton, replacing the brick or stone-clad walls (imitative of supporting walls) of the earlier skyscrapers. Opaque walls were exchanged for glass, decorative ornamentation for cubic simplicity, and fixed interior plans for open plans.

The Seagram Building was designed by Mies in collaboration with Philip Johnson; working drawings were prepared by Kahn & Jacobs. In 1932, Johnson had coauthored (with architectural historian Henry-Russell Hitchcock)

The International Style, a manifesto for the avant-garde, radical architecture of Walter Gropius, Le Corbusier, and Mies van der Rohe. Having received a degree in architecture from Harvard in 1943, Johnson's association with Mies van der Rohe on the Seagram Building was one of the highlights of a prestigious career.

The thirty-eight-story tower, which occupies only fifty-two percent of the site, was the first fully modular office tower designed to accommodate standardized interior partitioning, thus permitting unobstructed views through the floor-to-ceiling windows. Mies's decision to situate the monumental tower in a broad, elevated plaza (with a radiant heating system to keep it free of ice) was in accordance with a push by progressive architectural firms for revisions to outdated zoning regulations mandating full-site set-back towers. The tranquility of the plaza extends into the first-floor lobby, designed by Johnson. Unity is achieved through the use of continuous horizontal planes and transparent walls. While the traditional pink granite, travertine, and verde antique marble in the plaza contrast with the modern materials of the elegant curtain wall—bronze and pinkish-gray tinted glass—the bronze-clad columns and travertine floors and walls in the lobby provide a singleness of effect inside and out.

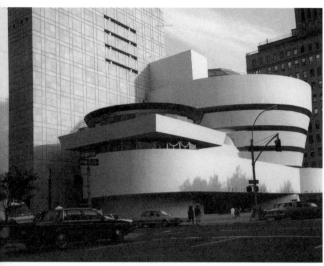

GUGGENHEIM MUSEUM

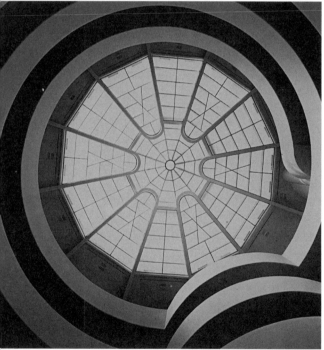

GUGGENHEIM MUSEUM SKYLIGHT

SOLOMON R. GUGGENHEIM MUSEUM

1956–59; ANNEX, 1992

1071 FIFTH AVENUE, MANHATTAN

ARCHITECT: FRANK LLOYD WRIGHT; ANNEX AND RESTORATION, GWATHMEY SIEGEL & ASSOCIATES

DESIGNATED (EXTERIOR AND INTERIOR): AUGUST 14, 1990

Frank Lloyd Wright's startlingly original, nautilus-shaped masterpiece was conceived with Solomon R. Guggenheim's need to find a permanent home for his equally radical collection of European works of art. In the years between the world wars, Guggenheim, a precious-metals mining magnate, amassed a vast collection of avant-garde, abstract works by such artists as Vasily Kandinsky, Piet Mondrian, Joan Miró, and Laszlo Moholy-Nagy. Guggenheim's adviser on emerging nonobjective European art was Hilla Rebay, a French abstract painter who escorted him on numerous buying trips to the continent. Rebay worked to convert her benefactor's enthusiasm for abstract painting into a revolutionary institution of modern art that would not only house finished pieces but would offer studio and exhibition space to young artists.

In 1943, Rebay convinced Guggenheim to commission Frank Lloyd Wright, the nation's most celebrated architect, to design a museum. Based on his conception of an organic architecture replicating nature's holistic structures, Wright at first proposed a ziggurat-like building. Sixteen years elapsed between Wright's first evocation of an

atmosphere appropriate to the museum's art and the opening.

The sculpted, circular mass rises in ever-widening concrete bands separated by ribbons of square-paned aluminum skylights. The irreverent curvilinear form radically breaks the street wall of Fifth Avenue, and the ample plantings surrounding it correspond with Central Park across the street. The buff-colored vinyl paint on the exterior is a typical Wrightian innovation—it was originally used to protect the finish on guns and airplanes in World War II. Inside, Wright's prairie-house cantilevers become projecting balconies, and a quarter-mile-long ramp spirals in widening loops, allowing one to follow an artist's chronological development.

"My Pantheon," is what Wright called the finished museum. It was completed only after he resolved numerous engineering challenges presented by the concrete, coiled-spring design and cleared most of the thirty-two objections initially raised by municipal building authorities. Many critics agree that the Guggenheim Museum, along with the Johnson Wax Building, are the crowning achievements of Wright's long, illustrious career.

After resolving a controversy between preservationists and expansionists, a ten-story, grid-patterned limestone annex by Gwathmey Siegel & Associates was approved and opened on June 28, 1992. It expanded the exhibition facilities by 27,000 square feet, and more exhibition spaces were created from offices and storage areas. Within the original building, the skylight was uncovered, fulfilling Wright's design intent.

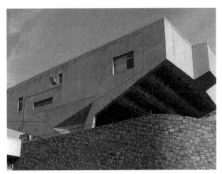

BEGRISCH HALL

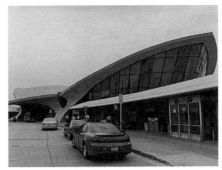

TWA TERMINAL A

BEGRISCH HALL AT BRONX COMMUNITY COLLEGE, CITY UNIVERSITY OF NEW YORK, FORMERLY NEW YORK UNIVERSITY

1956–61

2050 SEDGWICK AVENUE, UNIVERSITY HEIGHTS, THE BRONX

ARCHITECT: MARCEL BREUER & ASSOCIATES

DESIGNATED: JANUARY 8, 2002

This stunning trapezoidal building is in a cluster of five buildings that Marcel Breuer designed as part of his 1956 master plan for the University Heights campus of New York University (now Bronx Community College, p. 298). Breuer, an important mid-century modernist, studied architecture at the Bauhaus in Weimar and taught at Harvard University during World War II.

The building's massing is highly expressive of the steeply stepped lecture halls it encloses, creating a dramatic cantilevered building that appears to be taking flight, only touching the ground at the side-wall trusses. The east and west facades are decorated by a variety of geometric figures delineated by channels in the exposed reinforced concrete, and punctured by a few framed windows of different sizes and shapes. Breuer began to explore the expressive vocabulary of concrete, which he continued in his imposing design for the Whitney Museum of American Art.

TWA TERMINAL A, FORMERLY TRANS WORLD AIRLINES FLIGHT CENTER

1956–62; 2008

JOHN F. KENNEDY INTERNATIONAL AIRPORT, QUEENS

ARCHITECTS: EERO SAARINEN & ASSOCIATES (COMPLETED BY KEVIN ROCHE)

DESIGNATED (EXTERIOR AND INTERIOR): JULY 19, 1994

For its new Idlewild Airport (now John F. Kennedy International Airport) terminal, TWA hired Eero Saarinen to design a distinctive building worthy of its highly visible site. Dissatisfied with the restrictive minimalism of the International Style, Saarinen saw each of his designs as a unique application of architectural technology. His often monumental designs (including the St. Louis Gateway Arch, Dulles International Airport outside of Washington, D.C., and the CBS Headquarters in New York City) are distinctive, organic, and integrated with their surroundings. Saarinen died while the TWA terminal was under construction, and his associate, Kevin Roche, completed the project.

The terminal is Saarinen's spatial rendering of "the sensation of flying." Through the use of soaring, sculpted organic forms, he created a sense of the excitement and drama—motion given shape. The roof of the center portion rises above low, sweeping wings that follow the airport service road. The massive, curved concrete buttresses and roof define the structure, while green-tinted glass walls give surface to the negative spaces. The interior presents a complex but unified vaulted space, which is divided into three levels and joined by a central curved staircase. Imaginative sculptural forms and glass-linked surfaces gracefully define the outdoor-like atrium. Although Saarinen de-emphasized the analogy, the structure is often seen as a bird in flight. In 2001, TWA went out of business. The building, which stood vacant amongst a flurry of preservation advocacy, finally received a decision by the Port Authority for its future use. An $850 million, six-gate Jet Blue Airways terminal is to be designed by the architectural firm Gensler, with engineering by Ammann & Whitney and Arup. The new Y-shaped building, Terminal 5, has a low profile design, intended to respect the Saarinen design. It is scheduled to open in 2008.

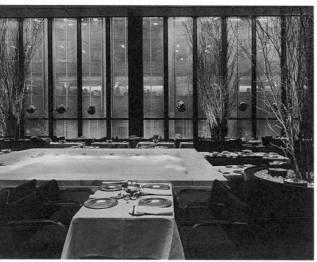
FOUR SEASONS RESTAURANT INTERIOR

FOUR SEASONS RESTAURANT

1958–59

99 EAST 52ND STREET, MANHATTAN

DESIGNER: PHILIP JOHNSON

DESIGNATED (GROUND AND FIRST
FLOOR INTERIORS): OCTOBER 3, 1989

Reflecting architectural theories
advanced by his mentor, Ludwig Mies
van der Rohe, designer Philip Johnson,
assisted by a team of consultants (interi-
or designer William Pahlman as princi-
pal designer, lighting designer Richard
Kelly, landscape architect Karl Linn, hor-
ticulturist Everett Lawson Conklin, weav-
er Marie Nichols, and artist Richard
Lippold), here created a series of under-
stated and elegantly proportioned dining
rooms. Advantage is taken of the modu-
lar system of design through varied ceil-
ing heights, an artful interplay of solids
and voids, and a wealth of highly
sophisticated detail—floor-to-ceiling
"draperies" of anodized aluminum

chains that ripple in the air blown in by
ventilators, an innovative scheme of
invisible recessed lighting, and designer
accessories, including Charles Eames
chairs. The use of rich materials
throughout—travertine marble on the
walls, grained French walnut paneling,
and bronze mullions and bowl planters,
all installed by expert craftsmen—made
this, at $4.5 million, the costliest restau-
rant built in 1959.

The restaurant's focus is divided
between two main dining spaces—the
Pool Room and the Grille Room. A lofty
square with twenty-foot-high ceilings,
the Pool Room is dominated by a cen-
tral, twenty-foot-square pool of white
Carrara marble filled with burbling
water. Four trees located one at each
corner are changed seasonally, along
with the menu, staff uniforms, and
other decorative details. The Grille
Room, a famous locale for "power
lunches," is a theatrical, French wal-
nut–paneled space with a balcony on the
eastern side, a sleek central dining area,
a lounge, and a laminated, "crackled"
glass wall that sections off a majestic
walnut bar. The square, solid bar stands
in dramatic contrast to Richard Lippold's
delicate overhead sculpture of gold-
dipped brass rods, which hangs from
the ceiling on invisible wires. This juxta-
position is balanced by his smaller
sculpture over the balcony. Critics have
praised this restaurant, located in the
Seagram Building, as one of the finest
International Style interiors in the
United States.

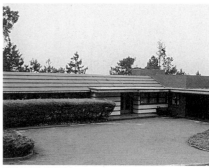
CRIMSON BEECH

WILLIAM AND CATHERINE CASS HOUSE, KNOWN AS CRIMSON BEECH

1958–59; 1970

48 MANOR COURT, STATEN ISLAND

ARCHITECTS: FRANK LLOYD WRIGHT,
FOR MARSHALL ERDMAN &
ASSOCIATES, AND MORTON H.
DELSON

DESIGNATED: AUGUST 14, 1990

Aside from the Guggenheim Museum,
this is Frank Lloyd Wright's only stand-
ing structure in New York City. An exam-
ple of the master architect's prefabricat-
ed home designs, known as Prefab
No. 1, it was created for the builder
Marshall Erdman of Madison, Wisconsin.
The Erdman prefabs were part of
Wright's last major attempt to address
the need for well-designed, moderately
priced housing in America.

This residence was commissioned by
Catherine and William Cass of Corona,
Queens, after seeing Wright in a televi-
sion interview. Components of the
house were trucked from Madison and
assembled on a steep three-quarter-acre
site overlooking historic Richmond-
town. The cost of the prefab materials

was only $20,000, but local contractors added $35,000 to the total. The July 1959 opening of Crimson Beech (named for an ancient copper beech tree that once grew in the front yard) generated great fanfare.

Like Wright's other Utopian American or "Usonian" houses, Crimson Beech extends itself horizontally along the ground, emphasizing spatial fluidity. Full advantage is taken of the southern exposure, with clerestory windows in front and large expanses of glass that open onto two levels of terraces in the back.

At least eight other Prefab No. 1 homes were built, each with some variation in detail and plan. A swimming pool was created for the Casses by Wright's associate Morton Delson in 1970.

ABN-AMRO Building, formerly the Pepsi-Cola Building

1958–60

500 Park Avenue (also known as 62 East 59th Street), Manhattan

Architects: Skidmore, Owings & Merrill

Design Partner: Gordon Bunshaft

Senior Designer: Natalie de Blois

Designated: June 20, 1995

With a beverage originally formulated as a stomach tonic called "Pepsin Cola" (pepsin is a digestive enzyme) by pharmacist Caleb D. Bradham in 1898, the Pepsi-Cola Company was founded in 1902. The company expanded steadily until the World War II, when its previously successful image as a bargain drink reminded too many people of the Depression, causing its profits to plummet. A sweeping reorganization in 1950, led by Alfred N. Steele, reversed Pepsi's fortunes, as sales jumped 112 percent in the following five years. With its increased profits, Pepsi-Cola built a new corporate headquarters in 1960.

Constructed during Manhattan's second wave of International-Style architecture, the eleven-story Pepsi-Cola Building was smaller than other Park Avenue International buildings, (Lever House and Seagram Building,), but no less striking. Today it houses a branch of the Dutch bank ABN-AMRO.

Occupying a corner lot, the structure is cantilevered over ten columns. The first-floor lobby is set back, giving the upper stories the appearance of floating. The nine floors of office space have a curtain wall of gray-green plate glass measuring nine feet by thirteen feet by one-half inch, separated by thin, polished aluminum mullions and spandrels. Top-floor penthouses are set back and barely visible from street level.

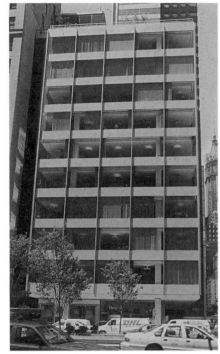

ABN-AMRO BUILDING

563

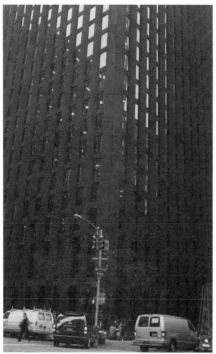

CBS BUILDING

CBS BUILDING

1961–64

51 WEST 52ND STREET, MANHATTAN

ARCHITECT: EERO SAARINEN & ASSOCIATES; DESIGN COMPLETED BY KEVIN ROCHE AND JOHN DINKELOO

DESIGNATED: OCTOBER 21, 1997

Eero Saarinen's only skyscraper ever built arguably achieves his goal of designing the "simplest skyscraper in New York." Composed of alternating triangular piers of gray granite and stripes of tinted glass, both five feet wide, the facade appears to open and close as one passes by, visually transforming the structure into a virtual tower of solid stone. Set back in a sunken plaza, this is one of the first towers built according to the zoning laws of 1961, regulations that Saarinen helped to create. The absence of setbacks and the lack of interruption in the facade, achieved by placing entrances on the side streets and concealing commercial tenants behind the uniform tinted glass panels, adds to the structure's massive simplicity.

Saarinen, the son of the distinguished Finnish architect, Eliel Saarinen, is best known for his undulating TWA terminal at JFK International Airport. He never saw the CBS Building design fully realized, but his firm's successors, Kevin Roche and John Dinkeloo, completed the project according to his plans. Now known as one of the country's greatest works of modern architecture, the austere tower remains the corporate headquarters for television and radio network CBS.

THE UNISPHERE

THE UNISPHERE AND SURROUNDING POOL AND FOUNTAINS

1963–64; 1993–94

FLUSHING MEADOWS-CORONA PARK, QUEENS

LANDSCAPE ARCHITECT: GILMORE D. CLARKE

ENGINEERING AND FABRICATION: UNITED STATES STEEL COMPANY

DESIGNATED: MAY 16, 1995

The Unisphere, a giant stainless-steel globe, was both the physical center and visual logo of the 1964–65 World's Fair. It embodied the fair's theme, "Peace through understanding in a shrinking globe and in an expanding universe." The Unisphere was designed by Gilmore D. Clarke, the noted landscape architect who also designed the grounds of the 1939–40 World's Fair, which took place on the same site. His 1964 plan set pavilions, sculptures, and fountains on axes radiating from the Unisphere in a

geometric, Beaux-Arts-inspired layout.

Towering over a circular reflecting pool punctuated with fountains, the Unisphere celebrates the dawn of the space age. The structural steel cage is 140 feet high and 120 feet wide, and its more than 500 components weigh over 700,000 pounds. Winding steel members represent lines of latitude and longitude, curved shapes represent the continents, and suspended rings mark the first man-made satellite orbits. The world's capital cities are marked by lenses, which were backlit during the World's Fair.

The fair was a financial failure, ending more than $11 million in debt, and its remaining assets were spent on demolishing the exhibitions and restoring Corona Park. The Unisphere remained, but there was little money to maintain it. By the 1970s, the fountains had been shut down, the pool drained, and the site covered in graffiti. Beginning in 1989, the Department of Parks and Recreation cleaned and restored Corona Park; the Unisphere was restored in 1993–94 with funds from the Queens Borough President's Office.

FORD FOUNDATION BUILDING

1963–67

321 EAST 42ND STREET AND 306-326 EAST 43RD STREET, MANHATTAN

ARCHITECT: EERO SAARINEN ASSOCIATES (LATER KEVIN ROCHE JOHN DINKELOO ASSOCIATES)

DESIGNATED: OCTOBER 21, 1997

One of New York City's most distinguished post–World War II modern buildings, this forward-thinking design creates an office tower within a 12-story glass cube, while also attending to contextual details that had often been overlooked in the surge of skyscraper construction in Midtown Manhattan. Kevin Roche and John Dinkeloo carefully considered the building site, aligning the roof with the setback of the neighboring tower, and created a scenic approach to the building with the careful placement of the entry and driveway. The facade is composed of glass, mahogany-colored granite, and Cor-Ten weathered steel, encasing a landscaped full height atrium, visible from the street.

Created by automobile manufacturer Henry Ford, and his son Edsel, the Ford Foundation, was the nation's largest private foundation. They chose to build a highly publicized headquarters, rare for organizations of this type, bringing attention to its initiatives in education, political action, and the arts and sciences. The foundation continues to operate in this stunning building.

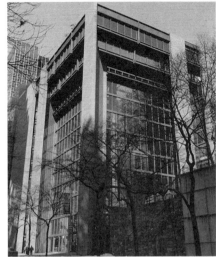

FORD FOUNDATION BUILDING

FORD FOUNDATION INTERIOR

SUTTON PLACE LAMPPOST

HISTORIC STREET LAMPPOSTS IN MANHATTAN, BROOKLYN, THE BRONX, AND QUEENS

DESIGNATED: JUNE 17, 1997

Approximately one hundred historic, cast-iron lampposts survive in New York City. The precise dates these lampposts were erected, as well as the designers and fabricators of most of them, have not been determined.

Gas streetlights were introduced in New York City in 1825, and by May 1828, the New York Gas Light Co. had installed gas lines and cast-iron lampposts on every Street between the East River and the Hudson River south of Grand and Canal streets. Two gas lampposts dating from the mid-nineteenth

century are extant: one at Patchin Place in Greenwich Village and one at the northeast corner of 211th Street and Broadway.

In 1880, electric lights made their New York City debut along Broadway from 14th to 26th Streets, and the first truly ornamental cast-iron lampposts were installed on Fifth Avenue in 1892. Called twin posts because they support two luminaires, these posts have a fluted base and shaft separated by a collar of acanthus leaves. Unusual spiral finials decorate each end of the crossarm, which is supported against the vertical shaft by C- and S-scrolls. Following this installation, a number of ornamental arc lamppost designs were introduced, the earliest and most ubiquitous of which is the bishop's crook, initiated circa 1900. Made from a single iron casting up to the arc, or "crook," it incorporates a garland motif that wraps around the shaft. The largest extant collection of bishop's crook lampposts can be found in City Hall Park.

By the 1930s, the city streets were lighted by a variety of lampposts, brackets, and pedestals. However, during the 1960s, most were replaced by modern, unadorned, steel-and-aluminum posts. The surviving historic lampposts continue to light the city streets, and are maintained by the Department of Transportation. Sixty-two lampposts and four wall brackets are included in this designation; the remaining posts are already protected within designated historic districts.

BRONX

LAMPPOST 70 AND 71: North side of Kazimiroff Boulevard, by the Haupt Conservatory entrance, New York Botanical Garden

LAMPPOST 83: West side of Broadway between 230th Street and Kimberly Place, adjacent to 5517 Broadway

LAMPPOST 96: Southeast corner of Mosholu Avenue and Post Road, adjacent to 5802 Mosholu Avenue

LAMPPOSTS 101 AND 102: Flanking the steps on West 256th Street, leading from the west side of Post Road to the east side of Sylvan Avenue

BROOKLYN

LAMPPOST 73 AND 103: Southern side of the pedestrian bridge crossing the Belt Parkway (Leif Erikson Drive) between Exit 4 (Bay 8th Street) and Exit 6 (Coney Island Avenue)

LAMPPOSTS 97, 98, 99, AND 100: Dyker Beach Park Golf Course on Park Drive east of 7th Avenue, opposite 88th Street

MANHATTAN

LAMPPOST 1: Southeast corner of 1 Battery Park Plaza (State and Bridge Streets)

LAMPPOST 3: Adjacent to 24 Beaver Street between Broad and New Streets

LAMPPOST 4: Adjacent to 50 Broadway

LAMPPOST 5: Adjacent to 80 Broadway

LAMPPOST 6: Adjacent to 10 Pine Street, The Equitable Building

LAMPPOST 7: West side of Greenwich Street between Battery Place and Morris Street

LAMPPOST 8: East side of Greenwich Street between Battery Place and Morris Street, adjacent to the Cunard Building

LAMPPOST 9: Intersection of Greenwich Street, the foot of Battery Place, and Trinity Place

LAMPPOST 10: Adjacent to 1–9 Trinity Place, also known as 29 Broadway

LAMPPOST 11: West side of Trinity Place overlooking depressed exit ramp of the Brooklyn Battery Tunnel

LAMPPOST 12: West side of Trinity Place overlooking depressed exit ramp of the Brooklyn Battery Tunnel, near Rector Street subway entrance

LAMPPOST 13: West side of Trinity Place on the traffic island

LAMPPOST 14: Adjacent to 34–38 Western Union International Plaza

LAMPPOST 15: Adjacent to 21–23 Morris Street

LAMPPOST 35: Southeast corner of Canal and Lafayette streets

LAMPPOST 45: North side of Gansevoort Street at the foot of Little West 12th Street

LAMPPOST 51: Northeast corner of Broadway and 23rd Street, adjacent to Madison Square Park

LAMPPOST 53: Adjacent to 314 Fifth Avenue

LAMPPOST 54: Southeast corner of Park Avenue and East 46th Street

LAMPPOST 55: Southwest corner of Park Avenue and East 46th Street

LAMPPOST 56: Southeast corner of Beekman Place at 51st Street, adjacent to 39 Beekman Place

LAMPPOST 57: Sutton Place at East 58th Street, east side of Sutton Square north of Riverview Terrace

LAMPPOST 58: Southeast corner of West 139th Street at Edgecombe Avenue, adjacent to 90–96 Edgecombe Avenue

LAMPPOST 59: Intersection of Amsterdam Avenue, Hamilton Place, and West 143rd Street, within Alexander Hamilton Square

LAMPPOSTS 60 AND 61: On the paths of Colonel Charles Young Triangle, at the intersection of West 153rd Street at Macomb's Place

LAMPPOSTS 63, 64, 65, 66. 67, AND 68: Lining both sides of the entrance ramp to Harlem River Drive on Adam Clayton Powell Jr. Boulevard, south of West 153rd Street

LAMPPOST 77 (WALL BRACKET): On 147 Nassau Street between Bruce and Beekman Streets

LAMPPOST 78: East side of the Western Union International Plaza between Morris Street and Battery Place

LAMPPOST 79: Northeast corner of Albany and West Streets

LAMPPOST 80: Adjacent to 107 and 109 Washington Street, between Rector and Carlisle Streets

LAMPPOST 81: South side of 48th Street between Park and Lexington Avenues, adjacent to the 48th Street side of 277 Park Avenue

LAMPPOST 82: South side of 49th Street between Park and Lexington Avenues, adjacent to the 49th Street side of 279 Park Avenue

LAMPPOST 84: Former intersection of Broome and Sheriff Streets

LAMPPOST 85: Northeast corner of West 211th Street and Broadway, adjacent to 4980–4988 Broadway

LAMPPOSTS 86, 87, AND 88: On the West 215th Street step street from Broadway to Park Terrace, west of Broadway

LAMPPOST 89: Southeast corner of Washington and Warren Streets

LAMPPOST 90: Southwest corner of Fifth Avenue and 28th Street, adjacent to Madison Square Park

LAMPPOST 91: Southwest corner of Walker Street and Sixth Avenue

LAMPPOST 92: Adjacent to 303 West 10th Street between West and Washington Streets

LAMPPOST 93 (WALL BRACKET): On 33–43 Gold Street, Excelsior Power Company Building

LAMPPOST 94 (WALL BRACKET): On 153 East 26th Street, at northwest corner of East 26th Street and Broadway Alley

LAMPPOSTS 105 AND 106: In Highbridge Park at the foot of West 187th Street and Laurel Hill Terrace

LAMPPOST 107: East side of Riverside Drive at West 163rd Street, inside Fort Washington playground

QUEENS

LAMPPOST 72: South side of 53rd Avenue step street between 64th Street and 65th Place, Maspeth

LAMPPOST 95: Rockaway Boulevard near 150th Street by Baisley Pond Park

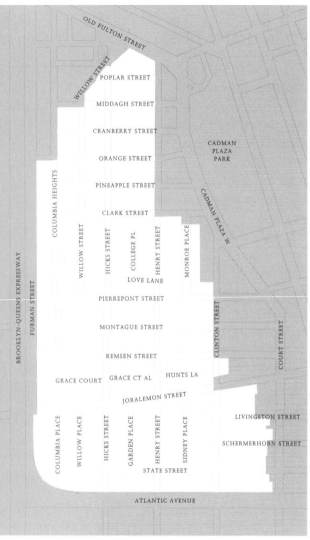

BROOKLYN HEIGHTS HISTORIC DISTRICT

BROOKLYN HEIGHTS HISTORIC DISTRICT

BROOKLYN

DESIGNATED: NOVEMBER 23, 1965

Brooklyn Heights is one of New York's best preserved and most attractive nineteenth-century historic districts. Occupying an elevated plateau just south of the Fulton Ferry Historic District and commanding dramatic views of Manhattan, Brooklyn Heights has been a residential community ever since it began to develop in the early 1800s. It is an area of dignified brownstone and brick houses and stately churches on streets bordered by stone sidewalks and lined with trees, as well as many carriage houses, preserved along picturesque and well-tended mews. Spared the constant restructuring that occurred in Manhattan, and left alone as Brooklyn expanded south, the configuration of streets and blocks in Brooklyn Heights is essentially the same as it was prior to the Civil War.

In 1965 Otis Pratt Pearsall, leader of the Historic Preservation Committee of the Brooklyn Heights Association, noted that of the 1,284 buildings fronting the streets of Brooklyn Heights, 684 were built before the Civil War, and 1,078 before the turn of the century. There are fine buildings in the Federal, Greek Revival, Gothic Revival, and Anglo-Italianate styles. The district is also particularly rich in Greek Revival architecture: there are more than 400 examples, including buildings by architects Richard Upjohn and Minard Lafever, two of the style's most distinguished practitioners. The completion of the Brooklyn Bridge in 1883 opened the rest of Brooklyn to development. Today, Brooklyn Heights remains a fashionable and elegant residential area.

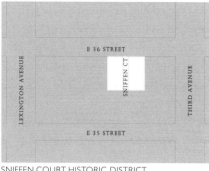

SNIFFEN COURT HISTORIC DISTRICT

SNIFFEN COURT HISTORIC DISTRICT

MANHATTAN

DESIGNATED: JUNE 21, 1966

Built by John Sniffen in the 1850s, this charming group of ten two-story houses in a blind alley on East 36th Street between Lexington and Third Avenues originally served as stables for families in Murray Hill. When automobiles began to replace carriages during the 1920s, most of the stables were converted into private residences.

The house at the south end of the court was used as a studio by the sculptor Malvina Hoffman from the 1920s through the 1960s. Its exterior wall, which she adorned with plaques of Greek horsemen, effectively terminates the narrow mews. Two of the stables were converted into a theater by the Sniffen Court Dramatic Society.

Minor exterior details of the houses have been altered over the years. The overall effect, however, is still unusually picturesque, providing a well-preserved example of New York City during the Civil War era.

TURTLE BAY GARDENS HISTORIC DISTRICT

MANHATTAN

DESIGNATED: JUNE 21, 1966

Turtle Bay Gardens, located near the United Nations, is named for a cove off the East River where turtles were once abundant. The cove, long since filled in, is now the site of the United Nations Park.

The twenty houses that surround the gardens were built during the 1860s. Although no two have identical plans, most are four stories high, with English basements. On the garden side, they have delicate balconies and porches.

The interior gardens were created by Mrs. Walton Martin, who bought the property in 1919–20, filled in the swampy backyards, and redesigned the houses. The result is reminiscent of an intimate Italian garden. Low masonry walls separate each private garden and surround the shared central esplanade, which is graced by a fountain copied from the Villa Medici in Florence. The characteristic charm of 1920s architecture is expressed here, and the use of a cast-iron turtle on the gateposts of the entrance railing adds some humor.

Over the years, the occupants of Turtle Bay Gardens have included Katharine Hepburn, Leopold Stokowski, and Tyrone Power, and Stephen Sondheim.

CHARLTON–KING–VANDAM HISTORIC DISTRICT

MANHATTAN

DESIGNATED: AUGUST 16, 1966

This site at the southwestern edge of Greenwich Village was the location of the famous Richmond Hill mansion, built in 1767 and used by George Washington during the Revolution as a headquarters. Situated on a hill four hundred feet high and surrounded by gardens and woods, it later became Vice-President John Adams's mansion. The property eventually passed first to Aaron Burr, who had the estate mapped out into lots in 1797, and then to John Jacob Astor, who began development in 1817.

The mansion, moved off the hill, was used as a theater, and the land was leveled. The large majority of the houses were built in the decade of the 1820s. Thanks to Astor's hold over the land and its development, the houses display unusual architectural harmony. The area includes the largest and best preserved groupings of Federal town houses in the city, as well as Greek Revival, Roman Revival, Anglo-Italianate, and later buildings, mainly on King Street.

The houses were bought originally by merchants, lawyers, and builders. Many were kept within the same families for generations, which explains their remarkable state of preservation. The area was able to resist the modernization of the city and the commercialization of surrounding areas.

TURTLE BAY GARDENS HISTORIC DISTRICT

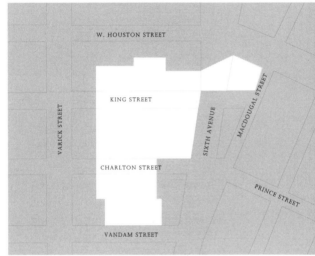

CHARLTON–KING–VANDAM HISTORIC DISTRICT

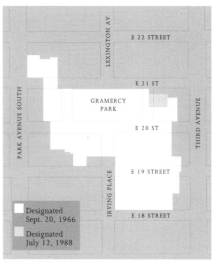

GRAMERCY PARK HISTORIC DISTRICT

GRAMERCY PARK HISTORIC DISTRICT

MANHATTAN

DESIGNATED: SEPTEMBER 20, 1966

Samuel B. Ruggles, a lawyer and real estate operator, purchased the land for Gramercy Park, the only private park in the city, in 1831. It was originally part of the estate of James Duane, the first mayor of post-Revolutionary New York. The original park was divided into sixty-six lots, each to be deeded to the owners of the surrounding property. An iron fence was built in 1832 and planting began in 1844. Private residences began to appear around the park and attract leading New Yorkers of the day, including Stuyvesant Fish, Samuel J. Tilden, and James Harper, who lived in the area in the 1860s and 1870s.

The residences surrounding the park today represent a wide variety of architectural styles, ranging from Greek and Gothic Revival to Anglo-Italianate. There are also a number of notable non-residential buildings, including the National Arts Club and the Players Club. Another notable building in the area is Pete's Tavern at 129 East 18th Street. Built in the mid-nineteenth century, it was frequented by the writer O. Henry and still remains intact. The Gramercy Park Historic District is unusual in that it is a serene, residential area in the midst of the city, and represents an early example of city planning.

ST. NICHOLAS HISTORIC DISTRICT

MANHATTAN

DESIGNATED: MARCH 16, 1967

These four rows of houses were built in 1891 by David H. King Jr., who was the developer for the first Madison Square Garden, the Equitable Building, and the base of the Statue of Liberty. King commissioned three prominent architectural firms to design these refined homes. They represent what was possibly the apex of the land speculation and investment in Harlem. Their location—on the heights overlooking St. Nicholas Park—allows unobstructed views and gives the district a feeling of openness. Though the rows of houses vary in design and detail, great care was taken by the architects to create a unified, distinct neighborhood, and the uniform block fronts add a cohesive element.

The twenty-five red-brick houses on the south side of West 138th Street were designed by James Brown Lord in a restrained, rhythmic style derived from the Georgian tradition. Complete blocks of houses by Bruce Price and Clarence S.

ST. NICHOLAS HISTORIC DISTRICT

Luce extend along the north side of West 138th Street, the south side of West 139th Street, and Seventh and Eighth Avenues. More detailed than the Lord houses, these are also Georgian-inspired, incorporating buff-colored brick and Indiana limestone. The thirty-two Italian Renaissance–style houses on the north side of West 139th Street were designed by McKim, Mead & White; built of dark brown mottled brick with unusual window arrangements, they stand in pleasing contrast to the other two groups.

The King Model Houses became known as "Striver's Row" during the 1920s and 1930s, in reference to the desirability of the neighborhood. Over the years, the district has been the home of many of Harlem's prominent doctors, in addition to such well-known entertainers as W. C. Handy and Eubie Blake.

MacDougal–Sullivan Gardens
Historic District

Manhattan

Designated: August 2, 1967

This block was purchased in 1796 by prominent New York merchant and financier Nicholas Low, whose estate built the twenty-two three-story Greek Revival houses that comprised the district in the 1840s and 1850s. The Hearth and Home real estate corporation bought the block in 1920. William Sloane Coffin president of Hearth and Home and an experienced property developer, renovated the block to preserve the charm of the neighborhood and to provide moderately priced housing for middle-class professionals. The houses were modernized, but changes to the facades were minimal. Architects Francis Y. Joannes and Maxwell Hyde removed the stoops and altered the basement entrances and doorways, adding Federal Revival elements, but retained the continuous cornice.

Coffin's plan included converting the open space in the center of the block into small private gardens and a large common area, with space specifically set aside for children's playground areas. A number of similar developments were inspired by MacDougal–Sullivan Gardens, including the Turtle Bay Gardens Historic District.

Treadwell Farm
Historic District

Manhattan

Designated: December 13, 1967

This charming residential neighborhood on the Upper East Side was originally part of the farms of Peter Van Zandt and William Beekman. The Van Zandt portion was sold at auction in 1815 to Adam Tredwell, or Treadwell, a wealthy fur merchant whose brother, Seabury Tredwell, owned what is now the Old Merchant's House at 29 East 4th Street. After Adam Tredwell's death in 1852, his daughter Elizabeth purchased the Beekman holdings, and the land was divided into lots and sold to buyers.

In 1868, the owners set standards for the dimensions of the buildings to be erected and specified the types of businesses that would be permitted in the area. As a result of their association, the neighborhood is architecturally uniform and quiet, with tree-lined streets and beautifully maintained houses. Most are three- or four-story brownstones constructed between 1868 and 1876. A number of well-known architects were involved, including Richard Morris Hunt and James W. Pirrson. The handsome Victorian Gothic Church of Our Lady of Peace, at 239–241 East 62nd Street, dates from 1886–87.

Through the efforts of its residents, among whom have been such notables as Walter Lippmann, Tallulah Bankhead, Kim Novak, Montgomery Clift, and Eleanor Roosevelt, this district has retained its peaceful elegance.

MACDOUGAL–SULLIVAN HISTORIC DISTRICT

TREADWELL FARM HISTORIC DISTRICT

HUNTERS POINT HISTORIC DISTRICT

HUNTERS POINT HISTORIC DISTRICT

QUEENS

DESIGNATED: MAY 15, 1968

This dignified residential section of Long Island City was built on land that belonged to the Van Alst family for nearly two hundred years, until the trustees of Union College purchased the property in 1861. In that year, the Long Island Railroad moved its terminus to Hunters Point, and the area began to change as inns and taverns opened to accommodate the commuters. In 1870, the land was acquired by Spencer B. Root and John P. Rust, developers who built many of the surviving houses. Completed between 1871 and 1890, the forty-seven houses exhibit diverse architectural styles including the Italianate, French Second Empire, and neo-Grec. A number of the original stoops, lintels, pediments, and other architectural details are intact.

After the area was developed, the houses were occupied first by old American families, then by people of Irish descent. The most notable of these was the last mayor of Long Island City, "Battle-Axe" Gleason, who lived on 12th

Street (now 45th Avenue) during the 1880s. When the elevated trains were extended to Long Island City early in the twentieth century, the noise caused many of the older families to move away. During the Depression, houses in the district were converted to multi-family dwellings, as most remain today.

ST. MARK'S HISTORIC DISTRICT

MANHATTAN

DESIGNATED: JANUARY 14, 1969

EXTENDED: JUNE 19, 1984

The legendary Governor Peter Stuyvesant once owned the land comprising this historic district in the East Village, and Stuyvesant Street was originally a lane dividing two of his farms. His great-grandson, also named Peter, eventually acquired most of these properties. In 1787, the land was surveyed and laid out by Evert Bancker Jr., who probably mapped out the street plan as well. The streets running east and west were named for male members of the family; those running north and south were named for Stuyvesant's four daughters.

St. Mark's-in-the-Bowery, begun in 1795 on the oldest site of worship in Manhattan, is one of the three existing buildings in the district that date from the younger Stuyvesant's lifetime. The other two are the Stuyvesant-Fish House at 21 Stuyvesant Street, and the house built in 1795 for Nicholas William Stuyvesant at 44 Stuyvesant Street. The lot once known as "Elizabeth Fish's Gardens" has since become "The

ST. MARK'S HISTORIC DISTRICT

Triangle," a group of houses, most completed in 1861, that extend around part of Stuyvesant and East 10th Streets on an unusual triangular plot. Most of the other buildings in the district display variations of the Italianate style and date from the mid-nineteenth century.

HENDERSON PLACE HISTORIC DISTRICT

MANHATTAN

DESIGNATED: FEBRUARY 11, 1969

During the eighteenth century, this compact residential neighborhood on the Upper East Side was part of William Waldron's farm. After the land was divided following Waldron's death, the block that comprises the historic district was acquired first by John Jacob Astor and Archibald Gracie and later by John C. Henderson. Henderson, a wealthy fur importer, retained the architectural firm of Lamb & Rich to design two-story Queen Anne houses; twenty-four of the original thirty-two remain, and for the most part they look as they did when they were completed in 1882.

Many of the picturesque dwellings

HENDERSON PLACE HISTORIC DISTRICT

are set back, and the resulting front yards and basement areaways are graced with hedges and shrubs. The houses have such characteristic Queen Anne details as gables, dormers, and double-hung frame windows with the upper sashes divided into many panes of glass. Gracie Mansion, the mayor's residence, is just across East End Avenue from Henderson Place. Over the years, the carefully preserved houses in this half-acre district have been owned or occupied by a number of well-known people, among them Alfred Lunt and Lynn Fontanne.

GREENWICH VILLAGE HISTORIC DISTRICT

GREENWICH VILLAGE HISTORIC DISTRICT

MANHATTAN

DESIGNATED: APRIL 29, 1969

The history of Greenwich Village can be traced back to Indian and Dutch days. Originally tobacco farms, the land was settled by prosperous colonists before the Revolution. After the Revolution, the population grew enough to accommodate tradesmen and merchants, and it became known as a village. Greenwich Village developed separately from the city proper at the southern end of Manhattan, although yellow fever epidemics in the early 1800s caused many New Yorkers to relocate here. As the city expanded and modernized, the Village remained intact. The gridiron plan of 1807–11 bypassed the irregular streets of the Village, and the emphasis on low and uniform architecture created a strong residential community that was able to escape large-scale commercial and residential development. Greenwich Village is the only area in the city where all of the architectural styles of early New York row houses exist side by side, in a state of excellent preservation. The predominant styles are Federal, Greek Revival, Italianate, French Second Empire, neo-Grec, and Queen Anne. Between the World Wars the Village expanded with the construction of taller apartment buildings. Known then as a low-rent district, Greenwich Village had already become home to artists and writers and developed a bohemian reputation.

MOTT HAVEN HISTORIC DISTRICT

THE BRONX

DESIGNATED: JULY 29, 1969

This district derives its name from Jordan L. Mott, the first major industrialist to locate in the Bronx. He established an ironworks on the Harlem River at East 134th Street in 1828 and called the surrounding area, which included his residence, Mott Haven.

Alexander Avenue, an airy, dignified thoroughfare once known as "The Irish Fifth Avenue," is home to two churches on the east side and two civic buildings on the west, as well as handsome row houses of the late nineteenth century. St. Jerome's Roman Catholic Church, built in 1898 by Dehli & Howard in the Italian Renaissance style, stands at the corner of East 138th Street; next to it are its French neo-Grec rectory and Victorian Gothic school. The Tercera glesia Bautista terminates the northern end of the district at East 141st Street; designed by Ward & Davis, this stark, symmetrical structure was extremely modern at the time of its construction in 1900–1902.

The Mott Haven Branch of the New York Public Library, opened in 1905, and the 40th Precinct Police Station, constructed in 1922–24, frame Alexander Avenue on its west side and effectively balance the two ecclesiastical buildings.

MOTT HAVEN HISTORIC DISTRICT

Designated
Dec. 20, 1969

Designated
June 7, 1988

COBBLE HILL HISTORIC DISTRICT

COBBLE HILL HISTORIC DISTRICT

BROOKLYN

DESIGNATED: DECEMBER 30, 1969

EXTENDED: JUNE 7, 1988

The name Cobble Hill originally referred to a steep conical hill at the present intersection of Atlantic Avenue and Pacific Street with Court Street. One of the highest hills on Long Island, it served as a lookout for American forces at the beginning of the Revolution. Until the early nineteenth century, Cobble Hill was an area of large orchards and farms. Development of the neighborhood, which is separated from Brooklyn Heights by Atlantic Avenue, followed its incorporation into the independent city of Brooklyn in 1834 and the opening of the South Ferry two years later.

The first buildings were rural homesteads, and suburban mansions along the west side of Henry Street, which had excellent views of the harbor. None of these survive today. The earliest extant structures are Greek Revival row houses dating from around 1832. There are fine examples of most of the late-nineteenth-century architectural styles, as well as buildings designed by some of New York's most distinguished architects. The 1843 house at 296 Clinton Street is the work of Richard Upjohn, architect of Trinity Church. The St. Frances Cabrini Chapel at Degraw Street and Strong Place was built in 1852 after a design by Minard Lafever. The Tower and Home buildings on Hicks, Warren, and Baltic Streets, and the Workingmen's Cottages on Warren Place were designed by

William Field & Son in the 1870s for laborers and their families; they are some of the nation's first planned low-income housing.

The 1988 extension added three buildings on Henry Street, two row houses from an original group of eight built in 1852–53 and the Polhemus Building of 1896–97, which was a free clinic for the poor who lived near the Brooklyn waterfront and a training facility for nearby Long Island College Hospital.

JUMEL TERRACE HISTORIC DISTRICT

MANHATTAN

DESIGNATED: AUGUST 18, 1970

The houses that comprise this district in Upper Manhattan provide an attractive setting for the Morris-Jumel Mansion. They are the original and only buildings constructed on this land. The oldest group, dating from 1882, consists of two rows of wooden houses along Sylvan Terrace. The other row houses, bringing the total to just under fifty, were built between 1890 and 1902 in the Queen Anne, Romanesque Revival, and Classical Revival styles. The only apartment house in the district is a 1909 Federal Revival brick and limestone structure at the corner of Jumel Terrace and West 160th Street. The buildings create a unified ensemble because they were constructed over a relatively brief period in complementary materials.

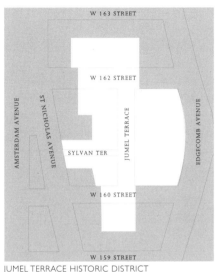

JUMEL TERRACE HISTORIC DISTRICT

CHELSEA HISTORIC DISTRICT

MANHATTAN

DESIGNATED: SEPTEMBER 15, 1970

EXTENDED: FEBRUARY 3, 1981

In 1750, Captain Thomas Clarke purchased land for an estate, which he named Chelsea, after the English village of Chelsea, now a part of London. In 1813, Chelsea was deeded to his grandson, Clement Clarke Moore, a poet, clergyman, and scholar. Moore first resisted the Commissioners' Plan of 1807–11, which called for a grid of roads and leveled land to replace the natural beauty of the estate. But he became a developer when his efforts were unsuccessful. Through the use of restrictive covenants, Moore was able to ensure that there would be open space in front of all of the houses, no stables or factories, as many trees as he deemed necessary, and houses constructed according to only

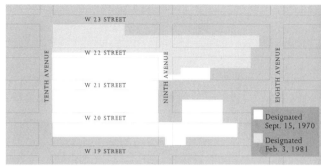

CHELSEA HISTORIC DISTRICT

the best designs.

The district today includes all of the land from Moore's former estate, showing his adaptation of the idea of the residential square. The center of the square is the General Theological Seminary, built between 1825 and 1902 on land donated by Moore; today it occupies the full city block bounded by Ninth and Tenth Avenues, and West 20th and 21st Streets. Surrounding it are a number of buildings erected in Moore's time. Notable among these is Cushman Row, 406–418 West 20th Street, one of the most handsome and well-preserved rows of Greek Revival town houses in New York. Chelsea also has some of the city's best Italianate buildings.

Chelsea's tradition of careful planning continued through the nineteenth century into the 1930s, affecting the design of the larger-scale apartment houses and tenement buildings on West 22nd and 23rd Streets. As a result, the district preserves the human scale and attractive appearance Moore originally envisioned.

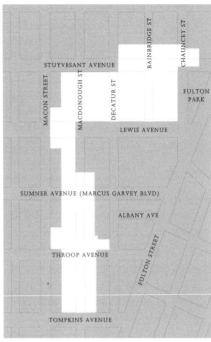

STUYVESANT HEIGHTS HISTORIC DISTRICT

STUYVESANT HEIGHTS
HISTORIC DISTRICT

BROOKLYN

DESIGNATED: SEPTEMBER 14, 1971

The ancestors of three of the original Dutch landowners held much of the farmland in this region of what is now Bedford-Stuyvesant for two centuries before it was acquired by developers and other investors, including the Brooklyn Railroad Company. The grid-iron street plan that exists today was laid out in 1835, and the blocks divided into lots, although most of the streets were not opened until the 1860s. Until the late nineteenth century Stuyvesant Heights remained predominantly rural, save for a few freestanding houses on MacDonough Street. Two of these early

country residences still stand: number 97, built in 1861 for Charles W. Belts, and number 87, erected two years later. The real development of the district spanned the years between 1870 and 1920, after Belts began to sell his MacDonough Street properties in 1869. The Prosser family, who owned land in the southern portion of the district, relinquished much of their holdings to developers during the 1890s.

In the 1870s and 1880s, rows of dignified masonry houses and brownstones, in a variety of styles, began to appear north of Decatur Street, creating a neighborhood whose appearance has changed little since that time. A number of well-designed four-story apartment houses were built between 1888 and 1903, marking the transition to an urban community and coinciding with the incorporation of Brooklyn within the City of New York in 1898. The district is almost entirely residential. There are three ecclesiastical groupings and only two buildings that were designed for commercial use: the two-story store and office building at 613 Throop Avenue, and the area's tallest structure, a five-story warehouse, also on Throop Avenue.

MOUNT MORRIS PARK
HISTORIC DISTRICT

MANHATTAN

DESIGNATED: NOVEMBER 3, 1971

Until the mid-nineteenth century, Harlem remained a rural area, but the opening of the elevated railroad in 1872 encouraged speculative building around

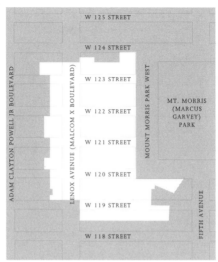

MOUNT MORRIS PARK HISTORIC DISTRICT

Mount Morris Park by William B. Astor, Oscar Hammerstein, and many others. The stately residences along Mount Morris Park West have been favorably compared with the mansions on Fifth Avenue. The large town house at the northwest corner of West 123rd Street and Mount Morris Park West is an especially fine example of the Renaissance Revival style.

The churches in this district include St. Martin's Episcopal Church and Rectory (1888) on Lenox Avenue, one of the best representations of the Romanesque Revival style in Manhattan. The modified neoclassical Mount Morris Presbyterian Church and the Ephesus Seventh-Day Adventist Church, with its lofty spire, are also impressive.

The district's residential architecture, including both town houses and apartment buildings, ranges over diverse styles, including classical, French neo-Grec, and Queen Anne.

CENTRAL PARK WEST–WEST 76TH STREET HD

CENTRAL PARK WEST-WEST 76TH STREET HISTORIC DISTRICT

MANHATTAN

DESIGNATED: APRIL 19, 1973

Originally part of a large parcel of land stretching down to present-day 42nd Street that Governor Nicolls, the first English governor, granted to five farmers, by 1811 this district consisted of portions of farms owned by John Delaplaine and David Wagstaff. The latter initiated development of the area by subdividing his farm in 1852. Among the factors that made the area ripe for growth were the introduction of a stage line along Bloomingdale Road (now Broadway), the Commissioners' Plan for Central Park and neighboring streets of 1868, and the increasing congestion in other parts of the city. Slowed temporarily by the financial panic of 1873, the "Great West Side Movement" gathered momentum after the completion of the American Museum of Natural History in 1877. Construction on West 76th Street began with two rows of houses erected in 1887 by the realtor Leonard Beeckman, and was largely completed by 1898.

The district includes apartment houses, town houses, a museum, and a church. They display a wide variety of late-nineteenth-century styles, including the neo-Grec, Renaissance Revival, Romanesque Revival, and Gothic Revival, but the French Beaux-Arts style is particularly prominent and its influence is evident not only in the more orthodox Beaux-Arts buildings but also in others that were designed in classicizing styles.

RIVERSIDE DRIVE–WEST 105TH STREET HISTORIC DISTRICT

MANHATTAN

DESIGNATED: APRIL 19, 1973

Until the end of the nineteenth century, the Upper West Side of Manhattan was known as Bloomingdale, after Bloemendael, the flower-growing area of Holland. Although it was the site of two large building complexes—the Bloomingdale Insane Asylum and the Leake and Watts Orphanage—it was not until the 1890s that development began on a large scale. The town houses built between 1899 and 1902 on West 105th and 106th Streets are the result of a period of great optimism, originally fueled by the hope that the proposed World's Columbian Exhibition of 1893 would be held in Riverside Park.

Built in the French Beaux-Arts style, these houses were intended to lure wealthy residents from the Upper East Side, which by then had developed into New York's most fashionable neighborhood. Among the neighborhood's

RIVERSIDE DRIVE–WEST 105TH STREET HD

amenities were the park, with its views of the river and the hills of New Jersey, and the quiet atmosphere of its side streets. The neighborhood is notable for the visual harmony of the streetscapes—the result of deliberate planning in the form of restrictive covenants dictating the height of buildings and the character of their facades. The use of such horizontal elements as cornices, balconies, and mansard roofs carries the eye from one building to the next; the gently curved masonry bays on the facades add a rhythmic effect.

Many of these buildings have had unusually long occupancies, which helps explain their exceptional state of preservation today.

PARK SLOPE HISTORIC DISTRICT

over the Brooklyn Bridge after it opened in 1883. Park Slope's tree-lined streets, wide avenues, and rows of brownstones preserve the turn-of-the-century Brooklyn that was known as "the city of homes and churches." Built largely between the mid-1880s and World War I, the houses exemplify practically every style of the late nineteenth century, including Italianate, French Second Empire, Queen Anne, neo-Grec, Victorian Gothic, Romanesque Revival, Classical Revival, and early Modern. The Montauk Club, 25 Eighth Avenue, a Venetian Gothic palazzo of 1891 by Francis H. Kimball, and Montgomery Place, between Eighth Avenue and Prospect Park West, much of which was designed by C.P.H. Gilbert, are particularly notable. The Romanesque Revival had a long life in Park Slope. With their broad, round entry arches and rugged stonework, these are some of the finest Romanesque Revival houses in the nation.

SOHO–CAST-IRON HISTORIC DISTRICT

PARK SLOPE HISTORIC DISTRICT

BROOKLYN

DESIGNATED: JULY 17, 1973

A semirural area until shortly before the Civil War, this district takes its name from the adjoining Prospect Park, designed by Olmsted & Vaux in 1866 and completed around 1873. The park, with its large, open meadow, woods, and lake, attracted many builders, who erected houses for merchants, lawyers, physicians, and other professionals, many of whom commuted to Manhattan

SOHO–CAST-IRON HISTORIC DISTRICT

MANHATTAN

DESIGNATED: AUGUST 14, 1973

The largest concentration of full and partial cast-iron facades anywhere in the world survives in the SoHo district. The earliest extant buildings date from the first decade of the nineteenth century, when the area was exclusively residential. By mid-century, however, most of the early Federal houses had either been replaced or converted to commercial

use. The commercial character of the area was firmly established by the 1870s, and the majority of buildings that incorporate full fronts of cast iron date from this decade.

The use of cast iron was an American architectural innovation. As a building material, it was cheaper than stone or brick. Architectural elements could be prefabricated in foundries from molds and used interchangeably for many buildings, while broken pieces could be easily replaced. A cast-iron building could be erected rapidly—some were completed in only four months. Previously, bronze had been the metal most often used for architectural detail. Architects now found that the relatively inexpensive cast iron could be formed into the most intricately designed

patterns. Classical French and Italian architectural designs were often used as models for cast-iron building facades. Since stone was the material associated with architectural masterpieces, cast iron, painted in neutral tints, was used to simulate stone.

SoHo became a limbo of small industrial and commercial enterprises, but in the 1960s, artists were attracted to the high-ceilinged, empty, and inexpensive lofts. Eventually, with the help of city agencies, they were permitted to migrate into the area. The result, over three decades later, is that SoHo is now one of the most important centers of fine art in the nation.

CARROLL GARDENS HISTORIC DISTRICT

BROOKLYN

DESIGNATED: SEPTEMBER 25, 1973

This quiet residential district adjacent to Cobble Hill was originally part of a tract of land purchased from the Mohawk Indians by the Dutch West India Company in 1636. Interest in the area was spurred by the opening of the Hamilton Avenue Ferry in 1846, the construction of the Gowanus Canal, begun in 1867, and the improvement of Carroll Park during the 1870s.

Carroll Gardens was laid out in 1846 by surveyor Richard Butts. He provided for blocks of unusual depth, so that the houses would be set back behind front yards between 25 and 39 feet deep. The result, when the rows of brownstones were completed between 1869 and 1884,

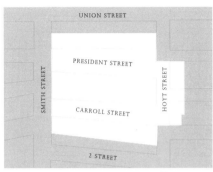
CARROLL GARDENS HISTORIC DISTRICT

was a neighborhood with a sense of remoteness and dignity.

The architectural unity of this district, which includes 160 buildings, stems from the brevity and high standards of its construction period. The houses were built to accommodate both wealthy merchants and residents of more modest means. A number of popular styles are represented here, including the late Italianate and French neo-Grec, and the varying arrangement of ornamental elements individualizes each house.

BOERUM HILL HISTORIC DISTRICT

BROOKLYN

DESIGNATED: NOVEMBER 20, 1973

This district is part of the area, bounded by Fulton Avenue, and Smith and Nevins Streets, that first acquired the name Breukelen, after the city in Holland with a similar topography. It was named after members of the Boerum family, who were prominent eighteenth-century farmers and civic leaders.

The construction of Boerum Hill began in the northeastern section during the 1840s. The rest of the district was

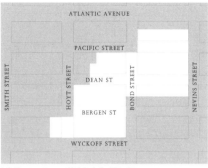
BOERUM HILL HISTORIC DISTRICT

developed in the 1860s and 1870s. Like Brooklyn Heights, Park Slope, and other nearby areas, it was built as a residential community for professionals who worked in Manhattan and downtown Brooklyn. Its nearly 250 buildings run the gamut of nineteenth-century architectural styles. The earliest are Greek Revival, a style that remained popular through the 1850s. The majority are in the Italianate style, which was popular in Brooklyn even after the Civil War, when it had become outmoded in Manhattan.

Most of the houses are of brick, with brownstone used primarily for trim and decoration. Those built after the Civil War show a more lavish use of brownstone, although it was never used as extensively here as in other parts of Brooklyn. One of the most appealing features is the well-preserved ironwork used on stoops and in front of yards; in some instances it literally tied together the facades of the rows and gave a unity to the streetscape. Another feature of houses in the district is the Queen Anne–style sunbursts and rosettes that were often incised in the 1880s on the brownstone basements of older houses.

579

CARNEGIE HILL HISTORIC DISTRICT

MANHATTAN

DESIGNATED: JULY 23, 1974

EXTENDED: DECEMBER 21, 1993

Throughout the nineteenth century, the villages of Harlem to the north and Yorkville to the south on what was to be the Upper East Side grew while Carnegie Hill lagged behind, retaining its semi-rural character. During this period, the area was comprised of churches and charitable organizations, shanties, squatters' shacks, and a few brownstones. With the construction of the New York Elevated Railroad on Third Avenue in 1881, the neighborhood began to change. As commerce pushed private residences out of midtown Manhattan, people moved farther uptown. During the late 1880s, luxury brownstones began to appear on the side streets. It was, however, the construction of Andrew Carnegie's mansion on Fifth Avenue between East 90th and 91st Streets that established the neighborhood as prime residential property. Carnegie himself bought land surrounding his mansion and sold it to developers only when satisfied with their plans.

Architecture in the district represents two periods of development. During the 1880s and 1890s, the neo-Grec, Romanesque, and Renaissance Revival styles dominated residential construction, echoing the styles of elegant mansions in other parts of the city. With the completion of the Carnegie mansion in 1902, larger private residences and apartment buildings replaced the row

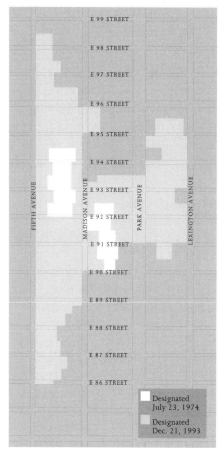

CARNEGIE HILL HISTORIC DISTRICT

house construction of the preceding decades. The majority of these buildings were in the Federal Revival style. Large mansions and town houses of great architectural distinction continued to be built in the district until the Depression hit in 1929. The Guggenheim Museum, considered one of Frank Lloyd Wright's masterworks, is also situated in the district. Still predominantly a residential area, today many Carnegie Hill buildings have been adapted for use as shops, museums, and schools.

HAMILTON HEIGHTS HISTORIC DISTRICT

MANHATTAN

DESIGNATED: NOVEMBER 26, 1974

EXTENDED: MARCH 28, 2000

This quiet, exclusively residential community on the Upper West Side was named after Alexander Hamilton, who built his country house, The Grange, in 1801 near the corner of Amsterdam Avenue and West 143rd Street. The house was moved in 1889 to its present location at 287 Convent Avenue.

The area remained mostly rural until 1879, when escalating real estate prices on the East Side, and the extension of the West Side elevated railroad, helped speed Hamilton Heights toward development. Nearly all of the row houses and low-rise apartment buildings in the district were built between 1886 and 1906. The successive architectural styles of those twenty years—Romanesque Revival, Flemish, Dutch, French and Italian Renaissance, and Beaux-Arts— are illustrated here.

St. Luke's Episcopal Church, built in 1892–95, is the earliest of the three handsome churches that mark the boundaries of Hamilton Heights. This massive Romanesque Revival structure, designed by R. H. Robertson, almost overshadows Hamilton Grange, now located alongside it. The two other churches, both built in the Gothic Revival style, are Convent Avenue Baptist Church of 1897–99 and the St. James Presbyterian Church of 1904.

The unusual street pattern in this

district and its well-preserved turn-of-the-century character create the impression of a protected enclave, insulated from the busy thoroughfares nearby.

HAMILTON HEIGHTS/ SUGAR HILL DISTRICT

MANHATTAN

DESIGNATED: JUNE 27, 2000

During the 1930s and 1940s this neighborhood became home to many accomplished African American professionals in the fields of law, business, literature, music, and arts. Originally developed for upper-middle-class white residents, the neighborhood was constructed between the late 1880s and the early 1910s, with the long rows of town houses and fine apartment buildings built on the promise of an up-and-coming area, newly accessible by cable car railroad. The 185 buildings in the district are varied in style, representing neo-Grec, Romanesque Revival, and Renaissance Revival.

The district became known as Sugar Hill in the 1930s, when many prosperous African Americans moved to the neighborhood. 409 Edgecombe Avenue became the neighborhood's most prestigious address; tenants included Supreme Court Justice Thurgood Marshall, painter Aaron Douglas, and scholar W. E. B. DuBois. While in residence at 749 St. Nicholas Avenue, Ralph Ellison wrote his critically acclaimed novel, *The Invisible Man*. St. Nicholas Avenue was also home to many jazz clubs and bars, associated with the legendary Miles Davis and Charlie "Bird" Parker.

HAMILTON HEIGHTS/ SUGAR HILL NORTHEAST HISTORIC DISTRICT

MANHATTAN

DESIGNATED: OCTOBER 23, 2001

The thirty-two buildings in this district were constructed primarily between 1905 and 1930, a time when development shifted to multiple-unit dwellings. Neville & Bagge, Schwartz & Gross, George F. Pelham, and Horace Ginsbern, all New York architects who specialized in high-density residences, designed buildings in this area. Stone and brick facades, with Renaissance and Colonial Revival features, create a cohesive neighborhood streetscape. Two attached, Queen Anne–style dwellings, designed by William Milne Grinnell, are the district's oldest houses. This area became famous in the 1930s and 1940s as the center to an affluent community of African American professionals and leaders, including Langston Hughes, Duke Ellington, and W. C. Handy.

HAMILTON HEIGHTS/ SUGAR HILL NORTHWEST HISTORIC DISTRICT

MANHATTAN

DESIGNATED: JUNE 18, 2002

Dating from the 1880s, this district is a cohesive unit of row houses and apartment buildings, showing fifty years of shifting residential preferences. In 1881, developers erected rowhouses, in a colorful array of styles including neo-Grec, Queen Anne, neo-Renaissance, and

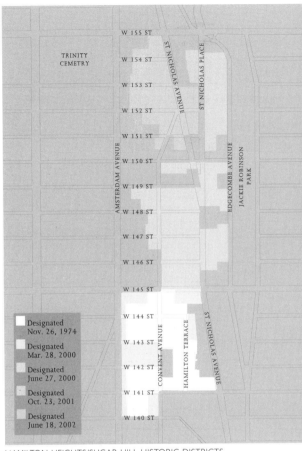

HAMILTON HEIGHTS/SUGAR HILL HISTORIC DISTRICTS

Beaux-Arts, which utilize a variety of materials. The first apartment building in this area remains at 468 West 153rd Street, designed by Henri Fouchaux as a companion to three row houses on that street. Built in 1886, it was one of the architect's first commissions. In the early-twentieth century, five- or six-story apartment buildings were constructed, and the brick and limestone facades integrated into the larger streetscape. The only free-standing house (1887) in the district is located 448 West 152nd Street.

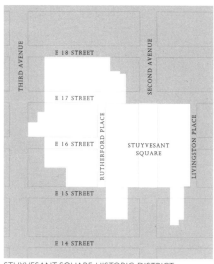

STUYVESANT SQUARE HISTORIC DISTRICT

STUYVESANT SQUARE HISTORIC DISTRICT

MANHATTAN

DESIGNATED: SEPTEMBER 23, 1975

Once owned by Governor Peter Stuyvesant, the land for Stuyvesant Square remained a predominantly rural part of his family's holdings until Peter Gerard Stuyvesant deeded it to New York City in 1836. The square, laid out in that year, is a particularly handsome example of a nineteenth-century park designed to relieve the gridiron pattern of city streets. Surrounded by a cast-iron fence and adorned by fountains, the park also contains a statue of Antonín Dvořák by Ivan Metrovi. Most of the houses in this fashionable neighborhood were built in the late nineteenth century. Development quickened with the construction of the Greek Revival Friends Meeting House and Seminary, built in 1860 on the west side of the square.

Nearly all of the residences are row houses, exemplifying a range of architectural styles. Richard Morris Hunt designed 245 East 17th Street in 1883 for Sidney Webster in a modified French Renaissance style. Also notable are the elegant four-story brick houses on East 16th Street, especially fine representations of the Anglo-Italianate style, and the Rainsford House at 208–210 East 16th Street with its elements of Tudor and Flemish architecture. The several religious institutions in the district include St. George's Church.

SOUTH STREET SEAPORT HISTORIC DISTRICT

MANHATTAN

DESIGNATED: MAY 10, 1977

EXTENDED: JULY 11, 1989

The East River waterfront of Lower Manhattan was a boat landing as early as 1625, when the Dutch West India Company set up a trading post there. Over the next two hundred years, it developed into one of the most prosperous commercial districts in New York, and one of the largest ports in the world. With the completion of the Erie Canal, which opened a navigable route to states on the Great Lakes, New York became the nation's foremost port, and the East River its busiest docks.

As the seaport began to prosper in the 1790s, the counting house became the standard commercial building type for merchant shipping companies in the area. The typical counting house

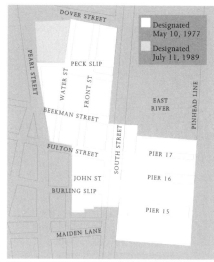

SOUTH STREET SEAPORT HISTORIC DISTRICT

consisted of three or four stories, topped by high-pitched slate or tile roofs and designed in the Georgian or Federal style, and contained storage lofts and a counting room for keeping accounts and records. It was from such buildings that great merchant families, including the Schermerhorns, the Macys, and the Lows, conducted their business.

The great fire of 1835 influenced subsequent development of the district, creating a demand for new warehouses and offices, which were constructed in the Greek Revival style. Many of the surviving buildings were remodeled in the new style, so that few retain much of their original Georgian detail.

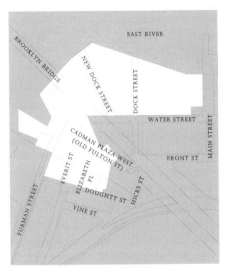

FULTON FERRY HISTORIC DISTRICT

FULTON FERRY HISTORIC DISTRICT

BROOKLYN

DESIGNATED: JUNE 28, 1977

Before it was extended with landfill in the mid-nineteenth century, this district was the waterfront site of the first ferry between Brooklyn and Manhattan. It was begun by the Dutch, who ran small, flat-bottomed boats between the two shores in the seventeenth century. In 1704, the "Road to the Ferry" was built, providing transportation to the port for farmers as far away as eastern Long Island. In 1814, a steam-propelled ferry was introduced by Robert Fulton, and the street was renamed in his honor.

The first structures built in the district were seventeenth- and eighteenth-century ferry buildings and taverns; these no longer survive. Examples of surviving nineteenth-century buildings include Federal-style houses as well as well-preserved commercial buildings in Italianate, Greek Revival, and

Romanesque Revival styles. The chief exponent of the latter was Frank Freeman, one of Brooklyn's most eminent early architects, whose Eagle Warehouse is at 28 Cadman Plaza West. In the twentieth century, Fulton Street was renamed Cadman Plaza after the popular Brooklyn preacher S. Parkes Cadman, although it is still called Fulton Street as well where it ends at the river.

With the opening of the Brooklyn Bridge in 1883, the ferry went into decline, finally closing in 1927. As a quiet backwater removed from the main channels of later development, the district has retained its nineteenth-century character. In the late 1960s, it attracted a number of preservation-minded investors who renovated many of the exteriors.

CENTRAL PARK WEST—WEST 73RD-74TH STREET HISTORIC DISTRICT

MANHATTAN

DESIGNATED: JULY 12, 1977

Originally part of a farm owned by Richard Somerindyck, the land in this district was subdivided into plots in 1835, although actual construction did not begin for almost fifty years. Edward Clark, president of the Singer Manufacturing Company, bought almost all of the land on this block between 1877 and 1881. At that time, the area was still predominantly rural, especially in comparison to the heavily populated East Side. Gas and water systems were underdeveloped and many cross streets remained unopened. The extension of

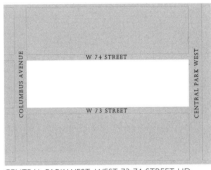

CENTRAL PARK WEST–WEST 73-74 STREET HD

the Ninth Avenue Elevated Railroad in 1879 brought more interest to the area and increased land values. A year later, construction was begun on Clark's Dakota. Called "Clark's Folly" at the time because it was a luxury apartment building built in a then-undesirable location, the Dakota became the center of a residential community. The Clark family architect, Henry J. Hardenbergh, designed the Dakota, as well as the row of houses on West 73rd Street.

The houses along West 73rd and 74th Streets display a variety of styles: German Renaissance, Georgian Revival, and Beaux-Arts. Restrictive covenants specified the setbacks and the heights of the structures, resulting in a graceful achievement in community planning. The Langham, at 135 Central Park West, a massive Beaux-Arts building of 1904–7, was one of the earliest luxury apartments on Central Park West.

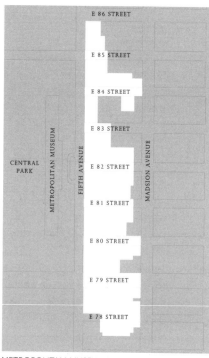

METROPOLITAN MUSEUM HISTORIC DISTRICT

ALBEMARLE–KENMORE TERRACES HD

METROPOLITAN MUSEUM HISTORIC DISTRICT

MANHATTAN

DESIGNATED: SEPTEMBER 20, 1977

Prior to the creation of Central Park in 1857, this land was an area of squatters' huts and squalid swamps. The park attracted residents, as did the Metropolitan Museum, begun in 1874. Widespread development really began in the district with the extensions of the elevated railroads along Second, Third, Park, and Madison Avenues. During this time, the area between 78th and 86th Streets was completely built up with brownstone houses. These houses were designed in the Queen Anne and neo-

Grec styles, mostly by architects who were not formally trained and who had previously been builders. Many were replaced in the early twentieth century and few remain today. By the end of the 1890s, a number of mansions had been constructed along Fifth Avenue in the upper 70s and lower 80s for such wealthy individuals as Isaac D. Fletcher and Louis Stern. Built in the François I style of the French Renaissance, the mansions gave the name "Millionaires' Mile" to this section of the avenue, and ushered in the era of large private residences. Meanwhile, major renovation of the older brownstones transformed their facades from the older neo-Grec and Queen Anne styles to the more ornate and popular Beaux-Arts and Renaissance Revival styles. Change came again to the area with the construction of Art Deco apartment buildings, predominantly in the 1920s. Thus, the variety of architectural styles shows the effects of change within a residential area.

ALBEMARLE-KENMORE TERRACES HISTORIC DISTRICT

BROOKLYN

DESIGNATED: JULY 11, 1978

The land on which these two quiet, residential courts now stand was owned by the Lott family from 1834 until 1916. Mabel Bull acquired the property and chose the architectural firm of Slee & Bryson to develop it over the following four years. The property is in the most historic section of Flatbush, near the Flatbush Dutch Reformed Church and Erasmus Hall, and it retains a tranquil character despite its proximity to the busy intersection of Church and Flatbush Avenues.

The Federal Revival brick houses that line Albemarle Terrace are raised above street level and set back behind terraces or small gardens. The two-and-one-half- and three-story dwellings are arranged symmetrically, creating a pleasing ensemble, and trees are planted in the gardens rather than along the curbs, providing a feeling of seclusion from the street.

Kenmore Terrace, stylistically joined to Albemarle Terrace by the three-story Federal Revival house at its entrance, exhibits the English garden city style in the six houses on its south side. The automobile provided a new challenge to urban planners—the need for space for the storage and parking of family cars—and the architects of Kenmore Terrace responded by incorporating garages into the ground floors of the two-and-a-half-story houses.

BROOKLYN ACADEMY OF MUSIC HISTORIC DISTRICT

BROOKLYN ACADEMY OF MUSIC HISTORIC DISTRICT

BROOKLYN

DESIGNATED: SEPTEMBER 26, 1978

Once a thirty-acre farm owned by John Jackson, the land in this district was sold and residential development begun in the mid-nineteenth century. Many of the surviving row houses were built between 1855 and 1859 by local architects. Primarily three- or four-story brick and brownstone houses, they were built on speculation for the large numbers of people who were then relocating to Brooklyn. The majority exhibit a modified Italianate style, abundant in its use of architectural detail. A few houses in the area, built during the 1870s, incorporate neo-Grec detail and have cast-iron facades, a rarity in residential architecture.

Change did not come to the area for almost fifty years after its initial development phase. In 1908, the Brooklyn Academy of Music moved to its present site at 30 Lafayette Avenue. The original Academy opened in 1861 but was destroyed by fire in 1903. The competition to design the new building was won by the firm of Herts & Tallant, which produced a large and richly detailed structure with an Italian Renaissance Revival facade. The other large-scale addition to the district was the 1929 Williamsburgh Savings Bank, whose 512-foot tower still dominates the Brooklyn skyline.

FORT GREENE HISTORIC DISTRICT

BROOKLYN

DESIGNATED: SEPTEMBER 26, 1978

Until the mid-nineteenth century, the Fort Greene area was dominated by four large farms that were subdivided for suburban "villas"—actually Greek Revival houses built from the same materials as the local farmhouses, which no longer survive. The major period of building took place between 1855 and 1875. Most of the buildings in the district are Italianate or closely related Anglo-Italianate and Queen Anne row houses, although the angular and geometric forms of the neo-Grec style of the 1870s are also in evidence.

A prominent landmark of the district is Fort Greene Park. The oldest urban park in America, it was the site of a fierce battle between the English and American forces at the beginning of the Revolution. Its conversion to a park is attributed to the poet Walt Whitman. As editor of the *Brooklyn Daily Eagle*, he argued that the land be set aside for the enjoyment of the less affluent. The park, however, deteriorated so that in 1867 the City Commissioners felt obliged to redesign it. The commission was given

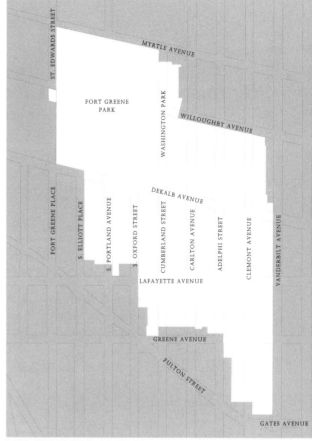

FORT GREENE HISTORIC DISTRICT

to Frederick Law Olmsted and Calvert Vaux, whose plan emphasized the long, sloping fields and views of Manhattan through the use of lawns and curved, intersecting walks. Within the park is the Prison Ship Martyrs' Monument, which contains the tombs of American prisoners who died in British prison ships during the Revolution. Designed by McKim, Mead & White, it has a monumental stairway leading to the vaults, which are surmounted by a two hundred-foot Doric column topped by a twenty-two-foot urn. It was inaugurated on November 14, 1908.

FRAUNCES TAVERN BLOCK HISTORIC DISTRICT

FRAUNCES TAVERN BLOCK HISTORIC DISTRICT

MANHATTAN

DESIGNATED: NOVEMBER 14, 1978

The block bounded by Pearl, Broad, and Water Streets and Coenties Slip was built on landfill in 1689. It is the first extension of the Manhattan shoreline for commercial purposes. The oldest surviving structure on the block is Fraunces Tavern, built in 1719. The block was almost completely built up by 1728, and soon became dominated by commercial interests. After a period of bleak commercial prospects, the block saw a revival in 1827, shortly after the opening of the Erie Canal. Eleven of the sixteen present buildings were constructed between the years of 1827 and 1833. The two most prominent styles on the block are the late Federal and Greek Revival. Red-brick facades and regularly spaced windows are characteristic of both styles. The Greek Revival commercial structures have large, open, granite storefronts featuring granite piers supporting a wide granite architrave. The red-brick facade begins above the architrave. Buildings with these characteristics are 3 Coenties Slip (1836–37), and 66 Pearl Street (1831). The New York City directory of 1851 lists the functions of various buildings on the block as freight forwarders, shipping agents, and wholesale merchants. The block retains its nineteenth-century character despite the presence of surrounding office towers.

AUDUBON TERRACE HISTORIC DISTRICT

MANHATTAN

DESIGNATED: JANUARY 9, 1979

Established on the former estate of the noted American artist and ornithologist John James Audubon, Audubon Terrace was conceived as a center for specialized research by Archer M. Huntington, a multimillionaire, philanthropist, and scholar. As a first step toward this goal, he founded the Hispanic Society of America in 1904. Buildings for the American Numismatic Society (1906–07), the American Geographical Society (1909–11), the Museum of the American Indian (1916–22), and the Church of Our Lady of Esperanza (1909–12) were soon added. The centralization of educational and cultural institutions outside of a university context was unique in America.

Huntington hoped that geographical closeness would promote cooperation among the various societies in their research fields. As a symbol of this cooperation and unity, he specified that all of the buildings be designed by his cousin Charles Pratt Huntington in an Italian Renaissance Revival style. Grouped

AUDUBON TERRACE HISTORIC DISTRICT

around a central courtyard, their monumental Ionic colonnades are faced with Indiana limestone. The American Academy of Arts and Letters and the National Institute of Arts and Letters (1921–30) were designed in the same style after Huntington's death by William Mitchell Kendall of McKim, Mead & White with Cass Gilbert. The terrace is decorated with sculpture by Anna Vaughn Hyatt Huntington and others.

Though several of the institutions have relocated and attendance remains low for those that remain, Audubon Terrace retains an innocent charm. Grand in aspirations, it is small and friendly in scale.

Prospect Park South
Historic District

Brooklyn

Designated: February 8, 1979

The development of this suburban district, the most architecturally significant in Flatbush, was spurred by the advancement of public transit, the construction of Prospect Park, and the opening of the Brooklyn Bridge, all of which contributed to the rapid growth of the City of Brooklyn. Approximately fifty acres of land, mostly belonging to the Dutch Reformed Church and the Bergen family, were purchased in 1899 by the real estate developer Dean Alvord. He hoped that Prospect Park South would "illustrate how much of rural beauty can be incorporated within the rectangular limits of the conventional city block."

After Alvord sold his interest in Prospect Park South to the Chelsea Improvement Co. in 1905, the forty-five vacant lots were filled in with new frame houses. The juxtaposition of various architectural designs typify development convention around the turn of the twentieth century: houses were built in a wide range of styles including Spanish Mission, Italian Villa, Queen Anne, Colonial Revival, and Tudor Revival. Despite the alterations many of the homes have undergone, Prospect Park South retains much of its pastoral, turn-of-the-century ambiance.

Prospect Lefferts Gardens
Historic District

Brooklyn

Designated: October 9, 1979

Originally known as Midwout, the area along what is now Flatbush Avenue was the center of the Dutch farming colonies on Long Island. The Prospect Lefferts Gardens Historic District occupies a portion of the estate of the Lefferts family, which had been prominent in Brooklyn since the seventeenth century. It was developed by James Lefferts between 1895 and 1925, with the greatest activity occurring in 1905–11, after the financial panic of 1903, which had slowed construction in the city. Lefferts planned a residential community of high quality; restrictive covenants still govern building heights, the setback from the streets, and other details intended to preserve the character of the neighborhood.

Two- and three-story row houses are interspersed with freestanding structures. The first were built in the Romanesque Revival style, although they represent a later, somewhat eclectic version. In addition to the customary rough-hewn stonework and round-arched windows and doorways, the houses often have such details as Palladian windows that reflect the classical revival at the turn of the century. There are also fine examples of the various Colonial Revival styles, such as the Federal and Georgian, as well as the Tudor Revival. Among the individual landmarks are the Lefferts Homestead and Flatbush Dutch Reformed Church.

PROSPECT PARK SOUTH HISTORIC DISTRICT

PROSPECT LEFFERTS GARDENS HISTORIC DISTRICT

587

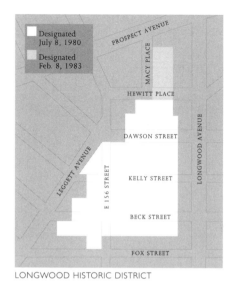

PROSPECT AVENUE

MACY PLACE

HEWITT PLACE

DAWSON STREET

LONGWOOD AVENUE

LEGGETT AVENUE

E 156 STREET

KELLY STREET

BECK STREET

FOX STREET

LONGWOOD HISTORIC DISTRICT

E 79 ST
E 78 ST
E 77 ST
E 76 ST
E 75 ST
E 74 ST
E 73 ST
E 72 ST
E 71 ST
E 70 ST
E 69 ST
E 68 ST
E 67 ST
E 66 ST
E 65 ST
E 64 ST
E 63 ST
E 62 ST
E 61 ST
E 60 ST
E 59 ST

CENTRAL PARK

FIFTH AVENUE

MADISON AVENUE

PARK AVENUE

LEXINGTON AVENUE

THIRD AVENUE

UPPER EAST SIDE HISTORIC DISTRICT

LONGWOOD HISTORIC DISTRICT

THE BRONX

DESIGNATED: JULY 8, 1980

EXTENDED: FEBRUARY 8, 1983

This district just west of Hunts Point in the South Bronx remained predominantly rural until it was transformed by plans to extend the IRT subway, which opened here in 1904. Located in a community now known as Pueblo de Mayaguez, the Longwood District was once part of Morrisania, a township of Westchester County established by the state legislature in 1788. George B. Johnson, who operated out of the S. B. White mansion (now the Patrolman Edward P. Lynch Center) at 734 Beck Street, developed almost the entire district.

Most of the houses in the primarily residential district were designed with elements of the Renaissance and Romanesque Revival styles by Warren C. Dickerson between 1897 and 1900. The semidetached residences line Dawson, Kelly, Beck, and East 156th Streets, and the north side of Marcy Place. Although house plans are repeated, the details are varied to avoid monotony.

The houses are set back from the street, a notable feature of Dickerson's designs, and the fenced-in gardens and basement areas contribute a sense of openness to the neighborhood. The irregular street plan provides long and short views.

UPPER EAST SIDE HISTORIC DISTRICT

MANHATTAN

DESIGNATED: MAY 19, 1981

The Upper East Side was originally developed as a summer retreat for downtown New Yorkers, who built estates and private houses there during the late eighteenth and early nineteenth centuries. Following the creation of nearby Central Park between 1857 and 1877, the district went through several phases of development. The first houses were brownstones built in the Italianate and Greek Revival styles of the 1860s to 1880s; examples of these may still be found on a number of side streets. Between roughly from 1880 and 1910, architectural firms such as McKim, Mead & White and C.P.H. Gilbert erected luxurious Beaux-Arts palaces and French Renaissance chateaus for some of New York's wealthiest families. A third phase, from 1910 to 1930, saw a waning of the late-nineteenth-century taste for opulent and eclectic styles and a corresponding rise in the demand for classical forms. The neoclassical revival spurred many owners to redesign the facades of their buildings.

It was also during the early 1910s that the first luxury apartment buildings were constructed on the Upper East Side. These are distinguished by a sense of scale and proportion in relation to surrounding structures, giving the neighborhood a unique balance between the larger apartment buildings situated on major avenues and the smaller buildings on the side streets.

DITMAS PARK HISTORIC DISTRICT

DITMAS PARK HISTORIC DISTRICT

BROOKLYN

DESIGNATED: AUGUST 29, 1981

Ditmas Park is one of several suburban neighborhoods built on the old farms of Flatbush after the opening of the Brooklyn, Flatbush, and Coney Island Railroad (now the Brighton Line of the BMT/IND) in the 1880s. It was created in 1902 by realtor Lewis H. Pounds, who purchased part of a large farm owned by the Ditmarsen family since the late seventeenth century. A land of high ridges, valleys, and no roads, it was leveled and divided according to a grid plan. Pounds established many restrictive covenants to preserve the suburban character of the area. All of the houses were originally single-family, two-story structures with attics, fronted by deep lawns and sidewalk malls with shrubs and flowers.

Most of the houses in Ditmas Park represent a free adaptation of colonial architecture, whose revival in the late nineteenth century was preceded by more than a decade of intense interest in seventeenth- and eighteenth-century traditions. Finished in clapboard and shingle, the houses are notable for the nostalgic adaptation of such elements as hipped and peaked roofs, dormer windows, columnar porches, splayed lintels, and Palladian windows. Later buildings include Tudor Revival houses with pseudo-half-timbered gables, brick siding, and leaded windows. The most unusual houses are thirteen bungalows on East 16th Street that adapt a Californian form to the eastern climate. Ditmas Park also contains the Flatbush-Tompkins Congregational Church, considered to be New York City's finest Georgian Revival religious building.

CLINTON HILL HISTORIC DISTRICT

BROOKLYN

DESIGNATED: NOVEMBER 10, 1981

Clinton Hill was originally farmland, owned principally by the Ryerson family. In the 1830s, it began to be divided and sold off for residential development. By 1880, the area became a suburban retreat, with villas on Clinton and Washington Avenues, surrounded by brownstones, stables, and carriage houses.

In the late nineteenth and early twentieth centuries, the area began to attract some of Brooklyn's wealthiest residents. Mansions replaced the old suburban villas, which lacked modern conveniences and were considered unfashionable. This second period of growth began in 1874

CLINTON HILL HISTORIC DISTRICT

when Charles Pratt, John D. Rockefeller's partner in the Standard Oil Company, erected a mansion for himself at 232 Clinton Avenue, and built four other residences as wedding presents for his sons. Other millionaires moved here, influenced by Pratt's commitment to the area, and Clinton Avenue became known as the "Gold Coast" of Brooklyn.

With the emergence of Manhattan as the preeminent borough, the very wealthy left Clinton Hill. By the 1920s most of the old residences had been destroyed or divided into apartments and rooming houses. Four of the Pratt mansions still exist today at 229, 232, 241, and 245 Clinton Avenue. Some of the finest residences in the area were purchased by or donated to the Pratt Institute and St. Joseph's College.

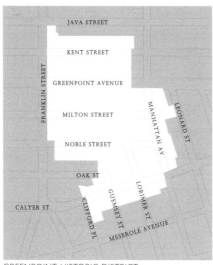

GREENPOINT HISTORIC DISTRICT

GREENPOINT HISTORIC DISTRICT

BROOKLYN

DESIGNATED: SEPTEMBER 14, 1982

The site of several large farms in the seventeenth and eighteenth centuries, Greenpoint became one of the most important industrial centers on the eastern seaboard. The mid-nineteenth century witnessed the flourishing of shipbuilding, as well as the growth of such related industries as iron and brass foundry. By the turn of the century, Greenpoint was a center not only for such major industries as china, glass, and oil, but also drugs, sugar refining, furniture, and many others.

In contrast to residents of Brooklyn Heights and Park Slope, who commuted to work, those who lived in Greenpoint worked in the plants and factories nearby. The neighborhood contains substantial row houses erected for owners of businesses and more modest row houses and apartments built for factory workers.

Most of these were designed by builders working from handbooks and using standardized cornices, windows, doors, and other architectural elements that could be purchased ready-made. Their work typically represents the vernacular version of a contemporary style. Rows of Italianate, French Second Empire, neo-Grec, and Queen Anne houses often have nearly identical lintels, iron railings, and shutters. In addition to the row houses, Greenpoint offers good examples of church architecture in both the Gothic and Romanesque Revival styles, and frame houses, which were often built by ship carpenters.

MORRIS HIGH SCHOOL HISTORIC DISTRICT

THE BRONX

DESIGNATED: DECEMBER 21, 1982

This section of the Bronx was once part of Morrisania, a township of Westchester County that was formally annexed to New York City in 1874. The region is named for two British officers, Colonel Lewis Morris and his brother Richard, who purchased a tract of land here in 1670. Though the construction of the Harlem and Hudson River Railroads and the creation of a brewing industry in the area helped populate Morrisania, the neighborhood remained largely rural until the beginning of the twentieth century. The real estate boom that completed Morrisania's development was spurred by the extension of the subway into the district and the opening of

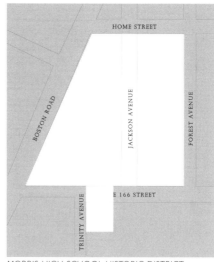

MORRIS HIGH SCHOOL HISTORIC DISTRICT

Morris High School in 1904. The modest Trinity Episcopal Church, begun in 1874, across from the high school at the corner of Trinity Avenue and East 166th Street, is the oldest original structure in the district, but was redecorated in High Victorian Gothic style in 1906.

The residences in the district are mainly two- and three-story brick row houses, designed by local architects in a free classical manner, incorporating elements of the English, Flemish, and Italian Renaissance revivals, and built primarily between 1900 and 1904. Richly detailed with cohesive block fronts, these houses along Forest and Jackson Avenues enhance the turn-of-the-century atmosphere of the district.

West End–Collegiate Historic District

Manhattan

Designated: January 3, 1984

This area of the Upper West Side remained predominantly farmland until the 1880s, when the extension of the Ninth Avenue Elevated Railroad made it more accessible and the creation of Riverside Park provided an inducement to live there. Land speculation increased and the construction of private residences began. During this period, what is generally regarded as the most elaborate and eclectic collection of row houses in New York was built in the West End–Collegiate district. The houses derived their stylistic inspiration from Romanesque, Renaissance, Elizabethan, and François I designs. Particularly notable are the houses by Lamb & Rich on West End Avenue between West 76th and 77th Streets, and those by Clarence F. True on Riverside Drive.

The next phase of building in the area lasted from 1911 through 1931 and resulted in the construction of eight large apartment houses, whose architects—among them Emery Roth and Schwartz & Gross—emulated the styles and materials of the already existing row houses, providing a counterpoint to the smaller-scale houses.

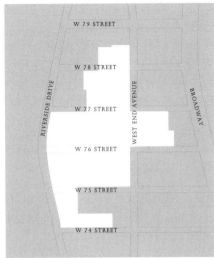

WEST END–COLLEGIATE HISTORIC DISTRICT

New York City Farm Colony–Seaview Hospital Historic District

Staten Island

Designated: March 26, 1985

The New York City Farm Colony was built on the site of the former Richmond County Poor Farm in 1902. Established to house and aid the able-bodied poor, the institution was predicated on the idea of the exchange of labor for shelter and food, although work was not compulsory. The first dormitories opened in 1904. Although three architects were involved—Raymond F. Almirall, Frank H. Quimby, and William Flanagan—their designs share the vocabulary of the so-called Dutch Colonial Revival style. The use of brick and fieldstone, gambrel roofs, and classical porticoes evoke the Colony's history as a farming community.

In 1915, the New York City Farm Colony was merged with Seaview

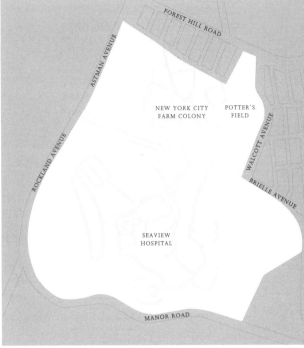

NEW YORK CITY FARM COLONY–SEAVIEW HOSPITAL HISTORIC DISTRICT

Hospital, which had been constructed on adjacent land. When it opened in 1914, it was the largest institution in the world dedicated to the cure of tuberculosis. Red tile roofs, stuccoed walls, and tile and mosaic decoration recall Spanish Mission architecture, but according to the architect, Raymond F. Almirall, these were chosen without regard to their historical or geographical character. The eight pavilions—four survive—provided views of land and sea and sunlit rooms year-round, as contemporary medical theory stressed the importance of pleasant surroundings to tubercular patients. After the discovery of a cure for tuberculosis in the late 1950s, Seaview was turned over to various community service offices.

RIVERSIDE DRIVE–WEST 80TH-81ST STREET HISTORIC DISTRICT

MANHATTAN

DESIGNATED: MARCH 26, 1985

Although it retained much of its rural atmosphere into the middle of the nineteenth century, the Upper West Side had been slated for development is early as 1811, when the engineer John Randel, Jr., drew up a street plan for the city's Board of Governors. Randel's plan, an extension of the grid plan of Lower Manhattan, was abandoned in 1867 when it became evident that the downtown street plan had dealt poorly with the congestion caused by development. Frederick Law Olmsted was given the task of designing Riverside Park and Drive, as well as some new streets and avenues. His plan took advantage of the contours of the land, creating gently curving roads and scenic perspectives. By the turn of the century, the area had become one of New York's most desirable neighborhoods.

The streets were relatively untouched by the wave of apartment house construction in the area that followed World War I. Their buildings are largely the work of two architects, Charles H. Israels and Clarence F. True. Influenced by the Beaux-Arts style of McKim, Mead & White, their designs are generally freer and more picturesque, utilizing such medievalizing details as bowfronts, oriels, parapets, and chimneys, and embellished with Roman brick, brownstone, limestone, leaded glass windows, terra-cotta, tile, and wrought iron.

RIVERSIDE DRIVE–WEST 80TH-81ST STREET HD

MORRIS AVENUE HISTORIC DISTRICT

MORRIS AVENUE HISTORIC DISTRICT

THE BRONX

DESIGNATED: JULY 15, 1986

This double row of two-family row houses and tenements along Morris Avenue between East 179th Street and East Tremont Avenue was built over a four-year period by August Jacob. Vast real estate speculation and a growing market for single-family dwellings developed in the Bronx with the extension of the IRT in 1904. The Morris Avenue district was designed by architect John Hauser to fill the needs of people seeking to move out of the increasingly crowded borough of Manhattan.

The block of Morris Avenue that comprises this residential district was once a tiny portion of the 3,200-acre Manor of Fordham. After changing ownership several times, the property was purchased by Jacob from the United Real Estate and Trust Company and developed in five building campaigns between 1906 and 1910. The mostly three-story, curved bow facade row houses are surprisingly homogeneous considering they were built in several stages. There are differences of detail, such as varying shades of brick and diverse patterns in the wrought-iron areaway railings. Along with the two tenement buildings on Tremont Avenue, these houses represent an intact early-twentieth-century neighborhood.

TUDOR CITY HISTORIC DISTRICT

MANHATTAN

DEVELOPER: FRED F. FRENCH COMPANY

ARCHITECT: H. DOUGLAS IVES

DESIGNATED: MAY 17, 1988

In a pioneering venture in urban renewal, Tudor City, a complex of apartment buildings overlooking the East River, was built to help ensure middle-class respectability in midtown Manhattan's East Side, a formerly working-class neighborhood of row houses and tenement buildings. The ten original residential buildings are in the Tudor Revival style, with elaborate skyline profiles complemented by scaled-down street levels and stained-glass windows, some illustrating scenes from New York's history.

TUDOR CITY HISTORIC DISTRICT

Considered a "city within a city," the district provides a generous amount of open space, including two private greens, two open parks, and a landscaped core, called Tudor City Place, with shops and services for tenants. The original scheme even included a small eighteen-hole golf course, complete with traps, nighttime illumination, and a golf pro. Tudor City was a prophecy of subsequent twentieth-century planned urban communities.

LADIES' MILE HISTORIC DISTRICT

MANHATTAN

DESIGNATED: MAY 2, 1989

Once the fashion center of New York's Gilded Age, this area was for the stylish women who shopped for French gloves, Japanese sunshades, bonbons, umbrellas, corsets, and other glamorous trifles. The area's financial success was ensured in 1860 by the Prince of Wales's stay at the Fifth Avenue Hotel on 23rd Street. Where princes led, society followed, and the commercial rush began in the early 1860s with A. T. Stewart's cast-iron retailing palace at Broadway and 9th Street.

B. Altman, Lord & Taylor, Arnold Constable, W. & J. Sloane, Tiffany & Co., Gorham Silver, and Brooks Brothers all located their stores here to cater to the emerging "carriage trade." The opulence of the area drew America's first ladies, those from high society as well as the undeniably famous: Ethel Barrymore, Lillian Russell, Isabella Stewart Gardner, and Lillie Langtry. Restaurants, professional offices, piano showrooms, publishing houses, booksellers, the Academy of Music, Steinway Hall, and the first Metropolitan Museum of Art further enhanced the ambience.

The growing commercialization of the district eventually drove its more fashionable residents—Emily Post, Washington Irving, Samuel F. B. Morse, Edith Wharton, Horace Greeley, and the Roosevelt family—uptown. By the end of World War I, most of the department stores had moved their operations further north, and the lavish buildings were converted to manufacturing use. However, the elegant structures remain as silent witness to a much-romanticized era, one characterized by gaslight, glitter, and glamour.

LADIES' MILE HISTORIC DISTRICT

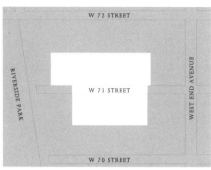

WEST 71ST STREET HISTORIC DISTRICT

West 71st Street Historic District

Manhattan

Designated: August 29, 1989

The West 71st Street Historic District encompasses thirty-three buildings that occupy nearly an entire block between West End Avenue and the railroad tracks, shielded by a wall, to the west. It is significant both for its display of Upper West Side residential development and for the original Renaissance Revival details that remain on many of the individual buildings.

The designs of the houses were primarily influenced by the Beaux-Arts movement, and they display various interpretations of Renaissance prototypes in their decoration and detail. The regular rhythms of bays, cornices, and oriels along the buildings lining both sides of the street lend order and symmetry to this block, yet allow each building to retain its own character.

The architects include Horgan & Slattery, known for both institutional and residential designs; John C. Burne and Neville & Bagge, who were active throughout Manhattan; and George

Keister, who is also known for his theater designs. The houses along this peaceful block have not been markedly altered over the years. The historic district remains a unique sampling of Renaissance Revival architecture from an active period of development on the Upper West Side.

Riverside–West End Historic District

Manhattan

Designated: December 19, 1989

Once called the "Acropolis of the world's second city," this district offers outstanding views of the Hudson River and Riverside Park. The early Upper West Side real estate boom is recalled by the remaining harmonious groups of Renaissance Revival, Georgian Revival, and Beaux-Arts row houses, many built by Clarence F. True, C. P. H. Gilbert, and Alexander Welch.

The district also includes many pre- and post–World War I apartment buildings. These early six- and seven-story elevator flats, related in materials, style, and ornament to the row houses, reflect the growing acceptance of luxury apartment living for prosperous residents. Postwar construction lined the avenues with fifteen-story apartment houses offering smaller, less expensive flats. Their modesty is reflected in the restrained facade treatments, with ornamental programs inspired by the Beaux-Arts, Gothic, Renaissance, and Romanesque styles generally restricted to the base and upper levels. Only a few

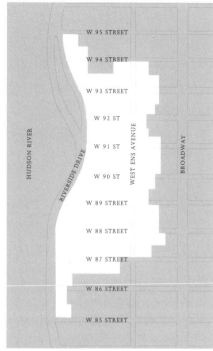

RIVERSIDE–WEST END HISTORIC DISTRICT

buildings in the district were constructed after the Depression, among them Emery Roth's 1939 Normandy, a notable combination of Italian Renaissance and Art Moderne.

Riverdale Historic District

The Bronx

Designated: October 16, 1990

The Riverdale area, along the east bank of the Hudson River, was part of the large region inhabited by the Mahican Indians until 1646, when it came under control of Adriaen Van der Donck, a Dutch trader. Although the area remained relatively untouched, the land immediately acquired a higher

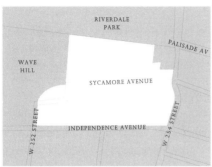

speculative value upon the completion of the Hudson River Railroad in 1849. A group of influential and wealthy businessmen purchased a one hundred-acre parcel in 1852 and founded Riverdale, which was to serve as a suburban summer community. Riverdale was for a time the only stop on the railroad between Spuyten Duyvil and Yonkers. The earliest known railway suburb of New York City, Riverdale was prototypical in its picturesque layout, which was conscientiously adapted to the topography.

The district itself corresponds to the seven original estates linked by a carriage alley, now Sycamore Avenue. Encompassing about fifteen acres of steeply sloping land overlooking the Hudson River and the Palisades, it comprises thirty-four buildings. These include villas of the 1850s with their later alterations; stables and carriage houses of the nineteenth and early twentieth centuries, later converted to residential use; and traditional houses from the first half of the twentieth century. All are sited to take advantage of the original landscaping and topography of the seven estates, including stone borders and retaining walls, terraces,

steps, paths and driveways, cobbled street gutters, individual specimen trees, and rows of trees and hedges.

UPPER WEST SIDE–CENTRAL PARK WEST HISTORIC DISTRICT

MANHATTAN

DESIGNATED: APRIL 24, 1990

This district incorporates two smaller, pre-existing districts that focused on Central Park West and the adjacent side street blocks: Central Park West at West 73rd-74th Streets and Central Park West at 76th Street. Known before its urbanization as "Bloomingdale," the area was developed primarily as a residential neighborhood over a fifty-year period beginning in the 1880s. Bloomingdale Road, later Broadway, followed an old Indian trail and was the northern route out of New York, past rural lodges and old shanties. The area remained largely undeveloped until the 1880s, when the extension of horsecar lines up Broadway and Amsterdam Avenue and the completion of the Columbus Avenue elevated railway linked this area with the commercial and financial centers.

Building types and styles range from busy storefronts on Columbus Avenue to residences on quiet side streets to dramatic apartment towers along Central Park West. The first building boom in the area is reflected in the row houses that dominate the side streets. Contemporary with these are the five- and six-story tenements and apartment buildings on Columbus and Amsterdam Avenues.

Later construction, particularly in the

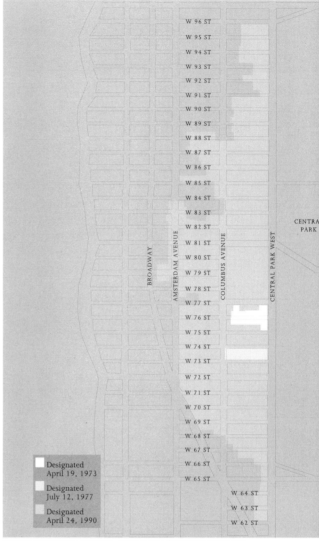

Designated
April 19, 1973

Designated
July 12, 1977

Designated
April 24, 1990

1920s and 1930s, added the distinctive skyline of tall apartment buildings along Central Park West. These are among the finest examples of three trends in twentieth-century residential architecture: Beaux-Arts from the first decade, neo-Renaissance from the 1920s, and Art Deco from the 1920s and 1930s.

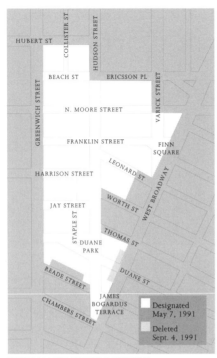

TRIBECA WEST HISTORIC DISTRICT

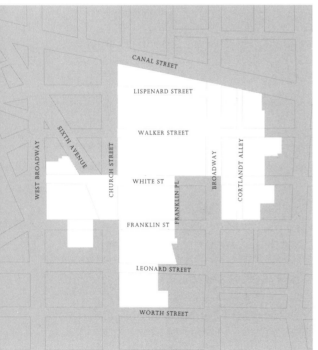

TRIBECA EAST HISTORIC DISTRICT

TRIBECA WEST HISTORIC DISTRICT

MANHATTAN

DESIGNATED: MAY 7, 1991

EXTENDED: SEPTEMBER 4, 1991

Upon the completion in 1825 of the Erie Canal, New York City became the pre-eminent port and trading center of the United States. Larger commercial ships that had once gingerly traversed the narrow East River could now be accommodated on the more easily navigable Hudson River. This new traffic also facilitated the development of markets for perishable goods on the west side of what is now known as Tribeca—the Triangle Below Canal Street.

The Washington Market, originally built in 1812 to the southwest, gradually expanded into this district and by the early 1880s had become New York's primary wholesale and retail produce outlet, offering imported cheeses, quail, squab, wild duck, swordfish, frogs' legs, venison, and bear steaks. The warehouses that were erected to store this bounty are the focal point of the Tribeca West Historic District.

The commercial vitality of the district is recalled by the buildings that form its dominant architectural character. Constructed between 1860 and 1910, these functional yet decorative stores and lofts include utilitarian structures derived from vernacular building traditions; others more consciously imitative of the popular period styles, such as Italianate, neo-Grec, Romanesque Revival, and Renaissance Revival; and the later, high-style warehouses that reflect their architects' interest in creating a particularly American building type. The buildings are unified by scale, building material, and ground-floor treatment—cast-iron piers and canopies rise above stepped vaults and loading platforms. Folding iron shutters, massive wooden doors, granite-slab sidewalks, and Belgian-block street pavers enhance the district's unique architectural flavor.

TRIBECA EAST HISTORIC DISTRICT

MANHATTAN

DESIGNATED: DECEMBER 8, 1992

These imposing brick buildings symbolize how important the businesses and merchants in this area were to the flourishing city and nation. Though utilitarian in function, the structures borrowed materials and a style ordinarily reserved for more prestigious buildings. Executed in an Italianate manner and built largely in the mid-1800s, some of these five-story loft and store buildings demonstrate the greater degree of ornamentation available to the metal fabricator. In contrast to earlier stone post-and-lintel storefronts, the new cast-iron and glass storefronts provided better illumination to the principal selling space and enhanced the display of merchandise.

The facade designs suggest the profound impact of Italian Renaissance palazzo architectural devices introduced by Joseph Trench and John B. Snook in their design of a marble-faced department store for A. T. Stewart's highly successful business.

TRIBECA SOUTH HISTORIC DISTRICT

MANHATTAN

DESIGNATED: DECEMBER 8, 1992

EXTENDED: NOVEMBER 19, 2002

This district is characterized by a row of well-preserved five-story store and loft buildings that were constructed in the mid-1800s. The buildings differ in their Italianate detailing—window openings are variously emphasized, for example, by pediments, arched hoods, or flat lintels. The widths of the buildings vary from three to six bays and collectively create continuous, strikingly unified streetscapes crowned by deep cornices. At street level they are linked by the rhythmic patterns created by the succession of columned cast-iron and glass storefronts.

Important cast-iron-fronted structures include the Gary Building, which has retained ornamental cast-iron facades on the Chambers and Reade Street elevations. The 147 West Broadway Building, built in 1969, provides a rare example of cast-iron cladding designed to mimic ashlar construction.

The district is representative of the once-much-larger wholesale district, dominated by the textile and dry-goods trade, that developed northward from Cortlandt Street following the destruction of the earlier dry-goods district on Pearl Street in the fire of 1835. After the Civil War, as the dry-goods trade moved north, hardware and cutlery merchants occupied the buildings, maintaining the mercantile nature of this district.

TRIBECA NORTH HISTORIC DISTRICT

MANHATTAN

DESIGNATED: DECEMBER 8, 1992

Most of the buildings in this district were constructed between 1880 and 1913, and they represent the last remnants of the once-thriving warehouse and manufacturing industries on the Lower West Side, an area that played a major role in the emergence of New York City as an international port and a major industrial center.

The district contains some of New York's largest late-nineteenth-century brick warehouses and earliest surviving industrial buildings. Notable among these is a storage warehouse at 461–469 Greenwich Street that was built in 1880 in the Renaissance Revival style. One of the earliest storage warehouses, this six-story brick building is constructed in fireproof sections of approximately 30 by 100 feet, each section served by a separate lift. Currently being used as a warehouse, another massive brick structure on Laight Street, between West and Washington streets, appears to be a pre–Civil War sugar refinery.

Additional interesting buildings in the area include the ten-story Fairchild Brothers and Foster pharmaceutical factory—designed in 1899 by Thomas R. Jackson at 76 Laight Street—and the 1913 Independent Warehouse Inc. and Erie Railroad Greenwich Street Station at 415–427 Greenwich Street.

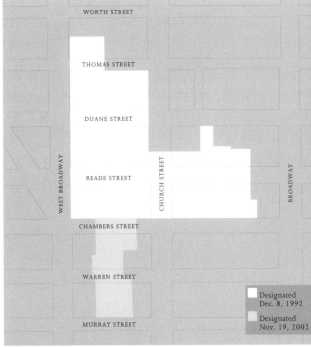

TRIBECA SOUTH HISTORIC DISTRICT

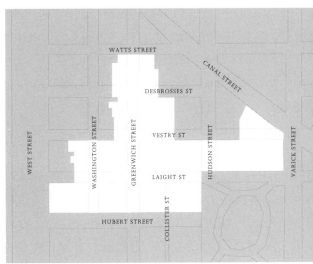

TRIBECA NORTH HISTORIC DISTRICT

597

AFRICAN BURIAL GROUND & THE COMMONS HD

JACKSON HEIGHTS HISTORIC DISTRICT

AFRICAN BURIAL GROUND AND THE COMMONS HISTORIC DISTRICT

MANHATTAN

DESIGNATED: FEBRUARY 23, 1993

This district was designated for the historical and archaeological importance of the ground on which it is situated, as it contains material from the earliest Dutch, African, and English settlements. A number of landmark buildings (City Hall, 52 Chambers Street, Surrogate's Court, Sun Building, and the Parking Violations Bureau) are located here.

Originally set aside as the Commons by the Dutch, this land has been one of the centers of New York's civic life since the seventeenth century. The English established the city's northern border—eventually with a palisades wall—midway through the Commons, at today's Chambers Street. Before the French and Indian War (1754–63), the southern half was converted into a military grounds, and, after independence, into City Hall Park and the seat of New York City government.

By the 1700s, the African population, including freed slaves as well as domestic and skilled slaves, accounted for approximately one of every seven city residents. New York's emancipated Africans were forced to bury their dead outside of the city, on the north side of the palisades. In the early nineteenth century, as the city expanded northward, the African burial ground was built over with residential, commercial, industrial, and public buildings.

JACKSON HEIGHTS HISTORIC DISTRICT

QUEENS

DESIGNATED: OCTOBER 19, 1993

The openings of the Queensborough Bridge in 1909 and the Roosevelt Avenue elevated subway line in 1917 encouraged the development of residential areas in northern Queens. About that time, Edward A. McDougall, president of the Queensboro Corporation real estate development firm, initiated the construction of a planned community in Jackson Heights for the managerial and professional class, inspired by the Garden City movement.

Eschewing the one-building-per-lot configuration, the planners used the full block as the unit of design for apartment houses surrounding spacious central gardens. These allowed for more effective use of space within the units, as well as ample light and ventilation. The buildings are typically about six stories high, with simple facades and details in the English, Spanish, and Italian modes. Later, designers created attached and semidetached single-family "garden homes," set back from the street and typically finished in the Georgian or Tudor Revival style.

The buildings in this district, most of which date between 1911 and 1950, demonstrate the integration of new types of housing with commercial, institutional, recreational, and transportation facilities. The area showcases many of the earliest examples of what became standard middle-class living, and it continues to be a vibrant community.

ELLIS ISLAND HISTORIC DISTRICT

MANHATTAN

DESIGNATED: NOVEMBER 16, 1993

As the flow of eastern and southern European immigration to the United States surged in the late nineteenth century, New York's modest processing center at Castle Clinton in the Battery became inadequate. In 1892, the federal government assumed control of immigration and relocated to the site of Fort Gibson on Ellis Island. The massive complex that stands today was begun in 1897, after the original station was destroyed by fire.

This district, situated in New York Harbor, encompasses the Ellis Island Federal Immigration Station. Efficient control of immigration procedures dictated Ellis Island's design and architecture. The complex of some thirty interconnected structures, built between the 1890s and the 1930s, includes major portions designed in a monumental Beaux-Arts style by the firm of Boring & Tilton, under the supervision of James Knox Taylor. One is the imposing brick-and-stone Main Building, which houses the Registry Room. The structures rest on a largely artificial, twenty-seven-and-one-half acre, E-shaped island, which was created solely to accommodate the immigration station. The island is composed of three land masses: the original island on which the Main Building sits, and two manmade islands—now connected—made of subway tunnel fill, which support medical, administrative, and dormitory buildings.

ELLIS ISLAND HISTORIC DISTRICT

Prior to the restrictive Immigration Act of 1924, Ellis Island processed approximately 12 million steerage-class (lower than third-class) immigrants; today, their descendants represent more than one-third of all Americans. Although immigration declined mark-edly after 1924, Ellis Island served an array of government functions until 1954. In 1965, it was made part of the Statue of Liberty National Monument, although it remained abandoned until the mid-1980s, when the Statue of Liberty centennial piqued interest in the island. In 1990, the National Park Service renovated and reopened the Main Building as the Ellis Island Immigration Museum, which it operates. Except for the restored portion, Ellis Island's structures are in very poor condition. On March 31, 1997, an arbitrator appointed by the Supreme Court deemed that the island be divided between New York and New Jersey, who have been at odds over its ownership for two hundred years. If the ruling is sustained, the original island, including the museum, would remain under New York's jurisdiction, while New Jersey would gain control over the twenty-two acres of added landfill.

599

MOTT HAVEN EAST HISTORIC DISTRICT

Mott Haven East Historic District

The Bronx

Designated: April 5, 1994

This two-block district, a small enclave between East 139th and East 140th Streets, is a rare island of original construction that survived the massive demolitions of the 1960s and 1970s in the economically depressed South Bronx. Mott Haven had been connected to Manhattan by rail as early as 1841, but it was the Third Avenue elevated train and several new bridges across the Harlem River in the 1880s that made real estate development in the Bronx profitable. This district is composed of lower- and middle-income housing groups, constructed between 1887 and 1903, that comprise a sort of "museum" of late-nineteenth-century speculative housing. There are several groups of two-and-a-half-story neo-Grec, Queen Anne, and Romanesque Revival row houses, as well as Romanesque and Renaissance Revival Old and New Law tenements.

The area was named for industrialist Jordan L. Mott, who located his home

and his ironworks factory in the South Bronx in 1828. Most of Mott Haven's original population was of Irish or other European origins. It remained a European-immigrant enclave through much of the twentieth century, while the surrounding areas became populated mostly by African Americans. The majority of the neighborhood is now of Latino descent. Despite the decline of the surrounding neighborhoods, the blockfronts of this district retain a high degree of their architectural integrity.

Clay Avenue Historic District

The Bronx

Designated: April 5, 1994

This district's land was once part of Fleetwood Park, an 1871 trotting track owned by William H. Morris of the landowning family for whom the Bronx town of Morrisania was named. The Fleetwood was maintained by the Driving Club of New York (whose members included the Vanderbilt, Rockefeller, and Whitney families), which was able to thwart the city's consistent efforts to develop the land. After the Third Avenue elevated train opened in 1888, however, property values rose and Morris's heirs closed the track in 1898, eventually selling the land in 1901.

This area is among the most uniform streetscapes in the Bronx. Developer Ernest Wenigmann built twenty-eight semidetached, two-family, Romanesque Revival houses dating from 1901. Intended to look like single-family buildings, they were rented primarily to

CLAY AVENUE HISTORIC DISTRICT

white-collar professionals. A single one-family house from 1906 was built by hardware manufacturer Francis Keil. Wenigmann also put up three New Law tenement apartment buildings in 1909–10. Designed by the firm of Neville & Bagge, they have neo-Renaissance details, and were built for working-class renters. Over the years, many of the buildings have undergone interior renovations—especially subdivisions during the 1940s and 1950s—but the exteriors remain largely intact. Today, the tree-lined street remains fully occupied and well maintained despite the general deterioration of the surrounding area.

St. George/New Brighton Historic District

Staten Island

Designated: July 19, 1994

This seventy-eight-building district, developed in distinct phases, lies along northern shore of Staten Island. The New Brighton Association began construction in the 1830s, hoping to take advantage of the new steamboat ferry service. Although that venture collapsed, the name has remained, along with four Greek Revival houses, and a distinctive crescent street plan, which follow the curves of a steep incline. Several Italianate and Second Empire structures also survive from the post–Civil War period.

In the 1880s, the ferry lines were consolidated, and the St. George terminal became the sole landing, giving the neighborhood its current name. Reportedly, ferry and railroad magnate Erastus Wiman derived the name from George Law, a financier for whom he promised canonization in return for backing the terminal plan. The majority of the houses were constructed in the 1880s and 1890s, and reflect a combination of Queen Anne, Colonial Revival, and shingle styles.

Following the consolidation of New York City in 1898, the Staten Island borough government moved from Richmondtown to St. George in 1906. This, coupled with the municipal takeover of the ferry in 1905, focused attention on the district. The historical significance of the St. George district comes in part from the prominence of some of its early residents, including the founders of such important local institutions as the Staten Island Institute of Arts and Sciences and the Staten Island Women's Club. By the 1950s, however, middle-class residents were abandoning St. George. In the 1970s, houses that had been multiple dwellings were restored to one- or two-family use, and it has again become a vibrant neighborhood.

Bertine Block Historic District

The Bronx

Designated: April 5, 1996

In the 1890s, developer Edward Bertine and architect George Keister built several groups of row houses in this once industrial South Bronx neighborhood. Among these is the Queen Anne–style Bertine Block, for which the district is named. This group of buildings is constructed of brick, stone, slate, and stained glass. Most have tall chimneys rising above such diverse rooflines as mansards and flat roofs, pediments, and steeped and scrolled gables. The brickwork is highly patterned, and the fenestration is varied. The district also contains eight low-income tenement buildings, erected in 1897 and 1899, which have Renaissance-inspired details and five-room, railroad-flat layouts.

The district was physically unchanged from 1900 until World War II. After the war, however, many of the town houses were subdivided, and several adjacent apartment buildings were combined. By the 1970s, entire neighborhoods, including those adjacent to the Bertine

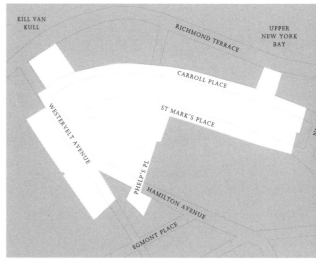

ST. GEORGE/NEW BRIGHTON HISTORIC DISTRICT

BERTINE BLOCK HISTORIC DISTRICT

Block Historic District were being demolished to make space for warehouses and housing projects. Today, the surviving thirty-one buildings that compose this district occupy than one-half of a block in economically depressed Mott Haven. Several of the buildings are currently unoccupied, and many of the structures are in disrepair.

the island's historic resources.

Between 1902 and 1912, the area of Governors Island was doubled to a quarter square mile using landfill from subway construction. This historic district covers 70 percent of the island, including the entire original island and a portion of the fill area. It also contains one hundred buildings dating from the early eighteenth century to the 1980s. Five of these are individually designated: Governor's House, Fort Jay, Castle Williams, Admiral's House, and Block House, McKim, Mead & White's Building 400 (1929–30) is also noteworthy. It was the first structure built to house an entire regiment (1,375 men), making it the largest military building in the world at that time.

STONE STREET HISTORIC DISTRICT

mercantile architecture, reflected the increasing commercialization of lower Manhattan. Adhering to the then ubiquitous Greek Revival style, the buildings are austere four- and five-story brick structures with simple granite pier-and-lintel storefronts. A later structure, the 1851 India House, is a rare example of the Anglo-Italianate style that once typified the Financial District.

The area was largely ignored during the later 1800s as commerce moved toward Midtown. At the turn of the century, an eclectic neo-Dutch Renaissance and neo-Tudor block emerged along the back of many of the Stone Street buildings, reorienting their addresses to South William Street. By the 1970s, the area was again commercially depressed and on the verge of changes that challenged the historic integrity of the area.

In 1995, Beyer Blinder Belle proposed a master plan for the rehabilitation of the neighborhood.

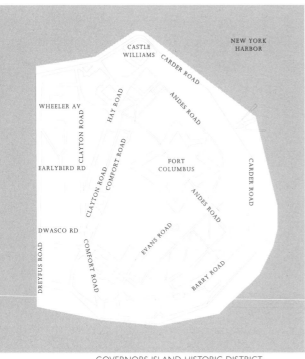

GOVERNORS ISLAND HISTORIC DISTRICT

GOVERNORS ISLAND HISTORIC DISTRICT

MANHATTAN

DESIGNATED: JUNE 18, 1996

The first Europeans to occupy this island, located one-half mile south of Manhattan, were the directors of the Dutch New Netherland Colony. Its name derives from its role as the estate of the Governors of the English Colony of New York. The U.S. Army maintained a base on the island from 1821 until 1966, and it became the U.S. Coast Guard's largest installation. The Coast Guard sold the island to New York City and New York State in 2003. Prior to the sale of the land, the Historic American Buildings Survey conducted an extensive study of

STONE STREET HISTORIC DISTRICT

MANHATTAN

DESIGNATED: JUNE 25, 1996

Built on the original Dutch colony street plan, the Stone Street district's two blocks wind through a rare surviving cluster of fifteen buildings, dating primarily from the 1830s, amidst the skyscrapers of the Financial District. When England seized the colony in 1664, this area became the "English Quarter" in what remained essentially a Dutch city. The colony's Jewish population also lived here. North America's oldest Jewish congregation, Shearith Israel, held its first services—clandestinely—in 1654.

The neighborhood was gutted by the Great Fire of 1835, and the reconstruction, prototypical of nineteenth-century

VINEGAR HILL HISTORIC DISTRICT

VINEGAR HILL HISTORIC DISTRICT

BROOKLYN

DESIGNATED: JANUARY 14, 1997

In 1798, the British Army crushed an Irish revolution at the Battle of Vinegar Hill in County Wexford, Ireland. Many Irish immigrated to New York in the aftermath, and a significant number of them settled between the current sites of the Brooklyn Bridge and the Navy Yard. John Jackson, a wealthy shipbuilder who owned that land, renamed it Vinegar Hill in honor of the Irish patriots. In 1801, the U.S. Government established the Navy Yard. During the War of 1812, it grew rapidly, as did neighboring Vinegar Hill, where most of the workers lived. By the turn of the century, the district was a dense residential, industrial, and commercial neighborhood.

By the 1950s, the Manhattan Bridge approach, new warehouses and factories, and the Brooklyn-Queens Expressway all but obliterated the existing neighborhood. The Navy Yard closed in 1966, resulting in the demise of many nearby warehouses and factories. But starting in the 1970s, diverse newcomers began to arrive in the all but abandoned area, rehabilitating homes and converting many warehouses into loft space.

This designation covers three isolated pockets containing thirty-nine buildings, mostly Greek Revival row houses, dating from 1830 to 1850. In Vinegar Hill, the style is expressed with pedimented windows and doors, denticulated cornices, and acanthus-leaf ironwork.

DOUGLASTON HISTORIC DISTRICT

QUEENS

DESIGNATED: JUNE 24, 1997

The Douglaston Historic District reflects three centuries of Queens history and development and provides an important example of an early-twentieth-century planned suburb adapted to the site of a nineteenth-century estate. The property, seized by Thomas Hicks in the 1660s, was acquired for agricultural use by Wynant Van Zandt, a prominent New York City merchant and city alderman, in 1813. George Douglas, a wealthy Scottish immigrant, acquired the estate from Robert B. Van Zandt in May 1835. Much of the landscaping, including a variety of exotic specimen trees, survives from the Douglas Manor estate, which was inherited by William Proctor Douglas after his father's death in 1862.

Most of the more than six hundred houses in the historic district were constructed in the early twentieth century as part of a planned suburb, also called Douglas Manor. It was developed by the Rickert-Finlay Company as part of the residential redevelopment of Queens, following its creation and annexation to

DOUGLASTON HISTORIC DISTRICT

the City of Greater New York in 1898. The houses were designed by local Queens architects in a variety of styles, including variants of Colonial Revival, Tudor Revival, English cottage, and Mediterranean Revival. One of America's first successful female architects, Josephine Wright Chapman, designed eight of the houses in the 1910s and 1920s. The Cornelius Van Wyck House built c. 1735 as a farmstead for an early Dutch settler, is the oldest extant house in the district and one of the oldest in New York City.

603

HARDENBERGH–RHINELANDER HISTORIC DISTRICT

EAST 17TH ST/IRVING PLACE HISTORIC DISTRICT

HARDENBERGH–RHINELANDER HISTORIC DISTRICT

MANHATTAN

DESIGNATED: MAY 5, 1998

Occupied, at times, by Andy Warhol and the Fertility Institute of New York, these seven buildings were designed by Henry J. Hardenbergh, the architect best known for the lavish Dakota Apartments and the Plaza Hotel. The Rhinelander family held a leading position in the development of the Carnegie Hill–Yorkville neighborhood, and these buildings were constructed for the Estate of William Rhinelander in 1888–89. His heirs owned all seven until 1948.

Six northern Renaissance Revival rowhouses and one French flat building line Lexington Avenue and the corner of 89th Street. The row houses, clad in red brick, brownstone, and terra-cotta, have a variety of window arrangements, entrance embellishments and roofline decorations. The flats building is clad in similar materials, yet employs other architectural features, such as a broken pediment entry surround, surmounted by a pedimented window. They all remain, at least partially, in use as residences, though some of the buildings now have storefronts.

EAST 17TH STREET/IRVING PLACE HISTORIC DISTRICT

MANHATTAN

DESIGNATED: JUNE 30, 1998

Ten residential buildings to the east of Union Square remain from the time when the neighborhood was filled with large residences for prosperous New Yorkers. Originally the street held a number of row houses, constructed in the 1800s, the oldest dates from about 1836–37. Most are single-family row houses built in the 1830s and 1840s, in the Greek Revival style, faced in red brick and brownstone, with small attic windows, simple molded cornices, and high stoops leading to parlor floor entrances. The Italianate town houses, dating from the 1850s, have brownstone facades.

Following the Civil War, Union Square became the heart of the city's art and entertainment district. The most famed residents were actress and interior designer Elsie de Wolfe, and her companion Elizabeth Marbury, a prominent theatrical agent. They lived at 49 Irving Place, as did photographer Clarence H. White, and, according to a false, but prevalent, legend so did Washington Irving.

A changing population prompted the construction of two flats buildings, the Fanwood (1890–91) and the Irving (1901–2) both employing some aspects of the Renaissance Revival style, which were quickly accepted into the fabric of the streetscape. Since 1955, one party has owned all of these buildings, which are still multiple dwellings.

NOHO HISTORIC DISTRICT

NoHo Historic District

Manhattan

Designated: June 29, 1999

The NoHo (from North of Houston) district's earliest extant structure is a house at 58 Bleecker Street, built for James Roosevelt in 1822–23, and by the 1840s, many fine residences were erected in the area. The majority of buildings are store and lofts constructed between 1850 and 1910, when this was one of New York City's major retail and wholesale dry goods centers. These buildings were lavish and ornate to attract customers, yet flexible enough for the sale and storage of goods. The earliest store and loft buildings took inspiration from the Italianate A. T. Stewart Store, and later

buildings reflect the various popular styles of the times in which they were built. Prominent materials include cast iron, masonry, brick and terra-cotta. In 1873–74, George E. Harney's retail store for men's clothier Brooks Brothers was constructed at 668–674 Broadway, a sign of the district's popularity for shoppers. The Wanamaker's Annex, (1903–7) by D.H. Burnham & Co. anchors the top of the district. Between 1910 and 1950, this area experienced a downturn as shops moved out and buildings fell into disrepair. But by the 1970s, the old manufacturing lofts were being converted to apartments, and today the layers of development are visible, as each style of building has been altered for continued use.

Fort Totten Historic District

Queens

Designated: June 29, 1999

In 1857, this 136-acre compound was known as The Fort at Willets Point. It was renamed in 1898 to honor Major General Joseph G. Totten, who helped devise the nation's coastal defense system prior to the Civil War. It became an important component of New York City's harbor defense. Most of the historic buildings were constructed between 1885 and 1914, including barracks for soldiers, a fire engine house, and a mess hall. Many of the buildings are brick, and take inspiration from the Colonial Revival style. The earliest surviving structure, known as Building 211, was constructed in the

FORT TOTTEN HISTORIC DISTRICT

Greek Revival style for the Willets family in 1829; it was remodeled in the Gothic Revival style in the late 1860s for the commanding officer.

The fort survives as one of the most intact, self-contained forts in New York City. Shifting defense methods are visible in the variations on building techniques and arrangements within the district. In the twentieth century, the fort was central to the advanced training of Army Engineers and research in military technology and military medicine. The majority of the buildings at Fort Totten have been turned over to the City of New York, and are now operated by the Fire and Parks Departments, as well as the Historic House Trust. The City of New York acquired ninety acres from the federal government in 2004 and plans to develop a new park on half the land.

STOCKHOLM STREET HISTORIC DISTRICT

STOCKHOLM STREET HISTORIC DISTRICT

QUEENS

DESIGNATED: NOVEMBER 28, 2000

This is a remarkable block composed of thirty-six brick row houses, flanking either side of Stockholm Street, between Woodward and Onderdonk Avenues. Designed by local architects Louis Berger & Company, and constructed by local developer Joseph Weiss, the houses were built for working-class German-Americans who were actively developing this area of Ridgewood, Queens, in the beginning of the twentieth century. Constructed in 1907–10, these houses feature full-width wooden porches, lined with columns. Projecting bays roll across the upper stories, and uninterrupted cornices create smooth rooflines stretching down the street. Bricks used in construction were manufactured on Staten Island, and this street stands out as the only one in Ridgewood that is still

MADISON SQUARE NORTH HISTORIC DISTRICT

paved with bricks. This remarkably intact street demonstrates an unusual harmony, during a period of rapid development that occurred as the working-class population grew in New York City.

MADISON SQUARE NORTH HISTORIC DISTRICT

MANHATTAN

DESIGNATED: JUNE 26, 2001

This district contains a wide assortment of building types and styles; its woven streetscape is a visual history of midtown Manhattan from the 1870s to the present. The ninety-six buildings, in approximately ten blocks, include are brownstone row houses, apartment buildings, hotels, and high rise office buildings, showing some of the work of the premier architects of their time: McKim Mead & White, Francis H. Kimball, Bruce Price, and Eli Jacques Kahn.

Madison Square Park opened in 1847, spurring the construction of the row houses; in the 1880s, many of these would be converted to commercial use. Speculative developers sought architec-

turally significant buildings in many fashionable styles, including Queen Anne, Moorish Revival, Classical Revival, Beaux-Arts, neo-Gothic and Art Deco. This area became an important entertainment center, later emerging as a mercantile district. After 1900, developers built for wholesale merchants, who required store-and-loft buildings, though many commercial offices were housed in the area as well. Few buildings have been constructed since the Depression era, and most buildings continue to serve their original or a similar purpose.

MURRAY HILL HISTORIC DISTRICT

MANHATTAN

DESIGNATED: JANUARY 29, 2002

EXTENDED: MARCH 30, 2004

This historic district takes its name from the eighteenth-century country estate of merchant Robert Murray, who arrived in New York City in 1753. In 1847, his heirs restricted all buildings developed on their land to residential and related uses. Three years later, changes to the now Park Avenue railway lines created a park and brought larger numbers to this area. Over the next twenty years, it became a community of upper-middle-class New Yorkers. The first homes were built on East 35th Street, numbers 102–112, 105–111, and 123–127 were constructed in 1852–54; these speculatively-built brownstones had Italianate detailing and tall parlor windows at the second story. Many later residences, some in the sec-

ond Empire style, housed well-known residents of the late nineteenth century, including Admiral David G. Farragut and Dr. Charles Parkhurst.

A second wave of development occurred between 1900 and 1910, when wealthy owners replaced row houses with mansions, like the Beaux-Arts-style Lanier House at 123 East 35th Street. In 1916, the architectural firm of Delano & Aldrich converted a stable on East 38th Street into a studio and office. They added a beautifully detailed neoclassical facade that complements the residential neighborhood around it.

The 2004 extension consists of two areas with a total of twelve buildings built between 1855 and 1950 that connect the two segments of the original district.

European immigrants. Many Italianate and neo-Grec row houses were constructed during this time, reflecting the popular styles of the city, and cast-iron window lintels, incised stone ornaments, and bracketed cornices are still visible today. At the end of the nineteenth century, store-and-loft buildings were widely constructed, and these became home to the center of the fur trade, and the textile and printing trades. After World War II, young artists converted these lofts into studios and galleries, and since the 1970s, many of these commercial buildings have been converted into residential use resulting in a vibrant mixed-use neighborhood.

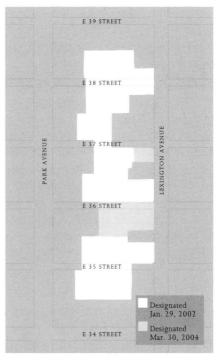

Designated Jan. 29, 2002

Designated Mar. 30, 2004

MURRAY HILL HISTORIC DISTRICT

NoHo East Historic District

Manhattan

June 24, 2003

The gentle curve of Bleecker Street and the closed vistas of Elizabeth and Mott Streets give this district a distinctive, close-knit, charming quality. The development of this area occurred in slow waves, allowing many early buildings to remain and retain their unique characteristics, while specific building use changed.

Clusters of Federal row houses remain from the early-nineteenth-century residential development. The area lost its fashionable reputation by the Civil War, and became a densely populated neighborhood of northern and eastern

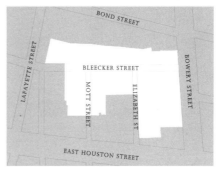

NOHO EAST HISTORIC DISTRICT

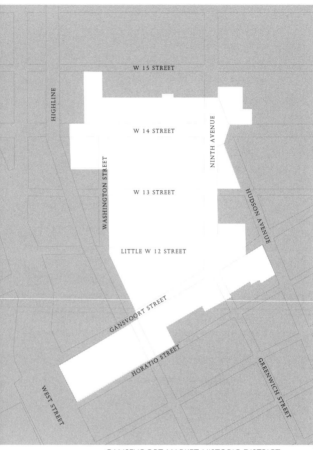

GANSEVOORT MARKET HISTORIC DISTRICT

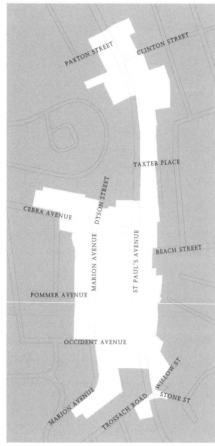

ST. PAUL'S AVENUE–STAPLETON HEIGHTS HD

GANSEVOORT MARKET HISTORIC DISTRICT

MANHATTAN

DESIGNATED: SEPTEMBER 9, 2003

Where the irregular grid pattern of Greenwich Village meets the 1811 Commissioner's Plan street grid, immense open intersections and unique public spaces are created. More than just defining this district as a unique neighborhood, these Belgian-brick-paved streets were the site of early food markets. Just prior to the War of 1812,

the only fort ever erected in Greenwich Village was constructed on pilings in the Hudson River and named after Revolutionary War hero Peter Gansevoort. By 1851, landfill had extended the area west of this district, and the districts oldest surviving buildings were constructed. At 3, 5, and 7 Ninth Avenue stand three Greek Revival houses, built in 1849 by the Estate of John G. Wendel, which remained in his family until 1943.

An open-air market was started in 1884 on Gansevoort Street, and three years later the West Washington Street Market opened, spurring the construction of many warehouses and market buildings, with their distinctive metal awnings. In 1890, a subterranean cold water pipe was installed, providing early refrigeration for meat and poultry in the market buildings. Today, many meatpacking companies still operate in this area, making unlikely neighbors to some of New York's most popular boutiques and restaurants.

ST. PAUL'S AVENUE–STAPLETON HEIGHTS HISTORIC DISTRICT

STATEN ISLAND

DESIGNATED: JUNE 29, 2004

"The St. Paul's Avenue-Stapleton Heights Historic District is an unusually well-preserved residential neighborhood. It is a significant reminder of the architectural and historic development of Staten Island and an excellent example of an early-nineteenth to early-twentieth-century suburban residential community.

Composed primarily of wood-frame freestanding houses, this type of neighborhood has become increasingly rare in New York City. The district encompasses ninety-two buildings located on or to the west of St. Paul's Avenue, a major thoroughfare that curves around Ward Hill and Grymes Hill, linking the villages of Tompkinsville and Stapleton."*

Douglaston Hill Historic District

Queens

Designated: December 14, 2004

"The Douglaston Hill Historic District consists of approximately 31 wood frame houses constructed largely between 1890 and 1930. Well-preserved turn-of-the-century residential suburbs of free-standing wood-frame houses are now becoming increasingly rare due to newer development or inappropriate alterations. The majority of the houses are designed using the Colonial Revival, Shingle or Queen Anne styles making the proposed district visually coherent.

Douglaston Hill was laid out as a suburban development in 1853 in anticipation of the Flushing & Northside Railroad line. Development did not start, however, until the 1890s. Most of the houses in Douglaston Hill combine stylistic elements from those architectural styles popular from 1890 to 1900. The picturesque qualities of the Colonial Revival, Queen Anne and Shingle styles with their intersecting rooflines, tall chimneys, clapboard and shingle cladding as well as spacious porches link many of the houses from this period.

The period from 1900 to 1930 was one of enormous growth for the borough of Queens and Douglaston. One observer noted "By 1910 the old farms are disappearing . . . by 1920 our village assumes an air of suburban dignity." The Douglaston Hill Historic District preserves this now rapidly disappearing era of the suburban development of Queens."*

Proposed Fieldston Historic District

The Bronx

Heard on: December 2, 2003

"The Fieldston neighborhood is one of New York City's most beautiful and well-planned early twentieth century suburban communities consisting of approximately 258 houses and related structures.

The land comprising Fieldston was purchased by Joseph Delafield in 1829 as part of a larger estate. In 1909, a year after subway services reached 242nd Street and Broadway, the owners of the Delafield estate decided to develop the property by selling several acres to Manhattan Teachers College, with the rest to be a "private park devoted exclusively to country homes." The estate hired engineer Albert Wheeler, who finalized the layout in 1914. Wheeler's plan incorporated winding roads that followed the natural topography and preserved as far as possible its "wooded knolls, dells, and hillocks." House plots varied in size from an acre to less than a quarter acre, to ensure variety and make "flat uninteresting rows of suburban houses impossible."

By 1923, only 80 of the lots had been developed and the Delafield Estate ordered that the property be liquidated. Fearing that the property would be developed with large apartment houses, in August 1923 the residents formed the Fieldston Property Owners Association. In February 1924, FPOA formed Fieldston Inc., which raised the money to purchase all the unsold property.

DOUGLASTON HILL HISTORIC DISTRICT

PROPOSED FIELDSTON HISTORIC DISTRICT

While the majority of buildings date from the early 20th century, there are a number of significant modern buildings that were built after FPOA's relaxation of its design guidelines in the 1950s. The proposed Fieldston Historic District is a rare, largely intact example of a romantic planned suburban community that has evolved over time."*

BROOKLYN

183-195 Broadway Building, 1990

103 Broadway, 2005

Bedford-Stuyvesant/Expanded Stuyvesant Heights HD, 1993

Brooklyn Trust Co. Bank and Interior
177 Montague Street, 1993

Christian Duryea House
562 Jerome Street, 1985. Demolished.

Church of the Anunciation Rectory and School, 255 N. 5th Street, 1993

Coney Island Pumping Station
2301 Neptune Avenue, 1980

Green-Wood Cemetery, 1981

Lady Moody-Van Sicklen House
27 Gravesend Neck Road, 1970, 2004

Namm's, 452 Fulton Street, 2004

Offerman Building, 505 Fulton Street, 2004

P.S. 90, 2274 Church Avenue, 1989

Pool: Betsy Head Play Center, 1990

Pool: McCarren Play Center, 1990

Pool: Red Hook Play Center, 1990

Pool: Sunset Park Play Center, 1990

Sea Gate Chapel, 3700 Surf Avenue, 1992

St. Ann's Protestant Episcopal Church Interior, Clinton Street, 1991

St. Augustine's Roman Catholic Church and Rectory, 116 Sixth Avenue, 1980

St. Barbara's Roman Catholic Church
Central Avenue, 1980

Union Methodist Church,
121 New York Avenue, 1980

THE BRONX

American Bank Note Company Printing Plant, Lafayette Avenue, 1992

Delafield Estate Hunting Lodge, 2004

Eli Nadelman House
4715 Independence Avenue, 1970

Estey Piano Company Factory
E. 132nd Street, 1992

First Presbyterian Church of Williamsbridge and Rectory, E. 225th Street, 1980

Gustav Schwab House
University Avenue on the Bronx Community College Campus, 1991

Immaculate Conception Church of the Blessed Virgin Mary, Convent, and Priests'

Residence, East 150th Street, 1980

Joseph Bicknell Residence, Post Road, 1993

Loring Place Houses
1928 Loring Place South, 1983

Mott Avenue Control House
149th Street off the 2/4/5 IRT Lines, 1979

Noonan Plaza Apartments
105-145 West 168th Street, 1992

P.S. 27, 519 St. Ann's Avenue, 1992

Pool: Crotona Park Play Center and Interior, 1990

Orchard Beach Bathhouse, 1992

Samuel Babcock House,
5525 Independence Avenue, 1970

Union Reformed Church of Highbridge
1272 Ogden Avenue, 1980

W.E. Ball House, 225 West 254th Street, 1970

Westchester-Bronx Branch of YMCA
2244 Westchester Avenue, 1966, 1970

MANHATTAN

190 Bowery, 2004

134 Greenwich Street Building, 1965

141 MacDougal Street Building, 1967

142 West 18th Street, 1986

177 West Broadway House, 1989

2 Oliver Street House, 1966

412 East 85th Street House, 1967

416-424 Washington Street, 1991

42nd Street Theaters and Interiors, 1982

45-47 Park Place Building, 1989

57-59 West 16th Street, 1986

63 Nassau Street Building, 1967

65 Liberty Street Interior, 1979

67 Greenwich Street Building, 1965, 2004

7 Leroy Street House, 1966

94-100 Lafayette Street, 1989

94-96 Greenwich Street, 1970

All Saint's Church, School and Rectory
East 129th Street, 1966, 2004

AT & T Building Interior, 195 Broadway, 1980

Baumann Brothers Store
22-26 East 14th Street, 2002

Bergdorf Goodman, 754 Fifth Avenue, 1970

Brill Building, 1619 Broadway, 1985

311-315 Broadway, 1989

Broadway Fashion Building
2309-2626 Broadway, 1987

Carnegie Hall Interior, 1985

Chambers Street Buildings
120, 122, 143 Chambers Street, 1989

Church of St. Paul the Apostle,
8 Columbus Avenue, 1966

Columbia University Club
4 West 43rd Street, 1983

Community Synagogue Center

323 E. 6th Street, 1967

150 East 38th Street, 1966

24 East 82nd Street, 1973

Excelsior Power Company Building
33-43 Gold Street, 1977

Expanded Site: Church of the Transfiguration, 1 East 29th Street, 1984

Fire Engine Co. 84,
515 West 161st Street, 1991

Fire Engine Co. No. 53
175 East 104th Street, 1991

Fire Hook & Ladder Co. 14
120 East 125th Street, 1991

Fiss Doerr & Carroll Stables
147 East 24th Street, 1989

Former Fire Engine Co. 79
160 Chambers Street, 1989

Governor Alfred E. Smith House
25 Oliver Street, 1991

Henry Street Buildings
48-50 Henry Street, 1965

Hotel Churchill, 252 West 76th Street, 1984

IRT Powerhouse
West 58-59th Streets, 11th-12th Avenues, 1990

Isaac T. Hopper Home
110 Second Avenue, 1970

James McCreery & Co. Building
801-807 Broadway, 1966

Loew's 175th Street Theater, 1970

Morningside Park, 1991

41–55 Murray Street, 1989

Mutual Reserve Fund Building
305 Broadway, 1989

New Apollo Theater Interior
West 43rd Street, 1982

P.S. 72, 131 East 104th Street, 1991

Pool: Highbridge
2301 Amsterdam Avenue, 1990

Pool: Jackie Robinson
89 Bradhurst Avenue, 1990

Pool: Thomas Jefferson
2180 First Avenue, 1990

President Chester A. Arthur House
123 Lexington Avenue, 1966

Renaissance Theater and Casino
2341-2359 Adam Clayton Powell Boulevard, 1991

Riverside/West 107-108 Street HD, 1968

Rogers Peet & Co. Building
258 Broadway, 1989

Sacred Heart of Jesus Roman Catholic Church
457 West 51st Street, 1985

Salvation Army Headquarters
120 West 14th Street, 1990

St. Aloysius Church
209-211 West 132nd Street, 1966, 2004

St. Benedict the Moor Roman Catholic Church, 342 West 53rd Street, 1966

St. Joseph's Church
401-403 West 125th Street, 1966

St. Michael's Episcopal Church, Parish House, and Rectory, West 99th Street, 1980

St. Paul's Church and School
121 East 117th Street, 1966

St. Paul's Rectory, 113 East 117th Street, 1966

St. Stephen's Church
149 East 28th Street, 1966

57 Sullivan Street House, 1970

Temple Tifereth Israel, 336 East 14th St, 1966

Union Square Park, 1977

Warren Street Buildings
41–53 Warren St, 1989

West 101st Street HD, 1986

West 16th Street Buildings
27-29, 43-47 West 16th Street, 1986

West 82nd Street HD, 1992

West 84th Street HD, 1993

West 89th Street Stable
167-171 West 89th Street, 1988

West Fourth Street Houses
132-134 West 4th Street, 1967

Windemere Apartments
400-406 West 57th Street, 1988, 2005

Wolcott Hotel
4-10 West 31st Street, 1991

Worth Street Buildings
39-41 Worth Street, 1989

YMCA, Jackie Robinson Youth Center
181 West 135th Street, 1991

Yuengling Brewing Co.
1361-1369 Amsterdam Avenue, 1991

QUEENS

191-01 Hollis Avenue House, 1983

Steinway Houses 20th Avenue, 40th-41st Street. Designation rescinded.

66-45 Forest Avenue House, 1983

Bell Homestead, 38-08 Bell Boulevard 1970. Demolished.

First Reformed Church and Sunday School of College Point
14th Avenue, NW corner of 119th Street, 1980

Morrell-Morgan House
Little Neck Parkway, 1967. Demolished.

Old Calvary Cemetery Gatehouse
Greenpoint Avenue, opposite Gale Avenue, off Borden Avenue, south side, 1973

P.S. 66 (85-11 102nd Street), 1981

Pepsi Cola Sign, 1988

Pool: Astoria Play Center, 1990

Sohmer & Co. Piano Factory
31-01 Vernon Boulevard, 1990

Spanish Towers
34-30, 34-32, 34-34, 34-36, 34-38, 34-42, 34-44, 34-46, 34-48, 34-52 75th Street, 1990

St. James Church, 84-07 Broadway, 1970

Strang House, 31-48 29th Street, 1973 Demolished.

Triboro Theater, 30th Avenue and Steinway St. 1973. Designation rescinded. Demolished.

STATEN ISLAND

122 Androvette Street House
Kreischerville, 1991

23-25 Belair Road House, 1980

387 St. Paul's Avenue House, 1980

71 Harvard Avenue House, 1981

92 Harrison Street House, 1980

218 Centre Street, 2004

Black Tupelo Tree
Rockland and Slayton Avenues, 1975

Blomeley House, 4927 Arthur Kill Road, 1966

Captain Cole House
1065 Woodrow Road, 1966

Christ Church, 76 Franklin Avenue, 1966

Cozine House, 40 Watchogue Road, 1979

Crocheron House, 47 Travis Avenue, 1970

Decker House, 2091 Forest Avenue, 1966

Dorothy Day Historic Site, calendared but not heard 2004. Demolished

Drake-Dehart House
134 Main Street, Tottenville, 1991

Former Westfield Township District School 7 (P.S. 4)
4210 Arthur Kill Road, 1991

Former Westfield Township District School 5 (P.S. 1 Annex), 58 Summit Street, 1991

Fountain Family Graveyard
Richmond and Clove Roads, 1966

Frost Building, Staten Island Hospital
101 Stanley Avenue, 1991

General William B. Ward House
631 Howard Avenue, 1991

George W. Curtis House
234 Bard Avenue, 1966

Hinkling Hollow, Flagg Estate Cottage
309 Flagg Place, 1993

Honeymoon Cottage, Flagg Estate Cottage
155 Four Corners Road, 1993

Horton's Row
411-417 Westervelt Avenue, 1991

House and Cottage, Flagg Estate Cottage
45 West Entry Road, 1993

J. Winant House, 2390 Arthur Kill Road, 1966

Jonathan Goodhue House
304 Prospect Avenue, 1966

King House, 29 McClean Avenue, 1966

Kornbau House, 2585 Amboy Road, 1966

Lakeman House, 2286 Richmond Road, 1966

Mariners' Family Home
119 Tompkins Avenue, 1966

Mariners' Harbor Baptist Church
72 Union Avenue, 1980

Middletown Township District School 2
98 Grant Street, 1991

Nathaniel J. Wyeth House
190 Meisner Avenue, 1966

Nathaniel Marsh Home, 30 Belair Road, 1966

New Dorp Moravian Church, Parish House, and Cemetery
1256 Todt Hill Road, 1979

Nicholas Killmeyer Store and Residence
4321 Arthur Kill Road, Kreischerville, 1991

Nicholas Muller House
200 Clinton Avenue, 1966

Paul Revere Smith House, Flagg Estate Cottage
143 Four Corners Road, 1993

Planters' Hotel, 360 Bay Street, 1966

Pool: Tompkinsville Play Center and Bathhouse Interior, 1990

Princess Bay Lighthouse and Keeper's House
Mount Loretto, 1966

Reformed Church of Staten Island
54 Port Richmond Avenue, 1966

Richmond County Country Club
135 Flagg Place, 1966

Rutan-Journeay House
7647 Amboy Road, 1991

Sailors Snug Harbor Historic District
1000 Richmond Terrace, 1984

Seaman's Cottage, 218 Centre Street, 2004

School District #3 Building
4108 Victory Blvd, 1966

South Gatehouse, Flagg Estate Cottage
180 Coventry Road, 1993

St. Mary's Church, Rectory, and Parish Hall
101 Bay Street, 1980

St. Mary's Roman Catholic Church and Rectory, 1101 Bay Street, 1966

St. Paul's Methodist Episcopal Church
7558 Amboy Road, 1991

Staten Island Savings Bank
81 Water Street, 1966

Sunny Brae House, 27 Colonial Court, 1966

T. Robjohn House, 651 Broadway, 1966

Trinity Lutheran Church
309 St. Paul's Avenue, 1977

Vanderbilt Mausoleum and Cemetery, 1980

W.T. Garner Mansion
Castleton Avenue and Bard Avenue, 1966

INDEX

Bold type refers to designated landmark
buildings and historic districts (HD)

PHOTOGRAPHY CREDITS

Christine Osinski, coordinator: 62 left, 69, 84 top, 87 top, 112 bottom, 113 left, 119 center, 121 top, 129 bottom, 134 left, 144, 149 left, 162 bottom, 163 top, 175 right, 199 right, 200 top, 205 left, 210 top, 214, 215 right, 235 bottom, 264, 285 right, 310 right, 329, 336 left, 347 top, 350 left, 352, 389 left, 390, 392 left, 393, 400 bottom, 402 bottom, 403, 404 right, 410 center, 431 left, 446 top, 452 top, 462 left, 490 left, 518 top, 528 top, 534, 539, 545

Leela Accetta: 155, 335, 406 left

David Allen: 54, 56 bottom, 57, 58 bottom, 61 left, 62 right, 74 left, 102 left, 124 top and bottom right, 130 bottom, 141 bottom, 154 top, 158 bottom, 171 right, 179 bottom, 186 top, 189 left, 193 left, 204 center, 258 left, 330 left, 362 left

American Museum of Natural History: 209 bottom

Argenis Apolinario: 273 right

Robert Baldridge: 457 top

Stephen Barker: 546 left

Richard Barnes for Polshek Partnership Architects: 309 bottom.

Max Becher and Andrea Robbins: 71 top, 73, 103 left, 143, 145 bottom, 162 top, 194 top, 201 top, 212 top right, 228, 255 right, 269 top, 282 bottom, 287, 301 bottom, 333 right, 369, 380 right, 389 right, 425, 469 right, 472 top, 522 right, 540 left, 542 top

Kaija Berzins: 150 left, 188 right, 327 right, 541 right

Olivia Biddle: 153 right, 271 left, 296 right, 331, 345 top, 353 top, 358 top, 366 bottom, 388 left, 463, 530 top, 560 top.

Julio A. Bofill: 185 left, 234 right, 235 top, 244 right, 307 top, 327 left, 448 left, 461 left, 464 right, 482 bottom, 489 bottom, 525 right

Andrew Bordwin: 82 top, 95 bottom, 102 center and right, 105 top, 108 top and bottom right, 117 right, 130 top, 146 bottom, 148 top, 153 left, 202 left, 232 right, 252 right, 254 right, 266 bottom, 316 right, 324 bottom left, 334 right, 354 left, 416 top, 418 bottom, 458 bottom, 459, 472 bottom, 490 right, 529 bottom.

Caroline Brown: 66 top

Building Conservation Associates: 200 bottom

Richard Cappelluti: 61 right, 138 top, 160 right, 272 left, 464 left, 470 bottom, 488 bottom, 489 top, 506 top, 546 right, 553, 562 right

Matthew Cazier: 218 top, 270 left, 280 top, 281 top, 289 bottom, 312 bottom, 314 bottom, 324 right, 325 left, 332 right, 333 left, 349 left, 405 left.

Lea Marie Cetera: 53 top, 196 right

Rona Chang: 156 left, 166 right, 173 bottom, 198 left, 224 right, 260 right, 296 left, 341 left, 381 top, 411 left, 414 right, 449 bottom, 481 top right and bottom left, 513 left

Alan Chin and Jorge Roldan: 252 left, 260 left, 281 bottom, 283 top, 284 top, 323, 358 bottom, 366 top, 413 right, 421 left, 429 left, 445 left, 448 bottom, 465 top, 502 bottom, 514 top, 542 bottom

Teresa Christiansen: 250 right, 408 bottom, 409 left, 420 bottom, 506 bottom, 523, 532 top, 550, 558 top

Eric C. Chung: 64 top, 67 left, 221 bottom, 229, 248 right, 251 right, 308, 319 bottom, 328 left, 370 bottom right, 372 bottom, 447, 474, 516, 535 left, 544 left, 561 bottom, 564 right

Clifton Cloud and Brian Downey: 480 bottom

Andy Cook: 168

Reuben Cox: 186 bottom, 245 right, 253 right, 375 left, 384 top, 410 left, 445 right, 462 right

Whitney Cox: 359, 494 center

Jeremiah Coyle: 223 right, 243, 320 right, 370 top left, 399 top, 408 top, 496 bottom, 501, 509 left

Carin Drechsler-Marx: 76, 77, 80, 81, 92 left, 122 right, 208 top, 209 top, 247 right, 275 bottom, 290 center, 300 left, 337, 344 right, 360 center and right, 364, 376 bottom, 399 bottom, 416 bottom, 417, 418 top, 441 top and second from bottom, 442 top and second from bottom, 468 second from bottom, 469 left, 475 top, 479 bottom, 487 center, 491, 495, 499, 500 top left, 512 bottom, 521

Joseph Durickas: 241 left, 286 right, 497 bottom

Nathaniel Feldman: 75, 83, 161 top, 190, 191 second from bottom and bottom, 212 top left, 262 right, 277, 304, 309 top, 344 left, 350 right, 365 left and center, 373 bottom, 375, 377, 395 bottom, 429 right, 434 right, 435 right, 444 left, 449 top, 451 right, 453 bottom, 460 right, 461 right, 471 top, 492 right, 500 top right, 526 right, 539 center, second from top and bottom

Stephen Fischer: 62 center, 64 bottom, 106 right, 159 top, 170 top, 175 left, 179 top, 181, 184 left, 187 bottom, 201 bottom, 207 left, 246 bottom, 267 left, 275 top, 283 bottom, 311, 322 bottom, 353 bottom, 363 bottom, 386 right, 395 top, 424 bottom, 450 right, 481 top left and bottom right

Karen Fried: 74 left, 84 bottom, 466 top

Andrew Garn: 65 left, 88 bottom three images, 96 top, 101 right, 111, 131, 140 right, 141 top, 147, 172 top, 174, 198 top, 208 bottom, 226 left, 237 left, 239 right, 242, 246 top, 248 left, 265 bottom, 272 right, 276 top, 278 bottom right, 280 bottom, 282 top, 292 right, 300 right, 301 top, 303 top, 306 left, 317 left, 325 right, 330 right, 336 right, 361 bottom, 368 right, 386 left, 422 left, 423 top, 440 top, 444 right, 457 bottom, 491 left, 498 bottom, 505 top, 515 right, 520 right, 522 left, 551 right, 554, 559

Jerry Ghiraldi: 322 top, 405 right, 415 right, 437 bottom, 465 right, 513 right, 519 left

Lesley-Ann Gliedman: 176

Tony Gonzales: 318 top, 363 top, 397 left, 420 top, 446 bottom, 509 right, 540 right, 556 bottom, 564 left, 565.

Gwathmey Siegel Associates Architects: 394

Timothy Dlyn Haft: 132 bottom, 171 left, 188 left, 222 right, 271 right, 293, 318 bottom, 370 top right

Serge Hambourg: 193 right, 240 right, 302 right, 346 top, 413 left, 424 top; 548 left.

Jeanne Hamilton: 50, 51 right, 52 rows 1 and 2, 53 bottom, 55 left, 56 top, 59, 60, 63, 65 right, 68, 70 top, 71 bottom, 72, 82 bottom, 85 right, 90 left, 191 second from top, 231 top.

David Heald, Solomon R. Guggenheim Museum: Back endpaper and 560 bottom

Robert Hickman: 377 right

HI-USA: 231

Kristin Holcomb: 204 right, 218 bottom, 257 left, 261 right, 299 right, 313 bottom, 349 right, 357, 392 right, 398 left, 410 right, 480, 493 right, 496 top and center, 536 top, 543, 563, 566.

Liz Hunter: 92 right, 93 center, 117 left, 118, 119 top, 123 top, 299 top and bottom left, 527 left, 541 left, 548 right

Claudia Joskowicz: 207 right, 231 bottom, 270 right, 290 left, 398 right, 430 right, 455 left, 465 left, 526 left

Abby Weitman Karp: 51 left, 52 rows 3 and 4, 66 bottom, 95 top, 115 top, 128 left, 137, 151 bottom, 178 bottom, 183 top, 184 right, 185 right, 192 left, 206 left, 216 left, 220, 222 left, 254 left, 256 right, 338 bottom, 339 bottom, 379 bottom, 467

Jeff Kaufman: 355 top, 427, 531, 547

James Kendi: 227 left, 284 bottom, 384 center, 423 bottom, 434 left, 555 top.

Michael Kingsford: 135 bottom, 486 right

Robert Kozma: 121 bottom, 178 top, 194 bottom, 215 left, 234 left, 244 right, 245 top, 273 left, 302 top, 348 right, 373 top, 412.

James Lane: 91 top, 152 top, 180 top, 216 right, 285 left, 294, 332 left, 518 bottom

Cynthia Larson: 158 top, 439, 451 left

Louis Armstrong House: 428.

Kai McBride: 88 top, 132 top, 142 top, 196 center, 230, 346 bottom, 383 right, 437 top.

Barbara Mensch: 55 right, 70 bottom, 85 left, 87 bottom, 113 right, 122 left, 182 right, 212 bottom left and bottom right, 249 top, 340 bottom, 378 left, 419 top, 421 bottom, 425 right, 436, 454.

Metropolitan Museum of Art: 210 bottom

Brian L. Mikesell: 203 right, 236, 268 right, 274 right, 310 center, 319 top, 372 right, 401, 455 center and right, 511 right, 551 left

Frederick J. Miller: 226 right, 400 top, 406 right, 407 left

Laura Mircik-Sellers: 49, 379 top, 415 right, 478 left, 488 top, 520 left, 555 bottom

Andrew Moore, New York City Art Commission: Front endpaper.

Vinny Montuoro: 317

Laura Napier: 44–45, 105 bottom, 107 right, 166 left, 177 top, 180 bottom, 191 top, 195 left, 256 top, 266 top, 295 left, 309 bottom, 343, 356, 362 right, 409 right, 511 left, 524 bottom, 528 bottom, 557 bottom

New York City Landmarks Preservation Commission: 197 right, 241 right, 268 left, 313 top, 345 bottom, 387 left, 391 center, 430 left, 440 bottom, 441 second from top and bottom, 442 second from top and bottom, 443, 468 second from top and bottom, 471 bottom, 475 bottom, 485, 487 bottom, 491 right, 494 left, 495 left and bottom right, 496 center, 500 bottom left and right, 504 bottom, 505 bottom, 507, 508 left, 512 right, 552 top

Miwa Nishio: 290 right, 295 right, 306 right, 381 bottom, 391 right, 432 bottom

Claudio Nolasco: 101 center, 269 bottom, 558 bottom

Ohlhausen Dubois Architects: 240

Perkins Eastman Architects: 239 left

Cosmo Prete: 93 right, 94 left, 96 bottom, 124 bottom left, 135 top, 139 bottom, 150 right, 151 top, 152 bottom, 164 bottom, 167, 249 bottom, 250 left, 257 right, 291 bottom, 396 top, 428 left, 466 bottom

Ronnie Quevedos: 338 top, 385 left

Nina Rappaport: 58 top, 161 bottom, 183 bottom, 192 right, 196 left, 204 left, 262 left, 278 top left, 324 top left, 351, 370 bottom left, 404 left, 411 right, 428 top, 470 top, 476 top, 530 bottom

Laszlo Regos: 145 top **Cervin Robinson:** Cover, 377

Steven Tucker: 46, 67 right, 78, 86, 89, 97 bottom, 99 left, 104, 106 left, 107 left, 119 bottom, 120, 127 left, 129 top, 133, 134 right, 140 left, 146 top, 154 top left, 157, 159 bottom, 163 bottom, 164 top, 177 bottom, 182 left, 189 left, 195 right, 206 right, 211, 217 right, 219 right, 223 left, 227 right, 233 left, 238 right, 255 left, 258 right, 259 top, 261 left, 267 left, 278 right and bottom left, 286 left, 288, 289 top, 297, 307 bottom, 310 left, 312 top, 320 left, 321 bottom, 326 top, 328 right, 334 left, 338 center, 340 top, 347 bottom, 355 bottom, 359, 360 left and center, 365 right, 368 right, 374 bottom, 383 left, 397 center and right, 407 right, 414 left, 419 bottom, 426 bottom, 431 right, 433, 438, 440 center, 453 top, 458 bottom, 460 left, 468 top, 470 center, 483, 508 bottom, 510 left, 514 bottom, 519 top right, 533, 552

Michael Vahrenwald: 114 top, 116, 139 top, 173 top, 238 left, 247 left, 321 top, 342 right, 436 bottom, 476 bottom, 477

Sarah van Ouwerkerk: 103 right, 138 bottom, 197 right, 199 left, 232 left, 263, 314 top, 382 left, 388 right, 527 right

Rene Velez: 259 bottom, 341 right, 342 left, 367, 376 bottom, 450 left, 484 bottom, 503, 524 top

Bill Wallace: 79, 90 right, 91 left, 94 right, 97 top, 100 left, 108 top and bottom right, 110, 112 top, 114 bottom, 115 bottom, 126, 127 right, 128 right, 136, 142 bottom, 145 top, 149 right, 154 bottom, 172 bottom, 197 left, 205 right, 224 left, 233 right, 251 center, 265 top, 274 left, 291 top, 292 left, 348 left, 380 left, 382 right, 422 center to right, 426 top, 432 top, 473, 482 top

Paul Warchol for Davis Brody Bond: 289 top

Jennifer Williams: 95 center, 98, 123 bottom, 160 left, 165, 203 left, 237 right, 253 left, 315, 326 bottom, 478 right, 535 left

Peter Wohlsen: 497 top, 525 left, 557 top, 561 left

Bryan Zimmerman: 47, 99 top, 100 center and right, 101 left, 202 right, 221 top, 225, 251 left, 276 bottom, 374 top, 378 right, 387 right, 396 bottom, 435 left, 486 left, 502 top, 510 right

Historic District Maps drawn by Alexandria Lee

ACKNOWLEDGMENTS

This book is the result of a collaborative effort involving many persons, including the owners, occupants, and managing agents of landmark buildings, concerned citizens, photographers, architects, preservationists, and a wide range of individual and institutional sources that help to continue to focus on the importance of the architecture of New York City. My special thanks to the late Paul Gottlieb, Eric Himmel, the Research Department of the New York City Landmarks Preservation Commission, Christine Osinski, Merin Urban, Michaela Bernhauer, Serianne Worden, Cynthia Tripp, Rachel Millman, Michael Kylis, Deborah Bershad, Christopher Gray, David Dunlap, Simeon Bankoff, Robert Tierney, Patrick Firmenich, and Carl Spielvogel.

Space does not permit the inclusion on this list of numerous others who gave their time, knowledge, and support to this project. To those whose names may inadvertently have been omitted, and to those who wished to remain anonymous, I extend my deep appreciation. Without their invaluable assistance, *The Landmarks of New York* would not have been possible.

Barbaralee Diamonstein-Spielvogel

*Entries marked with an asterisk are quoted directly from the designation reports of the New York City Landmarks Preservation Commission.